D1264921

THE ART OF BYZANTIUM

AND THE MEDIEVAL WEST:

SELECTED STUDIES

N
6250
.K57
1976

WITHDRAWN

THE ART OF BYZANTIUM

AND THE MEDIEVAL WEST:

SELECTED STUDIES

by ERNST KITZINGER

Edited by W. Eugene Kleinbauer

INDIANA UNIVERSITY PRESS

Bloomington / London

Copyright © 1976 by Indiana University Press
ALL RIGHTS RESERVED
No part of this book may be reproduced or utilized in any form
or by any means, electronic or mechanical, including photocopying
and recording, or by any information storage and retrieval system,
without permission in writing from the publisher. The Association
of American University Presses' Resolution on Permissions constitutes
the only exception to this prohibition.
Published in Canada by Fitzhenry & Whiteside Limited,
Don Mills, Ontario
Manufactured in the United States of America

Library of Congress Cataloging in Publication Data
Kitzinger, Ernst, 1912–
 The art of Byzantium and the medieval West.
 Includes bibliographical references and index.
 CONTENTS: A marble relief of the Theodosian period.—
On the interpretation of stylistic changes in late antique
art.—Mosaic pavements in the Greek East and the question
of a "Renaissance" under Justinian. [etc.]
 1. Art, Byzantine—Addresses, essays, lectures.
 2. Art, Medieval—Byzantine influences—Addresses,
essays, lectures. I. Title.
N6250.K57 709'.39'5 75–34728
ISBN 0–253–31055–5 1 2 3 4 5 80 79 78 77 76

⊷⟦ CONTENTS

[V

30453

✥[FOREWORD

Some years ago as I began to conceive a proposal for an anthology of twentieth-century writings on the visual arts by scholars of different nationalities, I realized that a collection that reproduces a single statement by each of the authors it anthologizes threatens to do injustice to the range of interests and scholarship pursued by minds as distinguished as those whose work I decided to draw from. In the preface to the volume that was eventually published I tried to underscore this danger, and in an attempt to set the record straight I introduced each writing by a brief biographical sketch of its author and a selected listing of his salient contributions. Nonetheless, it is true that some readers fail to consult prefaces, and I continue to be concerned that they might mistakenly assume that the authors whose writings the volume republishes tended to adopt a single method and approach in their scholarship. Even a volume composed entirely of the papers written by one historian of art, such as the collection that James Ackerman, Elisabeth B. MacDougall, and Richard Pommer compiled and edited from the writings of Richard Krautheimer (*Studies in Early Christian, Medieval, and Renaissance Art*, New York, 1969), distorts through the very process of selection (and, in the case of the Krautheimer volume, the translation of some papers from foreign languages into English as well) the extraordinary breadth and insight of its author's methods and points of view.

While collaborating with Ernst Kitzinger on the selection of papers for this volume I tried to keep these problems in mind but cannot claim to have attained complete success in avoiding or solving them. For this project one objective was to republish as many of his papers as the physical limitations of a single volume would permit, and to let the individual papers appear without abridgment and with all the illustrations and bibliographical apparatus that originally accompanied them. A second objective was to marshal papers that would appeal to the beginning student and the specialist alike. And a third was to compile a volume that would not only contribute to the historiography of art in our times, but also present a body of writings in a single volume by one of the leading and most gifted scholars to

[VII

have elucidated, probed, and interpreted critical aspects of late antique, Byzantine, and western medieval art.

In consultation with me, Ernst Kitzinger suggested the thirteen papers that are reproduced in this collection. Rather than arrange them by different approaches and methods, he tried to choose papers that interconnect with other papers, are not narrow in scope, and are not (in some instances) easily accessible. While this volume has been conceived as a body of interconnected writings that illustrate principal characteristics and problems of the visual arts from the fall of the Roman Empire to the Indian summer of Byzantium in the East and the Gothic age in western Europe, it is, as Kitzinger writes in the preface to this book, not intended as a systematic and all-inclusive treatment of its subject.

This volume serves not only as a primer on the origins and development of the visual arts in Byzantium and the Latin West but also as a source book on modern historiography. It comprises thirteen papers that exemplify the many facets of Ernst Kitzinger's scholarship. These papers have been published over a period of twenty-five years and disclose that he has not been committed to the application of a single method like formal analysis or iconography, nor has he been attempting to impose upon his readers the validity of any grand, comprehensive theory to explain the arts of Byzantium and medieval Europe. Rather, he has always been fully aware of the strengths and limitations of the various methods that have been employed by modern art historians, and he is fully capable of applying and modifying them in accordance with a wide range of works of art that pose quite different problems. Equally important, he never loses sight of the salient artistic or visual qualities of the work of art. He fully realizes that each individual work is characterized by a unique amalgam of such qualities. At all times he bears in mind that he is dealing with specific works of *art,* and he has been dedicated to the task of shedding light on the crucible of artistic creation from which they have sprung.

He has also focussed on the external factors motivating and shaping the artist and his work. The wide range of artistic problems that he has tackled reveals a critical "eye," insight, and flexibility of thought. For these reasons it is not possible to pigeonhole the contributions of Ernst Kitzinger. His scholarship does not fall naturally into this or that category of methodology; it is *sui generis.*

* * *

Born at Munich in 1912, Ernst Kitzinger attended the Max Gymnasium in that city from 1922 to 1931. From 1931 to 1934 he

studied art history, archaeology, and philosophy at Munich and Rome Universities, where his principal teachers were Wilhelm Pinder, Ernst Buschor, and Pietro Toesca, and in 1934 he received his doctorate from Munich University. His dissertation was entitled *Römische Malerei vom Beginn des 7. bis zur Mitte des 8. Jahrhunderts* ("Roman Painting from the Beginning of the Seventh to the Middle of the Eighth Century") and deals with the early medieval styles of wall paintings and mosaics in the city of Rome. It contended persuasively that these murals illustrate a variety of styles that range from a pure Hellenistic illusionism to a flat and strongly linear abstraction, and that during the early Middle Ages Roman wall paintings fail to exhibit any single Darwinian-like evolution of style from the one artistic mode to the other. It also demonstrated that Roman wall painting fell under the influence of fresh waves of Hellenistic style that came from the East Mediterranean. Although no particular locality was identified as the home of that style, this demonstration amounted to a powerful refutation of the theory of an Alexandrian school as a stronghold of Hellenism, a theory that had been evolved and disseminated by Charles Rufus Morey and the Princeton "School of Medieval Art History" in the 1920s and 1930s (see Myrtilla Avery, "The Alexandrian Style at Santa Maria Antiqua, Rome," *Art Bulletin,* 7 [1925], pp. 131–149). Some of the basic tenets first proposed in Kitzinger's dissertation have been followed up in his more recent publications, two of which appear in this volume: "On Some Icons of the Seventh Century" (1955) and "Byzantine Art in the Period between Justinian and Iconoclasm" (1958) (the second of which, incidentally, remains today the best single survey of our knowledge of the visual arts produced in the East Mediterranean before Iconoclasm). A model of scholarship to which specialists continually refer as a work of insight and fundamental importance, and from which American graduate students can inform themselves on the virtues of brevity, precise and sensitive stylistic analysis, and clear organization of thought, this dissertation introduced a major figure into the field.

From 1935 to 1940 Kitzinger served as an assistant in the Department of British and Medieval Antiquities in the British Museum, and this position provided him with the opportunity not only of studying a wide range of materials in England, but also of publishing a number of still valuable papers, including articles on the silver of the Sutton Hoo ship burial, Anglo-Saxon vinescroll ornament, and early Coptic sculpture. In 1940 he published his most popular work, *Early Medieval Art in the British Museum,* which has appeared in two editions and was published in this country by the Indiana University

Press. T. D. Kendrick, then Keeper of the British and Medieval Antiquities in the British Museum, commissioned Kitzinger to prepare this volume as part of a series of guide books of the British Museum that were to introduce art history into an official publication of that museum. This task was difficult and challenging, since the material had to be limited to objects in the British Museum. Restricted to sculptures and paintings of the period from late antiquity through the twelfth century, this small book avoids questions like "Orient oder Rom?" and "Toulouse or Santiago?" that were commonly debated by medievalists of that day, and attempts both to grasp more easily essential visual and iconographic qualities of specific works of art and to paint a large and well-constructed canvas depicting the period as a whole. No other book before or after, in any language, succeeds as admirably in these tasks as does this volume. In fewer than one hundred pages of text he outlines the unity of European artistic development from the end of antiquity to the age of the Gothic cathedral (the present collection of writings may be said to serve as a sequel to that volume). As in all his publications, he avoids oversimplifications and formulates artistic problems and complex relationships clearly and concisely. And his prose is comprehensive and easily followed, no mean achievement for a writer whose native tongue was not English.

In 1941 Kitzinger emigrated to the United States, and throughout the following twenty-six years was associated with the Center for Byzantine Studies of Dumbarton Oaks in Washington, D.C. From 1943 to 1945 he served first as assistant research analyst and then as research analyst in the Office of Strategic Services in Washington, D.C. and in London. In 1950–51 he was a Fulbright Scholar in Sicily to undertake research on the wall mosaics of the Norman period. In 1953–54 he was awarded a Guggenheim Fellowship and travelled in Italy, Greece, Yugoslavia, and Turkey. In 1955 he was appointed to succeed A. M. Friend, Jr., as director of studies of Dumbarton Oaks, a position he held for eleven years. In 1966–67 he was a member of the Institute for Advanced Study in Princeton, New Jersey. In 1967 Harvard University named him its first A. Kingsley Porter University Professor, which honors the memory of the Harvard archaeologist noted for his extensive work on medieval architecture. In 1974–75 he was elected Slade Professor of Fine Art at the University of Cambridge where he delivered a series of lectures on the representational arts from late antiquity to the outbreak of Iconoclasm.

* * *

The reader will miss some important papers in this volume. Kitzinger's paper on "The Hellenistic Heritage in Byzantine Art" that appeared in the *Dumbarton Oaks Papers*, 17 (1963), pp. 95–115 is well known, but has not been included because it was written in conjunction with George M. A. Hanfmann's "Hellenistic Art," and both articles derived from papers presented at an exploratory symposium on the Hellenistic origins of Byzantine civilization held at the Center for Byzantine Studies of Dumbarton Oaks in May 1962. Since Hanfmann's paper was intended to provide background for Kitzinger's discussion of the Hellenistic aspects of Byzantine art, it does not make much sense to reprint the one without the other. Further, both articles have been republished in abridged form in an anthology of art historical writings that was edited by H. Spencer, *Readings in Art History*, I: *Ancient Egypt through the Middle Ages* (New York, 1969), pp. 89–106 and pp. 167–188. Spencer's volume is easily accessible as a paperback edition.

Kitzinger has made a major contribution to our understanding of the arts of Norman Sicily by publishing a large monograph on *The Mosaics of Monreale* (1960) and a number of papers (other contributions to the subject are in various states of preparation), two of which are included in this collection. It was decided to reprint "The Byzantine Contribution to Western Art of the Twelfth and Thirteenth Centuries" (1966) rather than "Norman Sicily as a Source of Byzantine Influence on Western Art in the Twelfth Century" (1966), because the former is less narrow in scope than the latter, to which it serves as a kind of supplementary paper. On the other hand, the author's paper in the *Transactions of the Royal Historical Society* (1972) on "The Gregorian Reform and the Visual Arts" is broader than "The First Mosaic Decoration of Salerno Cathedral" (1972), which is included in this volume, but the former requires the "Salerno" paper to support it, while the "Salerno" paper represents an independent contribution that can stand on its own feet. Kitzinger's recent article on "The Threshold of the Holy Shrine: Observations on Floor Mosaics at Antioch and Bethlehem" (1970) was excluded for the reason that it is perhaps more specialized than those papers that have been included in this volume. However, the reader, especially the one interested in methodology and the total scope of the author's scholarship, is directed to this article. It reveals his skill in exploring the role and whole range of iconographic meanings for the motif known as Solomon's knot, a recurrent phenomenon in the art and folklore of many countries and periods, from precise symbolism via

the vaguely meaningful to the purely ornamental devoid of symbolic connotations, a notion akin to that of a "semantic range" in modern linguistics, as Kitzinger has pointed out in that article. And mention may be made of his "Observations on the Samson Floor at Mopsuestia" in the *Dumbarton Oaks Papers* for 1973, which is too recent a paper for us to have obtained permission to republish.

The reader may also query why the paper "On the Interpretation of Stylistic Change in Late Antique Art" does not precede "A Marble Relief of the Theodosian Period" in this volume. For some readers the first-named paper as the opening article might have too much the appearance of a programmatic statement on the interpretation of stylistic phenomena in terms of larger and deeper historical trends and attitudes, and they would look in vain for other papers taking up the same basic ideas. The author has pursued those ideas somewhat further in his Slade lectures in 1974, and it is to be hoped that these lectures will be published in the near future.

Because of the economic realities and because of the desire to keep the price of this publication within range of the widest possible audience, it was decided to reproduce all the papers in this volume by the photo-offset process. The original pagination of the individual papers has been retained side by side with the new overall pagination of this book because of the frequent cross references in the individual papers, the occasional cross references between them, and the citation of these articles in the writings of others. But in order to obtain the highest possible quality in the illustrations, which is essential for proper art historical investigation, new plates have been made for the works of art that were reproduced and accompanied each of the thirteen papers. With one minor exception, the illustrations accompany each paper as in the original publications.

I am indebted to Milton V. Anastos, Hugo Buchthal, Otto Demus, Richard Krautheimer, Irving Lavin, William C. Loerke, Carl Nordenfalk, and Kurt Weitzmann, whose generous support of the proposal for this volume is greatly appreciated. To Ernst Kitzinger himself I am deeply grateful for his consent to the publication of this collection, for his allowing me to serve as its editor, and for his thoughtful advice on a number of editorial questions. Without the advice and consent of all these persons, this selection of writings would never have seen the light of day.

W. Eugene Kleinbauer

Bloomington, Indiana

PREFACE

THIS VOLUME brings together a number of my writings on the history of art, primarily in the Mediterranean world, from the end of Greco-Roman antiquity to the age of Giotto. The coverage of this vast period is far from being either systematic or complete. A number of the papers deal with single objects or monuments, which are explored in some depth. Others focus on particular classes of objects or a particular problem. One of the purposes of this selection is, in fact, to illustrate a variety of different approaches and methods. But the studies also make a fairly well balanced chronological sequence. The first group concerns the history of art from the age of Constantine the Great to the age of Justinian I. This is followed by a number of papers focussing on the problematic and ill-defined but vitally important period from the latter part of the reign of Justinian to the outbreak of the iconoclastic crisis in Byzantium. Finally, the last group of papers deals with Western art of the eleventh, twelfth, and thirteenth centuries, mainly in terms of its relation to Byzantium.

The studies have been written and published over a period of more than twenty-five years. Although the principal substance of each one still seems valid to me, it would have been desirable to make changes and additions in the light of subsequent research by others and by myself. Since the papers are reproduced mechanically by photo-offset, such revisions were not feasible. The variety of type and format preserved from the original publications will serve as a constant visual reminder that these are, indeed, pure reprints. However, a brief bibliographical postscript for each article will be found at the end of the volume. While not intended to be exhaustive, these postscripts will guide the reader to more recent literature either on the general subject of the article concerned or on some important monuments or issues discussed therein.

Eugene Kleinbauer, the editor of this volume, in inviting me to contribute a prefatory statement, proposed that I take the opportunity to define in my own words the objective of my scholarship. Briefly, I would say that the central subject of all my research has been the process of cataclysmic change whereby the art of Greco-Roman antiquity came to an end and the art of the Middle Ages was

born. While I have always tried to view this process comprehensively and without geographic restrictions, I have paid special attention to the art of Byzantium, whose role in the overall development scholarship has long recognized as being both crucial and problematic.

If I am to define my approach to the history of art, as distinct from my subject area, I would say that my primary interest has always been the specifically artistic (that is, visual) aspect of the work of art. Much of my work has been concerned with processes of stylistic change and the interpretation of these processes in historical terms. To determine what aesthetic innovation can tell us about a particular period is surely the art historian's most baffling problem. Over the years I have experimented with a number of approaches. It is a truism to say that the form of a work of art is inseparable from its content; and the reader will find here several papers (III, X, XI, and XII) that are essentially iconographic or iconological, that is to say, primarily or exclusively concerned with the subject matter of a given monument or a group of monuments and the message this subject matter was intended to convey. In every instance the study was undertaken with a view to throwing light on the intellectual, religious, or political ambient in which the work of art was created. In my studies of Byzantine art of the late sixth and seventh centuries I have attempted to explore actual relationships between stylistic innovations and developments in the social and religious life of the period, particularly as these developments affected the role and function of religious images. I have also paid special attention in these studies to the phenomenon of artistic modes, that is, to a certain stylistic manner becoming conventionally associated with a particular kind of subject matter or a particular order of being. Finally, I have focussed on the person and role of the patron, whose normal concern will be with subject matter and content of the work he commissions, but who in certain circumstances and conditions may play a major role in determining its stylistic make-up as well (see II, IX). I believe that all these approaches (which are complementary and in part overlapping rather than mutually exclusive) are valid but that all have their limitations. All leave an unexplained rest. True innovation in the realm of form comes about through the artist's own "inner-directed" act. To identify that act as precisely as possible and to bring to bear on its interpretation all the data we have on the artist's period and cultural milieu continues to be for me a crucial and challenging problem.

It remains for me to express my warm thanks to Eugene Klein-

bauer for suggesting this publication and for undertaking the thankless task of editing it and to Mary Katherine Donaldson, my faithful assistant, for manifold aid in furnishing editor and publisher with the necessary material.

<div align="right">Ernst Kitzinger</div>

Cambridge, Massachusetts

ACKNOWLEDGMENT OF SOURCES

The articles reprinted in this book first appeared in the following works and are used with their permission.

 I. *Dumbarton Oaks Papers,* 14 (1960), 17–42.

 II. *Bucknell Review,* 15/3 (December, 1967), 1–10.

 III. *Actes du VIe Congrès International d'Études Byzantines, Paris, 27 juillet–2 août 1948,* 2 (Paris, 1951), 209–223.

 IV. *La Mosaïque Gréco-Romaine,* Colloques Internationaux du Centre National de la Recherche Scientifique, Paris, 29 août–3 septembre 1963, Paris, 1965, 341–352.

 V. *Dumbarton Oaks Papers,* 8 (1954), 83–150.

 VI. *Berichte zum XI. Internationalen Byzantinisten-Kongress, München 1958* (Munich, 1958), IV/1, 1–50.

 VII. *Late Classical and Mediaeval Studies in Honor of Albert Mathias Friend, Jr.,* ed. K. Weitzmann *et al.,* Princeton: Princeton University Press, 1955, 132–150.

 VIII. *Zbornik radova,* 8/1 = *Recueil des travaux de l'Institut d'Études byzantines,* No. VIII = Mélanges G. Ostrogorsky, I (Belgrade, 1963), 185–193.

 IX. *Jahrbuch der Österreichischen Byzantinistik,* 21 (1972) = Festschrift für Otto Demus zum 70. Geburtstag, 149–162.

 X. *Art Bulletin,* 31 (1949), 269–292.

 XI. *Proporzioni,* 3 (1950), 30–35.

 XII. *Proceedings of the American Philosophical Society,* 117/5 (1973), 343–373.

 XIII. *Dumbarton Oaks Papers,* 20 (1966), 25–47.

THE ART OF BYZANTIUM

AND THE MEDIEVAL WEST:

⋙ SELECTED STUDIES

PART ONE

FROM CONSTANTINE

TO JUSTINIAN

I

A MARBLE RELIEF
OF THE THEODOSIAN PERIOD

This study is in substance identical with a paper delivered at the Symposium on "The Dumbarton Oaks Collection: Studies in Byzantine Art" held at Dumbarton Oaks in May 1958.

I wish to thank Professor G. Sotiriou (Athens), Professor M. Gorenc (Zagreb), and Professor K. Wessel (formerly Berlin), for their courtesy in sending me the photographs reproduced in figures 8, 12, and 18 respectively and for granting me permission to publish these prints. Figure 15 is a detail from a negative in the possession of the German Archaeological Institute in Rome, reproduced here thanks to the kindness of Professors F. W. Deichmann and J. Kollwitz.

IN 1952 Mr. and Mrs. Bliss gave to the Dumbarton Oaks Collection a fragmentary marble relief depicting Christ healing a blind man (fig. 1).[1] The object merits a detailed study, partly because of its high artistic quality and partly because it bears so unmistakably the imprint of its art-historical habitat.

Before discussing its date and place of origin it will be well to give a description of the relief. The fragment, which is of white (Proconnesian?) marble, has a height of 26.5 cm. and a width of 28.7 cm. It is evidently incomplete at the top, where the present edge cuts off part of Christ's halo, as well as on the left and on the right. Yet all three edges are fairly smooth, a fact which suggests that the present size and shape of the relief are not the result of mere accident, but that its edges were trimmed with a tool in order to reduce it for use as a panel, approximately square in shape. Moreover, the condition of these three edges indicates that the trimming took place quite a long time ago. Only at the top of the right-hand edge, where the outline becomes irregular and the surface of the edge is very clean, is there a suggestion of recent breakage. A small piece seems to have been chipped off here subsequent to the original trimming (see fig. 10).

The only edge which is authentic and intact is the bottom one. It consists of a slightly curved frame, about 2 cm. wide, which is raised about 1.5 cm. above the surface of the relief, thus forming a sloping ledge for the figures to stand on. The frame is adorned by a row of big round beads. In the middle of these, just under the figure of Christ, is a small disk with an equal-armed cross in relief. The thickness of the slab—not including the raised frame or the figures which stand out in relief—is approximately 2 cm. No accurate measurement of this dimension is possible because of the extreme roughness of the back of the slab (fig. 11).

Christ stands squarely in the center of the fragment. Youthful and beardless, He wears His hair short and combed down smoothly over His forehead. His is the only head in the relief which is surrounded by a halo. He is dressed in a tunic of which the lower hem is visible just above His ankles while the wide sleeve covers His arm down to about His elbow. Over the tunic He wears a pallium, one end of which is draped over His left shoulder and arm, while the other is pulled across His body at the waist and cascades from His left wrist. On His feet the straps of His sandals are distinctly though lightly indicated in relief. Carrying a rolled-up *volumen* in His left hand, Christ turns His head half right and touches with the index finger of His raised right hand the left (or far) eye of the blind man who is seen in profile on His right approaching Him in a stooping position. The invalid is dressed in the short girded tunic which in the late Roman period characterized its wearer as a member of the working class,

[1] No. 52.8. *Handbook of the Dumbarton Oaks Collection* (Washington, D.C., 1955), p. 17, no. 41 and p. 33 (ill.).

and plain sock-shaped boots (*socci*?). He shows much the same facial type as Christ, and although he appears to be even more youthful he would, if erect, be a figure of about the same height. Both his hands reach forward towards the Saviour whose miracle-working arm he seems about to clasp. Actually, however, the blind man's left hand, of which only one finger is visible behind Christ's arm, must be assumed to be holding the top end of the heavy gnarled stick the outlines of which are incised on the empty ground between the two figures. It is, therefore, his right hand only that reaches out in eager anticipation towards his benefactor, while in his left he carries the stick which supports his stooping body and at the same time serves to guide his steps. Evidently, then, his sight has not yet been restored. Indeed, his eyes seem vacant and without life (fig. 13).

On Christ's left and aligned with Him on the same plane is an impressive figure of a companion or witness, which echoes that of the Saviour almost exactly in stance, attire, and position of arms. He is an older man, somewhat shorter than Christ and distinguished by a domed, bald forehead, a drooping moustache, and a long pointed beard. In his left hand, instead of a scroll he holds a scepter in the form of a cross which rests against his shoulder and the top of which extends above his head. Most of the upper part of this scepter, however, is lost owing to the break previously noted, and only one cross-arm remains. The bearded companion's right hand, part of which is concealed by Christ's shoulder, echoes the dramatic action of Christ's right hand; it is raised in an expressive gesture with the palm facing the beholder. Just above this hand there appears the head of another figure, presumably a second witness. Executed in low relief (in keeping with its position in the background), this head is of the same general type as Christ's and the blind man's. It is shown in semi-profile and its glance is directed not at what Christ is doing, but towards the scepter-bearing figure, thus lending added emphasis to the latter and picking up—by way of counterpoint to the major action portrayed—the secondary and contrary movement initiated by the invalid's eager profile. The body of the background figure must be assumed to be completely concealed behind Christ, but one hand is faintly visible in the space between the bearded man's head and right hand (fig. 14). It is executed in very low relief and its action is not altogether clear.

So much for the appearance of the relief. About its history, prior to its arrival at Dumbarton Oaks, little is known.[2] It is all the more fortunate that the stylistic character of the carving should be so unmistakable. The figures, in fact, bear all the characteristics that one finds in sculptures done in Constantinople toward the end of the fourth century, and specifically in the time of Theodosius I. Consider, for instance, the heads in the imperial entourage on the Theodosian reliefs of the base of the obelisk in the Hippodrome (figs. 2, 3).[3] The collective description of the faces on these reliefs which Kollwitz gives in his exhaustive study of Theodosian sculpture can be applied almost in its entirety to the head of Christ on our relief (fig. 4). He speaks of the large oval of the face with its softly rounded cheeks and full jaws; of the hair evenly combed down-

[2] It was formerly in the collection of Levi Benzion, who is said to have acquired it in Egypt.
[3] J. Kollwitz, *Oströmische Plastik der theodosianischen Zeit* (Berlin, 1941), pl. 35 f.

ward and forming a gentle wave which covers a large part of the forehead; of the gently ascending brow line and its sudden downward bend at the root of the nose; of the small cavities indicating the pupils; of the rather heavy eyelids outlined by grooves of which the upper ones deepen as they approach the nose; and, finally, of the large ears which are set rather low and are completely uncovered.[4] The figures in their entirety are equally characteristic products of the period. Their closest parallels are the apostles on the so-called Sarcophagus of a Prince found in Constantinople in 1933 and now in the Archaeological Museum (fig. 6),[5] and those on a fragmentary relief from Bakırköy, also in the same Museum (fig. 5).[6] The extremely soft draperies of the latter carving, with their folds lacking definite beginnings and ends and with lights playing gently over the highly polished surface, thus blurring all contours, are particularly similar, though compared with the Bakırköy figures ours are sturdier and much better defined anatomically. In this respect they are closer to the apostles on the Prince's Sarcophagus who also wear the same type of sandals as Christ and His companion to the right on our relief. All three works have in common another characteristic of Theodosian style, namely, a tendency for figures to lean over slightly.

In the light of Kollwitz' detailed study it is not necessary for me to insist on the fact that this soft, smooth, and delicate style which so obviously strives after classical ideals of formal perfection is characteristic of only a short period in Constantinopolitan sculpture, a period which coincides with Theodosius' reign (379–395). Only a few years later, in the reign of Arcadius, forms begin to harden noticeably,[7] while even the closest known derivatives of the Theodosian style *outside* the capital, namely, certain sarcophagus reliefs at Ravenna, exhibit different stylistic nuances.[8] We can say with confidence, therefore, that our marble was carved in Constantinople about the year 390.

To our concept of the sculptural style of that period in the capital the relief adds hardly anything new. One feature not previously noticed in other works is the use of incised lines to indicate the most distant objects (cf. especially the stick carried by the blind man). We shall have occasion later to refer to some Western ivory carvings which are products of a phase parallel to, and perhaps to

[4] *Ibid.*, p. 119.

[5] *Ibid.*, pl. 46 and p. 132 ff.

[6] *Ibid.*, pl. 48 and p. 153 ff.

[7] *Ibid.*, p. 166 and *passim*.

[8] For Ravenna sarcophagi closely related to Constantinopolitan work see *ibid.*, p. 155 ff., and especially Kollwitz' more recent study *Die Sarkophage Ravennas*, Freiburger Universitätsreden, N.F., Heft 21 (Freiburg i. B., 1956), p. 10 ff. The sarcophagus of Liberius in S. Francesco, which appears to be the most "Greek" and "classical" in this Ravennatic group, was first thought by Kollwitz to have been drastically restored in modern times (*Oströmische Plastik*, p. 165, note 5) and is now considered by him a Renaissance imitation after ancient models (*Die Sarkophage Ravennas*, p. 6 f.; *idem*, "Il problema del sarcofago ravennate detto di Liberio," *Corsi di cultura sull'arte ravennate e bizantina, Ravenna, 11–24 marzo 1956*, II [Ravenna, 1956], p. 61 ff.). G. Bovini, on the other hand, speaks only of the possibility of "qualche ritocco," especially in the faces (*Sarcofagi paleocristiani di Ravenna* [Città del Vaticano, 1954], p. 32), and this view seems to be borne out by the more detailed demonstration offered by G. de Francovich in a recent study ("Studi sulla scultura ravennate, I: I sarcofagi," *Felix Ravenna*, 77–78 [August–December 1958], p. 5 ff., esp. p. 12 ff.; *ibid.*, p. 20 ff., a stylistic analysis in which both the Constantinopolitan affinities of this sarcophagus and the features differentiating it from work done in the Eastern capital are duly stressed).

some extent influenced by, Theodosian art in Constantinople, and in which the same device is used.[8a]

While the dating and attribution of the Dumbarton Oaks fragment pose no particular difficulty, we face much harder problems when trying to visualize and define the object of which it formed a part and the setting for which that object was made.

Our principal guide in exploring these questions is the lower edge of the relief with its curved outline and its series of beads. The existence of this frame indicates that the relief cannot have stood vertically. Though it conceivably might be part of a roundel inserted in a wall in an upright position, a much more natural supposition is that it was placed horizontally.

There exists, in fact, a whole class of marble slabs of the kind we are presuming in this instance. The class is well known and has been studied repeatedly.[9] New examples turn up from time to time.[10] The more complete ones leave no

[8a] Cf. e.g., K. Wessel, "Eine Gruppe oberitalischer Elfenbeinarbeiten," *Jahrbuch des deutschen archäologischen Instituts*, 63/64 (1948/49), p. 111 ff., esp. pp. 117, 120.

[9] E. Michon, "Rebords de bassins chrétiens ornés de reliefs," *Revue biblique*, n. s., XII (1915), p. 485 ff.; XIII (1916), p. 121 ff. (survey of all pieces known at that time). G. A. S. Snyder, "The so-called Puteal in the Capitoline Museum at Rome," *Journal of Roman Studies*, XIII (1923), p. 56 ff. E. Thomas, "Bruchstück einer frühchristlichen Marmortischplatte mit Reliefverzierung aus Csopak," *Acta Antiqua Academiae Scientiarum Hungaricae*, III, 3 (1955), p. 261 ff. (with an incomplete list of examples compiled evidently without knowledge of Michon's basic survey).

[10] I append here a list of additional pieces which have come to my attention and which are not mentioned in any of the studies quoted in footnote 9:

Antioch — *Antioch-on-the-Orontes I: The Excavations of 1932* (Princeton, London, and The Hague, 1934), p. 49 f. and fig. 4.

Athens — D. I. Pallas in Ἀρχαιολογικὴ Ἐφημερίς (1930), p. 90 ff. (two fragments, from Arcadia and Melos, in Byzantine Museum).

Chicago — *Bulletin of the Art Institute of Chicago*, XVII, 4 (1923), p. 38 f. E. Michon in *Bulletin de la Société Nationale des Antiquaires de France* (1923), p. 170 ff. (fragment, allegedly from Mesopotamia, in Art Institute).

Crimea — *Otčet* of the Imperial Archaeological Commission (1902), p. 37 f. and fig. 60 a, b. E. Michon in *Bulletin de la Société Nationale des Antiquaires de France* (1920), p. 253 ff. (two fragments found outside church in excavation in Chersonese).

Hama — H. Ingholt, *Rapport préliminaire sur sept campagnes de fouilles à Hama en Syrie (1932-38)* (Copenhagen, 1940), p. 137 f. and pl. 42, 2.

Herakleion (Crete) — A. Orlandos in *Byzantinisch-Neugriechische Jahrbücher*, VI (1928), p. 160 ff. (two fragments from Gortyna in Museum).

Istanbul — Two recently acquired and unpublished fragments in the Museum, knowledge of which I owe to Dr. C. A. Mango; one shows a recumbent figure beneath a tree, the other parts of two animals.

Jerusalem — Two unpublished fragments in the Palestine Archaeological Museum, knowledge of which I owe to Prof. H. Ingholt; one depicts animal fights, the other a satyr and a maenad.

Nea Anchialos — G. A. Sotiriou in Ἀρχαιολογικὴ Ἐφημερίς (1929), p. 102 and fig. 137, top left. Pallas, *ibid.* (1930), p. 94 f. and fig. 4.

New York — Two pieces, both unpublished, were on the art market in 1958; one, allegedly from Egypt, is a complete, sigma-shaped slab with a relief border depicting a sea thiasos; the other is a fragment of a curved border depicting a head in profile and a hunting scene.

Nicosia — A. H. S. Megaw in *Kypriaka Grammata* (1956), p. 171 and fig. 4; *The Swedish Cyprus Expedition*, IV, 3 (Stockholm, 1956), p. 103 f. and pl. XIX, 3 (fragment from Salamis in Cyprus Museum; I owe the references to Mr. Megaw).

Rhodes — A. K. Orlandos, Ἀρχεῖον τῶν βυζαντινῶν μνημείων τῆς Ἑλλάδος, VI (1948), p. 18 ff. and fig. 15.

Varna — F. Gerke, *Der Tischaltar des Bernard Gilduin in Saint Sernin in Toulouse*, Mainz. Akademie der Wissenschaften und der Literatur. Abhandlungen der geistes- und sozialwissenschaftlichen Klasse (1958), no. 8, pp. 457, 464 and figs. 9, 10.

Vienna — R. Noll, *Vom Altertum zum Mittelalter*, exhibition catalog (Vienna, 1958), p. 24, nos. 1 and 2 (two fragments—one from Sirmium, the other of unknown provenance—in the Kunsthistorische Museum; I owe knowledge of these pieces to Dr. O. Demus).

doubt that we are dealing with marble table tops having a plain surface and a broad raised border adorned with figure reliefs and rimmed with beads (fig. 8). The subject matter of the reliefs in many instances is secular; mythological scenes, hunts, animal fights, pastoral and marine subjects all occur frequently. But there are also numerous instances in which the themes are biblical; witness, for instance, a fragmentary piece from Sbeitla which shows a sequence of scenes familiar from the iconography of catacomb frescoes and Early Christian sarcophagi, namely, the Raising of Lazarus, Noah's Ark, the Ascension of Elijah, Adam and Eve, and David with his sling.[11] In the majority of Christian examples of these table tops we find similarly disjointed sequences of biblical events whose common denominator is their relationship to the idea of salvation or of divine intervention on behalf of those in peril; the kind of subject so familiar from the art of the catacombs. As in the latter, Old Testament subjects by far predominate.[12] Indeed, the Raising of Lazarus which appears on the fragment from Sbeitla is very nearly the only Gospel scene so far known on these table borders, aside from the Dumbarton Oaks fragment now under discussion.[13]

I have said that the common characteristic of this whole class of table tops is the raised relief band with beaded rim. In shape, however, there is no uniformity. While some examples are circular,[14] others have the so-called sigma shape[15] known from many pictorial representations of late classical and early Christian times to have been one of the most common shapes of dining room tables. No example is known to me of a table top of this class that is definitely square or rectangular. It must be borne in mind, however, that the vast majority of known examples consist of fragments. Many of them are curved, while others are straight. Usually it is not possible to decide whether the straight fragments come from a rectangular or a sigma-shaped table, while in the case of curved fragments there is usually uncertainty as to whether the slab, when complete, was sigma-shaped or round. In the case of our fragment at Dumbarton Oaks we are obviously faced with this latter uncertainty. The reconstruction drawing (fig. 7), which I owe to the kindness of Mr. R. L. Van Nice, has been based on the assumption that the slab was circular, but the sigma shape is equally possible.

Before enquiring into the possible use of our object some features should be mentioned which distinguish it from the general run of specimens of the class to which I have referred. By and large the sixty odd known examples of these table tops with relief borders are remarkably uniform, so that in-so-far as our

[11] Michon, *Revue biblique* (1915), p. 502 ff. and pl. I, 1. A. Merlin in *Revue tunisienne* (1917), p. 279 ff.
[12] Aside from the Old Testament subjects already mentioned in connection with the piece from Sbeitla one finds the Three Youths in the Fiery Furnace, the Sacrifice of Isaac, Daniel in the Lions' Den, and the story of Jonah.
[13] The Raising of Lazarus occurs once more on a fragment in the Museum of Istanbul. This fragment depicts, in addition, a scene interpreted by Mendel as the Parable of the Figtree (G. Mendel, *Catalogue des sculptures grecques, romaines et byzantines*, II [Constantinople, 1914], p. 430 ff., no. 655; Michon, *op. cit.* [1915], p. 525 ff., no. 15; pls. II, III).
[14] E. g. Michon, *op. cit.* (1915), p. 520 ff., no. 11 = our fig. 8 (Athens, from Thera); Snyder, *op. cit.*, p. 56 and pl. I (Rome); also the slab in Rhodes referred to in note 10 *supra*. In these instances the circle is fully, or almost fully, preserved, so that there can be no doubt about the original shape.
[15] E. g. the slabs from Hama and in New York referred to in note 10 *supra*. Cf. also a sigma-shaped slab from Salona in Zagreb (Michon, *op. cit.* [1915], p. 509 ff., no. 5; see our fig. 12 and *infra*, p. 27f.).

piece differs from them it is in effect unique. This is especially true of its size. With a relief band 26.5 cm. wide—and evidently not entirely complete at that— the border was almost twice as wide as the borders of these table tops normally are. On the basis of the curvature of the rim, Mr. Van Nice has computed the total diameter of the presumed circular slab as having been about 1 m. 80, while normally the diameters of these circular slabs range from about 1 m. 10 to 1 m. 40. Another feature that sets our piece apart is the character of the beading. In the vast majority of cases this consists of the classical bead-and-reel motif; in some of beads only which, however, are small and somewhat elongated.[16] I know of only one fragment presumed to have belonged to a table top which has a beaded rim comparable to ours, namely, a piece in the Art Museum in Budapest. Of the figure frieze of this object only an animal remains.[17]

A third point which is distinctive is the roughness of the edge and back of our slab (figs. 9 and 11). It is true that in many instances the publications of the table tops of our class do not permit us to judge what the sides and the backs look like. But in those cases where a judgement is possible the backs are reasonably or entirely smooth.[18] In our case it is inconceivable that the slab was exposed to view in the manner of an ordinary table top supported by legs or a solid base. It must have been embedded in some fashion. How exceptional it is in this respect obviously cannot be judged without subjecting all the members of the group to a scrutiny such as cannot be carried out on the basis of published materials.

In trying to determine the purpose which our slab may have served we must avoid what would almost certainly be a fallacious premise, namely, that all the table tops of the same type, let alone this exceptionally large and splendid piece with its distinctive features, could have been put to only one use.[19] The finds are

[16] Michon, *op. cit.*, 1915, p. 515, no. 8 and pl. I, 2; 1916, p. 124, no. 21; p. 126f., no. 22; p. 140, no. 34. Snyder, *op. cit.*, pl. II, no. 1812. Also the pieces in Chicago and Varna quoted *supra* in note 10.

[17] A. Hekler, *Die Sammlung Antiker Skulpturen*, Museum der bildenden Künste in Budapest (1929) p. 147, no. 143. For the same type of beaded rim in metalwork see *infra*, note 20.

[18] In several instances publications include drawings of profiles and these invariably show the back to have been carefully finished; cf. P. Sticotti, *Die römische Stadt Doclea in Montenegro*, Kaiserliche Akademie der Wissenschaften, Schriften der Balkankommission, Antiquarische Abteilung, VI (Vienna, 1913), col. 152, fig. 93, and the publications of pieces in Athens and Herakleion referred to in note 10 *supra*. The pieces in New York referred to in the same note also have smooth and carefully worked backs, as I was able to ascertain personally, thanks to the kindness of the owners. G. Mendel describes the backs of two of the pieces in the Museum of Istanbul as "soigneusement dressée" (*op. cit.*, II, nos. 654 and 655, pp. 426, 430); that of a third as "dressée, non polie" (*ibid.*, no. 485, p. 169). Michon characterizes the backs of a number of pieces in Paris as "simplement dressée" (*op. cit.* [1915], p. 515, no. 8; p. 517, no. 9; p. 539, no. 18; [1916], p. 136, no. 30).

[19] Most scholars who have discussed the possible uses of these table tops have based their theses on this premise, at least so far as the examples with Christian subjects are concerned. O. Wulff suggested that they have to do with the *agape* (*Königliche Museen zu Berlin. Beschreibung der Bildwerke der christlichen Epoche. Altchristliche, mittelalterliche byzantinische und italienische Bildwerke*, I [Berlin, 1909], p. 11, no. 21); Mendel seems to have thought that both the pagan and the Christian examples were connected chiefly with the cult of the dead (*op. cit.*, II, p. 425ff., especially, p. 429f.), while Michon, the first to attempt a systematic survey of the whole material, came to the conclusion that all of these objects, regardless of whether the subject matter of their reliefs was pagan or Christian, were used in churches as basins for liturgical ablutions (*op. cit.* [1916], p. 146ff., especially p. 163ff.). Sotiriou, on the other hand, has interpreted the slabs—especially, but not exclusively, those adorned with biblical subjects—as table tops used in the prothesis and this interpretation has been adopted also by other Greek scholars (Sotiriou, in Ἀρχαιολογικὴ Ἐφημερίς [1929], p. 233f., *Idem, Guide du*

so numerous and so widespread that we are evidently dealing with what is basically a common type of utensil in the late classical world, though by far the greater part of the examples comes from the Eastern rather than the Western half of the Mediterranean. The type, as has long been recognized, originated in pagan metalwork. These marble slabs with their decorations are, in fact, large scale imitations of sumptuous silver platters.[20] The fact that there are more examples with pagan and secular subjects than with Christian ones suggests that these tables had been in common use before the type was adopted by the Church. If, however, we cannot be sure that all tables of the same type served the same purpose—or that all tables of different types served different purposes—it will be necessary to cast our net rather wide and consider in broad terms the uses to which tables were put in Christian contexts. In doing so it will soon become apparent that, for our particular piece at least, certain uses are much less likely than others, even though it will not be possible to conclude in completely unambiguous fashion what its original setting was and what purpose it actually served.

Since, as we have seen, the iconographic repertory of the tables with biblical friezes is that of the catacombs and early sarcophagi—and in this respect our fragment with the scene of Christ healing a blind man is no exception—it is natural to think first of *sepulchral* uses. Tables of various sizes and shapes, including the circle and the sigma, occur, in fact, quite frequently in early Christian funerary contexts. They may form actual covers or housings of tombs, as is frequently the case in Salona,[21] and in a number of instances in North Africa,[22]

museé byzantin d'Athènes [Athens, 1932], p. 34; J. M. Barnea, Τὸ παλαιοχριστιανικὸν θυσιαστήριον [Athens, 1940], p. 129; A. K. Orlandos, Ἡ ξυλόστεγος παλαιοχριστιανικὴ βασιλική, II [Athens, 1954], p. 486 ff.). E. Thomas, on iconographic grounds, suggests more specifically a connection with the rite of the blessing of the offerings (*op. cit.*, p. 271).

[20] A. Xyngopoulos in Ἀρχαιολογικὴ Ἐφημερίς (1914), p. 77 ff.; Snyder, *op. cit.*, p. 59 ff., especially p. 65. It is interesting to note that in metalwork of the fourth century one frequently finds a heavy beaded border substituted for the classical bead-and-reel (W. Grünhagen, *Der Schatzfund von Gross Bodungen* [Berlin, 1954], p. 39). In this respect, too, the sculptors of marble table tops followed suit, as our fragment and that in Budapest show (see *supra*, note 17).

[21] E. Dyggve, *History of Salonitan Christianity* (Oslo, 1951), p. 105 ff. and fig. V, 21 ff. The potentially great usefulness of this book is impaired by the fact that the text is written in all but unintelligible English.

[22] In North Africa the Christian funerary monument in form of a table is based on a strong pagan tradition of long standing; cf. W. Deonna, "Mobilier délien, I: Tables antiques d'offrandes avec écuelles et table d'autel chrétien," *Bulletin de correspondance hellénique*, LVIII (1934), p. 1 ff.; especially p. 12 ff. and p. 76 ff. In many instances the *mensa* was not found *in situ*, so that the physical relationship between it and the tomb is difficult to determine, but the funerary purpose is frequently attested by inscriptions (see the references given by Deonna, *op. cit.*, p. 77, note 2; also F. Cabrol and H. Leclercq, *Dictionnaire d'archéologie chrétienne et de liturgie*, I, col. 829 f.). At Tipasa, on the other hand, there is a whole series of *mensae* which are most intimately connected with tombs, the latter being encased in them in such a way that a banquet could be held directly on top of the burial. While some of these *mensae* were thought at one time to have been tables for the *agape* into which sarcophagi were subsequently inserted (St. Gsell, *Les monuments antiques de l'Algérie*, II [Paris, 1901], pp. 332 f., 336 f.), more recent investigators believe that these tombs were built in the form of tables from the outset (E. Albertini and L. Leschi, "Le cimetière de Sainte-Salsa à Tipasa de Mauretanie," *Académie des inscriptions et belles-lettres*: *Comptes-rendus* [1932], p. 77 ff., especially p. 81 f.; for further examples see *Bulletin archéologique* [1941–42], p. 355 ff.). This conclusion is borne out also by analogous finds in Spain (see next footnote). Other North African *mensae*, though associated with the cult of relics and martyrs rather than with actual burials, may still be called sepulchral in a wider sense (cf. Cabrol and Leclercq, *op. cit.*, I, col. 828 f., with further references).

Spain,[23] and elsewhere,[24] or they may be placed beside the tomb.[25] Their purpose may have been to serve for liturgical banquets commemorating the dead (particularly martyrs), or for the *agape*, or for ordinary funeral feasts. More frequently they seem to have been used simply to deposit offerings of food and drink for the departed.[26] But most of these tables are on a much smaller scale than that from which our fragment must have come. This is true not only of those that are physically separated from the grave. Even when the *mensa* is an integral part of the tomb the actual top is usually quite small. For instance, in the case of one of the large *mensa* tombs at Tipasa for which full data are available, the sunken sigma-shaped top —as distinct from the sloping surfaces around it which served as a *kline* for the banqueters—had a width of only 1 m.[27] In the cemeteries of Salona, on the other hand, we find a number of marble slabs shaped like table tops and apparently of considerable size. But these are oblong and preserved in such fragmentary condition that the dimensions attributed to them in the reconstruction drawings cannot be accepted as completely certain.[28] No example is known to me of a circular or sigma-shaped grave cover or graveside table of a scale comparable to that of our piece.

[23] J. Serra Vilaró, *Excavaciones en la necrópolis romano-cristiana de Tarragona*, Junta superior de excavaciones y antiguedades, 93 (Madrid, 1928), p. 63 ff., tomb no. 129, an example analogous to those at Tipasa (see preceding footnote), i. e., with the sarcophagus encased in a large semicircular masonry block which served as a couch for the reclining banqueters and in the midst of which the table itself was embedded (see especially fig. 25 on p. 64). Other examples are referred to in Serra Vilaró's ensuing report (no. 104 [Madrid, 1929], p. 58 ff.). While it appears that in all instances of similar *mensae* at Tipasa in which any trace of the original surface of the table top remains that surface consisted of an inscription in mosaic (Albertini and Leschi, *op. cit.*, p. 82 f.; *Bulletin archéologique* [1941–42], p. 355 ff.), in the case of tomb no. 129 at Tarragona the table itself is an inscribed marble slab. The top end of this slab repeats the semicircular outline of the masonry block in which it is embedded (Serra-Vilaró. *op. cit.*, no. 93, pl. LII,2). Theoretically our fragment at Dumbarton Oaks could have come from a slab of similar shape and could have been used in an exactly similar manner.

[24] Under the general heading of "*mensae martyrum* and *agape* tables" Barnea discusses a number of slabs from the Greek East which come from funerary contexts and show cavities suggesting that they were used for depositing food (*op. cit.*, p. 55 ff. and figs 7 and 8; cf. also Orlandos, *op. cit.*, II, p. 480 ff.).

[25] Cf. a *mensa* in the Rotunda at Tipasa adjoining an arcosolium (O. Grandidier, "Deux monuments funéraires à Tipasa," *Atti del II congresso internazionale di archeologia cristiana* [Rome, 1902], p. 51 ff., especially p. 72 f. and figs. 8 and 9). Similar structures exist in the catacombs of Malta (E. Becker, *Malta Sotterranea* [Strasbourg, 1913], p. 112 ff. and pl. XIX ff.). Small plates of glass, terracotta or stucco embedded in masonry plinths are frequently found in positions near tombs in the Roman catacombs (A. M. Schneider, "Mensae oleorum oder Totenspeisetische," *Römische Quartalschrift*, XXXV [1927], p. 287 ff. and pls. XIV–XVII). It is possible that many of the table slabs from the cemeteries of Salona were in positions near tombs rather than on the tombs themselves; this may be particularly true of small uninscribed slabs that are indistinguishable from ordinary domestic utensils (cf., e. g., *Forschungen in Salona*, III, p. 47, no. H/13; also *Archaeologia Jugoslavica*, I [1954], p. 65, no. 10, and figs. 8–10). For Eastern examples of what appear to have been graveside tables cf. Barnea, *op. cit.*, p. 57 ff. (Melos and Constantza), with further references.

[26] Dyggve, *History of Salonitan Christianity*, p. 110 ff.; Schneider, *op. cit.*; cf. also *id.* in *Gesammelte Aufsätze zur Kulturgeschichte Spaniens*, ed. by H. Finke, V (Münster i. W., 1935), p. 79 f., and F. J. Dölger in *Gnomon*, II (1926), p. 228 f.

[27] Gsell, *op. cit.*, p. 336 (the measurements given for this same tomb by J.–B. Saint Gérard in *Bulletin archéologique* [1892], p. 480 and repeated in part by Leschi, *ibid.* [1938–40], p. 425, are clearly erroneous). The sigma-shaped top of the *mensa* described by Gsell, *op. cit.*, p. 332 f., is of similar size, judging by the scale of the plan, *ibid.*, fig. 150. The corresponding feature of the *mensa* in the Rotunda (note 25, *supra*) measures only 75 × 80 cm. (Grandidier, *op. cit.*, p. 72), while the marble slab embedded in tomb no. 129 at Tarragona (note 23, *supra*) has a width of only 73 cm.

[28] Dyggve, *History of Salonitan Christianity*, fig. V, 28. *Forschungen in Salona*, II, p. 91 ff., fig. 54 ff.; III, pl. 8, figs. H/1–H/10. The slab *ibid.* H/5 and p. 37, fig. 52 f. (cf. *History of Salonitan Christianity*, fig. V, 29), which is almost complete, lacks a funerary inscription and seems to have belonged to the altar of the basilica at Marusinac (*Forschungen*, III, p. 46).

There exists, theoretically, the possibility that our fragment may have come not from a *mensa* tomb or graveside table, but from a sigma-shaped tomb stele. Stelai of this shape have been found in Egypt.[29] Presumably the type developed from *mensa* tombs or graveside tables, and in some instances there is actual evidence of a slab which must originally have been a table top having been put to secondary use as a stele by providing it with an inscription.[30] The change-over from table top to stele, however, almost certainly involved from the beginning a change from a horizontal to a vertical position and, as we have seen, a vertical position is practically out of the question in our case.

Parenthetically, a remark may be added here on a famous sigma-shaped slab from Salona (fig. 12),[31] and, concurrently, on a fragment of what appears to have been an almost identical companion piece now in Vienna.[32] Among all the slabs with border reliefs it is these two that could be imagined most readily in a vertical position. They differ from all other objects of this class known to me in that they show the figures with their feet placed "centripetally," i.e. inward rather than outward. This implies at least a weakening of interest in the functional role of a table top, the decoration of which would be—and was—normally designed to be viewed by the persons surrounding it.[33] The Coptic sigma-shaped stelai, on the other hand, which presumably were intended for a vertical

[29] M. Cramer, "Ein Beitrag zum Fortleben des Altägyptischen im Koptischen und Arabischen," *Mitteilungen des deutschen Instituts für ägyptische Altertumskunde in Kairo*, VII (1937), p. 119ff., especially p. 122f. (with further references) and pl. 20ff.

[30] *Ibid.*, p. 122f. and pl. 21 b; also C. Schmit's "Nachtrag," *ibid.*, p. 126f. with pl. 22 b. Dr. Cramer surely was rash in claiming that these table slabs re-used as tomb stelai must originally have been altars. The sigma shape is one of the common forms of tables in general, and, as we have seen, tables were widely used also in funerary contexts (see *supra*, notes 21–28). Table tops from cemeteries, especially when broken, were ready-made material for re-use as tomb inscriptions. A fragment of a table slab with relief border in the Hermitage in Leningrad also bears a—presumably secondary—Coptic inscription (Michon, *op. cit.* [1916], p. 134f., no. 28), but I have not been able to ascertain whether this is of a funerary character.

[31] J. Strzygowski, "Le relazioni di Salona coll'Egitto," *Bullettino di archeologia e storia dalmata*, XXIV (1901), p. 58ff. *Idem*, "Der sigmaförmige Tisch und der älteste Typus des Refektoriums," *Wörter und Sachen*, I (1909), p. 70ff., especially p. 74f. J. Brunšmid, "Kameni spomenici hrvatskoga narodnoga muzeja u Zagrebu," *Vjesnik hrvatskoga arheološkoga društva*, N.S., X (1908–9), p. 149ff., especially p. 213f. Michon, *op. cit.* (1915), p. 509ff. and fig. 6. A. Rücker, "Über Altartafeln im koptischen und den übrigen Riten des Orients," *Ehrengabe deutscher Wissenschaft, dem Prinzen Johann Georg zu Sachsen zum 50. Geburtstag gewidmet* (Freiburg i. B., 1920), p. 209ff., especially p. 214 and fig. 8. J. Braun, *Der christliche Altar*, I (Munich, 1924), p. 278, note 46. Cramer, *op. cit.*, p. 124 and pl. 22 a. *Forschungen in Salona*, III (1939), p. 47 and fig. 55. E. Condurachi, in *Ephemeris Daco-Romana*, IX (1940), p. 1ff., especially p. 56f. and fig. 14. Barnea, *op. cit.*, p. 134 and fig. 31. Dyggve, *History of Salonitan Christianity*, p. 107 and fig. V, 31. Orlandos, *op. cit.*, p. 486 and fig. 447. Thomas, *op. cit.*, p. 267, no. 32. A. A. Barb, "*Mensa Sacra*: The Round Table and the Holy Grail," *Journal of the Warburg and Courtauld Institutes*, XIX (1956), p. 40ff., especially p. 44 and pl. 8 b. Gerke, *op. cit.* (*supra*, note 10), p. 465.

[32] Kunsthistorisches Museum, Inv. I 360; Noll, *op. cit.*, p. 24, no. 2 ("find spot not known"). Cf. *supra*, note 10. In scale, subject matter, and style there appears to be complete identity between the pieces in Zagreb and Vienna, though there may be some slight difference in the beaded border. The figure on the fragment in Vienna, as distinct from all those on the Zagreb relief, is haloed.

[33] Superficially the arcades opening inward, as we find them on the Zagreb and Vienna pieces, resemble the scalloped borders without reliefs so commonly found on table tops (see, e. g., *infra*, notes 46, 56, 58). But the decoration of the Zagreb and Vienna slabs is really a relief band of the kind characteristic of the table tops studied by Michon, who quite properly included the Zagreb piece in his survey. There is one other known member of that class showing figures under arcades (Michon, *op. cit.* [1916], p. 134f., no. 28), but in this case the arcades open outward and the figures are placed accordingly, so that they stand upright from the point of view of the beholder at the table's edge. In this respect, then, the reliefs at Zagreb and Vienna are entirely exceptional.

position, show their decoration arranged "centripetally," like the Salona and Vienna relief slabs.[34]

From our enquiries so far we conclude that the Dumbarton Oaks fragment is not likely to have come from a sepulchral context. The extraordinarily large size, in conjunction with the curved shape, in effect rules out its use either as a tomb cover or as a graveside table; the size in conjunction with the horizontal position its use as a stele. This, of course, does not exclude the possibility of sepulchral use for other related slabs, especially since the main obstacle is the exceptional size of the Dumbarton Oaks piece.

We turn from the cemetery to the church, where one naturally thinks first of all of the table of the main altar. This, however, in the vast majority of early churches where any evidence still exists was of oblong shape.[35] To what extent sigma-shaped slabs were used for altars in the early Christian period is difficult to decide. There are well known examples in Coptic Egypt which are particularly interesting to us because in some cases they are embedded in masonry blocks, a position for which our piece with its rough edge and back would be well suited.[36] But it is not known whether this type of altar in Egypt goes back to early Christian times. Strzygowski long ago suggested that it does.[37] He recognized the sigma shape as being traditionally associated with ordinary dinner tables and therefore considered it a normal shape to adopt for the Christian altar, the eucharistic service being originally intended as a commemoration of the Last Supper. Actually, the Coptic altars could be derived more plausibly from North African *mensa* tombs,[38] especially since the masonry block supporting the altar slab usually contains an opening which, originally at least, may well have been intended for a relic.[39] Thus these Coptic altars would

[34] Cf., e. g., Cramer, *op. cit.*, pl. 20 c, where the base of the cross in the apex of the arch is clearly on the inside.

[35] See in general Braun, *op. cit.*, p. 245 ff.; Barnea, *op. cit.*, p. 127 f.; *Reallexikon für Antike und Christentum*, I (Stuttgart, 1950), col. 334 ff., especially col. 342; Orlandos, *op. cit.*, p. 442 ff. For Greece cf. also Sotiriou in Ἀρχαιολογικὴ Ἐφημερίς (1929), p. 230; and for the general area of Palestine, Father Bagatti's compilation of measurements of the supports of altars excavated in various churches (B. Bagatti "Gli altari paleo-cristiani della Palestina," *Studii Biblici Franciscani Liber Annuus*, VII [1956–57], p. 64 ff., especially, p. 71). While the exact size and shape of the slabs which these supports carried may in some instances be uncertain it is obvious that in the great majority of cases the altar was a transverse oblong. For the sigma-shaped slabs discussed by Father Bagatti see *infra*, note 58.

[36] A. J. Butler found two sigma-shaped altar slabs in the churches of Old Cairo (*The Ancient Coptic Churches of Egypt*, I [Oxford, 1884], pp. 118, 221 f.; cf. II, p. 7 f.), H. G. Evelyn-White a larger number in the monasteries of the Wâdi'n Natrun (*The Monasteries of the Wâdi'n Natrun, Part III: The Architecture and Archaeology* [New York, 1933], pp. 62, 71, 79, 93, 103, 117, 153, 203; cf. p. 18). According to Butler, stone slabs, when they occur at all on Coptic altars, are usually embedded in the masonry block that forms the body of the altar (*op. cit.*, II, p. 7 f. and fig. 2, ii; see also I, p. 118). Cf. also Strzygowski in *Wörter und Sachen*, I, p. 72 f., and Cramer, *op. cit.*, p. 120 and fig. 4. Evelyn-White, however, in several instances refers to the marble slab noncommittally as "covering" the substructure (*op. cit.*, pp. 18, 93, 117, 153, 203). Only in one case does he say unequivocally that the slab was "inlaid in the upper surface of the masonry" (p. 79). In another case where he found this arrangement it was due to a modern reconstruction (p. 103 with note 1). In two instances he says explicitly that the slab overlapped the substructure (pp. 62, 71; cf. also Rücker, *op. cit.*, fig. 5).

[37] Strzygowski in *Wörter und Sachen*, I, p. 70 ff., especially pp. 73 ff. and 78. See also Cramer, *op. cit.*, p. 119 ff. and Barnea, *op. cit.*, p. 130 ff.

[38] Cf. *supra*, note 22 (Tipasa).

[39] Butler, *op. cit.*, II, pp. 5, 12 ff. Evelyn-White, *op. cit.*, p. 17 f., also refers to these openings, but denies that they could have been used for relics.

be an instance where a form connected with the cult of martyrs and relics was adopted for ordinary church use.[40] But even this derivation is purely hypothetical.

J. Lassus claims that sigma-shaped altar tables, as well as oblong ones, were in use in early churches in Syria, but his arguments are based on inference only.[41] Fragments of a plain, sigma-shaped slab found in a small church on the island of Samos are thought to have belonged to the altar of that church,[42] but again the evidence is not conclusive.[43] Numerous other sigma-shaped table slabs have been found in or near churches in many different regions, but in no case is it at all certain that they were in use as altars—or, at any rate, as main altars—and in some instances there is definite evidence to the contrary.[44]

The existence of circular altar slabs is even harder to prove. A J. Butler found one in a small chapel in Old Cairo,[45] but again there is a question of its age. In Besançon a circular marble slab with a scalloped border has served as a high altar in mediaeval and post-mediaeval times, but we cannot be sure that this was its original destination or, for that matter, that it dates back to the early Christian period at all. Even though the type of table top with a scalloped border is ancient, it also exists in numerous mediaeval imitations.[46] Altogether, then, there hardly seem to be sufficient grounds to interpret our fragment as coming from the main altar of a church.

But churches contained other tables than that of the main altar. There may have been secondary altars, though these were infrequent at best in the early

[40] Cf. for this process in general A. Grabar, *Martyrium* (Paris, 1946), *passim*; and, with particular reference to grave *mensae* and altars, Rücker, *op. cit.*, p. 211 ff., and Dyggve, *op. cit.*, p. 109 ff. Strzygowski's theory concerning the origin of the Coptic sigma-shaped altar had at first been also confined to the sphere of the martyrium (*Bullettino di archeologia e storia dalmata*, XXIV [1901], p. 63 f.).

[41] J. Lassus, *Sanctuaires chrétiens de Syrie* (Paris, 1947), p. 200 ff.

[42] W. Wrede, "Vom Misokampos auf Samos," *Athenische Mitteilungen*, LIV (1929), p. 65 ff., especially p. 73, fig. 6, and p. 74. A. M. Schneider, "Samos in frühchristlicher und byzantinischer Zeit," *ibid.*, p. 96 ff., especially p. 108 f.; cf. also the reconstruction *ibid.*, p. 96, fig. 1.

[43] The exact find spot of the fragments is not indicated, and one wonders whether they should not rather be attributed to some other table in the church. The actual traces on the floor of the chancel would seem to fit better an altar of the normal oblong shape (Wrede, *op. cit.*, p. 71, and the plan, Beilage XXXI).

[44] See *infra*, notes 48–50 (Sbeitla), 54 (Sabratha), 55 (Tebtunis), and 58 (many examples).

[45] *Op. cit.*, I, p. 228.

[46] See the recent study by Gerke on the altar of Saint Sernin in Toulouse (for a full reference see *supra*, note 10, à propos of the fragment from Varna) and further literature cited in that study. Ch. Rohault de Fleury argued that the slab in Besançon had been an altar from the outset and attributed it to the seventh century though his illustration is captioned "10th century" (*La Messe*, I [Paris, 1883], p. 160 ff. and pl. 51). H. Leclercq also considered it an altar of an early date (Cabrol and Leclercq, *Dictionnaire*, II, 1 [Paris, 1910], col. 824 f.). Braun, however, thought that it was made in the early eleventh century (*op. cit.*, p. 246 ff. and pl. 42), and more recently P. de Palol has also called it mediaeval ("El baptisterio de la basilica de Tebessa y los altares paleocristianos circulares," *Ampurias*, XVII–XVIII [1955–56], p. 282 ff., especially p. 284). The early dating, on the other hand, has found a tentative advocate in A. A. Barb (*op. cit.*, p. 42 f. and pl. 5 b), who, in line with his theory on the origin of the Holy Grail, is altogether inclined to accept rather readily—probably too readily—potential evidence of the early and widespread use of circular slabs—particularly those with lobed borders—as altars for the eucharistic service (see also *infra*, note 57, à propos of Tebessa). In Gerke's study the Besançon altar figures as a Romanesque work intimately related to early Christian antecedents; in regard to the latter, however, no clear distinction is made between altars and other kinds of tables (*op. cit.*, p. 464 f.). Certainly the Besançon slab—even if it is mediaeval, as it may well be—owes both its shape and its decoration to an early Christian model. But whether that model was an altar is at least doubtful (see also *infra*, note 58).

period with which we are concerned.[47] There certainly were tables on which the faithful deposited their offerings, and others for different liturgical purposes. Excavations of early Christian basilicas have provided ample evidence of such additional tables. One, at least, of the table tops with figure reliefs—and it is these, of course, which interest us primarily—can be safely claimed to fall into this category. I refer to the example from Sbeitla, now in the Bardo Museum at Tunis, which has already been mentioned.[48] This fragmentary piece comes from the excavation of a church in the nave of which another stone slab was found. It is this second slab—oblong in shape—which in all probability was part of the main altar.[49] The fragments with the biblical frieze, on the other hand, were found, not in the nave, but above what remains of the walls of a small apse that belonged to the baptistery behind the main apse of the church.[50] It is tempting to assume that the Sbeitla slab when complete was a sigma-shaped table top which would have fitted neatly into the small apse adjoining the font.

Aside from this example only very few of the table tops with relief borders come from controlled excavations. At Chersonese in the Crimea two fragments were found in the immediate precincts of a church, as the Sbeitla fragments were, but since no trace of the altar was observed there is no way of concluding definitely whether they did or did not form part of the altar.[51] On the other hand, there is a number of undecorated table slabs—oblong, circular, or sigma-shaped—which have been excavated on church sites and were clearly used not as altars but in some other liturgical capacity. Thus the annexes and the atrium of Basilica A in Nea Anchialos have yielded fragments of several table slabs, including some with the characteristic scalloped borders,[52] and these are quite distinct from those belonging to the altar of the church.[53] The same is true of a sigma-shaped table found in the Justinianic basilica at the forum of Sabratha. In this church, too, the altar was of the normal oblong shape, and Dom Leclercq has suggested that the additional table may have been used for offerings.[54] Two other instances are particularly interesting because of the fact that table tops were found *in situ* in positions which rule out the possibility of their having been altars for the ordinary eucharistic service. One is in a church at Tebtunis where a sigma-shaped slab was found embedded in the floor in front of the entrance to the right-hand chapel of a tripartite sanctuary (fig. 17). One's

[47] Cf. Braun, *op. cit.*, p. 368 ff.; *Reallexikon für Antike und Christentum*, I, col. 347 f.
[48] See *supra*, note 11.
[49] Merlin, *op. cit.*, p. 266.
[50] *Ibid.*, p. 279; cf. the plan, fig. 1 (before p. 265).
[51] For references see *supra*, note 10.
[52] G. A. Sotiriou, "Αἱ χριστιανικαὶ Θῆβαι τῆς Θεσσαλίας," Ἀρχαιολογικὴ Ἐφημερίς (1929), p. 1 ff., especially p. 101 f. and figs. 135 and 136. Fig. 136 also includes some similar fragments found entirely outside the context of the church. There was also a fragment with relief (fig. 137, top left; cf. *supra*, note 10), but it is not stated whether it was found within the precincts of the church.
[53] For the slab of the altar see *ibid.*, p. 26 and fig. 25 on p. 24.
[54] Cabrol and Leclercq, *Dictionnaire*, XV, 2 (1951), col. 1955 f. and fig. 11048 (s. v. "Table d'oblation"). Cf. J. B. Ward Perkins and R. G. Goodchild, "The Christian Antiquities of Tripolitania," *Archaeologia*, LXXXXV (1953), p. 1 ff., especially pp. 15, 65 f. Barb's interpretation of this slab, which measures 1.50 × 1.46 m. and is .14 m. thick, as a portable (*sic*) altar is hardly convincing (*op. cit.*, p. 56, note 29).

natural inclination in this case would be to consider it as a table for the offerings. The excavator, however, rejects this possibility (because, so he says, the place where offerings were deposited was elsewhere in the church) and instead suggests that this was the place where the neophytes stood when receiving baptism.[55] While the question must remain open in this case, our second example is quite unambiguous. Excavations carried out a few years ago in the baptistery of the great basilica at Tebessa have revealed that the bottom of the font was formed by a circular slab with a scalloped border (fig. 16), a slab of the type familiar from marble tables such as the one at Besançon.[56] It has been suggested, if only very tentatively, that there may have been a profound symbolic intent in this rendering of the place of baptism as a giant platter or table.[57] The problem merits further study. In any case, however, the Tebessa font affords a striking illustration of the fact that marble table tops were employed in early Christian churches for fittings other than the altar or, for that matter, the table for offerings. One wonders whether other table slabs, and especially slabs of circular or sigma shape, which have come to light —often in indubitably Christian contexts—in many parts of the Mediterranean world have not been interpreted too readily as altars.[58]

[55] G. Bagnani, "Gli scavi di Tebtunis," *Bollettino d'arte*, XXVII (1933), p. 119ff., especially p. 124f. and p. 128, fig. 11.

[56] E. Seree de Roch, "Tebessa (Theveste): Le baptistère de la basilique," *Libyca: Archéologie – Epigraphie*, I (1953), p. 288ff.

[57] Palol, *op. cit.*, p. 286. Barb's suggestion that the slab, which was subsequently covered with a layer of cement, was placed at the bottom of the font only "for...careful hiding...at a sacred place" (*op. cit.*, p. 55, note 26) is surely untenable and explicable only by the author's desire to vindicate it as an altar table.

[58] Bagatti, *op. cit.*, p. 66ff., refers to a number of sigma-shaped slabs, with or without scalloped borders, excavated on ecclesiastical sites in Palestine (for Mount Nebo cf. also S. J. Saller, *The Memorial of Moses on Mount Nebo* [Jerusalem, 1941], p. 291ff. and pls. 60, 3 and 126, where additional examples are described and illustrated). None of these were found *in situ* and the original use is uncertain in every instance. The same is true of a circular slab with lobed border found in the ruins of a church at Delos (*Ecole francaise d'Athènes: Exploration archéologique de Delos*, XVIII [Paris, 1938], p. 62f. and pl. 27, no. 192; cf. *Bulletin de correspondance hellénique*, LVIII [1934], p. 84ff. and figs. 59–60); of a fragment with a lobed border found at Hippo (*Libyca: Archéologie-Epigraphie*, I [1953], p. 215f., figs. 1 and 2); and apparently also of a sigma-shaped slab in "Church No. 5" at Leptis Magna (R. Bartoccini, in *Rivista di archeologia cristiana*, VIII [1931], p. 52; Ward Perkins and Goodschild, *op. cit.*, p. 33), though Dom Leclercq (*Dictionnaire*, XV, 2, col. 1956) claims—I have not been able to ascertain on what authority—that at Leptis Magna a fragment was found *in situ* in the pavement (in which case it might be a "floor table" comparable to that at Tebtunis). In the case of sigma-shaped tables found in houses, albeit not far from churches, at Ephesos (*Jahreshefte des österreichischen archäologischen Institutes in Wien*, XXVI [1930], Beiblatt, col. 40 and fig. 18) and Stobi (*Glasnik Hrvatskog Zemaljskog Muzeja* [1942], p. 488, fig. 29) it is altogether uncertain whether they may be interpreted as ecclesiastical furnishings. It must always be borne in mind that the same types of tables were in use in indubitably secular contexts (cf., e. g., *Antioch-on-the-Orontes, II: The Excavations of 1933–36* [Princeton, London, and The Hague, 1938], pl. 21, no. 226 and p. 178). Therefore, when the nature of the building that yielded the find is uncertain, as seems to be the case, for instance, in respect of the example from Donnerskirchen (A. A. Barb in *Jahreshefte des österreichischen archäologischen Institutes*, XXXIX [1952], Beiblatt, col. 5ff.), one cannot claim with any assurance that the slab was in Christian use at all (see also Gerke, *op. cit.*, p. 466, note 1). A sigma-shaped slab from Rubi, near Egara, on the other hand, leaves no doubt in this regard since it bears on the edge a Christian inscription (J. Vives, "Un nuevo altar romano-cristiano en la Tarraconense," *Analecta Bollandiana*, LXVII [1949], p. 401ff.; P. de Palol Salellas, *Tarraco Hispanovisigoda* [Tarragona, 1953], p. 33ff. and pl. XIII). But, since the inscription records an individual's private prayer, one may doubt whether the stone could have been intended as an altar in a church. Mention should be made also of an unpublished sigma-shaped table with a lobed border in the Metropolitan Museum in New York, knowledge of which I owe to the kindness of Mr. W. Forsyth. Here again Christian use is certain since the lower frame is adorned with four

Let us return to the table to which the fragment at Dumbarton Oaks belonged. In the light of what has been said it seems likely that this great disk or slab was associated with some secondary piece of church furniture rather than with an altar. The example at Tebessa is particularly suggestive. The extremely large size of our piece is a serious obstacle to any reconstruction envisaging it in an elevated position, but would cause no difficulty if one imagines it embedded in the floor. While reliefs as delicate as those of our fragment — and as sacred in subject matter — would hardly have been put on the open floor, in the manner of the table at Tebtunis, they might well have been fitted into an enclosure such as that of the Tebessa font. We may also recall once more the example at Sbeitla, where the table slab with its Christian reliefs may have been inside the small apse adjoining the font.

Our search has not furnished us with a definite solution to the problem of the use of our slab, let alone of the whole class of related slabs. Our conclusions may be summed up by stating that in this specific case its use either in a sepulchral context or as a main altar in a church is extremely unlikely. The best possibility is that the fragment comes from a table used for offerings or in connection with the rite of baptism, and it may well be that this "table" was embedded in the pavement rather than in a raised plinth.

The history of the class of marble tables to which our fragment belongs remains to be written. The Dumbarton Oaks piece is without doubt not only the largest but also artistically the most outstanding of all. One might, therefore, be tempted to put it at the beginning of the whole series. But this would certainly be a mistake. Normally, these marble tables with relief borders are attributed to dates ranging from the late third to the fifth century.[59] While an exact chronology remains to be established, there are certainly many, at least among the pieces with secular iconography, that are earlier than ours. One must, therefore, conclude that the Constantinopolitan artist of the late fourth century who

lambs flanking a Chi-Rho. But this piece was acquired in the art market (allegedly it came from Rome) and the possibilities of its use within a Christian context are manifold. This table is interesting also because its decoration comprises most of the elements that occur on the slab at Besançon (see *supra*, note 46). Assuming that the latter is mediaeval its source of inspiration must have been a slab such as that in New York, which is certainly of early date. The problem of early Christian original versus mediaeval copy remains to be studied also in regard to sigma-shaped tables at Mettlach and Vienne (Barb in *Journal of the Warburg and Courtauld Institutes* [1956], pl. 6 b, c; Braun, *op. cit.*, p. 159 with pl. 14, and p. 248), but in any case neither can be claimed with any certainty as an altar.

[59] Xyngopoulos attributed the example from Thera (our fig. 8) to the first quarter of the fourth century, mainly on the strength of a comparison of one of the heads adorning the rim with coin portraits (Ἀρχαιολογικὴ Ἐφημερίς [1914], p. 83; cf. also *ibid.*, p. 263f.). Snyder questioned the validity of this argument without, however, putting forward a substantially different view; for the pieces he discussed he tentatively suggested dates ranging from the late third to the early fourth century (*Journal of Roman Studies* [1923], pp. 65, 68). Michon reviewed the opinions expressed by previous writers on a number of individual pieces and concluded that, while many of the slabs adorned with pagan subjects may be attributable to the fourth century, and in some instances perhaps to the third, those with biblical subjects are not likely to be earlier than the fifth century (*op. cit.* [1916], p. 166ff.). Sotiriou drew a similar distinction between secular and biblical pieces, but suggested that both series were produced mainly within the fourth century (Ἀρχαιολογικὴ Ἐφημερίς [1929], p. 233f.). More recently E. Thomas assumed for the whole group much wider time limits ranging from the third to the sixth or even seventh century (*op. cit.*—*supra*, note 9—p. 274). A systematic investigation of the problem would have to take into account the silver vessels with analogous relief bands, some of which can be dated at least approximately. The type certainly was well established by the late fourth century.

fashioned our table conformed to a well-established type current all over the Eastern Mediterranean area; but only to create a wholly exceptional piece, presumably for one of the great churches of the Imperial capital.

If any further evidence were needed for the attribution of our relief to Constantinople, it could be found in the iconographic analysis.

The scene represented on our fragment is probably that narrated in John 9:1 ff., the episode in which Christ, with clay made with His spittle, anoints the eyes of a man born blind and tells him to wash his eyes in the pool of Siloam, whereupon he gains sight. Among the numerous similar episodes in the Gospels this and the scene at Bethsaida related by Mark (8:22–26) are the only ones which involve Christ touching the eyes of a single blind man. Of the two, John's story is by far the more celebrated. Other possibilities would be the events told in Matthew 9:27 and 29, 30, but these would presuppose that there was originally a second blind man to the left where the relief is now broken. Although, as we have seen, the fragment is incomplete on the right side too, the group of four figures preserved is so well balanced that one would like to assume that no further figures ever formed part of this scene.

It is the impressive figure of the bearded "witness" to the right which at once attracts our attention. In sarcophagus reliefs, where the subject is very common, these "witnesses" are usually anonymous and nondescript. The earliest instances in which they can be identified occur in sixth-century Greek miniatures, specifically in the Gospels of Rossano and Sinope, in which the Healing of the Blind, like most other scenes, is accompanied by figures of Old Testament prophets bearing scrolls which are inscribed with appropriate quotations from their writings.[60] On the basis of these examples the "witnesses" in stone and ivory reliefs depicting the Healing of the Blind and other miracles have also sometimes been identified as prophets.[61] In our case, however, this identification is ruled out by the fact that the figure carries a scepter in the shape of a cross. The person most commonly provided with this attribute is the Apostle Peter.[62] The facial features of the figure on our relief, however, are definitely not those of Peter but of Paul, whose bald head and long beard emerge as unmistakable personal characteristics at a quite early period—witness, for instance, the so-called Prince's Sarcophagus from Constantinople[63] or some of the early fifth-century sarcophagi from Ravenna (compare figs. 14 and 15).

The prominent featuring of the Apostle Paul—certainly most unusual in a scene from the Gospels depicting a miracle of Christ—must be considered a characteristic of Constantinopolitan art of precisely the period to which our relief belongs. Paul was the first apostle to receive individual characterization

[60] Rossano Gospels: A. Muñoz, *Il codice purpureo di Rossano* (Rome, 1907), pl. XI. Sinope Gospels: A. Grabar, *Les peintures de l'évangéliaire de Sinope* (Paris, 1948), pl. IV.

[61] E. Capps, Jr., "An Ivory Pyx in the Museo Cristiano and a Plaque from the Sancta Sanctorum," *Art Bulletin*, IX (1926–27), p. 331 ff., especially p. 333 f. and note 24.

[62] M. Lawrence, *The Sarcophagi of Ravenna*, College Art Association Study No. 2 (1945), p. 24 f. with further references.

[63] Kollwitz, *Oströmische Plastik*, p. 140 f. and pl. 47, 1 and 2; our fig. 6.

in the art of the capital, while Peter still remained in the anonymous group of Christ's disciples, witness again the Prince's Sarcophagus.[64] On the strength of Kollwitz' studies it seems very probable that the composition in which Christ gives the Law to Paul—a composition found on the sarcophagi of Ravenna and strikingly different from the well-known Roman representations of Christ giving the Law to Peter—goes back to a Constantinopolitan model.[65] According to Kollwitz one should resist the temptation of seeing in this exaltation of the Apostle of the Gentiles a "political" gesture whereby the New Rome demonstrated its independence vis-à-vis the Old.[66] He suggests that the prominence given to Paul in the art of the capital is simply due to the important role played by the readings from his Epistles in the liturgy, to his travels and activities in that general area, and to the fact that he was the teacher of the church par excellence.[67] While all this is certainly true it does not apply to the Theodosian period more than to any other. The fact that in our relief Paul appears—quite exceptionally—in a miracle scene from the Gospels shows to what length artists in late fourth-century Constantinople went in the "cult" of the Saint. One must reckon with a special vogue and ought to seek an explanation that would apply specifically to this particular phase in Constantinopolitan history.

It may be pointed out in this connection that it was precisely during the last decades of the fourth century that Old Rome began to concentrate on the person of the Apostle Peter as sole founder and first occupant of the Roman see,[68] and that during this same period the church of Constantinople showed an increasing determination to settle its own affairs without Western interference. This latter tendency first became clearly manifest in connection with the Council of 381 convoked by Theodosius I and intended at first as a purely regional gathering.[69] In these circumstances there may well have developed in the imperial capital a trend to "play down" Peter in favor of Paul who was not as definitely identified with a specific see and so was better able to stand for the universal church. It certainly was not a question of opposing to the claim of apostolicity put forward by the see of Old Rome a corresponding claim on behalf of New Rome, where the whole issue of apostolicity had not at that time assumed any great importance.[70] But it may have been felt desirable in the capital to find means of stressing the law and the doctrines that governed the life of the entire church, to which all sees were equally subject, and of which the emperor in Constantinople considered himself the chief guardian. Of that law and of these doctrines Paul had been the first great exponent and his figure could well serve

[64] *Ibid.*, p. 141. It is curious, on the other hand, that during the same period Epiphanius of Cyprus should have known of a distinctive type used by artists for St. Peter and of two different types for St. Paul; cf. K. Holl, "Die Schriften des Epiphanius gegen die Bilderverehrung," *Sitzungsberichte der kgl. preussischen Akademie der Wissenschaften* (1916), p. 828 ff., especially p. 839 no. 26 (= *idem, Gesammelte Aufsätze zur Kirchengeschichte,* II [Tübingen, 1928], p. 362).

[65] Kollwitz, *op. cit.,* p. 154 ff.

[66] *Ibid.,* p. 156 ff.

[67] *Ibid.,* p. 158.

[68] See most recently: F. Dvornik, *The Idea of Apostolicity in Byzantium and the Legend of the Apostle Andrew,* Dumbarton Oaks Studies IV (Cambridge, Mass., 1958), p. 43 ff.

[69] *Ibid.,* p. 50 ff.

[70] *Ibid.,* chap. II, *passim;* especially pp. 44, 47 f.

to embody and subtly stress those tendencies that Constantinople wished to promote as against those that were increasingly coming to the fore in Old Rome.[71]

These remarks are offered as a possible approach to a problem in the history of Constantinopolitan iconography which has not as yet found a satisfactory solution. It is clear, in any case, that a comprehensive explanation is needed of all the phenomena indicating a particular preference for Paul in East Roman art of the period of Theodosius I. An interpretation solely in terms of the specific scene depicted in the Dumbarton Oaks relief would not be adequate. At the same time it is also true that, given the subject matter of our carving, the inclusion of Paul, however improper from a narrowly historical point of view, was singularly meaningful. Had not Paul himself recovered from blindness through Christ's power? And had he not, in his own words, been sent by God to the Gentiles "to open their eyes that they may turn from darkness to light" (Acts 26:18)? He could be identified with the event in both a passive and an active sense. He himself had been a blind man, but also a miracle worker, illuminator and teacher—through the power of Christ Whose cross he carries.

It is tempting to make use of the presence of Paul in our scene for a more precise and pregnant interpretation of its meaning, bearing in mind the possibility that the slab of which it is a part comes from a baptistery.[72] The healing of the blind was one of the natural and obvious themes in a baptismal context. Baptism itself is an act of illumination (φώτισμα, φωτισμός).[73] The symbolism of light played an important part in baptismal liturgy, and by the same token the healing of the blind-born, and particularly his washing his eyes in the pool at Siloam, was often interpreted as a symbol of baptism.[74] Indeed, St. John's account of the miracle was referred to or recited in a number of early liturgies in connection with baptismal or prebaptismal rites.[75] In relation to such speci-

[71] An analogous explanation has been proposed previously by K. Wessel in regard to the sarcophagi at Ravenna on which the scene of Christ giving the Law to St. Paul appears ("Das Haupt der Kirche," *Archäologischer Anzeiger*, LXV–LXVI [1950–51], col. 298 ff., especially col. 315 f.). Wessel's interpretation has been challenged by Francovich who, however, fails to provide a satisfactory explanation of his own for this iconographic theme (see p. 118 ff. of the study quoted *supra* in note 8). For possible manifestations of a "Pauline" trend in Constantinople in subsequent periods see K. Onasch, "Der Apostel Paulus in der byzantinischen Slavenmission," *Zeitschrift für Kirchengeschichte*, 4th ser., VI (= vol. 69) (1958), p. 219 ff., though this author's conclusions may well go too far (cf. the critical remarks by H. G. Beck in *Byzantinische Zeitschrift*, 52 [1959], p. 200 f.).

[72] See *supra*, p. 32 (Sbeitla, Tebessa).

[73] See Du Cange, *Glossarium*, s. v. φωτίζειν. Cf. Justin Martyr, *Apologia I*, 61 (ed. Otto, I, 1, p. 168); Clement of Alexandria, *Paedagogus* I,6 (Migne, *PG*, VIII, col. 281A) and *Cohortatio ad gentes*, 12 (*ibid.*, col. 240 ff.); Gregory of Nazianzus, *Orationes*, 39 and 40 (*PG*, XXXVI, cols. 336, 360 ff.). Cf. also the inscription of the font at Djemila in H. Grégoire's convincing interpretation (*Byzantion*, XIII [1938], p. 589 ff.).

[74] Cf. e. g. Augustine, *In Joannis Evangelium Tractatus XLIV*, 2 (Migne, *PL*, XXXV, col. 1714); Ambrose, *Epistola LXXX* (*PL*, XVI, col. 1326 ff.) and *De sacramentis*, 3,2 (*Florilegium patristicum* [B. Geyer and J. Zellinger, edd.], fasc. 7: *Monumenta eucharistica et liturgica vetustissima* [J. Quasten, ed.], pt. 3 [Bonn, 1936], p. 154); or—to quote an author close in both time and location to the sculptor of our relief—Asterius of Amasea, *Homilia VII* (*PG*, XL, col. 257).

[75] In the early liturgy of Naples John 9:1–38 was read on the Saturday following the third Sunday in lent after the *scrutinium* of the catechumens (A. Dondeyne, "La discipline des scrutins dans l'église latine avant Charlemagne," *Revue d'histoire ecclésiastique*, XXVIII [1932], p. 5 ff., 751 ff., especially p. 19 f.). In the seventh century the same reading is attested in the Roman liturgy on the Wednesday of the fourth week in lent, when the stational mass was celebrated at S. Paolo f. l. m. (Th. Klauser, *Das*

fically baptismal symbolism, too, the presence of Paul in our relief is singularly appropriate since his own baptism took place simultaneously with the recovery of his sight.[76] Furthermore, it was his teaching—and more particularly, of course, his Epistle to the Romans—which provided the fullest and most profound explanation of what baptism means in Christian life.

It seems appropriate to mention this possibility of what would be a very full interpretation of the spiritual content of our scene. But it cannot be more than a possibility since it is by no means certain that our table slab does come from a baptistery. Also, we must not forget that the healing of the blind was only one in a frieze of many episodes, though the little disc with the cross at just this point suggests that the scene did occupy one of the cardinal positions.

Whether or not our scene was meant to have a particular reference to baptism, the presence of St. Paul as an unmistakably identifiable witness singles it out among all early Christian representations of the subject known to me and, indeed, appears to be almost unique altogether. In other respects, however, as I have said, the rendering is not basically different from what we find on other early Christian monuments. Normally, it is true, the composition is arranged in such a way that action develops from left to right. Christ stands at the left and is shown in profile, so that His right arm, with which He touches the eyes of the blind-born, is nearest to the beholder and the action becomes patently obvious.[77] Of the many representations of the scene on early Christian sarcophagi the great majority follows this scheme (fig. 19).[78] However, on a number of frieze sarcophagi which certainly are substantially older than our relief the blind man is placed on Christ's left, perhaps in order to enable the artist to depict Christ Himself in an *en face* view while the action of His right arm inevitably recedes more into the background.[79] It is this arrangement that our artist, clearly more interested in a solemn and statuesque presentation of the Protagonist than in lively and dramatic action, preferred. His choice is not accidental. It enabled him to depict Christ performing the miracle with an air of sovereign ease and composure. The Saviour figure in our relief has the bearing of the true

römische Capitulare Evangeliorum, Liturgiegeschichtliche Quellen und Forschungen, XXVIII [Münster i. W., 1935], p. 22), and it evidently owes this place in that liturgy to the fact that the miracle symbolized the "illumination" of the catechumens (on the history of the Roman liturgy of that day and its probable relationship to the early history of the *scrutinia*, see Dondeyne, *op. cit.*, pp. 758 ff., 778 ff.; and A. Chavasse, "Le carême romain et les scrutins prébaptismaux avant le IXe siècle," *Recherches de science religieuse*, 35 [1948], p. 325 ff., esp. pp. 341, 344, 361 ff., 369; see also Dondeyne, *op. cit.*, p. 781 for evidence of the use of John 9:1 ff. in other Western liturgies during lent). In the Ambrosian rite the miracle of Siloam figured as one of the "types" of baptism in the prayers of consecration of baptismal water (H. Scheidt, *Die Taufwasserweihgebete*, Liturgiegeschichtliche Quellen und Forschungen, XXIX [Münster i. W., 1935], pp. 59,81; this rite, however, may not be quite so early: cf. *ibid.*, p. 7). It appears to be much more difficult to prove the use of John 9:1 ff. in baptismal contexts in early Greek liturgies.

[76] Acts 9:17 ff. See the commentary on this passage in *The Beginnings of Christianity, Part I: The Acts of the Apostles*, ed. by F. J. Foakes Jackson and K. Lake, IV (London, 1933), p. 104.

[77] Cf., e. g., E. Baldwin Smith, *Early Christian Iconography and A School of Ivory Carvers in Provence* (Princeton, 1918), p. 97 ff., figs. 84, 87, 88–90.

[78] Cf., e. g., G. Wilpert, *I sarcofagi cristiani antichi*, I (Rome, 1929), pls. 29, 3; 91; 92, 2; 96; 111, 2 and 3; 126, 2 (= our fig. 19; note the gnarled stick carried by the blind man as in our relief); 127; 128; etc.

[79] *Ibid.*, I, pls. 115, 1; 152, 5; II, pl. 206, 7.

aristocrat. In fact, in a subtle way the whole scene has been recast to assume a courtly dignity. Christ's head is surrounded by a halo—at that time still essentially an imperial attribute. No longer is He portrayed as a curly-haired youth—the saviour boy as imagined by the popular mind of late antiquity— but in the likeness of a prince of the Theodosian house.[80] The blind man whom the sculptors of the sarcophagi had depicted as a little puppet serving solely as a prop to illustrate the action, has become a fully grown person approaching Christ with the humility of the supplicant subject appearing before his sovereign. The cross is, of course, the symbol of Christ's triumph, the scepter of His power; and Paul, the acclaiming witness who carries it, becomes the heavenly ruler's standard bearer, exactly as he is visualized by St. John Chrysostom in the exordium of one of his homilies on the Saint in which the preacher hails Paul's mission to the world in terms of an imperial *adventus*.[81]

The assimilation of Christian to imperial art is a familiar process. As the emperor became God's vice-regent on earth the heavenly court came to be visualized more and more in the image of the earthly one. Beginning with the age of Constantine, this development reached a climax in the very period to which our marble belongs.[82] In this respect again the relief is a characteristic product of its time. Later renderings of the theme retain some, though not all, of the same characteristics. Thus in S. Apollinare Nuovo, one hundred years later, we find a scene composed very similarly to ours.[83] Two blind men are shown here, dressed in the costumes of officials and approaching Christ from the left with gestures similar to that of our figure. The youthful haloed Christ is also reminiscent of ours though his hair is now long. The standard bearer, however, has disappeared. There is only *one* acclaiming witness, an anonymous youthful disciple. Among the numerous examples of the scene on ivory carvings of the fifth and sixth centuries we find the same partial retention of the imperial tenor of our relief. The one which follows its iconography most closely is a box lid from the Sancta Sanctorum Treasure in the Museo Sacro of the Vatican (fig. 20).[84] Although the artist who designed this object reverted to the more common and more "drastic" rendering of the scene, with the blind man—here once more shrunken in size—to the right, Christ in profile, and the action of His arm in the very forefront and center of the panel, the Saviour still retains the essentials of the imperial type of face and the imperial hair style. His footwear also is that of the Christ in our relief. Above all, the figure of the "witness" to the right is very similar, in regard to both the facial type and the acclaiming action of the right hand. Now, however, he is no longer the imperial standard

[80] Kollwitz (*Oströmische Plastik*, p. 164) and Gerke (*Christus in der spätantiken Plastik* [Berlin, 1940], p. 68) have cited Theodosian court portraiture in connection with representations of Christ of this period. In no instance is the relationship as close and striking as in the case of our relief; compare especially our fig. 4 with Kollwitz, *op. cit.*, pl. 34.

[81] *De laudibus S. Pauli Homilia VII* (*PG*, L, col. 507 f.).

[82] Kollwitz, *op. cit.*, *passim*, especially p. 145 ff.

[83] F. W. Deichmann, *Frühchristliche Bauten und Mosaiken von Ravenna* (Baden-Baden, 1958), pl. 161.

[84] W. F. Volbach, *Elfenbeinarbeiten der Spätantike und des frühen Mittelalters* (Mainz, 1952), p. 68, no. 138 (with further references) and pl. 46.

bearer. He carries in his left hand a book, not a cross, and perhaps is meant to be an evangelist or even a prophet.

What makes the comparison between our marble and the ivory particularly interesting is the fact that the Sancta Sanctorum panel in turn is the closest forerunner known for any of the reliefs on Maximian's Chair in Ravenna (fig. 21). A lame man on a crutch is added to the Ravenna relief, but otherwise its relationship to the Vatican panel is evident. It is also evident that the latter is a substantially older work. The Sancta Sanctorum ivory is usually considered a work of the fifth or the early years of the sixth century, while the Ravenna Chair belongs to the middle of the sixth. Incidentally, on the Ravenna relief the scepter with the cross reappears, but is now in the hand of Christ.[85]

From its position in iconographic history between the early sarcophagus reliefs, on the one hand, and the group of ivory carvings of which Maximian's Chair is the main exponent, on the other, there emerges the great significance of the Dumbarton Oaks relief for the history of early Christian and early Byzantine art. This significance can be brought out most clearly by means of a brief digression into the Latin West. It is well known that in the West what might be called a gradual regeneration of classical artistic values took place in the course of the fourth century. The extreme abstractness and seemingly deliberate provincialism characteristic of most of the sculptures of the earliest decades of the century and exemplified by the reliefs on the Arch of Constantine and the bulk of the frieze sarcophagi, can hardly be matched in any relief even of the middle of the century. One need only think of the sarcophagus of Junius Bassus dated A.D. 359 with its fully rounded, organically functioning figures, its soft and "positive" drapery style, and its generally classicizing, one might almost say, lyrical atmosphere.[86] This process of regeneration received a great impetus, particularly in Rome, through the well-known pagan reaction movement of the last decades of the century bound up with the names of Q. Aurelius

[85] C. Cecchelli, *La cattedra di Massimiano ed altri avorii romano-orientali* (Rome, 1937), pl. 32. The general scarcity, among ivories of the fifth and early sixth centuries, of clear iconographic and stylistic antecedents for the reliefs of Maximian's Chair is one of the reasons why it has proved so extremely difficult to define the place of these reliefs in the history of early Byzantine art. There is, of course, a sizable group of ivory carvings which are widely accepted as contemporaries and close relatives of those on the Chair, or even as products of the same "school" or workshop (see, e. g., E. Gombrich, "Eine verkannte karolingische Pyxis im Wiener kunsthistorischen Museum," *Jahrbuch der kunsthistorischen Sammlungen in Wien*, N. F. VII [1933], p. 1 ff., esp. p. 7 ff.; Volbach, *op. cit.*, p. 69). But this fact only serves to make the dearth of forerunners all the more puzzling. In this respect the Sancta Sanctorum panel, which is certainly of a date earlier than Maximian's Chair, is a notable exception. It shows the healing of the blind in a rendering so similar to that on the Chair that there can be no doubt about a close relationship between the two works. The fact that the sculptor of the Chair changed a number of details and added a lame man to the healing scene justifies Cecchelli's denial of the existence of a "prototipo assoluto" for the Ravenna panel (*op. cit.*, p. 179), but does not detract from the importance of its basic similarity to the panel in the Vatican. While Gombrich rightly considers the latter as an antecedent of Maximian's Chair (*op. cit.*, p. 9), K. Wessel obscures the true relationship between the two works by listing the Vatican panel—along with several other undoubtedly pre-Justinianic ivories—among works belonging to the "Umkreis" of Maximian's Chair, without distinguishing between contemporaries and antecedents ("Studien zur oströmischen Elfenbeinskulptur," *Wissenschaftliche Zeitschrift der Universität Greifswald*, II [1952–53], *Gesellschafts- und sprachwissenschaftliche Reihe*, 2, p. 63 ff.; *ibid.*, III [1953–54], 1, p. 1 ff.; see especially p. 2 of the latter volume; also *idem*, "La cattedra eburnea di Massimiano e la sua scuola," *Corsi di cultura sull'arte ravennate e bizantina, Ravenna, 16–29 marzo, 1958*, I [Ravenna, 1958], p. 145 ff., especially p. 150).

[86] F. Gerke, *Der Sarkophag des Iunius Bassus* (Berlin, 1936), p. 8 ff.

Symmachus, Virius Nicomachus Flavianus, and other members of the senatorial class.[87] The artistic manifestations of this movement are familiar.[88] They include such pieces as the ivory diptych of the Symmachi and Nicomachi,[89] with its pagan subject matter and its studied and academically precise imitation of figures of the remote classical past. This was a real revival consciously fostered by a small circle of die-hard aristocrats. But artificial as this movement was and limited as it was in time, geographic extent, and social range, it was nevertheless exceedingly important for the future. The main point in our context is that it carried over into Christian art. The links are well known. They lead via the Probianus Diptych,[90] so clearly indebted to the late fourth-century revival, to works such as the relief with the Marys at the Sepulcher from the Trivulzio Collection,[91] or the panel with the same subject in the Bavarian National Museum in Munich.[92] In these works, in which we find the Gospel story endowed with the elegiac charm of a Greek tomb relief, the full debt which the development of Christian art (and particularly Christian narrative art) owed to the pagan revival becomes apparent. As Christian art emerged from the humble and stenographic stage represented by catacomb frescoes and early sarcophagi, it received inspiration and enrichment from the classical revival movement, whose challenge it was called upon to meet and whose influence found expression both in iconographic elaboration, particularly of the Gospel story, and in a new standard of formal perfection. The latter, it is true, was not long maintained. Western ivory carvings of the fifth century show what must be described, from the point of view of classical aesthetics, as a fast falling-off.[93] But the element of humanism that was injected into Christian art in the period about A.D. 400 was never entirely lost and became indeed a part of the heritage of mediaeval Christian art.

In the East this whole process is only much more dimly discernible. What is often referred to as the "Theodosian Renaissance" cannot be set off as clearly as it can in Rome against a wholly different phase in the early fourth century. There is no real equivalent to the reliefs of Constantine's Arch and the whole vogue of officially fostered provincialism which they represent. Nor can we follow a process of regeneration through the fourth century. We have no real concept of the kind of work that was created in Constantinople when the court

[87] A. Alföldi, *A Festival of Isis in Rome under the Christian Emperors of the IVth Century*, Dissertationes Pannonicae, Ser. II, fasc. 7 (Budapest, 1937), p. 37 ff. Cf. also H. Bloch, "A New Document of the Last Pagan Revival in the West," *The Harvard Theological Review*, 38 (1945), p. 199 ff.

[88] R. Delbrück, *Die Consulardiptychen und verwandte Denkmäler* (Berlin and Leipzig, 1929), p. 29 f.; E. P. de Loos-Dietz, *Vroeg-Christelijke Ivoren* (Assen, 1947), p. 83 ff. Cf. also E. Weigand's review of Delbrück's book in *Kritische Berichte zur kunstgeschichtlichen Literatur* (1930–31), p. 33 ff., especially p. 44 ff. and p. 55.

[89] Volbach, *op. cit.*, p. 39, no. 55, and pl. 14.

[90] *Ibid.*, p. 41, no. 62, and pl. 18.

[91] *Ibid.*, p. 58, no. 111, and pl. 33.

[92] *Ibid.*, p. 57 f., no. 110, and pl. 33.

[93] For the study of the stylistic development in Western ivory carvings of the fifth century A. Haseloff's paper on a fragment of a diptych in Berlin is still of basic importance ("Ein altchristliches Relief aus der Blütezeit römischer Elfenbeinschnitzerei," *Jahrbuch der kgl. preussischen Kunstsammlungen*, 24 [1903], p. 47 ff.). See also Gombrich, *op. cit.*, p. 5 f., and K. Wessel, "Eine Gruppe oberitalischer Elfenbeinarbeiten," *Jahrbuch des deutschen archäologischen Instituts*, 63–64 (1948–49), p. 111 ff.

first moved there. The art of the capital becomes identifiable for us first in the stone sculptures of the Theodosian period with their characteristic soft and mellow style deeply imbued with classicism. The antecedents of this style still elude us.[94] The fact that the Emperor Theodosius, and after him Arcadius, chose to commemorate their victories by means of triumphal columns modelled on those of Trajan and Marcus Aurelius, vividly illustrates the retrospective attitude in the official art of the Constantinopolitan court at the end of the fourth century, but the historical motivation, so evident in Rome, is not equally apparent. In the East we can as yet define neither the stylistic setting nor the ideological carriers of Theodosian classicism and must simply accept it as a historical fact.

It has long been recognized that in the East as in the West this secular classicizing art of the late fourth century has a Christian counterpart. Works like the Prince's Sarcophagus (fig. 6)[95] and the fragment from Bakırköy in the Museum of Istanbul depicting standing figures of apostles (fig. 5)[96] are prime examples of this, while the earliest and best of the Ravenna sarcophagi are without any doubt under the direct influence of this Constantinopolitan production.[97] But all the Christian works of pure Theodosian style known so far were ceremonial representations with statuesque figures and a minimum of action, and were lacking in narrative content. It is in this respect that the Dumbarton Oaks relief opens a new perspective. It shows that in the East as in the West a Christian *narrative* art was created under the direct impact of the classicizing taste of the Theodosian period, and that this narrative art—like the ceremonial reliefs just referred to—was deeply affected by the spirit, and, indeed, by the iconography, of the imperial court. Our artist, called upon to carve one of the table border reliefs common at that time throughout the Aegean region, conformed to tradition for its general layout, but created a work unlike any other known member of its class either in scale or in style. He used a familiar Christian theme but recast it in the mould of Theodosian court art. One must speak here of a regeneration of Christian narrative art similar to that in the West.

Christian narrative reliefs of a more derivative kind from the general area of the Eastern capital have been known for a long time. One which is of particular interest to us is a fragment from the neighborhood of Sinope, now in the Berlin Museum (fig. 18). Though this is a substantially later work it evidently stands in the direct tradition of our relief with which it has a close iconographic relationship. Indeed, viewing the two carvings side by side one cannot entertain any doubt that Wulff was correct in interpreting the Berlin piece as a fragment of a scene depicting one of Christ's miraculous healings.[98] The figure in profile to the left is identical in attitude and attire to our blind man except that it faces in the opposite direction. It thus presupposes a Christ figure of the more usual kind, i.e. turning towards the right. The witness on the right is an exact counter-

[94] Kollwitz, *Oströmische Plastik*, pp. 1, 143.
[95] *Ibid.*, pls. 45–47 and p. 132 ff.
[96] *Ibid.*, pl. 48 and p. 153 ff.
[97] Cf. *supra*, note 8.
[98] *Op. cit.* (*supra*, note 19), p. 18, no. 29.

part, in position, gestures, and attribute, to our St. Paul. The facial features, however, clearly show that he is meant to be St. Peter and thus the figure serves to point up once more the fact that the iconographic emphasis on St. Paul, which our relief bespeaks, was indeed a passing phase. Stylistically the contrast between the two works is considerable. Evidently, by the time the Sinope relief was made the process of hardening and schematization which took place in Eastern as in Western sculpture in the course of the fifth century was well advanced. The carving has been attributed convincingly to the middle of the fifth century.[99]

Another fragment—this one found in the capital itself and now preserved in the Museum of Istanbul—is much closer to ours in style and in date.[100] It, too, depicts a miracle scene—the Raising of the Widow's Son—and thus provides a further indication of the interest which Constantinopolitan artists of the late fourth and early fifth century took in scenes from the Gospels. But it does not show as clearly as does our carving how deeply and intimately this Christian narrative sculpture of the capital is rooted in the art of the court of Theodosius I. The Dumbarton Oaks relief must surely be a product of the imperial atelier, which may not be true of any of the other Christian carvings referred to, with the exception of the Prince's Sarcophagus. The chief significance of our small fragment, then, lies in the fact that it allows us for the first time to grasp, so to speak, the moment when in the capital the spark was transmitted from imperial to Christian narrative art. The narrative reliefs previously known, less close to the art of the court in style and iconography, merely permitted the inference that such a transmission must have taken place. Our fragment provides tangible evidence of this transmission and shows that in the period of Theodosius I Constantinople began to take a hand in the shaping of Gospel subjects, imbuing them with its own characteristic style and spirit. Even at this relatively early date the development of New Testament iconography in the East had ceased to be a monopoly of Syria and Palestine.[101]

A further point is equally important. None of the previously known early reliefs with Christian scenes from the Constantinopolitan region are closely connected with subsequent developments. In the case of our representation of the Healing of the Blind we believe we have discerned iconographic links with

[99] K. Wessel, "Ein kleinasiatisches Fragment einer Brüstungsplatte," *Staatliche Museen zu Berlin: Forschungen und Berichte*, I (1957), p. 71 ff. Wessel's dating has been criticized by Francovich in his recent study on Ravenna sarcophagi quoted *supra* in note 8. The Italian scholar attributes the Sinope relief to the end of the fourth century, because of alleged affinities with sculptures of the Theodosian period and particularly with some of the reliefs on the base of the Obelisk (p. 73 f. and note 123). However, a comparison with the Dumbarton Oaks carving, a work so similar to the Sinope relief in subject matter and composition, serves to bring out those stylistic features whereby the latter work differs from sculptures of the time of Theodosius I, and thus helps to confirm Wessel's dating as against Francovich's.

[100] Kollwitz, *op. cit.*, pl. 55,1 and p. 188.

[101] *A fortiori* the thesis of G. de Francovich that throughout the pre-Iconoclastic period artists in Constantinople on the whole fought shy of illustrating the Gospel story is plainly untenable ("L'arte siriaca e il suo influsso sulla pittura medioevale nell'oriente e nell'occidente," *Commentari*, II [1951], pp. 3 ff., 75 ff., especially p. 78 ff.). Cf. also my remarks in *Byzantine Art in the Period between Justinian and Iconoclasm*, Berichte zum XI. Internationalen Byzantinisten-Kongress, IV, 1 (Munich, 1958), p. 37, note 141.

later works, and especially with an important group of ivories of which Maximian's Chair in Ravenna is the chief exponent. While all of the imperial connotations of our relief were not retained in these later examples the tradition nevertheless lingered on. When speaking of the West we found that lasting importance attached to the innovations introduced into Christian pictorial art during the late fourth century. Now we can see that the same is true in the East where the impact of the "Theodosian Renaissance" can likewise be claimed to have been of long duration. In the East, too, the high standards of refined classicism characteristic of the late fourth century were lost rather rapidly in the course of the fifth, as both stone and ivory sculptures of that period show. But Eastern ivory carvers of the advanced fifth and sixth centuries, like their Western counterparts, can now be seen to have been indebted to a distinctive phase of metropolitan art of the Theodosian period. As is well known, many of these ivories have frequently been attributed to workshops in Egypt.[102] The Dumbarton Oaks relief, of course, cannot by itself be decisive in determining their place of origin, but it does show that some of their most important antecedents lie in Constantinople.

Thus the art of the capital in the Theodosian period can be shown to have played a crucial role in the over-all development of Christian art. Established formulae of Christian iconography, familiar patterns long used by the craftsmen of the region, were remolded to conform with the official manner of presentation and with the classicizing standards of form evolved by the imperial ateliers. The action of these Constantinopolitan workshops may be compared to that of an optical lens in which rays from various sources are gathered and concentrated to be re-emitted with new force to illumine the path ahead. Our carving permits us to define this achievement much more sharply than was possible previously. It leads us directly into the main current of Greek Christian art and is, indeed, a key piece, showing as it does that as early as A.D. 400 art had its focus in Constantinople and hence should be called Byzantine.

[102] See, for instance, K. Wessel's "Studien zur oströmischen Elfenbeinskulptur," quoted *supra* in note 85. In his study of 1958, quoted in the same footnote, Wessel offers a somewhat modified version of his thesis regarding the origin of Maximian's Chair.

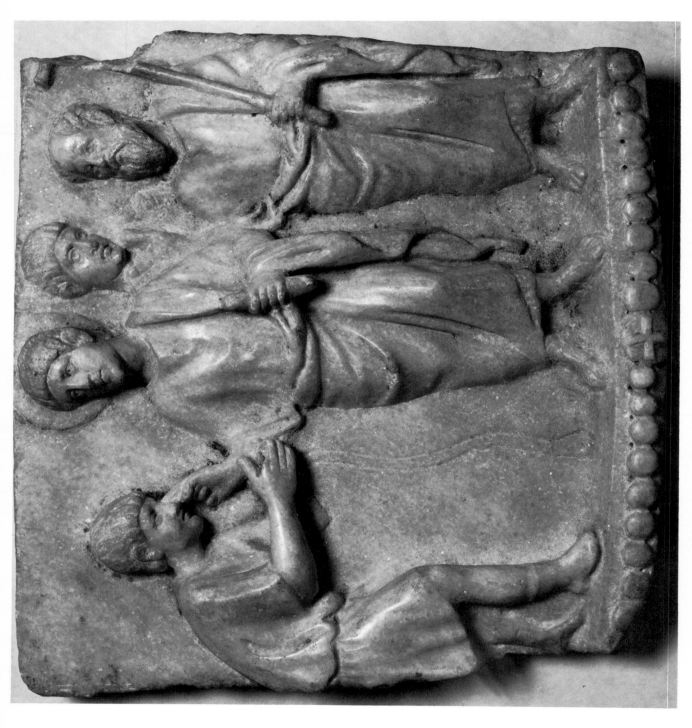

1. Dumbarton Oaks Collection. Marble Relief showing Christ Healing a Blind Man

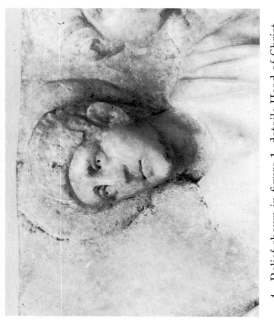

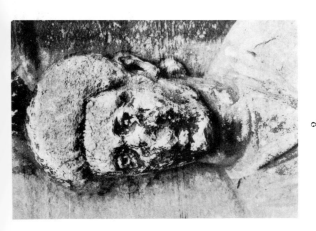

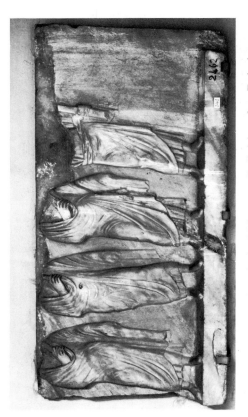

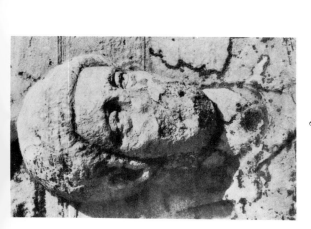

4. Relief shown in figure 1, detail: Head of Christ

6. Istanbul, Archaeological Museum. So-called Sarcophagus of a Prince, detail

2.
3.
Istanbul, Atmeydan (Hippodrome). Base of Obelisk, details of Reliefs of the Period of Theodosius I

5. Istanbul, Archaeological Museum. Relief found at Bakırköy

THEODOSIAN MARBLE RELIEF [27

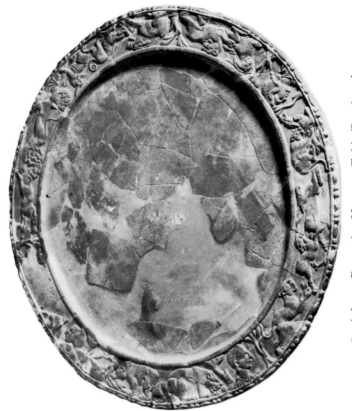

8. Athens, Byzantine Museum. Table Top found
on the Island of Thera

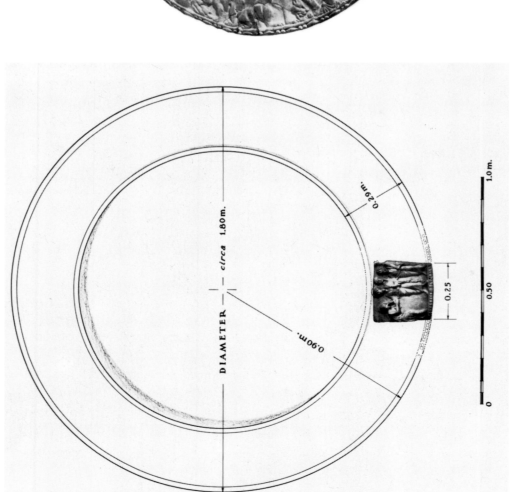

7. Tentative Reconstruction of Table Top incorporating
Fragment shown in figure 1

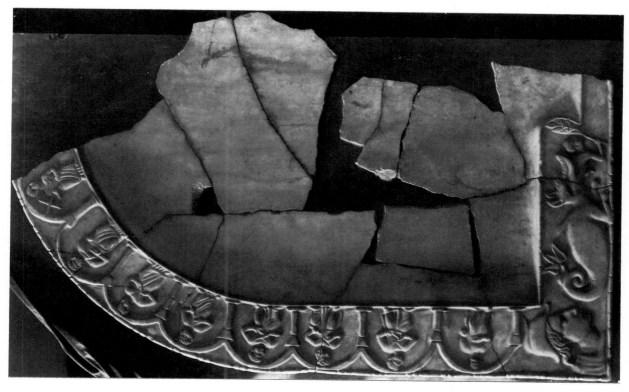

12. Zagreb, Archaeological Museum. Fragment of Table Top (?) found at Salona

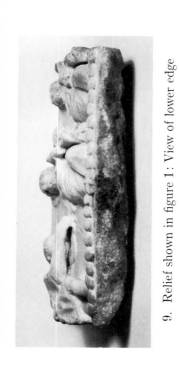

9. Relief shown in figure 1: View of lower edge

10. Relief shown in figure 1: View of right edge

11. Relief shown in figure 1: Back

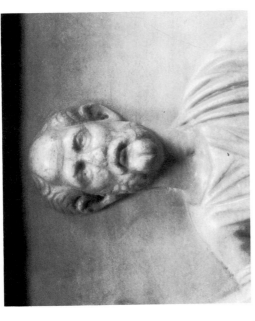

15. Ravenna, Cathedral. Sarcophagus of Exuperantius, detail: Head of St. Paul

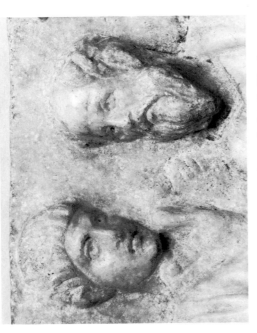

14. Relief shown in figure 1, detail: Heads

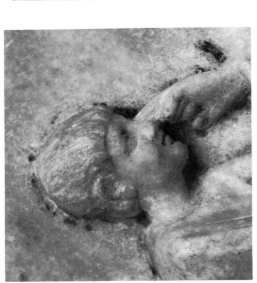

13. Relief shown in figure 1, detail: Head of Blind Man

17. Tebtunis, Church. View of south Chapel showing Table Slab set in Floor at Entrance

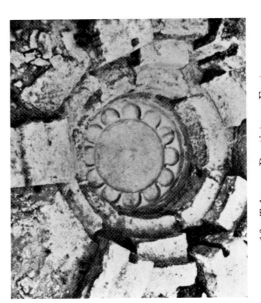

16. Tebessa, Baptistery. Font

18. Berlin, State Museums. Fragment of
Relief found near Sinope

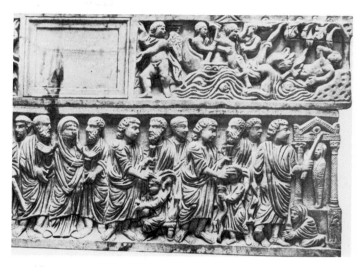

19. Rome, National Museum. Frieze Sarcophagus,
detail: Miracles of Christ

20. Vatican, Museo Sacro.
Ivory Box Lid, showing
Christ Healing a Blind Man

21. Ravenna, Archbishop's Palace. Ivory Chair
of Bishop Maximian, detail: Christ Healing
a Blind and a Lame Man

On the Interpretation of Stylistic Changes in Late Antique Art

MUCH has been done in our time to correlate works of art of the past with social history, with the history of ideas, and with contemporaneous trends in such fields as philosophy, theology, literature, and science. In general, however, it is the *content* of works of art, the choice of subject matter and the iconographic program and detail which have proved most revealing in these respects and are most amenable to interpretation in terms of nonartistic phenomena. This is only natural, because in these matters the artist tends to be under the actual dictation (direct or indirect) of nonartists, be they clerics, scholars or lay patrons. Subject matter and iconography, then, almost by definition are "other-directed," to borrow David Riesman's term. The relationship to outside forces and trends is far more problematic in the case of style. The art historian may ignore this problem so long as he uses stylistic analysis merely as a means of dating and attribution, or to find evidence of physical influence of one "school" or artist upon another. But few of us can resist the temptation at least occasionally to interpret stylistic phenomena in terms of larger and deeper historical trends and attitudes. It is the validity of such "leaps beyond form" which I wish to discuss.

I shall choose my examples from a single period, namely, the centuries from the late second to the early sixth. This period, which may be loosely called the late antique, has the merit of

1

2

being particularly rich in dramatic stylistic changes and fluctuations. But I shall have to be brief and a certain amount of oversimplification is inevitable.

I shall begin with a very clear case—an ivory relief in London (fig. 1) belonging to a well-known group of works made in Rome about 380-390.[1] Seen against the background of preceding late antique developments—as embodied, for instance, in the reliefs made for the Arch of Constantine ca. A.D. 315 (figs. 5, 6)— these works are startling in their refined classicism. It has long been recognized that they originated in the sphere of the ultra-conservative pagan aristocracy of Rome, which at that time made a last-ditch stand against the new Christian order.[2] Members of the Symmachi family, whose name appears on the ivory, were prominent in this group. It is obvious that they not only insisted on subjects pertaining to traditional religious beliefs and practices —in this case a priestess performing a sacrifice—but also saw to it that these subjects were represented in a style which, via that of the period of Augustus, harks back to classical Greece and thus in itself evokes the heroic age of the cult of the Olympian gods. Whether or not the attempt to imitate classical forms was entirely successful we need not discuss. There is something academically dry and pathetically nostalgic about this revival. The purpose and the historical setting are evident. I would call this a case of a deliberate and programmatic "quoting" of an earlier style for the sake of its associations. Obviously we cannot take such a work as an expression of humane ideals in the same way as a figure from the Parthenon.

Three characteristics of this Greek revival are particularly important for our purpose: (1) the consciousness (not to say self-consciousness) of the effort; (2) the minimal relationship to the prevalent style of its own time and place, and the maximum attachment to another, preexistent, style for associative reasons; (3) the presumable interference by the patron who must have, in effect, "dictated" the style as part of his cultural program, thereby constituting in his person a concrete and tangible link between the

[1] R. Delbrueck, *Die Consulardiptychen* (Berlin, 1929), pp. 29 f., 209 ff. and pl. 54.

[2] *Ibid.;* see also H. Bloch, "The Pagan Revival in the West at the End of the Fourth Century," *The Conflict between Paganism and Christianity,* ed. A. Momigliano (Oxford, 1963), pp. 193 ff.

cultural sphere in general and the specifically aesthetic sphere; thus, in this case not only the iconography is "other-directed," but the stylistic change as well.

In the history of late antique art such cases are relatively rare. Most stylistic changes are neither so self-conscious, nor so clearly oriented toward a preexistent style, nor so tangibly inspired by persons or forces outside the realm of art. The difficulty of valid historical interpretation increases in direct proportion as these three factors decrease. But let me anticipate here that the importance of such interpretation also increases in the same proportion.

There is, in effect, a whole spectrum of stylistic changes from the totally conscious, totally associative, totally "other-directed," to the totally, or almost totally unconscious, unassociative and "inner-directed." If the programmatic change embodied in these Roman ivories represents one end of the spectrum, at the other end is what might be called a purely "graphological" change introduced almost involuntarily and without associative intent by an artist who works within an established style.

My example for this opposite extreme is taken from the realm of architectural ornament. Between the early fifth and early sixth centuries there emerges a new type of capital, the so-called Ionic impost capital.[3] It comes into being through a merger of an originally plain or nearly plain impost block—placed as a link between column capital and spring of arcade—with a regular Ionic capital. Gradually these two originally disparate elements are fused into a unified whole. Not only do they become physically one, but they are also merged aesthetically, in overall outline, in proportion and, above all, in ornamentation. At first comprised of detachable and distinct motifs—egg-and-dart, acanthus leaves, etc.— in the traditional manner, the ornament develops into a lacelike web, a semiabstract pattern completely at one with the body of the capital and enveloping the whole of it with its restless chiaroscuro effects. The capitals reproduced in figs. 2 and 4 respectively illustrate stages close to the beginning and to the end of this development: Intermediate steps can be clearly traced in a series of what George Kubler has so aptly called "linked

[3] R. Kautzsch, *Kapitellstudien* (Berlin, 1936), pp. 165 ff.

solutions."[4] Fig. 3 illustrates what is in effect a first such step—
a capital in which the impost block begins to dominate and de-
termine the overall contour, the foliate ornament begins to "take
over" the "Ionic" element (while the egg-and-dart motif is about
to lose its identity), and the chiaroscuro effect begins to be more
important than the ornamental motifs as such. I shall call this
capital "B," while the morphologically earlier one shown in
fig. 2 will be called "A." The question for us is whether it is
possible to interpret historically a relatively small, but evidently
significant stylistic change such as that from "A" to "B."

Applying the same criteria we used previously for our late
fourth century ivory, we may assume here, first of all, a far lesser
degree of consciousness. Presumably the sculptor of "B" reacted
to "A" quite unselfconsciously, and perhaps indeed almost un-
consciously. Second, "B" and the whole direction in which it
develops have little or nothing to do with any other preexistent
style. Its creator is not evoking or "quoting" anything, as our
ivory carver so clearly did. There never had been any capitals
such as those which will emerge from this development. True, in
introducing his changes *vis-à-vis* "A," the sculptor of "B" may
have been influenced by forms he had seen. But, if so, this may
be presumed to have been a matter of aesthetic preference and
without any programmatic intent. By the same token interference
by a patron is most unlikely. Conceivably a patron may have
chosen the artist of "B" over some other artist because he shared
the former's aesthetic preferences. But he cannot have inspired
it. In other words, the stylistic change introduced by the man
who carved "B" is as "inner-directed" as anything can possibly
be in the history of art. It is a graphological change, a very pure
reflection of the artist's mind, and consequently a clue to that
mind, if only we can "read" it. But here, of course, is the rub.
We have no leads here as to the social milieu; there is no sub-
ject matter to give us even the most general indication; and, so
far as I know, no one has ever been able to point to any general
development in fifth-century social or intellectual history to which
the surely not altogether meaningless stylistic change embodied
in our capitals might stand in any sort of relationship.

I have said that there is a gamut of possibilities between the two

[4] *The Shape of Time* (New Haven, Conn., 1962), pp. 33 ff.

extremes illustrated so far. My next example is what I take to
be an intermediate case. Great and far-reaching changes took
place in Roman sculpture in the third century. It was an epochal
transformation which involved the breaking down of the Greco-
Roman canon of forms and led to the radically unclassical style
exemplified by the Arch of Constantine (figs. 5, 6).[5] In consider-
ing this development I shall again use the same three criteria as
in the two previous examples—degree of consciousness, relation-
ship to a preexistent style, and the role of the patron. As to the
first, we have no way of knowing. No ancient source alludes to
the truly cataclysmic change which took place in Roman art in
the third century. A colleague once in a conversation neatly
summed up this aspect of the problem by pointing out that Rome
in A.D. 300 had no coffee houses where artists might have met
to discuss their ideas. But on Constantine's Arch at least, where
the abstract, protomedieval work of the period was placed cheek
by jowl with "classical" reliefs of the period of Trajan, Hadrian
and Marcus Aurelius (fig. 5), the difference must have leapt to
the eye of a contemporary observer—be he artist, patron, or a
member of the public—no less than of a modern one. (There
is a beautiful though, alas, apocryphal scene in Evelyn Waugh's
Helena which deals with this subject.)

The relationship to a preexistent style is very interesting here.
Certainly no drastic change of direction is involved such as we
observed in our first example. The process which leads up to the
style of the Constantinian reliefs was a gradual one, a slow dis-
integration of the classical canon of ideals and form. It was a
step-by-step evolution which can be traced through the whole of
the third century (indeed, its beginnings can be observed in
Imperial Roman art of the second century, as we shall see) and
in this sense it is more nearly comparable to the process we ob-
served in our second example. But there is here a much clearer
approximation to a preexistent style than in the case of those
capitals. The relationship to an undercurrent of local, popular art
which had always existed in Italy even during the periods of
greatest artistic subservience to Hellas is undeniable.[6] For our

[5] G. M. A. Hanfmann, *Roman Art* (Greenwich, Conn., 1964), pp. 31 ff.
[6] G. Rodenwaldt, "Römische Reliefs. Vorstufen zur Spätantike," *Jahrbuch des deutschen archäologischen Instituts,* LV (1940), 12 ff. R. Bianchi-Bandinelli, in *Enciclopedia dell' arte antica,* VI (1965), 984 ff.

6

present purposes we may widen the concept of this undercurrent by using the term "sub-antique," a term which includes not only the popular art of Italy itself, but also provincial Roman art East and West, and even the semi-Hellenized art of some of Rome's neighbors. There can be no doubt that to this "sub-antique" art— here exemplified by a well-known second-century tomb relief in Rome depicting a circus scene—the late antique sculptural style as it emerges on the reliefs of Constantine's Arch is deeply indebted (cf. figs. 6 and 7). This is where the salient features of the Constantinian style—jerky, drastic movements, abrupt changes in proportion, and the presentation of all parts of the composition in a single plane without any attempt to create an illusion of spatial depth—were clearly prefigured; and, particularly if we include Eastern examples, we also find in the realm of "sub-antique" art the repetition of identical motifs and the replacement of modelling by sharp linear incisions.[7]

One should, it seems to me, consider the possible role of patrons in fostering and encouraging this approximation to the "sub-antique," particularly during the Tetrarchy and the early Constantinian period. In the case of the Arch of Constantine it has been suggested that employment of artists of a popular sort was a result of special economic and political conditions in Rome at the time.[8] But the anti-classical wave as a whole is too big and sweeping a movement to be accounted for in this way. For instance, the famous porphyry group of the emperors of the Tetrarchy in Venice (fig. 10)—a prime exponent of the style— is an Eastern Mediterranean work and thus betokens the existence of the same trend in a totally different geographic area. One should not, in my opinion, exclude the possibility that the anti-classical style was consciously encouraged by a succession of soldier-emperors who relied on the support of the broad masses and the army, were out of sympathy with the *haute bourgeoisie* and the Hellenic ideals it traditionally espoused, and instead tended to stress the sturdy, if less polished, Roman values of a bygone age. To the extent to which this may be true, the emergence of

[7] See, for instance, some of the Sassanian rock-hewn reliefs of the third century at Bishapur and Naqsh i Rustam (E. Herzfeld, *Iran in the Ancient East* [London, 1941], pp. 314 ff. and pls. 113-118).
[8] H. P. L'Orange and A. von Gerkan, *Der spätantike Bildschmuck des Konstantinsbogens* (Berlin, 1939), pp. 218 f. B. Berenson, *The Arch of Constantine or the Decline of Form* (London, 1954), pp. 31 ff.

the "sub-antique" style would be "other-directed" rather than "inner-directed," and programmatic rather than aesthetic in its motivation; that is to say, cultivated for the sake of its associations rather than for intrinsic reasons; and to the same extent it would be a phenomenon comparable to the academic classicism of the ivories in our first example.

Certainly the case is not the same as that of those ivories. There can be no question here of a direct and systematic "quoting" of the style of a remote past. The third-century reaction against classical art is too broad and, above all, too gradual to be accounted for entirely in this way. But to the extent to which it may be "other-directed" and associative, the anti-classical style of the period would not be simply a mirror of the artist's own mind. It would not be, to that extent, a graphological document to be read directly as a clue to that mind and the mind of its time.

What we have here, then (and I think this is a frequent case in the history of art), may well be a mixture of the conscious and the unconscious, the "other-" and the "inner-directed," the associative and the graphological; and in theory we should discount the former element before we try to "read" the style in terms of the latter. In practice, of course, this is difficult. These late Roman sculptures tend to be taken at face value, as it were, and "read" directly as mirrors of their time, as in Hans Peter L'Orange's stimulating recent study.[9] I think one should recognize that to the extent to which the style is associative and "other-directed," the legitimacy of L'Orange's "graphological" interpretation is limited. Undoubtedly, however, his approach can claim some or even a considerable amount of legitimacy; and in this case, as distinct from that of our fifth-century impost capitals, there are ample controls. L'Orange has shown how many of the basic characteristics of the art of this period have their corollary in what he calls "civic life," in the organization of the state, particularly under the Tetrarchy, and also in the intellectual life of the period. He has noted the general trend towards the impersonal, the standardized, the rigidly regimented, and has drawn analogies between the rendering and composition of figure groups and such seemingly unrelated phenomena as Diocletian's tax laws.

[9] *Art Forms and Civic Life in the Late Roman Empire* (Princeton, N. J., 1965).

In other words, he has proposed a very broad and sweeping graphological, or, to use Meyer Schapiro's term, physiognomic,[10] interpretation of stylistic forms; and he is able to cite chapter and verse to support his interpretation.

L'Orange's physiognomic interpretation of late Roman sculptures has this in common with the programmatic or associative interpretation of these sculptures which I suggested first—that both lead beyond the purely formal and aesthetic sphere and relate the work of art to broad historical currents of its period. Also, the general direction in which the two interpretations point is the same, such terms as militarization and simplification being applicable in either case. Nevertheless, the distinction between the two approaches should not be slurred, for they pertain to quite different sets of circumstances and relationships. The data revealed by the programmatic interpretation are concrete, but narrowly confined. The physiognomic, or graphological interpretation penetrates into much deeper levels of the psyche of the period but is necessarily nebulous and vague with regard to actual links between artistic and nonartistic phenomena, relying, as it ultimately must, on a period mentality, or *Zeitgeist,* as a common denominator and motivating force. There is no other way to get from relief style to tax laws. In the case of the programmatic interpretation, as I said before, the dictating patron provides in his person a concrete link between art and society; but it would be, as I have also said, impossible to account for the whole stylistic revolution in third-century Roman art by the associative preferences of patrons. A *Zeitgeist* may be a historian's construct—a mere methodological crutch—but I do not see how any really deep and meaningful interpretation of a major historical style can do without it or some equivalent term.

A cynic of course might say, "why bother?" The best that either approach can accomplish is to tell us something that we already know. We already know that the age of Diocletian was one of political, economic, and social regimentation and of domination of life by the military. We would know this even if not a single work of art of the period had survived. Similarly, in our first example, our knowledge of the last-ditch stand made by the diehard de-

[10] M. Schapiro, "Style," in *Anthropology Today: An Encyclopedic Inventory* (Chicago, 1953), pp. 287 ff., esp. p. 307 f.

fenders of paganism among the Roman aristocracy at the end of the fourth century is not really affected by those ivories, though it may be made a little more vivid and concrete by these pretentious carvings. The only case where the interpretation of stylistic change seems capable of providing entirely fresh historical insights is the one represented by our second example. It is the purely "inner-directed," graphological change lacking evident connections with other known phenomena of its period which is potentially the most revealing.

We thus arrive at a curious antinomy: the case in which style has potentially the greatest source value is also the one least amenable to valid scientific interpretation. Conversely, the cases where such interpretation is possible, either because of a demonstrable interference by a patron, or because of the existence of clearly parallel phenomena in other areas of life, are in a sense the least interesting because they are, so to speak, tautological. It sounds like an impasse, a hopeless deadlock.

I think there are several possible ways out, but I shall name only one which is perhaps the most obvious, namely, the possibility of extrapolation. We start with cases where the graphological interpretation of a given stylistic phenomenon seems certain by virtue of analogous phenomena in other areas, and from these cases infer similar mental states when we encounter similar formal developments, even though we may lack corroborative documentation. For instance, the significant stylistic differences in the renderings of identical subjects on the Columns of Trajan and Marcus Aurelius (figs. 8, 9) might be taken to show that late antique regimentation, carried to extremes under Diocletian, was latently present well before the end of the second century.[11] We use here what Meyer Schapiro has called "commonsense psychology" and "intuitive judgments."[12] But these judgments are founded on and controlled by our knowledge of more fully documented cases.

Potentially a truly graphological change is, indeed, a first-rate

[11] For a detailed analysis of the stylistic innovations introduced by the sculptors of the reliefs of the Column of Marcus Aurelius *vis-à-vis* those of the Column of Trajan and the emergence of late antique concepts in the former work, see M. Wegner, "Die kunstgeschichtliche Stellung der Marcussäule," *Jahrbuch des deutschen archäologischen Instituts,* XLVI (1931), 61 ff., esp. 173 f., and, for the two reliefs illustrated in our figs. 8 and 9, pp. 116 f., 120, 135 f.

[12] *Op. cit.,* pp. 287, 307.

10

historical source. By definition it is a direct and pure reflection of the artist's mind, which, in turn, may be an extremely sensitive barometer of hidden trends in the mood, thought and feeling of the artist's time. But to read this indicator correctly we must be sure that we are reading the arist's mind and not someone else's; in other words, that we have before us an "inner-directed" change, not an "other-directed" one, and one that is motivated aesthetically and not purely associatively.

I make bold to say that art history's claim to be an autonomous discipline ultimately rests on our ability to isolate and interpret such genuinely "inner-directed" changes. Our field, of course, possesses a sort of false and deceptive autonomy. As James Ackerman has shown, it is possible to establish a seemingly "closed system" of historical evolution in art entirely in terms of formal sequences, reactions and influences.[13] This is because artists, no matter whether "other-" or "inner-directed," always react to, and create in terms of art, not of society or government or church, or other extraneous factors. But at every step the aesthetic reaction even of the most "inner-directed" artist is conditioned by forces and experiences outside the realm of form. The more surely and correctly we can pinpoint these motivating forces, the better our chance as art historians to make an independent contribution to the exploration of man's past.

[13] J. S. Ackerman and Rhys Carpenter, *Art and Archaeology* (Englewood Cliffs, N. J., 1963), p. 177.

Fig. 1—Leaf of Ivory Diptych with Priestess Sacrificing (ca. A.D. 380-390). London, Victoria and Albert Museum

Fig. 2—Ionic Impost Capital (Fifth century). Kampia, Greece (Capital "A")

Fig. 3—Ionic Impost Capital (Fifth century). Corinth, Greece (Capital "B")

Fig. 4—Ionic Impost Capital (A.D. 532-537). Istanbul, Church of St. Sophia

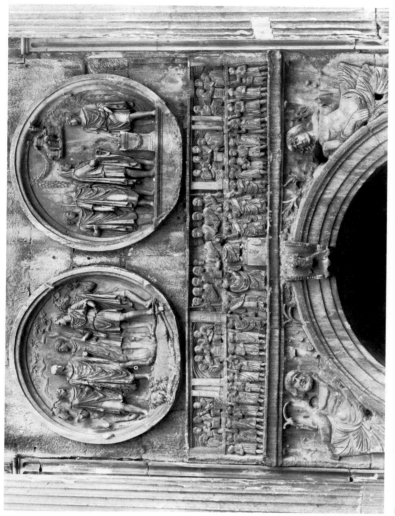

Fig. 5—Detail of Arch of Constantine, Rome. Above: Two Re-used Medallions of the Period of Hadrian (A.D. 117-138); below: Frieze showing Constantine distributing Largesse (A.D. 312-315)

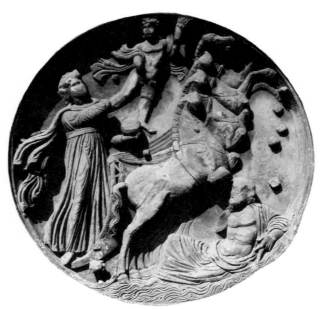

Fig. 6—Detail of Arch of Constantine, Rome: Medallion with Personification of Rising Sun (A.D. 312-315)

Fig. 7—Tomb Relief with Portrait of Deceased and Circus Scene (Second century). Rome, Lateran Museum

Fig. 8—Detail of Relief Band of Column of Trajan, Rome (A.D. 113): Soldiers on the March

Fig. 9—Detail of Relief Band of Column of Marcus Aurelius, Rome (A.D. 180-193): Soldiers on the March

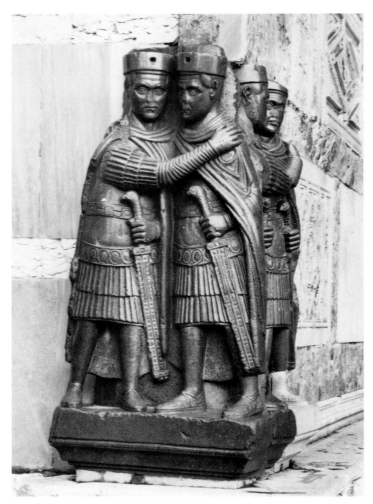

Fig. 10—Porphyry Group of the Four Emperors of the Tetrarchy (A.D. 293-305). Venice, S. Marco

ERNST KITZINGER

III

MOSAIC PAVEMENTS IN THE GREEK EAST AND THE QUESTION OF A « RENAISSANCE » UNDER JUSTINIAN

It was, I believe, Ernest Renan who first formulated the concept of a « Justinian Renaissance » in the arts. In the year 1862 he became involved in a controversy with G. B. de Rossi on the subject of the famous mosaic pavement from the church of St. Christopher at Kabr Hiram discovered by Renan himself and now in the Louvre. De Rossi argued that the decoration of this mosaic with its hunting and vintage scenes and its personifications of Months, Seasons, and Winds could not be of the period of the dedicatory inscription — which clearly yields the date 575 A. D. — but must be of a far earlier date, and, indeed, must have been made originally for a pagan building of the fourth century[1]. In his « Mission en Phénicie », which appeared in 1864, Renan gave a detailed answer to De Rossi's argument. He not only advanced a number of technical points which, in his opinion, proved conclusively that inscription and decoration must all be of one date, but he also attempted to explain an artistic phenomenon which to De Rossi, with his Roman background and experience, seemed an impossibility. Renan pointed out that, as De Vogüé's investigations in the field of architecture had shown, classical traditions still survived in Syria during the fifth, sixth and seventh centuries. As for the Kabr Hiram pavement, it must be considered « un fruit de la grande renaissance du temps de Justinien, renaissance qui a laissé tant de traces dans tout l'Orient, en Égypte, en Syrie, au Mont Sinaï, dans le Hauran »[2].

The discussion concerning the date of the Kabr Hiram mosaic

1. Académie des Inscriptions et Belles-Lettres : Comptes rendus des séances de l'année 1862, pp. 153, 157 ff., 160 ff.

2. E. Renan, *Mission en Phénicie*, Paris, 1864, p. 625 f. For a more recent discussion of « renaissance » tendencies in the art of Justinian, see G. Rodenwaldt, in : *Archaeologischer Anzeiger*, 1931, col. 327 ff. (cf. G. Downey, in : *Transactions of the American Philological Association*, 1940, pp. 68 ff.).

has continued to our own day[1]. My paper, however, is concerned not so much with this particular question as with Renan's general thesis, in so far as it applies to pavement decoration. A great many discoveries have been made in this field since Renan's day. Mosaic floors of the second half of the sixth and the early seventh century are no longer rarities, especially not in Syria, Palestine and Transjordan. I need mention only Madaba, which in Renan's days was still unknown and which toward the end of last century yielded so many splendid mosaics belonging to that general period[2]. Then, in more recent decades, the discoveries have moved back in time. The joint British and American excavations at Gerasa have brought to light a rich series of floors, particularly of the first half of the sixth century[3]. The activities of the former Department of Antiquities in Palestine and of various private organizations operating in that country have resulted in the discovery of numerous pavements belonging mostly to the fifth and sixth centuries[4]. Others have come to light in Greece and the Aegean islands and in North Africa. Finally, in the last decade before World War II, the joint French and American excavations at Antioch[5], supplemented by the Belgian excavations at Apamea[6], yielded an overwhelmingly large material ranging all the way from the first to the sixth century and thus closing the gap between the classical period and the age of Justinian.

Renan's contention that there was in Syria a continuous and uninterrupted tradition troughout those centuries has been born

1. As late as 1935 it was proposed by M. Avi-Yonah that at least the mosaics in the aisles should be divorced from the dated inscription (cf. Quarterly of the Department of Antiquities in Palestine V, 1935-36, p. 29, n. 1). On this question see below.

2. The relatively fullest treatment of these mosaics is in the *Izvestia of the Russian Archaeological Institute in Constantinople*, vol. VIII, pt. 2, 1903, and in *Nea Sion* I, 1904, pp. 49 ff., 540 ff. ; III, 1906, pp. 139 ff.

3. F. M. Biebel, in : *Gerasa, City of the Decapolis* (C. H. Kraeling, éd.), New Haven, Connecticut, 1938, pp. 297 ff. and pls. 58 ff.

4. M. Avi-Yonah, in : *Quarterly of the Department of Antiquities in Palestine*, II, 1932, pp. 136 ff. ; III, 1933, pp. 26 ff., 49 ff. ; IV, 1934, pp. 187 ff. Cf. also subsequent issues of the same journal.

5. *Antioch-on-the-Orontes* (Publications of the Committee for the Excavation of Antioch and its Vicinity), Princeton — London. — The Hague, vol. I, 1934 ; II. 1938 ; III, 1941. Also : Doro Levi, *Antioch Mosaic Pavements*, Princeton — London — The Hague, 1947.

6. *Bulletin des Musées Royaux d'Art et d'Histoire*, Brussels, 1931 pp. 23 ff. ; 1932, pp. 42 ff. ; 1933, pp. 2 ff., 50 ff. ; 1935, pp. 2 ff. ; 1936, pp. 1 ff. ; 1938, pp. 98 ff. ; 1940, pp. 1 ff. Cf. also *Rivista di Archeologia Cristiana* 13, 1936, pp. 331 ff.

out in full. That part of his thesis needs qualifying only to the
extent that the phenomenon can no longer be regarded as belonging
exclusively, or even primarily, to the South-Eastern corner of
the Mediterranean. One of the latest and most spectacular of
all the discoveries in the field of pavement decoration, the
peristyle floor from the Imperial Palace in Constantinople uncovered
by St. Andrews University, shows that leadership in this branch
of artistic endeavor, at any rate by the fifth century, had passed
to the capital on the Bosphorus[1].

But what about the other contention of Renan's, namely,
that there was not only a continuous tradition from the classical
to the early Byzantine period, but, in addition, a revival,
a renaissance, in the age of Justinian ? This can have been
hardly more than a guess on Renan's part, since in his days the
relevant material was almost entirely lacking. Today, however,
when we do possess a rich and continuous series of floor mosaics
spanning the whole period from the first to the sixth century,
we are in a much better position to judge, at least within this one
field, the specific achievement of the sixth century, including any
possible renaissance phenomena. Renan's thesis, therefore,
can and should now be re-examined.

This can be done from various points of view : iconography,
composition, figure style, ornament, epigraphy. In all these
respects a survey of sixth century floor decoration discloses certain
striking phenomena which should be investigated in the light of
Renan's thesis. In this paper I can deal with only one aspect
of this art which to me seems significant, namely, the frequent
occurrence, particularly in Syria, Palestine and Transjordan, but
also elsewhere, of Christian pavements with purely secular, and
especially topographic, geographic and cosmographic subject
matter.

The emergence of this distinctly secular iconography can be
observed particularly well at Gerasa. Of three important churches
built there before the sixth century only one, that of the Prophets,
Apostles and Martyrs (464-5) received a floor mosaic. What is
left of this decoration[2] shows mainly geometric motifs with
figures of birds in some of the panels. The type of floor with
isolated figures of animals and birds in a geometric framework

1. G. Brett, in : *The Great Palace of the Byzantine Emperors;* being a first report
on the excavations carried out in Istanbul on behalf of the Walker Trust (the University
of St. Andrews) 1935-1938, Oxford, 1947, pp. 64 ff. and pls. 28 ff.

2. Biebel, *loc. cit.*, p. 337 and pl. 78.

is characteristic of the fifth century, for instance, in Greece. In Gerasa it was used extensively in the earlier ones of the numerous churches built there during the first half of the sixth century, in the church of Procopius of 526[1], and in the church of St. George of 529-30[2]. But in the church of John the Baptist of 531[3] an entirely different type of decoration makes its appearance. Since the pavement of this church is in a very fragmentary condition a certain effort of the imagination is required in order to visualize its original lay-out.

The central field has disappeared almost entirely, but one can tell from its scanty remains that it showed a vine rinceau populated by animals and perhaps also human figures as in Kabr Hiram. The frame of this central square consisted of a meander enclosing sixteen busts personifying the twelve Months and — presumably — the four Seasons. In the four corners are four candelabra, a very striking motif which, in Antioch at least, occurs only at a much earlier period. Of the three intervening segments only that to the South (fig. 1) and part of that to the North are reasonably well preserved. They showed Nilotic landscapes with water plants, water birds and fishes in the « river » below, and cities, trees, human figures and animals on « land » above. Only one of the cities, on the North side, still bears its name inscription : « Alexandria ». This, then, is a portrayal of a specific country — Egypt — with specific labels, a geographic theme on the church floor, coupled with the Months and the Seasons. The floor of the church of Sts. Peter and Paul[4], not precisely datable but very closely related to St. John's, shows an abbreviated version of the same program. First a strip with the four Seasons, then a vine rinceau, and in the center of the nave a strip with two city views, inscribed « Alexandria » and « Memphis », followed by another vine panel.

This program appears at Gerasa suddenly about the year 530. Evidently it was not invented there in that year. The most reasonable explanation is that a migrant workshop brought it from somewhere else. But even outside Gerasa this type of subject matter was at that time rather novel for a church pavement. In the whole field of Christian pavement decoration I know of only one fairly close precedent for the geographic themes displayed

1. *Ibid.*, pp. 338 ff. and pls. 79-84.
2. *Ibid.*, p. 329 f. and pls. 71-72.
3. *Ibid.*, pp. 324 ff. and pls. 66-70.
4. *Ibid.*, pp. 333 ff. and pls. 75-76.

Fig. 1 Gerasa, St. John the Baptist: Fragmentary Floor Mosaic of South Segment and Southeast Exedra (composite photograph)

at Gerasa, namely, the transept floors of the church of the Multi-
plication of the Loaves and Fishes at Tabgha on the Sea of Galilee[1].
The nave and aisles of this church are paved with geometric motifs ;
in the transept wings are two panels filled entirely with Nilotic
motifs (fig. 5). These floors were thought originally to belong to
the fourth century, but the discovery of an earlier church
underneath has made that dating impossible, and for stylistic
reasons they are likely to be closer to the year 500 than to the
year 400[2]. The representations are not as varied, nor as articu-
lately geographic, as those in Gerasa. Although the motifs are
all taken from Nilotic landscapes they are limited almost entirely
to birds and water plants. The only specifically Egyptian object
is a Nilometer. There are no labels identifying the country or
any particular site. The mosaic occupies a position halfway
between the generic animal and plant genre common on church
floors in the fifth century and the specifically geographic represen-
tations at Gerasa. At Tabgha, probably in the second half of
the fifth century, geography and topography are introduced
cautiously, at Gerasa, about 530, much more boldly, emphatically,
and articulately.

Geography makes its appearance about the same time on a
well-known church pavement in Greece The basilica of Dumetios
at Nikopolis[3] is usually attributed to the second half of the fifth
century, but as I hope to show in a longer paper dealing primarily
with this church, a combination of various archaeological and
historical data leads to the conclusion that it originated in the
period between about 520 and 550 A. D. In Greece, as I have
remarked before, the typical church pavement of the fifth century
has a geometric framework with individual pictures of animals,
birds, and plants. Most of the pavements in Bishop Dumetios'
church follow that type. But in the transept wings, in a position
comparable to that of the Nilotic panels at Tabgha, there are
two floors with more elaborate representations. In the Southern
wing there is a badly damaged hunting scene, for which I hope to
propose at least a tentative interpretation in the longer paper
referred to above, in the Northern wing a panel (fig. 2), which,
as the inscription tells us, depicts the earth surrounded by the

1. A. M. Schneider, *The Church of the Multiplying of the Loaves and Fishes*, London
1937.
2. Cf. Doro Levi, *loc. cit.*, p. 467, n. 260.
3. A. Philadelpheus, in : *Archaiologike Ephemeris* 1916, pp. 33 ff., 65 ff., 121 f. ;
1917, pp. 48 ff. G. A. Sotiriou, in : *Hieros Syndesmos*, Dec. 1-15, 1915, n⁰ˢ 255-6 (reprint
Athens 1915). *Id.*, in : *Archaiologike Ephemeris*, 1939, pp. 206 f.

ocean. The earth is represented by a « forest » of trees with birds below and in the air above. The sea is indicated by means of a broad frame of « water » populated by numerous fish and two fishermen. The inscription, which is in hexameters of a Homeric flavor and actually includes a literal quotation from Homer, reads in translation :

Here you see the famous and boundless ocean
Containing in its midst the earth
Bearing in the skillful images of art everything that breathes and creeps
The foundation of Dumetios, the great-hearted archpriest.

In our context this floor is remarkable mainly for two reasons :

1. Earth and ocean are represented, as it were, realistically, by means of objects belonging to their respective spheres, rather than in the more common allegorical manner by means of personifications ; and,

2. They are shown in their actual physical relationship, or at least in what poets and laymen (as distinct from scholars) believed to be their relationship.

A specific geographic concept is projected on the floor in concrete, graphic form. The mosaic is actually a diagram of the world, in which the landscape and the fishing scenes play the role of map symbols or vignettes. This geographic diagram appears at Nikopolis during the same period in which, as we saw, similar subjects appear on church floors at Gerasa.

The development which we have observed at Gerasa and Nikopolis continues in the second half of the sixth and into the seventh century. I cannot discuss in detail all the church floors of that period showing specific localities[1] or countries[2], earth[3] or sea[4]. But I must mention the map mosaic at Madaba, an outstanding example of cartography projected on the church

1. Pavement at Ma'in (*Revue Biblique*, 1938, pp. 227 ff.). See also below.
2. An unpublished pavement in Haditha, Palestine, knowledge of which I owe to photographs generously supplied by the former Department of Antiquities. The pavement which is in fragmentary condition, has a border with aquatic scenes representing the Nile valley ; a conventional city view in the corner is inscribed « ΕΓΥΠΤΟС ». An inscription in the central field gives clear proof that the context is Christian.
3. Pavement in a church at El-Muhayet (*Rivista di Archeologia Cristiana* 13, 1936, p. 130 f. and fig. 19) ; probably also another church floor in the same locality (*ibid.*, p. 136 f.).
4. Pavement in the church of the Apostles at Madaba (*Revue Biblique*, 1902, p. 599).

Fig. 2 Nikopolis, St. Demetrius: Floor Mosaic in North Wing of Transept

floor[1]. This is not a generalized and artistically composed diagram like the mosaic at Nikopolis, but a detailed map of Palestine, parts of Egypt, and originally perhaps other parts of the inhabited world. It shares with Nikopolis the cartographic lay-out and with the Gerasa floors the views of cities with identifying labels. But it goes much further than these. At Gerasa and Nikopolis the cartographic elements are concealed by, or subordinated to an artistic composition ; at Madaba the map is spread out openly and without disguise.

In addition to geographic themes we find on these Eastern sixth century floors other elements of cosmography, the sun and the moon[2], the months[3], and the seasons[4], and often, in association with these subjects, hunting and vintage scenes. The Kabr Hiram mosaic, with its figures of Months, Seasons and Winds and its hunters and vintagers finds its logical place in this large group[5].

The role of the hunts and vintage scenes in this pavement iconography cannot be discussed here. I want to draw attention

1. P. Palmer and Dr. Guthe, *Die Mosaikkarte von Madaba*, Leipzig, 1906.
2. G. M. Fitzgerald, *A sixth century Monastery at Beth Shan* (Scythopolis) (Publications of the Palestine Section of the University Museum, University of Philadelphia, vol. IV), Philadelphia 1939, frontispiece.
3. Beth Shan Monastery, cf. Fitzgerald, *ibid.* Beth-Shan-El Hammam, cf. Avi-Yonah, in : *Quarterly of the Department of Antiquities in Palestine*, V, 1935-36, pp. 11 ff. Gerasa, Cathedral Chapel, cf. Biebel, *loc. cit.*, p. 313 and pl. 59 a. Gerasa, Church of St. John, cf. *ibid.*, p. 325 f. and pl. 66 b.
4. Gerasa, Church of Sts. Peter and Paul, cf. Biebel, *loc. cit.*, p. 335 and pl. 75 b ; perhaps also Church of St. John, cf. *ibid.*, p. 325. Church at Deir Solaib, cf. *Mélanges de l'Université Saint-Joseph*, XXII, 1939, pp. 23 ff. and pls. XIV ff. Churches II and V at El-Muhayet, cf. *Rivista di Archeologia Cristiana*, 13, 1936, pp. 132, 137.
5. Stylistically, too, the pavement cannot be placed in any other period than the sixth century. There are, it is true, striking discrepancies between certain parts. In particular, a comparison of the busts and some of the animals in the North and South aisles, and also of the panels in the intercolumniations, shows that the rendering on the North side is in many instances more « impressionist » than that on the South side, which is more abstract and solidified. But it is impossible to draw a sharp distinction between the two groups, and the central panel seems to occupy an intermediate position. The pavement is undoubtedly a unified creation ; the stylistic discrepancies must be due to the employment of different hands or varying degrees of influence from classical models, or both. The work as a whole must be judged by its most advanced characteristics which are those of the sixth century (cf. e. g. the busts of « Hyperbereteos » and « Metopros » in the South aisle). In quality, however, it is superior to all comparable mosaics of the same period and region. Whether or not the strikingly classical elements in its style deserve to be called a « renaissance » phenomenon is a question which can be decided only within the framework of a broader enquiry into the style of sixth century pavements. The first prerequisite would be a photographic reproduction of this outstanding work of early Byzantine art.

merely to the prominence given to topographic, geographic and cosmographic themes on these sixth century floors. In many instances a specific motivation of a religious nature has been or can be found, which might explain the choice of subject matter in a particular case. The Madaba map with its numerous Scriptural references has been connected with the cult of Moses on nearby Mount Nebo[1]. The prominence given to Egypt in several instances, at Gerasa for example, may have something to do with ecclesiastical politics of the period[2]. The Nikopolis floor has been characterized as a kind of sermon on the Creation and God's love for His creatures[3]. Though in this case the inscription, which I have quoted, gives no hint that this was the underlying thought, I do not deny that elsewhere the choice of a particular geographic subject may have been determined by specific religious considerations[4]. Nor do I deny that some of the subjects occurring on these floors were used in Christian art long before the sixth century. The Seasons, for example, a subject with old symbolical associations, were depicted on one of the earliest of all known church pavements, that of Aquileja of the early fourth century[5]. The Nile genre also had been used in

1. F. Cabrol et H. Leclercq, *Dictionnaire d'Archéologie Chrétienne et de Liturgie*, vol. 10 pt. 1, col. 859 f.

2. Biebel, *loc. cit.*, p. 342.

3. J. St. Pelekanides, in : *Zeitschrift für Kirchengeschichte*, 59, 1940, p. 114.

4. The topographic frieze at Ma'in has been interpreted by Père de Vaux as a pictorial list of bishoprics (cf. *Revue Biblique*, 1938, pp. 251 ff.). Although this interpretation is open to weighty objections, as its author himself admits, we do know that pictorial representation of the churches of a given diocese was already a subject of church decoration under the Emperor Zeno (474-491). Cf. *Acta Sanctorum*, February, II, p. 61, no. 9 and E. Bertaux, *L'Art dans l'Italie Méridionale*, Paris, 1903, p. 66. M. A. Frolow has drawn my attention to the description of St. Mary Peribleptos in Constantinople, which proves the existence of what seems to be likewise a pictorial catalog of dependencies in a later Byzantine church (Clavijo, *Embassy to Tamerlane*, edited by G. Lestrange, London, 1928, p. 64 f.).

5. *La Basilica di Aquileja*, Bologna, 1933, pls. 31, 33, 34. Cf. also the pavement in Tegea with representations of the Months and the Rivers of Paradise, which is thought to belong to the first half of the fifth century. A final verdict as to the date of this mosaic must, however, await a fuller publication. There also seems to be some doubt as to whether the building to which it belonged was not perhaps a synagogue rather than a church (cf. Atti del IV° *Congresso Internazionale di Archeologia Cristiana*, vol. I, Rome, 1940, p. 365 f. and also *Bulletin de Correspondance Hellénique*, 17, 1893, p. 13 f.). Similar uncertainties both as regards date and destination exist in the case of a partially excavated pavement in Argos with Months and hunting scenes, full publication of which is also eagerly awaited (cf. *Mededeelingen der Koninklijke Akademie van Wetenschappen*, Afd. Letterkunde, Deel 72, Serie B, No. 3, 1931, pp. 3 ff.).

Christian art before the sixth century. But there can be no doubt that as a group our pavements represent something new. In no previous phase of Christian art had there been such a concentration of subjects pertaining to the physical world, nor had these subjects ever received such objective, even scientific treatment, with emphasis on physical appearances and relationships (at least in the case of the cartographic mosaics), and with identifying labels and captions as an almost constant feature. One gets the impression that the subjects must be taken at their face value and not as parts of a symbolical vocabulary. Whatever special meaning the choice of a particular geographic or cosmographic theme may have in a given case, in its entirety this whole large iconographic program evinces an emphatic and articulate interest in, and concern with the facts of the physical universe, such as Christian art had not displayed at any previous stage.

The beginnings of this phase of pavement decoration lie before the period of Justinian. The Tabgha mosaics provide clear proof of this, and there may be other instances elsewhere. On the other hand, it can hardly be doubted that, so far as church pavements are concerned, the geographic and cosmographic repertoire reaches its fullest expansion in the sixth century. It belongs primarily to the era of, and immediately after Justinian, and in view of its secular character it may be called a « renaissance » phenomenon.

This term, however, can be used only in a very limited sense in connection with the repertoire here described. Many of the subjects which appear on our pavements were not the result of a revival but were part of a living tradition in secular art. At Antioch, for instance, we find on the floors of private houses and other secular buildings of the fourth and fifth centuries many a representation of the « Earth », the Seasons, and other similar subjects. Antioch also provides an outstanding example of a topographic theme on a pavement : the famous border of a fifth century floor in a villa at Yakto representing views of buildings and streets in Antioch and the suburb of Daphne[1]. Such subjects, then, were available. They were part of the regular stock of patterns used by the mosaicists. They were not revived but simply transferred from the secular to the ecclesiastical field. Whether this applies to all secular subjects on sixth century church pavements I cannot say. For instance, Antioch provides no precedent for the influence of cartography on floor mosaics. But

1. *Antioch-on-the-Orontes*, I, p. 128 ff.

this is altogether unprecedented, there being no known example of a mosaic map even in classical times.

There are certain stylistic and ornamental elements in sixth century floor decoration, which, in my opinion, can be explained only in terms of a real revival. Certain formal devices are used which belong to classical Graeco-Roman art and which had been in eclipse for a considerable period prior to the time when they appear on these floors. The « emblemata » in the Nikopolis transepts and perhaps also the corner candelabra at St. John's, Gerasa, are cases in point. The same may well be true of some of the iconographic subjects which occur on our pavements. But by and large we can use the term « revival » only in the sense of a new expansion of, a new emphasis on a repertoire which was still a living tradition in the mosaic workshops. The fact that this repertoire was now admitted into the church gave the tradition a new scope and a new impetus. But the movement is not primarily a retrospective one.

The term « renaissance » must be qualified in yet another sense. It has connotations of worldliness, of a renewal of secularism, which probably do not apply in this case. It is at least doubtful that the secular repertoire was introduced into the church for its own sake. Although we have seen that in most cases it was presented in such a way as to suggest that it must be taken at face value, was there not a religious motivation nevertheless that would account for its presence ?

In a recent study of a Syriac hymn of the seventh century which describes the sixth century church of St. Sophia in Edessa in terms that are at least in part symbolic of the cosmos, Prof. Grabar has shown that through the spread of the mysticism of Pseudo-Dionysius in the Christian East of the sixth century, the stage was set for a very concrete identification of the church building with the cosmos, as visualized by contemporary « science »[1]. Perhaps the new cosmographic and encyclopaedic genre in pavement decoration should also be seen in the light of this observation. There is at least one mosaic in our group which definitely calls to mind the symbolism of the Syriac hymn. I refer to the pavement in the Northern transept wing of the basilica of Dumetios in Nikopolis, which, as we have seen, is given over entirely to a kind of *mappa mundi*. Standing in the centre of this room, the visitor has beneath him the entire earth with the ocean all around. The room expands into an image of the world,

1. *Cahiers Archéologiques*, II, 1947, pp. 41 ff., especially pp. 54-59.

just as the Edessa church did in the eyes of the Syriac poet. Indeed, the situation of that church between two lakes induced the poet to liken it to the earth surrounded by the ocean[1], which is

Fig. 3 Turin, S. Salvatore: Floor Mosaic, detail (*in situ*)

exactly the concept so tangibly expressed in the Nikopolis pavement. One may wonder, then, whether the encyclopaedic genre in

1. *Ibid.*, pp. 30, 33, 55.

pavement decoration, far from being purely secular, is not bound up with a desire to bring the physical world into the confines of the church. It is interesting to note, incidentally, that this development in pavement decoration coincides with the lifetime of Cosmas Indicopleustes, the first author who attempted to create a complete and systematic cosmography on a purely Christian basis.

The « secular » phase in pavement decoration was short-lived, at least in the East. In general, mosaic floors with pictorial subjects were not used extensively in Greek lands after the iconoclastic period. The idea of the church as a microcosm survived, but mainly in the spiritualized (and, incidentally, purely anthropomorphic) form of an ascending hierarchy of holy figures culminating in the Pantokrator in highest heaven. It was primarily the Latin West which took up the tradition of the cosmographic pavements of the Justinian era. Parts of the cosmic encyclopaedia were depicted frequently on church pavements, particularly in Italy and France, in the eleventh and twelfth centuries. This material unfortunately has never been studied systematically, and there is a lack of adequate reproductions and reliable archaeological investigations of many of the monuments concerned[1]. I shall describe only one example of a cosmographic floor of the twelfth century, a mosaic found underneath the Cathedral at Turin (fig. 3)[2]. It covered the floor of the chancel of an early medieval church which once stood on that site. A large square was spread out in front of the altar. Only one corner was found more or less intact, but this is enough to reconstruct the composition. The outer frame is decorated with various ornaments; among them are interlacing circles filled with animals, a motif reminiscent of one of the ornamental borders of the Nikopolis floor. The inner frame is even more strongly reminiscent of Nikopolis because it represents water. But instead of a landscape the water frame here encloses a wheel of Fortuna, with various states of human destiny shown in the compartments of the wheel. In the four corners are the four Winds, a motif which we found in the Kabr Hiram pavement, though without the pairs of secondary Winds which are here added. The water frame differs from that in Nikopolis by being without fish. But

1. The most useful and extensive compilations are found in : E. Aus'mWeerth, *Der Mosaikboden in St. Gereon zu Coln*, Bonn, 1873 ; P. Clemen, *Die romanische Monumentalmalerei in den Rheinlanden*, Düsseldorf, 1916, pp. 168 ff. ; P. Toesca, *Storia dell'Arte Italiana* I, Turin, 1927, p. 1138 f., n. 25.

2. P. Toesca, in : *Boilettino d'Arte* 4, 1910, pp. 1 ff.

instead it has islands. The two which are visible in the quadrant of the Northwind are, appropriately, « Britania Insula Interfusa Mari » and « Scocia Insula Proxima Britanie ». The water frame, therefore, stands for the outer Ocean, as in Nikopolis, but here it is depicted in more distinctly cartographic fashion with its islands shown and labelled. I have no doubt that in Turin as in Nikopolis the field enclosed by the « Ocean » is the Earth, which here, however, is characterized by means of a moral allegory rather than by natural features. A *mappa mundi* is spread out on the church floor, as it had been at Nikopolis six hundred years earlier.

On quite a number of Romanesque pavements the subjects and motifs of the cosmographic floors of the Justinian era reappear, and there are indications that these Western pavements are not unconnected with their Eastern forerunners of the sixth century. Naturally, there was always an aversion to the representation of sacred subject matter on floors. The cosmographic repertoire was one which could be used safely without incurring the danger of sacrilege. But this negative reason surely is not enough to explain the resumption of this repertoire in Romanesque art. As every medievalist knows, the encyclopaedia of nature and science, the « speculum naturae », became a definite part of the comprehensive iconographic program of the Romanesque and Gothic cathedral, not merely on floors, but on facades and other parts of the building as well. Byzantium after the iconoclastic period conceives the church building as a spiritual cosmos. The Western medieval church admits nature and the sciences and through these subjects it expresses visibly and tangibly its concern with, and claim over the physical universe.

This glimpse down the centuries is revealing from the point of view of the problem of « East and West ». At the same time it serves to place the « secular » pavements of the Justinian period in a historical perspective in which they appear less as belated heirs of a classical tradition than as forerunners of much later developments. In so far as they entailed a revival or a new expansion of old, non-Christian subject matter we may perhaps speak of a renaissance phenomenon. But within the context of the church they helped to inaugurate an iconographic category that is essentially and emphatically medieval.

STYLISTIC DEVELOPMENTS IN PAVEMENT MOSAICS IN THE GREEK EAST FROM THE AGE OF CONSTANTINE TO THE AGE OF JUSTINIAN

Résumé

M. Kitzinger trace l'évolution stylistique des mosaïques de pavement dans l'Orient grec depuis l'époque constantinienne jusqu'à celle de Justinien. Le trait le plus caractéristique de cette évolution lui paraît être une modification esthétique fondamentale. Avant le ɪᴠᵉ siècle, le mosaïste insère un tableau illusionniste, l'*emblema*, dans un tapis géométrique. Il ne tient donc pas compte de la surface plane (à deux dimensions) du pavé. A partir du ɪᴠᵉ siècle, le mosaïste respecte cette surface en tant que donnée esthétique. D'où la primauté du décor géométrique au ɪᴠᵉ siècle.

Au ᴠᵉ siècle commence l'interpénétration des sujets figurés avec les motifs géométriques et végétaux. Bien qu'à l'époque justinienne il y ait un apparent retour à l'*emblema*, celui-ci ne redevient jamais plus illusionniste. L'image figurée reste à deux dimensions.

L'observation est importante, car elle s'applique aussi aux mosaïques murales dont beaucoup moins d'exemples sont conservés. De façon plus générale, elle est valable pour toute l'histoire de l'art de l'Orient grec entre le ɪᴠᵉ et le ᴠɪᵉ siècle. L'intérêt de la rédaction d'un *corpus* général des mosaïques est donc évident. Il réunira et présentera les documents les plus nombreux qui peuvent nous renseigner sur l'art de cette période. (H. S.).

It must be admitted at the outset that in relation to the proper topic of this Colloquium my subject is marginal. Only by stretching the term " Graeco-Roman " beyond its normally accepted limits can this term be made to apply to mosaics of the fourth, fifth, and sixth centuries of our era. At the same time it is true to say that these " late " floors are not only singularly important for the history of late antique and early Byzantine art, but also intimately connected by manifold ties with those belonging to the Graeco-Roman period itself. Certainly, for the student of post-classical decorations close attention to their classical antecedents is vital. He can only hope that his findings, in turn, may be of some interest to the classicist. (*)

(*) I should like to record here my gratitude to the Centre National de la Recherche Scientifique for inviting me to participate in the first international Colloquium on Graeco-Roman mosaics. My paper presents in a highly condensed form the contents of Part III of my " Studies on Late Antique and Early Byzantine Floor Mosaics ", a first partial draft of which was written in 1949/50. Part I of these Studies was published in *Dumbarton Oaks Papers*, VI, 1951. The other two parts are still unpublished, but a summary of a section of Part II was presented at the Sixth International Congress of Byzantine Studies in Paris in 1948 and printed in the Acts of that Congress. For help in procuring illustrations for the present paper I am indebted to Prof. M. Avi-Yonah, Jerusalem; Prof. C. H. Kraeling, New Haven, Conn.; Dr. H. Sichtermann, Rome; and Prof. R. Stillwell, Princeton, N. J.

341

I shall attempt to define some major trends in the stylistic development of floor mosaics in the Eastern Mediterranean region during the period between ca. 300 and 550 A.D. The hazards of such an undertaking hardly need emphasizing. The material is widely scattered; much of it is not yet adequately published; the dating of many key monuments is still in doubt. To attempt any kind of synthesis under these conditions may seem rash; and to do so in a brief paper, foolhardy. Obviously, what I can offer is only the roughest kind of sketch, a tentative outline and working hypothesis, subject to rectification in the light of subsequent enquiries and future discoveries.

My observations will be concerned with those aspects of the mosaicist's art which have to do specifically with the function of his work as floor decoration. Such questions as the rendering of figures, of draperies, of architecture and other background features, or of individual ornamental motifs, will be left aside. Much can be learnt from floor mosaics about the stylistic treatment of these and other features in the period in question. But my topic will be the floor as a whole, i.e., the development of its over-all design rather than its individual elements.

For some regional groups of mosaics — notably those of Antioch and Palestine — the outlines of this development are already fairly well known (1). But these regional evolutionary patterns have not as yet been correlated with each other or tested as to their applicability to the material from other regions, such as Asia Minor, Greece and the Balkans. Obviously, in this paper I cannot discuss each region individually. In choosing my examples I have tried, however, to maintain as wide a geographic spread as possible. In this way I hope to support my claim that the trends I am going to illustrate are, indeed, broadly based and that the framework to be erected, crude and tentative as it is, has validity for the Eastern Mediterranean area as a whole.

The most important and most fundamental phenomenon in the stylistic development of floor decoration in this area during the period concerned is the elimination of devices which *dissemble* or *contradict* the material existence of the floor as a solid, opaque and unified surface and the introduction of others which imply an *acceptance* of that surface as a basis of the design. This process takes place between 350 and 450 A.D. and is never reversed thereafter. It can be observed particularly well in the rich and consecutive series of pavements from Antioch (2). Two examples from that site — one of the third century, the other of the late fifth — will serve to illustrate the limits, the two poles, so to speak, between which the evolution takes place. The designer of the earlier floor (fig. 1, 3) (3) has used what was throughout the Roman period a common device for dissembling the solidity of the surface. He has introduced an *emblema*, a panel picture with figures

(1) For Antioch see especially C. R. MOREY, *The Mosaics of Antioch*, London, New York and Toronto, 1938 Though brief and in some respects controversial (see below, p. 345), this text brings the development of over-all designs into sharper focus than does Doro-LEVI's monumental *Antioch Mosaic Pavements*, Princeton, London and The Hague, 1947. For Palestine see the preface by Meyer SCHAPIRO and the introduction by M. AVI-YONAH to *Israel: Ancient Mosaics*, Unesco World Art Series, 1960.

(2) Cf. MOREY, *op. cit.*, and the forthcoming study by I. LAVIN cited below (n. 26).

(3) LEVI *op. cit.*, I, p. 156 ff., II, pl. 30.

342

and scenery in receding planes which effectively create an illusion of depth. The beholder is made to feel that he is looking through a window in the floor, as it were, and that through this window he sees real figures in their true physical and psychological relationships. In this instance the illusion of depth is reinforced by means of an elaborate frame, cunningly designed to represent an aedicula in perspective, through which we seem to look out on the scene and which pushes the latter even further back into space. Such *trompe l'œil* effects, of course, are common in Roman pavements. Evidently the artist wants to tease the beholder; the illusion of the third dimension is so convincing that we seem to be deprived of the ground under our feet.

By contrast, in the fifth century floor (fig. 2, 4) (4) the ground is fully accepted and has itself become the carrier of the composition. There is no staging in depth, no overlapping of figures or scenery that would imply different planes. Nowhere is the surface broken into. What we see here is actually the *disiecta membra* of a hunting scene, spread out evenly over the surface so as not to disrupt it, and forming a huge, abstract pattern of two concentric rings around a central figure. And thus the floor is accepted not only in its opaqueness and solidity, but also in its full lateral extent. For the pattern formed by the figures is co-extensive with the floor itself. In this respect, too, our fifth-century example differs strikingly from the earlier floor, in which the figure composition occupies only a small part of the surface.

When we ask where at Antioch this full acceptance of the floor surface first occurs we find that the earliest examples are not figure compositions but pavements of purely geometric design. Of course, there had always been at Antioch floors with unified geometric patterns. But until the period of crucial change in the fourth century these are found only in rather small rooms (5). Whenever extensive surfaces were to be covered there was always a tendency to break them up into panels. This is true not only of all the larger rooms but also of many of the elongated surfaces of corridors and porticoes (6). The first examples at Antioch of large floor surfaces with a fully unified design are in the cruciform Martyrium at Kaoussie, securely dated in the eighties of the fourth century (7). The relatively well-preserved mosaic in the north arm of the church with its evenly spread geometric carpet covering an area of about 24 × 11 m. is a particularly impressive exponent of the new trend (fig. 5).

These large, geometric carpets, through which the solidity and unity of the floor was first proclaimed, are an innovation in the Eastern Mediterranean region in the late fourth century, an innovation by no means confined to Antioch. Naves of churches with their large, open expanses provided special opportunities for this

(4) *Ibid.*, I, p. 363 ff., II, pls. 86 *b*, 90 *a*, 144 *b-d*, 170-173, 176 *b*, 177.

(5) E. g., *ibid.*, I, p. 260, fig. 100; II, pl. 101 *c* (cf. *Antioch - on - the - Orontes*, III, *The Excavations 1937-1939*, Princeton, London and The Hague, 1941, p. 211, nos. 171 *f.* and Plan VIII, Rooms 4 and 5).

(6) LEVI, *op. cit.*, I, p. 41, fig. 13; p. 87, fig. 32; p. 89, fig. 34; p. 107 ff., figs. 41 ff. (with II, pl. 19 *a*); p. 150, fig. 58; p. 157 f., fig. 59 f. (with II, pl. 31 *a*); p. 192, fig. 71; p. 214, fig. 79; p. 222, fig. 84; p. 223 (with II, pl. 50 *d*).

(7) *Ibid.*, I, p. 283 ff.; II, pl. 113 ff.

343

vogue, the more so since at precisely this time an austerity movement seems to have swept through much of the Christian world resulting in the banishment from the church floor of the exuberant figure repertory characteristic both of an earlier age (8) and of subsequent periods (9). This interesting iconographic aspect of the problem can be mentioned here only in passing. But to further illustrate the stylistic trend in the Greek East in the late fourth century I refer to the pavements in the naves of the basilicas at Epidaurus (10), Daphnousion (11), and Pisidian Antioch (12). All these are roughly contemporary with the Martyrium at Kaouissie; all display unified geometric designs over large open spaces (13).

Of course, such acceptance of the floor in its solidity and unity was achieved more readily with geometric allover patterns than with figure compositions. How the principle was extended to the latter can again best be illustrated at Antioch. A floor attributed by Levi to the third quarter of the fifth century shows a geometric allover pattern with a small figure inset, a bust of " Ananeosis " framed by a wreath with heads of the Four Seasons (fig. 6) (14). Such insets are found in Antioch much earlier (15). What is new is the extension of the geometric design over a disproportionately large area (8 × 6,90 m), and, above all, the fact that the inset is no longer a window affording a glimpse into " space " in which the figure may move freely. The bust in the fifth century floor is not only quite flat, but it is placed on an axis dictated by the geometric pattern *outside* the medallion rather than by the medallion itself (the same is true of the figures of the Seasons on the frame). Nothing could show more clearly how figures in this period are, so to speak, trapped in the surface design and become a part of it. From here it is only one step to the " figure carpet " proper, in which figure motifs actually take the place of the geometric repeat pattern surrounding the central medallion (fig. 7)(16). The essence of these carpets is an avoidance of any device that would diminish, or cast doubt on, the role of the floor surface itself as the carrier of the composition. How adaptable these figure carpets are, how readily they provide unified

(8) Cf. Theodorus' churches at Aquileia.

(9) See below, p. 347.

(10) P. KAVVADIA, in *Archaiologike Ephemeris*, 1918, p. 172 ff. For the date cf. G. SOTIRIOU, *ibid.*, 1929, p. 201; E. KITZINGER, in *Dumbarton Oaks Papers*, III, 1946, p. 125 ff.

(11) A. C. ORLANDOS, in *Byzantion*, V, 1929-30, p. 207 ff.; G. SOTIRIOU, *loc. cit.*, p. 207 f.

(12) Unpublished. I owe knowledge of the layout of this floor to the late Professor D. M. ROBINSON, who excavated the church and was kind enough to lend me his drawings and blue-prints. For the inscriptions on this pavement see *Transactions and Proceedings of the American Philological Association*, LVII, 1926, p. 234 f., nos. 67-70 and pl. 39 f. They state that the mosaics were laid in the time of Bishop Optimus (ca. 381 A. D.; cf. W. ENSSLIN, in Pauly-Wissowa, *Real-Encyclopaedie der classischen Altertumswissenschaft*, XVIII, 1, col. 805).

(13) Another example of this type of decoration probably is provided by the lower of the two pavements found on the site of the Basilica of St. Anastasia at Arkassa (Karpathos), judging by the description and illustrations in *Clara Rhodos*, VI-VII, 1932-33, p. 553 and figs. 1-4. The published information does not suffice, however, to visualize the layout of this pavement in its entirety. The pavement appears to be closely related to that of the church at Daphnousion (compare *Clara Rhodos*, VI-VII, p. 555, fig. 2, and *Byzantion*, V, pl. 35) and must be of roughly the same date. It was attributed to the fourth century by LEVI (*op. cit.*, I, p. 415 f., n. 27).

(14) LEVI, *op. cit.*, I, pp. 320 f., 626, II, pl. 73.

(15) E. g., *ibid.*, II, pl. 10 a.

(16) *Ibid.*, I, p. 323 ff., II, pls. 76-78; cf. also I, p. 357 f. (fig. 147), II, pls. 85 a, 174 b.

344

designs for floors of any shape or size, is well illustrated by the ambulatory floors of the Martyrium at Seleucia. These curved and complicated spaces are covered in their entirety by disjointed arrays of animals in a continuous spread (17).

Thus full acceptance of the floor surface through geometric carpets was followed by an equally full acceptance in terms of figure compositions. The figure carpet replaces the emblema. It does so during the fifth and sixth centuries, not only at Antioch, but all over the Eastern Mediterranean. Let me refer here at least briefly to one of the most remarkable floor decorations discovered in recent years, that of a church at Mopsuestia, near Adana in Cilicia (18). Though a final verdict must await full publication, I venture to suggest that this decoration is not much earlier than the middle of the fifth century. The central panel in the nave, which shows Noah's Ark surrounded by animals, still retains certain vestiges of an emblema, witness its relation to the rest of the floor and the fact that the two rings of animals have groundlines to stand on. Essentially, however, this is a figure carpet, closely comparable in its composition to the Antioch hunting pavements. Another Cilician example from a church at Ayas has rightly been compared with the floor of the Martyrium at Seleucia (19). Moving further west, we find in the Great Palace of Constantinople the most splendid of all the " figure carpets " known so far (20). This mosaic, which covered in an even and continuous spread all four porticoes of the great peristyle uncovered by St. Andrews University, is now known to be not earlier than the second half of the sixth century (21), and thus shows that the figure carpet, first tangible for us at Antioch about 450 A.D., remained in vogue over a considerable period, and not only in the provinces, but at the very center of the Eastern Empire and on the highest artistic level.

Acceptance of the floor surface — of which the figure carpet is the purest and fullest expression — was, as I have said, the most fundamental stylistic innovation in Eastern Mediterranean floor decoration during the period in question. It is not possible within the present context to discuss in any detail the antecedents of this development, which has often been interpreted in terms of a growing ascendancy of ancient and deeply rooted oriental ideals of form over the Hellenistic world, a " gradual relapse of the Hellenistic East into ancestral habits " (22). As against this interpretation, it is important to bear in mind the fact that even during the early Imperial era there had existed in the Eastern Mediterranean region itself compositional schemes other than the emblema, and that some of these schemes anticipate those employed by the designers of the great figure carpets of the fifth

(17) *Ibid.*, I, p. 359 ff., II, pls. 87-89.

(18) L. BUDDE, « Die frühchristlichen Mosaiken von Misis-Mopsuhestia in Kilikien », *Pantheon*, XVIII 1960, p. 118 ff.; cf. also *id.*, in *Rivista di Archeologia Cristiana*, XXXII, 1956, p. 41 ff.

(19) M. GOUGH, " A Temple and Church at Aias (Cilicia) ", *Anatolian Studies*, IV, 1954, p. 49 ff., especially p. 57 ff.

(20) *The Great Palace of the Byzantine Emperors* (Walker Trust, University of St. Andrews): *First Report*, Oxford, 1947, p. 64 ff. and pl. 28 ff.; *Second Report*, Edinburgh, 1958, p. 121 ff. and pl. 42 ff.

(21) Cf. C. MANGO, in *Art Bulletin*, XLII, 1960, pl. 67 ff. Quite recently P. J. NORDHAGEN has proposed a date as late as 700 A. D. (*Byzantinische Zeitschrift*, LVI, 1963, p. 53 ff.).

(22) MOREY, *op. cit.*, p. 47.

and subsequent centuries (23). Of far greater moment, however, is the fact that the entire Eastern development which I have sketched had been anticipated centuries earlier in the Latin West. The coverage of large or elongated surfaces, such as corridors, by a unified ornamental design occurs in the West as early as the first or second centuries (24). " Figure carpets ", in the sense here defined, are characteristic of black and white mosaics, a specifically Italian form of floor decoration which had its heyday in the Antonine period (25). For polychrome figure compositions the emblema with its " window " space had never gained as wide an acceptance in the West as it had in the East. Particularly in North Africa, in the third and fourth century, other and more abstract compositional schemes were frequently employed, schemes which made possible a unified treatment of large surfaces, while at the same time the " real " and spatial relationships of the elements within a " picture " tended to be weakened or completely dissolved. The possible influence of these Western antecedents on the development in the East is the subject of a forthcoming study by Professor Irving Lavin (26). I must limit myself to this brief reference, but in order to make the problem visually concrete I am borrowing from Professor Lavin's study a comparison of one of the best Eastern figure carpets — the hunting floor from Apamea of 539 A.D. (fig. 9) (27) — with a hunting floor from Djemila, which is probably as much as one hundred and fifty years earlier and in which the basic principle of composition is much the same (fig. 8) (28). Certainly, from a dispassionate examination of the evidence, the Greek East emerges as an area in which — not unnaturally — Hellenistic concepts of floor decoration survived longer than elsewhere, to succumb finally, not so much to influences from the hinterland (though these did exist, too) as to ideals which had long been practised in the Latin world. It is also noteworthy, however, that there is no *contemporary* counterpart in the West to the development here outlined.

I now turn to certain other significant developments which take place in the East during the fifth and first half of the sixth century *within* the category of designs based on the acceptance of the floor surface. One such trend involves a gradual replacement of geometric motifs by organic ones. To be sure, the geometric carpet (whose history is, of course, rooted deeply in the Greek and Roman past) never disappears entirely. But the special vogue it had in the late fourth century is followed by a period in which many mosaicists seem bent on disturbing, enriching, or transforming the geometric designs. The floors of the Church of the Navitity at Bethlehem, which I believe to be of the first half of the fifth century, provide striking examples of an abrupt juxtaposition of geometric and floral motifs, with

(23) I refer to compositions such as those based on the principle of the *asarotos oikos* (e. g., LEVI, *op. cit.*, II, pl. 178; cf. I, p. 606) or on schemes of ceiling decorations with diagonal partitions (*ibid.*, II, pl. 46 *a*).

(24) Cf., e. g., S. AURIGEMMA, *I mosaici di Zliten*, Rome and Milan, 1926, p. 60, fig. 31.

(25) See G. BECATTI's contribution to the present volume.

(26) I. LAVIN, " The Hunting Mosaics of Antioch and their Sources : A Study in the Development of Early Mediaeval Style ", *Dumbarton Oaks Papers*, XVII, 1963. Cf. also the pertinent remarks by P. J. NORDHAGEN in H. P. L'ORANGE and P. J. NORDHAGEN, *Mosaik*, Munich, 1960, pp. 45-47.

(27) F. MAYENCE, « La Vᵉ campagne de fouilles à Apamée », *Bulletin des Musées Royaux d'Art et d'Histoire*, 3rd series, VIII, 1936, p. 1 ff.

(28) Y. ALLAIS, *Djemila*, Paris, 1938, pp. 74 f.

346

the latter appearing almost as intruders (fig. 10) (29). In other instances one senses not so much an intrusion as a peaceful penetration whereby organic motifs, especially animals and birds, occupy first some and then all compartments of a geometric carpet. A floor from the important Christian building at Curium in Cyprus exemplifies an early stage of this process (30); a recently published floor from a basilica at Delphi, a later one (31). Such geometric floors with animal and bird panels evenly distributed over their entire expanse are particularly common in Greece, the Balkans, and the Aegean islands, but the same evolution also takes place in Syria and Palestine, for instance, at Gerasa, where the nave floor of the Church of Sts. Cosmas and Damian, dated 533, is a fully representative example (fig. 11) (32). In a sense, of course, this is an iconographic development, involving a gradual breaking-down of that wave of completely uniconic austerity which I previously referred to as a characteristic of the decoration of church floors in the late fourth century. But I am convinced that the phenomenon must be viewed also (if not indeed primarily) as a stylistic one, especially since it can be observed in secular contexts as well (33). Nor is it only a question of organic fillers for geometric compartments. Increasingly the basic design itself tends to be made up of organic motifs such as florets and rinceaux. An ensemble of floors in a building at Antioch, attributed by Levi to the second quarter of the fifth century, provides an example. Many of these mosaics are modest and unpretentious and thus serve particularly well to illustrate the widespread adoption of floral motifs as basic elements during this period (fig. 12) (34). A few decades earlier such floors undoubtedly would have been adorned by purely geometric patterns. When, as often happens at Antioch and elsewhere, a framework of florets is combined with organic fillers a

(29) W. HARVEY and J. H. HARVEY, " Recent Discoveries at the Church of the Nativity, Bethlehem ", *Archaeologia*, LXXXVII, 1937, p. 7 ff. A detailed exposition of my reasons for attributing the Bethlehem floor to the first half of the fifth century — a dating which agrees approximately with that proposed by Père H. VINCENT (*Revue Biblique*, 1937, p. 93 ff.) — cannot be given within the framework of this paper. In my opinion the pavement presupposes the stage in the stylistic development of floor decoration represented by the great geometric carpets of the late fourth century previously referred to (compare especially the east wing of the Martyrium at Kaouissie, LEVI, *op. cit.*, II, pl. 113 *b*; also that of the nave of the basilica at Marusinac, E. DYGGVE and R. EGGER, *Der altchristliche Friedhof Marusinac = Forschungen in Salona*, III, Vienna, 1939, p. 53 ff. and pl. 9), and therefore cannot be of the Constantinian period. One should note also the abundance of elements of the " rainbow style ", which had its heyday in the late fourth century (LEVI, *op. cit.*, I, Index, s. v. " pattern of decoration: rainbow elements "; e. g., p. 424 f.). The geometric carpet, however, appears at Bethlehem enriched by certain new elements which emerge in Eastern Mediterranean floor decoration in the course of the fifth century. Thus in my opinion the most plausible date for the pavement is the era of Theodosius II. LEVI's attempt (*op. cit.*, I, p. 464 ff., n. 260) to ascribe it to the early Justinianic period appears to me untenable on many grounds. His principal argument is the undeniable similarity of some of the looped patterns with those employed in sixth century floors at Gerasa. He ignores the fact — which he himself had mentioned, or at least implied, on an earlier page (p. 457, n. 220) — that the patterns as such, even the most elaborate among them, occur as early as the fourth century (cf. W. HOLMQUIST, *Kunstprobleme der Merowingerzeit*, Stockholm, 1939, p. 233 ff. and pl. 14 f.) and that their compositional function at Gerasa, where they are employed either in isolation or as center pieces and focal " insets " (C. H. KRAELING, ed., *Gerasa, City of the Decapolis*, New Haven, 1939, pls. 62 *b*, 81 *b*, 83 *a*), is quite different from what it is at Bethlehem.

(30) University of Pennsylvania, Philadelphia, *University Museum Bulletin*, VII, 1938, no. 2, p. 4 ff. and pls. 1,3: XIV, 1950, no. 4, p. 27 ff. and pl. 7 (*ibid.*, p. 33, a reference to a chronological clue provided by coins, a clue which should actually read " 407 A. D. ", as Mr. DE COURSEY FALES has kindly informed me). A definitive publication of this building with its interesting floor decorations and inscriptions is eagerly awaited.

(31) *Archaiologikon Deltion*, XVI, 1960, p. 167 and pl. 149 f.; cf. also *Bulletin de Correspondance hellénique*, LXXXIV, 1960-61, p. 752 ff.

(32) KRAELING, *op. cit.*, p. 331 f. and pl. 73.

(33) Cf., e. g., LEVI, *op. cit.*, II, pls. 68 *b*, 85 *b*.

(34) *Ibid.*, I, p. 311 f., II, pls. 124-126.

new luxuriance results, witness, e.g., the " Striding Lion " mosaic at Antioch (fig. 13), attributed by Levi to the third quarter of the fifth century (35), or a pavement in the church at Khaldé in the Lebanon, attributed by the Emir Chehab to approximately the same period (36). The development culminates in the sixth century when, in Syria and Palestine at least, the " inhabited rinceau " or " peopled scroll " becomes a common device for the even and unified decoration of large surfaces (37). The motif itself, of course, is old (38), but there can be no doubt that, so far as floor decorations in the Greek East are concerned, its vogue as a field design in the sixth century is the end result of an evolutionary process which had begun with geometric carpets. These sixth-century rinceaux patterns are, in fact, essentially geometric constructions in an organic disguise, and the disguise is often quite thin (fig. 15). I should add that here again the West provides antecedents of substantially earlier date. The inhabited rinceau had long been in use as an all over design in mosaic floors in Italy and North Africa (39), and some of these floors — for instance, that in the House of *Asinus Nica* at Djemila (fig. 14) (40) — anticipate strikingly Eastern renderings of the sixth century. Thus, the question of possible Western influences arises once more.

Finally, there is another important trend to which I must draw attention, namely, the organization — or, perhaps, I should say polarization — of carpet designs by means of central foci and heavily emphasized borders. One notices, as the fifth century progresses, increasingly frequent attempts to counteract the inherent tendency of carpet patterns — be they composed of geometric, floral or figure elements — to assume the character of a completely even and potentially endless allover design. The " Striding Lion " pavement at Antioch, already referred to, is a good example of a carpet design organized by both a strong central accent and a strong border (fig. 13) (41). It is, I believe, this tendency to organize, to articulate, to keep things within bounds and in harmonious relationships and proportions, which, in due course (more precisely, in the early years of the Justinianic

(35) *Ibid.*, I, p. 321 ff., II, pl. 74.

(36) M. CHEHAB, *Mosaïques du Liban* (= *Bulletin du Musée de Beyrouth*, XIV and XV), Paris, 1958-1959, p. 107 ff. and pls. 66-68.

(37) The earliest dated instance so far in the area of Syria and Palestine of an inhabited rinceau used, indisputably as a field design is a floor in the church at Zahrani (Lebanon) with an inscription of the year 524 A. D. (*ibid.*, p. 81 ff., especially p. 95 f., 104 f., and pl. 51, 57, 2). The example from Beisan-El Hammam illustrated in our fig. 15 is not earlier than the middle of the sixth century; cf. M. AVI-YONAH, in *The Quarterly of the Department of Antiquities in Palestine*, V, 1936, p. 11 ff., especially p. 29. For other Palestinian floors of this type see *ibid.*, p. 20, with further references, and *id.*, in *Bulletin of the Louis M. Rabinowitz Fund for the Exploration of Ancient Synagogues* (The Hebrew University, Jerusalem, Department of Archaeology), III, 1960, p. 25 ff. Ma'on-Nirim). The emergence of the rinceau as a field design is well exemplified by three dated examples at Gerasa. In the Procopius Church of 526 A. D. a rinceau — perhaps uninhabited — appears in one of the aisles (KRAELING, *op. cit.*, p. 340 and pl. 83 *c*). In the Church of St. George of 529 A. D. there is a " peopled " rinceau, again in one of the aisles (*ibid.*, p. 330 and pl. 72 *d*). In both these churches the floor decorations are otherwise predominantly geometric. But in the Church of St. John the Baptist of 531 A. D. the main square was given over to an inhabited rinceau (*ibid.*, p. 326 and pls. 66 *b*, 67 *a*) and here the motif goes together with a new floral luxuriance in the other parts of the pavement decoration (cf. our fig. 18).

(38) J. M. C. TOYNBEE and J. B. WARD PERKINS, " Peopled Scrolls: A Hellenistic Motif in Imperial Art ", *Papers of the British School at Rome*, XVIII, 1950, p. 1 ff.

(39) *Ibid.*, pp. 17, 22, 25, 41; cf. also the magnificent examples at Piazza Armerina (B. PACE, *I mosaici di Piazza Armerina*, Rome, 1955, fig. 34 f.).

(40) ALLAIS, *op. cit.*, p. 67 and pl. 11, fig. 21.

(41) See above, n. 35.

348

era), brings about a return to a natural arrangement of figures and landscape elements in panels of limited size. A comparison of the Nilotic mosaics of the fifth century at Tabgha (42) with those at St. John's in Gerasa (531 A.D.) (43) illustrates the point. Tabgha is a pure figure carpet, with the elements of the landscape totally disjointed and taken apart, so as to give full and undisturbed play to the neutral surface on which these elements are spread (fig. 17). At Gerasa they are recomposed to the extent that we see the bank of the Nile with buildings, trees and people, and water birds and water plants in the river below (fig. 18). But — and this is important — there is no attempt to reintroduce any illusion of depth. The principle of the acceptance of the floor surface as an opaque, two-dimensional matrix is nowhere abandoned. In effect this is a " pseudo-emblema ", and the same term is appropriate for the floors of the two wings of the transept of the Church of St. Demetrius at Nikopolis, which are of roughly the same date (44). The hunting floor in the South wing (fig. 16) is related to, and at the same time significantly different from, the fifth century hunting " carpets " at Antioch. Like the great Antioch floor at Worcester, Mass. (fig. 2, 4), it comprises three elements : a triumphant hunter (or, in this case, a pair of hunters) in the center; satellite hunting scenes all around; and a rinceau border. But the satellite scenes and the rinceau border have been merged to become a single heavy frame for a central panel that is no longer a " figure carpet " but an appropriately scaled and appropriately emphatic setting for the central group only. Here again, however, the composition remains completely two-dimensional. In my opinion, these " pseudo-emblemata " must be understood as characteristic exponents of the Justinianic Renaissance (45). The re-attachment to the Graeco-Roman past is particularly evident in the North wing panel at Nikopolis with its multiple frame reminiscent of classical emblemata (46). There is no attempt, on the part of the sixth century artists, to return to the *trompe-l'œil* effects of the old emblema floors. What they do try to recapture, however, is the reasonableness of scale and proportion and the sense of natural relationships between objects which those floors conveyed. It is surely pertinent in this connection to call attention once more to the fact that the Greek East, as distinct from the Latin West, had previously displayed a special attachment to the emblema and that during the critical late antique centuries the East had clung to this form much more tenaciously than the West (47). The Justinianic Renaissance here manifests itself as a reassertion in the Greek world of local traditions that had been submerged in the great anti-classical upheavals of the fourth

(42) A. M. Schneider, *The Church of the Multiplying of the Loaves and Fishes*, London, 1937, pl. A, B, 2-17.

(43) Kraeling, *op. cit.*, p. 327 ff. and pls. 67-69.

(44) E. Kitzinger, " Studies on Late Antique and Early Byzantine Floor Mosaics, I: Mosaics at Nikopolis ", *Dumbarton Oaks Papers*, VI, 1951, p. 81 ff. and figs. 18-22. Prof. A. Grabar recently raised objections to my iconographic interpretation of the mosaic in the south wing (*Cahiers Archéologiques*, XII, 1962, p. 142 ff.). I hope to reply to his arguments on another occasion. To discuss them here would lead too far away from the stylistic problems with which this paper is concerned.

(45) E. Kitzinger, " Mosaic Pavements in the Greek East and the Question of a ' Renaissance ' under Justinian, " *Actes du VIᵉ Congrès International d'Études Byzantines (Paris, 1948)*, II, Paris, 1951, p. 209 ff.; see especially, p. 220.

(46) *Dumbarton Oaks Papers*, VI, figs. 18, 19 and p. 98 ff.

(47) See above, p. 342.

and fifth centuries. It is the reassertion of the emblema, rather than the emergence of the great carpet compositions in the preceding era, that can properly be called a " relapse of the Hellenistic East into ancestral habits " (48). But this reassertion was only partial; it did not affect fundamentals (i.e., the acceptance of the floor surface); and it was very temporary.

Thus there emerges an evolutionary pattern which is of great interest to the art historian. To illustrate its significance I should like to go outside the field of floor decoration for a moment and call attention to the greatest of the surviving *wall* decorations of the Justinianic era, that of S. Vitale in Ravenna. When we compare this decoration (fig. 20), which is an almost exact contemporary of St. John's in Gerasa (fig. 18) anf St. Demetrius in Nikopolis (fig. 16), with that of S. Apollinare Nuovo (fig. 19), which is about one generation earlier, it becomes apparent that an evolutionary process analogous to the one we have observed in floor decoration must have taken place — admittedly on a much higher level of artistry and sophistication — inthe design of wall mosaics also. In wall mosaics, too, there had been in the fifth century a full acceptance of the neutral surface as a basis of the composition (this is well illustrated by S. Apollinare with its large plain areas of gold ground). And here, too, we observe in the Justinianic work a new luxuriance of vegetable forms combined with a new organization of the surface in terms of pseudo-natural picture panels which convey a sense of reality without actually " breaking through " into the third dimension. Floor mosaics give us insights into the genesis and antecedents of these compositional principles, such as no other extant group of monuments can provide. Thanks to them we can define the Justinianic pictorial style as a fruit of certain trends which had been coming to the fore in the Greek East — *and in the Greek East only* — in the course of the fifth century and produced a climax (but also a partial return to earlier ideals) in the first half of the sixth (49).

This is a reminder that floor mosaics are of interest not only in themselves, and not only iconographically, but also in relation to the general history of style. Their potential in this respect has as yet hardly been exploited. Admittedly this importance may not be equally great in all periods. But it is very great indeed in the centuries between Constantine and Justinian because of the scarcity and uneven distribution of extant works in other media, and in mural painting and mosaic particularly. Floor mosaics, in fact, are the only pictorial documents of this crucial formative stage of Byzantine art that are preserved in sufficiently dense chronological sequences in all regions of the Mediterranean world to permit a detailed study of stylistic developments and an assessment of the relative roles of individual regions within these developments.

The Byzantinist therefore has a vital interest in this material. But — and I think my exposition must have made this abundantly clear — he cannot study it

(48) Cf. above, n. 22.

(49) The relevance of the stylistic development of floor decoration to the study of the evolution of wall mosaics can be pointed out here only in the broadest and most general terms. S. Vitale actually provides an opportunity to demonstrate this relationship in more concrete and tangible fashion, thanks to its ceiling mosaic which has antecedents and affinities not only among other ceiling decorations but among floor mosaics also.

350

without constant reference to its Graeco-Roman antecedents. Without a full knowledge of these antecedents he cannot interpret correctly either the " progressive " or the " reactionary " elements in the development. What I have said about the emblema and its revival illustrates the point particularly well, but the same is true also of the various " carpet " designs of which I have spoken. The classicist may be able to stop in the age of Constantine, but the historian of Byzantine art needs the earlier material along with his own. What he requires is a series of regional *corpora* comprising for each area the entire material, classical as well as post-classical.

I should like to close with a further plea. Whenever a *corpus* is undertaken it should furnish for each mosaic as much information as possible on its architectural setting. This information is needed not only because it frequently provides chronological clues but also because of its stylistic implications. The relationship of the pavement to the room in which it is situated is an important stylistic criterion, as I hope this paper has shown. To fulfill their purpose completely all future *corpora* should provide the possibility to study mosaics not only as patterns and panels but also as functional parts of architectural organisms (50).

DISCUSSION

M. Petsas se réjouit de cette vue d'ensemble sur les mosaïques grecques-orientales, allant du IVe au VIe siècle. Il regrette qu'on n'ait pas traité des mosaïques grecques qui se placent entre le IIIe siècle avant Jésus-Christ et le IVe siècle après notre ère, dont pourtant le nombre est élevé et la qualité parfois remarquable (mosaïques trouvées en Macédoine, à Lesbos, sur le Péloponnèse et ailleurs).

M. Stern attire l'attention sur le fait que pour la période traitée par M. Kitzinger on ne possède pas seulement des mosaïques de pavement, mais aussi des mosaïques murales et de voûte alors que jusqu'au début du IVe siècle celles-ci manquent presque complètement. Même la peinture murale de cette époque ancienne est peu connue (malgré les ouvrages de Wirth et de De Witt). Pour la Gaule, par exemple, la documentation est très pauvre.

M. Picard se félicite que l'exposé de M. Kitzinger et l'intervention de M. Parlasca terminent de façon heureuse la partie proprement historique du colloque. Il pense avec M. Parlasca qu'à l'époque impériale il y a eu une influence de l'Occident sur l'Orient, non pas l'inverse (cf. *supra*, p. 337). M. Petsas a raison de regretter l'absence d'un spécialiste pour la mosaïque romaine en Grèce. Malgré les invitations adressées par le C. N. R. S. à MM. Orlandos et Makaronas, il n'a pas été possible d'assurer la présence d'un spécialiste grec de cette période. Il y a là une lacune. Ce n'est pas la moindre utilité de ce Colloque de faire ressortir ces lacunes et, au besoin, de les faire combler. En résumé on peut dire que l'art de la mosaïque a eu ses centres producteurs davantage en Occident qu'en Orient, au moins pendant les trois premiers siècles de notre ère. Cette constatation, qui est valable aussi en dehors de la mosaïque, renverse une opinion courante sur le mouvement artistique dans l'art romain. — M. Kitzinger a montré que, même à une époque plus tardive, l'évolution de la mosaïque en Orient se caractérise par une adaptation de faits esthétiques, admis auparavant en Occident. La dissolution de la représentation classique et rationaliste de l'univers est le grand fait de l'époque impériale romaine. Cette dissolution s'est produite d'abord en Occident, au moins autant que plus tard en Orient. C'est un fait qui a été ignoré longtemps et dont il faudra désormais tenir compte (H. S.).

(50) M. H. STERN's new *corpus* of the mosaics of Gaul and Mme V. von GONZENBACH's *Die römischen Mosaiken der Schweiz* (Basel, 1961) have set excellent precedents in this as in every other respect.

351

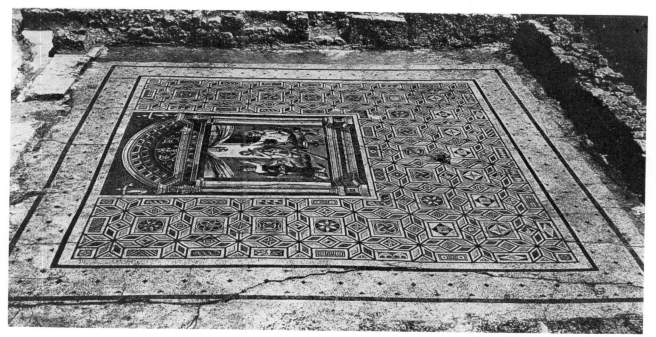

FIG. 1. — Antioch, House of the Drinking Contest, Room 1. Pavement *in situ*.

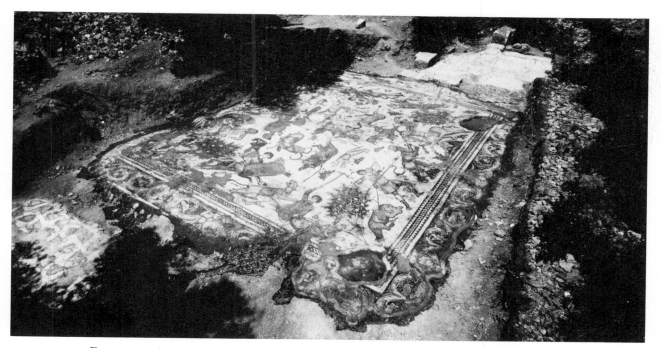

FIG. 2. — Antioch, House of the Worcester Hunt, Room 1. Hunting Pavement *in situ*.

STYLISTIC DEVELOPMENTS IN MOSAICS [75

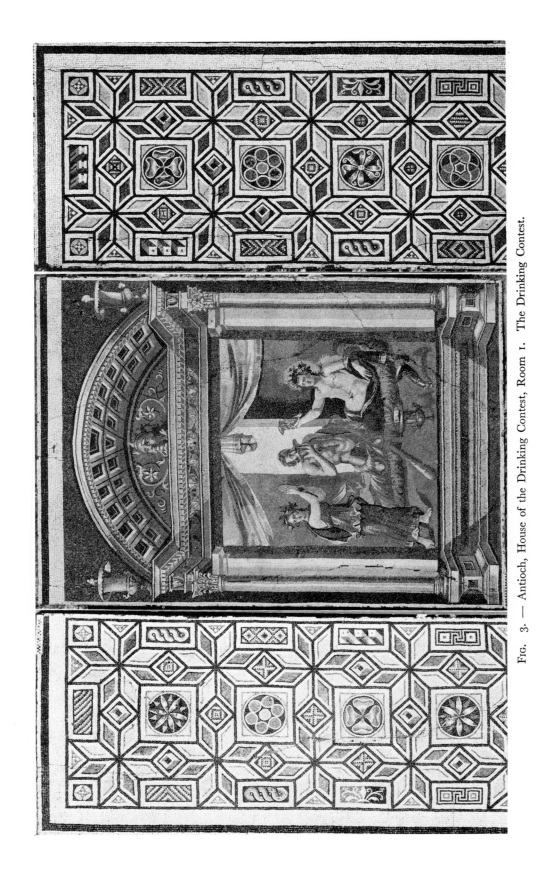

FIG. 3. — Antioch, House of the Drinking Contest, Room 1. The Drinking Contest.

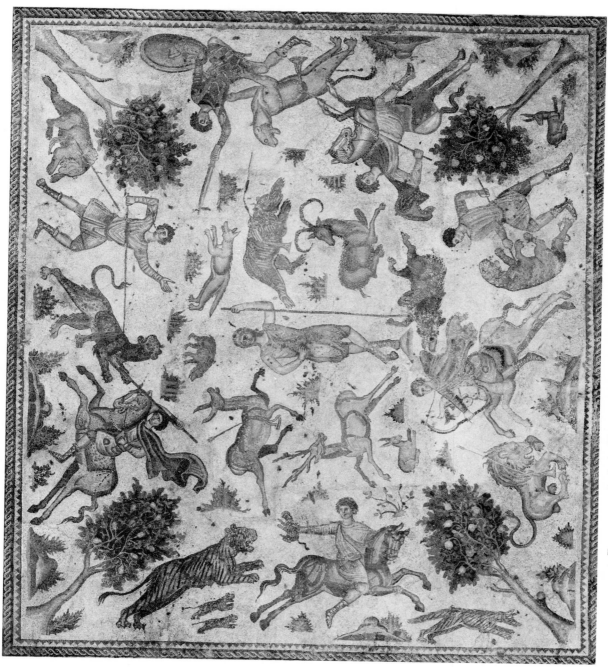

Fig. 4. — Antioch, House of the Worcester Hunt, Room 1. Hunting Pavement.

STYLISTIC DEVELOPMENTS IN MOSAICS [77

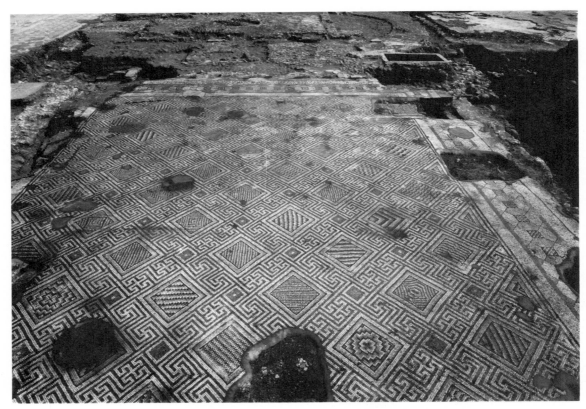

FIG. 5. — Antioch, Church of Kaoussie. Pavement of North Aisle.

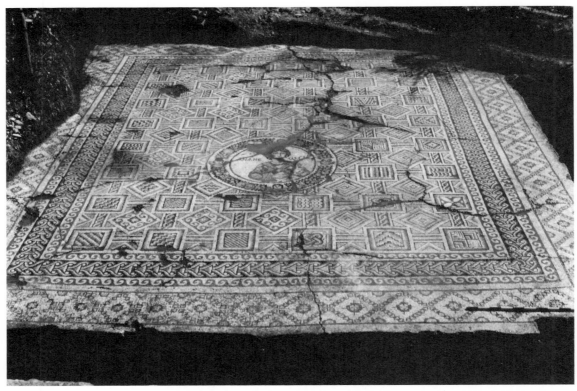

FIG. 6. — Antioch. Mosaic of Ananeosis.

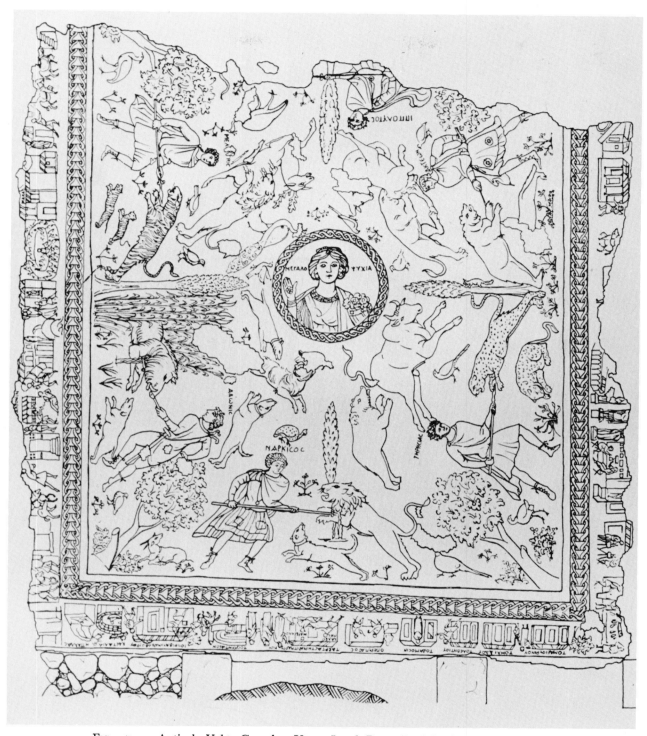

Fig. 7. — Antioch, Yakto Complex, Upper Level, Room B. Mosaic of Megalopsychia.

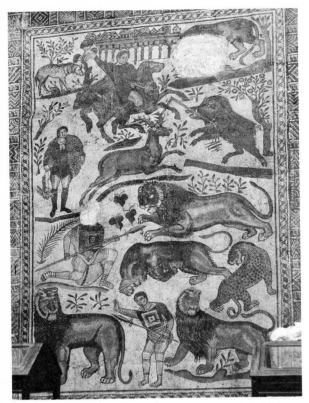

FIG. 8. — Djemila, Building South of Large Baths.
Hunt and Amphitheater Scenes.

FIG. 9. — Apamea, *Triklinos*. Hunting Scenes.

Fig. 10. — Bethlehem, Church of the Nativity. Fragment of Pavement in Octagon (composite photograph).

Fig. 11. — Gerasa, Church of Sts. Cosmas and Damian. Pavement in Nave (composite photograph).

Fɪɢ. 12. — Antioch, Daphne Harbie, House of the Buffet Supper, Upper Level. Pavement of Room 4.

Fɪɢ. 13. — Antioch, Mosaic of the Striding Lion.

Fig. 15. — Beisan-el Hammam, Hall in Necropolis. Detail of Upper Pavement.

Fig. 14. — Djemila, House of Asinus Nica, Frigidarium of Private Baths.
Detail of Pavement.

FIG. 16. — Nikopolis, Basilica of St. Demetrius. Pavement in South Wing of Transept.

STYLISTIC DEVELOPMENTS IN MOSAICS [85

FIG. 17. — Tabgha, Basilica of the Multiplying of the Loaves and Fishes. Pavement of North Transept.

FIG. 18. — Gerasa, Church of St. John the Baptist. Fragmentary Pavement of South Segment and Southeast Exedra (composite photograph).

FIG. 19. — Ravenna, Basilica of S. Apollinare Nuovo, Nave.
Detail of South Wall.

FIG. 20. — Ravenna, Church of S. Vitale, Chancel.
South Wall.

ERNST KITZINGER

PART TWO

FROM JUSTINIAN

TO ICONOCLASM

V

THE CULT OF IMAGES
IN THE AGE BEFORE ICONOCLASM

INTRODUCTION

IN the entire history of European art it is difficult to name any one fact
more momentous than the admission of the graven image by the Chris-
tian Church. Had Christianity persisted in the categorical rejection of
images, and, indeed, of all art, which it proclaimed during the first two cen-
turies of its existence, the main stream of the Graeco-Roman tradition would
have been blocked, driven underground, or, at best, diverted into side chan-
nels of purely secular or decorative work. To speculate in any detail about
so hypothetical a course of events is futile. On the other hand, the stages and
means whereby the original resistance was overcome are a legitimate and
important subject of historical inquiry. The process is often thought to have
been completed for all practical purposes during the third century or, at the
latest, with the victory of Christianity under Constantine the Great. By that
time the Church appears to have entered fully into the heritage of classical
artistic media and iconographic and stylistic formulae and the problem of
the admissibility of images in the Church seems to have been settled, at least
on principle, not to be re-opened until centuries later in the period of Icono-
clasm in Byzantium.

In recent years this concept of the course of events has begun to undergo
a marked change. Historians and church historians have uncovered an
increasing number of instances of Christian opposition to images in the
period preceding the outbreak of official Iconoclasm in Byzantium under
Leo III in the eighth century, and scholars are more and more inclined to
seek the roots of that movement within rather than without the Church.[1]
Accordingly, Byzantine Iconoclasm tends to be linked more closely to the
uniconic phase of early Christianity.[2] An undercurrent of at least potential
iconoclasm does in fact run through the entire history of the Church in the
intervening centuries. Instead of assuming a simple alternation of anti-iconic
and pro-iconic periods, it is necessary to think more in terms of a continuing
conflict, which finally erupted in an explosion of well-nigh world-historical
import.

The "fever curve" of this conflict, as it developed through the centuries,
can be discerned more clearly if a distinction is made between three ele-

[1] S. Der Nersessian, "Une apologie des images du septième siècle," *Byzantion*, XVII (1944–
45) 58 ff. N. H. Baynes, "The Icons before Iconoclasm," *The Harvard Theological Review*,
XLIV (1951) 93 ff.

[2] G. Florovsky, "Origen, Eusebius and the Iconoclastic Controversy," *Church History*, XIX
(1950) 77 ff. These links are also stressed in the introductory chapter of Prof. P. J. Alexander's
still unpublished monograph on the Patriarch Nicephoros, which the author kindly let me
read in manuscript.

ments that chiefly contributed towards it: practice, opposition, and apologetic theory. Throughout the centuries of the growth of Christian art it was practice which played the leading role. The setting up of images, and increasingly also the acts of devotion or propitiation of which they became the instruments or the objects, inevitably gave rise to opposition and this, in turn, called forth defensive statements of a theoretical kind. This is not to say that opposition and theory did not help on their part to promote practice. Undoubtedly there were occasions when the partisans of images were spurred by opposition to intensify their devotion. There were also times when theoretical considerations helped to promote the creation and veneration of images, and to remove scruples obstructing such practices.[3] Explicit statements on the nature and function of images were, however, mostly *ex post facto* rationalizations of developments which had already taken place.[4] Usually such statements owe their existence to the pressure of opposition and quite often they fall short of the realities of their time.

There are two periods during which the leading role of practice is particularly in evidence: In the third and fourth centuries and again in the generations between the reign of Justinian I and the outbreak of Iconoclasm. It is a striking fact that when painting and sculpture first began to infiltrate Christian assembly rooms and cemeteries they did so practically unheeded by either opponents or apologists of Christianity — engaged though these were in passionate disputes over idols and idolatry. No literary statement from the period prior to the year 300 would make one suspect the existence of any Christian images other than the most laconic and hieroglyphic of symbols.[5] When, in the early fourth century, Christian art did become a subject of more articulate comment, such comment at first was hostile, or, at any rate, restrictive.[6] It was not before the second half of the fourth century that any writer began to speak of Christian pictorial art in positive terms. Even then it was a matter of fleeting references rather than systematic de-

[3] See below, pp. 120 f.

[4] An important exception is the Eighty-Second Canon of the Council of A.D. 692, in which the theologian takes the offensive in explicit terms. For this see below, pp. 121, 142.

[5] The only references to Christian religious representations in the literature of this period are some critical remarks by Tertullian on images of the Good Shepherd on chalices (H. Koch, *Die altchristliche Bilderfrage nach den literarischen Quellen* [Goettingen, 1917] 9 f. and W. Elliger, *Die Stellung der alten Christen zu den Bildern in den ersten vier Jahrhunderten* [Leipzig, 1930] 28 f.) and Clement of Alexandria's list of symbolic subjects suitable for representation on seals. The latter passage is somewhat in contrast to Clement's hostile attitude towards religious imagery in general (cf. Koch, *op. cit.*, 14 ff.; Elliger, *op. cit.*, 38 ff.) and thus illustrates the dichotomy which began to manifest itself in the early third century between theory and practice.

[6] Council of Elvira (Koch, *op. cit.*, 31 ff.; Elliger, *op. cit.*, 34 ff.). Eusebius' letter to the Empress Constantia (Koch, *op. cit.*, 42 ff.; Elliger, *op. cit.*, 47 ff.; see also below, n. 28).

fense.[7] Defense lagged behind attack, as attack had lagged behind practice. Such justifications of Christian images as were attempted during the second half of the fourth century were based exclusively on the usefulness of pictures as educational tools, particularly for the illiterate. There are reasons to believe, however, that by the time these statements were formulated the actual use of images was no longer confined to the purely didactic. For only a short time later the first voices of protest were raised against Christians indulging in image worship.[8]

Practice once more took a decisive lead during the period that followed the reign of the great Justinian. At that time the Christian image began to assume a role more central, a function more vital in everyday life in the Greek East than it ever had held in previous centuries. But again reaction was delayed. Though hostile voices and defensive statements were not lacking at the time, an opposition commensurate to this great expansion of devotional, and indeed idolatric, practices did not crystallize until the second quarter of the eighth century. It is the Iconoclastic movement itself which constitutes the full reaction to the development of the post-Justinianic era. Indeed, the violence of that movement becomes understandable only in the light of the spectacular intensification of the cult of images during the five preceding generations. The Iconoclasts' onslaught, in turn, led to the elaboration of a theoretical defense of Christian images, far more systematic and profound than any that had been attempted previously. Thus, for a broad over-all view, the period from the sixth to the ninth century offers a pattern similar to that encountered in the third and fourth, i.e. a regular sequence of practice, opposition and defense.

It is with the expansion of the cult of images in the period between Justinian and Iconoclasm that the present study is concerned. The critical role of this period, and particularly of the sixth century, in the development of idolatric beliefs and practices among Christians was recognized long ago.[9] The pages which follow are intended to bring this development into sharper focus and to draw attention to its outstanding importance. It will be their principal purpose to bring together as much as possible of the textual evidence which testifies to an intensification of cult practices at that time and to explore the forces which motivated this development. Naturally, in order to throw into relief those phenomena which were new at that time, the evi-

[7] Cf. the Cappadocian Fathers as quoted by Koch, *op. cit.*, 69 ff. and Elliger, *op. cit.*, 60 ff.

[8] See below, pp. 92 f.

[9] K. Schwarzlose, *Der Bilderstreit* (Gotha, 1890) 19; E. von Dobschuetz, *Christusbilder* (= *Texte und Untersuchungen zur Geschichte der altchristlichen Literatur*, Neue Folge, III) (Leipzig, 1899) *passim*, especially p. 35; and, recently, A. Grabar, *Martyrium*, II (Paris, 1946) 343 ff.

dence concerning the cult of images in the preceding centuries must be taken into account. But the focus will be on the period between Justinian and Iconoclasm.

The study is the work of an art historian who has become convinced that an understanding of the changing attitudes which Christians took towards religious imagery in the course of the centuries is essential for an understanding of Christian art. Increasingly positive attitudes on the one hand, restraining or outright hostile forces on the other, are bound to have left their imprints on the monuments. The post-Justinianic era offers singularly rich opportunities for such an approach. The literary record concerning images is quite extensive, as we shall see; the changes it reveals in their function, uses and meanings are very striking; and there are many developments in the history of the pictorial arts of that period to which these changes appear to be directly relevant. The reader should bear in mind that the study, limited though it is to literary sources, was undertaken with an eye on the monuments of the same period. It is a preparatory step on which, it is hoped, a new appraisal of an important phase of early Byzantine art may eventually be based.

The literary controversies of the Iconoclastic period are outside the scope of this study. Opposition and defense were not, however, altogether silent even during the preceding century and a half of expanding cult practices. These voices confirm the magnitude of the change which then took place in the Christian attitude towards images. They form an essential part of the literary record of that era, and will be reviewed in the last two chapters. The apologists' attempts to provide the new roles and functions of religious imagery with a theoretical foundation are particularly relevant. Such statements make it possible to interpret the monuments of the period in the light of contemporary thought as well as practice.[10]

I. THE BEGINNINGS OF THE CHRISTIAN CULT OF IMAGES

Christianity's original aversion to the visual arts was rooted in its spirituality. "But the hour cometh and now is when the true worshipers shall worship the Father in spirit and in truth" (John 4:23). The concept of spiritu-

[10] I wish to acknowledge the help I have received in this work from my colleagues at Dumbarton Oaks, particularly from Prof. A. M. Friend, Jr., Prof. S. Der Nersessian, and Mr. C. A. Mango, who have read the paper in manuscript and have contributed a number of valuable suggestions and additions. Prof. Friend has also offered certain fundamental criticisms, which have prompted me to make some major changes in the text and have helped me to clarify my own views. While gratefully recognizing the benefits derived from constructive criticism, I cannot disclaim responsibility for any controversial matter the paper may contain. The manuscript was completed in August 1953.

alized worship found what is perhaps its most eloquent expression in the words of Minucius Felix, written at a time when the ideal was already endangered from several directions: "Do you suppose we conceal our object of worship because we have no shrines and altars? What image can I make of God when, rightly considered, man himself is an image of God? What temple can I build for him, when the whole universe, fashioned by His handiwork cannot contain him? Shall I, a man, housed more spaciously, confine within a tiny shrine power and majesty so great? Is not the mind a better place of dedication? our inmost heart of consecration? Shall I offer to God victims and sacrifices which He has furnished for my use, and so reject His bounties? That were ingratitude, seeing that the acceptable sacrifice is a good spirit and a pure mind and a conscience without guile. He who follows after innocence makes prayer to God; He who practices justice offers libations; He who abstains from fraud, propitiates; He who rescues another from peril, slays the best victim. These are our sacrifices, these our hallowed rites; with us justice is the true measure of religion." [11]

As this passage shows, the radical rejection of the visual arts by the primitive Church was part and parcel of a general rejection of material props in religious life and worship. The resistance to figure representations was, however, particularly strong, partly because of the prohibition of graven images which formed part of the Mosaic Law, and partly because of the very central role which statuary, and images generally, occupied in the religions of Graeco-Roman paganism. Naturally, the resistance on both these counts was concerned primarily with those forms of representation which came under the heading of idols or lent themselves to idolatric abuse. There were many modes of representation to which no real objection could be taken on this score. Decorative and symbolic devices, narrative and didactic images — all these were relatively harmless, and it was in these guises that art did, in fact, enter Christian assembly rooms and cemeteries in the third century. Much of the art of the Roman catacombs betrays a studied attempt to avoid any suspicion or encouragement of idolatric practices. Nevertheless this first and seemingly harmless step proved decisive.

The way for image worship was paved in the fourth century by the increasingly widespread adoption of other material props which were not barred by any specific prohibitions, notably crosses and relics. Worship of the cross may have been practiced here and there even during the period of persecutions, but received its major impetus through the symbolic identification of the instrument of Christ's Passion with the victorious standard of

[11] Minucius Felix, *Octavius*, 32, 1–3 (Loeb ed. [London, 1931] 412 f.).

the army of Constantine the Great, an identification graphically expressed in the sign of the labarum, which appears on coins in the third decade of the fourth century.[12] By the end of the fourth century *proskynesis* before the Sign of the Passion was considered a perfectly natural thing for a Christian.[13] The cult of relics must have spread even more widely and rapidly. Particles of the True Cross, allegedly re-discovered in the reign of Constantine, were soon eagerly sought by the faithful all over the world, according to Cyril of Jerusalem (*ca* A.D. 350).[14] Julian the Apostate, while apparently not yet able to hurl the accusation of idolatry back at the Christians, inveighed against their cult of tombs and their prostration before the wood of the cross.[15] During the same period Gregory of Nyssa wrote an ecstatic passage — to be quoted later in this study — in which he extolled the cult of the relics of the martyrs.[16]

The cult of the cross and of relics, then, was in full swing in the time of the great Cappadocian Fathers. Image worship, however, does not come into their purview even in a negative way. At least the worship of *religious* images does not. It is well to remember when considering the rise of idolatric practices among Christians that the Fathers of the fourth century did admit the propriety of the honors and respects traditionally paid to the image of the emperor. According to Malalas, Constantine instituted the practice of having his own image carried in solemn procession on the anniversary day of the founding of his Capital City and of having the emperor of the day bow before it. Whether this is true or not, we should certainly believe the sixth

[12] J. Maurice, *Numismatique Constantinienne*, II (Paris, 1911) 506 ff. and pl. XV, 7. The story in the *Vita Constantini*, which explains the origin of that famous standard through a vision experienced by Constantine prior to the battle on the Milvian Bridge, has been the subject of a great deal of controversy in recent years. Some scholars consider it a later fabrication (cf. especially H. Grégoire, "La Vision de Constantin'liquidée'," in *Byzantion*, XIV [1939] 341 ff.; also *Id., ibid.*, XIII [1938] 568, 578 f.; and, more recently, G. Downey in *Dumbarton Oaks Papers*, VI [1951] 64). Others uphold it as basically authentic, though according to Prof. Alfoeldi it was a monogram of Christ, rather than a cross, which Constantine saw in his vision (A. Alfoeldi, "Hoc signo victor eris. Beitraege zur Geschichte der Bekehrung Konstantins des Grossen," *Pisciculi. Studien zur Religion und Kultur des Altertums Franz Joseph Doelger zum 60. Geburtstage dargeboten* [Muenster i.W., 1939] 1 ff., especially 6 ff.; *Id., The Conversion of Constantine and Pagan Rome* [Oxford, 1948] 16 ff.; cf. also J. Vogt, "Berichte ueber Kreuzeserscheinungen aus dem 4. Jahrhundert n. Chr.," *Université Libre de Bruxelles. Annuaire de l'Institut de Philologie et d'Histoire orientales et slaves*, IX [1949] 593 ff.).

[13] St. Asterius Amasenus, *Homilia XI in laudem S. Stephani* (Migne, *PG* 40, col. 337 BC; Koch, *op. cit.*, 67).

[14] *Catechesis* IV, 10 and X, 19; *Epistola ad Constantium Imperatorem*, c. 3 (*PG* 33, cols. 469A, 685B–688A, 1168B).

[15] C. I. Neumann, *Iuliani Imperatoris librorum contra Christianos quae supersunt* (Leipzig, 1880) 196, 225 f. *Id., Kaiser Julians Buecher gegen die Christen* (Leipzig, 1880) 25, 43 f.

[16] See below, p. 116.

century chronicler when he says that this was the custom in his own day.[17] There is no lack of evidence that the traditional worship of the imperial portrait suffered little if any interruption through the triumph of Christianity.[18] Numerous sources of the fourth century show that once the emperor had become a Christian such practices were no longer objected to by most ecclesiastical authorities. The famous quotation from Saint Basil's Treatise on the Holy Ghost,[19] so often utilized in later centuries in defense of the cult of images of Christ, as well as passages by other writers of this period in which adoration of the imperial image is adduced to illustrate a point,[20] show that this form of worship was, in fact, considered customary and proper.[21] Gregory of Nazianz, in his first diatribe against Julian, states the Christian attitude in regard to what he calls "the customary honors of the sovereign" more explicitly: ". . . they must needs have adoration through which they may appear more awful — and not merely that adoration which they receive in person, but also that received in their statues and pictures, in order that the veneration may be more insatiable and more complete." [22]

How much headway the cult of the ruler portrait had over the cult of religious images is well illustrated by a confrontation of two passages in the Ecclesiastical History of Philostorgius, written during the first half of the fifth century. If we may trust the testimony of Photius, admittedly a hostile excerptor of the lost text, the cult of the statue of Constantine on the Forum

[17] Joannes Malalas, *Chronographia*, XIII (Bonn ed., p. 322). A paragraph in the *Patria Constantinopoleos* (II, 42) seems to refer to the same rite, though it differs in some details. According to this text the solemnities included a crowning of the statue (*Scriptores Originum Constantinopolitanarum*, ed. Th. Preger, fasc. 2 [Leipzig, 1907] 172 f.). I owe this reference to Mr. C. A. Mango.

[18] A. Alfoeldi, in *Roemische Mitteilungen*, XLIX (1934) 77 f. H. Kruse, *Studien zur offiziellen Geltung des Kaiserbildes im roemischen Reiche* (Paderborn, 1934) 34 ff. K. M. Setton, *Christian Attitude towards the Emperor in the Fourth Century*, New York, 1941, 196 ff. See also below, pp. 122 f.

[19] *PG* 32, col. 149 C. See below, n. 260.

[20] S. Ambrosius, *Hexaemeron*, VI, 9 (*PL* 14, col. 281 D); quotations in John of Damascus, *De imaginibus oratio III*, ascribed to St. John Chrysostom and Severianus of Gabala (*PG* 94, cols. 1408 C, 1409 A; cf. Kruse, *op. cit.*, p. 35 n. 2, p. 36 n. 1; also below, n. 260). There is even an instance from the period prior to the triumph of Christianity: In his Treatise on the Resurrection, which is directed against Origen, Methodius of Olympos (d. A.D. 311) illustrates his belief in the bodily resurrection of man (the image of God) with a reference to "the images of the kings . . . held in honor by all regardless of the material of which they are made. They must all be honored here on account of the form which is in them" (G. N. Bonwetsch, *Methodius = Die griechischen christlichen Schriftsteller der ersten drei Jahrhunderte*, XXVII [Leipzig, 1917] 379 f.).

[21] For a voice of protest see St. Jerome's Commentary on the Book of Daniel, c. 3 (*PL* 25, col. 507 C). In 425 Theodosius II tried to curb, through an edict, the excesses of such worship: Cod. Theod. 15,4,1.

[22] *Contra Iulianum* I, 80 (*PG* 35, col. 605 C). For "the customary honors of the sovereign" see I, 81 (*ibid.* col. 608A).

Constantini was, by the time of Philostorgius, complete with propitiatory sacrifices, burning of candles and incense, prayers and apotropaic supplications.[23] But the same Philostorgius, when speaking of the famous statue of Christ at Paneas, is at pains to show that when, prior to its alleged destruction during the reign of Julian, the statue was transferred from a location near a public fountain to the diaconicon of a church, it was not an object of worship or *proskynesis*, but merely of due respect, expressed in its more honored position and in the joyful approach of those who came to see it.[24] Here Philostorgius evidently describes what he considers the proper behavior of a Christian of his own day vis-à-vis a religious image.

In actual fact, however, practice had by this time gone beyond a mere joyful approach, at least in some instances. It is from St. Augustine that we first hear in unambiguous terms of Christians worshiping images. Among those who had introduced superstitious practices in the Church, he mentions *sepulcrorum et picturarum adoratores*, thus linking the cult of images to the cult of tombs.[25] What had been feared in the early years of the century by some authorities [26] had now become an actuality. As was pointed out long ago by Holl,[27] this course of events provides a logical background for the writings and activities of Epiphanius of Salamis in Cyprus, Augustine's contemporary, who seems to have been the first cleric to take up the matter of Christian religious images as a major issue. The exact scope of Epiphanius' campaign depends on whether certain writings attributed to him by the Iconoclasts of the eighth century are accepted as genuine. Specific references to actual *worship* of images by Christians occur in certain

[23] J. Bidez, *Philostorgius Kirchengeschichte* = *Die griechischen christlichen Schriftsteller*, XXI (Leipzig, 1913) p. 28 no. 17.

[24] *Ibid.*, 78. See also below, p. 137.

[25] *De moribus ecclesiae catholicae*, I, 34 (*PL* 32, col. 1342). Euodius, Bishop of Uzala (d. A.D. 424), had recorded by an anonymous writer a story of a quasi-miraculous appearance of a *velum* depicting a miracle which had been operated the previous day by the relics of St. Stephen preserved in the city (*PL* 41, col. 850 f.; Dobschuetz, *op. cit.*, 35 ff., 115° ff.; see also below, p. 113). This might be considered additional testimony of the practice of image worship in the sphere of St. Augustine. The writer speaks of a crowd inspecting and admiring the picture, but — Dobschuetz to the contrary notwithstanding — he does not describe any act of worship before the image. The phrase . . . *tam divinitus pridie gestum salutis beneficium recolebatur, quam postea in veli imagine advertebatur* indicates worship of the miracle rather than the image. The latter plays the role of a mute sermon arousing *stupor . . . amor, admiratio et gratulatio* and thus has the same didactic and edifying function that images have in the writings of the Cappadocian Fathers. Indeed, the chapter ends with a short speech addressed to the citizens of Uzala and introduced as *Dei . . . quaedam allocutio in velo tacite significantis quodammodo et dicentis: etc.*

[26] See above, n. 6.

[27] "Die Schriften des Epiphanius gegen die Bilderverehrung" (= *Sitzungsberichte der Königlich Preussischen Akademie der Wissenschaften*, 1916, no. XXXV), reprinted in K. Holl, *Gesammelte Aufsaetze zur Kirchengeschichte*, II (Tuebingen, 1928) 351 ff., especially 384 f.

passages which some scholars do not accept as authentic.[28] But even the most sceptic do not doubt that Epiphanius was an opponent of Christian religious imagery,[29] and at least one of the reasons for his hostility becomes clear from a passage in one of his undisputed writings: "When images are put up the customs of the pagans do the rest." [30] This surely reflects the experience of his own age.

[28] G. Ostrogorsky, *Studien zur Geschichte des byzantinischen Bilderstreites* (Breslau, 1929) p. 68, no. III (= Holl, *op. cit.*, p. 356, no. I) and nos. 5 and 6; p. 69, no. 9 (= Holl, p. 358, no. 7); p. 70, no. 19 (= Holl, p. 359, no. 16); p. 71, no. 22 (= Holl, p. 360, no. 19). The problem of the disputed writings of Epiphanius is too intricate and too technical to be dealt with by a non-specialist. Having been vindicated by Holl, the writings, with the exception of the "Testament" (Ostrogorsky, *op. cit.*, p. 67 f., nos. 1 and 2 = Holl, p. 363, nos. 32 and 33), were rejected by Ostrogorsky (*op. cit.*, 61 ff.), whose arguments were, however, not found convincing by other leading Byzantinists (cf. F. Doelger, in *Goettingische Gelehrte Anzeigen* [1929] 353 ff.; H. Grégoire, *Byzantion* IV [1927–28 – published 1929] 769 ff.; V. Grumel, in *Echos d'Orient*, XXIX [1930] 95 ff. Cf. also, for the letter to John of Jerusalem, P. Maas, in *Byzantinische Zeitschrift*, XXX [1929–30] 279 ff., especially 286). It would seem that the last word on the subject has not yet been spoken. But it may be pointed out that a vigorous and emphatic campaign against images, which acceptance of all or most of the controversial passages makes it necessary to assume, would be a perfectly logical phenomenon for the late fourth century. Furthermore, the argument which really forms the core of Ostrogorsky's thesis hardly carries conviction. He is troubled by the fact that certain fragments, notably his no. 16 (= Holl no. 13), reckon with, and attempt to refute, a defense of images based on the contention that Christ may be depicted because He became a Man. This line of reasoning, according to Ostrogorsky, is characteristic of the defenders of images of the Iconoclastic period. He argues that if writers of the fourth century really had used the christological argument they surely would have been quoted at the Council of 787. Hence the treatise in which this argument is refuted cannot be by Epiphanius. But the defense of images on the basis of the Incarnation is, after all, an obvious one and was anticipated already in Eusebius' letter to the Empress Constantia, in which he refuses her request for an image of Christ (Migne, *PG* 20, cols. 1545 ff. J. D. Mansi, *Sacrorum Conciliorum nova et amplissima collectio*, XIII [1767] col. 313. Cf. above, n. 6). In the light of that letter it certainly cannot be maintained, as is done by Ostrogorsky (*op. cit.*, 79), that image problem and christology were not brought together till the time of John of Salonika (who, incidentally, wrote *ca.* A.D. 600 and not *ca.* 680; see below, p. 142). Indeed, the manner, and sometimes even the wording, of Eusebius' refutation of the christological argument anticipates what we find in the disputed fragments of Epiphanius: cf. especially Ostrogorsky, p. 70, no. 15 (= Holl, p. 359, no. 12) and Migne, *PG* 20, col. 1548 AB. On these grounds, then, there is no difficulty in accepting the fragments. The fact that the orthodox party in 787 did not produce any authority of the fourth century in defense of the christological argument need not disturb us. At that time a really articulate defense of Christian images had not yet been attempted on any grounds other than purely utilitarian ones. As was pointed out above (pp. 86 f.), defense lags behind attack. Epiphanius' disputed fragment, however, need not be a reply to an articulate defense of the image of Christ by recognized authorities. All it maintains is that "some say" (φασίν τινες) Christ is represented as a Man because He was born of the Virgin Mary (Ostrogorsky no. 16 = Holl no. 13). This goes hardly beyond Eusebius who deals with the same argument as one likely to be advanced against him by his imperial correspondent.

[29] Ostrogorsky, *op. cit.*, 75, 95, 110 f.

[30] στήσαντες . . . τὰς εἰκόνας τὰ τῶν ἐθνῶν ἔθη λοιπὸν ποιοῦσι (*Panarion haer.*, 27, 6, 10 = *Die griechischen christlichen Schriftsteller*, XXV, edited by K. Holl [Leipzig, 1915] 311). For the connection between Epiphanius' opposition to images and his christology see Holl, *op. cit.* (above, n. 27), 378 f., 386 f.; Elliger, *op. cit.*, 57 ff.

It is possible that the turn of the fourth century also witnessed the first symptoms and expressions of a belief in magic powers of Christian images. Such a belief is expressed with startling ingenuousness in Rufinus' very free translation of Eusebius' account of the bronze group in Paneas. Rufinus interprets Eusebius' somewhat ambiguous description of a strange plant of great healing power growing at the feet of the figure of Christ and touching the hem of his garment as referring to a real herb which derived its miraculous power from its contact with the Savior's image.[31] Significant as this passage is as an indication of what at least one author of the period around the year 400 expects his devout readers to accept in the way of magic powers of images, it is, of course, nothing more than a piece of free embroidery of an earlier text, and is not based on actual observation of magic practices or miraculous effects. What Theodoretus tells us forty years later about images of St. Symeon the Stylite being placed as apotropaia at the entrances of workshops in Rome has a far more factual ring and indicates a workaday use of a Saint's portrait in a prophylactic capacity.[32]

Finally, in the first half of the sixth century, we encounter the first hint in literature of *proskynesis* being practiced before images in churches. It appears to have been contained in an inquiry received by Bishop Hypatius of Ephesus from one of his suffragans, Julian of Atramytion. We know of this inquiry only from Hypatius' reply, a highly important document in the history of Christian theory concerning images which will be discussed later. For the moment we are concerned only with the fact that, judging by this letter, Julian, though worried about the propriety of sculpture in churches, in view of the Old Testament prohibition of graven images, took no exception to paintings and even tolerated their worship in the form of *proskynesis*.[33]

[31] *Eusebii ecclesiasticae historiae liber VII*, 18, 2. The edition by E. Schwartz and Th. Mommsen (*Die griechischen christlichen Schriftsteller*, IX, pt. 2 [Leipzig, 1908]) shows Eusebius' and Rufinus' texts conveniently printed side by side (672 f.). Cf. also Dobschuetz, *op. cit.*, 201, 252*, 256*.

[32] Theodoretus, *Religiosa Historia*, c.26 (*PG* 82, col. 1473 A); cf. also H. Lietzmann, *Das Leben des heiligen Symeon Stylites = Texte und Untersuchungen zur Geschichte der altchristlichen Literatur*, 3. Reihe, 2. Band, Heft 3 (Leipzig, 1908) pp. 8, 253. For the date of the text see *ibid.*, 237 f., and, more recently, P. Peeters, in *Analecta Bollandiana*, LXI (1943) 30 ff. For a possible relic of this early cult of St. Symeon in Rome cf. H. Delehaye in *Atti del IIo Congresso Internazionale di Archeologia Cristiana tenuto in Roma nell'Aprile 1900* (Rome, 1902) 101 ff. For Holl's theory that the Stylite Saints had a great deal to do with the rise of image worship see below, p. 117.

[33] F. Diekamp, "Analecta Patristica" = *Orientalia Christiana Analecta*, 117 (Rome, 1938) 127 ff. Baynes, *op. cit.* (above, n. 1), 93 ff. P. J. Alexander, "Hypatius of Ephesus: A Note on Image Worship in the Sixth Century," *The Harvard Theological Review*, XLV (1952) 177 ff. Hypatius quotes, or paraphrases, Julian as saying: "Προσκυνητὰς ἐπὶ τῶν ἱερῶν ἐῶμεν

Looking over what we have learnt about actual worship of religious images or magic practices and beliefs involving images prior to the middle of the sixth century, we must admit that the evidence, though incontrovertible from the end of the fourth century on both in the Greek East and the Latin West, is scattered and spotty. How widespread such practices actually were during the fifth and first half of the sixth centuries is impossible to say. In any case, however, there can be no doubt that in the second half of the sixth century the cult of images was vastly increased and intensified, primarily in the East, and that it maintained this new strength throughout the seventh century and, indeed, until the outbreak of Iconoclasm.

II. THE INTENSIFICATION OF THE CULT IN THE ERA AFTER JUSTINIAN

It cannot be pure coincidence that the mere volume of literary notices concerning images increases enormously at this time. Professor Grabar, who has written eloquently and brilliantly on the rise of the cult of images,[34] has observed that the accounts of pilgrims to the Holy Land, previously silent about religious images, now begin to feature them prominently. Images of various kinds also begin to play a conspicuous role in the writings of historians. But the richest mine of information is in the realm of hagiography and popular fiction, in which images and miracles connected with images are frequently found from this time on. Much of this latter material is difficult to date and all too easily dismissed as legendary and tendentious. A great many of the relevant texts were adduced in defense of images at the Second

εἶναι γραφάς, ἐπὶ ξύλου δὲ καὶ λίθου πολλάκις οἱ τὰ τῆς γλυφῆς ἀπαγορεύοντες οὐδὲ τοῦτο ἀπλημμελὲς ἐῶμεν, ἀλλ᾽ ἐπὶ θύραις" (Diekamp, *op. cit.*, 127). Prof. Alexander (*op. cit.*, p. 179, n. 16) has clarified the meaning of this sentence by showing that it draws a distinction between painting and sculpture and that Julian is opposed only to the latter, except on doors (on this point see below, p. 131). I would, however, amend slightly Prof. Alexander's version of the first part of the sentence. Instead of saying: "We allow the paintings to be worshiped in the sanctuaries . . . ," I would translate: "We let be in the sanctuaries the paintings which are worshiped . . . ," or even: "Worshiped as they are, we let be the paintings in the sanctuaries" Julian envisages three possible attitudes of the clergy towards images: Toleration of worship; admission of existence; destruction. For paintings he adopts the first two (with emphasis on the second), for sculpture he is inclined to advocate the third, and this is the object of his inquiry (see the first paragraph of Hypatius' letter). The main object of his concession is the existence of paintings (ἐῶμεν εἶναι). The εἶναι is not brought out in Prof. Alexander's translation and the οὐδὲ τοῦτο in the second part of the sentence is interpreted as referring to τὰ τῆς γλυφῆς, which is impossible grammatically. It must refer back to εἶναι and means that, so far as sculptures are concerned, Julian will admit "not even" their existence. The claim, then, that Julian's attitude amounts to an official approval of the worship of paintings seems to me exaggerated. One can merely say that Julian is aware that they do in fact receive *proskynesis*, but that he is willing to admit them since in Scripture only sculpture is specifically prohibited. For the import of Hypatius' reply see below, p. 138.

[34] *Op. cit.* (above, n. 9), 343 ff.

Council of Nicaea in A.D. 787. While some of them probably were then of recent invention and designed to meet the challenge of Iconoclasm, a considerable number is also preserved in sources other than the Acts of that Council, and in many instances attribution to writers of the late sixth or seventh century has not been, and need not be, doubted, the less so, since similar tales are also preserved in writings which quite indisputably belong to that period, including the works of chroniclers and pilgrims. It is true, of course, that many of these stories are essentially apologetic. One of the results of the great increase in image worship was a stepping-up of opposition, as we shall see, and this in turn called forth defense. The plots of some stories are actually based on acts of aggression against images. In others the influence of theorists attempting to justify images on theological grounds is quite evident. But some tales undoubtedly are spontaneous expressions of popular beliefs. Even a story written for defensive purposes may be woven around a nucleus of reality, or, granted that its plot may be pure invention, it presumably reflects actual conditions at least in its circumstantial detail. The chief interest these stories have for us at the moment lies precisely in the information they impart, almost incidentally, about every-day practices and beliefs concerning images. These details must have been plausible or else the whole story would have been liable to rejection as idle fantasy and thus its purpose — if purpose there was — would have been defeated. There is all the less reason to reject this information since it merely serves to fill in the picture derived from the writings of pilgrims and historians without materially changing it. Provided they are used judiciously and critically the stories about images which blossomed forth in hagiographic and other legendary literature of the late sixth and seventh centuries can be of great help in making our concept of the great vogue of image worship of that period more lively and three-dimensional.

The information given on the rising cult of images by pilgrims, historians, and writers of legends may be summarized under four headings:

1. Devotional practices.
2. Belief in, and exploitation of, magic properties of images.
3. Official use of images as apotropaia and palladia.
4. Belief in images of miraculous origin.

Devotional Practices

The first Palestine pilgrim who explicitly speaks of worship of images is Antoninus of Piacenza (*ca.* A.D. 570). He prayed (*oravimus*) in the Praetorium of Pilate, where there was a picture of Christ said to have been

painted in His lifetime.[35] A clearer statement is made by the same pilgrim in connection with a miraculous image of Christ preserved at Memphis: *pallium lineum in quo est effigies salvatoris . . . que imago singulis temporibus adoratur, et nos eam adoravimus.*[36] In the following century Arculf (*ca.* 670) reports veneration of a tapestry with figures of Christ and the twelve apostles which he saw in Jerusalem and which allegedly was woven by the Virgin Mary.[37]

These direct testimonies by persons who themselves performed or witnessed acts of worship do not specify the forms of the ritual. The miracle stories are more explicit and supply the desired detail. In the *Pratum Spirituale* of John Moschus (d. A.D. 619) we find a story of a hermit who, before undertaking a journey, was in the habit of praying to an image of the Virgin and Child, which he had in his cave, and of lighting a candle before it. He would ask the Virgin not only to grant him a prosperous journey, but also to look after the candle during his absence. As a result he always found it burning upon his return even if he had stayed away as long as six months.[38] Even if one takes a sceptical view and assumes that this particular tale did not form part of John's original work, which underwent changes and additions in course of time,[39] the use of lights before images is attested also by the Life of St. Symeon the Younger (d. A.D. 592), written not long after the Saint's death.[40] This author tells of a citizen of Antioch who, after having been cured of an illness by the Saint, put up an image of his benefactor over the door of his workshop in a conspicuous and public place in the city and adorned it with curtains as well as lights for the sake of greater honor.[41] In the younger version of the invention of the miraculous image of Christ at Camuliana, a text which goes under the name of Gregory of Nyssa but was written, according to Dobschuetz, sometime during the seventh century, we hear of a hanging lamp and an incense burner placed in front of the pic-

[35] T. Tobler, *Itinera et descriptiones terrae sanctae*, I (Geneva, 1877) 104. Dobschuetz, *op. cit.*, 99°, has what appears to be a better text, taken from Gildemeister's edition.

[36] Tobler, *op. cit.*, 116. Dobschuetz, *op. cit.*, 135°.

[37] Tobler, *op. cit.*, 156. Dobschuetz, *op. cit.*, 109°.

[38] Joannes Moschus, *Pratum Spirituale*, c.180 (*PG* 87 ter, col. 3052). The story was quoted at the Council of 787: Mansi, XIII, 193 E–196 C.

[39] K. Krumbacher, *Geschichte der byzantinischen Literatur*, 2nd edition (Munich, 1897) 187 f. Th. Nissen, "Unbekannte Erzaehlungen aus dem Pratum spirituale," *Byzantinische Zeitschrift*, XXXVIII (1938) 351 ff., especially, 353. E. Mioni, "Il Pratum Spirituale di Giovanni Mosco," *Orientalia Christiana Periodica*, XVII (1951) 61 ff., especially 81.

[40] For this Life and its attribution to Arcadius, bishop of Cyprus, see H. Delehaye, *Les Saints Stylites = Subsidia Hagiographica*, 14 (Brussels and Paris, 1923) pp. LIX ff.

[41] Quoted by John of Damascus (*PG* 94, col. 1393 D) and at the Council of 787 (Mansi, XIII, col. 76 DE).

ture.[42] The writer furnishes the image of Christ with paraphernalia which, as we have seen, were accorded to imperial images already in the fifth century.[43]

It will be noted that some of the pictures in the stories just quoted are located in places other than churches. At least one of them, the image owned by John Moschus' hermit, is purely an object of private devotion. Religious images had existed in private dwellings before this time,[44] but it is striking how frequently we hear of such objects in the hagiographic literature of the late sixth and seventh centuries.[45] From the texts one gets the impression that images of Christ, the Virgin, and the Saints became common in the domestic sphere at that time. Once admitted to that sphere their use and abuse was beyond control.

We know that images were prayed to ever since the days of Augustine and Epiphanius. The prayers may be acts of veneration, such as Antoninus of Piacenza seems to describe, or a means of obtaining specific favors. Prayers of the latter kind are common in miracle stories.[46] What gestures and actions such prayers entailed is often left vague, but genuflections and *proskynesis*, already attested in the early sixth century, as we have seen,

[42] Dobschuetz, *op. cit.*, 17°°; for the date of the text see *ibid.*, 27°°.

[43] See above, pp. 91 f. For a possibly interpolated episode in one of the miracles related in Sophronius' Encomium of Sts. Cyrus and John, in which an oil lamp burning before an image of Christ in the Tetrapylon at Alexandria figures as an accessory, see below, p. 106. For a similar episode in the Coptic Encomium of St. Menas see below, pp. 106 f.

[44] Cf. e.g. above, p. 94 (images of the Elder St. Symeon); also a frequently quoted passage in St. John Chrysostom's Encomium of Meletius (*PG* 50, col. 516).

[45] Cf. the general statement with which Gregory of Tours prefaces a story of a miracle wrought by an image of Christ (*De gloria martyrum*, c.22; *PL* 71, col. 724 A), and, for specific instances of religious images in domestic contexts, the following texts: Photinus, Life of John the Faster (d. A.D. 593) as quoted at the Council of 787 (Mansi, XIII, col. 85 B; see also below, pp. 108 f.); Joannes Moschus, *Pratum spirituale*, c. 45 (*PG* 87 ter, col. 2900 B-D; for this work see above n. 39); Life of St. Symeon the Younger (cf. above n. 40) as quoted at the Council of 787 (Mansi, XIII, col. 76 B and DE; the second passage also in John of Damascus' Third Oration: *PG* 94, col. 1393 D); Arculf, *Relatio de locis sanctis*, III, 5 (Tobler, *op. cit.*, 200); Life of St. John Chrysostom, as quoted by John of Damascus (*PG* 94, col. 1277 C) and by later authors (for this text, which goes under the name of George of Alexandria, see C. Baur, in *Byzantinische Zeitschrift*, XXVII [1927] 1 ff., especially 5, 6, and 9: The episode which concerns us seems to have been invented by the writer, who was active between 680 and 725). We may add some examples whose pre-Iconoclastic date is less certain: Lives of Sts. Cosmas and Damian, Miracle 15 (L. Deubner, *Kosmas und Damian* [Leipzig and Berlin, 1907] 137 f.; Mansi, XIII, col. 68 B; Deubner, *op. cit.*, 82, and apparently also Delehaye, *Analecta Bollandiana*, 43 [1925] 8 ff., consider this text as pre-Iconoclastic); story of an image of Christ at Beirut, related at the Council of 787 (Mansi, XIII, col. 25 B); and a related story in a Coptic sermon on the Virgin (W. H. Worrell, *The Coptic Manuscripts in the Freer Collection* [New York, 1923] 369 f.; for the dates of the two last-named texts see below, n. 59).

[46] See below, p. 108.

are mentioned repeatedly by writers of the seventh century.[47] A story in which some devout workmen, in addition to saluting an image of the Virgin, "embraced it and kissed its hands and feet and continued to salute it a long time pressing it to their bosoms in great faith" unfortunately cannot be dated with any precision.[48] But there can be no doubt, in the light of the sources just quoted, that during the late sixth and seventh centuries devotional practices in front of images became elaborate, common and intense.

Two episodes deserve separate notices because they show that the increasing cult of religious images extended beyond the sphere of private piety. In A.D. 656 a theological disputation was held between Maximus Confessor and Theodosius, Bishop of Caesarea, in the castrum of Bizya in Bithynia, where Maximus was confined. At a given point in the proceedings when agreement appeared to have been reached, all participants rose, prayed, kissed the gospel book, the cross and the icons of Christ and the Virgin, in whose presence the conversation was evidently held, and placed their hands on these objects in confirmation ($\beta\epsilon\beta\alpha\acute{\iota}\omega\sigma\iota\varsigma$) of what had been transacted.[49] Here we are confronted with an official ecclesiastical ceremony enacted by clerics and featuring icons as quasi-legal instruments along with the book of the gospels on which oaths had been sworn ever since the fourth century.[50]

An even more public and conspicuous employment of an icon by priests was recorded at the very beginning of our period in the earliest extant account of the image of Christ at Camuliana. In this text, which is contained in an anonymous Syriac compilation apparently completed in A.D. 569, we are told that in the years from 554 to 560 a copy of the miraculous image was carried by priests in solemn procession through various cities in Asia Minor in order to collect funds for a church and a village destroyed in a barbarian

[47] Joannes Moschus, episode quoted above, n. 45; Life of St. Symeon the Younger (cf. above, n. 40) as quoted by John of Damascus (PG 94, col. 1396 B) and at the Council of 787 (Mansi, XIII, col. 77 B); Life of St. Theodore of Sykeon (d. A.D. 613) by his pupil George, c.13 (Th. Ioannes, Mnemeia Hagiologika [Venice, 1884] 372; Mansi, XIII, col. 92 AB); Arculf, Relatio de locis sanctis, III, 4 (Tobler, op. cit., 198). For a possibly interpolated episode in Sophronius' Encomium of Sts. Cyrus and John, in which the two Saints — perhaps themselves part of a picture — are seen in a dream prostrating themselves before an image of Christ, see below, p. 106.

[48] Worrell, op. cit., 370; cf. above, n. 45 and, for the date, below, n. 59.

[49] S. Maximi Confessoris Acta, II, 18 and 26 (PG 90, cols. 156 AB, 164 AB); quoted by John of Damascus (PG 94, cols. 1316 BC, 1413 B) and at the Council of 787 (Mansi, XIII, cols. 37 E–40 B). For the date of the dispute cf. V. Grumel, in Echos d'Orient, XXVI (1927) 31; for the Acts cf. Krumbacher, op. cit., 64; for $\beta\epsilon\beta\alpha\acute{\iota}\omega\sigma\iota\varsigma$ below, p. 122.

[50] Joannes Chrysostomus, Homiliae de statuis, XV, 5 (PG 49, col. 160, last paragraph); cf. Codex Iustinianus, 2, 58, 2; 3, 1, 14, 4; 7, 72, 10, 3. See also E. Seidl, Der Eid im roemisch-aegyptischen Provinzialrecht, II (Munich, 1935) pp. 48 ff.; ibid., p. 49, perhaps another instance of an oath rendered before images of saints (Papyrus London, 1674: "before A.D. 570"). Cf. also John of Damascus, De imaginibus oratio II, 21 (PG 94, 1308 C).

raid.[51] Here an image of Christ is described as receiving the same kind of public display which was traditional in the cult of the imperial image.[52] The parallelism was not lost on the contemporaries. Our Syriac author, having said that the procession was organized for the highly practical purpose of fund raising, apparently was dissatisfied with so materialistic a motivation and proceeded to interpret the procession as symbolic of the Second Advent of the King and Lord, which he considered imminent.[53] The author himself, then,— and, possibly, the clergy (assuming that the event described is authentic) — was quite aware that the ceremony was essentially a royal or imperial one. We shall return to this point later.

Perhaps one can even go one step further and discover in the author's remarks overtones of a belief in a possible magic efficacy of the ceremony described. Dobschuetz has already recalled in connection with this passage the entry in the Chronicon Paschale for the year 562 — the terminal year of the first Paschal cycle — , from which it seems that expectations of an imminent Second Advent were rife at the time when the procession is said to have taken place.[54] Could such ceremonial acts have been thought of as not only symbolizing but perhaps hastening the event? In so far as such overtones may be present in our text it leads us on to the subject of magic beliefs and practices, to which we shall now turn.

Magic

In all acts of worship, even the most elaborate and intense, it is possible to claim — as was, in fact, maintained over and over again by defenders of images of all times — that the icons served merely as a symbol, a reminder, a representative of the deity or saint for whom the honor is intended. Wherever magic is involved this claim tends to become void. The common denominator of all beliefs and practices, which attribute magic properties to

[51] Dobschuetz, *op. cit.*, p. 6** f. (using, with minor changes, Noeldeke's translation published by R. A. Lipsius, "Zur edessenischen Abgarsage," *Jahrbuecher fuer protestantische Theologie*, VII [1881] 189 ff.); F. J. Hamilton and E. W. Brooks, *The Syriac Chronicle known as that of Zacharias of Mitylene translated into English* (London, 1899) 321; K. Ahrens and G. Krueger, *Die sogenannte Kirchengeschichte des Zacharias Rhetor* (Leipzig, 1899) 248 f. On the date of this text cf. Hamilton and Brooks, *op. cit.*, 5; Ahrens and Krueger, *op. cit.*, XVI; A. Baumstark, *Geschichte der syrischen Literatur* (Bonn, 1922) 184.

[52] Cf. above, pp. 90 f. and below, p. 122. Cf. also the processions in Rome in which the Acheiropoieta of the Lateran was solemnly paraded, and the imperial antecedents of these processions as pointed out by W. F. Volbach ("Il Cristo di Sutri e la venerazione del SS. Salvatore nel Lazio," *Rendiconti della Pontificia Accademia di Archeologia*, XVII [1940–41] 97 ff., especially 124 f. — a reference which I owe to Prof. Grabar). There is no proof, however, that the Roman processions *with the image* were instituted in pre-Iconoclastic times.

[53] All the translators quoted above, n. 51, agree that this is the general meaning of the passage, though they differ in detail.

[54] Dobschuetz, *op. cit.*, 8**.

an image, is that the distinction between the image and the person represented is to some extent eliminated, at least temporarily. This tendency to break down the barrier between image and prototype is the most important feature of the cult of images in the period under review.

It is likely that in the popular mind the barrier was never very formidable, even in ordinary worship. Indeed, we already found in literary sources of the fifth century occasional signs of a belief in the magic efficacy of certain representations.[55] But the true era of such beliefs starts in the second half of the sixth century. Their clearest expression is the tremendous vogue which miracle stories then began to enjoy.

In the miracle stories, some of which are thinly disguised or rationalized as dreams, the image acts or behaves as the subject itself is expected to act or behave. It makes known its wishes, as in the well known story told by Gregory of Tours of a painted picture of the crucified Christ at Narbonne, which demands to be covered.[56] It enacts evangelical teachings, as in the dream in which an image of Christ at Antioch appears clothed with garments previously given to a beggar.[57] When attacked it bleeds, as it does in another story told by Gregory of Tours about an image of Christ pierced by a Jew,[58] and in a story about an attack by Saracens on an image of St. Theodore, which John of Damascus quotes from the writings of Anastasius Sinaita (A.D. 640–700).[59] In some cases it defends itself against infidels with physical force, for instance, in a previously quoted story about an image of St. Symeon

[55] See above, p. 94.

[56] *De gloria martyrum*, c. 23 (*PL* 71, col. 724 f.).

[57] The story was published by Th. Nissen, in *Byzantinische Zeitschrift*, XXXVIII (1938) 367 f., no. 12, from the Vienna codex of the *Pratum spirituale* of Joannes Moschus (Cod. hist. gr. 42). For this work see above, n. 39.

[58] *De gloria martyrum*, c. 22 (*PL* 71, col. 724).

[59] *PG* 94, col. 1393 A–C; for the author see Krumbacher, *op. cit.*, 64 ff. These are the first of a whole series of such legends in Byzantine and medieval literature. The most famous is the story of an icon of Christ at Beirut related at the Council of 787 (Mansi, XIII, cols. 24 ff.) and many times subsequently (cf. Dobschuetz, *op. cit.*, 280°° ff.). The Beirut legend, in which the icon is made to undergo Christ's entire Passion at the hands of Jews and, quite logically, produces water as well as blood when pierced, is so much more elaborate than the simple tale related by Gregory of Tours that one is inclined to attribute it to a more advanced date. It may, in fact, be an invention of an apologist of orthodoxy during the first Iconoclastic period. In Sigebert's early twelfth century chronicle the events related in the story are placed in the year A.D. 765 (*PL* 160, col. 145). A Coptic sermon, which falsely claims as its author Theophilus, bishop of Alexandria, relates a story of an icon of the Virgin which shares many features with the Beirut legend. It is, however, so much less coherent that it should probably be regarded as a derivative of the latter (Worrell, *op. cit.* — above, n. 45 — , pp. 367 ff.; for other derivatives see Dobschuetz, *op. cit.*, 281°° f., n. 3). The seventh century date suggested for this work by E. H. Kantorowicz (in *Varia Variorum: Festgabe fuer Karl Reinhardt* [Muenster and Cologne, 1952] p. 188 n. 36) may therefore be too early. The only safe *terminus ante quem* is the date of the Ms., which was written in A.D. 975 (Worrell, *op. cit.*, 125).

at Antioch related in the Life of that Saint,[60] and in a legend told by Arculf in connection with an image of St. George on a column in Lydda, to which the Saint was allegedly tied while being scourged.[61] In others it demonstrates its immunity to attack through various miraculous deeds.[62] It makes promises.[63] But it also demands fulfillment of promises made to it by others, as in a second story told by Arculf in connection with the image of St. George at Lydda.[64] By far the most common type of miracle, however, is that in which the image bestows some kind of material benefit upon its votaries.

[60] For references see above, n. 41.

[61] *Relatio de locis sanctis*, III, 4 (Tobler, *op. cit.*, 195 ff.).

[62] Cf. Arculf's story of an image of the Virgin miraculously exuding oil after it had been rescued from desecration (*Relatio*, III, 5; Tobler, *op. cit.*, 200). Cf. also the miracles operated by the Beirut image (Mansi, XIII, col. 29 AB) and the parallel motif in the related Coptic legend (Worrell, *op. cit.*, 372).

[63] Cf. the dream of the Emperor Mauricius (d. A.D. 602), in which the image of Christ of the Chalke Gate promises him that he may expiate his sins in this life. Though the story refers to events of the early seventh century it should perhaps not be included among legends of the pre-Iconoclastic period, since it is known only from later sources (Theophanes, *Chronographia*; Bonn ed., p. 439 f. Zonaras, *Epit. Hist.*, XIV, 13, 30 ff.; Bonn ed., III, 194 f. Nicephoros Callistes, *Eccles. Hist.*, XVIII, 42; *PG* 147, col. 413). But there is at least a possibility that it is actually of early origin. I owe to Mr. C. A. Mango's unpublished thesis on the Chalke knowledge of what appears to be part of the original version of the story in an excerpt from the early seventh century chronicle known as that of John of Antioch (*Excerpta historica iussu Imperatoris Constantini Porphyrogeniti confecta, III: Excerpta de insidiis*, ed. C. De Boor [Berlin, 1905] p. 148, no. 108). In this text there is no specific mention of Christ or Christ's image; but Mauricius' vision takes place at the Chalke, and it is difficult to make sense of the story without giving it some such meaning as Theophanes gave it in the early ninth century. The suspicion that the version in the *Excerpta* may be incomplete is strengthened by the fact that "expiation now rather than later" was, indeed, the subject of a request of Mauricius *to Christ* according to Theophylaktos Simokatta, another nearly contemporary writer (*Historiae*, VIII, 11, 6, ed. De Boor [Leipzig, 1887] 305). If this reasoning is sound it would prove, incidentally, that the famous Christ image of the Chalke was in existence about the year A.D. 600. As Mr. Mango points out, this image actually came to be known as the "Guarantor" (ἀντιφωνητής), and seems to have been the archetype of later icons bearing that epithet. It had been suggested already by Ducange (*Historia Byzantina*, II [Paris, 1680] 116) that the two texts in which the Antiphonetes image first appears both relate to the image of the Chalke, though they refer to it as located in the Chalkoprateia. One of these texts is a, presumably spurious, letter of Pope Gregory II to the Emperor Leo III (I. Hefele and H. Leclercq, *Histoire des Conciles*, III, 2 [Paris, 1910] p. 608), the other the well-known story of the Jew Abraham and his Christian debtor, the most elaborate example of an icon not only making a promise, but also fulfilling it (Fr. Combefis, *Historia haeresis monothelitarum* [Paris, 1648] cols. 611 ff.). While the first-named text obviously is not pre-Iconoclastic, the second may have an early nucleus. It contains an interesting passage about "silver with five stamps" (*ibid.*, col. 641A), a passage which has provided the key to an understanding of the actually extant hall-marks on Byzantine silver objects of the sixth and seventh centuries (I. I. Smirnov, in *Zapiski of the Imperial Russian Archaeological Society* [in Russian], N. S. XII [1901] 505 ff.; M. Rosenberg, *Der Goldschmiede Merkzeichen*, 3rd ed., IV [Berlin, 1928] 615 f.; L. Matzulewitsch, *Byzantinische Antike* [Berlin and Leipzig, 1929] 1 f.). In this sense the claim that the events described in the story took place in the time of Heraclius (Combefis, *op. cit.*, col. 616 B) is in striking agreement with archaeological evidence.

[64] *Relatio*, III, 4 (Tobler, *op. cit.*, 197 f.).

Foremost in this category is the famous story of the image of Christ at Edessa and the role it allegedly played during the Persian siege of that city in A.D. 544. Whether the story actually originated at that time or only in the ensuing decades, it is one of the first instances in Christian literature of a specific miraculous benefit ascribed to a religious image. The incident is first referred to at the end of the sixth century in the Ecclesiastical History of Euagrius.[65] In Procopius' account of the siege, which was written shortly after the event, and on which Euagrius' text is admittedly based, there is no mention of the image, let alone a miracle. Dobschuetz[66] and, following him, Runciman[67] have suggested that, in spite of Procopius' silence, the legend has a historical foundation. According to this view an icon of Christ played a part in the defense, was considered by certain groups in the city as the true source of victory, and thus became the miraculous image of subsequent fame. Be this as it may, the story certainly became known within fifty years of the victory. It points up the rise of the belief in the magic power of images better than any other miraculous tale. Dobschuetz has pointed out that the miraculous intercession of the image is nothing but a materialized proof of the ancient belief that the city of Edessa enjoyed the special protection of Christ. In His famous letter to King Abgar Christ is said to have promised that no enemy should ever enter the city. Procopius relates that Christ's letter was inscribed on the city gate in lieu of any other phylactery.[68] Although he himself doubts the authenticity of the promise, he also tells us that the Persian King's ambition to capture the city was due to the unbeliever's attempt to disprove Christ's power and the validity of His promise.[69] If the siege was a test of Christ's power even for the enemy it is natural that the failure of the enterprise should have been ascribed by the defenders to divine intervention. But the significant point is that this intervention should have been thought — if not already at the time at any rate soon thereafter — to have been effected by means of a picture. It is true that at Edessa the ground was prepared, though only vaguely and theoretically, through an addition to the Abgar story known already in the fourth century according to which Christ sent to the King of Edessa not only a letter but His portrait as well.[70] But there is no record of that image's actually being considered extant, let alone of its being worshiped, at Edessa prior to the siege and

[65] Dobschuetz, *op. cit.*, 68** ff.

[66] *Ibid.*, 117 ff.

[67] St. Runciman, "Some Remarks on the Image of Edessa," *The Cambridge Historical Journal*, III (1931) 238 ff., especially 244.

[68] Procopius, *History of the Wars*, II, 12, 26 (Loeb ed., I, pp. 368 ff.).

[69] *Ibid.*, II, 12, 6 ff., especially 30 (pp. 364 ff., 370).

[70] Dobschuetz, *op. cit.*, 113, 171* (*Doctrina Addai*).

Procopius tells us that the city's only *apotropaion* was the letter inscribed on the gate. The idea of making the protection traditionally vouchsafed by Christ concrete in an image was a recent development in the time of Euagrius. The story reveals not a new and more intense faith, but a new desire to make the object of that faith palpable. Here undoubtedly lies a mainspring of magic beliefs and practices. Charged with the task of making Christ's protection manifest, the image cannot remain passive. It becomes an extension and executive organ of divine power and it is only logical that in Euagrius' account of the siege the image is not merely described as present in the city but as taking an active part in the defense at the most critical moment. The very appropriateness of the visual presentation makes it impossible to pretend that it is merely a metaphor. The barrier between image and subject breaks down. Christ is palpably present in His image and fulfills His promise through it.

The manner of the alleged intervention of the image is also worth noting. According to Euagrius the image was instrumental in kindling a fire which consumed an artificial hill built by the Persians as an assault tower. It brought about this effect through the intermediary of water which was sprinkled on the divine countenance before being applied to the fire.[71] The seemingly paradoxical, and therefore all the more miraculous, phenomenon of fire being fanned by water is based on Procopius' account where it is given a perfectly rational explanation.[72] But it also brings the Edessa story into line with a group of miracle stories in which images — like saints [73] and relics [74] — exercise their beneficial effects through some intermediary substance.

Before turning to these stories we must speak of one text of the same period which belongs to the class of factual reporting rather than edifying fiction, and suggests that stories such as Euagrius' account of the siege of Edessa, whatever their historical foundation, reflected — or, perhaps, stimulated — actual magic practices involving images. In his description of his journey to the Holy Land Antoninus of Piacenza tells us of an image of Christ which was visible on the Column of the Flagellation in Sion Church.[75] Actually, according to Antoninus, this was not really a complete image but merely an impression of Christ's chest and hands miraculously left on the

[71] *Ibid.*, 70**, line 35 ff.
[72] Procopius, *op. cit.*, II, 27, 14 (Loeb ed., I, p. 506).
[73] K. Holl, "Der Anteil der Styliten am Aufkommen der Bilderverehrung," reprinted in his *Gesammelte Aufsaetze zur Kirchengeschichte*, II (Tuebingen, 1928) 388 ff., especially 396 f.; cf. also Nicephoros Uranos, *Vita S. Symeonis Iunioris*, c. 7 (*PG* 86 bis, col. 3037 D).
[74] See below, p. 119.
[75] Dobschuetz, *op. cit.*, 139*, after Gildemeister; the text in Tobler, *op. cit.*, 103, is misleading, as Dobschuetz points out.

stone while He was tied to it. Already forty years earlier, however, the pilgrim Theodosius had claimed that not only Christ's arms and hands but also His face were impressed on the column.[76] The object evidently was a borderline case between simple relic and miraculously produced image, a phenomenon characteristic of the period of incipient intensification of the cult of images.[77] What interests us at the moment is Antoninus' statement that from this impression *pro singulis languoribus mensura tollatur; exinde et circa collum habent et sanantur.* This at first sight somewhat puzzling practice is mentioned once more in the next chapter in connection with the impression of Christ's feet seen by Antoninus on the stone on which He had stood during His interrogation in the Praetorium of Pilate.[78] Dobschuetz suggested that *mensurae* were wax impressions which were used as amulets.[79] But no such meaning of the word is known. Unless and until the term is shown to have been used in this sense in other contexts we are obliged to take it literally as signifying measure.[80] We must assume that persons suffering from disease took from the reproductions of Christ's body the measurements of the appropriate limb. They must have done this either by means of a string, a strip of papyrus, or similar material, which they then tied around their necks with salutary effects, or by means of a ruler, in which case they must then have transcribed the numerical value on a small tablet suitable for suspension as an amulet. The belief in the importance of measurements, which Antoninus' report reveals, calls to mind a practice known to have been employed by early medieval architects when confronted with the task of building a copy of the Holy Sepulchre. Rather than attempt a faithful reproduction of the Anastasis in Jerusalem they were apt to be satisfied with a selective inclusion of some of the principal measurements of that building in a structure of sometimes quite dissimilar shape.[81] The practice of sixth century pilgrims in Sion Church and the Praetorium of Pilate, as described by Antoninus, helps to explain this phenomenon. A transfer of measurements was enough to insure a transfer of the divine powers believed to reside in the original building. On the other hand, the existence of such transfers in architecture shows that Antoninus' *mensurae* may, indeed, be taken literally.[82]

[76] Tobler, *op. cit.*, 65.

[77] See below, p. 116.

[78] Tobler, *op. cit.*, 104.

[79] *Op. cit.*, 139°.

[80] *Thesaurus linguae latinae*, VIII, 5 (Leipzig, 1949) col. 762, lines 61–64 (s.v. *mensura*).

[81] R. Krautheimer, "Introduction to an 'Iconography of medieval Architecture,'" *Journal of the Warburg and Courtauld Institutes*, V (1942) 1 ff., especially 4, 12 f.

[82] Cf. in general for measurements as "sympathetic parts and representatives" *Reallexikon fuer Antike und Christentum*, edited by Th. Klauser, fasc. 1 (Stuttgart, 1950) col. 17 (s.v. *Abmessen*).

To the pilgrim measurements served as intermediaries between image and objective just as, according to Euagrius, water did to the defenders of Edessa.

In a number of stories relating miraculous cures we hear of other vehicles serving as intermediaries. Already Rufinus' version of the Paneas story had envisaged an intermediary of this kind: A real herb growing at the feet of the bronze group and deriving its healing power from its contact with the figure of Christ.[83] The seventh century Life of St. Theodore of Sykeon tells of a cure being effected through dew drops which fall from an icon of Christ as the patient is set down at the entrance to the altar;[84] and of another cure accompanied by a mysterious sweetness, more delicate than honey, felt in the mouth when praying to an image of Christ.[85] One of the miraculous cures related in Sophronius' Encomium of St. Cyrus and John is effected through the intermediary of oil taken from a lamp which burns before an image of Christ in the Tetrapylon at Alexandria. The image is the source of the beneficial power of the oil at least by implication.[86] A similar motif figures in an

[83] See above, p. 94.

[84] *Life of St. Theodore of Sykeon*, c. 8; Ioannes, *op. cit.* (above, n. 47), 368. The icon stood "ἐπάνωθεν . . . αὐτοῦ ἐν τῷ σταυροδόχῳ," i.e. above him — or perhaps, more plausibly, above the altar — in a receptacle for [a relic of] the Holy Cross, which is important in view of other instances in which icons appear to owe their miraculous powers to an association with relics (see below, p. 116). E. Dawes and N. H. Baynes, *Three Byzantine Saints* (Oxford, 1948) 91, translate: ". . . above him where the cross was set there hung an icon . . .," but they are not happy about their own translation; cf. *ibid.*, 187. Holl's interpretation of the passage as indicating the existence of an icon above the chancel parapet has no basis in the Greek text ("Die Entstehung der Bilderwand in der griechischen Kirche," reprinted in *Gesammelte Aufsaetze zur Kirchengeschichte*, II, 225 ff., especially 230).

[85] c. 13; Ioannes, *op. cit.*, 372.

[86] Sophronius, *SS. Cyri et Ioannis Miracula*, c. 36 (*PG* 87 ter, cols. 3548 ff., especially col. 3560 CD). In an earlier part of this long and complicated tale the author had spoken of the healing powers of oil taken from the lamps which burn before the relic shrines of martyrs (col. 3553 C) and it would seem that in the final denouement he assigns to the Christ image a pointedly analogous role as a source of the beneficial power of the oil. Image and relic thus appear to be deliberately placed on the same level. But it is not sure whether this text is really a single, unified composition. Already in the section preceding the cure itself great prominence is given to a picture: The patient (a heretic, whom the two Saints have just managed to convert to orthodoxy by force and by threats) has a dream in which he is taken by the Saints to a wonderful and immensely tall church. Inside he sees a huge picture showing Christ surrounded by the Virgin, St. John, and some of the apostles, prophets, and martyrs. Among the latter are also Sts. Cyrus and John. The two Saints — it is not clear whether the "originals" who had taken him to the church or their representations in the painting — then prostrate themselves before Christ and ask him for orders to cure the patient. After two unsuccessful applications Christ finally agrees. The patient is instructed to go to the Tetrapylon at Alexandria, where, after having fasted and slept, he is to gather a little oil from the lamp which burns before the image of Christ. This he is to bring back to the Saints, whereupon an application of the oil will cure him. He wakes up, acts according to the instructions, and is cured. It should be noted that part of this narrative may be interpolated. Neither the large composition with Christ and the

episode in the Coptic Encomium of St. Menas, a text which unfortunately cannot be dated with any precision.[87]

Instances where an image exerts its power not through an intermediary substance but through direct physical contact are not very common. John Moschus tells of a woman who obtained water from a dry well by lowering into it an image of the saintly abbot Theodore, specially procured for the purpose from his monastery in Cilicia.[88] In one of the miracles of St. Artemius, composed sometime before A.D. 668, a diseased member is cured through an application of the melted wax of a seal bearing the Saint's portrait. The patient had found the seal in his hands after awakening from a dream during incubation at the sanctuary of the Saint. In the dream St. Artemius himself had appeared and had given him the seal "to drink." [89]

Saints nor the image of Christ in the Tetrapylon can be assumed with certainty to have figured in the original version of the story, since just before the first of these pictures is introduced the narrative changes abruptly from the third to the first person. There is at least a suspicion that originally the story involved no images at all. On the other hand, the grammatical inconsistency may be due simply to Sophronius' peculiar methods of composition (cf. Delehaye, in *Analecta Bollandiana*, 43 [1925] 20 ff.), and since the story was known in its present form already to John of Damascus, who quotes it in his Third Oration (*PG* 94, cols. 1413 ff.), it cannot be later than the early years of Iconoclasm. The text was quoted also at the Council of 787 (Mansi, XIII, 57 D–60 B). For the importance of the composition described in the dream in connection with the early history of the "Deesis" iconography, see E. H. Kantorowicz, *Laudes Regiae* (Berkeley and Los Angeles, 1946) p. 50 f., n. 129 (with further references).

[87] The Saint's mother, grieved about her childlessness, prays to an image of the Virgin, dips her finger in the oil of the lamp burning before the image and thereupon hears a voice from the mouth of the Christ Child held in the Virgin's arms, saying: "Amen." She conceives in the following night. Cf. J. Drescher, *Apa Mena* (Cairo, 1946) 133; for the date, *ibid.*, 127. See also below, n. 138. The idea of an icon exercising its miraculous power through an intermediary substance also plays a role in the story of the Christ image of Beirut, in which cures are effected by the blood and water exuded by the image (Mansi, XIII, col. 29 AB; cf. above, nn. 59, 62).

[88] *Pratum spirituale*, c. 81 (*PG* 87 ter, col. 2940 AB); quoted at the Council of 787 (Mansi, XIII, col. 193 DE). For the date of this work see above, n. 39.

[89] A. Papadopoulos-Kerameus, in *Zapiski of the Hist.-Phil. Faculty of the Imperial University of St. Petersburg*, XCV (1909) 16 f.; for the date, *ibid.*, p. II; cf. also P. Maas, in *Byzantinisch-Neugriechische Jahrbuecher*, I (1920) 377 ff.; H. Delehaye, in *Analecta Bollandiana*, XLIII (1925) 32 ff. In Miracle no. 13 of Sts. Cosmas and Damian an application of an ointment made from a κηρωτή is prescribed by the Saints as a prophylactic treatment (Deubner, *op. cit.*, p. 134, line 50 ff.). From the context it would seem that this κηρωτή is identical with an image of the Saints mentioned earlier in the story as an amulet owned by the patient's husband (*ibid.*, p. 132, lines 4 ff.; p. 133, lines 13 ff., 33 ff.; for this see also below, p. 148). In other words, it appears to be an object analogous to that which figures in the miracle of St. Artemius. Κηρωτή, however, does not always imply an image; cf. other miracles of Sts. Cosmas and Damian in which it appears simply as an ointment distributed to the sick at the sanctuary of the Saints (*ibid.*, p. 232, s.v. κηρωτή; also Delehaye, *op. cit.*, 13; Maas, *op. cit.*, 380). A clear case of the material substance of an image serving as a medicine occurs in Miracle no. 15 of Sts. Cosmas and Damian, in which a patient mixes plaster from a fresco depicting the two holy physicians with water and drinks it with salutary effects (Deubner, *op. cit.*, 137 f., lines 17 ff.; cf. also below, pp. 147 f.). For the problem of the date of these Miracles see above, n. 45.

Crude as such practices may seem, what Antoninus of Piacenza tells us about the *mensurae* suggests that the hagiographical writers of the seventh century did not stray too far from the realities of their time. In many stories, however, the desired result is obtained without there being any material contact, direct or indirect, between image and beneficiary. Quite commonly a prayer, often accompanied by *proskynesis* before the image, is enough to make the miracle operative. We have already heard of John Moschus' story of the anchorite who successfully implored the Virgin to look after the candle burning before Her image during his absence.[90] When the image of Edessa becomes the instrument of King Abgar's miraculous cure — a development of that ancient legend which Dobschuetz places soon after the events of A.D. 544 — the ailing king is described as obtaining health by falling down and worshiping the image sent to him by Christ.[91] In the Life of St. Mary the Egyptian, ascribed to Sophronius, access to a church previously barred to her as if by divine force is granted to the repentant sinner after she has prayed to an image of the Virgin in the atrium.[92] In the Miracles of St. Anastasius the Persian we are told of a woman who is cured of a sickness, previously inflicted upon her as a result of her refusal to worship the relics of the Saint upon their arrival in Caesarea, when she prostrates herself at the newly erected shrine containing an image of the Saint as well as his relics.[93] The *translatio* of the relics took place in A.D. 631, but our text, which was read at the Council of 787,[94] cannot be claimed with certainty to antedate the Iconoclastic period.[95] Furthermore, in this story the healing power seems to emanate from the relics rather than from the picture. The latter — and this is a frequent motif in hagiographic texts — serves mainly to enable the patient to identify the saint who had previously appeared to her in a dream. But we may close our survey of magic cures and benefits with two stories which can be attributed with reasonable certainty to authors of the pre-Iconoclastic period, and which leave no doubt as to the magic power imputed to images. In both cases the writer makes special efforts to show that the mere presence of the image is enough to produce the desired effect. The first comes from the Life of John the Faster, Patriarch of Constantinople (d. 595), written soon after his death

[90] See above, p. 97.

[91] *Acta Thaddaei*, c. 4 (C. Tischendorf, *Acta Apostolorum Apocrypha* [Leipzig, 1851] 262. Dobschuetz, *op. cit.*, p. 182*, no. 24; for the date *ibid.*, p. 121, p. 31** f.).

[92] *Vita S. Mariae Aegyptiae*, c. 3 (*PG* 87 ter, col. 3712 f.); quoted at the Council of 787 (Mansi, XIII, cols. 85 D–89 A). Sophronius' authorship, accepted by Krumbacher (*op. cit.*, 189), is doubted by O. Bardenhewer (*Geschichte der altchristlichen Literatur*, V [Freiburg, 1932] 38) because of the style of the narrative.

[93] H. Usener, *Acta Martyris Anastasii Persae* (Bonn, 1894) 22 f.

[94] Mansi, XIII, cols. 21 C–24 C.

[95] Usener, *op. cit.*, p. V; Krumbacher, *op. cit.*, p. 192, no. 8.

by his disciple Photinus. This text is all the more interesting since it was evidently not composed for apologetic purposes. The demonstration of the power of the icon is a mere by-product of a story really intended to demonstrate the modesty of the Patriarch. Photinus had interceded with the latter on behalf of a woman who had been told by a hermit that her husband, who was plagued by an evil spirit, would be cured if she obtained in Constantinople an image of the Virgin blessed by the Patriarch. The Patriarch had been indignant at the suggestion that he, a sinful mortal, should be the instrument of such a miracle. Photinus then tells of the pious fraud which he perpetrated in order to satisfy the woman. He gave her an icon of the Virgin which looked rich enough to have come from the Patriarch. The end of the story is that this image, without any special blessing and by its mere presence in the house (where it had been "reverently and fittingly" placed on the wall of a room), chases away the evil demons.[96] The other story is from the Life of St. Symeon the Younger, and concerns an image of that Saint set up by a woman in her own home in gratitude for a cure which the Saint had effected in person. The icon worked many miracles. Thus it restored to health a woman suffering from an issue of blood who "coming in faith to look upon the image . . . said within herself: If I may only behold his likeness I shall be saved." There can be no clearer profession of faith in the absolute power of an image.[97]

Palladia

In the last two instances, in which no specific rites are performed, the role of the image might be described as simply apotropaic, except for the fact that it serves to remedy an evil rather than to prevent it. It is safe to assume that a purely prophylactic use of images by private individuals — attested, in connection with images of the Elder St. Symeon, already in the fifth century — also existed, and indeed flourished, along with other expressions of the belief in the magic power of images in the advanced sixth and seventh centuries.[98]

[96] Mansi, XIII, cols. 80 E–85 C; cf. Krumbacher, *op. cit.*, p. 187, no. 4.

[97] *Life of St. Symeon the Thaumatourgos*, c. 118 (A. Papadopoulos-Kerameus, in *Vizantiiskii Vremennik*, I [1894] 606 f.); quoted at the Council of 787 (Mansi, XIII, cols. 73 C–76 C). See also below, pp. 144 f. For the authorship of the text see above, n. 40.

[98] The practice of placing an image ἐν . . . τοῖς τῶν ἐργαστηρίων προπυλαίοις, which had been mentioned by Theodoretus in connection with the apotropaic use of portraits of St. Symeon the Elder (above, n. 32) is described again in almost identical words in the Life of St. Symeon the Younger, apropos the story of a citizen of Antioch who wished to demonstrate his gratitude to the Saint (for references see above, n. 41). This parallelism was duly noted by H. Delehaye, *Les Saints Stylites*, p. LXXI. Cf. also above, n. 89, and below p. 148 for Miracle no. 13 of Sts. Cosmas and Damian, in which an image of the two Saints carried as an amulet in the armpit (sic!) plays an essential role.

But aside from the private use of images as apotropaia, this period saw the beginning of what was to become one of the principal manifestations of the cult of images in Byzantium, namely, the employment of religious images as apotropaia and palladia for cities and armies, particularly in war time. This, of course, was an ancient pagan practice. Its revival has long been recognized as characteristic of the post-Justinianic era.[99]

The role of the image of Edessa in the siege of 544 as described by Euagrius is not really that of a palladium. As we have seen, Euagrius' account resembles ordinary miracle stories of the period. It differs from these only through the fact that a whole city, rather than an individual, is the beneficiary. The operation by which the power of the image is brought to bear on the fire takes place in secret in an underground passage. A palladium, on the other hand, is a public cult object recognized by all. It must be capable of instilling courage into those to whom it belongs and fear into their opponents, though in an emergency it may also be expected to perform specific acts. The image of Edessa did not play this role in the sixth century. But it is interesting to note that it gradually grew into something more like a palladium in later accounts of the siege. The letter addressed in 836 by the Patriarchs of Alexandria, Antioch and Jerusalem to the Emperor Theophilos has the Persians surround the city with fire and the bishop carry the sacred image in procession around the walls (as, indeed, had been done by this time more than once with other images in similar situations), with the result that a wind came and turned the flames back onto the enemy.[100] In the following century we find this public employment of the image combined with a version of Euagrius' secretly operated miracle, and the whole story preceded by the discovery of the image in a place appropriate for an apotropaion, namely, above the city gate, where it takes the place of Christ's verbal promise to King Abgar actually inscribed in that location according to Procopius.[101]

The evolution in the Edessa story from privately operated magic to public display and employment is symptomatic of the rise of Byzantine iconic palladia from the seedbed of popular beliefs. Actually, aside from this story, there are no other examples in the pre-Iconoclastic period in which images are actively and materially involved in military offense or defense. But even in the less active role in which they do make their appearance in the late

[99] Dobschuetz, *op. cit.*, 50 ff. Grabar, *Martyrium*, II, 352.

[100] L. Duchesne, "L'iconographie byzantine dans un document grec du IXe siècle," *Roma e l'Oriente*, V (1912–13) 222 ff., 273 ff., 349 ff., especially 279 f.

[101] Dobschuetz, *op. cit.*, 110 ff. and 39** ff. Dobschuetz suggests (112 f., 98** f.) that the story of the rediscovery of the image may derive from a local Edessene tradition. This tradition may go back as far as the late sixth or early seventh century if he is right in his theory that Pseudo-Gregory's account of the image of Camuliana dates from the seventh century and was influenced by it (cf. 24**). As we shall see presently, this is the time when religious images actually seem to have made their appearance on city gates.

sixth century the iconic apotropaia and palladia call to mind the similar —
and in part earlier — use of saints' images in the domestic sphere.

Thus a number of icons which figure in the hagiographic legends of the
post-Justinianic era are described as being situated not in churches or private
houses but in public places and particularly on or near public gateways,
where they evidently fulfill an apotropaic function comparable to that of the
image of Edessa in the later versions of that story, but reminiscent also of the
role of the images of St. Symeon the Elder on the doors of private work-
shops.[102] The Tetrapylon of Alexandria figures as the location of an image of
Christ; [103] another Tetrapylon in the center of the city of Caesarea was
chosen as the location of the shrine and image of St. Anastasius the Per-
sian; [104] at Antioch there was an image of Christ at or near the gate of the
Cherubim.[105] Perhaps the image of Christ of the Chalke, the main gateway
of the imperial palace in Constantinople, also made its appearance at that
time.[106]

Even more striking is the use of religious images as palladia in battle.
Theophylaktos Simokatta (early seventh century) relates that in the year
586 the image of Christ not made by hand — according to Dobschuetz he
refers to the image of Camuliana which was brought to Constantinople in
574 — was used by Philippikos in the battle of the Arzamon River to instil
courage into his troops.[107] Less than a generation later Heraklius put his
naval campaign designed to oust Phokas under divine tutelage by setting
against "that Gorgon's head, that corrupter of virgins, the awe-inspiring
image of the Pure Virgin." [108] In the following decade Heraklius, as master
of the Empire, used the miraculous image of Christ — again we must think
of the image of Camuliana — as a palladium in his Persian campaign.[109]

[102] See above, nn. 32, 98.

[103] See above, n. 86. The image survived the first Iconoclastic period and was still in
existence in A.D. 787; cf. Mansi, XIII, col. 60 C.

[104] Usener, *op. cit.* (above, n. 93), p. 23.

[105] This image figures in the story referred to above, n. 57. For the locality named Cherubim
and its relation to the city wall — and specifically to a gate — see G. Downey, in *Jewish
Quarterly Review*, 29 (1938) 167 ff.

[106] See above, n. 63.

[107] *Historiae*, II, 3, 4 ff., ed. De Boor (Leipzig, 1887) 73 f.; cf. Dobschuetz, *op. cit.*, 51 f.,
127° f.

[108] Georgios Pisides, *Heraclias*, II, 13 ff.; Bonn ed., 79. Cf. A. Frolow, "La dédicace de
Constantinople dans la tradition byzantine," *Revue de l'Histoire des Religions*, CXXVII
(1944) 61 ff., especially p. 104. Strangely enough, Dobschuetz (*op. cit.*, p. 52 f., n. 2 and
p. 128°) ignores this passage and is puzzled by the fact that Theophanes, according to him
the earliest witness, names Georgios as his source. Theophanes amplifies Georgios' statement
and speaks of shrines (κιβώτια) and icons of the Virgin on the masts of Heraclius' ships (Bonn
ed., I, 459 f.).

[109] Georgios Pisides, *De expeditione persica*, I, 139 ff.; also II, 86 ff. (Bonn ed., 9, 17). Cf.
Dobschuetz, *op. cit.*, 53, 129°.

More memorable than any of these occasions was the role played by images in the defense of Constantinople during the siege of the Avars of 626. Of this we have an account by an eye-witness,[110] identified by Vasilievsky with Theodore Synkellos,[111] who tells us that the patriarch had images of the Virgin and Child painted on all the gates on the west side of the city "whence the breed of darkness came," [112] and that later, when the city was threatened by fire, he carried the miraculous image of Christ around the walls imploring the Lord's help.[113] This is a historical record of images placed above gates and carried around walls during a siege, exactly as in the later versions of the Edessa story. The patriarch's procession around the walls with the miraculous image of Christ was recorded also by another contemporary, George Pisides.[114] In connection with the siege of Constantinople by the Arabs in 717 we hear once more of an image, this time that of the Virgin, carried around the walls together with the relics of the True Cross.[115] In all these instances the images are intended to produce a psychological and perhaps apotropaic effect, but they do not intervene to change the course of battle by direct magic action. The official use of images follows in the footsteps of private practice, but — except in the case of the siege of Edessa as described (or imagined) by Euagrius — it stops short of the extremes recorded in the sphere of popular devotion by pilgrims and hagiographers of the same period.[116]

Acheiropoietai

In both private and public practices recorded in the foregoing pages images not made by human hands play a conspicuous role. Their rise to

[110] *De obsidione Constantinopolitana sub Heraclio Imp.*; A. Mai, *Patrum Nova Bibliotheca*, VI (Rome, 1853) pt. 2, pp. 423 ff.

[111] V. Vasilievsky, in *Vizantiiskii Vremennik*, III (1896) 91. This attribution has been accepted by recent authorities: cf. Frolow, *op. cit.*, 95 f.; A. A. Vasiliev, *The Russian Attack on Constantinople in 860* (Cambridge, Mass., 1946) 106; L. Bréhier, *Vie et mort de Byzance* (Paris, 1947) 51 f., 545 (no. CCXLV). In Krumbacher's second edition the text is still listed as anonymous and undated (*op. cit.*, p. 251, no. 4, with a wrong citation of the pages of Mai's edition). Dobschuetz considered it to be a paraphrase of the sermon on the Akathistos composed after A.D. 717 (*op. cit.*, 132° f.).

[112] Mai, *op. cit.*, 427.

[113] *Ibid.*, 428.

[114] Georgios Pisides, *Bellum avaricum*, 370 ff. (Bonn ed., 61 f.). Cf. Frolow, *op. cit.*, 95. This passage was omitted by Dobschuetz, *op. cit.*, 131° ff.

[115] *Oratio historica in festum tes akathistou* (F. Combefis, *Hist. haer. monothel.*, cols. 805 ff., especially col. 818 C = *PG*, 92, col. 1365 C).

[116] For an instance in hagiographic literature of a saint's image serving as a palladium see below, n. 138 (Coptic Encomium of St. Menas, which, however, may not be of pre-Iconoclastic date).

prominence is indeed the best known aspect of the vogue of image worship in the second half of the sixth and the seventh centuries.[117] In regard to this subject we need do little more than summarize some well known facts.

Acheiropoietai are of two kinds: Either they are images believed to have been made by hands other than those of ordinary mortals or else they are claimed to be mechanical, though miraculous, impressions of the original. Neither type of image was entirely new in Christian worship in the second half of the sixth century. A story written in the early fifth century by a North African cleric concerns a painted *velum* which made its appearance under mysterious circumstances. The picture, which represented a miracle performed in the town of Uzala by the relics of St. Stephen, was given to a sub-deacon of the local church in a neighboring town, on the day after the miracle took place, by a stranger who probably was an angel rather than a man.[118] Evidently the speed with which the appearance of the finished picture followed the event it depicted, combined with the fact that its donor had never been seen in those parts before, indicated that the image was produced *non omnino absque mysterio dei.* This is what may be called a celestially produced image. A century later the pilgrim Theodosius was the first to mention a mechanical imprint of a sacred nature. We have already referred to his account of the Column of the Flagellation.[119] The impression of Christ's face and arms, which he claims to have seen impressed on it, is a secondary feature intended to enhance the value of the column as a relic by demonstrating in the most concrete fashion possible that Christ's body was in actual physical contact with the stone. An impression of the face is not really needed for this purpose. Indeed, a generation later we find Antoninus of Piacenza claiming only to have seen an impression of Christ's chest and hands on the column.[120]

Here the relic rather than the image remains the principal object of interest. But fullfledged acheiropoietai of Christ also appeared at this time. At Memphis Antoninus saw *pallium lineum in quo est effigies Salvatoris,* and he was told that this had been produced by Christ himself who had pressed the piece of cloth against His face.[121] This is an exact parallel to the legend concerning the miraculous origin of the image of Edessa, apparently elaborated about the same time. Dobschuetz has shown that probably not until after the siege of 544, when the portrait allegedly sent by Christ to Abgar

[117] Dobschuetz, *op. cit., passim,* especially p. 35; Grabar, *Martyrium,* II, 347. For the apologetic implications of the term ἀχειροποίητος see below, p. 143.
[118] For reference see above, n. 25.
[119] See above, n. 76.
[120] See above, n. 75.
[121] For references see above, n. 36; add Dobschuetz, *op. cit.,* 61 ff.

was first claimed to be extant,[122] did the tradition take shape that that portrait was produced not by an ordinary painter but by Christ Himself, who was said to have pressed His face against the piece of cloth.[123] Euagrius, the first to speak — at least by implication — of the image of Edessa as extant, presumably referred to this legend when he called it "the divinely wrought image, which human hands have not made." [124]

Finally, the image of Camuliana also made its appearance at the same time. It was brought from Camuliana to Constantinople during the reign of Justin II in 574.[125] Its history had been recorded already some years before in the Syriac chronicle of 569, in which we are told that a woman who desired to see Christ face to face found it in a water basin in her garden.[126] It thus fits into the category of celestially produced images rather than into that of the direct impressions. But the image promptly produced a mechanical copy on the cloth in which it was wrapped by its finder, and this (or a second copy produced later) became known under the name of ἀχειροποίητος.[127] The two varieties of miraculous images are thus combined, but in the later version of the Camuliana story the origin of the image is brought into line with the Memphis and Edessa legends: Christ himself appears and presses His face against the cloth.[128]

Two points stand out from this survey: the images of Edessa and Camuliana, the most famous acheiropoietai of the pre-Iconoclastic period, as well as the more obscure one at Memphis, all made their appearance at almost exactly the same time.[129] Furthermore, at this stage at least, the idea

[122] See above, pp. 103 f.

[123] The story first appears in the Greek *Acta Thaddaei*, c. 3 (see above, n. 91). Runciman, *op. cit.* (above, n. 67), 240, 245, ignores this text and quotes John of Damascus as the first to report the legend. On the other hand, Runciman asserts (242) that a miraculous reproduction of Christ's face on cloth had appeared in literature already at a much earlier date in connection with the Veronica legend. But the *"Death of Pilate,"* which he quotes in support of this statement is certainly not of the fourth century. Runciman ignores Dobschuetz' elaborate proof that the episode of a miraculously produced image is a medieval addition to the Pilate Cycle, an addition of which the *"Death of Pilate"* is not even the earliest representative (Dobschuetz, *op. cit.*, 248 f.; 278* f., no. 8; 301* f., no. 49).

[124] "τὴν θεότευκτον εἰκόνα, ἣν ἀνθρώπων μὲν χεῖρες οὐκ εἰργάσαντο"; cf. Dobschuetz, *op. cit.*, 70**; also *ibid.*, 118. After Euagrius the earliest texts referring to the image as an existing one appear to be the Armenian treatise on images ascribed to Vrt'anes K'ert'ogh (Der Nersessian, *op. cit.* — above, n. 1 — p. 60) and the Syriac *sougitha* on the Cathedral of Edessa (A. Dupont-Sommer, in *Cahiers Archéologiques*, II [1947] 31, 35; A. Grabar, *ibid.*, 52 and, for the date of the text, 58).

[125] Cedrenus, *Hist. Comp.*, Bonn ed., I, 685.

[126] For references see above, n. 51.

[127] This is probably the earliest known use of the term in connection with a Christian image. See also below, p. 143.

[128] Dobschuetz, *op. cit.*, 9** ff., especially 16**.

[129] The only other acheiropoieta which figures in a text of definitely pre-Iconoclastic date is

of mechanical reproduction — originally a sideline of the cult of relics and sometimes curiously prophetic of methods used in photography — seems to be more popular than that of a celestial origin. It is tempting to seek an explanation for this preference in the fact that this type of legend epitomizes more clearly, concretely and dramatically than any amount of theory the role of the icon as an "extension," an organ of the deity itself. It is the myth which fits most completely the magic concept of the icon and the belief in its divine power, crucial elements in the increased cult of images in the generations after Justinian.

III. ROOTS AND CAUSES

The literary evidence reviewed in the foregoing pages is unmistakable. It clearly indicates a tremendous increase and intensification of the cult of images, beginning in the second half of the sixth century and lasting until the outbreak of Iconoclasm. One wonders how this striking development came about and why it took place at that particular time.

In a highly stimulating chapter, which forms the conclusion of his great work on the artistic aspects and expressions of the Early Christian cult of relics, A. Grabar has interpreted the vogue of image worship with which we are dealing as the beginning of a process whereby the icon replaced the relic as a principal object of devotion in the Greek Orthodox Church.[130] Although objections have been raised against this thesis,[131] as a general proposition it can hardly be doubted. We have already seen that in point of time the relic preceded the image as an object of worship.[132] Although in later periods the cult of relics continued side by side with the cult of images, certainly by comparison with the medieval West the relic played a smaller and the icon a much larger and more central role in later Greek Christianity. Nor can it be denied that the change of emphasis began in the

an image of St. George on a column in Lydda, referred to in Arculf's *Relatio*, III, 4 (Tobler, *op. cit.*, 195 ff.; cf. above, nn. 47, 61, 64); Arculf does not claim to have seen it himself, as Dobschuetz asserts (*op. cit.*, 90), but only to have heard about it in Constantinople. For the relation of this image to the Column of the Flagellation of Christ and to later traditions about a miraculous image of the Virgin, also at Lydda, see Dobschuetz, *op. cit.*, 79 ff., 91 ff. Perhaps Arculf's report about a tapestry woven by the Virgin should also be mentioned here once more, since it refers to an image thought not to have been made by an ordinary mortal (see above, n. 37). Images allegedly painted by St. Luke probably cropped up only under Iconoclasm (Dobschuetz, *op. cit.*, 269** ff.). The Roman acheiropoieta is mentioned for the first time under Pope Stephen II (752–7); cf. L. Duchesne, *Le Liber Pontificalis*, I (Paris, 1886) 443.

[130] Grabar, *Martyrium*, II, 343 ff.
[131] A. M. Schneider, in: F. Doelger and A. M. Schneider, *Byzanz* (Bern, 1952) 289.
[132] See above, pp. 89 f.

late sixth and seventh centuries and that the forms which the cult of icons took are strikingly similar to those one encounters in the cult of relics.[133]

Belief in magic power — the core of the great development in the cult of images — had been associated with relics all along. Moreover, in the Greek East the cult of relics had contained from the beginning a strong visual element and thus carried within it the germ of the subsequent change. One of the earliest and most eloquent statements in praise of relics was made by Gregory of Nyssa in his Encomium of St. Theodore.[134] He speaks of the faithful who treasures the dust he has collected from the martyr's tomb,[135] and he describes the delight of those who have had the great good fortune to touch the relics themselves: "Those who behold them embrace, as it were, the living body itself in its full flower, they bring eye, mouth, ear, all their senses into play, and then, shedding tears of reverence and passion, they address to the martyr their prayer of intercession as though he were hale and present." In this ecstatic passage, in which the shapeless relic is merely a tool for conjuring up the physical presence of the saint, one can discern something of the roots of future image worship. For if a sensual perception of the living form is the devout's primary need, it is obvious that the work of the painter and sculptor can be of greater assistance to him than a handful of dust and bones. It is in the body in its fulness that the martyr's glory is really beheld. Hence the pictorial rendering of the living form was able to inherit the virtues of the relic and to gain an equal, and eventually more than equal, importance.

Professor Grabar has found striking proof of his thesis in the observation that when the cult of images first began to spread widely it was usually concerned with an object which, because of its actual or reputed origin or because of its associations, partook of the nature of a relic or a *brandeum*.[136] Most of the early notices of adoration or other ceremonial worship of images, and also many of the early testimonies concerning magic beliefs and practices, involve either acheiropoietai, which were thought to owe their existence to direct contact with a divine person and — in the case of mechanical impressions — actually started as "by-products" of relics;[137] or images which, though man-made, were physically associated with sacred relics;[138] or,

[133] Grabar, *op. cit.*, 357, and below p. 119.
[134] *PG* 46, col. 740 AB.
[135] On dust as an intermediary substance see Holl, *op. cit.* (above, n. 73), 397.
[136] *Op. cit.*, 346.
[137] See above, nn. 36 (Memphis); 37 (Jerusalem tapestry); 42 and 51 (Camuliana); 61 and 64 (Lydda); 65 and 91 (Edessa); 75 (Column of the Flagellation).
[138] See above nn. 35 (Praetorium of Pilate); 84 (Theodore of Sykeon); 89 (St. Artemius); 93 (St. Anastasius the Persian). A particularly striking example of an association of image and

finally, images which had originated with, and perhaps been blessed by, a saint still living, such as a stylite.[139] For these latter a specially prominent role in the development of the cult of images has been claimed by Holl,[140] and it is certainly true that the first recorded instance we have of a Christian image being put to apotropaic use concerns portraits of a stylite.[141] It is also striking to find that the palladia carried in battle are very often acheiropoietai. On the other hand, Prof. Grabar has also pointed out that it would be wrong to search in every early instance of the cult of images for some sort of association with the cult of relics.[142] He has laid great stress on the innate suggestive power possessed by the image as such (even when it claims to be nothing more than an ordinary man-made artefact and is not associated with any sacred person or object), a power to whose influence the Greeks and hellenized Semites in the Eastern Mediteranean were particularly susceptible. Among the broad masses the concept that divine forces were present in religious images was deeply rooted in the pagan past. Neoplatonism had merely provided a philosophical foundation for beliefs going back to

relic is afforded by the Coptic Encomium of St. Menas, in which the following story is told by way of reconciling the presence of the Saint's body in Egypt with his martyrdom in Phrygia: The commander of a Phrygian regiment, who had taken the body of the Saint from its original resting place in Phrygia to serve as a palladium during a military expedition to Libya, found himself unable to move the sacred relics from their chosen abode in the Maryut. He therefore had an image of the Saint painted on a wooden tablet and he "placed the image on the Saint's remains for his blessing and power to remain in the image that he might take it with him to be a succour to him not only at sea but wherever he went, as an invincible weapon." Here the image clearly serves as a substitute for the relics and is purposely put in direct contact with them, in the manner of a *brandeum*, in order to endow it with magic power, although, with a slight break in logic, the writer then proceeds to tell us that the commander left the image on the Saint's remains and took with him another "like the first" (Drescher, *Apa Mena*, 140 ff.). The story is repeated — without bringing in an additional copy — in the Ethiopic version of the Passion of St. Menas (C. M. Kaufmann, *Ikonographie der Menas-Ampullen* [Cairo, 1910] 42 f.; E. A. W. Budge, *Texts relating to Saint Mena of Egypt and Canons of Nicaea in a Nubian Dialect* [London, 1909] 54 ff.). The legend may well be a product of the period when images began to acquire a status equal to that of relics and were increasingly used as military palladia. But the only safe chronological clues are "after 640" and "before 892/3" (Drescher, *op. cit.*, 127).

[139] See above n. 88 (Abbot Theodore) and, for the stylites, below, p. 118 with nn. 143 f.

[140] *Op. cit.* (above, n. 73).

[141] See above, n. 32 (Theodoretus). It must be remembered, however, that this practice is recorded for Rome and that Westerners may have acted with greater ingenuousness in this matter (see also above, p. 94, for Rufinus' version of the Paneas story). Holl perhaps was inclined to overemphasize the specific role of Syria, and of the stylites in particular, in promoting magic practices. His other instances are taken from the Life of the Younger St. Symeon (*op. cit.*, p. 390 f., nos. 3b and 3c; cf. below, n. 144); by the time this text was written miraculous powers were being claimed for all kinds of other images, including some which had no special associations, as will be seen presently. For a critical review of Holl's paper see H. Delehaye in *Analecta Bollandiana*, 27 (1908) 443 ff.

[142] *Op. cit.*, 348 ff.

much more ancient times. This deep-seated animistic attitude naturally re-asserted itself vis-à-vis the Christian religious image regardless of whether it had any special association with a relic, and long before it in turn became a subject of profound philosophical speculation.

In many of the examples of the incipient cult of images which we have been able to quote the connection with a holy person or a sacred object is at best a very tenuous one. For instance, the statue of Christ at Paneas, though considered to have been made in the Savior's life-time, had no direct association with Him. It was said to have been erected in gratitude by the Haemor-rhoissa after she had been cured. When miraculous powers were ascribed to this image, as was done as early as A.D. 400, it cannot be said that these powers were thought to derive from any direct contact with Christ. The images of St. Symeon the Elder used as apotropaia in Rome may have been εὐλογίαι brought back from visits to the Saint himself, as Holl suggests,[143] but in the case of miracles ascribed to images of St. Symeon the Younger there is no evidence that these images had at any time been in contact with the Saint.[144] The miracle story related in the Life of John the Faster specifi-cally deprecates the idea that an εὐλογία by a living person, however holy, could impart miraculous power to an image and, in effect, the legend extols the magic efficacy of an ordinary icon with no special antecedents.[145] Indeed, by the end of the sixth century other miraculous tales were in circulation which involved quite ordinary pictures,[146] and their number increased dur-ing the seventh.[147] Images placed as apotropaia on city walls and public gates were rarely claimed as being of any special nature; nevertheless many of them were believed to possess magic powers.[148]

Thus the cult of images, though clearly prepared and encouraged by the

[143] Op. cit., 391.

[144] It is true that in connection with St. Symeon the Younger we hear of portraits of the Saint brought back from visits to him as εὐλογίαι (cf. Holl, op. cit., p. 390, no. 3a). But in the two instances in his Life in which images play a part in miracles these images are described as having been put up in gratitude by persons after they had returned home from successful visits to the Saint. There is no indication that these portraits should be thought of as having been blessed or even seen or touched by him; for these miracles see above, pp. 101 f., 109.

[145] See above, pp. 108 f.

[146] See above, nn. 56, 58 (Gregory of Tours).

[147] See above nn. 38 (Joannes Moschus); 57 (do.); 59 (Anastasius Sinaita); 62 (Arculf); 85 (Theodore of Sykeon); 86 (Sophronius); 92 (do.). Admittedly the seventh century date of the texts attributed to John Moschus and Sophronius is not entirely certain. Other examples are Miracles nos. 13 and 15 of Sts. Cosmas and Damian (above, n. 89) and the Beirut legend and its Coptic derivative (above, n. 59), but, as we have seen, none of these can be safely assumed to be pre-Iconoclastic.

[148] See above nn. 86 (Tetrapylon of Alexandria); 57 and 105 (Cherubim at Antioch); 63 (Chalke at Constantinople). The battle incidents referred to above in nn. 108, 112, 115 also involve ordinary images.

cult of relics, was never entirely dependent on it and, in the course of the seventh century, emancipated itself almost completely. Certain forms which the cult took offer particularly striking evidence of this emancipation. We have seen that images were apt to serve as *brandea*, that is to say, as intermediaries between holy persons or objects and their votaries. But we have also seen that images — and sometimes even quite ordinary images which did not themselves possess the character of a relic or *brandeum* — were credited in their turn with producing miraculous effects through some intermediary substance, in a manner traditional in the cult of relics.[149] In other words, the image assumes a status analogous to that of a relic. The parallelism is especially evident in cases where oil is given the role of intermediary.[150] Oil had long been treasured by the faithful as a link with holy sites or relics, witness the pilgrims' flasks which have survived to this day. A story about a miracle wrought by Sts. Cyrus and John, already referred to in an earlier note, expressly features oil taken from a lamp at a relic shrine and from a lamp burning before an image of Christ as agents of equivalent power.[151]

When we recall the words of Gregory of Nyssa the development of the cult of images as an increasingly independent form of devotion is hardly surprising. What is more difficult to explain is the reason why the cult of images received such a tremendous impetus at that particular time.

To probe into the causes of a movement so deeply rooted in ancient beliefs and practices and so obviously carried by broad masses of common people is a difficult undertaking. No doubt the inclination to worship and to make magic use of religious images began to operate as soon as such images started to be created [152] and was on the increase steadily from that time on. The momentum of this groundswell appears to have increased in the second half of the sixth century, but what the causes of this increase were is almost impossible to say. We have spoken of a growing quest for the palpable presence and intervention of the deity.[153] This perhaps stemmed from a growing sense of insecurity which may well have seized large sections of the population of the Eastern Mediterranean countries during those perilous times. But to try to identify with any precision the forces which seem to have pressed

[149] See above, pp. 104 ff. For the role of intermediary substances and objects in the cult of relics see F. Cabrol and H. Leclercq, *Dictionnaire d'archéologie chrétienne et de liturgie*, II, 1, cols. 1132 ff., s.v. "Brandeum"; XIV, 2, cols. 2313 ff., s.v. "Reliques et Reliquaires"; also above, p. 116 (dust as an intermediary substance).

[150] See above, nn. 86, 87.

[151] See above, n. 86; note, however, that this text may not be a single unified composition and that the analogous roles assigned to oil from the two locations may be due to an afterthought.

[152] Holl, *op. cit.*, 388.

[153] See above, pp. 103 f.

from below could only be guesswork. What can be suggested, however, is that the resistance to such pressures on the part of the authorities decreased notably in that period, and that this relaxation of counterpressure from above was at least a major factor in the development. The historian, at any rate, is almost compelled to confine his search for causes to possible contributing factors in the official sphere, where the sources permit a certain amount of scrutiny.

So far as the clergy was concerned, the adaptation of Neoplatonic philosophy to Christian needs, which had been effected towards the end of the fifth century in the writings of Pseudo-Dionysius, provided a theoretical basis on which to build up a defense of Christian image worship. We shall see later that ecclesiastical authorities were not slow in availing themselves of this convenient and respectable source to allay their own scruples in the matter.[154] They also became increasingly aware of the usefulness of icons in the fight against heretics, and this seems to have been one of the reasons for the official blessing and sponsorship accorded particularly to the acheiropoietai, whose christological aspects will be mentioned later.[155] Dobschuetz[156] and Runciman[157] have suggested that the image of Edessa may have been "invented" during the siege of 544 by the Greeks and Chalcedonians in the city in opposition to, or for the benefit of, the powerful monophysite element then under the leadership of the famous Jacob Bar Adai. It is certainly true that monophysites often tended towards iconoclasm,[158] but, on the other hand, as Dobschuetz himself points out,[159] the monophysites at Edessa were not loath to claim the image for themselves, though they may not have accepted the story of its miraculous origin.[160] There is more solid evidence of the use of icons for dogmatic purposes in connection with the image of Camuliana. George Pisides extols it as tangible proof of the Incarnation and as a means of confounding the phantasiasts,[161] and in Pseudo-Gregory's sermon on this image, also of the seventh century according to

[154] See below, p. 138, on Hypatius of Ephesos. Cf. also Holl's excellent remarks on the role of theology in the development of the cult of images (*op. cit.*, 389).

[155] See below, pp. 143 f.

[156] *Op. cit.*, 119 f.

[157] *Op. cit.* (above, n. 67), 242 ff.

[158] See below, p. 131 (Philoxenos).

[159] *Op. cit.*, 141 f.

[160] Dobschuetz finds some slight support for his "Chalcedonian" thesis in the fact that later orthodox legend ascribed the discovery of the icon to a bishop with the Greek name Eulalios, a personage not otherwise known (*op. cit.*, 119, 64** f.). This name, incidentally, occurs already in the version of the legend given by the oriental patriarchs in their letter to Emperor Theophilos (Duchesne, *op. cit.* — above, n. 100 — p. 280), though not in Combefis' text of that letter, which was used by Dobschuetz (*op. cit.*, 68**).

[161] *De expeditione persica*, I, 145 ff. (Bonn ed., 9).

Dobschuetz, its miraculous appearance and effects are described and interpreted consistently as a re-enactment of Christ's Incarnation.[162] The most conspicuous example of active promotion of images for doctrinal reasons is the Eighty-Second Canon passed by the Quinisext Council at Constantinople in A.D. 692. The Canon concerned one specific type of representations, namely, the symbolic rendering of Christ in the form of a lamb, and prescribed that this should be replaced by representations of Christ in human form, "so that we may perceive through it the depth of the humiliation of God the Word and be led to the remembrance of His life in the flesh, His Passion and His death, and of the redemption which it brought to the world." Here the making of images — and specifically of anthropomorphic images — is officially prescribed by the highest authority. The purpose is clearly stated: The image is to make palpable the Incarnation of the Logos in Christ. It is used as a gauntlet, as a challenge to those whose christological views were not in agreement with orthodox dogma. There is no other text of the pre-Iconoclastic period which shows with equal clarity the authorities themselves taking the initiative in the matter of graven images, though nothing is said on the question of their worship.[163]

There were instances, then, when theoretical, and particularly theological and doctrinal, considerations served not only to defend images and their cult but also to promote them. But theology cannot be considered as being more than a contributing cause of the expanding cult of images. Had it been a primary cause one might well expect that expansion to have taken place in the fifth and early sixth centuries when the struggle with monophysitism was at its height and the need to demonstrate the reality of the Incarnation was particularly great. One would also expect opposition and defense called forth by the expanding cult of images in the second half of the sixth century to be centered much more clearly on theological and particularly christological issues than they actually were. As we shall see later, christology did play a part in both — and had done so already at a much earlier date — but neither was as yet focussed on it. Still less could it be maintained that the image was as yet a vital part of doctrinal strife. The areas of theology and image cult overlapped, but it was only in the course of the Iconoclastic controversy that they were made to coincide.

Perhaps the official promotion of the cult of religious images in the second half of the sixth century owed at least as much to secular developments involving the Byzantine court as it did to theological considerations. To appreciate the possible importance of the cult to the court it is necessary to recall

[162] Dobschuetz, op. cit., 55 ff., 12°° ff.
[163] Mansi, XI, cols. 977 E–980 B.

what was stated on an earlier page in regard to imperial images and their continued use and veneration in Christian times.[164] The portraits of the rulers were hardly affected by the official Christian aversion to any form of idolatry. Their continued veneration was freely admitted as early as the fourth century. It is true that, as a rule, sacrifices were no longer offered to them,[165] but in every other respect they continued to enjoy a prominent and important role in the *culte imperial*. They were carried in solemn procession and received acclamations and *proskynesis*.[166] Candles and incense figure in this cult long before such paraphernalia can be found in use in connection with religious images.[167] These external features are expressions of a clearly recognized and precisely defined function of the imperial portrait, whose official status, unlike that of Christian religious imagery, was assured from the start. The imperial image, had, in fact, a specific constitutional and legal role which had been laid down in Roman times and was not affected by the advent of Christianity. For Christian as for pagan emperors their own portraits served to represent them wherever they were unable to be present in person. They were sent to distant provinces, to co-rulers and subordinates to receive obeisance on behalf of a new sovereign, and their acceptance or refusal meant acceptance or rejection of the sovereign himself.[168] In the law courts, market places, assembly rooms and theatres they served to represent the sacred person of the absent emperor,[169] and to confirm the magistrates' acts.[170] They had their definite role among the insignia of the army [171] and in the complicated protocol of imperial appointments and administration in general.[172] Most striking of all, perhaps, was their recognized function as legal protectors of the individual citizen. *Ad statuas confugere* was a tradi-

[164] See above, pp. 90 ff.

[165] See, however, above, pp. 91 f. and n. 23.

[166] See above, pp. 90 f., with n. 17, and the texts quoted by Kruse, *op. cit.* (above, n. 18), p. 35, n. 2 (attributed to St. John Chrysostom) and p. 36, n. 1 (probably from Severianus of Gabala: cf. Der Nersessian, *op. cit.* — above, n. 1 — p. 61); Setton, *op. cit.* (above, n. 18), 200.

[167] See above, pp. 91 f., with n. 23. For pictorial illustrations of this practice see H. Omont's edition of the *Notitia Dignitatum* (Paris, Ms. lat. 9661, published by the Bibliothèque Nationale, Département des Manuscrits, Paris, n.d.), pls. 17, 62 (cf. Kruse, *op. cit.*, 100).

[168] Kruse, *op. cit.*, 23 ff.

[169] *Ibid.*, 79 f.

[170] ἵνα βεβαιῶται τὰ γινόμενα; cf. Severianus of Gabala, *De mundi creatione oratio VI*, 5 (*PG* 56, col. 489; quoted by Kruse, *op. cit.*, p. 79, n. 3). Severianus uses the same expression which the author of the Acts of Maximus Confessor was to use 250 years later to describe the function of the icons of Christ and the Virgin in confirming the agreement of the disputing clerics at Bezya (see above, p. 99 with n. 49). There seems to be no evidence, however, of an actual oath being taken on an imperial image.

[171] Kruse, *op. cit.*, 64 ff.

[172] *Ibid.*, 89 ff. Cf. also the summary given by A. Grabar, *L'empereur dans l'art byzantin* (Paris, 1936) 4 ff.

tional right of any person seeking the protection of imperial law,[173] a right that was clearly circumscribed but not eliminated in the codifications of Theodosius [174] and Justinian.[175] The Church did not reject this legal usage; witness a passage ascribed to St. John Chrysostom and quoted subsequently by other writers.[176]

Clearly, then, there was an old-established and never seriously challenged tradition which accorded to the imperial portrait an importance and vicarious power, such as could hardly be granted to religious images without arousing scruples and opposition. It is true that this power was based on a premise which did not apply in the religious sphere: Unlike the Deity the ruler could not be omnipresent and his not being present in person was, so to speak, the condition for according so much power and such great honors to his portraits.[177] In any case, however, this meant a considerable blurring of the line of demarcation between image and prototype.[178] As is always the case when images are used to make palpable the authority or power of the person portrayed, the role legally assigned to the imperial portrait, particularly in connection with the right of asylum, fell little short of magic. There is at least one instance of a miracle ascribed to an imperial statue, a story told by Joshua the Stylite as having taken place at Edessa in the year 496: After the population of the city had celebrated the end of a drought with an outburst of frolics unworthy of Christians, divine disapproval was expressed through the intermediary of a statue of the Emperor Constantine, which for a period of three days let go of the cross it held in its hand.[179] Time and place are suggestive; less than half a century later the same city was said to have been the scene of a spectacular miracle operated by an image of Christ.

Belief in the magic power of images — this should be stressed once more — was never far from the surface in the Greek world. The court was not a prime mover in the matter. We have already seen that throughout the critical period private practice was ahead of official practice. But the least one must

[173] *Reallexikon fuer Antike und Christentum,* edited by Th. Klauser, fasc. 6 (Leipzig, 1943) col. 839 f. (s.v. *Asylrecht*).

[174] *Cod. Theod.,* 9, 44, 1.

[175] *Cod. Iust.,* I, 25, 1. *Dig.* 47, 10, 38; 48, 19, 28, 7.

[176] Treatise ascribed to Vrt'anes K'ert'ogh (Der Nersessian, *op. cit.,* 60); John of Damascus, *Sacra Parallela* (*PG* 96, col. 17 A).

[177] Cf. the passage from Severianus of Gabala referred to above, n. 170; also a quotation from Anastasius, Patriarch of Antioch in the late sixth century, cited by John of Damascus (*PG* 94, cols. 1316 CD, 1412 B) and at the Council of 787 (Mansi XIII, col. 56 E). The same thought occurs in Jewish and Early Christian literature as an explanation of the origin of idolatry; cf. E. Bevan, *Holy Images* (London, 1940) 68 f.

[178] Cf. Alfoeldi, *op. cit.* (above, n. 18) 70 f.

[179] P. Martin, *Chronique de Josué le Stylite écrite vers l'an 515* (Leipzig, 1876) p. XXVI; Dobschuetz, *op. cit.,* 177*.

admit is that when the vogue of image worship surged up in the Eastern Church with unprecedented force in the second half of the sixth century the emperors made no attempt to check what was in effect an infringement of a domain of ritual hitherto reserved to them. The fact that the religious image was growing into a role analogous to the traditional role of the imperial portrait did not escape the notice of contemporaries. A most interesting illustration of this is the previously mentioned account of a series of ceremonial processions in the years between 554 and 560, in which a copy of the image of Camuliana was paraded through various cities. The anonymous Syriac chronicler, who finished his work in 569, described these processions in terms of an emperor's *adventus* and interpreted them as a symbol of Christ's Second Advent.[180] It seems that at one point he even referred to the image of Christ as a λαυρᾶτον, which is a technical term for the portrait of the ruler.[180a] Not very much later, writers began to defend the worship of images of Christ and the Virgin — and to denounce lack of respect towards such images — by arguing *a fortiori* from the laws and customs governing the worship of the portrait of the basileus.[181] The argument was to be repeated more than once in the course of the Iconoclastic controversy,[182] when it was supplemented by other statements implying or defining connections between the cults of

[180] See above, pp. 99 f.

[180a] The word in question was read as a Syriac form of the Greek λαυρᾶτον by Hamilton and Brooks, *op. cit.* (above, n. 51), p. 321 and n. 10. Other editors of the text have interpreted the word differently — Noeldeke, whose version was used by Dobschuetz, *op. cit.*, p. 7**, n. 3, read ἑορτή (with a question mark), while Ahrens and Krueger, *op. cit.* (above, n. 51), 248, 393, proposed ὁρατής — , but the reading of Hamilton and Brooks seems to be the most acceptable. Mr. C. Moss of the Department of Oriental Manuscripts of the British Museum, who was kind enough to look up the original text in Add. Ms. 17202, informs me that palaeographically the disputed word presents no difficulty. The question is merely whether the letter *lamed* at the beginning is part of the root or whether it is a preposition. Since the word is coordinated with the immediately preceding one, which is without a preposition, Mr. Moss concludes that the *lamed* is likely to be part of the root and he therefore is inclined to accept Brooks' reading. I am most grateful to Mr. Moss for giving me the benefit of his expert knowledge in this matter. For λαυρᾶτον as a term for the image of the ruler see Kruse, *op. cit.*, 47 ff.

[181] St. Symeon the Younger, *Letter to Justin II* (Mansi, XIII, col. 161 AB; see also below, p. 130). Treatise ascribed to Vrt'anes K'ert'ogh (Der Nersessian, *op. cit.*, 61); this writer makes his point in the form of a quotation from Severianus of Gabala. But John of Damascus' fuller version of this passage (*PG* 94, col. 1408 f.) makes it clear that Severianus had spoken of the honor paid to the imperial image as a precedent not for the worship of images of Christ but for the worship of the cross. The passage lent itself to such misuse because Severianus, for the purpose of his analogy, had described the cross as ἀθανάτου βασιλέως εἰκών. It is one of the numerous instances of a literal use being made by defenders of image worship in the seventh and eighth centuries of patristic passages in which the term εἰκών had been intended figuratively.

[182] Cf. John of Damascus' use of the passage from Severianus (see preceding footnote), and his own direct statement to the same effect (*PG* 94, col. 1357 AB). Cf. also Nicephoros (*PG* 100, col. 485 AB).

religious and imperial images.[183] One of the most interesting statements of this kind occurs in a previously quoted, but, unfortunately, not precisely datable, sermon by a Coptic preacher, who bases the argumentation *a fortiori* specifically on the protective power of the imperial image: "For if the image of the Emperor of this world, when painted and set up in the midst of the marketplace, becoming a protection to the whole city, and if violence is committed against any one, and he goeth and taketh hold of the image of the Emperor: *then* no man will be able to oppose him, even though the Emperor is *naught but* a mortal man; and he is taken to a court of law. Let us, therefore, my beloved, honor the eikon of our Lady the veritable Queen, the holy Theotokos Mary . . . etc." [184]

We conclude that the position and function which religious images were acquiring in the second half of the sixth century, were understood from the outset — and, as time went on, increasingly — to be analogous to those enjoyed all along by the imperial image. This course of events would have been impossible without the acquiescence of the emperors themselves. Indeed, it must have had their active support. There is perhaps a slight indication of this already in the Syriac chronicle of 569, when it is said that the processions in which Christ's image was "royally" paraded were organized by the priests on the advice of somebody in the entourage of the Emperor Justinian himself.[185] According to the chronicler this happened in the year 554, the twenty-seventh of Justinian's reign. Thus, if we take the story at face value, official encouragement of an "imperial" ritual involving an icon of Christ must have been forthcoming already during that Emperor's final years. In the time of his immediate successors the evidence becomes unmistakable. Whether the image of Camuliana was brought to Constantinople under imperial auspices we cannot say. Cedrenus, our only authority for this *translatio*, simply says the image "came" from Cappadocia in the seventh year of the reign of Justin II.[186] But it certainly acquired an official status and function very soon. It was in this period that the Byzantine rulers and local authorities began to make public and official use in civic and military contexts of the protective and salutary properties of religious images which private devotion had ascribed to them for some time.[187] In view of the monopoly previously enjoyed in these contexts by the imperial image the development must be described as a voluntary surrender of a privilege on the

[183] P. Lucas Koch, "Christusbild-Kaiserbild," *Benediktinische Monatsschrift* (1939) 85 ff.; especially 88 ff., 103 f.

[184] Worrell, *op. cit.* (above, n. 45), 375.

[185] For references see above, n. 51.

[186] See above, n. 125.

[187] See above, pp. 109 ff.

part of the monarch. In the army the only images previously employed in Christian times in the manner of palladia were the imperial busts on the labarum and other military standards.[188] The image of Christ on the gate of the Chalke, if indeed it was first put up in this period,[189] took the place of the image of the Emperor Constantine previously placed over the entrance to the palace, according to the *Vita Constantini*.[190] Probably it was Tiberius II (578–82) who first placed his own throne in a position of palpable sub-ordination to that of Christ by having an image of the enthroned Savior depicted in the apse of the Chrysotriklinium.[191] Tiberius II was also the first emperor to renounce the representation of his own enthroned image on coins — a type which had been in use under most of his predecessors — and this "majestas" representation suffered an almost complete eclipse from this time on until it was revived by the Iconoclasts.[192] But the most striking evidence of a new spirit was to come towards the end of the seventh century, when Justinian II revolutionized Byzantine coinage by placing on his coins an image of Christ. The legend *"Rex Regnantium"* makes it clear that Christ is proclaimed here not merely as ruler in general but specifically as the ruler of those who rule on earth. Justinian II made his point even more explicit in those issues which bear on the opposite side his own full length figure (standing, to demonstrate his reverence before the Higher Ruler) with the inscription *"Servus Christi."* The emperor emphasizes before all the world his subordinate position in relation to Christ.[193]

A new mood, a new attitude, seems to have obtained among at least some of these rulers of the late sixth and seventh centuries. There is an at-mosphere of pietism which one may sense in the biography of a monarch such as Justin II,[194] and which contrasts sharply with the self-confident auto-cratic pose of the Great Justinian. It is from such premises that the emperors'

[188] Kruse, *op. cit.*, 64 ff.

[189] See above, n. 63.

[190] Book III, 3 (*Die griechischen christlichen Schriftsteller, VII: Eusebius Werke, I*, edited by I. A. Heikel [Leipzig, 1902] 78).

[191] We know of this image only from post-Iconoclastic sources, which refer to a new decora-tion of the room by Michael III, but one of these sources says explicitly that "Christ pictured *again* shines above the imperial throne" (*Greek Anthology*, I, 106; Loeb ed., I, 46). Since the room received its first decoration under Tiberius II (Leo Grammaticus, *Chronographia*, Bonn ed., 137 f.) it is not unreasonable to assume that this decoration already comprised an image of Christ in the apse. Cf. S. Der Nersessian, "Le décor des eglises du IXe siècle," in *Actes du VIe Congrès International d'Etudes Byzantines*, II (Paris, 1951) 315 ff., especially 320.

[192] Grabar, *op. cit.* (above, n. 172), 24 f.

[193] Cf. especially "Type 2" in W. Wroth, *Catalogue of the Imperial Byzantine Coins in the British Museum*, II (London, 1908) 331 ff. and pl. XXXVIII, nos. 15, 16, 20, 21, 24; pl. XXXIX, no. 3. Grabar, *op. cit.*, 164 ff.

[194] Cf. particularly Cedrenus, Bonn ed., I, 680 ff.

conscious policy of boosting an official cult of religious images at the expense of their own previous monopoly seems to have sprung.[195]

When one tries to fathom the reasons for this change of mood in the Empire one is reduced largely to speculations. We have already mentioned the eschatological expectations which may have been attendant upon the end of the first paschal cycle in 562.[196] Prof. Grabar, who was the first to assemble the numismatic and related evidence indicating a profound spiritual change about that time, has suggested other and more durable and powerful factors, which may have exerted an influence more specifically upon the imperial administration itself and may have transformed its concepts of its own role and function.[197] This was, after all, the period of the great retrenchment during which the Emperor ceased to be *de facto* master of the *oikumene*. Was it not perhaps natural that under these circumstances the theme of universal power, which lay at the very center of Byzantine political thinking from first to last, should be embodied less frequently and palpably in the person of the earthly ruler, to be re-emphasized all the more strongly on a level where it was not dependent on the vagaries of military and diplomatic fortunes? Of course, imperial power in Byzantium had from the very beginning been conceived as derived from Heaven. The emperor was the Vicar of Christ, his earthly representative. It could not be maintained for a moment that this was a new concept in the late sixth century. What may be

[195] Perhaps this meant an altogether more abundant use of religious representations than Justinian — for whatever reason — had been willing to provide for his churches. One should certainly examine in the light of what has been said above the statement which Theophanes placed at the very beginning of his account of Justin II and his reign: "Being a pious man he adorned the churches built by Justinian; the Great Church that of the Apostles, and other churches and monasteries" (Bonn ed., I, 373). This sounds like a change of policy rather than like a simple completion of a task left unfinished by his predecessor, as Heisenberg suggested ("Die alten Mosaiken der Apostelkirche und der Hagia Sophia," in Ξένια, *Hommage international à l'Université Nationale de Grèce à l'occasion du soixante-quinzième anniversaire de sa fondation* [Athens, 1912] 121 ff., especially 140, 145). It is true that Theophanes does not explicitly speak of figure representations, but at least in the case of St. Sophia we know that there had been such representations prior to the Iconoclastic period, since the post-Iconoclastic emperors described their work as a renewal (S. G. Mercati, "Sulle iscrizioni di Santa Sofia," *Bessarione*, XXVI [1922] 200 ff., especially 204 f.). As in the case of the Chrysotriklinium (above, n. 191) it is reasonable to ascribe the original work to a ruler who is actually recorded as having provided decoration for the building. Thus a case can be made for Justin II without utilizing the poem of Corippus and other somewhat ambiguous texts adduced by Heisenberg. But the problem of the first figure decorations of St. Sophia and of the Church of the Holy Apostles is very complex and cannot be solved merely by means of a reference to a general trend of enthusiastic and aggressive "iconophilia" under Justinian's successors. Cf. also Der Nersessian, *loc. cit.* (above, n. 191).

[196] See above, p. 100 and n. 54.

[197] *L'empereur*, 163 ff. For an excellent summary of the general significance of this period, which inaugurated what may be properly called the medieval phase of Byzantine history, see G. Ostrogorsky, *Geschichte des byzantinischen Staates*, 2nd ed. (Munich, 1952) 65 ff.

suggested, however, is that there was perhaps within this concept, which implied both supreme power on earth and subordination to a still higher power in Heaven, a subtle change of emphasis from the former to the latter. Granted even that there was a shift of this kind, it could not have produced by itself the vogue of worship of religious images with which we are dealing. But it may well have been a reason for official encouragement of this trend.

Considerations of this order were introduced by Prof. Grabar in order to explain, not the increased devotion to religious images in the late sixth century, but their subsequent radical elimination by the Iconoclastic emperors. He suggested, in fact, — and the idea was then elaborated by L. Koch and G. Ladner — that the outbreak of Iconoclasm was in essence a re-assertion of imperial power and an affirmation of its absolute superiority vis-à-vis the Church.[198] This explanation of Byzantine Iconoclasm perhaps had a particular appeal for scholars living and working under the impact of European experiences in the years before the Second World War, just as earlier interpretations of that highly complex and many-faceted movement were influenced by contemporary events.[199] But it certainly has thrown into high relief an essential aspect of Iconoclasm. Though the emperors of that era did not cease to consider themselves as vicegerents of Christ, and carried out their policies in that capacity, they did emphasize with new vigor the absolute power of the monarch on earth, witness the various manifestations of absolutism in the imperial iconography of that period.[200] The thesis outlined in the foregoing pages is a logical complement to that of Prof. Grabar, and, indeed, its almost indispensable presupposition. If re-assertion of the absoluteness of the monarch's authority on earth did figure as a central issue in Iconoclasm it could do so only because the emperors of the preceding era had promoted the worship of religious images as a means of emphasizing their own subordination to a transcendental power. Though considerations of this nature may not have been prime movers in the matter either in the eighth century or in the sixth, they may have served both times to encourage the emperor to give focus and direction to strong existing trends.[201]

[198] Grabar, *L'empereur*, 169 f. P. Lucas Koch, *op. cit.* (above, n. 183). G. B. Ladner, "Origin and Significance of the Byzantine Iconoclastic Controversy," *Mediaeval Studies* (published by the Pontifical Institute of Mediaeval Studies, Toronto), II (1940) 127 ff., especially 133 ff.

[199] Cf. Ladner's references (*op. cit.*, 133, 136) to "anachronistic" interpretations of Byzantine Iconoclasm in terms of nineteenth century rationalism and sixteenth century protestantism, and his own allusions (*ibid.*, 138, 140) to contemporary events.

[200] Grabar, *op. cit.*, 166 ff.

[201] For a criticism of this approach to Iconoclasm, particularly with reference to Prof. Ladner's paper, see M. V. Anastos, "Church and State during the First Iconoclastic Contro-

IV. OPPOSITION

Throughout the Early Christian and early Byzantine period moves in the direction of image worship always engendered opposition. The vogue which we have been studying, unprecedented in scope and intensity, also produced resistance on an unprecedented scale.

The full reaction came with the Iconoclastic crisis of the eighth century. The two movements are interrelated not only in the exalted but crucial sphere of imperial policy, which has just been referred to, but also on the humbler level which provided the fuel for the official campaigns. The Isaurian emperors could not have made of the religious icon a central issue but for the vastly increased practice of image worship in the preceding generations and the opposition this development had provoked, if only in certain specified quarters.

The Iconoclastic movement itself, and the elaborate theoretical defense of image worship which resulted from it, are outside the scope of this paper. But both opposition and defense were aroused long before the issue was joined in the reign of Leo III. Compared with the great explosion which ensued these were little more than preliminary rumblings. But, sporadic as it was, the existence of such opposition is much more in evidence in the latter half of the sixth and in the seventh century than during the preceding period, and thus provides a measure of the increased importance the icon had acquired.

Demonstrations of hostility may be divided into two categories: Those that came from within the fold and those for which non-Christians were responsible. The latter constitute an altogether new phenomenon not recorded in any source prior to the second half of the sixth century. We have already mentioned the miracle stories of the post-Justinianic era which describe attacks on, or desecrations of, sacred images by infidels, particularly Saracens or, more frequently, Jews.[202] Since at precisely this period defense of

versy," to be published in *Ricerche Religiose*. By stressing the legitimacy of Byzantine absolutism Prof. Anastos, who kindly permitted me to read his study in manuscript, does not in effect rule out the possibility of temporary changes of emphasis *within* the concept of the emperor as a vicegerent of Christ, as proposed above. While writing this chapter I received word from Prof. Grabar, to whom I had submitted some of the main results of the present study in a letter, that he is at present working on exactly similar lines, in preparation of a monograph on Iconoclasm. Though he still maintains the derivation of the worship of religious images from the cult of relics, as he did in *Martyrium*, he, too, now attaches great importance to the precedent which the toleration of the cult of the ruler portrait by the Church had created, and to the voluntary action of Justinian's successors, who actively promoted the worship of images of Christ and the saints.

[202] See above, pp. 101 f. In the texts referred to in nn. 60 and 61 the attackers are described as infidels. The story of Anastasius Sinaita (n. 59) concerns an attack by Saracens. Jews figure in

icon worship also began to play a role in polemical writings against Jews,[203] it is probable that the physical attacks related in the miracle stories are not completely legendary, though terms such as "Jew" or "Infidel" may have been used rather loosely and freely by orthodox writers of edifying tales. Physical aggression may well have been a counterpart to the literary polemics which Jews evidently started at that time.[204] In addition we hear of attacks on Christian images by the Samaritans, witness a passionate, and apparently authentic, letter of St. Symeon the Younger to the Emperor Justin II.[205] There is also some evidence in the literature of this period that the last surviving elements of Graeco-Roman paganism may have been alert enough to realize, and strong enough to exploit, the apparent self-contradiction involved in the new attitude of the Church, an attitude which was in such striking contrast to the Early Christians' denunciation of images and their worship.[206]

Saracens and Samaritans, Jews and pagans can hardly have been out to save Christians from idolatric excesses. Probably in most cases the attacks on images served as a simple and dramatic means of hurting Christians in what had evidently become a vital part of their religious life. In addition — and this applies particularly to literary polemics — opponents of Christianity

the attacks related by Gregory of Tours (n. 58), and Arculf (n. 62), and in the Beirut legend and its Coptic derivative (n. 59).

[203] See below, p. 135.

[204] This raises an interesting and as yet unsolved problem concerning the time when the Jews themselves abandoned figure representations, and their reasons for doing so. According to J. B. Frey ("La question des images chez les Juifs à la lumière des récentes découvertes," *Biblica*, XV [1934] 265 ff., especially 298) the Jews returned to a rigorous interpretation of the law against graven images during the late fifth and the sixth centuries. The chronological limits can be narrowed down somewhat — and perhaps considerably — on the evidence of a group of mosaic floors of Palestinian synagogues with representations of animate subjects; cf. M. Avi-Yonah, "Mosaic Pavements in Palestine," *The Quarterly of the Department of Antiquities in Palestine*, II (1933) 136 ff., 163 ff.; III (1934) 26 ff., 49 ff.: No. 22 (Beit Alfa); 69 ('Ein Duk); 86 (El Hammeh); 345 (Esfia; see also *ibid.*, III [1934] 118 ff.). Leaving aside no. 86 (which seems to be unpublished), these mosaics form a coherent group, which, on the strength of the fact that an emperor named Justin is mentioned in one of the inscriptions of the floor at Beit Alfa, must be assigned to the sixth century. Sukenik (*The Ancient Synagogue of Beth Alpha* [Jerusalem and London, 1932] 57 f.) was inclined to identify the emperor of the inscription with Justin I (518–27), but he readily admitted the possibility that Justin II was meant, in which case animate subjects would still have been represented by Jews in the sixties and seventies of the sixth century. Their polemics against Christian idolatry started not long after this time. There was evidently a rather sudden return to rigorism on the part of the Jews. Could this have been caused by the spectacle of vastly increased image worship among the Christians, which the Jews could hope to exploit more effectively for polemic purposes if they themselves could claim to be strict observers of Biblical Law?

[205] *PG* 86 bis, cols. 3215 ff. Mansi, XIII, cols. 160 D–161 E. See Delehaye, *op. cit.* (above, n. 40), p. LXXV.

[206] Baynes, *op. cit.* (above, n. 1), 96. Cf. below, p. 135.

could hardly have failed to take advantage of so vulnerable a spot in order to embarrass the church and, if possible, divide the ranks of the faithful. They put the clergy in a position of having to defend what must have been to many a questionable cause. Baynes has suggested that some of the apologies addressed to Jews were "indirectly intended to meet the scruples of Christians impressed by the Jewish contention."[207] To arouse such scruples must have seemed a promising strategy, the more so since resistance within the Church to the departure from Early Christian ideals of spirituality had never entirely ceased.

It is this internal opposition which is of particular interest and importance. We have already mentioned voices of protest and warning raised as early as the fourth century.[208] In the fifth century there was opposition to religious imagery among the Monophysites. Philoxenos of Mabbug, one of their leaders, objected specifically — and quite logically — to images of Christ, but also to the representation of angels in anthropomorphic form and to renderings of the Holy Ghost in the shape of a dove.[209] Doves representing the Holy Ghost were said also to have attracted the wrath of Severus of Antioch.[210] While this opposition is rooted in heretical doctrine, doubts and scruples also arose among apparently quite orthodox clerics, who were simply worried about the Second Commandment. Such was the case of Julian of Atramytion, a cleric of the first half of the sixth century, who, in literal adherence to the word of Scripture, confined his opposition to sculpture.[211]

[207] *Ibid.*, 103.

[208] See above, pp. 86, 92 f.

[209] Cf. excerpt from the *Ecclesiastical History* of Ioannes Diakrinomenos read at the Council of 787 (Mansi, XIII, cols. 180 E–181 B). For this extract see Pauly-Wissowa, *Real-Encyclopaedie der classischen Altertumswissenschaft*, Zweite Reihe, V (Stuttgart, 1934) col. 1879 f., s.v. *Theodoros Anagnostes*. I owe this reference to Prof. P. J. Alexander, who also drew my attention to the fact that the reference to Philoxenos' iconoclasm in the Chronicle of Theophanes (Bonn ed., I, 207) appears to be inexact. According to Theophanes Philoxenos objected to images of Christ and the *saints*, but this is probably a simple mistake caused by the word ἁγίων being read for ἀγγέλων.

[210] Mansi, XIII, col. 184 A.

[211] See above, p. 94 with n. 33. Why Julian exempts sculptures on doors is difficult to say. Did he mean the main door of the church facing the street, where any abuse could be readily detected? In any case, the distinction made by Julian between paintings and sculpture is of great interest, in view of the preferred position which painting did in fact occupy throughout the history of Early Christian and Byzantine art. Sculpture — and especially sculpture in the round — was the idol *par excellence* against which Christian — and pre-Christian — opposition was directed from the start: Cf. particularly the references to the vileness of the sculptor's materials, which is one of the common-places not only of Early Christian but also of Jewish and pagan polemics against pagan idolatry (for references see J. Geffcken, *Zwei griechische Apologeten* [Leipzig and Berlin, 1907] p. XXI, n. 1 and p. XXVI; *ibid.*, pp. 102, 146, 188 n. 3, 223, for the apologists' use of Herodotus' story of the footbath of Amasis. Cf. also J. Geffcken,

The developments of the second half of the sixth century must have added considerably to this uneasiness and, as Baynes suggests, in all probability the situation was skillfully and successfully exploited by outsiders. Direct evidence of increased opposition within the church as a result of the expansion of the cult of images comes from two widely disparate sources on the periphery of the Byzantine world.[212] By the end of the century the wave of idolatric worship had reached the West in sufficient strength to induce Bishop Serenus of Marseilles to destroy or remove the images which he saw being adored in his churches. His action called forth a rebuke from Pope Gregory, who clearly felt that the time had come to clarify once and for all the position of the Roman Church in the matter of religious images. The two letters he addressed to the Bishop of Marseilles [213] became indeed classical expressions of the Western attitude, opposed alike to complete elimination of images and to their worship.

It is striking that at exactly the same time iconoclastic troubles broke out at the other extreme of the Byzantine Empire. In the last decade of the sixth century, some rebellious priests in Armenia started to preach the destruction of images. We have their opponents' testimony to the effect that they found a large following. The issue was bound up with complicated political and religious conflicts which divided Armenia at that time. It flared

"Der Bilderstreit des heidnischen Altertums," in *Archiv fuer Religionswissenschaft*, XIX [1916–19] 286 ff., especially 288 f.). For rabbinical writers objecting specifically to images in the round see Bevan, *Holy Images*, 53 f. On the other hand, when opposition to *Christian* art first became articulate it was directed exclusively against painting: Cf. Council of Elvira (above, n. 6); Eusebius' letter to the Empress Constantia (above, nn. 6, 28; see especially *PG* 20, col. 1545 C); Augustine (above, n. 25). The fragments ascribed to Epiphanius also show a constant and consistent preoccupation with painting; cf. Ostrogorsky, *op. cit.* (above, n. 28), pp. 67 ff., nos. 3, 5, 6, 14, 15, 17, 22, 23, 24, 25, 27, 31 or Holl, *op. cit.* (above, n. 27), pp. 356 ff., nos. 1, 5, 12, 14, 21, 22, 23, 24, 25, 26, 29, 30, 34. The reason was surely not that sculpture was considered more admissible, but, on the contrary, that it was altogether beyond the pale (cf. Holl, *op. cit.*, p. 377 and n. 5, and Bevan, *op. cit.*, 51 ff., with quotations from Epiphanius). Julian, in limiting his opposition to sculpture, was decidedly a moderate, and, in a sense, his attack was actually a shield for a defense of painted imagery. In the second half of the sixth century more radical opponents of religious images were to resume the attack on painting. They even adapted the old argument concerning the vileness of the sculptor's material so as to make it applicable to the painter's pigments: Cf. Der Nersessian, *op. cit.* (above, n. 1), 68, 76.

[212] Ch. Diehl seems to have been the first to add to the two examples of sixth century iconoclasm which are about to be quoted a "veritable rebellion" against images at Antioch (*Manuel d'art byzantin* [Paris, 1910] 335; the same statement in the second edition, I [1925] 361). This rebellion has since acquired all the rights of an authenticated event in standard literature. Could it be an exaggerated reference to the raid by some infidels on an image of St. Symeon the Younger, which took place at Antioch according to the Saint's Life (above, n. 60)?

[213] *PL* 77, cols. 1027 f., 1128 f.

up once more in Caucasian Albania in the eighties of the seventh century.[214] Armenian Paulicianism, which also made its appearance about this time, was likewise opposed to images.[215]

There is, then, no century between the fourth and the eighth in which there is not some evidence of opposition to images even within the Church. The fact that opposition was at least latently present throughout this period is of great interest to the art historian. Not only during the earliest phase of Christian art, but even in the time of its apparently unrestricted expansion artists and their patrons had to reckon with potential hostility. The fact should be borne in mind when analyzing the religious imagery of this period.

The precise motivation of the opposition in each particular instance is not easy to determine. Originally, as we have seen, the issue was one of spirituality of worship, adherence to Old Testament law, and revulsion against the cult practices of the pagan masses. The stand taken by such men as Julian of Atramytion and Serenus of Marseilles in the sixth century seems to have been inspired by these considerations, and indicates an at least sporadic persistence of the original ideal. Already in the fourth century, however, theological arguments were injected into the discussion, arguments which had to do with the divine nature in Christ and the consequent impossibility to depict His likeness.[216] The selective iconoclasm of some of the monophysite leaders was clearly inspired by their theological, and particularly christological, views. Matters of doctrine may also have played a part in the opposition to images in Armenia. But asked in so many words why they would not accept the image of God Incarnate, the Armenian iconoclasts replied that images were foreign to the Commandments and that the worship of images was not prescribed in Holy Scripture.[217] They thus took their explicit stand on disciplinary rather than theological grounds. Their opponents in turn tried to convert them by quoting precedents, particularly from the Old Testament and from the writings of the Fathers, rather than through theological reasoning.[218] It was only in the course of the Iconoclastic controversy of the eighth century that the opposition to images was based firmly on doctrinal arguments.

[214] Der Nersessian, *op. cit.*, 70 ff. Prof. P. J. Alexander is preparing a paper on the political aspects of the conflict. The paper is to be published in a volume of studies in honor of Prof. A. M. Friend, Jr.

[215] Der Nersessian, *op. cit.*, 73 f.

[216] See above, nn. 28, 30 (Eusebius, Epiphanius).

[217] Der Nersessian, *op. cit.*, 72. Cf. *ibid.*, pp. 85 ff., n. 131, on the question of the sectarian affiliations of these iconoclasts.

[218] *Ibid.*, 58 ff., 72, 78.

The instances of effective opposition prior to the outbreak of the controversy are admittedly sporadic and, compared with the virulent attack that was to follow, relatively insignificant. It is perhaps surprising that after the great upsurge of icon worship in the late sixth century these hostile elements did not crystallize more swiftly, and that a really concentrated reaction did not take place until a century and a half later. We have already mentioned the role which imperial policy may have played in promoting and shielding the cult. That it was an imperial decision which finally reversed the trend is an established fact. It may well be that without such a decision the opposition would never have gained enough strength and impetus to become effective on a large scale. Why the reversal of the imperial position took place at that particular moment in history is a problem beyond the scope of the present study. One motivation that may have been of some importance has been mentioned above, when we spoke of an inclination to re-assert the absolute nature of imperial authority on earth.[219] It is doubtful, however, whether the adoption of iconoclasm as an official Byzantine policy in the third decade of the eighth century can be explained adequately without a push from outside. In this connection the famous Edict of Yezid certainly deserves close scrutiny. As described by John the Monk at the Council of 787, it does not sound like a crude anti-Christian demonstration, but like a shrewdly devised apple of discord which combined the drastic character of earlier physical attacks on images by non-Christians with the embarrassing effect of their literary polemics. For according to John it was a general measure directed against all representations of animate subjects, including those in purely secular contexts, and therefore it could not readily be dismissed as a simple act of hostility against the Christian religion.[220] It is quite possible, then, that this edict was peculiarly effective in arousing latent opposition among the Christians themselves in a way in which the frontal attacks previously made by outsiders had not done.

V. DEFENSE

Throughout the centuries defense of religious images was conditioned by attacks. It was in response to the iconoclastic onslaughts of the eighth and early ninth centuries that a definitive theory of religious images and their cult was worked out. But just as the massive attacks of that period had their antecedents in earlier centuries so had the defense. The intensity of the

[219] See above, p. 128.

[220] Mansi, XIII, cols. 197 A–200 B. In Creswell's translation (*Ars Islamica*, XI–XII [1946] 164) an important sentence (Mansi, XIII, col. 197 DE) is omitted. A new study of the Edict of Yezid was being prepared by Prof. A. A. Vasiliev during the last months of his life.

latter increased in the late sixth century, along with — and plainly as a result of — the acceleration and intensification of the former.

There was no really systematic attempt to establish a Christian theory of images prior to the sixth century.[220a] The frequently quoted remarks on the subject by authors such as Basil, Gregory of Nyssa and Nilus were incidental to their descriptions or rhetorical praises of specific images or decorations.[221] They were not full-fledged apologies. The earliest known text which is dedicated entirely to this problem and attempts to deal with specific criticisms and objections is a letter written by Bishop Hypatius of Ephesos to his suffragan, Julian of Atramytion, in the first half of the sixth century.[222] It was followed in the late sixth and seventh centuries by apologies addressed to Jews,[223] to pagans (or, at least, answering arguments such as pagans might have used),[224] and to Christian heretics.[225] As we have seen, this period also witnessed the emergence of legends and stories involving images, many of which were undoubtedly written and propagated for apologetic purposes. In some miracle stories there is definite evidence that the writer was familiar with current defensive theory and used it, if not as a basis for his tale, at least to point up its moral. Such passages form a definite and important part of the body of theoretical writings on images during this period. Over and above such abstract statements the very plots of some of the stories are admirably poignant illustrations of certain theoretical concepts which were then in the making. These parallels should at least be pointed out, even in cases where it cannot be decided whether the story was invented and written with apologetic intent or was a spontaneous expression of intensified beliefs.

In analyzing the "case for the defense" the arguments based on biblical or historical precedent may be left aside. They are of minor interest compared with those which reveal the writer's own attitude towards, and thoughts about, religious images. What we chiefly wish to know is whether

[220a] I am concerned only with statements which have to do with actual images. For the "image" as a theoretical concept in patristic literature see G. B. Ladner, "The Concept of the Image in the Greek Fathers and the Byzantine Iconoclastic Controversy," *Dumbarton Oaks Papers*, VII (1953) 1–34. Prof. Ladner traces the influence of this concept on the defense of religious images during Iconoclasm and touches only incidentally upon the defense of actual Christian images in pre-Iconoclastic times, which alone interests us here.

[221] See above, n. 7.

[222] See above, p. 94 with n. 33, p. 131 with n. 211, and below, p. 138.

[223] By Leontius of Neapolis (see below, pp. 140 f.) and others; cf. Der Nersessian, *op. cit.*, 79 ff. and Baynes, *op. cit.*, 97 ff.; *ibid.*, 103, the suggestion that some of these were really intended for the benefit of Christians.

[224] Der Nersessian, *op. cit.*, 82 (John of Salonika; homily ascribed to St. Symeon the Younger; Constantine Chartophylax). Cf. Baynes, *op. cit.*, 95 f.

[225] Treatise ascribed to Vrt'anes K'ert'ogh (Der Nersessian, *op. cit.*, 58 ff.).

the literary pronouncements made in defense of images during the period between Justinian I and Iconoclasm reflect in any way the profound changes in the function of religious imagery which took place at that time. Even though a systematic iconosophy was not evolved until later we may expect to find in the literature of this period signs of awareness of these changes and attempts to provide them with a theoretical foundation.

It may be well to anticipate one general conclusion to which this inquiry leads: The new functions of religious images have a theoretical counterpart in a number of attempts to justify such images not through their usefulness to, or meaning for, the beholder, but through their inner relationship to their prototypes. In a sense this result seems paradoxical. We have seen that the period under discussion witnessed a vast increase in the day-to-day use of icons. Image and beholder were brought into a closer and more intimate contact than ever before in Christian times. Yet it was not so much this relationship which the apologists attempted to defend and explore. On the contrary, they tried to lift the icon out of the sphere of human needs and demands altogether and to anchor it securely in a transcendental relationship to the Godhead. In actual fact this was, of course, the surest way to motivate and justify the increasing intensity of ritual practice.

In order to appreciate the new departure made by the defenders of Christian images it is necessary to cast a brief glance on the development of apologetic thought during the preceding centuries. The original Christian defense of the visual arts, initiated by the Cappadocian Fathers in the second half of the fourth century, was based on their usefulness as educational tools. Imagery was γραφὴ σιωπῶσα,[226] a means of instruction or edification, especially for the illiterate.[227] The stress may be either on intellectual nourishment[228] or on moral education.[229] It was on these purely pragmatic lines that Pope Gregory the Great was to take his stand two hundred years later in his letters to Bishop Serenus of Marseilles.[230] In the East it soon proved impossible to confine apologetic thought within such narrow limits. But although the functions assigned to the image became increasingly weighty, up to and including the era of Justinian, they were always defined in terms of what the image could do for the beholder.

[226] Gregory of Nyssa, *Oratio laudatoria Sancti ac Magni Martyris Theodori* (PG 46, col. 757 D). Cf. also a similar expression used by a North African writer of the early fifth century (above, n. 25).

[227] The same argument had been used before by apologists of pagan image worship; cf. Ch. Clerc, *Les théories relatives au culte des images chez les auteurs grecs du IIme siècle après J.-C.* (Paris, 1915) 234.

[228] Elliger, *op. cit.* (above, n. 5), 85 f. (Paulinus of Nola).

[229] *Ibid.*, 61 f. (Basil), 65 (Gregory of Nyssa), 77 f. (Nilus).

[230] See above, n. 213.

Perhaps the first departure from the purely didactic argument may be found in Gregory of Nyssa, who speaks of a picture of the Sacrifice of Isaac as a source of a deep emotional experience.[231] A more decisive step forward was taken when contemplation of an image was claimed not merely to benefit a beholder's religious education or stimulate his emotion, but to constitute some sort of channel enabling him to approach the Deity. This line of reasoning, in which the image becomes a means of visualizing the invisible or of conveying to it love or respect, had been elaborated in various forms by apologists of pagan image worship.[232] It was, as we have seen, a standard concept for defining the role of the ruler portrait, and in that sphere it was adopted by Christian writers as early as the fourth century.[233] In the first half of the fifth century it was applied to a religious image by Philostorgius. We have spoken previously of his account of the statue of Christ at Paneas, in which he describes what he considers the proper demeanor in front of a religious image.[234] The apologetic nature of his remarks is self-evident. He writes with an eye on critics inside or outside the Church when he deprecates all thought of worship or *proskynesis*, "since it is not permitted to prostrate oneself before bronze or other matter." Nevertheless he sees in a joyful approach and gaze on the image a way of demonstrating one's love for its archetype.[235] It is a somewhat colorless formula worked out at a time when practice was already going well beyond what Philostorgius considered proper boundaries.

The idea that the image may serve the faithful as a channel of communication with the Deity received a powerful impetus toward the end of the fifth century through the anagogical concepts introduced into Christian thought by Pseudo-Dionysius. These concepts formed part of that great Neoplatonic mystic's interpretation of the physical and intelligible worlds as superimposed hierarchies. "The essences and orders which are above us . . . are incorporeal and their hierarchy is of the intellect and transcends our world. Our human hierarchy, on the contrary, we see filled with the multiplicity of visible symbols, through which we are led up hierarchically and according to our capacity to the unified deification, to God and divine virtue. They, as is meet to them, comprehend as pure intellects. We, however, are led up, as far as possible, through visible images to contemplation of the

[231] *Oratio de deitate filii et spiritus sancti* (PG 46, col. 572 C).

[232] Clerc, *op. cit.*, 95 (Plato), 206 ff. (Dio Chrysostom), 255 (Olympiodorus); Geffcken, "Der Bilderstreit . . ." (above, n. 211), 306 (Porphyry).

[233] See above, p. 91.

[234] See above, p. 92 with n. 24.

[235] Bidez, *op. cit.* (above, n. 23), 78.

divine."[236] To Pseudo-Dionysius the entire world of the senses in all its variety reflects the world of the spirit. Contemplation of the former serves as a means to elevate ourselves toward the latter. He does not elaborate his theory specifically in the realm of art, but its special applicability in that field was obvious and enhanced further by his frequent references to the objects which make up the world of the senses as εἰκόνες. Small wonder, then, that Areopagitic concepts and terms were promptly seized upon by clerics anxious to provide a theoretical foundation for the increasingly conspicuous role accorded to images in the life of the Church. It is as the earliest known document testifying to this step that the letter written by Bishop Hypatius of Ephesos to Julian of Atramytion has its peculiar and outstanding importance.[237] The Bishop brushes aside his suffragan's legalistic distinctions between painting and sculpture and stresses the necessity of probing more deeply into the reasons for the Scriptural prohibitions. The defense of images which Hypatius works out is essentially a traditional one, namely, that images are useful for the religious education of simple and uneducated people. But the simple and uneducated now have become part of a hierarchic system, and the tools provided for them have a legitimate place, indeed, an important function in the divine order of things: "We leave material adornment in the churches . . . because we conceive that each order of the faithful is guided and led up to the Divine in its own way and that some are led even by these [i.e. the material decorations] toward the intelligible beauty and from the abundant light in the sanctuaries to the intelligible and immaterial light."[238] This is unmistakably the thought and, indeed, the very language of Pseudo-Dionysius,[239] language which the Bishop applies to the concrete problem of the admissibility of images in churches.[240] Written within little more than a generation of the appearance of the Areopagitica, Hypatius' letter shows how rapidly the concepts and terms of the theology of Pseudo-Dionysius were taken up by the defenders of Christian images.[241] The anagogical function of images is stressed also in

[236] *De ecclesiastica hierarchia*, I, 2 (*PG* 3, col. 373 AB).

[237] See above, p. 94 with n. 33, p. 131 with n. 211.

[238] . . . κόσμον ὑλικὸν ἐῶμεν ἐπὶ τῶν ἱερῶν . . . ὡς ἑκάστην τῶν πιστῶν τάξιν οἰκείως ἑαυτῇ χειραγωγεῖσθαι καὶ πρὸς τὸ θεῖον ἀνάγεσθαι συγχοροῦντες, ὥς τινων καὶ ἀπὸ τούτων ἐπὶ τὴν νοητὴν εὐπρέπειαν χειραγωγουμένων καὶ ἀπὸ τοῦ κατὰ τὰ ἱερὰ πολλοῦ φωτὸς ἐπὶ τὸ νοητὸν καὶ ἄυλον φῶς (Diekamp, *op. cit.* — above, n. 33 – , p. 128).

[239] *De coelesti hierarchia*, I, 3 (*PG* 3, col. 121 CD).

[240] Hypatius, like his correspondent, is mainly concerned with justifying the *existence* of images in churches (see above, n. 33). He leaves open the question of the faithful's proper demeanor. An approval of the *worship* of images can be read into his remarks only by the most stringent interpretation: Alexander, *op. cit.* (above, n. 33), pp. 181, n. 39; 182.

[241] On the dates of Hypatius see Diekamp, *op. cit.*, 109 ff.

an epigram on a picture of an archangel by Agathias (d. A.D. 582) and in a closely related epigram by Nilus Scholasticus. The markedly defensive tone of these verses is perhaps due to the fact that the representation of angels had long been a particular target of the opponents of Christian images.[242]

The apologetic statements encountered so far all have to do with the effects of images on the beholder and their usefulness to him. Many of these arguments occur again in the apologies of the post-Justinianic era. Especially the contention that images serve to convey our respects to the Deity, or to lead us up from the visible to the invisible, can be found again and again.[243] But in addition the apologists of the late sixth and seventh centuries began to use a number of arguments in which the beholder does not figure at all, and which are concerned solely with the establishment of a timeless and cosmic relationship between the image and its prototype. The role of the onlooker was reduced. Ways were sought to justify the icon as such, irrespective of personal and momentary experience, and to find its true meaning in its objective existence. It was lifted out of the pragmatic sphere of tools and utensils (however sacred) and was given a status of its own in the divine order of the universe.

This vital step was implicit in Areopagitic thought no less than the "anagogical" argument. It is, in fact, the reverse aspect of the latter. Just as, by virtue of the hierarchic order of the universe, there is an ascent from the lower and sensual to the higher and intellectual sphere and ultimately to God, so, in turn, God is reflected, according to the law of universal harmony and in gradual descent, in the lower orders and ultimately even in the material objects which make up our physical surroundings. It is in their capacity as reflections that such objects may be called εἰκόνες. Plotinus, the Areopagite's spiritual ancestor, had already formulated a defense of the

[242] *Greek Anthology*, I, 33, 34; Loeb ed., I (1916) 20 ff. The date of Nilus is not known. The defensive tone is equally marked in another epigram by Agathias (I, 36). I am much indebted to Prof. Der Nersessian for drawing my attention to these texts. For opposition to representations of angels see some of the fragments ascribed to Epiphanius: Ostrogorsky, *op. cit.* (above, n. 28), pp. 69 f. nos. 8, 9, 13 or Holl, *op. cit.* (above, n. 27), p. 357 f., nos. 4, 7, 11. See also above, p. 131 with n. 209 (Philoxenos).

[243] John of Salonika, who concedes that this was an argument also used by the pagans (Mansi, XIII, col. 164 CD); Leontius of Neapolis, *Sermo contra Iudaeos* (*PG* 93, cols. 1600 C, 1604 C); treatise ascribed to Vrt'anes K'ert'ogh (Der Nersessian, *op. cit.*, 66, 69); cf. also a passage from a sermon ascribed to St. Symeon the Younger (A. Mai, *Patrum Nova Bibliotheca*, VIII, 3 [Rome, 1871] 35 f. = *PG* 86 bis, col. 3220 AB; 94, cols. 1409 C–1412 A; cf. Delehaye, *Les saints stylites*, p. LXXIV f.). This last writer introduces, aside from the relationship of the visible image to its invisible subject, the idea of an at least metaphorical presence of the deity in the icon; for this see below, p. 147.

images of the gods on this basis.[244] But no text of the period prior to the outbreak of Iconoclasm is known in which the concept is used in its specifically Areopagitic form for the defense of actual images. When Christian apologists of the late sixth and seventh centuries began to claim the relationship between image and prototype as a transcendental one the authority on which they drew was Scripture itself.

Man's own relationship to God is that of image and prototype. "God created man in his own image, in the image of God created he him" (Genesis 1:27). Consequently even the image of man is still a reflection of the Deity and may serve to represent It.[245] Since the man-made image is necessarily confined to man's physical appearance, the real problem involved in this argument is to what extent the human form may be claimed to partake of the godlikeness of man. The early Fathers who wrote on the subject of religious images rejected any such thought. They made use of the passage in Genesis only in order to show up the absurdity of the pagan cult image and its worship. The godlikeness of man was claimed as a purely spiritual relationship.[246] It would lead us much too far were we to trace the history of the interpretations given to Genesis 1:27 by different writers in various contexts between the third and the sixth centuries.[247] Suffice it to say that it is in a text of the late sixth century that we first find the godlikeness of man cited in defense of Christian religious images. Nothing points up more dramatically the change which the attitude of the Church towards art had undergone in the course of time than the fact that Genesis 1:27 came to be used in a sense exactly opposite to that found in the early Fathers. In his Sermon against the Jews Leontius of Neapolis defends Christian images with a number of

[244] *Enn.*, IV, iii, 11 (*Plotini Enneades*, ed. by R. Volkmann, II [Leipzig, 1884] 23). Cf. Clerc, *op. cit.*, 252; Geffcken, "Der Bilderstreit . . ." (above, n. 211), 304; Bevan, *Holy Images*, 75 ff.

[245] The argument was not contingent upon the biblical account of Creation. Some of the apologists of pagan cult images had already found a justification for the anthropomorphic representation of the gods in the claim that such representations symbolized man's own likeness to God; cf. Clerc, *op. cit.*, 206, 212 (Dio Chrysostom), 220 ff. (Chrysippos), 235 (Maximus of Tyre), 255 (Pagan of Macarius). According to Geffcken, *op. cit.*, 295 ff., this line of argument goes back to Poseidonios.

[246] Cf. e.g. Clement of Alexandria, *Cohortatio ad gentes*, 10 (*PG* 8, col. 212 C–213 A); also Minucius Felix in the passage quoted above, p. 89.

[247] See now Ladner, in: *Dumbarton Oaks Papers*, VII, 10 ff. Attention may be drawn to the fact that even Epiphanius, certainly an outspoken opponent of religious images, was not wholly opposed to the idea that man's likeness to God, as proclaimed in Genesis, extends to his body; cf. *Ancoratus*, 55, 4 ff. (K. Holl, *Epiphanius, I = Die griechischen christlichen Schriftsteller*, XXV [Leipzig, 1915] 64 f.): "We do not say that either the body or the soul is not made in the image [*scil.* of God]." While this statement is rooted in his opposition to Origen, his stand in the matter of images was taken on entirely different grounds; see above, n. 30.

conventional arguments (including biblical precedent and the honors paid to images of rulers) and then proceeds: "The image of God is Man, who is made in the image of God, and particularly that man who has received the indwelling of the Holy Ghost. Justly, therefore, I honor and worship the image of God's servants and glorify the house of the Holy Ghost." [248] "God's servants" are the saints. It is they who have received "the indwelling of the Holy Ghost" and therefore they are more especially "images of God." [249] In worshiping their image the faithful glorifies the "house of the Holy Ghost." Granted, then, that what the artist depicts is only a shell, a "house," this shell is hallowed and transfigured by the Holy Ghost, at least in the case of a saint. The house reflects its divine inhabitant. It is in this way that Leontius vindicates the dignity of the human form and its claim to reverence. In the descent from God to the saint and from the saint to his portrait the continuity is not entirely broken. What ensures this continuity is the "image" element which is present in both steps. At the basis of Leontius' use of Genesis 1:27 lies an essentially Neoplatonic belief in the divine manifesting itself in a descending sequence of reflections. [250] By implication at least, the work of the artist becomes an extension of the divine act of creation, a concept far removed from Early Christian indictments of the artist as a deceiver. [251]

Christian defenders of images had always had at their disposal another line of reasoning which had its point of departure in the New Testament: In Christ God had become Man and therefore capable of visual representa-

[248] εἰκὼν τοῦ θεοῦ ἐστιν ὁ κατ' εἰκόνα τοῦ θεοῦ γεγονὼς ἄνθρωπος, καὶ μάλιστα ἐκ Πνεύματος ἁγίου ἐνοίκησιν δεξάμενος. Δικαίως οὖν τὴν εἰκόνα τῶν τοῦ θεοῦ δούλων τιμῶ καὶ προσκυνῶ, καὶ τὸν οἶκον τοῦ ἁγίου Πνεύματος δοξάζω (PG 93, col. 1604 CD).

[249] This part of the argument is not brought out by Baynes, op. cit. (above, n. 1), 102. It is quite clear from the context that in this passage Leontius is concerned particularly with the defense of the worship of images of saints.

[250] Gen. 1:27 is quoted in defense of man-made images also by Stephen of Bosra, again in a treatise addressed to the Jews. John of Damascus cites him in his Third Oration on Images (PG 94, col. 1376 CD) and a fuller version of his argument is preserved in a fragment in a Milan Codex published by J. M. Mercati in Theologische Quartalschrift, LXXVII (1895) 663 ff. (cf. especially 666). Stephen, however, does not elaborate on the relationship between image and prototype as Leontius does. Nothing appears to be known about this author; see A. L. Williams, Adversus Judaeos (Cambridge, 1935) 167. Cf. also Ladner, in Dumbarton Oaks Papers, VII, 14 f.

[251] For the artist as a deceiver cf. e.g. Clement of Alexandria, Cohortatio ad gentes, 4 (PG 8, col. 136 A); Tertullian, De spectaculis, 23 (Loeb ed., 286); also Bevan, Holy Images, 80 f., 86 ff. The revaluation of the artist's work as an extension of the divine act of creation was to play a part later in Theodore the Studite's defense of images against the Iconoclasts; cf. G. Ladner, "Der Bilderstreit und die Kunstlehren der byzantinischen und abendlaendischen Theologie," Zeitschrift fuer Kirchengeschichte, Series III, vol. I (1931) 10; Id., op. cit. (above, n. 198), 144 with n. 103. Something of the Early Christian attitude perhaps survives in the cult of the acheiropoietai, which does not involve a revaluation of human handiwork; see below, n. 257, and, for a possible anticipation of this in pagan times, Bevan, op. cit., 78 f.

142

tion. He had become incarnate, He had lived, acted, suffered on earth. The saints likewise had been actual human beings who had lived and died among us and therefore they could be depicted. This argument had appeared very early. Eusebius and — presumably — Epiphanius both reckoned with it.[252] It was particularly effective in drawing a line of demarcation between pagan idols (depicting in anthropomorphic form gods who had no claim to such representation), on the one hand, and Christian images, on the other, and was used for this purpose by John of Salonika[253] and Constantine Charto-phylax.[254] The role these writers assign to the image is essentially a didactic one. The picture serves to demonstrate a historical fact. It teaches the doctrine of the Incarnation. We have seen that icons were, in fact, considered to be useful instruments in the defense of orthodox theology and that they were also attacked on these grounds.[255] In particular, we drew attention to the Eighty Second Canon of the Council of 692, a pronouncement which goes beyond an apology and actively promotes images as reminders of orthodox dogma. The Canon is important also because of its insistence on anthropomorphic representations and its rejection of symbolic ones. At the time when it was formulated Christian art had long passed from the symbolic to the direct representation of holy persons. In this respect the Canon is nothing more than a recognition of an accomplished fact. But the determination to eliminate even the last remnants of Early Christian symbolism is remarkable. Opposition to certain types of images on dogmatic grounds had been expressed much earlier, particularly by proponents of heretic doctrines.[256] But here the attack on one type of image is coupled with the promotion of another. The implication is that certain forms of pictorial presentation carry more meaning than others. Although in promoting the anthropomorphic image of Christ at the expense of the symbolic one the authors of the Canon were clearly prompted by a desire to instruct and impress the beholder, there is at least a silent recognition of an inherent virtue and power of visual form, a power contingent upon its being a direct reflection of (as distinct from an allusion to) its prototype.

At the time when this Canon was formulated apologetic thought had, in fact, already begun to place the connection between Christ and His image on a transcendental level. The image had begun to be thought of not simply as a reminder of the Incarnation, but as an organic part, an extension, or even a re-enactment thereof. Slowly concepts had begun to evolve whereby

[252] See above, n. 28.
[253] Mansi, XIII, col. 164 DE.
[254] *Ibid.*, col. 188 A.
[255] See above, pp. 120 f., 131.
[256] See above, nn. 209 (Philoxenos), 210 (Severus).

the Byzantine religious image was to become a means of demonstrating the Incarnation not merely as past history but as a living and perpetual presence. The role of the image ceased to be purely didactic and was in the process of becoming sacramental like the Sacrifice of the Mass.

There is no text of the pre-Iconoclastic period which makes this sacramental and transcendental relationship between God Incarnate and His image entirely explicit. But we see the concept, as it were, germinating in a variety of ways.

It appears, perhaps first of all, in mythological form in the legends of the acheiropoietai. Undoubtedly one reason why the cult of these miraculous images began to enjoy official approval and encouragement was that they could be defended relatively easily against charges of idolatry. They were immune, at any rate, to the objection — liable to be raised by Jews, but also by conscientious Christians — that the Church was admitting the worship of man-made images. A defensive intention of this kind may, in fact, be implicit in the very term ἀχειροποίητος, which, as we have seen, was used in connection with the image of Camuliana as early as A.D. 569. The image was declared to be the very opposite of χειροποίητος, a term which, aside from its literal and general meaning of "man-made," also had the specific connotation of idolatric.[257] But the acheiropoieta also dramatizes the idea of the image as Incarnation perpetuated. This is particularly true of those images which were thought to be mechanical impressions of the divine face or body. These images, which, as we have seen, soon won out over those of more mysterious origin, express in a most drastic form the belief in a direct and intimate relationship between the divine prototype and its pictorial representation. Not only does the acheiropoieta appear as a direct and lasting record of the Incarnate God, it owes its existence to a reproductive act which repeats, on a lower level, the miracle of the Incarnation. Hence the use made of these images in defense of orthodox christology.[258] If Dobschuetz' dating of Pseudo-Gregory's sermon on the image of Camuliana is correct, the inner

[257] Dobschuetz, *op. cit.*, 38. C. Cecchelli, in *Dedalo*, VII, 2 (1926–27) 295, quotes two interesting studies on this subject by A. Pincherle (*Gli Oracoli Sibillini Giudaici* [Rome, 1922] 120 ff.; *Id.*, in *Ricerche Religiose*, II [1926] 326 ff.). Cf. also *The Beginnings of Christianity, Part I: The Acts of the Apostles*, edited by F. J. Foakes Jackson and K. Lake, IV (London, 1933) 81 (a propos Acts 7, 48: "The meaning is . . . the Jews were verging on idolatry"). In a papyrus of the first century the word χειροποίητος appears to be used to denote the work of artists, without any derogatory overtones (F. G. Kenyon and H. I. Bell, *Greek Papyri in the British Museum*, III [London, 1907] 205 f. no. 854). Ἀχειροποίητος, therefore, perhaps may mean not only "not idolatric," but also "not in the realm of art." In this sense the term could be helpful to one intent on promoting the cult of an image while at the same time maintaining the Early Christian antagonism to the artist and all his works (see above, n. 251).

[258] See above, pp. 120 f.

connection between the miracle embodied in that image and the miracle of the Incarnation was made fully explicit as early as the seventh century. The author refers to Camuliana as "a new Bethlehem." Christ appears in a new Epiphany to impress His features on a cloth ceremonially prepared by a devout follower. The whole story of the image is described and hailed consistently as a new Incarnation.[259]

The concept of the image as an extension or re-enactment of the Incarnation is also present — far less clearly, it is true, but in a manner more definitely capable of providing a defense even of ordinary non-miraculous pictures — in statements linking actual images with references to Christ Himself as an "image." Such statements carry the implication that since God Incarnate is Himself in the nature of an image, His image in turn partakes of the nature of an Incarnation. It is an argument somewhat parallel to that which made of man-made images an extension of God's creation of man in his own "image" and, like the latter, it was based on Scriptural authority. Had not St. Paul spoken of Christ as "the image of God" (2 Corinthians 4:4)? Pseudo-Gregory quotes these words in the very beginning of his sermon on the image of Camuliana. The author of the apology addressed to the Armenian iconoclasts introduces into his defense two quotations from the Fathers which refer (or, at least, were thought to refer) to Christ as an image. These passages, which evidently were selected because they extolled Christ, the "image," as an object of worship, were taken — we do not know with how much good faith — to authorize the worship of derivative and man-made images as well.[260] Again it is the idea of the relationship between prototype and image as an all-pervading cosmic principle which provides a justification for the spreading cult of images.

Admittedly these texts lack explicitness. A passage in the Life of St. Symeon the Younger contains what is perhaps the most clear-cut statement in the literature of the pre-Iconoclastic period, envisaging a perpetual bond between the Incarnation and man-made images. The author relates that an image of St. Symeon, set up in gratitude by a woman whom the Saint had freed from obsession by a demon, worked miracles "because the Holy Ghost

[259] Dobschuetz, *op. cit.*, 12°° ff.; for the date p. 27°°; see also L. Koch, "Zur Theologie der Christusikone," *Benediktinische Monatsschrift* (1937 and 1938); especially 1938, 437 f. Another legend which dramatizes the concept of the icon as a "re-Incarnation" of Christ is that of the image at Beirut, which is made to re-enact not only Christ's miracles but also His entire Passion. But this text cannot be claimed definitely as pre-Iconoclastic. See above, nn. 59, 62, 87.

[260] The Armenian apologist quotes Gregory the Illuminator, the apostle of Armenia, who, in a long prayer recorded by Agathangelos, his biographer, had contrasted in rhetorical fashion the wooden idols worshipped by the heathens with the cross of Golgotha bearing the dead body of Christ, which, for the purpose of this comparison, he had called an image (Der

which dwelt in him [i.e. the Saint] overshadowed it [i.e. the image]." [261] Like Leontius of Neapolis (whose perhaps slightly younger contemporary he was) the author envisages two steps: From God to the Saint, and from the Saint to his image. But more clearly than Leontius he describes both steps as emanations of the Holy Ghost taking place in a descending sequence. The first step is described as "indwelling" as it is by Leontius. The second is an "overshadowing" in evident allusion to the words spoken by the Archangel to the Virgin Mary: "The Holy Ghost shall come upon thee and the power of the highest shall overshadow thee" (Luke 1:35). Thus it is a divine act analogous to the Incarnation of the Logos in the Virgin Mary which imparts to the image miraculous power.[262] And the image in this case is not an acheiropoieta but an ordinary artefact of recent manufacture depicting not Christ but a local saint. Here the image becomes indeed a sacred and perpetual vehicle of the Incarnation.

It will be noted that some of the texts quoted in the foregoing pages go further than others in the degree of concreteness or intimacy attributed to the relationship between image and prototype. As far as concreteness is concerned the ultimate degree was reached in those legends which ascribed the origin of an image to direct physical contact of the divine person with the material surface of the stone or canvas. More important, however, are

Nersessian, *op. cit.*, 61; cf. *Acta Sanctorum Septembris*, VIII, 337 f.; in modern times the passage has given rise to the unwarranted thesis that in Armenia worship of crosses started as early as the third century: Cf. R. Garrucci, *Storia dell'arte cristiana*, I [Prato, 1881] 432 f. and M. Sulzberger, in *Byzantion*, II [1925] 387). The Armenian author also cites Severianus of Gabala, who — again rhetorically — had spoken of the cross as "the image of the immortal King (ἀθανάτου βασιλέως εἰκών)" and contrasted it with images of earthly rulers and their worship (Der Nersessian, *op. cit.*, 61; cf. above, n. 181). The same passages were to be used again by defenders of orthodoxy during Iconoclasm: Severianus is quoted by John of Damascus (*PG* 94, col. 1408 f.) and Gregory by Nicephoros (J. B. Pitra, *Spicilegium Solesmense*, I [Paris, 1852] 501). At that time they were, however, overshadowed by the famous passages from Basil (see above, n. 19) and Athanasius (*Oratio III contra Arianos*, 5; *PG* 26, col. 331 AB), which illustrated the relationship of the Son and the Father through the analogy of the worship paid to the ruler through his image. Though these passages were not intended to refer to actual images of Christ, any more than those of Gregory the Illuminator and Severianus of Gabala, they served the purposes of the apologists more adequately, because they not only referred, in connection with Christ, to images and worship, but applied the image concept specifically to the Father-Son relationship and thus linked the cult of man-made images more definitely with the doctrine of the Incarnation. Cf. Ladner, in *Dumbarton Oaks Papers*, VII, 8.

[261] ἐπισκιάζοντος αὐτῇ τοῦ ἐνοικοῦντος αὐτῷ πνεύματος ἁγίου. This is the text of the Jerusalem Ms. (S. Sabas 108), published by Papadopoulos-Kerameus, *op. cit.* (above, n. 97), 607. Holl, *op. cit.* (above, n. 73), 390, quotes from Cod. Monac. gr. 366, f. 155r, which says more explicitly: ἐπισκιάζοντος τῇ εἰκόνι τοῦ ἐνοικοῦντος ἐν τῷ ἁγίῳ πνεύματος ἁγίου. For date and authorship of the Life see the reference quoted above, n. 40.

[262] For subsequent use of this concept by John of Damascus see H. Menges, *Die Bilderlehre des hl. Johannes von Damaskus* (Muenster, 1938) 79, 92 f.; Bevan, *op. cit.*, 144 f.

those statements which, instead of a single bodily contact, stipulate a continuing flow of divine energy from prototype to image. For with such statements we leave behind the concept of the image as a purely static and lifeless mirror reflection and enter the realm of thoughts and ideas attributing to images some form of animate life and power.

This was the most difficult and delicate, but also the most urgent problem with which the apologists of the post-Justinianic era were faced. We have seen to what an extent and with what elementary force magic beliefs and practices came to the fore during that period. To the common man, at any rate, Christ and the saints acted through their images. In effect the Christian image had become indistinguishable from the pagan idol. The defenders of the cult of images had to decide to what extent to acknowledge these animistic tendencies and how to incorporate them into their apologies.

The idea of supranatural power working in and through images is implicitly present in all stories about miracle-working icons. In so far as this type of story, so prominent in the literature of the period, was produced and circulated for apologetic purposes it points to a very wide acceptance of naively animistic ideas. But usually this acceptance is only implicit. The reader is not told how and why the icon acquired its power. There are, however, literary statements which show an awareness of the problem involved. Certain authors speak of the supranatural power of the image in explicit terms, thus following a path mapped out centuries before by some of the apologists of the pagan cult of images.[263] While some writers think in terms of divine substance, force or energy flowing from prototype to image, others go further and stipulate actual residence of the former in the latter.

We have already quoted the statements belonging to the first category, statements which remain within the framework of Scriptural "precedent" and define the force which flows from prototype to image as the Holy Ghost. Such statements evidently were intended to provide a theological motivation for the popular beliefs and practices of the time. They appear to have been prompted by a desire to sublimate the naive, animistic ideas of the masses, to elevate them to a plane where they became theologically acceptable by substituting for primitive magic the idea of the miraculous as a divine act pre-ordained in Scripture.[264] In this connection it is worth noting that

[263] Clerc, *op. cit.* (above, n. 227), 182 (Plutarch), 252 (Plotinus). Geffcken, "Der Bilderstreit . . ." (above, n. 211), 309 (Jamblichus), 312 (Julian), 313 (Olympius). Cf. also E. R. Dodds, "Theurgy and its Relationship to Neoplatonism," *Journal of Roman Studies,* XXXVII (1947) 55 ff., especially 62 ff. (particularly for late classical texts concerning statues made animate by specific human action).

[264] The importance of this distinction between the "magic" and the "miraculous" was pointed out to me by Prof. Friend.

Leontius of Neapolis, who at least implies a descent of the Holy Ghost into the image, was, so far as we know, the first author who utilized in an apology of Christian images the claim that they work miracles.[265] In the Life of St. Symeon the Younger the causal connection between popular practice and theological formula is quite evident. The author introduces his allusion to the Incarnation in order to explain a miracle wrought by an image (and not vice versa, the miracle in order to defend the Incarnation).[266] It is true that a belief in the miraculous power of an image may have been promoted at times by the clergy itself for dogmatic purposes.[267] But when it came to a theoretical formulation and motivation of such beliefs theologians seem to have yielded ground rather than to have led the way.

The intensity of the iconophile movement was indeed such that it ultimately led to statements and formulas no longer compatible with the word of Scripture, though more frankly responsive to the animistic tendencies of the masses. A number of writers of the post-Justinianic era at least toyed with the idea of the image as an actual abode of the person portrayed. We hear of images being approached "as if" their subjects were present in them,[268] a concept familiar from the cult of the ruler portrait.[269] With obvious awareness of the rhetorical effect Photinus, the biographer of John the Faster, makes a last minute withdrawal from the abyss of sheer animism when he closes his story of a miracle-working icon of the Virgin with a reference to the image as ὁ τόπος, ὁ τύπος δὲ μᾶλλον τῆς παρθένου μητρός.[270] The writer was clearly aware that he was touching upon a sensitive and controversial point. The same is true of another author, who, however, by deliberate choice took an extreme position and produced what may well be some of the most radical statements on images in all Byzantine literature. In a previously mentioned miracle of Sts. Cosmas and Damian, in which a sick woman is cured by drinking a medicine prepared from plaster which she

[265] PG 93, col. 1601 CD. Cf. Baynes, op. cit., 101.

[266] See above, pp. 144 f. with n. 261.

[267] See especially above, p. 120 (Edessa episode).

[268] Cf. the sermon ascribed to St. Symeon the Younger (above, n. 243): "When we see the Invisible through the visible picture we honor Him as if He were present (ὁρῶντες τὸν ἀόρατον διὰ τῆς ὁρωμένης γραφῆς, ὡς παρόντα δοξάζομεν)." Agathias, in a previously quoted epigram on an image of an archangel, says of the beholder that "imprinting the image in himself he fears him as if he were present (ἐν ἑαυτῷ τὸν τύπον ἐγγράψας ὡς παρεόντα τρέμει)"; The Greek Anthology, I, 34, cf. above, n. 242. Anastasius Sinaita, in a passage quoted by John of Damascus in his Third Oration, says that the image of Christ produces an illusion of His actually gazing at us from heaven (PG 94, col. 1416 C). Arculf speaks of a man talking to an image of St. George quasi ad presentem Georgium (Relatio de locis sanctis, III, 4; Tobler, op. cit., 197).

[269] See above, pp. 122 f.

[270] Mansi, XIII, col. 85 C; for the miracle see above, pp. 108 f.

has scratched from a fresco representation of the two saints, the act of drinking the plaster is blandly described as "the entering in of the saints." [271] This amounts to complete identification of picture and prototype. The author states his position more explicitly in another story, also quoted previously, in which an image of the saints carried along on a journey is instrumental in the cure of the traveller's wife. The tale stands out among a host of similar ones by the fact that the beneficiaries not only. make no effort, by prayer or action, to secure divine assistance through the icon but are not even aware of the presence of the icon, at least when it first begins to operate on their behalf. The story dramatizes the objective power of the icon which is shown to be effective regardless of the faithful's consciousness. Its key theme, however, is the actual presence of the saints in the image. The sick woman first sees the two holy physicians in a dream in which they assure her that they are with her. That these words refer to the icon is made clear by what they say to her in a second dream after the icon has been discovered: "Did we not tell you that we are here with you?" This is the main point of the story. In his concluding sentence the author stresses once more the actual presence of the saints, as distinct from a mere manifestation of their power.[272] It is possible, however, that he was pushed into this extreme position by the fury of eighth century Iconoclasm. There is no conclusive evidence that these Miracles were written before the outbreak of the Controversy.[273]

We have completed our survey of statements concerning the nature and function of religious images which have survived from pre-Iconoclastic times. They amount to little more than a collection of aphorisms. In elaborateness, profundity and lucidity they cannot compare with the great systematic apologies subsequently worked out under the impact of organized opposition. But some of the outlines of future theories already appear in

[271] ἡ τῶν ἀγίων ἐπιφοίτησις; Deubner, op. cit., 138; cf. above, nn. 45, 89.

[272] Deubner, op. cit., 132 ff.; cf. above, nn. 89, 98.

[273] See above n. 45 with references to the opinions of Deubner and Delehaye. Actual identity of the saint with his image is implied also in a story of the figure of St. Mercurius absenting itself momentarily from a picture, in which he was represented together with the Virgin, in order to carry out St. Basil's request to slay Julian the Apostate. The emergence of this story can be fixed within fairly narrow chronological limits. Because of its evident dependence on a dream of St. Basil recorded by Malalas (*Chronographia*, XIII; Bonn ed., 333 f.) it must be later than the sixth century. But since it appears in John of Damascus' First Oration on Images (*PG* 94, col. 1277 B), written in all probability about A.D. 726 or soon thereafter (Menges, *op. cit.*, 6), it is likely to have taken shape before the outbreak of Iconoclasm and not during Iconoclasm as suggested by Binon (S. Binon, *Essai sur le cycle de Saint Mercure* [Paris, 1937] p. 23, n. 5). In this text, however, which was ascribed to Basil's pupil Helladius, the presence of the saint in his image is not stated as explicitly as in the abovementioned Miracles of Sts. Cosmas and Damian.

them.[274] In intensity, at any rate, the image concepts of the late sixth and seventh centuries do not fall short of those evolved later by orthodox thinkers and at times perhaps go beyond them. This provides a measure of the importance which the icon acquired in theory as well as in practice during the generations that followed the reign of Justinian.

VI. CONCLUSIONS

Taken in its entirety the evidence reviewed in this study reveals a major revolution in the sphere of religious art. It was a revolution primarily in the extent and degree of the everyday use made of religious images by private persons, by the clergy and by secular authorities, not only in devotional practices but also for the attainment of concrete and specific purposes. At the root of this movement was a vastly increased desire to make the presence of the Deity and of the saints and the succour which they could be expected to give visually palpable. Actively fostered by secular and clerical authorities this desire inevitably led to a breakdown of the distinction between the image and its prototype. For practical purposes the two tended to merge more and more. In the wake of this development, which remained by no means unopposed and uncriticized even before the outbreak of official Iconoclasm under Leo III, Christian thinking on the subject of images also made important strides. Two developments in the realm of apologetic theory are particularly significant: An increasing preoccupation with the relationship of the image to its prototype (rather than to the beholder) and an increasingly strong belief in the potentialities of the image as a vehicle of divine power.

For the art historian these facts are of the greatest interest. It is hardly conceivable that the important new functions which images were called upon to perform; the intensity of the worship they received; above all, the magic qualities with which they were increasingly thought to be endowed, and the theoretical concepts which served to motivate these beliefs should have failed completely to find expression in the images actually produced at that time. One need only confront in one's imagination the apologist and the artist of the period in order to realize the profound effect which the development must have had upon the latter. For the first time the Christian artist is exempted by the apologist from the necessity of justifying his work by educating and teaching the beholder or by appealing directly to his emotions. The image need not narrate an event or convey a message, nor need the artist

[274] In particular they foreshadow some of the concepts subsequently elaborated by John of Damascus and Theodore the Studite. For these see the studies by Ladner, Koch and Menges referred to above in nn. 251, 259, 262.

make it a primary aim to arouse in the onlooker a particular state of mind, such as awe or reverence, piety or compassion. Instead the artist is charged with the task of creating an image timeless and detached, in contact with heaven rather than humanity, an image capable of mirroring, as if by direct reflection, its divine or sainted prototype and, indeed, of serving as a vehicle for divine forces, as a receptacle for divine substance. Self-sufficient vis-à-vis the beholder the image must at the same time be "open" towards heaven. What the artist is called upon to create is a shell, limp and meaningless in itself, ready to receive power and life from on high, from the Holy Ghost which will overshadow it, from the heavenly persons who will take up their abode in it.

Clearly these are concepts which were bound to affect the artist's work. It is not necessary, however, to assume that painters and sculptors were actually acquainted with the apologetic literature of their age. As we have seen, there is an intimate connection between the theoretical statements and the everyday practices of the period. In essence the former are but reflections and sublimations of beliefs drastically and spontaneously expressed in the latter. Artists may not have been familiar with the literary discussions concerning images. But they knew what uses their works would be called upon to serve, what functions they were expected to fulfil.

There should follow, then, as a sequel to this study an examination of the monuments of the period between Justinian and Iconoclasm in the light of the results which have been obtained. Here is an instance where the chances for a successful integration of art-historical studies with social and intellectual history are unusually bright, because the latter offers what is, by the standards of early medieval documentation in general, a relatively rich array of data peculiarly relevant to the former. Any achievement in the sphere of art that can be singled out as characteristic of this age has a good chance of standing in some inner connection with the new social and religious functions which images then acquired. But this is a step into uncharted land.[275] The present study will have fulfilled its purpose if it has succeeded in presenting with a fair amount of completeness the textual evidence for the intensified cult of images in the era after Justinian.

[275] In a paper to be published in a volume of studies dedicated to Prof. A. M. Friend, Jr., I have dealt with some aspects of the art of the seventh century which appear to me to be significant in the light of the conclusions reached in the foregoing pages.

VI

BYZANTINE ART IN THE PERIOD BETWEEN JUSTINIAN AND ICONOCLASM

It cannot be the purpose of this paper to present in exhaustive fashion the history of Byzantine art in the era between the death of Justinian I and the outbreak of Iconoclasm. Those who have done me the honor of asking me to submit a discussion of the art of this period to the Congress have agreed that I leave the history of architecture to others who have specialized in that field, and confine myself to the pictorial arts. But this is only the most obvious of several respects in which I have limited my subject. The extant mosaics, paintings, sculptures and products of the minor arts admittedly are not very numerous when one considers the length of time involved. Even so, were I to discuss these monuments, or, at any rate, the more important among them, one by one, giving in each instance a full account of known facts, as well as of the present state of the scholarly discussion, I would have to exceed by far the space allotted to me, and would still not be likely to arrive at a satisfactory overall picture. Nor is a summary description of the development of each of the major crafts feasible. The distribution of extant works in the various media is too uneven and spotty. The course I propose to follow is to discuss some of the major *problems* which face the art historian dealing with this period. In doing so I shall choose my examples from among the more important works, regardless of medium, and, when introducing monuments that pose special problems, briefly summarize the state of our knowledge concerning them. Primarily my enquiry will be concerned with matters of form and style. I shall trace the major stylistic trends of the period; explore their regional affiliations; and finally, in the last section, attempt to interpret these trends in relation to a somewhat larger framework, taking into account also other contemporary developments.*

Undoubtedly the reason why the art of the era between 565 and 726 has been chosen by the organizers of the Congress as one of the major topics of discussion is that our present concepts of that art are singularly obscure and confused. This state of affairs, in my opinion, should not be blamed simply on the obtuseness of us scholars, nor even, as is often done, on the scarcity of extant monuments. It is true that less work has been done on the art of the seventh and eighth centuries than on that of the preceding and succeeding

* A Symposium entitled "Byzantium in the Seventh Century" and dealing not only with art but in general with Byzantine history and civilization of that period, was held at Dumbarton Oaks in May 1957. The present paper is based on a lecture delivered on that occasion and also incorporates ideas and suggestions put forward by other participants. To them, and particularly to my colleagues at Dumbarton Oaks, I express my warmest thanks.

2

"Golden Ages" – the Justinianic, the Macedonian, the Comnenian and the Palaeologan. It is true also that the losses must be tremendous, and particularly so in the sphere of the pictorial arts because of the systematic destruction of images during Iconoclasm. But I believe that the art of the period in question never did have as sharply defined a character, as clear-cut a stylistic physiognomy as that of the preceding and succeeding phases.

In order to become aware of the singular lack of stylistic unity in Byzantine art of the seventh century it is enough to place side by side two works by Greek artists that must be very nearly contemporary. Fig. 2, a picture of the Maccabees with their mother Solomone, is a fresco in the Church of Sta. Maria Antiqua in the Roman Forum, painted about the year 630 or 640 by one of the Greek artists active in Rome at that time[1]; fig. 1 a mosaic in the Church of St. Demetrius at Salonika, showing the patron saint of the church in the company of two donors, and dating likewise from the period before or around the middle of the seventh century.[2] The fresco was done by an artist still in almost full possession of those impressionist techniques which had been developed by hellenistic painters some seven hundred years earlier, techniques which enabled him to render faces, bodies and draperies almost entirely by coloristic means and to produce, by bold strokes of the brush representing high-lights and shades, an impression of three-dimensional bodies freely moving and turning in space. The contrast between this painting and the Salonikan mosaic with its purely conceptual rendering of the human form, its rigidly symmetric display of three fully facing figures immobilized in an architectural framework, its use of heavy and, wherever possible, straight and parallel lines to describe shapes, could hardly be greater. It will be part of our task to try to account for the existence side by side of two such widely divergent styles.

The Roman fresco and the Salonikan mosaic may serve, in fact, to indicate two extreme positions, two opposite poles that will help toward a first rough orientation in a material somewhat bewildering in its variety. The "hellenistic" and the "abstract" – these are two principal headings under which much of the art of the seventh century can be quite naturally classified. To be sure, the dichotomy is not peculiar to this one period. It had existed in earlier phases of Byzantine art and will continue later. But it appears in particularly accentuated form in the art of the period with which we are concerned. We are thus provided with an obvious means of organizing our discussion of stylistic problems. Although in many individual instances ingredients from both currents appear united most often it is not difficult to say whether it is the "hellenistic" or the "abstract" style which predominates. To encompass in a relatively brief account the artistic development of an entire era always involves a certain amount of artificial schematization. But

[1] J. Wilpert, *Die römischen Mosaiken und Malereien der kirchlichen Bauten vom IV. bis XIII. Jahrhundert*, Freiburg 1917, IV, pl. 163. For the date see E. Kitzinger, *Römische Malerei vom Beginn des 7. bis zur Mitte des 8. Jahrhunderts* (diss., Munich 1934), p. 8 ff.

[2] See below, p. 25 f.

in the present instance a broad division is naturally provided by the material itself. I shall discuss the hellenistic style first, the abstract second.

I.

When speaking of hellenism in Byzantine art of the period between Justinian and Iconoclasm one's thought inevitably turns first to a group of silver plates with figure reliefs which not only are amazingly classical in style but classical also in subject matter (figs. 3, 8). These plates were generally considered as works of the second, third or fourth centuries A. D. until L. Matsulevich, in a famous book published almost a generation ago and based in part on earlier researches by I. I. Smirnov, showed conclusively that the Byzantine hallmarks on their backs, many of which date from the reigns of Justinian and Heraclius, were applied before the reliefs were finished and that these reliefs, consequently, were made in the sixth and seventh centuries. Matsulevich showed that in style, too, they differ considerably from classical works of the Roman Imperial period. They are, in fact, products not of the true classical age, but of what he called the "Byzantinische Antike".[3]

Although art historians in general have accepted Matsulevich's thesis – and its truth is in fact incontestable – surprisingly little has been done in the years since his book was published to explore further the important vistas which he has opened up. Recently Miss Erica Cruikshank, working first as a Junior Fellow at Dumbarton Oaks and subsequently as a graduate student at London University, has tested and enlarged upon Matsulevich's results examining at first hand a large number of silver objects in Western European and American collections and taking into account later literature. In almost every case in which a judgment was possible she has found, as did Smirnov and Matsulevich, that hallmarks were applied before the vessel was finished and therefore may serve as a *terminus post quem* (and in most instances surely as an approximate *terminus ad quem*). She has been able to add substantially to the catalogue of hallmarks published by M. Rosenberg in 1928,[4] and, on the strength of this enlarged material, she has refined Matsulevich's methods of dating these marks. Her conclusions regarding the system of control

[3] L. Matsulewitsch, *Byzantinische Antike*, Berlin and Leipzig 1929 (hereafter quoted as Matsulevich 1929). See also *Id.*, "Argenterie byzantine en Russie", *L'art byzantin chez les Slaves. Deuxième recueil dédié à la mémoire de Théodore Uspenskij*, part II, Paris 1932, p. 292 ff.; *Id.*, "L'antique byzantin et la région de la Kama" (in Russian), *Académie des Sciences de l'URSS. Matériaux et recherches d'archéologie de l'URSS*, I, 1940, p. 139 ff. (hereafter quoted as Matsulevich 1940; a short résumé of this article in English with some illustrations was published in *Gazette des Beaux-Arts*, 6th series, vol. 31, 1947, p. 123 ff.). Several objects which fall under the heading of "Byzantinische Antike" are in the Dumbarton Oaks Collection; see *The Dumbarton Oaks Collection, Handbook*, Washington D.C. 1955, no. 126 (= H. Peirce and R. Tyler, *L'art byzantin*, II, Paris 1934, pl. 45), no. 127, no. 132 (= Matsulevich 1940, pl. V, 1). Others have been published by St. Pelekanides in *Archaiologike Ephemeris*, 1942–1944, p. 37 ff. and by H. Kähler in *Die Kunst und das schöne Heim*, 50, 1952, p. 321 ff.

[4] M. Rosenberg, *Der Goldschmiede Merkzeichen*, 3rd ed., IV, Berlin 1928, p. 613 ff.

underlying the marks are still somewhat tentative, but tend to confirm Matsulevich's thesis[5] that hallmarks – at least of the normal "imperial" type – were applied in one center only, namely, in Constantinople.[6]

Many specifically art historical questions still await solution. I shall draw attention only to one which is particularly relevant to the present context: Do these classicizing silver reliefs owe their existence to an artificial and academic revival, a sort of neoclassicism, under Justinian, followed by a similar and equally ephemeral movement under Heraclius – or, are they exponents of a perennial hellenistic current, a living tradition which had existed all along? Miss Elizabeth Rosenbaum, in an article to which I shall refer again presently, has addressed herself briefly to this problem. Asserting that "no mythological silver vessels with hallmarks seem to have survived of the period between Justinian and Heraclius" she reckons with "two distinct 'revivals' of classical art with no straight line of development between them".[7] In actual fact, continuity between the materials dating from the two reigns is not lacking entirely. At least one fragmentary plate with a secular figure subject has hallmarks which may be ascribed to the period of Justin II.[8] What is more important, however, is the internal evidence of the reliefs themselves. It can be shown, I believe, that although a limited revival of earlier forms was brought about by silversmiths in the time of Heraclius that revival was based on a living, broadly flowing and continuous classical tradition to which most of the objects that come under the heading of "Byzantinische Antike" owe their existence.

In order to demonstrate this point we must extend our enquiry to a group of silver objects closely related to those with mythological reliefs, the famous set of nine plates with scenes from the life of David which was part of a great treasure unearthed in the year 1902 near Kyrenia on the island of Cyprus (figs. 4, 6).[9] Three of the plates are in the Museum of Nicosia, the rest

[5] Matsulevich 1929, p. 61 ff.

[6] For a brief preliminary account of some of Miss Cruikshank's findings see her note in *Dumbarton Oaks Papers*, XI, 1957, p. 239 ff.

[7] E. Rosenbaum, "The Andrews Diptych and Some Related Ivories", *The Art Bulletin*, XXXVI, 1954, p. 233 ff.; see especially p. 260, n. 58.

[8] Matsulevich 1940, p. 151 ff. and pl. IV (= *Gazette des Beaux-Arts*, 1947, p. 125, fig. 4). The interpretation of the hallmarks on this object as dating from the period of Justin II is due to Miss Cruikshank.

[9] The basic literature on this treasure is quoted by W. F. Volbach, *Metallarbeiten des christlichen Kultes*, Mainz 1921, p. 17. See now also M. C. Ross, "A Byzantine Gold Medallion at Dumbarton Oaks," *Dumbarton Oaks Papers*, XI, 1957, p. 247 ff. The plates now in New York are lavishly reproduced in C. H. Smith, *Collection of J. Pierpont Morgan. Bronzes Antique Greek, Roman, etc., including some antique objects in gold and silver*, Paris 1913, pp. 44, 47 and pls. LXIII–LXVI. For the hallmarks see Rosenberg, *op. cit.*, p. 636 ff. A plate closely related to the set from Cyprus was formerly in the Alin Collection and was published by Matsulevich (1940, p. 147 ff. and pl. III, 1 = *Gazette des Beaux-Arts*, 1947, p. 124, fig. 2). It shows David's fight with the lion, but in a rendering somewhat different from that of the same theme in the Cyprus series. The present whereabouts of this piece, which seems to have been found in the Ural region and may or may not have hallmarks, are unknown.

in the Metropolitan Museum in New York. All the plates bear hallmarks which afford clear evidence that the set was made in the first two decades of the reign of Heraclius.[10]

Matsulevich dealt with this group only peripherically pointing out its numerous stylistic connections with his plates with mythological subjects.[11] But although the relationship is obvious it is odd to find that none of the mythological reliefs of the time of Heraclius can be readily accepted as works of the same artists or the same workshop which produced the David plates. In any close comparison of heads, of draperies, of the entire treatment of the relief, the latter turn out to be far more precise, far less cursory and sketchy than the great majority of the former.[12] The best comparisons for these stylistic characteristics of the David plates can be found invariably not in Heraclian work but in works of the fourth and fifth centuries. It is on reliefs such as those of the great amphora from Concesti or the missorium of Theodosius I in Madrid or the fragmentary vessels from Gross Bodungen in Halle (fig. 7) that one finds details similarly executed.[13] Revealing comparisons can be made also with ivory carvings of the late fourth and fifth centuries. It is one of the soldiers guarding Christ's Sepulcher on the famous Trivulzio plaque[14] who wears a flying mantle rendered similarly to that of David killing the lion in the Cyprus series. It is the figure of an apostle on a plaque in the Louvre[15] generally ascribed to the fifth century which affords far and away the best comparison for the bearded men draped in long garments on the Cyprus plates (figs. 4, 5). The Louvre plaque, it is true, is one of several ivory carvings which Miss Rosenbaum has tried to ascribe to the period of Heraclius for the very reason that they bear, to a greater or lesser degree, stylistic resemblances to the David plates. In my opinion, Miss

[10] Matsulevich 1929, p. 22 f. Ross, *op. cit.*, p. 249.

[11] See especially Matsulevich 1929, p. 52 ff.

[12] Compare the treatment of the relief on the David plates with that on the plates reproduced in Matsulevich 1929, pls. 1, 2, 7–11, 12–15, 19–21 (all with hallmarks of Heraclius) and also pl. 35 (without hallmarks). Specifically one may compare the heads of David, in the scenes of his marriage (our fig. 6), his arming and his fights with the lion and with Goliath, with heads of pagan youthful heroes in semiprofile (Matsulevich 1929, pls. 1, 8; see also the enlargement Matsulevich 1940, pl. VI = our fig. 8) or the bearded heads of Saul with those reproduced in Matsulevich 1929, pls. 9 and 35. None of the mythological reliefs of the Heraclian period show a flying drapery as elaborately rendered as those depicted on several of the David plates.

[13] Miss Rosenbaum, *op. cit.*, p. 260, n. 57, has already compared the bodyguards on the plate showing David's Introduction to Saul with those on the Madrid missorium, particularly in regard to their hair. Compare also the head of David in the scenes in which he appears in semiprofile with the head of the personification in the lower part of the Madrid relief. The Concesti amphora (Matsulevich 1929, pl. 42) affords a better comparison for the helmeted warrior at the right of the scene of David's arming than do Byzantine mythological plates (*ibid.*, pls. 3, 35). For the Gross Bodungen relief with its youthful heads in profile which may be compared with those of the David plates (our figs. 6, 7) see W. Grünhagen, *Der Schatzfund von Groß Bodungen*, Berlin 1954. I am indebted to Dr. Grünhagen for the photograph reproduced in fig. 7.

[14] W. F. Volbach, *Elfenbeinarbeiten der Spätantike und des frühen Mittelalters*, 2nd ed., Mainz 1952, p. 58, no. 111 and pl. 33.

[15] *Ibid.*, p. 63, no. 123 and pl. 35.

Rosenbaum's attempt was unsuccessful and merely served to underline the close dependance of the David plates on works that are centuries older.[16]

A general resemblance of the Cyprus plates to the Madrid missorium and other works of the late fourth and early fifth centuries was noted already when they were first published and has often been remarked on since.[17] In itself this resemblance might indicate nothing more than the persistence of certain compositional conventions in Byzantine art. In conjunction with the specific relationship of stylistic details, however, it assumes much greater significance. These details, so we have seen, are not common to all the silver reliefs made in the period. We must reckon in the case of the David plates with a conscious and somewhat studied effort to imitate – and vie with – work of the Theodosian period.[18]

The setting for this revival was the court of Constantinople in the early years of Heraclius. The hallmarks with which the David plates are provided not only permit us to be quite definite about the date, but also, so we have seen, make manufacture in the capital exceedingly probable.[19] Moreover, it has been shown by Professor Grierson that the sumptuous gold girdle which was found with the plates, and which is adorned with four consular medallions of Maurice Tiberius as well as rare coins of the fifth and sixth centuries, must have belonged to an individual or a family of high rank and great wealth closely connected with the imperial court.[20] M. C. Ross has

[16] Miss Rosenbaum's thesis (op. cit., passim) has been refuted in detail by K. Wessel ("Das Diptychon Andrews", *Byzantinische Zeitschrift*, 50, 1957, p. 99 ff.). His study relieves me of the necessity to enter into a detailed discussion here. I agree with Dr. Wessel and a number of other scholars who have written on the subject in considering the Andrews Diptych itself, which stands in the center of Miss Rosenbaum's discussion, as a Carolingian work. Whatever the Andrews Diptych and the Cyprus plates may have in common – and, as Dr. Wessel points out, it is not very much – is simply due to the fact that both were made "in the manner of" works of the late fourth and early fifth century. Miss Rosenbaum's attempt to attribute ivories of the early fifth century to the period of Heraclius has an illuminating pendant in a statement by P. E. Arias who – ignoring the evidence of the hallmarks – claims on the contrary that the Cyprus plates are "pieno V secolo d. C." (*Annuario della Scuola Archeologica di Atene*, XXIV–XXVI, 1946–1948, p. 321). Both these scholars were misled by the retrospective style of the plates.

[17] O. M. Dalton, in *Archaeologia*, LX, 1906, pp. 4 ff., 21; Volbach, *Metallarbeiten*, p. 17; Grünhagen, op. cit., p. 29; Rosenbaum, op. cit., p. 260.

[18] In this respect I find myself in disagreement with K. Wessel who denies in general terms the possibility that works of the period of Theodosius ever served as models for classicist revivals in later centuries. According to him one should not speak of revivals at all, but solely of "stete Fortwirkungen" of the hellenistic heritage (op. cit., p. 109). If this were so the features which distinguish the David plates from their near relatives and contemporaries among the mythological silver plates would be hard to explain.

[19] Many scholars have attributed the David plates to Syria. Cf. the critical discussion of this theory by G. de Francovich who claims them for Constantinople ("L'arte siriaca e il suo influsso sulla pittura medioevale nell'oriente e nell'occidente," *Commentari*, II, 1951, pp. 3 ff., 75 ff., 143 ff.; especially p. 13 ff.). Aside from the likelihood that "imperial" hallmarks in general are Constantinopolitan, the improbability of the particular hallmarks of the David plates having been applied in Antioch has been demonstrated by Ross, op. cit., p. 249. For silver that can be associated with Syria see below, n. 124.

[20] Ph. Grierson, "The Kyrenia Girdle of Byzantine Medallions and Solidi", *Numismatic Chronicle*, 6th series, XV, 1955, p. 55 ff.

reached analogous conclusions in regard to the great gold medallion with Christian scenes (now at Dumbarton Oaks) which comes from the same treasure.[20a] There can be little doubt that the owner's high connections also account for his possession of the David plates which quite clearly have strong imperial connotations.[21] This is not liturgical silver. The David plates are products of court art and reflect a conscious effort – not unnatural for a victorious usurper such as Heraclius – to stress the traditional and particularly to emulate standards and ideals associated with the early days of the Empire.[22]

We are thus able to isolate within the hellenistic current so strongly represented in silver work a frankly retrospective group characterized by a classicizing style which can be explained only in terms of a leap back across the centuries. By the same token, however, those reliefs which show a kind of "free-wheeling" hellenism, a bolder, more sketchy and cursive manner, must be accepted as products of a living tradition. The majority of mythological representations fall in this category.[23] The stylistic tradition to which they owe their existence obviously provided an excellent seed-bed, a ready start for the revival of Theodosian classicism which we find in the David series, but a clear distinction must nevertheless be made between the two.

This perennial hellenism is at once a most important and a most elusive force in the early history of Byzantine art. Its power is felt throughout the period with which we are dealing in this paper, and beyond. It crops up in different media and in different places. In the work of silversmiths no example is at present known later than 630 A. D. Those frescoes in Sta. Maria Antiqua in Rome which most startle us by their bold hellenistic style also date from the first half of the seventh century, though the influence of the Greek artists who produced them left its mark on Roman painting down to the early decades of the eighth century.[24] Indeed, as we shall see, during the period about 700 A. D. Roman art may have been exposed to fresh influences from the Greek East. It was from Italy, but also, in all probability, direct from the Greek world that works of art exhibiting a lively hellenistic style reached England and helped to spark the so-called Anglo-Saxon Renaissance

[20a] *Op. cit.*, especially pp. 258f., 261.

[21] A. Grabar, *L'empereur dans l'art byzantin*, Paris 1936, p. 95 ff.

[22] For other manifestations of this attitude in the early years of Heraclius see Ph. Grierson, "The Consular Coinage of 'Heraclius' and the Revolt against Phocas of 608–610", *Numismatic Chronicle*, 6th series, X, 1950, p. 71 ff., especially p. 85 f.; cf. also A. Frolow, "IC XC NIKA", *Byzantinoslavica*, XVII, 1956, p. 98 ff., especially p. 101. The fact that Heraclius' first-born son (born in 612 A.D.) was named Constantine may also be noted.

[23] For those of the period of Heraclius see above n. 12. The following silver vessels with mythological reliefs have sixth century hallmarks: Matsulevich 1929, pls. 3–5, 16, 31–32, and p. 72, fig. 7; Matsulevich 1940, pl. IV, 1 and – probably – pl. V, 1. While in most instances the treatment of the relief is summary and cursive the Shepherd plate from Klimova (Matsulevich 1929, pl. 31) stands out by the precise and elaborate rendering of its relief (cf. Matsulevich 1940, p. 154f.).

[24] M. Avery, "The Alexandrian Style at Santa Maria Antiqua, Rome", *Art Bulletin*, VII, 1925, p. 131 ff. Kitzinger, *Römische Malerei*, passim.

of the late seventh century.[25] At exactly the same moment similar influences made themselves felt more strongly at the opposite end of the ancient world, forming, as they did, one of the chief ingredients in the style of the decorations of the sumptuous castles and sanctuaries on which the Umayyad caliphs expended so much of their recently acquired wealth.[26] Nor was the power of this current throttled by the outbreak of Iconoclasm in Byzantium. Hellenism was still a living tradition when, at the end of the eighth century, Charlemagne's artists fell under its spell.[27] The reflections of this current in Carolingian art are particularly important since they afford a link between the pre-Iconoclast and the post-Iconoclast age and show that the classical revival of the Macedonian era drew on living forces and not merely on ancient models.

I have taken a rather broad view, following in this respect the example of Charles Rufus Morey. Only in this way can we recognize the hellenistic current as a persistent force. What we cannot do is to demonstrate its continuity by means of a coherent series of monuments in a single medium or from a single center. Hence the difficulty of distinguishing different strands within this broad movement or phases in its evolution. An evolution there certainly was within the hellenistic tradition, despite its inherently conservative bent. But when external indications are lacking monuments belonging to this tradition are notoriously hard to date. Such a monument is the cycle of frescoes of Sta. Maria di Castelseprio. I shall not discuss it here since those works of hellenistic stamp which definitely belong to the seventh and early eighth centuries, i. e., primarily the silver reliefs and the Roman frescoes, do not in my opinion afford sufficiently specific stylistic analogies to justify one's ascribing the paintings of the little Lombard church to the period with which this paper is concerned. While the Castelseprio paint-

[25] T. D. Kendrick, *Anglo-Saxon Art to A. D. 900*, London 1938, p. 111ff. See also F. Saxl, "The Ruthwell Cross", *Journal of the Warburg and Courtauld Institutes*, VI, 1943, p. 1ff., especially p. 7ff., and my analysis of the figures on the coffin-reliquary of St Cuthbert in *The Relics of Saint Cuthbert* (C.F.Battiscombe, ed.), Oxford 1956, p. 202ff., especially p. 258ff. a propos of the Virgin and Child.

[26] K. A. C. Creswell, *Early Muslim Architecture*, I, Oxford 1932, pp. 147ff. (mosaics of the Dome of the Rock and of the Great Mosque at Damascus), 253ff. (Qusayr Amra), 350ff. (Mshatta). To these famous monuments must now be added the important finds of paintings and sculptures at Qasr el-Heir el-Gharbi (D.Schlumberger, in *Syria*, XX, 1939, pp. 195ff., 324ff. and *ibid.*, XXV, 1946–1948, p. 86ff.) and of mosaics and sculptures at Khirbat al Mafjar (R. W. Hamilton in *The Quarterly of the Department of Antiquities in Palestine*, XI, 1944, p. 47ff.; XII, 1945, p. 1ff.; XIII, 1948, p. 1ff.; XIV, 1950, pp. 100ff., 120; also *Palestine Exploration Quarterly*, 81, 1949, p. 40ff.). For the last-mentioned site see also below, p. 34. In most of these decorations there is, of course, also a greater or lesser admixture of oriental elements deriving from sources entirely outside the Mediterranean sphere.

[27] For evidence that Carolingian art was influenced not merely by ancient models but by living traditions of hellenistic style transmitted either direct from the East or by way of Italy see the recent studies by A. Böckler on the portraits of the evangelists in the Ada Mss. (*Münchner Jahrbuch der bildenden Kunst*, 3rd series, III–IV, 1952–1953, p. 121ff., especially p. 142ff.) and by D. Tselos on the illuminations of what he calls the "Aachen-Reims" school (*Art Bulletin*, XXXVIII, 1956, p. 1ff.); also the very pertinent remarks by M. Schapiro in *Art Bulletin*, XXXIV, 1952, p. 162f.

ings stem from the same broad current which we have been following they show that current in a more advanced stage. I agree with those who consider them to be certainly not earlier than the Carolingian period.[28]

[28] The Castelseprio frescoes, discovered during the Second World War, were attributed to the seventh century in the basic publication by G. P. Bognetti, G. Chierici, and A. De Capitani d'Arzago (*Santa Maria di Castelseprio*, Milan 1948). Bognetti has sought to reinforce the attribution in subsequent writings ("Aggiornamenti su Castelseprio", *Rassegna Storica del Seprio*, IX–X, 1949-50, p. 28 ff.; "Un nuovo elemento di datazione degli affreschi di Castelseprio," *Cahiers Archéologiques*, VII, 1954, p 139 ff.). Other leading advocates of a seventh century date are P. Toesca ("Gli affreschi di Castelseprio", *L'Arte*, LI, 1948–51, p. 12 ff.), C. R. Morey ("Castelseprio and the Byzantine 'Renaissance'", *Art Bulletin*, XXXIV, 1952, p. 173 ff.), V. N. Lazarev ("The Frescoes of Castelseprio" [in Russian], *Vizantiiskii Vremennik*, VII, 1953, p. 359 ff.), and G. de Francovich ("Problemi della pittura e della scultura preromanica", *Settimane di studio del Centro italiano di studi sull'alto medioevo*, II: *I problemi comuni dell'Europa post-carolingia, 6–13 aprile 1954*, Spoleto 1955 p. 355 ff., especially p. 455 ff.; also previously in his paper on Syrian art in *Commentari*, II, 1951, p. 82 f.). K. Weitzmann, on the other hand, in an important monograph has put forward the thesis that the Castelseprio frescoes are a product of the Macedonian Renaissance in Byzantine art and has attributed them to the first half of the tenth century (*The Fresco Cycle of S. Maria di Castelseprio*, Princeton, 1951). It is a great merit of Weitzmann's to have formulated with precision a number of characteristics whereby the hellenism of the Castelseprio paintings differs from that of the Roman frescoes and mosaics of the seventh and early eighth century (see especially pp. 14 f., 19 ff.). In my opinion these observations, which also apply to the silver plates of the Heraclian era, are in themselves sufficient to rule out the possibility that the Castelseprio paintings belong to the period with which the present paper is concerned. Indeed, Weitzmann's observations, which, so far as I can see, have not been effectively refuted by any advocate of a seventh sentury date, make it possible to discern an evolutionary process within the tradition of "perennial hellenism" in Byzantium in the period between the seventh and the tenth century. But it is quite another question whether the stage represented by Castelseprio was reached only in the first half of the tenth century as Weitzmann believes. Serious obstacles stand in the way of interpreting the fresco cycle as a pure product of the Macedonian Renaissance of that period, as he has done. It may well be that the difficulty can be resolved through Castelseprio's affinities with works of Carolingian art, affinities which in recent years have played an increasingly large role in the literature on the Lombard frescoes. Indeed, it is becoming apparent that the living tradition of Byzantine hellenism, which undoubtedly is an important ingredient in Carolingian art (see preceding footnote), must have been possessed of many of the essential features that characterize Castelseprio and that consequently these features must have been evolved as early as 800 A. D. This, coupled with the realization that Castelseprio, in turn, may not be free of Carolingian influences, has induced a number of scholars to advocate a date in the late eighth or early ninth century for these controversial frescoes (see especially Meyer Schapiro's reviews of the original Italian publication in *Magazine of Art*, 43, 1950, p. 312 f. and of Weitzmann's book in *Art Bulletin*, XXXIV, 1952, p. 147 f.; also E. Arslan in *Storia di Milano*, II, Milan 1954, p. 631 ff.). This dating, which in my opinion may well be the correct one, has been arrived at on various different grounds also by C. Cecchelli (in *Byzantinische Zeitschrift*, 45, 1952, p. 97 ff.), P. Lemerle ("L'Archéologie paleochrétienne en Italie: Milan et Castelseprio, 'Orient ou Rome'", *Byzantion*, XXII, 1952, p. 165 ff., especially p. 184 ff.) and G. Giacomelli (in *Felix Ravenna*, LIII, 1950, p. 58 ff.; LIV, 1950, p. 54 ff.). A. Grabar, who was one of the first to draw attention to the Carolingian affinities of the Castelseprio frescoes ("Les fresques de Castelseprio", *Gazette des Beaux-Arts*, 6th series, XXXVII, 1950, p. 107 ff.) has been somewhat non-committal in the matter of dating, but seems to favor a late or post-Carolingian date ("Les fresques de Castelseprio et l'Occident", *Frühmittelalterliche Kunst in den Alpenländern*, Olten and Lausanne 1954, p. 85 ff.). D. Tselos, who also stresses Carolingian connections (especially points of contact with the Utrecht Psalter), blurs the chronological – and stylistic – issue by speaking of a "seventh or eighth century" date ("A Greco-Italian School of Illuminators and Fresco-Painters", *Art Bulletin*, XXXVIII, 1956, p. 1 ff., especially p. 26 ff.).

The lack of tangible continuity among the monuments of hellenistic character also hampers the task of defining the style more precisely in geographical and historical terms. Morey and his school, as is well known, singled out Alexandria as the focus and fountainhead of the hellenistic style and sought to explain its emergence in other places through the emigration of Christian artists at the time of the Arab invasion.[29] Others, including a number of students of Umayyad art, have stipulated a strong local survival of hellenistic artistic traditions in Syria and Palestine, a survival which supposedly accounts for the vigorous assertion of these traditions in decorations such as those of the Mosque at Damascus, the Dome of the Rock and the desert castle of Qusayr Amra.[30] In recent years, on the other hand, a number of scholars have stressed the importance of Constantinople itself as a guardian of the hellenistic heritage in art during the period with which we are concerned.[31]

I shall briefly discuss the actual evidence from Egypt, Syria and Palestine below. Whereas such evidence will be found to be very meager indeed, there are, among the various manifestations of the hellenistic current which I have mentioned, at least two which have definite links with Constantinople. The control marks on the silver vessels afford, as we have seen, very strong evidence that the objects concerned (at least in their raw state, but in the majority of cases surely also in their finished state) issued from the imperial capital. And for the Umayyad mosaics we have literary records indicating that artists and materials were brought from Constantinople. Although a number of Islamic scholars have tried to discredit these records

[29] The basic studies are Avery, *op. cit.*, and C. R. Morey, "The Sources of Mediaeval Style", *Art Bulletin*, VII, 1924, p. 35 ff.; *Id.*, "Notes on East Christian Miniatures", *ibid.*, XI, 1929, p. 5 ff.; *Id.*, *Early Christian Art*, Princeton, 1942 (second ed. 1953). For critical reviews see below, n. 146.

[30] Among students of Christian art Capitani d'Arzago has tried to make a case for Syria and Palestine in the sense indicated (*Santa Maria di Castelseprio*, especially p. 692 ff.). Among students of Umayyad art who have argued in favor of a strong survival of hellenistic traditions in this area as late as 700 A. D. I cite E. de Lorey ("L'hellénisme et l'orient dans les mosaïques de la Mosquée des Omaiyades", *Ars Islamica*, I, 1934, p. 22 ff., especially p. 42), Marguerite van Berchem (in Creswell, *op. cit.*, pp. 227, 251) and K. A. C. Creswell (*ibid.*, p. 267 f.). The last-named author quotes a number of other scholars who have derived the frescoes of Qusayr Amra from Syrian antecedents and says that these frescoes "belong, not to the hieratic art of Byzantium, but to the late Classical art of Syria, and bear eloquent witness to its vitality." How untenable such an antithesis is, both on the Byzantine and on the Syrian side, will I hope emerge clearly from the present study. For Syria see also below, p. 33 ff. A. Frolow's demonstration that in the early ninth century mosaic work was done in the Church of the Holy Sepulcher by an artist from Damascus does not materially affect our problem since this artist belongs to a later period and his style is not known ("Le peintre Thomas de Damas et les mosaïques du Saint Sepulcre", *Bulletin d'Etudes Orientales*, XI, 1945–46, p. 121 ff.).

[31] M. Schapiro, review of Morey, *Early Christian Art* in *The Review of Religion*, 1944, p. 165 ff., especially p. 170; V. N. Lazarev, *History of Byzantine Painting* (in Russian), I, Moscow 1947, p. 53 ff.; Weitzmann, *The Fresco Cycle of S. Maria di Castelseprio*, p. 12 f.; Francovich, *op. cit.* (above n. 19; see also below n. 111).

their reliability has now been demonstrated beyond any reasonable doubt.[32] The literary data can be supplemented most happily by visual evidence, thanks to some recent finds in Constantinople. The mosaic decoration of a room over the southwest ramp of St. Sophia includes acanthus rinceaux (fig. 10) which afford a better comparison for the luxuriant style of Umayyad ornamental foliage than any of the examples from other regions which scholars had previously adduced.[33] The comparison applies specifically to the mosaics of the Dome of the Rock (fig. 9) and thus supplements the evidence of the literary sources which speak of workmen and materials being sent by the Byzantine emperor to decorate the mosques at Damascus and at Medina. The rinceaux decoration in St. Sophia, while certainly earlier than the Iconoclastic era, must be later than the original construction of the church under Justinian, that is to say, it probably dates from the latter half of the sixth or the seventh century.[34]

Silver plates and ornamental mosaics,[35] then, bear clear witness to the persistence of hellenistic taste in Constantinople itself in the seventh century. As for the Roman seventh and early eighth century frescoes and mosaics of hellenistic style, the thesis that they, too, owe much to Byzantium has a great deal to recommend it. They have been attributed to refugee artists from Alexandria largely on the basis of certain iconographic arguments. However, a comprehensive analysis of this material, and particularly of the scenes from the life of Christ in Sta. Maria Antiqua and in the Oratory of Pope John VII in Old St. Peter's, shows that from the iconographic point of view the Roman picture cycles, far from being "Alexandrian", are direct forerunners of those which appear in such indisputably Constantinopolitan works of the post-Iconoclastic period as the miniatures of Ms. Par. gr. 510 (880–886 A. D.).[36]

[32] This was done by H. A. R. Gibb in a lecture delivered at Dumbarton Oaks in October 1956 and due to be published in vol. XII of the *Dumbarton Oaks Papers*. Prof. Gibb has shown that the contrary opinion put forward by Marguerite van Berchem, J. Sauvaget and others is without foundation.

[33] For a brief preliminary account of this decoration see P. A. Underwood, "Notes on the Work of the Byzantine Institute in Istanbul: 1954", *Dumbarton Oaks Papers*, IX–X, 1956, p. 291 ff., especially p. 292 f. and figs. 107, 108.

[34] *Ibid.*, p. 293. This dating applies only to the rinceaux shown in figs. 107 and 108, not to those in the adjoining space illustrated in fig. 110. For the latter see *ibid.*, p. 294.

[35] For the likelihood that certain Umayyad floor mosaics must also be credited to imported rather than local Syrian artists see below p. 34 f.

[36] To demonstrate this point in detail would far exceed the scope of this paper. It should be said, however, that Miss Avery's "Alexandrian" theory (above, nn. 24, 29) was based on an arbitrary selection of iconographic details culled from frescoes of varying dates and styles in Sta. Maria Antiqua only, rather than on a systematic investigation of the whole iconography which appears in seventh and early eighth century Rome in association with work of hellenistic character, excluding, however, work not clearly related to that style. Only an investigation of this latter kind can do justice to the problem. A derivation of the Roman frescoes of hellenistic character from Constantinople has been advocated by Lazarev in his *History of Byzantine Painting* (p. 54; p. 286 f., n. 8) on the basis of stylistic comparisons with a mosaic fragment from the imperial capital published by H. Zhidkov (*Byzantinische Zeitschrift*, XXX, 1929–30, p. 601 ff.) and with the mosaics of the Church of the Dormition at Nicaea, which will be discussed presently.

The case for a strong survival of hellenistic style in the Constantinopolitan region in the period under discussion might be strengthened further, and, indeed, decisively, if full certainty could be obtained regarding the history of the mosaics in the bema of the Church of the Dormition at Nicaea. Lazarev in his History of Byzantine Painting has treated these mosaics, which are now lost but of which we have good photographs thanks to the publication by Schmit,[37] as a key monument with which to form an idea of pictorial art in the area of the Byzantine capital in the seventh century.[38] More recently the Nicaea mosaics have been the subject of a special study by G. de Francovich.[39] It is necessary, therefore, to devote to them a brief discussion, though it will not be possible in the present context to deal exhaustively with the many intricate problems connected with them, problems which have to do not only with style, but also with iconography and the theology underlying the choice of subjects, not to mention considerations of architecture, sculpture, epigraphy and historical sources which have a bearing on the question of date.

The crucial element for our purposes is the group of four angels arrayed in pairs in the two halves of the barrel vault preceding the apse (fig. 11). It is in them, and particularly in their heads, that all scholars concerned with the history of style in Byzantine art have recognized a remarkable instance of a survival of a fluid pictorial manner of evidently hellenistic derivation. For the date of that part of the mosaic decoration to which the figures of the angels belong we have two clues both of which yield, unfortunately, only rather vague *termini ante quos*. The first is very definite evidence that the decoration as a whole underwent changes as a result of a reaction to iconoclastic puritanism. A representation of the Virgin and Child was put in the center of the apse in place of a cross which had been there previously (fig. 28)[40] and the work of pious "anastelosis" was commemorated in a brief metric inscription which was wedged in between the two figures of angels in the right half of the same vault and which records the name of one Naukratios.[41] Since the Virgin is so clearly a later insertion and since no sutures comparable to those surrounding her appear in any other part of the mosaic decoration of the apse and the bema, it follows that all the rest, the angels included, is of a date earlier than Naukratios' "anastelosis".

[37] Th. Schmit, *Die Koimesis-Kirche von Nikaia*, Berlin and Leipzig 1927, pls. XIIff.

[38] Lazarev, *op. cit.*, p. 52ff.

[39] G. de Francovich, "I mosaici del bema della Chiesa della Dormizione di Nicea", *Scritti di Storia dell'Arte in Onore di Lionello Venturi*, Rome 1956, p. 3ff. The author provides a survey and bibliography of earlier discussions of these mosaics and their chronology. See, however, below, nn. 52,53, for certain serious omissions in his presentation of the problem.

[40] Schmit, *op. cit.*, pl. XX and p. 34.

[41] *Ibid.*, pl. XIII and p. 23; our fig. 11. E. Weigand draws attention to the similarity between the tenor of this inscription and that recording the "anastelosis" of holy images in the apse of St. Sophia in Constantinople after 842 A.D. (*Byzantion*, VI, 1931, p. 420). For the latter see below, n. 168.

The rest of the decoration appears to be indeed all of a piece, also as regards ornament and epigraphy.[42] But the date of Naukratios' restoration cannot be determined with certainty. While most scholars believe that an ostentatious act such as his could not have been performed until after the empire's definitive return to orthodoxy in 843, Schmit connected it with the first orthodox interlude that followed the Seventh Oecumenical Council held at Nicaea in 787.[43] This difference of opinion is perhaps not too important for our purposes. What is much more relevant is to determine the length of time by which the original decoration preceded Naukratios' work. According to some, this decoration, dominated, as it was, by a monumental cross, is a characteristic work of the Iconoclastic period,[44] while others, notably Schmit, Lazarev and Francovich, consider it pre-Iconoclastic.[45] Unfortunately our second clue does not provide a decisive answer to this problem. This second clue is the identity of the founder of the church whose monogram appears in the mosaic decoration itself, as well as on capitals, on the lintel of the main entrance to the church and on a parapet slab subsequently used as an altar table.[46] His name was Hyakinthos and, thanks to Professor Grégoire, we possess for him a *terminum ante quem* of 787 A. D.[47] This, however, still does not suffice to date the church and its original decoration with any precision and further arguments must be adduced.

To date Hyakinthos' decoration with its four monumental figures of angels in the period of Iconoclasm is impossible. As Wulff points out[48] such figures would have been highly objectionable at that time. One cannot get

[42] See Schmit, *op. cit.*, pls. XII–XIV and XX. Most scholars are agreed that the whole decoration, aside from the Virgin, is homogeneous, though Schmit points out that the hand of God in the celestial sphere above the Virgin is a later insertion (*ibid.*, p. 34). Wulff in his later writings ascribed the whole decoration, *including the Virgin* and with the sole exception of the cross, the ornamental frame of the apse, and the inscription surrounding the apse, to one period, namely, that of Naukratios' anastelosis, which he places after 842 A. D. (review of Schmit's book in *Repertorium für Kunstwissenschaft*, 52, 1931, p. 74 ff.; *Bibliographisch-Kritischer Nachtrag zu Altchristliche und Byzantinische Kunst* [*Handbuch der Kunstwissenschaft*], Potsdam n. d., p. 72). This view is untenable because of the absence of any break between the *background* of the arms of the cross (which must needs be of a period earlier than the Virgin) and the sphere with the triple rays and inscription above (which consequently must also antedate the Virgin). The sphere in turn is inseparable from the Hetoimasia in the center of the vault of the bema, which in turn links up with the angels (see below, n. 55). Thus, with the exception of the Virgin, everything hangs together.

[43] *Op. cit.*, p. 40f.

[44] Thus Weigand in his review of Schmit's book (*Deutsche Literaturzeitung*, 1927, col. 2601 ff.); see also his paper in *Byzantion*, VI, 1931, p. 411 ff.

[45] Schmit thought the original work to be of the sixth century (*op. cit.*, p. 38 f.). Lazarev attributes it to the seventh (*op. cit.*, p. 52 ff.). Francovich agrees with Schmit, though he would really prefer to go back as far as the fifth century (*op. cit.*, p. 13). Yet, at a later point in his study, he cites the Nicaea angels, along with the silver plates, as proofs that Constantinople remained faithful to hellenism down to the period of Iconoclasm (*ibid.*, p. 24). Here again we have an instance of the difficulty of dating work that comes under the heading of "perennial hellenism".

[46] Schmit, *op. cit.*, p. 12 f.

[47] H. Grégoire, "Encore le monastère d'Hyacinthe a Nicée", *Byzantion*, V, 1929–30, p. 287 ff.

[48] *Repertorium für Kunstwissenschaft*, 1931, p. 77.

around the difficulty by referring to angels as "niedrigere Geisteswesen".[49] Indeed, the anthromorphic representation of angels was traditionally a particularly serious stumbling block to those critical of the admission of the graven image by the Christian church.[50] Nor is it likely on historical grounds that Hyakinthos' activities fall in the period of Iconoclasm.[51] On the other hand, those who place Hyakinthos and his work as early as the sixth or early seventh century ignore to their peril Weigand's analysis of the ornaments of the parapet slabs and of the inscription in the form of monograms which the founder placed on one of these slabs.[52] The most likely date, then, for Hyakinthos' building and its decoration is the late seventh or early eighth century, i. e., the decades just before the outbreak of Iconoclasm.

We thus seem to have gained for the period in which we are interested a monument of capital importance in close vicinity to Constantinople itself. Yet for the history of style in the pictorial arts the gain is somewhat deceptive. For the four great figures of angels (and, as I have said, it is they that are principally of interest in this connection) cannot be accepted as reliable documents of the style of that period.

It seems strange that Naukratios' "anastelosis" should have been recorded so awkwardly in the space between two of these angels with which he supposedly had little or nothing to do.[53] Schmit has credited him only with a *pentimento* in the design of the wing of the angel inscribed "Dynamis" and with some additional minor repair work.[54] In actual fact his activity

[49] Weigand in *Deutsche Literaturzeitung*, 1927, col. 2607.

[50] E. Kitzinger, "The Cult of Images in the Age before Iconoclasm", *Dumbarton Oaks Papers*, VIII, 1954, p. 83 ff., especially, pp. 131, 139 with n. 242.

[51] Grégoire, *op. cit.*, pp. 290, 292 f.

[52] Schmit, *op. cit.*, pl. X f.; cf. Weigand as quoted above n. 44. Francovich omits all mention of Weigand's article in *Byzantion*. Weigand's outline history of monogrammatic inscriptions provides a strong argument against those who ascribe an early date to Hyakinthos (even though, as H. Stern has pointed out to me, Weigand has failed to mention the fact that such inscriptions do have an early forerunner in the West in the frontispiece of the Calendar of 354 A. D.; cf. H. Stern, *Le Calendrier de 354*, Paris 1953, p. 118 and pl. I). Surely Weigand's argument cannot be disposed of by saying that only stylistic considerations are valid (Francovich *op. cit.*, p. 6). In actual fact, Weigand had made extensive use also of stylistic arguments (cf. especially *Deutsche Literaturzeitung*, 1927, col. 2605 f.). The fact that these arguments have to do with Hyakinthos' *sculptures* rather than with his mosaics makes them no less pertinent to the problem of date. Weigand should not, however, have cited as a safe chronological landmark the so-called Heraclius capitals (R. Kautzsch, *Kapitellstudien*, Berlin and Leipzig 1936, p. 202 f., nos. 688–690), for the inscription on capital no. 755 in the Istanbul Archaeological Museum, on which the dating of these capitals has been based, is without any doubt a secondary feature. Even so Weigand was certainly right in insisting that the style of Hyakinthos' sculptures indicates a relatively advanced date.

[53] The circumstance has troubled Wulff (*Repertorium für Kunstwissenschaft*, 1931, p. 76), though the conclusions he draws from it are unacceptable; cf. above n. 42. In Francovich's paper the inscription of Naukratios is not mentioned at all.

[54] *Op. cit.*, pp. 23, 26 ff. It should be noted here that the fastening of the setting-bed with nails is standard procedure in mosaic work and no indication of repair; see e. g. G. Matthiae, *SS. Cosma e Damiano e S. Teodoro*, Rome 1948, p. 41; H. Torp, "Quelques remarques sur les mosaïques de l'église Saint-Georges à Thessalonique", *Acts of the Ninth International Congress of Byzantine Studies, Salonika 12–19 April 1953* (title in Greek), I, Athens 1955, p. 491.

must have been quite extensive. Throughout the work at Nicaea one can observe what is indeed standard practice of Byzantine mosaicists, namely, the "trimming" of all shapes (figures, inanimate objects, letters of inscriptions) with gold cubes which follow the contours of the pattern concerned and against which the – normally horizontal – rows of cubes of the background (presumably set *after* the figures) abut. At Nicaea, both in the work of the first period and also in the figure of the Virgin which is wholly the work of Naukratios, there is normally a single row of cubes which make up this trimming. Schmit's plates permit one to follow their course quite clearly in most places. The trimming can be seen to surround the standards carried by the four angels and there can thus be no question that four standard bearing angels were from the outset part of the decoration.[55] But in the figures themselves the trimming becomes quite irregular. In places there is the normal single row of cubes,[56] in others there are two rows,[57] in others again none at all.[58] This is a sign of repairs far more extensive than those noted by Schmit. One should not look here for a continuous suture such as that which surrounds the figure of the Virgin and marks the shape of the cross that once was in her place. In the case of the angels no change of subject was involved. Hence Naukratios was able to carry out major repairs and to insert his inscription without there resulting a clear and continuous line of demarcation between his work and the pre-existent mosaic surface. A fairly skillful blending of the new with the old was entirely possible, and in areas where such blending occurred a minor symptom such as disturbances in the trimming may assume great significance. It is particularly noteworthy that in the four haloes the original trimming appears greatly disturbed. The damage repaired by Naukratios may have been done deliberately during Iconoclasm and may have affected particularly the heads. In the circumstances it is no longer possible to judge with any accuracy the degree to which these heads, or, for that matter, the rest of the figures, preserve their original appearance. They cannot be considered as pure examples of the style of the period when they were first made, nor, on the other hand, of the period when they were repaired. They may have features of both periods. Iconographically they can be considered as belonging defi-

[55] See particularly Schmit, *op. cit.*, pl. XII, which shows clearly that in point of technique the standards are of a piece with the gold ground in the central part of the vault and with the aura surrounding the Hetoimasia. This undisturbed area with normal trimming also includes the name inscriptions of the four angels (which may therefore also be accepted as being of the original period), with the exception of the first two letters of "Arche" which lack the trimming and are irregularly spaced (see our fig. 11). It is from this zone down that one must reckon with extensive repairs.

[56] E. g. around the lower contours of "Arche" and "Kyriotites".

[57] E. g. around the lower left hand contours of "Dynamis".

[58] This appears to be true especially of large portions of the haloes, though that of "Exousie" has normal trimming at least in part (see Schmit's pl. XIX). In the lower half of the figure and the wings of "Exousie" the trimming, if present at all, is irregular.

nitely to the pre-Iconoclastic age.[59] But their stylistic identity is blurred. While it is not likely that in their pristine aspect they differed radically from what has been preserved for us on Schmit's plates, for the purposes of a detailed analysis they cannot be regarded as reliable documents of seventh century style.

I would hesitate, therefore, to assign to the angels of Nicaea a key role in an assessment of the art of the Constantinopolitan region in this period. Only in a vague sense may they be said to reinforce the thesis that the art of the capital in the seventh century was characterized by a strong survival of hellenistic traditions. Even so there can be little doubt that this thesis is correct. The other witnesses I have mentioned alone suffice to bear it out. Thus although I cannot agree either with Lazarev's or with Francovich's views concerning the Nicaea mosaics themselves, I entirely concur with these scholars in their insistence on the importance of Constantinople as a center and guardian of the hellenistic tradition in pre-Iconoclastic art. It does not follow, however, that this was the *only* artistic tradition which prevailed in the capital at that time. Indeed, this is a notion which one must reject as soon as one looks more closely into the history of the other stylistic current characteristic of the period, the abstract, linear and two-dimensional.

II.

To illustrate this style let us turn first to a series of major monuments in Rome which are reliably dated and thus permit us to follow its growth. In the mosaic of the apse of SS. Cosma e Damiano,[60] dating from the pontificate of Felix IV (526–530) – i. e., in Byzantine terms, the earliest years of the reign of Justinian – we find that remarkable synthesis, that inner tension generated by a balancing of opposing forces which makes many of the greatest works of that era so powerfully impressive (fig. 12). Figures are three-dimensional, not to say ponderous, organically built and seemingly autonomous. They are like heroic actors moving on a spacious if shallow stage against a dramatic backdrop of dark blue sky and purple clouds. Yet they are rigidly organized, subordinated to a nearly symmetrical overall scheme which is essentially two-dimensional and imposes a bold and clear surface pattern on the whole composition. There is a corresponding contrast in individual faces which show a heavy mass and an intense vitality barely contained in a firm and strongly emphasized framework of lines (fig. 15). In the mosaic of the triumphal arch of S. Lorenzo fuori le

[59] For the purpose of interpreting the program of the original decoration of the time of Hyakinthos should one not reckon with the possibility that there was in the center of the apse a figure of the Virgin and Child which was then replaced by a cross during Iconoclasm, while the angels in the bema were merely defaced? In other words, Naukratios would simply have restored the *status quo* that had existed under Hyakinthos. This would remove Wulff's objection (*Repertorium für Kunstwissenschaft*, 1931, p. 77) that the three rays issuing from the celestial sphere in the apex of the apse, and particularly the quotation from Ps. 110,3 surrounding that sphere, do not make good sense in relation to the cross.

[60] Matthiae, *op. cit*. For the state of preservation see *ibid.*, p. 9ff. and pl. I.

mura, a work of the period of Pope Pelagius II (578–590),[61] no such tension remains (fig. 13, 16). Although a heritage of the earlier work can still be felt, both in the composition and in individual motifs, the figures are little more than specters, ghosts of their former selves, statically aligned before a neutral gold ground. Heads have shrunk, bodies have lost their weight and volume, draperies are reduced to linear schemes.[62] Obviously, a tremendous change lies between these two mosaics, a change which one is tempted to describe largely in negative terms. Loss of action, loss of bodily substance and spatial depth, loss of force – these are some of the expressions one inevitably uses in connection with this and other Italian monuments of the second half of the sixth century.[63] What this change means in positive terms becomes more clearly apparent in another Roman mosaic, done some forty years later, in the Church of S. Agnese (fig. 14).[64] In this work abstraction, elimination of the third dimension, linearism and passivity have become means of establishing a new order of geometric simplicity. Three gaunt and rigid figures are evenly and symmetrically spaced on a vast expanse of gold ground. There is no tension, no conflict between volume and plane, between dramatic action and static pattern. The latter dominates entirely and imposes its laws upon the figures. Each of them confronts the spectator motionlessly and quietly and impresses him by its simple, lonely presence.

Other Roman mosaics of the seventh century, notably those of the Oratory of S. Venanzio[65] and of S. Stefano Rotondo[66], show essentially similar

[61] A. Muñoz, *La Basilica di S. Lorenzo fuori le mura*, Rome 1944, pl. LXXXII f. For the state of preservation see *ibid.*, p. 47 f. and pl. LXXXV. Cf. also G. Matthiae, "Tradizione e reazione nei mosaici Romani dei Sec. VI e VII", *Proporzioni*, III, 1950, p. 10 ff., with close-up views of two heads (pl. XII f.).

[62] This characterization remains valid even if one assumes with P. Baldass that only a small part of the mosaic has come down to us in its original state ("The Mosaic of the Triumphal Arch of San Lorenzo fuori le Mura", *Gazette des Beaux-Arts*, 6th series, XLIX, 1957, p. 1 ff.). In my opinion, however, this author has gone much too far. There are, it is true, within this work certain stylistic discrepancies which the known restorations of post-medieval times can hardly account for (cf. also Matthiae, *op. cit.*, p. 11 ff.). But to ascribe five of the figures almost in their entirety to the period about 1100 A. D. raises more problems than it solves. A parallel for these figures (and also for some of the linear conventions so strongly apparent in the rendering of their draperies) is provided by a fresco in the catacomb of S. Ponziano which can hardly be later than the sixth century (J. Wilpert, *Die Malereien der Katakomben Roms*, Freiburg i. B. 1903, pl. 255). Incidentally, although Baldass considers so large a portion of the mosaic as restored in later times, he characterizes the style of Pelagius' period in substantially the same terms as I have done (*op. cit.*, p. 8).

[63] Kitzinger, *Römische Malerei* (above, n. 1), p. 5, p. 47, nn. 3, 4.

[64] M. van Berchem and E. Clouzot, *Mosaïques chrétiennes du IV^e au X^e siècle*, Geneva 1924, p. 195 ff. For the state of preservation see Kitzinger, *op. cit.*, p. 38.

[65] Berchem and Clouzot, *op. cit.*, p. 199 ff. E. Dyggve, *History of Salonitan Christianity*, Oslo 1951, figs. IV, 46, 47 (close-up views of two heads). For the state of preservation see D. Redig de Campos in *Atti dell. Pontificia Accademia Romana di Archeologia*, Serie III, *Rendiconti*, XXIII–XXIV, 1947–49, p. 401, fig. 30 and p. 402; also Kitzinger, *op. cit.*, p. 38.

[66] Berchem and Clouzot, *op. cit.*, p. 205 f. Matthiae, *op. cit.* (above, n. 61), pl. XIV, fig. 7, and Baldass, *op. cit.*, p. 3, fig. 2, reproduce close-up views. For the state of preservation see Kitzinger, *op. cit.*, p. 38.

characteristics. Figures lack bodily substance – those of the saints aligned on either side of the apse of S. Venanzio are perhaps the most insubstantial and phantom-like which the century has left us – and in each case they are presented as parts of a simple, tidy surface pattern which firmly closes off the third dimension.

Nowhere else can one observe as clearly as in these Roman mosaics the tremendous strides towards a purely conceptual, abstract art that were made in the hundred years between the early part of the reign of Justinian and the age of Heraclius. Although the radically unclassical tendencies which here come to the fore had long been in the making these mosaics bear witness to a decisive break-through in the direction of purely mediaeval ideals of form. Care must be taken, it is true, in considering the monuments I have mentioned as exponents of a single and consecutive evolutionary process even within Rome, and still greater care in accepting them as evidence of such a process in the East. Each work exhibits different stylistic nuances, for in Roman art of this period Byzantine influences of various kinds mix in varying degrees with local elements. But there can be no doubt that in broad terms these Roman mosaics do testify to a general development which, in different local variants, took place during the same period in the Eastern Mediterranean regions as well and to which the art of Constantinople itself was not immune.

When it comes to demonstrating that the capital, in addition to harboring a tradition of perennial hellenism, was also a center actively involved in the promotion of a radically abstract style we are again impeded by the shortage of works of art of the late sixth and seventh centuries which can be securely ascribed to Constantinople. Once more we shall have to operate to some extent by inference, though direct evidence is not lacking entirely.

Thirty years ago Marc Rosenberg pointed out that the famous Cross of Justin in the Treasury of St. Peter's in Rome, according to its inscription an imperial gift and without any doubt donated to Rome by the second Justin and his wife Sophia, must be a product of Constantinopolitan court art (fig. 18).[67] Subsequently, Peirce and Tyler drew attention to the stylistic connection between the figures on the Vatican cross and those on the silver paten from Stuma in the museum of Istanbul (fig. 19).[68] This connection becomes particularly significant in the light of Miss Cruikshank's observation that the hallmarks of the Stuma paten date from the reign of Justin II.[68a] Hallmarks furnish not only a precise date but also, as we have seen, strong evidence that the object concerned comes from the capital. We thus have two metal objects of the period around 570 A. D. which independently point to Constantinople as their place of origin and which

[67] M. Rosenberg, "Ein goldenes Pektoralkreuz", *Pantheon*, I, 1928, p. 151 ff., especially p. 154. *Ibid.*, p. 155, fig. 8, good close-up views of details. Peirce and Tyler, *L'art byzantin*, II, pls. 136, 199 b.
[68] *Ibid.*, pl. 140 and pp. 111 f., 114 f.
[68a] *Dumbarton Oaks Papers*, XI, 1957, p. 244 n. 30. The hallmarks are visible on pl. 140 B of Peirce and Tyler.

exhibit characteristics quite different from those which we had previously associated with the work of silversmiths in the capital. The figures both on the cross and on the paten are rendered in a sharp, linear manner, heads are small, faces schematized and lifeless, attitudes rigid and draperies turned into conventional patterns.[69]

I am aware that the Stuma paten has been considered almost universally as a product of Syria. Even scholars who have insisted on the importance of hallmarks as affording evidence of Constantinopolitan origin have failed to draw the logical conclusion so far as the Stuma paten is concerned and have in this instance relied on the findspot as an indication of the place of manufacture.[70] But it is difficult to see why the findspot should be any more decisive in this case than in that of other stamped silver objects, especially since, thanks to the stylistic relationship to the cross of Justin II, we have for the Stuma paten an additional pointer indicating manufacture in the capital. Rather than try to explain through regional factors the vast stylistic discrepancy which sets off these two pieces from the silver reliefs previously ascribed to Constantinople, it would seem more natural to call to mind the fact that in the case of the cross and the paten we are dealing with liturgical objects with decidedly Christian subject matter. I shall have to say more about the correlation of function and subject matter, on the one hand, and style, on the other, in later sections of this paper.

Our survey has led us to the two extremes of hellenism and abstraction that can be found in silver objects with imperial hallmarks. In a more detailed study of this particular material one would have to take into account in addition works which from the stylistic point of view occupy what might be called an intermediate position and thus add further to the complexity of the historical picture. Thus it is well known that the Stuma paten has a companion piece, now at Dumbarton Oaks, identical in subject matter but strikingly different in style (fig. 20).[71] It is devoid of the linear conventions of the Stuma paten, though on the other hand its figures also lack the ease and elegance of the mythological reliefs and instead appear consumed by an intense emotional life. This plate, too, was found in Syria and is generally considered as an example of Syrian "expressionism".[72] But the Dumbarton Oaks paten has imperial hallmarks and, unless there are really compelling reasons to the contrary, it, too, should be ascribed to a workshop in the capital. If it does not measure up either to the free and relaxed manner of the mythological reliefs or the classicist precision of the

[69] See also below, n. 116, for the unclassical type of ornament on Justin's cross.

[70] Matsulevich, *Byzantinische Antike*, p. 63. Francovich, in *Commentari*, II, 1951, pp. 7, 13f., 16. K. Weitzmann, "Das klassische Erbe in der Kunst Konstantinopels", *Alte und Neue Kunst*, III, 1954, p. 41ff., especially p. 47. But Matsulevich certainly and Francovich and Weitzmann possibly were unaware of the hallmarks on the Stuma paten.

[71] L. Bréhier, "Les trésors d'argenterie syrienne", *Gazette des Beaux-Arts*, 5th series, I, 1920, p. 173ff. Peirce and Tyler, *op. cit.*, II, pl. 144. *The Dumbarton Oaks Collection, Handbook*, 1955, no. 129. For the hallmarks see Rosenberg, *Der Goldschmiede Merkzeichen*, IV, p. 686f.

[72] See especially Bréhier, *op. cit.*, and Francovich, *op. cit.*

David plates, should one not take into account here again the purpose of the object and the subject matter depicted on it?

The emergence of frankly unclassical or, indeed, anticlassical tendencies in the art of the capital can be observed also by studying the rendering of the imperial portraits on coins. Though stylistic trends in coinage are not always reliable guides to the general history of style in a given reign, over a longer period they do inevitably reflect larger developments. Comparing the portraits of Justinian (fig. 21a, b) and his successors down to the end of the sixth century on Constantinopolitan coins one notices a steady falling-off of organic substance. The portraits of Phocas constitute a low point in this process of shrivelling and reduction (fig. 21c). In those of Heraclius and his immediate successors we find a frank assertion of abstract patterns in composition and outlines, as well as in the rendering of facial features, hair and beard (fig. 21d). The die-sinker's work, in fact, permits us to discern, if only rather dimly, a line of evolution strikingly parallel to that which we have observed in the Roman mosaics.[73]

What makes this current in Constantinopolitan art of the late sixth and seventh centuries so difficult to grasp is the lack of large scale monuments. We do, however, have such monuments in Salonika, the second city of the empire, and particularly in the great church of St. Demetrius where a number of mosaics of this period have survived. One of these has already been cited earlier in this study as an outstanding example of the abstract manner. We must now examine these mosaics more closely, especially also with a view to exploring their relationship to the art of the capital. For in Salonika, as in Rome (and Ravenna), any post-classical and early mediaeval monument must be considered with the question of foreign versus local factors in mind.

Among the mosaics of the church of St. Demetrius, which are votive gifts by various individuals rather than parts of a single overall decoration with a unified iconographic program, two groups must be distinguished: those made before the fire which destroyed part of the church in the early seventh century and those made afterwards. The first group, which was concentrated mainly in the inner north aisle of the basilica, was sadly decimated in the disastrous fire of 1917. Some fragments, however, remain and photographs, copies and descriptions exist of the entire series.[74] The second group consists

[73] The process here outlined can be studied with the help of the photographic reproductions in W. Wroth, *Catalogue of the Imperial Byzantine Coins in the British Museum*, London 1908, and I. I. Tolstoi, *Monnaies Byzantines* (in Russian), St. Petersburg 1912–14. Our fig. 21 offers a selection of enlargements of imperial portraits on Constantinopolitan gold coins in the Dumbarton Oaks Collection.

[74] The principal series of mosaics of the first group was on the northern arcade of the inner north aisle. The best photographic reproductions of this series are on seven consecutive plates accompanying an article by Th. I. Uspenskii and N. K. Kluge ("On the newly discovered mosaics in the Church of St. Demetrius in Salonika" [in Russian], *Izviestiia of the Russian Archaeological Institute in Constantinople*, XIV, 1909, p. 1 ff.; see especially pls. 6–12). These mosaics were destroyed in 1917, except for part of an orant figure of St. Demetrius (*ibid.*, pl. 6) now exhibited in the crypt of the church; cf. G. and M. Sotiriou, *The Basilica of St. Demetrius in Salonika* (in Greek), Athens 1952,

of a few additions to and restorations of the aisle mosaics after the fire,[75] a fragmentary panel on the west wall of the nave,[76] and another set of votive images on the piers flanking the entrance to the chancel.[77]

The date of the mosaics of the first group has been much debated. Sotiriou believes that they were made as early as the fifth century, at least in part;[78] others have attributed them to the sixth century;[79] Lazarev has suggested the period just before the early seventh century fire;[80] while yet others, denying or ignoring the relevance of that fire as a *terminus ante quem*, have proposed a date in the seventh century without qualification.[81] In part the difficulties which many scholars have experienced in dating this group no doubt are due to the fact that after 1917 only a small portion of it could be studied in the original. But a more important reason is the evident and inherent lack of stylistic homogeneity in the mosaics themselves. This can be clearly seen in the extant fragments, particularly in that in the south aisle in which a landscape background boldly sketched in the manner inherited from hellenistic impressionism contrasts oddly with the flat and linear rendering of the human figures. The garments of the latter, with their geometric-

p. 188 and p. 190, fig. 77. Kluge's text (*op. cit.*, p. 62 ff.), based on a minute and careful examination of the originals, establishes beyond all possible doubt the fact that the majority of these mosaics antedate the fire of the early seventh century. Some of his technical observations can be verified even on the photographs. It is to be hoped that the colored copies of the lost mosaics which are in the possession of the British School in Athens will soon be published and that these will permit a more detailed study of this important material (cf. D. Talbot Rice, "The lost mosaics of St. Demetrios, Salonica", *Acts of the Ninth International Congress of Byzantine Studies, Salonika 12–19 April 1953* [title in Greek], I, Athens 1955, p. 474; also Sotiriou, *op. cit.*, p. 189 f.). After the fire of 1917 a fragmentary mosaic panel was discovered on the west wall of the same aisle (Sotiriou, *op. cit.*, pl. 60 f.; p. 186 fig. 74, p. 191), while another fragmentary panel came to light as early as 1907 in a corresponding position in the inner south aisle (*ibid.*, pl. 62 and p. 192 f.; our fig. 22). Both these panels are still extant. While not identical in style both exhibit characteristics of the mosaics made before the seventh century fire rather than of those made afterwards (see below). For a detailed iconographic analysis of the whole series see A. Grabar, *Martyrium*, Paris 1946, II, p. 87 ff.

[75] Kluge, *op. cit.*, p. 62 ff. and pls. 8, 9. Ch. Diehl, M. Le Tourneau, H. Saladin, *Les monuments chrétiens de Salonique*, Paris 1918, pl. XXXII, 1. Sotiriou, *op. cit.*, p. 189, fig. 76 (three medallions with inscription referring to the fire).

[76] Sotiriou, *op. cit.*, pl. 69 f. and p. 198; cf. below n. 105.

[77] *Ibid.*, pls. 63–68 and 71a; p. 193 ff. Our figs. 1, 23.

[78] *Ibid.*, p. 191 (for his pl. 60 f.); for his pl. 62 he proposes a date in the Justinianic era (*ibid.*, p. 192 f.).

[79] O. Wulff, *Altchristliche und byzantinische Kunst (Handbuch der Kunstwissenschaft)*, II, Berlin-Neubabelsberg 1918, p. 446 f. Diehl, *op. cit.*, p. 104 (cf. also *Byzantion*, VII, 1932, p. 336 f.). S. Der Nersessian, review of Morey, *Early Christian Art* in *Art Bulletin*, XXV, 1943, p. 80 ff., especially p. 85. A. Xyngopoulos, *The Basilica of St. Demetrius in Salonika* (in Greek), Salonika 1946, p. 43 ("sixth or even fifth century"). A. Frolow, "La mosaïque murale byzantine", *Byzantinoslavica*, XII, 1951, p. 180 ff., especially p. 188.

[80] *History of Byzantine Painting*, p. 56 f. with n. 12 on p. 288 f.

[81] N. P. Kondakov, *Iconography of the Mother of God* (in Russian), II, St. Petersburg 1914, p. 354 ff. C. R. Morey, "A Note on the Date of the Mosaic of Hosios David, Salonica", *Byzantion*, VII, 1932, p. 339 ff., especially p. 343 f. (cf. also *Id.*, *Early Christian Art*, 1953, p. 188 f.).

ally conventionalized folds, appear to be draped on wire frames rather than bodies of flesh and blood (fig. 22).[82] It is easy to recognize the same combination of seemingly incompatible styles in the reproductions of some of the lost mosaics of the north aisle.[83] While those features that fall under the heading of "perennial hellenism" are, as usual, difficult to date it is possible to suggest an approximate date for the group on the strength of these flat and linear elements. Anaemic and wraith-like figures such as those of the donors in the extant panel in the south aisle, with their tiny heads and their uncertain stance, evidently presuppose that process of dematerialization which we have found characteristic of the advanced sixth century. They belong to a phase comparable to that which in Rome is represented by the mosaic of S. Lorenzo fuori le mura (fig. 13). If we find in the Greek work a looseness, a volatility unfamiliar in Western mosaics or paintings of the period, if it shows less firmness of line, less sharpness in the design, this is undoubtedly due to the hellenistic tradition which was still alive in the Eastern workshops and was given free rein in some of the backgrounds. But the period taste for the linear, the wraith-like and immaterial is unmistakable. There clearly were many figures also in the lost mosaics in the north aisle which exhibited these characteristics.[84] In my opinion the bulk of the mosaics of the first group in St. Demetrius must be attributed to the end of the sixth or the beginning of the seventh century. Given the fact that they are individual ex-votos their execution could well have been spread over several decades. In any case, however, I agree with Lazarev that the majority of these mosaics was still fairly new at the time of the fire.

Their curiously ambiguous style appears to be rooted in local tradition. To substantiate this assertion it is necessary to speak briefly, and by way of a digression, of other mosaic decorations of the early Byzantine period which have survived in Salonika. The city boasts certain monuments which are truly metropolitan, that is to say, executed by artists from the imperial capital and without local roots. Such a work is the mosaic decoration of the rotunda of St. George, the church which stands in the precincts of the imperial palace. Thanks to a recent cleaning these mosaics stand revealed as being of a quality barely equalled and certainly not surpassed by any other relic of Byzantine mural decoration prior to the "Second Golden Age". This is pure imperial Constantinopolitan art. The very fact that these mosaics are of such extraordinarily high quality makes them difficult to date[85], for there

[82] Sotiriou, *op. cit.*, pl. 62.

[83] Cf. especially Uspenskii and Kluge, pl. 7.

[84] *Ibid.*, pls. 6, 7, 11, 12. The head at the extreme left of pl. 11 – a portrait of St. Peter, according to Grabar, *Martyrium*, II, p. 98 f. – may be compared with that of St. Hippolyt at S. Lorenzo (Matthiae, *op. cit.* – above, n. 61 – pl. XII, fig. 3; our fig. 16).

[85] While E. Weigand ("Der Kalenderfries von Hagios Georgios in Thessalonike", *Byzantinische Zeitschrift*, XXXIX, 1939, p. 116 ff.) ascribed these mosaics to the early sixth century, H. Torp, who was able to study them after they had been cleaned and to take into account certain technical observations made on that occasion, has proposed a date in the period of Theodosius I; see *op. cit.*

are no adequate comparisons. But they certainly belong to an age preceding by a considerable margin that with which we are concerned. It stands to reason that the impact of so outstanding an achievement should be felt in other mosaic work in Salonika.

Indeed, in the ornamental mosaics of the Basilica of the Acheiropoietos, as well as in the ornamental frame of the apse mosaic of Hosios David, one encounters details which look like somewhat debased versions of motifs which occur in their pure form in St. George and evidently had become part of the local tradition[86]. Both these works, then, are in a certain sense derivative. For our purposes it is chiefly the mosaic of Hosios David which is of interest. For here we find somewhat the same mixture of styles that characterizes the first group of mosaics in St. Demetrius, a wavering and oscillating between impressionism and linearism. The mosaic of Hosios David was first published as a work of the last decades of the fifth century, but this dating rests on nothing more substantial than a rather general comparison with the mosaic of the Good Shepherd in the mausoleum of Galla Placidia at Ravenna.[87] In actual fact the tapestry-like density of the composition, which in spite of the landscape background is essentially two-dimensional, would be hard to match in any fifth century work, as would the heavy reliance on outlines in the design of faces and draperies. Analogies at least as convincing as the Ravenna mosaic can be found much closer at hand. The aisle mosaics of St. Demetrius not only show or showed a similar combination of a loose and diffuse mosaic texture with a linear figure design and similarly cluttered compositions, they also offer comparisons for a number of specific details.[88] Several scholars have already felt

(above, n. 54). A full publication of this extraordinarily important monument has been promised and it is to to be hoped that it will settle the question in a definitive way. See also the next footnote.

[86] For the ornament in Hosios David see A. Xyngopoulos, "The Church of the Latomus Monastery in Salonika and its Mosaic" (in Greek), *Archaiologikon Deltion*, 12, 1929, p. 142 ff., especially p. 160, fig. 20; on p. 170 the comparison with St. George. I lack the illustrations with which to demonstrate certain connections between ornaments in the Acheiropoietos Church and in St. George, connections of which I became aware when studying the mosaics on the spot. For the mosaics of the Acheiropoietos Church see in general Diehl-Le Tourneau-Saladin, *op. cit.*, p. 52 ff. and pls. VIII–XII. The church was built certainly not much later than the middle of the fifth century (Kautzsch, *Kapitellstudien*, p. 134 ff., on the capitals) and is considered by many as dating from before 450 A. D.; see most recently A. Xyngopoulos, "Constantine Harmenopoulos' Notices on the Church of the Acheiropoietos in Salonika" (in Greek), *Tomos Konstantinou Harmenopoulou* (University of Salonika, School of Legal and Economic Sciences, *Epistemonike Epeteris*, VI, 1952), p. 1 ff., especially p. 11 f. Since the mosaic decoration, which is surely an original part of the building, appears to presuppose that of St. George it may provide an approximate *terminus ante quem* for the latter, at least in the sense that Weigand's early sixth century date would seem to be too late (see preceding footnote).

[87] Xyngopoulos, in *Archaiologikon Deltion*, 1929, p. 171 f.

[88] Xyngopoulos himself (*ibid.*, p. 166) compared the head of the angel in Hosios David (his fig. 25) with a lost one from St. Demetrius. Among the extant fragments in that church it is chiefly that at the west end of the south aisle (our fig. 22) which should be compared. Thus the head of the patron saint with its regular outlines and blurred, fuzzy features recalls that of Christ at Hosios David (*ibid.*, fig. 22); compare also the trees (*ibid.*, pl. 7).

the need to ascribe to the mosaic of Hosios David a date somewhat later than the one originally proposed.[89]

Exactly how much later it may be is a debatable question which I shall not attempt to settle here. The difficulty is that in a work of the sixth century one would expect to find signs of either the approach or the impact of Justinianic art as we know it from monuments at Ravenna and elsewhere. Of such signs there are few or none. But this is precisely the point which is of interest to us. The mosaic, though more plausibly dated in the sixth century than in the fifth, seems to stand outside the main stream of the Byzantine development of that period. The natural conclusion is that at Salonika there was a school of mosaicists sustained by a strong heritage of perennial hellenism, but sliding imperceptibly into a more and more linear and two-dimensional manner without ever accepting the discipline of Justinianic form with its consistent interpenetration and dynamic synthesis of the organic and the abstract. It is this same tradition which accounts for the aisle mosaics of St. Demetrius. Although in some of the latter one may discern echoes of Justinianic types and forms[90] these merely serve to blur further the physiognomy of this curiously elusive and eclectic style. Wulff very properly has spoken a propos of these mosaics of a "Verflauung" of Justinianic monumentality.[91] The ex-votos which the good citizens of Salonika commissioned for the church of their patron saint prior to the fire, and in which they had themselves depicted paying their devotions to him, clearly were local products.[92]

It was necessary to define in some detail the artistic milieu to which these mosaics owe their existence. Only in this way can we arrive at a correct evaluation of the second group of mosaics in the basilica, i. e. those executed after the fire. The point which needs to be stressed is the lack of any direct continuity between the two groups. Though they are often lumped together in art historical discussions, the later mosaics share with the earlier ones only the most general characteristics. There is in the later panels a firmness and precision of line, a tightness in the overall arrangement, noticeable particularly in the rigid enframement of the figures by their back-

[89] While Xyngopoulos' date was accepted without reservation by Diehl ("A propos de la mosaïque d'Hosios David à Salonique", *Byzantion*, VII, 1932, p. 333 ff.), Wulff (*Bibliographisch-kritischer Nachtrag*, p. 46), Der Nersessian (*Art Bulletin*, 1943, p. 84 f.) and Grabar (*Martyrium*, II, p. 98, n. 2), Weigand proposed a date about 500 A. D. (*Byzantinische Zeitschrift*, XXXIII, 1933, p. 211 ff.), Peirce and Tyler the period 535–40 (*L'art byzantin*, II, p. 91 f.), Lazarev the early sixth century (*History of Byzantine Painting*, pp. 49, 283 f.). Morey considered the mosaics of Hosios David and those in the aisles of St. Demetrius as seventh century works under Alexandrian influence (*Byzantion*, VII, 1932, p. 339 ff.).

[90] Diehl-Le Tourneau-Saladin, *op. cit.*, p. 104 f. The panel at the west end of the north aisle discovered in 1917 (Sotiriou, *The Basilica of St. Demetrius in Salonika*, pl. 60 f.) has features which seem to echo the art of S. Vitale; cf. especially the stylized clouds and the angel emerging from them (P. Toesca, *S. Vitale de Ravenne : Les Mosaïques*, Milan and Paris, 1952, pl. XVII: "Sky" behind symbol of St. Luke; pl. XVIII: angel of St. Matthew).

[91] *Altchristliche und byzantinische Kunst*, II, p. 446.

[92] There may still be echoes of the mosaics of St. George here, particularly in the representa-

drops, a frank and bold use of geometric principles as a positive means of organizing forms, and a vigor and liveliness of color such as cannot be found in the earlier ones. In terms of the Salonikan past, at least so far as we know it, this is a new departure.

The core of this second group is a series of ex-votos on the narrow western and eastern faces and the broad inner faces of the two piers at the entrance to the chancel. With one exception these six panels form a single set, undoubtedly devised and executed at one time. On the sides facing west are two complementary panels each with the gaunt, tall orant figure of a saint in court costume. The one on the left (fig. 23),[93] who is shown offering his protection to two children, is uninscribed and is usually called St. Demetrius. He does not, however, show the typical features of the patron saint, as depicted with remarkably little variation in so many representations in this church and elsewhere, and since his pendant on the right[94] is inscribed "St. Sergius" it seems more likely that he should be identified with Sergius' twin saint, Bacchus. The two would seem to appear here as "synnaoi" of St. Demetrius, as they do also on a little enamel reliquary in the Dumbarton Oaks Collection.[95] Demetrius himself may be seen in the two panels on the eastern faces of the same piers which were only uncovered in recent years. On the northern pier he is shown alone, in the attitude of an orant and with an inscription below which records the vow "of him whose name is known to God".[96] In the corresponding panel to the south the patron saint is represented placing a protective hand on the shoulder of a deacon.[97] This panel must be viewed in conjunction with that which adjoins it on the inner face of the same pier, the well known representation of St. Demetrius flanked by a bishop and a high secular official, who, in the inscription below, are referred to as "founders" (fig. 1).[98] All these ex-votos appear to form part of a single scheme. While on the southern pier a lay dignitary, a bishop and a deacon are shown under the protection of the patron saint, on the northern one we find two children in the care of one of the "synnaoi". The broad inner face of this latter pier, which would be a logical place for the portrayal of the dignitary's lady, is now occupied by a mosaic of later date.[99]

tions of the orant saint in front of his ornate edicula or "ciborium" (Uspenskii and Kluge, *op.cit.*, pls. 6, 12; Sotiriou, *op.cit.*, pl. 62).

[93] Sotiriou, *op. cit.*, pl. 65 b and color plate. A better color plate in Grabar, *Byzantine Painting* (Skira), frontispiece; *ibid.*, p. 48, a detail.

[94] Sotiriou, *op. cit.*, pl. 65 a.

[95] A. Grabar, "Un nouveau reliquaire de Saint Démétrios", *Dumbarton Oaks Papers*, VIII, 1954, p. 305 ff. It could be argued against this interpretation that Bacchus, like Sergius, ought to be shown wearing the officer's *maniakion* (cf. D. Ainalov, in *Vizantiiskii Vremennik*, IX, 1902, p. 357 ff.). For "synnaoi" of St. Demetrius see Grabar, *Martyrium*, II, p. 121 f.

[96] Sotiriou, *op. cit.*, pl. 71 a; for other examples of this formula see Diehl-Le Tourneau-Saladin, *op. cit.*, pp. 57, 95.

[97] Sotiriou, *op. cit.*, pl. 67 f.

[98] *Ibid.*, pl. 63 f. and color plate. A better color plate in Grabar, *Byzantine Painting* (Skira), p. 50.

[99] Sotiriou, *op. cit.*, pl. 66; for this mosaic cf. below, n. 105. That its place originally was occupied by an ex-voto portraying the wife of the dignitary opposite (and mother of the children

The date of this set of votive panels can be determined approximately thanks to the protraits of the bishop and the deacon. As Sotiriou points out, these are the same individuals who were depicted in two medallions in that section of the mosaics of the north aisle which, by evidence of an accompanying inscription, was restored after the fire, and they must be clerics who held office at the time of that restoration.[100] The fire, judging by the context in which it is recorded in the *Miracula S. Demetrii*, occurred in the third, or, at the latest, in the fourth decade of the seventh century and the rebuilding of the church probably took place soon afterwards.[101] Hence the fact that among the persons portrayed in our ex-votos are the bishop and the deacon who helped rebuild the church after the fire, means that the set of mosaics is not likely to have been made much later than the middle of the seventh century.[102]

on the adjoining panel) is, of course, nothing more than a hypothesis. Against it it could be argued that the correct place for a woman is on the left side of the altar as viewed from the apse; cf. the imperial portraits in S. Vitale. The portrayal of an entire family would be in the tradition of the first group of ex-votos in St. Demetrius; cf. also the chapel of Theodotus in Sta. Maria Antiqua.

[100] Sotiriou, *op. cit.*, pp. 194, 196 f. For reproductions of the medallions see above, n. 75. The fact that the same bishop is portrayed in the aisle and on the pier was noted already by Kluge (*op. cit.*, p. 63) and others. The discovery on the pier of a portrait of a deacon identical with the second of the two clerics portrayed in the aisle has brought welcome confirmation that aisle medallions and pier mosaics do indeed belong together. It is evident also that the two panels on the pier, though separated by a corner, must be viewed as a unit.

[101] P. Lemerle, "La composition et la chronologie des deux premiers livres des Miracula S. Demetrii", *Byzantinische Zeitschrift*, XLVI, 1953, p. 349 ff., especially p. 356. Cf. also A. Burmov, "The Slav attacks on Salonika in the 'Miracula S. Demetrii' and their chronology" (in Bulgarian), *Annuaire de l'Université de Sofia. Faculté de Philosophie et Histoire*, XLVII, book 2, 1952, p. 167 ff., especially p. 212. F. Barišić, *Miracles de St. Démétrius comme source historique* (Académie Serbe des Sciences, *Monographies*, CCXIX, Institut d'études byzantines, No. 2), Belgrad 1953, p. 100 ff. One of the clues for dating the fire is that it is recorded as having occurred after the death of Bishop John. The bishop portrayed in the mosaics therefore cannot be John as Sotiriou claims (*op. cit.*, p. 194).

[102] Another potential clue to the date of these mosaics is provided by a reference, in the inscription of the "founders" panel, to a naval attack on Salonika (Sotiriou, *op. cit.*, p. 193). If, as is likely, the event was a recent one it cannot be the siege of Chatzon (related in Ch. 1 of Book II of the *Miracula*) with which it has usually been identified, since that siege took place in the lifetime of Bishop John who is not the bishop depicted (see preceding footnote). Naval operations are related also in connection with the "long siege" described in Ch. 4 of Book II (A. Tougard, *De l'histoire profane dans les actes grecs des Bollandistes*, Paris 1874, p. 166), but widely differing dates have been proposed for this siege. For the earlier opinions see the tabulation by Barišić, *op. cit.*, p. 10 f., and his critical comments p. 109 ff. He himself favors the year 677; Lemerle first hesitated between 662 and 677 (*op. cit.*, p. 358 f.), but subsequently also decided in favor of 677 ("Invasions et migrations dans les Balkans", *Revue Historique*, CCXI, 1954, p. 265 ff., especially p. 301 f.), a dating also followed by J. D. Breckenridge ("The 'Long Siege' of Thessalonika: Its Date and Iconography", *Byzantinische Zeitschrift*, XLVIII, 1955, p. 116 ff., especially p. 119 f.). Burmov, on the other hand, argues in favor of the year 647 (*op. cit.*, p. 202 ff.). This last-named date is the one most readily compatible with the evidence assembled here, which indicates a quick succession of fire, rebuilding of the church and naval incursion, with the two latter events apparently taking place under the same bishop, as the mosaics imply. Perhaps the critical edition of the *Miracula* which Prof. Lemerle has promised us will provide a definitive solution of the problem.

In point of time, therefore, the gap between the ex-votos made before the fire and those made after the fire is not great. Granted that all of the former may not have been done in a single operation, by and large they belong to the late sixth and early seventh century, as we have seen. It is odd to find in the later group hardly a trace of the same stylistic tradition. The negative evidence seems quite incontrovertible. To state positively where the roots of the style of the pier mosaics lie is more hazardous. But I venture to suggest that these mosaics, which clearly originated on quite a different social level than the earlier ones (representing as they do the leading officials of the city, rather than private citizens, and referring in their inscriptions, not to personal favors received from the patron saint, but to his actions on behalf of the city as a whole), were inspired by examples of Constantinopolitan court art. They are best explained through one of those periodic intrusions from the imperial capital which punctuate the history of art in Salonika. The severity of line and the sombreness of mood which are so striking in these panels are salient features of imperial portraits of the late and post-Heraclian era on coins. The mosaics perhaps even show an influence of court fashion. On the coins struck after Heraclius' final defeat of the Persians (629 A. D.) the emperor is shown with a huge beard and even more enormous mustaches, features which numismatists are apt to treat as belonging to the realm of caricature, but which may well have been meant to recall a facial style long associated with the conquered enemy.[103] The fashion, which is continued on coin portraits of Constant II, would thus come under the heading of Persian and, in general, barbarian influences on the manners and customs of the Byzantine court.[104] Be this as it may, beards and mustaches only a little less generous than those of the ageing Heraclius and his successor, are sported by some of our Salonikan donors, whose excessively grave and gloomy mien seems to be what was expected in a state portrait of that period (figs. 1, 21 d). It is not difficult to visualize in mid-seventh century Constantinople an official art bearing much the same characteristics as our panels.

These mosaics, then, may be considered as indicative of an aspect of Constantinopolitan art.[105] Viewing in the aggregate the evidence assembled in

[103] For Heraclius' bearded portrait on coins see Wroth, *op. cit.* (above, n. 73), I, p. XXIV and pl. XXIII, 9; our fig. 21d. Though more common in the early Sassanian period, some rather impressive mustaches and beards may be found also on late Sassanian royal portraits; see *A Survey of Persian Art* (A. U. Pope, ed.), IV, Oxford, London and New York 1938, pls. 229B, 254K. For the mustaches alone see also a late Sassanian silver phalera at Dumbarton Oaks (A. Alföldi and E. Cruikshank, "A Sassanian Silver Phalera at Dumbarton Oaks", *Dumbarton Oaks Papers*, XI, 1957, p. 237ff.). As Prof. Grierson has pointed out to me, striking analogies to the facial style of Heraclius after 629 can be found on the very much earlier coins of Elymais-Susiana (G. F. Hill, *Catalogue of the Greek Coins of Arabia, Mesopotamia and Persia*, London 1922, pls. XL, 10ff.; XLI, 1ff.).

[104] N. P. Kondakov, "Les costumes orientaux à la cour byzantine", *Byzantion*, I, 1924, p. 7ff.

[105] I leave open the question as to whether they were executed by artists from the capital or merely inspired by Constantinopolitan models. The fact that in two instances the draping of the patron saint's chlamys is at odds with the movement of his left arm may suggest a derivative

the foregoing pages we arrive at the conclusion that in the post-Justinianic era the capital of the Byzantine world, while harboring a tradition of "perennial hellenism", also witnessed a stylistic development analagous to that known to us from monuments in Italy; that is to say, a drastic shrinkage of forms, a loss of organic and three-dimensional qualities in the second half of the sixth century was followed in the first half of the seventh by a positive assertion of abstract, linear and geometric principles which involve a more radical breach with classical ideals and norms than any yet achieved during the long process of disintegration of ancient art. Indeed, we must assume that Constantinople was a fountainhead from which such forms spread and radiated both to Salonika and to Rome. Hence the similarities that have so often been noted between monuments in the two latter cities and especially between the second group of mosaics of St. Demetrius on the one hand and those of S. Venanzio (which are of practically the same date) on the other.

In the purely artistic sense the creation of this radically abstract style was the cardinal achievement of the period which we are discussing. It was not, of course, a creation *ex nihilo*. Many of its elements were already present, at least implicitly, in earlier phases of late antique and early Byzantine art. Some of the figures in the mosaics of St. Demetrius could well be derived through a process of abstraction from works of Justinianic court art as exemplified for us by the imperial panels at S. Vitale.[106] On the other hand, one must also reckon with new influences from the oriental hinterland of the Byzantine world.[107] The problem is complex and difficult. Let

rather than direct knowledge of the art of the court (Sotiriou, *op. cit.*, pls. 63,65 b; our figs. 1,23). M. van Berchem and E. Clouzot are mistaken in claiming this as a peculiarity of only the second of the two panels and the distinction they draw between the two on this basis is unfounded (*op. cit.*, p. 73 ff.). In any case, our set of ex-votos bears witness to a stylistic intrusion which, like others in Salonika, left its mark on subsequent work. A panel recently discovered on the west wall of the nave (Sotiriou, *op. cit.*, pl. 69 f.) and showing St. Demetrius flanked by two bishops, a deacon and another cleric, looks like a – not much later – imitation of the great "founders" panel on the south pier. The mosaic which now occupies the principal face of the north pier (*ibid.*, pl. 66) seems to me a substantially later work, but it, too, in some respects still imitates the style of the mid-seventh century ex-votos which it adjoins. Perhaps on account of these "archaisms" it has proved extremely difficult to date; see Kondakov, *op. cit.* (above, n. 81), I, p. 357: probably ninth century; Diehl-Le Tourneau-Saladin, *op. cit.*, p. 111: tenth or eleventh century; Wulff, *op. cit.* (above, n. 79), p. 447: perhaps later than other mosaics on piers; Xyngopoulos, *op. cit.* (above, n. 79), p. 41: eleventh or twelfth century; Lazarev, *op. cit.*, p. 56: ninth to tenth century; Frolow, *op. cit.* (above, n. 79), p. 192: eleventh century; Sotiriou, *op. cit.*, p. 196: not later than ninth century.

106 Compare Grabar, *Byzantine Painting* (Skira), p. 48 with p. 67.

107 In this connection the curious backgrounds of the donor panels in St. Demetrius may be mentioned. As Sotiriou points out, they combine the representation of crenellated walls with the function of square haloes for the portraits (*op. cit.*, p. 193). In the semi-oriental paintings of the Dura synagogue one finds what appears to be a precedent for this device; cf. C.H. Kraeling, *The Synagogue (The Excavations at Dura-Europos, Final Report*, VIII, part 1), New Haven 1956, pl. LXXVI. But it existed also in the Mediterranean sphere long before the seventh century; see A. Calderini, G. Chierici, C. Cecchelli, *La basilica di S. Lorenzo Maggiore in Milano*, Milan n. d., pls. XCV–XCVIII.

me refer here only to one monument which might be considered as providing an important clue, namely, the mosaics of the monastery of St. Catherine on Mount Sinai.[108] Some of the most essential and striking qualities of the ex-votos of St. Demetrius can be matched in this work more adequately than in any other known to me. In particular, one finds here that powerful simplification of line and outline, that monumental directness, which makes the Salonikan donor portraits so impressive (compare figs. 1 and 17). If, as is often stated, the Sinai mosaic is a somewhat provincial product of Syro-Palestinian art of the Justinianic era,[109] that school could well be claimed to have been a source of the radically abstract style in Byzantine art of the seventh century. But although the Sinai church was built, apparently largely by local talent, between 548 and 562, it is by no means certain that the mosaic is also of that period.[110] The relationship to the Salonikan mosaics might, indeed, suggest that it is somewhat later, and, since it is in reality a work of very great artistic merit and far from provincial, one may also consider the possibility that, rather than being local work, it is itself a product of the abstract current in Constantinopolitan art of which we have spoken.

I shall return to the problem of Constantinople versus the provinces shortly. So far as the capital is concerned we have arrived at a frankly dualistic conception of its art in the post-Justinianic and particularly the Heraclian era. Though we have operated to a certain extent by inference, the conclusion is nevertheless inescapable that the hellenistic and the abstract

[108] G. Sotiriou, "The Mosaic of the Transfiguration of the Church of the Monastery of Sinai" (in Greek), *Atti dello VIII congresso internazionale di studi bizantini, Palermo 3–10 aprile 1951*, II, Rome 1953, p. 246ff. Cf. also A. Guillou, "Le monastère de la Théotokos au Sinaï", *Mélanges d'archéologie et d'histoire*, LXVII, 1955, p.217ff. Guillou in my opinion is excessively sceptical regarding the state of preservation of this mosaic (p. 226ff.). Even if the inscription of Presbyter Theodore should be a completely new insertion made in 1840 – and this is far from proven – any restoration carried out at that time could hardly be so skillful as not to be fairly readily recognizable. Judging by the photographs, some figures (particularly among the prophets in the medallions) do indeed show what appear to be rather clumsy restorations. Others, however, seem to be free of such features (e.g. many of the busts of apostles; cf. Sotiriou, *op. cit.*, p. 249). A proper scrutiny of what may be old and what restored can be carried out only in front of the original. A comparison of the present state of the mosaic with Laborde's illustration is not a satisfactory means of determining restorations carried out since 1830. Laborde himself in effect warns us that his drawing is not reliable (L. de Laborde, *Voyage de l'Arabie Pétrée*, Paris 1830, p. 67).

[109] Lazarev, *op. cit.*, p. 58. Wulff (*op. cit.* – above, n. 79 –, p. 419f.) and Francovich (*op. cit.*– above, n. 39 –, p. 19) speak of a mixture of Byzantine and local elements. G. Galassi ("I Musaici Sinaitici", *Felix Ravenna*, LXIII, 1953, p. 5ff.) characterizes the mosaic as a provincial product with composite antecedents.

[110] For the date of the building see H. Grégoire, "Sur la date du monastère du Sinaï", *Bulletin de Correspondance Hellénique*, XXXI, 1907, p. 327ff. The hazards of dating the mosaic on the basis of its dedicatory inscription have not been overcome, but, on the contrary, made obvious, by the study by V. Beneshevich ("Sur la date de la mosaïque de la Transfiguration au Mont Sinaï", *Byzantion*, I, 1924, p. 145ff.). So far as I am aware no attempt of this kind has been made since.

manner (as well as different nuances and variants of both) were in vogue in Constantinople side by side.[111]

In reality, of course, the distinction between the two currents is not always as clear and sharp as the foregoing demonstration might suggest. There were artists who sought to combine elements of both, and the result is not necessarily as eclectic and blurred a style as that of the earlier Salonikan mosaics. Even within the second group of ex-votos of St. Demetrius one may distinguish degrees of abstraction. The faces of the saints, particularly those of the "synnaoi" on the Western faces of the piers (fig. 23), are relatively more lifelike and three-dimensional than those of the founders (fig. 1), though this does not lessen the rigid solemnity of the figures or the strict geometric organization of the panel. In other instances one finds a much bolder, though still severely controlled, mingling of styles. I have in mind particularly two examples, both portable objects of uncertain provenance, but both perhaps to be linked to the art of the capital.

One is a splendid encaustic icon on Mount Sinai depicting the Virgin and Child with two saints and two angels (fig. 24).[112] The two saints, tightly and rigidly aligned on either side of the Virgin and possessed of regularized features, fixed gazes and strangely insubstantial bodies, call to mind those on the piers of St. Demetrius. But they are rendered in a broad and soft "painterly" technique without the use of lines. This lively brush work is more strongly in evidence in the central group of Mother and Child, and it is given completely free rein in the two remarkable figures of angels in the background which, in striking contrast to the solemn and immobile array in the foreground, are shown in a quick and spirited movement, turning in space and glancing upwards to the hand of God and the ray of light that emerges from a segment of heaven. In these angels impressionist technique combines with lively action to produce one of the most startling examples of a "Pompeian" survival in early Byzantine art. Though the icon has been considered a Syrian or Palestinian work of the sixth century,[113] the affinities, not only with the mosaics of St. Demetrius but also with some of the "Greek" frescoes in Sta. Maria Antiqua in Rome, are more compatible with a seventh century date and an origin in the orbit of Constantinople.[114]

[111] An analogous conclusion was previously reached by Francovich, *op. cit.* (above, n. 19), p. 10 ff. In his more recent article on the Nicaea mosaic (above, n. 39), however, this author appears to have abandoned this concept in favor of a one-sided emphasis on the hellenistic element in Constantinopolitan art, an emphasis which also characterizes Lazarev's treatment of the period (*op. cit.*, p. 52 ff.). Weitzmann, on the other hand, has stressed the multiplicity of styles in the art of the capital (*op. cit.* – above, n. 70 –, p. 43). See also below, n. 150.

[112] G. Sotiriou, "An Encaustic Icon of the Enthroned Virgin of the Sinai Monastery" (in Greek), *Bulletin de Correspondance Hellénique*, LXX, 1946, p. 552 ff. and pl. XXV f. G. and M. Sotiriou, *Icones du Mont Sinaï*, I, Athens 1956, pl. 4 ff.

[113] Sotiriou, *BCH*, LXX, p. 556.

[114] E. Kitzinger, "On some Icons of the Seventh Century", *Late Classical and Mediaeval Studies in Honor of Albert Mathias Friend, Jr.*, Princeton 1955, p. 132 ff., especially p. 136 ff. and figs. 4–6

In quite a different way the abstract meets with the hellenistic in a work of miniature painting which is rightly considered one of the most sumptuous and precious relics of that art to have survived from the early Byzantine period. I refer to two fragmentary leaves in the British Museum (Add. Ms. 5111) with part of the prefatory matter of what must have been an extremely splendid and ornate Gospel book (fig. 25). The fragments and their decoration have been studied in detail by Nordenfalk, who tentatively, but in my opinion convincingly, attributed them to a Constantinopolitan scriptorium of the seventh century.[115] Nordenfalk has called attention to the completely unclassical manner in which ornament is used on these pages to embellish the architectural motifs which frame the text. It is the ornament which dominates, while the column shafts, capitals and arches to which it is meant to give substance are reduced to a mere linear grid. The ornament, moreover, is purely two-dimensional, rigidly stylized, and in large part of oriental rather than hellenistic origin.[116] Wedded to the gold surface of the page it forms a pattern of brittle openwork bands devoid of body and substance and recalls enamels rather than paintings. But there is another aspect to the art of this book. Sprouting from the springs of the phantom arches are rich and succulent leaves of acanthus, freely curved and three-dimensionally rendered. They are in the best tradition of hellenistic ornament and comparable to the luscious acanthus rinceaux we have previously encountered in the mosaics of St. Sophia (see above p. 11). Two styles of ornament diametrically opposed in character and utterly different in origin are thus combined in one and the same composition.

The British Museum leaves, then, particularly when viewed in conjunction with the St. Sophia mosaics and their relatives, afford striking proof of the dualism of which I have spoken, and show that this dualism extended to the realm of ornament. The abstract and the hellenistic are here juxtaposed in a much more abrupt and uncompromising fashion than in the Sinai icon, but with a corresponding skill in creating out of seemingly irreconcilable opposites a harmonious whole. The hellenistic component was not confined to acanthus "acroteria". On top of the arcades were birds (which have largely disappeared) and inserted in the arches were tiny busts in medallions, tentatively identified by Nordenfalk as portraits of apostles. These birds and busts, painted in broad soft brush strokes reminiscent of

(comparisons with Sta. Maria Antiqua). A seventh century date had previously been proposed tentatively by Weitzmann, *The Fresco Cycle of S. Maria di Castelseprio*, p. 11.

[115] C. Nordenfalk, *Die spätantiken Kanontafeln*, Göteborg 1938, p. 127ff. and pls. 1–4.

[116] Cf. particularly the simple alignment of highly stylized floral elements in the shafts and arches on fol. 11a (*ibid.*, pl. 3; our fig. 25), an absolute antithesis to the classical rinceau with its suggestion of movement and growth. For early antecedents of this type of ornament in Syria see E. Weigand in *Palmyra* (Th. Wiegand, ed.), Berlin 1932, p. 155 and fig. 176. For Palmyra see also H. Seyrig in *Syria*, XXI, 1940, pls. XXIX, 2; XXX. N. Glueck has published a good example from the Nabataean site of Khirbet et-Tannur (*American Journal of Archaeology*, XLI, 1937, p. 365, fig. 3). As Nordenfalk points out (*op. cit.*, p. 143f.) floral ornaments similarly composed adorn the cross of Justin II (above, n. 67), as well as certain silk textiles.

those of the Sinai icon,[117] are decidedly three-dimensional in their effect and in as striking a contrast to the flat ornament of the arches as the acanthus leaves. Were any of the pages of the manuscript preserved in their entirety the juxtaposition of the two styles no doubt would be still more apparent and its effect still more startling and intriguing.

Already in earlier phases of Constantinopolitan art a hellenistic and an abstract manner had existed side by side, sometimes in the same monument.[118] In demonstrating the existence of such a dualism in the seventh century we are merely asserting the continuance of an earlier phenomenon. There are, however, two factors which seem to me specifically characteristic of the art of this period. Both in the rendering of figures and, as we have just seen, also in ornament the abstract, dematerialized style is carried to an extreme unknown in any earlier phase of Byzantine art. And, in contrast particularly to many of the outstanding works of the Justinianic era, there is no attempt to achieve a real synthesis between the purely conceptual and the organic, the essentially unclassical and the hellenistic, no attempt to weld and fuse the antithetic forces and to achieve heightened effects through the tensions they generate. The intensity, the dynamic quality one so often finds in Justinianic art is largely lacking. Much of the art of the seventh century seems strangely flat and remote.

This comparison with Justinianic art must be qualified somewhat. There are certain works of the end of the seventh and the beginning of the eighth century in which one seems to discern a return to Justinianic ideals. In paintings in Sta. Maria Antiqua in Rome dating from the period of John VII (705–7) a bold geometric pattern is superimposed on the free and organic manner that had become traditional in the paintings of the "Greek" school in that church. Both in the rendering of individual figures and of entire compositions monumental effects are achieved through a synthesis of the two styles, and the results are often strongly reminiscent of work of the first half of the sixth century.[119] I was originally inclined to consider this a local Roman phenomenon, but thanks to the publication by Sotiriou of an encaustic icon from Mount Sinai with a most impressive half-length figure of St. Peter it has become possible to suggest that the "Justinianic revival" in Rome had a counterpart in the East and was, in fact, a reflection of a primarily Eastern phenomenon. The St. Peter icon of Mount Sinai is in many ways comparable to the apostles depicted on the walls of Sta. Maria Antiqua at the time of John VII, though it is far superior in quality (fig. 26).[120] The

[117] Cf. particularly the enlargement of one of the busts reproduced by Nordenfalk, *op. cit.*, p. 133 fig. 13.

[118] Cf. the observations by Francovich, *op. cit.* (above, n. 19), p. 10f. (Vienna Dioscurides, consular diptychs, reliefs of Theodosius Obelisc).

[119] Kitzinger, *Römische Malerei*, p. 15 ff.

[120] G. Sotiriou, "An Encaustic Icon of the Apostle Peter of the Sinai Monastery" (in Greek), *Annuaire de l'Institut de philologie et d'histoire orientales et slaves*, X, 1950 (*Mélanges H. Grégoire*, II), p. 607ff. and pls. I–II. G. and M. Sotiriou, *Icones du Mont Sinaï*, I, pls. 1–3 and color pl. For the date see Kitzinger, *op. cit.* (above, n. 114), p. 138.

thesis that there was in the late seventh century a Justinianic revival in the East gains support from the fact that an analogous trend can be observed in Byzantine coinage.[121]

Aside from this ephemeral revival, however, there was no synthesis. The two antithetic styles – and different variants of both – were in use side by side without being integrated. And they flourished in the same milieu. Viewed from the standpoint of metropolitan Byzantine art the use of such concepts as "Alexandrian hellenism" and "Asiatic abstraction" is misleading. During the period which concerns us both currents were well established in, and radiated from, the capital.

III.

To what extent, then, did the other – and much older – centers of artistic activity in the East retain a distinctive identity, a stylistic tradition of their own? In particular, were the regional "schools" of Syria, Palestine and Egypt still major factors in the overall picture? We must try to answer this question, though in the space available we can do so only in summary fashion.

Syria and Palestine have often figured in scholarly discussions of the history of art of the seventh century as strongholds of hellenistic traditions.[122] It so happens that among the extant groups of material definitely associated with this region there are two that one would naturally expect to offer a great deal of scope to such traditions, namely, silver vessels and floor mosaics. Neither group bears out the contention.[123]

Those silver objects which can actually be claimed as Syrian work of the late sixth and seventh centuries are decidedly provincial in character; such figure reliefs and ornaments as appear on them are done either in a debased (rather than a pure) hellenistic style or a frankly abstract one.[124] The evidence

[121] For the Justinianic revival in the coinage of Constantine IV see A. R. Bellinger, "The Gold Coins of Justinian II", *Archaeology*, III, 1950, p. 107 ff. The author also draws attention to the fact that Constantine gave the name Justinian to his son. The revival is evidenced primarily by the large size of the bronze coins (*ibid.*, figs. 8, 9) and the reappearance on the gold coins of a type of imperial portrait last used in the early years of Justinian (*ibid.*, figs. 11–13; our fig. 21 a, e). But there was also a temporary and partial abandonment of the rigid and schematic manner that had become traditional for the rendering of the imperial portrait; cf. some of the solidi of Constantine IV (*ibid.*, fig. 13 – an issue of which artistically respectable specimens exist; see our fig. 21 e) and of the first reign of Justinian II (*ibid.*, fig. 14); also the bust of the long-haired Christ which makes its appearance on coins of that reign (*ibid.*, fig. 18).

[122] See above, n. 30.

[123] Brehier's unfortunate attempt (*op. cit.* above, n. 71) to attribute practically all known silver work of the late classical and early Byzantine period to Syria was made at a time when this material had received as yet little attention and the study of hallmarks and their significance had barely begun. Brehier makes no chronological or stylistic distinctions.

[124] Such objects come primarily from deposits of liturgical and votive utensils which not only were excavated locally but include few or no objects with hallmarks. I would consider as typical products of Syrian silversmiths of the period which concerns us: the objects allegedly found together with the Antioch Chalice and now in the Metropolitan Museum in New York (G. A.

afforded by floor mosaics is equally negative. Thanks to the French-American excavations at Antioch we know what a flourishing craft the paving of floors with figure mosaics was in the Syrian metropolis. But almost as startling as the richness of the finds from the first five centuries of our era is the suddenness of the decline in the early sixth.[125] Even in the fifth century Antioch has nothing that can match the purity of the classical tradition or, for that matter, the sheer quality of the great mosaic found in the imperial palace in Constantinople.[126] To be sure, the floor mosaicists' craft was still to enjoy a long lease of life in other places in Syria and particularly in the churches of Palestine and Transjordan. Much pagan and secular lore was perpetuated by these artists through the Justinianic era and beyond[127] and in this sense they are comparable to the silversmiths of the "Byzantinische Antike". But rarely did they succeed as well as the latter in reproducing the essence of hellenistic form even in the sixth century[128] and never, to my knowledge, in the seventh. A mosaic floor such as that from the bath of the Umayyad palace at Khirbat al Mafjar with its magnificent fruit tree and spirited animals cannot be explained at all in terms of the local development of Christian floor decoration in the preceding era.[129] Although trees with or without groups of animals abound in Palestinian floor mosaics of the sixth and seventh centuries they are far more stylized.[130] To be sure, the artist at

Eisen, *The Great Chalice of Antioch*, New York 1933, p. 20 f.; for the inscriptions see G. Downey in *American Journal of Archaeology*, LV, 1951, p. 349 ff.); most of the objects in the large "Hamah Treasure" in the Walters Art Gallery, Baltimore, which may or may not be part of the same find as the "Antioch Treasure" (Ch. Diehl, "Un nouveau trésor d'argenterie syrienne", *Syria*, VII, 1926, p. 105 ff.; only three of the objects have hallmarks and in one case – no. 11, p. 109 and pl. XXVII, 2 – these are considered by Miss Cruikshank to be not of the normal "imperial" kind; cf. *Dumbarton Oaks Papers*, XI, 1957, p. 243 f.); another small treasure also allegedly from Hamah (M. C. Ross, "A Second Byzantine Silver Treasure from Hamah", *Archaeology*, III, 1950, p. 162 f.; *ibid.*, VI, 1953, p. 38); and a group of liturgical objects now in the Museum of Cleveland (L. Brehier, "Un trésor d'argenterie ancienne au Musée de Cleveland", *Syria*, XXVIII, 1951, p. 256 ff.; cf. G. Downey, "The Dating of the Syrian Liturgical Silver Treasure in the Cleveland Museum", *Art Bulletin*, XXXV, 1953, p. 143 ff.). A curious silver relief now in the Louvre with a representation of St. Symeon the Stylite (J. C., "Une pièce d'argenterie paléo-chrétienne", *La Revue des Arts*, V, 1955, p. 115 f. and front cover) is said to be part of the same find as the so-called "Small Hamah Treasure". I am indebted to Mr. M. C. Ross for giving me the benefit of his expert knowledge on Syrian silver, a subject on which he is preparing a special study.

[125] D. Levi, *Antioch Mosaic Pavements*, Princeton, London and The Hague 1947, I, p. 625 f. (chronological table).

[126] G. Brett in *The Great Palace of the Byzantine Emperors* (The Walker Trust, University of St. Andrews), London 1947, p. 64 ff.

[127] E. Kitzinger, "Mosaic Pavements in the Greek East and the Question of a 'Renaissance' under Justinian", *Actes du VIe Congrès International d'Etudes Byzantines, Paris 27 juillet – 2 août 1948*, II, Paris 1951, p. 209 ff.

[128] See *ibid.*, p. 217, n. 5 (on the mosaic of Kabr Hiram).

[129] *Quarterly of the Department of Antiquities in Palestine*, XIV, 1950, p. 120 and pl. XLVI; cf. above, n. 26.

[130] See e.g. S. J. Saller and B. Bagatti, *The Town of Nebo*, Jerusalem 1949, pls. 8; 14, 1; 20, 1–3; 40, 5. S. J. Saller, *The Memorial of Moses on Mount Nebo*, Jerusalem 1941, II, pl. 106 f.

Khirbat al Mafjar also employed conventional devices for the rendering of the foliage and the modelling of the animals' bodies. But he achieved effects far more lifelike than anything known in Palestinian pavements of the preceding era. To find antecedents for this Umayyad mosaic one must leave the local orbit and turn to the – admittedly very much earlier – pavement of the Great Palace of Constantinople.[131] The artists who decorated the floor at Khirbat al Mafjar must have been imported along with those who executed the Umayyad wall mosaics.[132] So far as a strong local survival of hellenistic style in Syria and Palestine through the seventh century is concerned the evidence is all negative.

Syria, however, is often credited with a stylistic specialty of another kind (though also of hellenistic descent), namely, a strong bent towards narrative realism and an almost excessive interest in the expression of emotions, qualities which find their principal scope in the illustration of biblical stories.[133] The prime witness for this trait, so far as our period is concerned, is the Syriac illuminated Gospel book in Florence written by the monk Rabula in 586 A. D.[134] The illuminations in this book undoubtedly are based on Greek models,[135] models which, as Morey has pointed out, must have shown affinities with the miniatures of the Rossano Gospels.[136] Thus the problem of Syrian expressive realism cannot be separated from that of the three famous Greek manuscripts with illustrations on purple ground, the Vienna Genesis, the Rossano Gospels and the Sinope fragment, in all of which, in fact, the same basic quality is apparent, though artistically they are on a much higher level than the miniatures of Rabula's codex.

It is impossible in the present context to unfold the question of these purple codices in all its complexity. Suffice it so say that although opinions have long been divided regarding their place of origin and although, particularly after the discovery of the Sinope fragment, Asia Minor was favored by many scholars, there has been in recent years an increasing consensus

[131] Brett, *op. cit.*, e. g. pl. 28.

[132] See above, p. 10 f.; also A. M. Schneider's analogous conclusions in regard to the frescoes of Qusayr Amra (*Bericht über eine Reise nach Syrien und Jordanien = Nachrichten der Akademie der Wissenschaften in Göttingen, I. Philologisch-historische Klasse*, 1952, no. 4, p. 21 f.). I do not wish to rule out altogether the possibility that local artists were employed by the Umayyads, but merely emphasize the fact that the hellenistic component in their decorations cannot be explained adequately from local antecedents.

[133] See most recently Francovich, *op. cit.* (above, n. 19).

[134] H. Buchthal and O. Kurz, *A Hand List of Illuminated Oriental Christian Manuscripts*, London 1942, p. 11 f. (bibliography). A facsimile edition of the whole manuscript is due to appear soon. It has recently been argued by J. Leroy that the colophon of 586 A. D. does not apply to the miniatures in the codex, but even so they can hardly be of a substantially different date (*Académie des Inscriptions et Belles-Lettres. Comptes rendus des séances de l'année 1954*, p. 278 ff.).

[135] Nordenfalk, *Die spätantiken Kanontafeln*, p. 255 ff. K. Weitzmann, *Illustrations in Roll and Codex*, Princeton 1947, p. 117.

[136] C. R. Morey, "The Painted Panel from the Sancta Sanctorum", *Festschrift zum sechzigsten Geburtstag von Paul Clemen*, Bonn 1926, p. 151 ff., especially p. 164 f.

that they were indeed produced in Syria or Palestine.[137] In my opinion this view may well be correct. For us, however, the real problem is to what extent the expressive realism which distinguishes their illustrations can be considered a specifically Syrian characteristic. And even if it was at one time, how long did it remain so? At the present state of our knowledge it would be difficult to maintain that miniatures of similar character could not also have been painted in Asia Minor, or, for that matter, in Constantinople itself.

One must chiefly beware lest the concept of a regional school or style become confused with that of an artistic "mode" appropriate to a particular type of object or a particular subject. Vivid and dramatic rendering with a great deal of descriptive detail naturally befits the illustration of historical and narrative texts. A creation of the hellenistic age, it is compatible with harmonious compositions, balanced movements, and atmospheric and idyllic landscape settings such as we find in many miniatures of the Vienna Genesis. But the landscape backgrounds and secondary elements may be reduced or eliminated for the sake of a more monumental or solemn effect or a more exclusive concentration on the dramatic essence of the story; harmony of composition, elegance of movements and composure of facial expression may likewise be sacrificed to greater emphasis on the emotional content. This is most frequently apt to happen in the case of New Testament subjects. It is no accident that in this respect the miniatures of the Rossano and Sinope Gospels differ considerably from those of the Vienna Genesis. In the two former manuscripts, background scenery and secondary detail are much sparser and the expressive elements much stronger. Similar distinctions can be observed again and again in the history of Early Christian and Byzantine art.[138] One of the reasons, if not the principal reason, for this phenomenon must be sought in the fact, now becoming increasingly apparent, that the illustration of the Old Testament has far older roots than that of the New,

[137] I cite P. Buberl's studies of the Vienna Genesis, in which the manuscript is attributed to an Antiochene workshop of the third quarter of the sixth century ("Das Problem der Wiener Genesis", *Jahrbuch der kunsthistorischen Sammlungen in Wien*, N. F. X, 1936, p. 9 ff.; *Id.* in *Beschreibendes Verzeichnis der Illuminierten Handschriften in Österreich*, VIII, part iv, Leipzig 1937, p. 63 ff.; *ibid.*, p. 68 ff. a survey of earlier opinions) and A. Grabar's attribution of the Sinope manuscript to Syria or Palestine (preface to the facsimile edition *Les peintures de l'évangéliaire de Sinope*, Paris 1948, p. 22 ff.; *ibid.*, p. 31, n. 30, references to scholars who had previously attributed the manuscript to Asia Minor or Constantinople). K. Weitzmann, who in his *Byzantinische Buchmalerei des IX. und X. Jahrhunderts* (Berlin 1935, p. 49) had attributed the three purple codices to Asia Minor, more recently has likewise favored Syria or Palestine (*The Fresco Cycle of S. Maria di Castelseprio*, p. 66). Nordenfalk, on the other hand, in a critical review of Buberl's work adhered to the view that they originated in Constantinople (*Zeitschrift für Kunstgeschichte*, VI, 1937, p. 250 ff.).

[138] Cf. the nave mosaics of Sta. Maria Maggiore as against those of the triumphal arch or the Old Testament scenes in the chancel of Sta. Maria Antiqua as against the New Testament scenes. The principal cycles of miniatures characteristic of the style of the Macedonian Renaissance are also Old Testament illustrations. Traces of the traditional contrast are apparent as late as the twelfth century in the Old and New Testament scenes of the mosaic decorations in Sicily.

roots which may even go back to the hellenistic period itself.[139] The embedding of figures in landscape backgrounds, a harmonious balancing of compositions and a generally "conservative" manner had become, so to speak, a normal and proper "mode" or "key" for Old Testament subjects. Although New Testament scenes may also appear in a serene hellenistic garb[140] they were much more apt to be stripped down to essentials and to have their expressive power correspondingly enhanced. One must be careful not to interpret all such works as products of "Syrian expressionism".[141] It is true that Syria, and more particularly Palestine, played an important role in the development of New Testament iconography.[142] It may also be true that expressive emphasis was originally a characteristic of Syro-Palestinian (or more generally, Asiatic) Christian art and appeared there more prominently and exclusively than elsewhere.[143] But by the late sixth century the trait was no longer foreign to metropolitan Byzantine art. We have al-

[139] K. Weitzmann, "Die Illustration der Septuaginta", *Münchner Jahrbuch der bildenden Kunst*, 3rd series, III–IV, 1952–53, p. 96 ff., especially p. 116 ff.; Kraeling, *op. cit.* (above, n. 107), p. 392 ff. The "hellenism" of Old Testament illustrations was explained in this sense already by Morey (*Early Christian Art*, 2nd ed., pp. 68 ff., 151 f. and passim), who, however, interpreted the contrast that can so often be observed between Old and New Testament illustrations in terms of a lasting antithesis between regional "schools". M. Schapiro in his review of Morey's book (*Review of Religion*, 1944, p. 181 f.) rightly points out that it is rather a question of "modes" which might be practised by one and the same artist and that, depending on the nature of the subject, Old Testament scenes, too, may be rendered in the "mode" more often associated with Gospel scenes. Nevertheless the fact remains that the hellenistic "mode" is more frequently linked with Old Testament subjects and there can be little doubt that the reason is a historical one having to do with the early phases of biblical illustration.

[140] This is true, for instance, of certain works of the "Theodosian Renaissance", or, at a later period, of the Castelseprio frescoes. One of the reasons why they are so startling is that they show a "mode" familiar mostly from Old Testament subjects applied to the Gospel story.

[141] Francovich's division of monuments between Constantinople and Syria (*Commentari*, II, p. 6 ff.) amounts almost to a division between Old Testament and nonreligious subjects on the one hand and New Testament subjects on the other. With the exception of the Vienna Genesis and Ms. syr. 341 in Paris he ascribes no object with an Old Testament iconography to Syria, and he attributes no monument that has narrative representations of New Testament subjects to pre-Iconoclastic Constantinople. In fact, he explicitly states that in the pre-Iconoclastic period interest in narrative scenes from the life of Christ was slight or nonexistent in the capital (p. 78 ff.), or, at any rate, confined to modest monastic establishments under Syro-Palestinian influence (p. 82). He thus goes further than Morey in that he links not only an artistic "mode" but a whole category of subjects to a regional school. That christological scenes were depicted in Constantinople since the late fourth century is evident from extant examples in sculpture (J. Kollwitz, *Oströmische Plastik der theodosianischen Zeit*, Berlin 1941, pp. 178–191). For the problem of larger pictorial cycles in sixth and seventh century Constantinople see below, p. 43.

[142] Wulff, *Altchristliche und byzantinische Kunst*, I, especially p. 293 ff. Grabar, *Martyrium*, II, p. 129 ff. The role of Syria and Palestine in the overall development of New Testament iconography can, however, be overrated. Morey, *Early Christian Art*, 2nd ed., p. 115 ff., provides a synopsis of relevant monuments that definitely belong to the area.

[143] Thus the trait seems to be less pronounced in the miniatures of the Cotton Genesis, which is presumably Alexandrian (K. Weitzmann, "Observations on the Cotton Genesis Fragments", *Late Classical and Medieval Studies in Honor of Albert Mathias Friend, Jr.*, Princeton 1955, p. 112 ff.) than in those of the Vienna Genesis which is generally agreed to be Asiatic.

ready vindicated for Constantinople two works of the latter half of that century which are commonly characterized in terms of "Syrian expressionism", namely, the Riha and Stuma patens.[144] As for the seventh century, I see no evidence that Syria was still a potent artistic force in this or any other sense.[145]

Thus in a discussion of Byzantine art of the period between Justinian and Iconoclasm, Syria and Palestine assume the role of a backwater. With the exception of the Umayyad decorations, which are essentially products of new impulses coming from other regions, none of the works of that period that are indubitably Syrian or Palestinian would lead one to think otherwise.

In regard to Egypt I can be much briefer. Morey's concept of Alexandria as a perpetual guardian of hellenism down to the time of the Arab conquest has already been refuted by others.[146] A thorough transformation of the hellenistic heritage took place as early as the fifth century, when the characteristic "Coptic" style first emerged in sculpture and textiles, and thereafter examples of "perennial hellenism" occur in Egypt only by way of intrusion.[147] Our chief witnesses for the art of the era after Justinian are the more developed among the sculptured stelae and ornamented tapestries, and, above all, many of the frescoes in the monastic chapels of Bawit and Saqqara.[148] For all three classes we lack as yet reliable chronological clues, but it is safe to say that much of this material falls within the limits of the period which concerns us. The frescoes in particular are of great importance in that they offer a wealth of iconographic themes unrivalled in any other extant group of monuments of this period.[149] But for Byzantine art as a whole they are important only to the extent to which they reflect more general developments, developments which here appear translated into an entirely local idiom.

[144] See above, p. 18ff.

[145] As an incontrovertible example of Syrian art of the seventh century we may cite a miniature in a Gospel Ms. in Wolfenbüttel dated 634 A.D. (Buchthal and Kurz, *Hand List*, p. 22f., no.66). Mention may also be made here of the illustrations of the Job Ms. of Patmos (Ms. no. 171), the first – and greater – part of which appears to be the work of a provincial – though not necessarily Syrian – follower of the style of the Vienna Genesis and perhaps dates from the seventh or early eighth century (G. Jacopi, "Le miniature dei codici di Patmo", *Clara Rhodos*, VI–VII, 1932–33, p. 569ff., especially pp. 574ff., 584ff., fig.91ff. and pl.XVff.; cf. Weitzmann, *Die byzantinische Buchmalerei*, p. 49ff.). Lazarev, however, attributes these miniatures to the ninth century (*History of Byzantine Painting*, p. 288).

[146] See especially the reviews by S. Der Nersessian (*Art Bulletin*, XXV, 1943, p. 80ff.) and M. Schapiro (*Review of Religion*, 1944, p. 165ff.).

[147] Cf. my paper in *Archaeologia*, LXXXVII, 1938, p. 181ff., For a different view see J. B. Ward Perkins, in *Papers of the British School at Rome*, XVII, 1949, p. 60ff.

[148] For the stelae see M. Cramer, *Koptische Inschriften im Kaiser-Friedrich-Museum zu Berlin*, Cairo 1949, and *Archäologische und epigraphische Klassifikation koptischer Denkmäler des Metropolitan Museum of Art, New York, und des Museum of Fine Arts, Boston, Mass.*, Wiesbaden 1957. For the frescoes of Bawit see *Mémoires publiés par les membres de l'institut français d'archéologie orientale du Caire*, XII, 1904 (J. Clédat); LIX, 1931–43 (J. Maspéro and E. Drioton); for those of Saqqara J. E. Quibell, *Excavations at Saqqara 1906–1907* (Cairo 1908); *1907–1908* (Cairo 1909); *1908–9, 1909–10* (Cairo 1912).

[149] See the discussion by A. Grabar, *Martyrium*, II, p. 207ff.

There can be no doubt, then, that by the late sixth century, and probably already long before, the older artistic centers of the Greek world had yielded leadership to Constantinople. Byzantine art by this time was highly centralized, as it was to remain thereafter. Although the capital undoubtedly absorbed influences from other areas it must not be thought of as an eclectic upstart living on the riches of its older rivals. It had itself become a fountainhead. The provinces on their part were hardly in a position to determine Constantinople's artistic fortunes simply by dispatching thither their craftsmen and their products. We cannot adequately understand Byzantine art of this period if we think in terms of a haphazard chemistry of regional influences.

Other means must be found to help account for the congeries of styles in metropolitan Byzantium and for the incongruities and contradictions that became so particularly marked there in the period with which we are concerned. One might be tempted to associate different styles with different strata of society or to set off the art of the capital against that of its Asiatic hinterland. But this, too, is hazardous, particularly in view of the variety of artistic expressions that can be connected directly or indirectly with the imperial court itself. On the other hand, we have found, as others have before, that to some extent the different styles which exist side by side can be understood as different "modes" between which an artist might choose according to the subject matter of his work, the function it was to serve, or the effect he wished to achieve.[150]

Here evidently are important leads, if only of a crude and approximate sort. The staid, academic and retrospective manner of the David plates seemed to arise from particular circumstances at the court of Heraclius. One of the main carriers of the free, relaxed and cursive style which I have called "perennial hellenism" is the secular and particularly the pagan mythological genre, as is only natural. But related forms of loose and cursive hellenism are strong also in narrative illustrations of biblical – and more especially Old Testament subjects – while New Testament themes tend more towards expressionism and abstraction. The proper domain of a radically abstract style is the solemn portrayal of holy figures, but also of mortals, in apse mosaics, on votive images and on coins.

What may be called the functional approach certainly can help to unravel some of the complexities that defy solution in terms of regional "schools". We shall learn more about the possibilities, but also the limitations, of this approach in the final section of this study in which we shall view the art of the late sixth and seventh centuries in the light of certain developments outside the purely artistic sphere.

[150] See the remarks by Francovich and Weitzmann quoted above, n. 111, and especially M. Schapiro in *Review of Religion*, 1944, p. 181 f. For similar observations in the field of Roman art see O. Brendel, "Prolegomena to a Book on Roman Art", *Memoirs of the American Academy in Rome*, XXI, 1953, p. 7 ff., especially p. 68 ff. Cf. also F. W. Deichmann, *Frühchristliche Kirchen in Rom*, Basel 1948, p. 65 f. (Sta. Maria Maggiore mosaics).

IV.

One of the major historical factors, or perhaps the most fundamental of all such factors, that affected the fortunes of the pictorial arts in the post-classical and early mediaeval period was the slow and eventful process whereby Christianity came to terms with the graven image. When one tries to find out how it happened that Christians, originally entirely averse to pictorial actualization of religious themes, became, in the course of about five hundred years after first admitting such representations, so addicted to the worship of holy images as to provoke within their own ranks the fierce Iconoclastic crisis of the eighth century, one's attention soon becomes focused on the period with which this paper is concerned. Although from the end of the fourth century on we have texts acknowledging not only the existence of religious pictures but occasionally also their worship, the literary record clearly shows that beginning with the second half of the sixth century there took place, primarily in the Greek East, a sharp upswing of the cult of images. The eventual result was the virulent reaction of eighth century Iconoclasm.

From the texts of the post-Justinianic era we learn of the vastly intensified role of religious images in public life and private devotion, and of the increasingly strong and widespread faith in their miraculous powers. The holy image tended to be thought of and treated more and more as though it were the holy person it depicted. We hear of ritual practices ranging from simple prayers, lighting of candles, draping of curtains, burning of incense, genuflexions and kissing, to distinctly magic devices involving not only an increasingly frequent use of images for the protection of a house or a traveller, an entire city or an army, but also a number of rather crude and direct operations designed to procure some specific benefit.[151]

These phenomena, in which it is easy to recognize symptoms of the material and spiritual crises of the age, properly belong to the realms of social and religious history. It is reasonable to assume, however, that they should also have found a reflection in the works of art themselves, and they should certainly be taken into account by the art historian studying the period. Our survey of artistic manifestations of the late sixth and seventh centuries already suggested an interpretation of the monuments in terms of their function. The present considerations make this approach seem promising also from a historical point of view, and provide a specific focus for such an investigation.

In trying to determine to what extent Byzantine art of the age between Justinian and Iconoclasm reflects the new role of the religious image in public and private life let us for the moment set aside the conclusions to which our stylistic enquiry has led us. To correlate developments in the

[151] Grabar, *Martyrium*, II, p. 343 ff. J. Kollwitz, "Zur Frühgeschichte der Bilderverehrung", *Römische Quartalschrift*, 48, 1953, p. 1 ff., especially p. 9 ff. Kitzinger in *Dumbarton Oaks Papers*, VIII, 1954, p. 83 ff.

realm of form with the new social and religious phenomena of the period is the most delicate and elusive aspect of our problem. It is best to concentrate first on certain more measurable and concrete characteristics of post-Justinianic art which appear to have indeed a tangible connection with the rising cult of images.

These characteristics generally fall under the heading of increased accessibility of sacred representations and greater intimacy between them and the beholder. Thus it is surely significant that in churches paintings and mosaics with figure subjects were apt to be placed lower than they had been heretofore and in some instances were allowed to invade the zone beneath the principal cornice, traditionally the dividing line between imagery and panelling or dado.[152] The ex-votos on the chancel piers and the west wall of the nave of the church of St. Demetrius in Salonika are cases in point. So is the fresco decoration which Pope John VII provided for the chancel of Sta. Maria Antiqua in Rome. Here the painted "curtain" which adorns the dado zone was abruptly cut in the center of the left hand wall to make room for a picture (now almost entirely destroyed) of the Virgin or a female saint. The figure was exactly on axis with a small niche which presumably contained some object of devotion or ritual.[153] On the opposite wall in the same zone is a well preserved icon of St. Ann with the Infant Mary and a small fragment of another panel adjoining it to the left.[154] These may well be paintings of the seventh century that were respected by the artists of John VII. In any case, they, too, are striking examples of saints' images appearing in the dado zone, below the stucco molding which in this room emphatically separated the lower from the upper part of the walls.

Not only were images brought closer to the level of the beholder, but, as the example of Sta. Maria Antiqua shows, they were also apt to be associated with spots where liturgical activities took place.[155] The classical expression of this trend is the iconostasis. It is at least highly doubtful whether the iconostasis proper, i. e., a tall and opaque screen entirely closing off the chancel and adorned with icons, can be traced back to the period in which we are interested.[156] The normal chancel enclosure of pre-Iconoclastic times was semiopaque, i. e., it consisted of a low parapet, surmounted by columns and an entablature from which curtains could be suspended.[157] The relatively

[152] Kollwitz, *op. cit.*, p. 13. The tendency was to have a logical counterpart later in the attempt to satisfy iconoclastic scruples by removing images only from low positions; cf. E. J. Martin, *A History of the Iconoclastic Controversy*, London n. d., p. 165.

[153] Wilpert, *Die römischen Mosaiken und Malereien*, IV, pl. 152.

[154] *Ibid.*, pls. 153, 159 f.

[155] For saints' images at Sta. Maria Antiqua associated with niches see also Grabar, *Martyrium*, II, p. 119 n. 2; Kollwitz, *op. cit.*, p. 13.

[156] As was claimed long ago by K. Holl ("Die Entstehung der Bilderwand in der griechischen Kirche", *Archiv für Religionswissenschaft*, IX, 1906, p. 365 ff.; reprinted in his *Gesammelte Aufsätze zur Kirchengeschichte*, II, Tübingen 1928, p. 225 ff.).

[157] H. Stern, "Nouvelles recherches sur les images des conciles dans l'Eglise de la Nativité à Bethléem", *Cahiers Archéologiques*, III, 1948, p. 82 ff., especially p. 93 ff.

best evidence that there may have been as early as the seventh century screens coming closer in form to a real iconostasis is found in an area which Byzantinists are apt to neglect, namely, the British Isles. Bede tells of a "tabulatum" which Benedict Biscop built in the church at Wearmouth in connection with pictures of the Virgin and the twelve Apostles which he had brought from Rome. The meaning of the term is not clear but it has often been thought to denote a wooden screen in front of the chancel on which the pictures were placed.[158] Another seventh century text, describing the monastic church at Kildare in Ireland, is less ambiguous. The chancel of this church was marked off by a transverse screen which had two lateral doors and was covered with linen cloth and adorned with images.[159] Even in this case we cannot be sure that it was a screen of full height. For us, however, the exact shape of the screen is less important than the tendency, certainly present at Kildare, to place images on the chancel enclosure. In this the humble Irish sanctuary echoed a trend which first appeared in no less a church than St. Sophia in Constantinople. It has often been remarked that Justinian planned and built his great temple as an uniconic one. But when the chancel area was rebuilt after the first collapse of the dome in 558 A. D. the altar screen was adorned with a rich array of silver reliefs depicting Christ, angels, the Virgin, prophets and apostles.[160] In effect the screen received the equivalent of a complete church decoration of a kind that later was to become canonical in Byzantium.[161] Evidently, then, there was already during the last years of the reign of Justinian a tendency to concentrate images in the focal area of ritual activity. A passage in Nicephorus shows that the trend was, or soon became, a conscious one.[162]

The most accessible picture of all is the portable icon. Readily movable and manoeuverable at will, such icons figure frequently in texts relating to the role and use of images outside the church. They naturally play a prominent part in the domestic sphere and in public ceremonials such as processions. Portable pictures were easily destroyed and few have survived from pre-Iconoclastic times. Statistics therefore are hazardous and further com-

[158] S. Pfeilstücker, *Spätantikes und germanisches Kunstgut in der frühangelsächsischen Kunst*, Berlin 1936, p. 138.

[159] M. Mesnard, "L'église irlandaise de Kildare d'après un texte du VIIᵉ siècle", *Rivista di Archeologia Christiana*, IX, 1932, p. 37 ff.

[160] S. G. Xydis, "The Chancel Barrier, Solea, and Ambo of Hagia Sophia," *Art Bulletin*, XXIX, 1947, p. 1 ff. Xydis was certainly right in concluding that the chancel barrier was of the normal semi-opaque type. E. Weigand's paper "Die 'Ikonostase' der Justinianischen Sophienkirche in Konstantinopel" (*Gymnasium und Wissenschaft. Festgabe zur Hundertjahrfeier des Maximiliansgymnasiums in München*, Munich 1950, p. 176 ff.) was not accessible to me; judging by the summary in *Byzantinische Zeitschrift*, XLIII, 1950, p. 469, his conclusions are similar to Xydis'.

[161] S. Der Nersessian, "Le décor des églises du IXᵉ siècle", *Actes du VIᵉ Congrès International d'Etudes Byzantines, Paris 27 juillet-2 août 1948*, II, Paris 1951, p. 315 ff. We now know, however, that the church described in Photius' homily is not the Nea but Our Lady of the Pharos (R. J. H. Jenkins and C. A. Mango, "The Date and Significance of the Tenth Homily of Photius", *Dumbarton Oaks Papers*, IX–X, 1956, p. 123 ff.)

[162] *Antirrheticus III*, 45; Migne, *PG* 100, col. 465.

plicated by uncertainties of dating. But it is nonetheless possible to correlate the archaeological with the literary evidence and to infer, on the basis of the extant material, a notable increase in the use of this medium for religious subjects in the post-Justinianic era (figs. 24, 26).[163]

Often when a picture is made more accessible it is also released from its iconographic context. This is the period when the isolated panel and the ex-voto first came into its own not only in the form of portable icons but also in fixed positions in the church. Again the decorations of St. Demetrius in Salonika and Sta. Maria Antiqua in Rome provide obvious examples. So do the frescoes in the monastic cells of Bawit and Saqqara and the mosaic panel with the figure of St. Sebastian in S. Pietro in Vincoli in Rome (fig. 27).[164] It would be interesting to determine to what extent this development may have temporarily eclipsed the traditional cyclical type of church decoration with its sequences of narrative scenes and its choirs of holy figures, the type so well known to us from the churches of Rome and Ravenna in the West and from texts such as those of St. Nilus[165] and Choricius of Gaza[166] in the East. It is true that in the decades immediately after Justinian the tendency in Byzantium seems to have been rather to give new scope to this traditional type. The reigns of Justin II and Tiberius II seem to have brought a reaction to the vogue of entirely uniconic decorations which the interior of Justinian's St. Sophia so conspicuously exemplified. Comprehensive iconographic schemes may have been devised at that time for the newly built Chrysotriklinium,[167] for St. Sophia,[168] and possibly also for the Church of the Holy Apostles,[169] though in no instance is the evidence at all conclusive. But it is

[163] Kollwitz, *op. cit.*, p. 13 and my study quoted above, n. 114.

[164] Berchem and Clouzot, *Mosaïques chrétiennes*, p. 207 f.; Kitzinger, *Römische Malerei*, pp. 21, 38 f. It appears unlikely that the panel ever formed part of a larger ensemble.

[165] Migne, *PG* 79, col. 577.

[166] *Laudatio Marc.*, I, 47 ff. (*Choricii Gazaei Opera*, ed. R. Foerster and E. Richtsteig, Leipzig 1929, p 14 ff.).

[167] Der Nersessian, *op. cit.*, p. 320. Only the image of Christ in the apse, however, can be claimed with certainty to have been put up originally in pre-Iconoclastic times; see also my remarks in *Dumbarton Oaks Papers*, VIII, 1954, p. 126, n. 191.

[168] Francovich (*Commentari*, II, 1951, p. 79, n. 1) is right in denying the validity of the arguments which have been used by Heisenberg and others to establish the existence of an iconic decoration in St. Sophia in the time of Justin II. The creation of mosaics with figures – though not necessarily, or even probably, with scenes – at that time can, however, be inferred by combining the testimony of Theophanes (ed. C. de Boor, Leipzig 1883, p. 241 f.) with that of an inscription recording the "anastelosis" after Iconoclasm (S. G. Mercati, "Sulle iscrizioni di Santa Sofia", *Bessarione*, XXVI, 1922, p. 200 ff., especially p. 204 f.; cf. my remarks in *Dumbarton Oaks Papers*, VIII, p. 127, n. 195). Whether the newly discovered mosaic decoration of the room over the south west ramp, which comprised medallions with busts of saints, was part of the work of Justin II we cannot say, but it certainly dates from a time later than the original building and earlier than Iconoclasm (cf. above, n. 33 f.).

[169] A case for a pictorial decoration of this church in pre-Iconoclastic times cannot be based on the descriptions by Constantine of Rhodes and Nicholas Mesarites, but solely on Theophanes' statement (referred to in the preceding note) that Justin II "adorned the churches built by Justinian, the Great Church, the Holy Apostles, etc.". If this statement indicates, as it well may, a new

interesting to note the apparently total lack of evidence, either literary or monumental, that during the subsequent reigns down to the period of Iconoclasm any religious building in Constantinople was provided with a major pictorial decoration involving a coherent iconographic scheme. The cyclical form of decoration certainly did not die out. At Sta. Maria Antiqua we find it side by side with detached panels.[170] But the seventh century is essentially the era of the latter and this phenomenon, too, comes under the heading of greater accessibility of images. Released from the serried ranks of a narrative cycle or of a pictorial litany or calendar and no longer part of a universal scheme, an objective, supra-personal order, the sacred representation may become the object of a more intimate rapport, a more personal relationship. Nothing is more characteristic in this respect than the repetition of the same figure or subject in different panels in close proximity to one another, as we find it, for instance, in the church of St. Demetrius. Each picture stands for a separate (though frequently concerted) act of devotion by an individual or a group, whose piety it expresses and whose prayers it receives. Though the eclipse of the traditional form of church decoration was only partial and temporary one is reminded of developments in Western art in the late Middle Ages when the heyday of the great systems of cathedral decoration had passed and votive images and individually commissioned altars often took their place.[171]

These, then, are tangible symptoms which clearly have to do with the new function of images in religious life. If, however, this new function is so distinctly expressed in purely external matters, such as the location of pictures in the church or the choice of medium, is it not reasonable to expect that it also affected the painter's work in its more definitely artistic aspects?

One phenomenon which is certainly significant is the increased boldness displayed by artists of this period in prominently placing before the faithful holy figures in complete repose. Certain apse compositions are particularly interesting from this point of view. In SS. Cosma e Damiano the figures, solemn and awe-inspiring though they are, still participate in a drama (fig. 12). The motif of the introduction of the martyr into paradise is combined with that of a sudden theophany. With a heroic gesture Christ appears to be

departure (in the sense of a fairly ambitious iconic program) in the case of St. Sophia one may be justified in attributing to it the same meaning in regard to the church of the Holy Apostles. But admittedly the argument is tenuous.

[170] Even prior to the comprehensive scheme of frescoes devised for the chancel by John VII there was a cycle of scenes – apparently of "Greek" style – on the sidewalls of the chancel; cf. Kitzinger, *Römische Malerei*, p. 42; E. Tea, *La basilica di Santa Maria Antiqua*, Milan 1937, p. 162.

[171] The analogy with the late medieval development was observed by Grabar, *Martyrium*, II, p. 121. Grabar, however, looks upon the "gallery" of individual ex-votos, which has certain precedents in pagan sanctuaries, as a type of decoration that was in use continuously throughout the early centuries of Christian art side by side with comprehensive cycles (*ibid.*, p. 118 ff.). But there is no Christian example of such a "gallery" earlier than the ex-votos of St. Demetrius and Sta. Maria Antiqua and it is obvious that images expressive of, and intended for, private devotion were much harder to reconcile with the prevailing fear of idolatric abuse than large and "impersonal" schemes which often had a didactic message. In fact, until the late sixth century the serial

descending from the clouds. By contrast, the mosaic of S. Agnese a century later shows nothing but three motionless figures on neutral ground, figures which appear to have no other raison d'être but to offer themselves quietly to the beholder's gaze (fig. 14). Similarly, in the mosaic of S. Venanzio, though it is roughly modelled on an Ascension scene, all dramatic elements are eliminated.[172] In the East among the frescoes of Bawit and Saqqara one finds related compositions in which elements of the Ascension are compounded with others from the Vision of Ezekiel and from the Apocalypse in completely static arrays.[173]

With all action avoided the holy figures lend themselves to functions analogous to those of the cult image in the pagan temple. They are ready to receive the homage of the faithful, to listen to his prayers and to fulfill his wishes. What is particularly significant is the convergence of the trend towards the passive, motionless figure with that toward the isolated panel. A number of the detached ex-votos and portable panels of which I have spoken portray single saints in complete repose, a form of representation to which churchmen had often objected and which Christian art in earlier times had on the whole eschewed except in serial schemes. Taken out of its context the serial portrait becomes a portrait icon. The widespread acceptance of this genus, whether in the form of fixed or movable pictures, is one of the most significant phenomena in the art of our period (figs. 26, 27).[174]

But what about style in the strict and narrow sense? If the new role of religious art, the new relationship between image and beholder, found an expression in the choice of medium and subject, in the arrangement and in the poses of figures, did they not also affect their actual rendering, that is to say, the area of artistic creation which is most definitely, exclusively and intimately the artist's own?

We are thus brought back to our survey of stylistic currents in the late sixth and seventh centuries. And it is obvious that the current which primarily requires consideration is the radically abstract one, for it is this style that we found most frequently associated with the portrayal of holy persons and saints. But here we seem to face a paradox. From a social and religious point of view the saint's image takes on an unprecedented actuality and reality, it begins on a broad scale to speak and act for the saint himself and to be approached, venerated and used more and more as though it were animate. Should one not expect artists to respond to what was clearly an emotional and spiritual need of their time by making such images as lifelike and tangible as possible? Yet it is just in these images that the taste for the immaterial, the weightless, the abstract and remote so often comes to the fore.

and cyclical type of church decoration entirely predominated. This does not preclude the possibility that authentic or supposedly authentic portraits may have served as models for certain figures within these schemes.

[172] For references see above, n.65.

[173] Grabar, *Martyrium*, II, p. 207 ff.

[174] See my paper quoted above in n.114, especially p. 143 f.; also Kollwitz, *op. cit.*, p. 4 ff. (on the specific character of this type of image and the opposition it encountered in the early centuries).

This apparent contradiction is easily resolved. We need only turn to those writers of the late sixth and seventh centuries who tried to defend, motivate and explain the new intensity of Christian devotion to, and faith in, images. We find that the most important step they took in their apologetic quest was to add to the traditional arguments defending images on the strength of their usefulness as tools of education, edification or communication with the deity, others that disregarded the effect on the beholder altogether and were based solely on the transcendental relationship of the image to its prototype. Borrowing from Neoplatonic philosophy the concept of a descending hierarchy of mirror reflections, they claimed that the holy spirit which indwells the saint is reflected also in the saint's image.[175] The icon thus becomes a receptacle for the holy spirit. It is from on high that it receives power and potency. The artist's role is that of creating a receptacle, a house or shell for the divine substance, a vehicle for the supernatural.[176]

It is wrong, therefore, to look in saints' images of our period for realism in the external sense in which the art historian uses the term. Theirs is a realism of a peculiarly mediaeval kind. What appeared to be a paradox is actually a key to the understanding of the distinctive aesthetic quality that characterizes so many of these portrayals, their lack of bodily substance, their remoteness and transparency. And inasmuch as the creation of a consistently abstract style, as we find it, for instance, in the mosaics of S. Agnese and S. Venanzio, or in the ex-votos on the piers of St. Demetrius, was the major artistic achievement of the period, a definite link may be said to have been found between aesthetic innovation on the one hand and social and spiritual forces on the other.

The functional approach thus seems to bear fruit. It helps us to understand the most important stylistic phenomenon of the age and to place that phenomenon into a broader context of cultural and intellectual developments. Yet we must guard against oversimplification. For the equation between saints' images and abstract style is far from complete. We need only think of Sta. Maria Antiqua, where a number of images clearly devotional in character are executed in, or strongly affected by, the hellenistic manner and appear lifelike and three-dimensional. In other instances, and these are particularly revealing, we noted a meeting or juxtaposition of the two opposing stylistic tendencies. Let us briefly return to these instances once more.

[175] *Dumbarton Oaks Papers*, VIII, p. 139 ff.

[176] This implies neither a dependence of the artist on theoretical formulations nor an aesthetic deficiency of his work. On the contrary, I would insist, with R. Berliner, on "the freedom of medieval art" (*Gazette des Beaux-Arts*, 6th series, XXVIII, 1945, p. 263 ff.). More will be said about the autonomy of aesthetic creation presently. It is, however, a striking fact that what may be called the ultimate defense of the image—namely the defense which disregards the effect on the beholder altogether and is conducted entirely on a metaphysical plane—should make its appearance in Christian writing during the same period during which artists made their most extreme advance toward abstract forms. Similarly the first appearance of this "ultimate defense" in *pagan* thought of the third century had coincided with the first great departure from classical ideals of form (see A. Grabar, "Plotin et les origines de l'esthétique médiévale", *Cahiers Archéologiques*, I, 1945, p. 15 ff.).

With their help we may hope to achieve a less simplified and more accurate view of the whole problem.

There was the icon of the Virgin on Mount Sinai (fig. 24) with its rigidly aligned, stiff and insubstantial figures of saints and its startlingly impressionist angels. It is not the only instance in which a particularly striking display of impressionist verve and virtuosity has gone into the rendering of angels. The same phenomenon occurs among the paintings of Sta. Maria Antiqua[177] and elsewhere.[178] At times it appears as though a bold, sketchy manner were, so to speak, in the nature of an "iconographic attribute" of angels. An obvious explanation is that it was a means of expressing the fact that they belong to a different order of beings, that they are incorporeal, ἀσώματοι. Hellenistic pictorial technique in these cases serves as a means not of actualizing physical, but of accentuating spiritual existence.

On the other hand, we found that in the set of ex-votos in St. Demetrius it is in the figures, and especially the faces of living persons, rather than those of the saints that abstraction is carried to the greatest extreme (cf. figs. 1, 23). Here again there seems to be an attempt to differentiate between two orders of being, in this case the saint and the mortal, and it is important to note that the artist's ideal of simplified linear form has found an even more radical application in the latter than in the former.

More interesting still is the stylistic dichotomy in the ornamentation of the canon arcades in Brit. Mus. Ms. Add. 5111 (fig. 25). Nordenfalk has suggested that the lively and three-dimensional character of the acanthus decoration and the birds on top of the arches, as distinct from the extremely stylized ornament covering the arches themselves, corresponds to what would be in reality sculpture in the round as opposed to merely "painted" ornament.[179] Certainly there is in this case, too, an attempt to express different orders of existence. The plants which "grow", the birds which "perch" on top of the architecture are meant to be a degree more "real" than the ornamentation of the architecture itself; the little portraits incorporated in the arches partake of the order of the former rather than the latter.

All these are examples of different styles being employed simultaneously in one and the same context for the – evidently deliberate – purpose of expressing different orders of being or different levels of reality. In other words, we must considerably broaden, and at the same time refine, our concept of what I have called "modes". It is not enough to point to the association of different styles with different iconographic categories, different degrees of solemnity and importance of content, or with objects serving different social functions. They also serve as a means of establish-

[177] See especially Wilpert, *Römische Mosaiken und Malereien*, IV, pls. 143, 1; 156, 3.

[178] Cf. e.g., at an earlier period, the angels in the vault of S. Vitale (Peirce and Tyler, *L'art byzantin*, II, pl. 126) by contrast to other figures in the same decoration. The angels above the apse of SS. Cosma e Damiano in Rome are also rendered in a somewhat looser manner than the figures in the conch (Matthiae, *SS. Cosma e Damiano e S. Teodoro*, pls. 14–16, 19, 20, 23–28; *ibid.*, p. 49 ff., an attempt – in my opinion not cogent – to ascribe them to a different period).

[179] *Die spätantiken Kanontafeln*, p. 138 f., n. 2.

ing, so to speak, a hierarchy in the realm of the visual, and the role of the different "modes" in denoting these ranks is strangely fluid. Hellenism we find may stand for an emphasis on material reality but also for a purely spiritual existence.

The marked contrasts, the lack of stylistic unity in Byzantine art of the late sixth and seventh century thus appears to have sprung at least in part from an unprecedented awareness of, and need to express, different levels of beings and degrees of spirituality. Hellenism was kept alive not only by the conservatism of certain workshops and by its traditional association with certain iconographic categories, but also by its seemingly contradictory potentialities to express both a "natural" and an immaterial existence. On the other hand, it was this same need to enlarge the gamut of possible forms of existence which led to a new extreme of abstraction, an abstraction which could be applied not only to holy icons, but also to images that served no devotional purposes and even to ornament. Artists created these forms not with an eye on one specific social function only, but to increase the range, to push back the frontier, of visual reality and experience in general. In ornament the abstract tendencies emerge with particular strength in the course of the seventh century.[180] It would be impossible to understand this phenomenon if the abstract style were to be understood simply as the artist's response to the rising cult of images. Aesthetic creation – and this is the crux of the whole problem – is in the last resort autonomous.

It is autonomous but not divorced from the cultural environment of the artist. The fact that so bold an advance towards a purely conceptual style occurred during the same period which saw the spectacular rise of the cult of images is not accidental. A direct causal relationship between the two phenomena cannot be claimed. But both grew on the same soil. The milieu in which the artists lived and worked was the same in which the urge to behold the unseen, to have the ineffable made palpably real and present, broke through with unprecedented strength. The same experiences which motivated the actions and aspirations of society as a whole also went into the process of artistic creation, and the new forms that were evolved could not but correspond to the spiritual needs of the age. No wonder, therefore, that we find the abstract style so often associated with images that lent themselves to devotional use. Artists clearly were not unaware that their handiwork was assuming a new and unprecedented role and that the whole relationship between beholder and religious image was undergoing a fundamental change.[181] In the making of devotional images their own aesthetic aspirations naturally coalesced with the demands of contemporary society.

[180] See e.g. G. A. Sotiriou, "Byzantine Sculpture in Greece in the seventh and eighth centuries" (in Greek), *Archaiologike Ephemeris*, 1937, p. 171 ff.

[181] Berliner (*op. cit.*, p. 276) even envisages the possibility of "studio discussions" of a fairly theoretical sort among Byzantine artists. In any case, they must have been aware of the practical uses to which pictures were put.

To unravel the give and take between the aesthetic sphere, on the one hand, the social and intellectual, on the other, is a problem that ultimately eludes rational analysis. But it seems to me that something is gained from a methodological point of view if, rather than relating a major stylistic innovation to a vague and general Zeitgeist or to developments entirely outside the range of the artist's experience, we can point to specific social and intellectual phenomena that have a demonstrable connection with the world and work of the artist and can be shown to be consistent with the forms he creates. The functional approach cannot lay bare the roots of artistic creation, but it can help to narrow the gulf of the unexplorable. In looking at images of saints such as those of S. Agnese (fig. 14), of the ex-votos of St. Demetrius (figs. 1, 22, 23) or the Sinai icon (fig. 24) it surely is relevant to recall that figures such as these were prayed to and expected to work miracles and were thought of as indwelt by the Holy Ghost. In their stillness and transparency they are capable of conveying – more than any works of Byzantine art of previous ages – a sense of the numinous. Remote and withdrawn, they yet exert a power of a quietly hypnotic kind. They may be claimed to be the first truly iconic figures in Byzantine art.

Thus the period between Justinian and Iconoclasm saw the icon emerge as a major art form not only in the purely external sense that isolated and accessible images became more frequent, but also in the sense that an aesthetic ideal profoundly appropriate to the icon found its full realization. Therein lies the crucial and essential achievement of this period, an achievement which puts it on a par with any of the other great ages of Byzantine art. To measure the significance of this advance it is enough to look ahead, beyond the hiatus of Iconoclasm, to the great church decorations of the Macedonian and Comnenian eras. In these decorations the isolated iconic panel was to be raised to its full dignity and importance. It became a basic element in a canonically ordered pictorial system which in turn was welded into an architectural organism that portrayed in material, yet spiritualized form the Christian universe.[182] And in the gaunt, still and unearthly figures which dominate in lonely grandeur the apses of these later churches we recognize descendants of those created in the seventh century (compare figs. 14 and 28).[183]

Post-Iconoclastic art therefore is indebted to the period we have surveyed not only for the preservation of the hellenistic heritage (a fact without which the Macedonian Renaissance cannot be seen in its proper proportion) but also for creating new forms that proved peculiarly appropriate to holy images. It is a mistake to think of the icon as a fruit of the Iconoclastic crisis. Challenged by violent opposition the theologians of the eighth and ninth century gave a unique and definitive articulation to the

[182] O. Demus, *Byzantine Mosaic Decoration*, London 1947, especially p. 14.

[183] The mosaic of S. Agnese has been compared with later Byzantine apse compositions already by Toesca (*Storia dell'arte italiana*, I, Turin 1927, p. 221).

function and meaning of Christian religious art. But in the artistic sense the icon was then already an accomplished fact. It was the central achievement of the age before Iconoclasm and has deep roots in the social and spiritual travail of that era. The essential forms created at that time proved lastingly capable of sustaining the vital role of the religious image in Byzantine life, even after that role had been enhanced further by the final defeat of its detractors in the ninth century.

Fig. 1. Salonika, St. Demetrius. Mosaic: St. Demetrius and donors (Tsimas photograph)

Fig. 2. Rome, Sta. Maria Antiqua. Fresco: The Maccabees with Solomone, their mother
(after Wilpert)

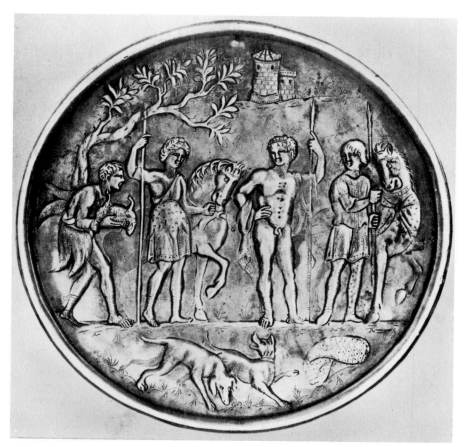

Fig. 3. Leningrad, Hermitage Museum. Silver plate: Meleagar and Atalante (after Matsulevich)

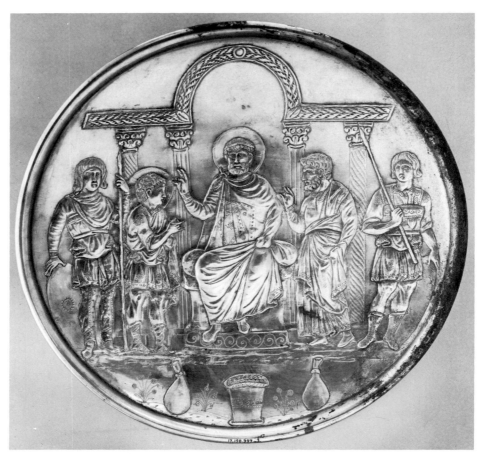

Fig. 4. New York, Metropolitan Museum. Silver plate: David being introduced to Saul
(photograph by courtesy of the Museum)

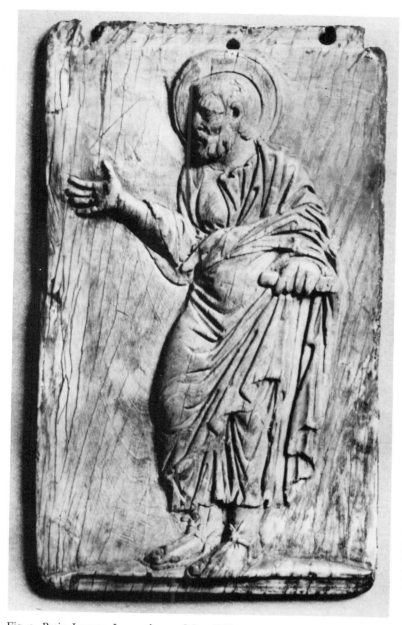

Fig. 5. Paris, Louvre. Ivory plaque: Saint. Fifth century (Giraudon photograph)

Fig. 6. Nicosia, Cyprus Museum. Silver plate: David's marriage, detail
(photograph by courtesy of the Museum)

Fig. 7. Halle/Saale, Landesmuseum für Vorgeschichte. Fragment of silver vessel from Gross
Bodungen. Late fourth century (photograph by courtesy of Dr. W. Grünhagen)

Fig. 8. Detail of fig. 3 (after Matsulevich)

Fig. 9. Jerusalem, Dome of the Rock. Mosaic: Rinceaux (after Creswell)

Fig. 10. Istanbul, St. Sophia, Room over south west ramp. Mosaic: Rinceaux
(photograph by courtesy of the Byzantine Institute, Inc.)

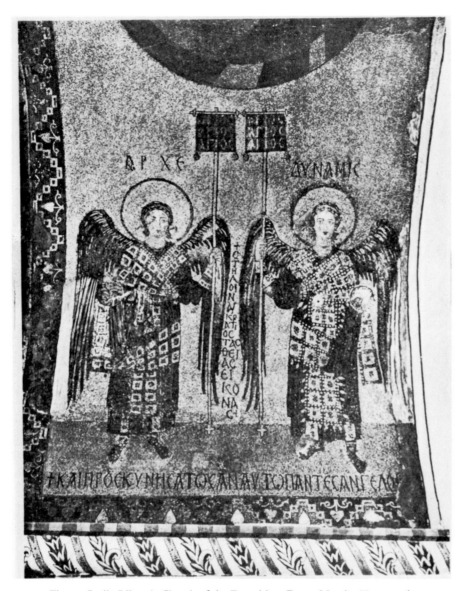

Fig. 11. Iznik (Nicaea), Church of the Dormition, Bema. Mosaic: Two angels
(destroyed; reproduced after Schmit)

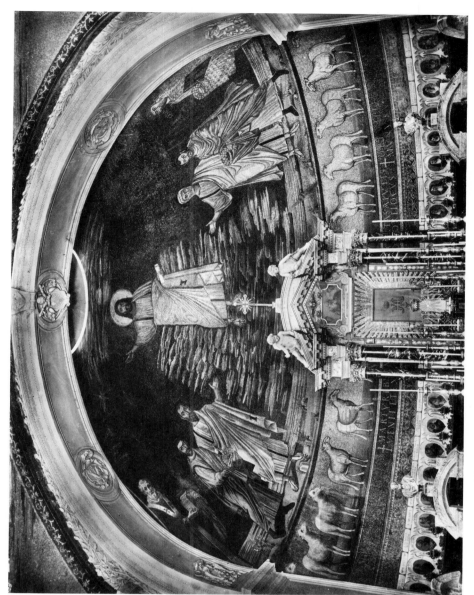

Fig. 12. Rome, SS. Cosma e Damiano, Apse. Mosaic (Anderson photograph)

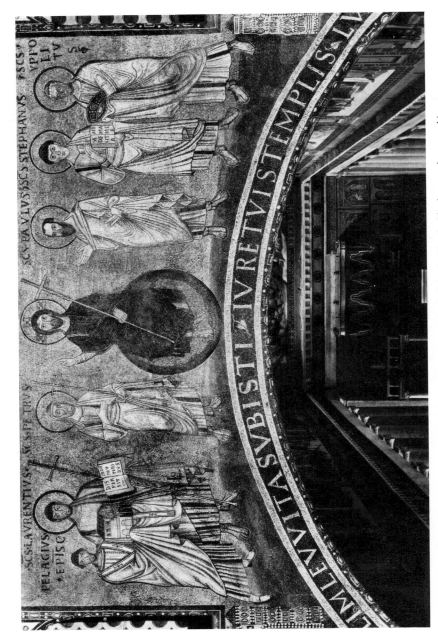

Fig. 13. Rome, S. Lorenzo fuori le mura, Triumphal Arch. Mosaic (Anderson photograph)

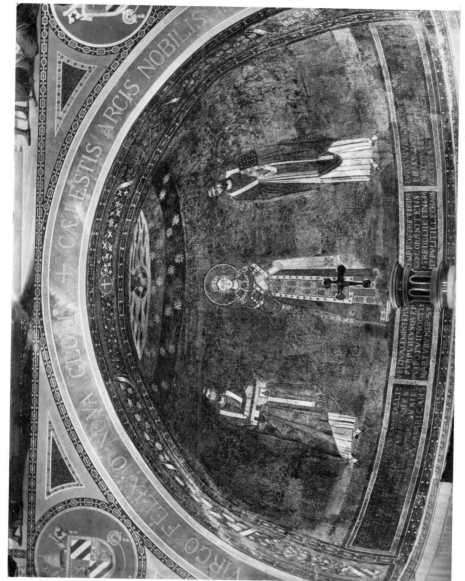

Fig. 14. Rome, S. Agnese, Apse. Mosaic (Anderson photograph)

Fig. 15. Detail of fig. 12: Head of St. Peter (after Matthiae)

Fig. 16. Detail of fig. 13: Head of St. Hippolyt (after Matthiae)

Fig. 17. Mount Sinai, Monastery of St. Catherine, Church. Mosaic in apse,
detail: Busts of St. Mathias and of Abbot Longinus (after Sotiriou)

Fig. 18. Rome, St. Peter's, Treasury. Cross of Justin II, detail
(after Peirce and Tyler)

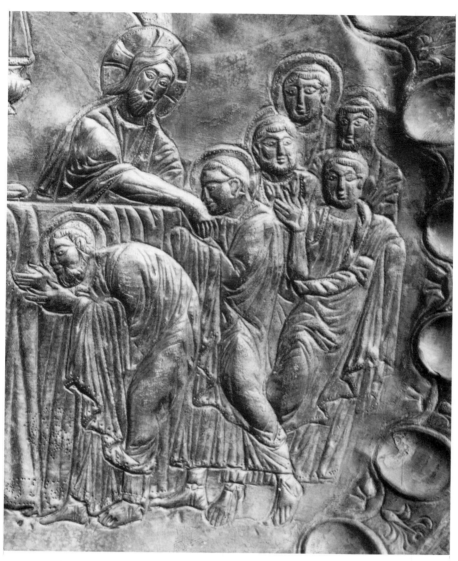

Fig. 19. Istanbul, Archaeological Museum. Silver paten from Stuma, detail
(Giraudon photograph)

Fig. 20. Washington D. C., Dumbarton Oaks Collection. Silver paten from Riha
(photograph by courtesy of the Collection)

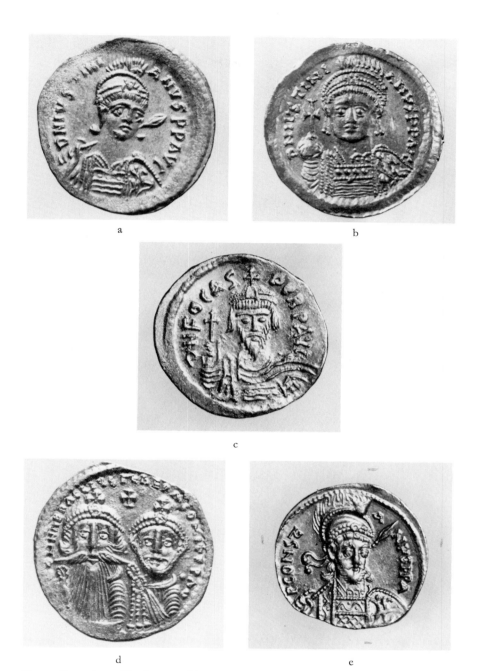

Fig. 21. Byzantine gold coins: a and b Justinian I; c Phocas; d Heraclius; e Constantine IV
(enlarged photographs by courtesy of the Dumbarton Oaks Collection)

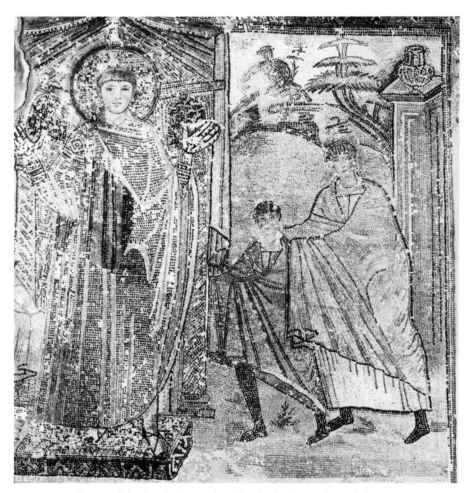

Fig. 22. Salonika, St. Demetrius. Mosaic: St. Demetrius and donors
(Tsimas photograph)

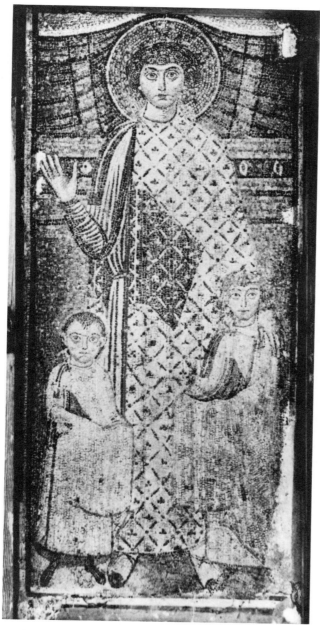

Fig. 23. Salonika, St. Demetrius. Mosaic: Saint and children
(Tsimas photograph)

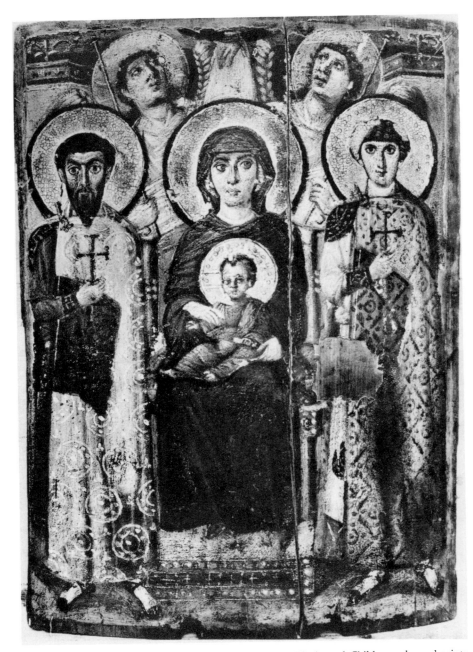

Fig. 24. Mount Sinai, Monastery of St. Catherine. Icon: Virgin and Child, angels, and saints
(after Sotiriou)

Fig. 25. London, British Museum. Ms. Add. 5111, f. 11r
(photograph by courtesy of the Trustees of the British Museum)

Fig. 26. Mount Sinai, Monastery of St. Catherine. Icon: St. Peter (after Sotiriou)

Fig. 27. Rome, S. Pietro in Vincoli. Mosaic: St. Sebastian
(Alinari photograph)

Fig. 28. Iznik (Nicaea), Church of the Dormition, Apse. Mosaic: Virgin and Child
(destroyed; reproduced after Schmit)

VII ON SOME ICONS OF THE SEVENTH CENTURY

CHRISTIAN panel paintings of pre-Iconoclastic date are rare. Since much less is known about this class of monuments than about mosaics and frescoes, it is apt to be assigned a rather peripheral position in the art historian's panorama of the period. Three recently discovered examples—one in Rome, the other two on Mount Sinai—make it necessary to revise this concept somewhat. Their artistic merits are so great that panel painting must now be accepted as having been an important medium in Christian art already at a relatively early date. The first part of this paper will be devoted to these newly found examples. In the second part an attempt will be made to place pre-Iconoclastic panel-painting as a whole in a larger historical context.

I

The "Madonna di S. Luca" in Sta. Francesca Romana on the Roman Forum was thought until a few years ago to be a work of the thirteenth century, disfigured by later repaintings. Pico Cellini, who set out to restore the medieval painting to its pristine shape, was the fortunate and skillful discoverer of an earlier canvas, which lay concealed beneath what proved to be indeed a work of the early Dugento. All students of Early Christian and early Byzantine art owe him a debt of gratitude for this find, which he has made accessible promptly in a splendidly illustrated article.[1]

Hidden beneath the *incamottatura* of the thirteenth century[2] lay two neatly cut pieces of canvas painted in wax colors and representing respectively the heads of the Mother and the Child.[3] The two fragments were pasted directly onto the wooden foundation of the picture. But this was not their original position. Sig. Cellini found that, although the material is identical in both fragments, the threads of the canvas do not correspond.[4] Furthermore, the heads are too big for the panel and presuppose a composition of considerably larger scale.[5]

No attempt will be made in these pages to reconstruct the compositional scheme of the original canvas, which must indeed have been a monumental work. The face of the Virgin alone—much less remains of that of the Child[6]—will form the subject of a brief analysis intended to throw light on the date and place of origin of the work (Fig. 1).[7]

[1] P. Cellini, "Una Madonna molto antica," in *Proporzioni*, III (1950), 1ff. See also G. Ansaldi, in *Atti dello VIII congresso internazionale di studi bizantini, Palermo 1951*, Rome 1953, pp. 63ff. Two further studies of this painting have appeared since the present article was completed: A. Grabar, "Note sur l'iconographie anciennes de la Vierge" in *Cahiers Techniques de l'Art*, III (1954), 5ff.; C. R. Morey, "The Madonna of Sta. Francesca Romana," in *Studies in Art and Literature for Belle da Costa Greene*, ed. D. Miner, Princeton 1954, pp. 118ff.

[2] Cellini, *op. cit.*, figs. 4, 5, 8, 10. [3] *ibid.*, figs. 6, 7, 9 and frontispiece (in color).

[4] *ibid.*, p. 4. [5] *ibid.*, p. 5 and fig. 7. [6] *ibid.*, fig. 6.

[7] I wish to express my gratitude to Prof. E. Lavagnino, whose kindness enabled me to examine the painting at leisure.

We have before us a Madonna in the heroic manner. The scale is far over lifesize.[8] The face, a full and very regular oval, is of Grecian type with a long aristocratic nose and small but full lips. Indeed, the painter was steeped in Hellenism. Not only did he visualize the Virgin as a classical heroine, he had at his command the coloristic means of Hellenistic painting. He was a master of the art of modeling flesh through delicate and imperceptible transitions from pink to near-white and through subtle use of light and shade. Like some of the figures in the frescoes of Sta. Maria Antiqua, which so startled scholars with their classicism when they were first discovered, this face brings up the thought of a "Pompeian" survival in Christian art.

As a matter of fact, the comparison with Sta. Maria Antiqua is not purely generic. When one tries to find in the whole range of Early Christian and Byzantine painting prior to the thirteenth century any work or group of works characterized by this particular kind of Hellenism combining a heroic mood with extreme subtlety of pictorial technique, one is quickly led to concentrate on certain frescoes on the walls of the ancient church at the foot of the Palatine Hill. The paintings which are of special interest are those of the second layer on the back wall of the sanctuary, which includes the famous head of an angel, the most purely classical of all the paintings in the church (Fig. 2).

Here the similarity is quite specific. It extends to the elongated oval of the face, the full cheek and chin (with almost a suggestion of a double chin), the curvature of the brows and of the eyelid (which ends in the outer corner in a small, elegant curl) and the long straight nose and full and fleshy, though small, lips. The mouth of the Virgin from Sta. Francesca Romana, which is imperfectly preserved, can, in fact, be readily visualized in its pristine shape on the strength of the fresco. The dark line between the two lips has lost its right end.[9] If it is extended a little the mouth will not seem so unduly small and the boundary between mouth and cheek less abrupt. A further characteristic which the Virgin on the canvas shares with the Angel on the fresco is a deep shadow on the right or near side of the nose, which one would imagine—also in view of the shadow cast by the chin—to be fully lit. In both instances—and here we have a first indication that we are not dealing with true products of classical times—it is, in fact, impossible to indicate a single unified source for the light by which the various parts of the face are thrown into relief.[10]

It would be quite impossible to find similarly close analogies for details of the Roman canvas, for instance, on Egyptian mummy portraits, which one might feel

[8] The canvas fragment with the head and neck of the Virgin measures 53 x 41 cm.; that with the head of the Child 30 x 13 cm.

[9] Throughout this paper "left" and "right" are intended to refer to the viewpoint of the beholder.

[10] On the floor mosaics of Antioch one can observe the gradual emergence during the fourth and fifth centuries of what appears to be an intentionally irrational use of shadows for modeling faces. Heads of the period of Constantine can still be understood as lit from a single source (D. Levi, *Antioch Mosaic Pavements*, Princeton, London, and The Hague, 1947, II, pl. 162). In the case of certain faces of the period about A.D. 400 the direction of the light modeling the features is no longer clear (*ibid.*, pls. 167, 168b) and in the course of the fifth century one finds increasingly often a shadow line on the "wrong" side of the nose, with the result that faces shown *en face* or in three quarter view incongruously appear to have their noses drawn in full profile (*ibid.*, pls. 169, 170ff.).

133

tempted to compare on the purely technical ground that they, too, are painted with wax colors. A glance at the color plates in Flinders Petrie's "Hawara Portfolio"[11] suffices to bring out the lack of specific resemblance of our Madonna to this class of monuments, which, moreover, had its classical phase in the centuries preceding the rise of Christian art. The mummy portraits of the fourth and fifth centuries, which alone could be relevant chronologically, are particularly unsuitable for stylistic comparisons.[12] Such comparisons—and the same is true of those with Greek works of post-Iconoclastic date—can only serve to underline the specific points of resemblance with the Angel in Sta. Maria Antiqua and to make this connection appear more valid and meaningful.[13]

The Angel is a work of the seventh century. It belongs to a group of frescoes of that period in the church on the Forum, in which Hellenistic traditions of figure design, composition, and pictorial technique survive to an amazing degree.[14] So far as impressionistic boldness of the brushwork is concerned, the outstanding representative of the group is a panel depicting the Mother of the Maccabees with her seven sons, a work which shows full mastery of the art of producing an illusion of lifelike figures in atmospheric space through broad patches of color, dramatic highlights, and a minimum of outline and shading.[15] The painter of the Angel used this technique in a more restrained way. He has avoided excessive contrasts and has produced an impression of threedimensional form through a gradation of colors and modeling shadows, rather than through sudden highlights on an indefinite, dark foil. As a result the face of the Angel, compared with the elusive forms of the Maccabees, appears relatively solid, tangible, and clearly defined. The painter of the Virgin at Sta. Francesca Romana has carried the tendency towards crystallization of form very much further. The individual brush stroke is no longer perceptible. Each tone merges into the next and the whole face becomes a configuration of smoothly modeled surfaces, now quite sharply set off against one another. The eye-sockets are like convex shells or cups, divided by sharp grooves from the likewise convex surfaces of the cheeks. Front and side of the nose meet in an equally sharp ridge, which forms with the right eyebrow a single curve of geometric precision.

[11] W. M. Flinders Petrie, *The Hawara Portfolio: Paintings of the Roman Age*, London 1913.

[12] H. Drerup, *Die Datierung der Mumienportraits*, Paderborn 1933, pls. 16ff.

[13] The late Prof. A. M. Schneider suggested that the Roman Virgin is a work of the twelfth century and adduced for comparison the Virgin in the Tretyakov Gallery in Moscow (F. Doelger and A. M. Schneider, *Byzanz*, Bern 1952, p. 301). Presumably he had in mind the Virgin of the *Annunciation* icon reproduced by V. N. Lazareff, *History of Byzantine Painting* (in Russian), II, Moscow 1948, pl. 214. Though comparable in general type this figure cannot be compared with ours in the specific details which we have mentioned. Furthermore, this work of the Comnenian period has an emotional content entirely absent from our canvas, which seems archaic by comparison.

[14] M. Dvořak, "Die kunstgeschichtliche Bedeutung der Mosaiken in der Markuskirche zu Rom," originally published in Ph. Dengel, M. Dvořak, H. Egger, *Der Palazzo di Venezia in Rom*, Vienna 1909, pp. 33ff.; reprinted in M. Dvořak, *Gesammelte Aufsaetze zur Kunstgeschichte*, Munich 1929, pp. 19ff., especially pp. 38ff. M. Avery, "The Alexandrian Style at Santa Maria Antiqua, Rome," in *Art Bulletin*, VII (1925), 131ff., especially pp. 131, 135, 137f. E. Kitzinger, *Roemische Malerei vom Beginn des 7. bis zur Mitte des 8. Jahrhunderts*, Munich 1936, pp. 5, 8ff.

[15] J. Wilpert, *Die roemischen Mosaiken und Malereien der kirchlichen Bauten vom IV. bis XIII. Jahrhundert*, IV, Freiburg i.B. 1917, pl. 163. Cf. Avery, *op. cit.*, p. 137f. and fig. 24; Kitzinger, *op. cit.*, pp. 8ff.

As these last observations indicate, the style of our Virgin is by no means identical with that of the Angel. The former lacks the warm painterly quality of the latter and has acquired a crystalline, almost icy coldness. The contrast is perhaps greatest in the eyes, which are much larger than those of the Angel and seem lifeless by comparison.

Curiously enough, some of the features which distinguish the Virgin from the Angel are reminiscent of another painting in Sta. Maria Antiqua, in close proximity to the latter, but situated on an earlier layer of plaster and executed in an utterly different style. This is the famous "Maria Regina" with worshiping angels, a fresco which was painted on the back wall of the sanctuary sometime during the sixth century (Fig. 3).[16] It is the work of an artist who thought entirely in terms of solid, opaque forms and unbroken surfaces delineated against one another with the utmost clarity. Faces and garments—particularly the white ones—have an icy quality. The whole composition is rigidly symmetric. The figures seem petrified, an impression further enhanced by a profusion of precious stones on the costume of the Virgin and on her throne.

The element of chilliness in our canvas, and particularly the size and shape of the eyes, are reminiscent of the "Maria Regina." As far as one can judge from the fragmentary remains, the Virgin on the fresco also had a "Greek" profile, with forehead and nose united in a single unbroken surface clearly cut on both sides by the geometric curves of the brow lines. It is the combination of the cool precision of this earlier work with the painterly manner of the Angel, which lends our canvas its specific character. Its style, in fact, turns out to be a remarkable blend of two seemingly irreconcilable opposites and perhaps one should add that the fusion attempted by the artist is not completely satisfying.

By a strange coincidence the two frescoes which have helped us towards an understanding of the formal characteristics of our icon happen to be the most critically important among all the extant remnants of painting in Rome in the centuries between Justinian and Charlemagne. With the exception of a small number of mosaics, the "Maria Regina" at Sta. Maria Antiqua is the most outstanding remnant of pictorial art in Rome in the sixth century. Byzantine in its solemnity and in antiquarian detail, the fresco has no counterpart in the East so far as consistency and rigidity of its symmetrical organization and the radical rejection of all cursive and painterly qualities are concerned. In these respects it reflects Roman tradition and taste of the incipient Dark Ages.[17] But its greatest importance lies in its physical relationship to the layer of plaster on which the "Pompeian"-looking Angel is painted. The incontrovertible fact that the Angel was painted *over* the radically unclassical "Maria Regina" has provided art historians with a key to an understanding of the evolution of Roman painting in the centuries following the age of Justinian. It was the stratification of these frescoes on the chancel wall of Sta. Maria Antiqua which led to the conclusion—then confirmed by a study of other monuments in Rome—that a new wave of Hellenism must have reached the papal city from outside in the early seventh century. Art historians are

[16] Wilpert, *op. cit.*, pls. 133f. Cf. Avery, *op. cit.*, pp. 132ff.; Kitzinger, *op. cit.*, p. 5.
[17] Kitzinger, *op. cit.*, pp. 6f.

135

agreed that this wave originated in the Greek East, though no agreement has yet been reached on its specific source.[18]

The history of style in Roman painting of the seventh and eighth centuries is primarily that of the reception, absorption, and transformation of the Hellenistic elements imported from the East at that time. To be sure, all painting of that period in Greek lands did not bear the hallmarks of an illusionism as pure and bold as that which appears in the picture of the Maccabees. We need only remember the mosaics on the piers of the church of St. Demetrius in Salonika with their rigid, hieratic figures and the reflection of their style in the almost contemporary mosaics of the oratory of S. Venanzio at the Lateran in order to become aware of the diversity of styles emanating from the Greek sphere in the seventh century. Even the more abstract artists in the East, however, did not carry linear and geometric tendencies to the extreme which such tendencies were apt to assume in Rome, where, by the sixth century, pictorial illusionism was a lost art, witness the "Maria Regina" of Sta. Maria Antiqua. When in the early seventh century Eastern influences began to flow westward in a broad stream, painters in Rome went to work on the Greek models and transformed and reinterpreted them in terms of clear outlines, solid surfaces and rigidly geometric compositions, in keeping with local tradition. The result of this meeting of Eastern and local currents in Rome was a great variety of compromises and interpenetrations.[19] The Madonna of Sta. Francesca Romana is one of the works in which these local tendencies clearly reassert themselves while many essentials of the Greek tradition are still retained. No other painting is known which shows exactly the same blend. But the ingredients are unmistakable and their encounter is so unparalleled that the attribution of the Virgin of Sta. Francesca Romana to an artist working in Rome in the seventh, or, possibly, early eighth, century may be proposed with some confidence.[20]

It is true that this conclusion conflicts with a tradition according to which the icon was brought to Rome from the East, and more precisely from Troy. This tradition will be discussed in an excursus. It is bound up with the attribution of the picture to St. Luke, and although there is a possibility that it may be very old it cannot be traced back with any degree of certainty beyond the thirteenth century.

The thesis that our Madonna was painted in Rome and reflects a mingling of currents peculiar to the Roman school receives support from a comparison with the two indubitably Eastern panels on Mount Sinai published by Sotiriou. One of these represents an enthroned Virgin and Child flanked by two saints in court costumes and by two angels (Fig. 4), the other the bust of a bearded saint, presumably St. Peter, as Sotiriou suggests (Fig. 7).[21] As far as one can judge from the photographs—and all such

[18] Dvořák, op. cit., pp. 37ff. Avery, op. cit., pp. 140ff. Kitzinger, op. cit., p. 12. C. R. Morey, Early Christian Art, Princeton 1942, p. 185. A. Capitani d'Arzago, in G. P. Bognetti, G. Chierici, A. Capitani d'Arzago, Santa Maria di Castelseprio, Milan 1948, pp. 68off.

[19] For the details of this process see Dvořák, op. cit., pp. 41f.; Avery, op. cit., pp. 135ff.; Kitzinger, op. cit., passim.

[20] Similar dates have been proposed by Morey and Grabar in their papers quoted in note 1 above. Both these scholars, however, seek the origin of the painting in the East.

[21] Icon of the Virgin: G. A. Sotiriou, "Icones Byzantines du Monastère du Sinai," in Byzantion, XIV (1939),

136

judgments are necessarily tentative—the hard, icy quality of the Roman canvas is absent from both these panels. Faces are painted as organic units, not as composites of convex surfaces set off against one another sharply and precisely. To be sure, neither of these works approaches the extremes of illusionism which we found in the picture of the Maccabees. We have already said that all painting in the Greek East was not of that kind. But the geometric conception, the mathematical precision which gives the canvas fragment its specific note is absent from both these panels.

With the exception of the largely provincial work in Coptic monasteries, few paintings of pre-Iconoclastic times have survived in the East. Our best chance to find comparisons for the icons from Sinai is by turning once more to works of the "Greek" current in Rome. As a matter of fact, Sta. Maria Antiqua furnishes parallels for both works. The beardless saint on the icon of the Virgin invites comparison with the fresco-"icon" of St. Demetrius in the Forum church (Fig. 5). Not only does this comparison enable us to identify with virtual certainty the saint represented on the Sinai icon as St. Demetrius,[22] it may be suggested in addition that the two works cannot be far removed from one another in date. The Roman fresco is a cruder piece of painting. Lights and shades are apt to appear as so many juxtaposed lines, an effect not compatible with the illusion of threedimensional shapes which they are intended to produce, whereas in the eastern work they merge softly and gently. Nevertheless, the resemblance in type, features, and expression is very strong. Further indication of some kind of relationship with this particular phase of the work in Sta. Maria Antiqua is provided by the fact that the head of St. Barbara—a figure which forms a pendant to St. Demetrius on the opposite pier of the Forum church—has much in common with the face of the Virgin on the Sinai icon (Figs. 4, 6). Again we must allow for an imperfect understanding of the technique of illusionism on the part of the fresco painter. But he must have seen, and evidently strove to imitate, such fleshy, well-rounded faces as the Virgin from Sinai possesses.

The complementary figures of St. Demetrius and St. Barbara are among the earliest works of the "Greek" phase in Rome. Both were painted, presumably by local painters following closely the recipes of the Greek masters, before—but not long before—the middle of the seventh century.[23] It is not too bold to suggest that the phase of Greek painting from which these Roman works derive is one that must have included works such as the Sinai icon. Hence this panel should probably be assigned also to the first half of the seventh century.[24] It must be left to further studies to define in more precise

325ff., especially p. 326 and pl. I; *Idem*, "Encaustic Icon of the Enthroned Virgin of the Sinai Monastery" (in Greek), in *Bulletin de Correspondance Hellénique*, LXX (1946), 552ff. and pls. XXV-XXVI. Icon of St. Peter: *Idem*, "Encaustic Icon of the Apostle Peter of the Sinai Monastery" (in Greek), in *Annuaire de l'Institut de Philologie et d'Histoire Orientales et Slaves*, X (1950) = *Mélanges H. Grégoire*, II, 607ff. and pls. I-II.

[22] This identification (with St. George as an alternative) had already been proposed by Sotiriou (*BCH*, LXX, p. 553).

[23] Kitzinger, *op. cit.*, pp. 10ff.; p. 48, n. 24.

[24] A date in the seventh century had already been suggested tentatively by K. Weitzmann, who discussed this icon in *The Fresco Cycle of S. Maria di Castelseprio*, Princeton 1951, pp. 11f. (with fig. 12).

137

historical and geographic terms the relationship between the Sinai icon and the Roman frescoes and their prototypes, a task which has a bearing on the problem of the exact provenance of the "Greek" style of the latter.

The bust of St. Peter calls to mind a somewhat more advanced phase of painting in Rome. It is true that the Saint's drapery, with its suggestion of a brittle surface of glossy silk broken by many deep, straight and narrow folds and lit by bundles of thin highlights, again invites comparison with the fresco of St. Barbara and even with the Maccabees. But in the massive, towering head of this saint with its large, dark eyes resting quietly on the beholder a new note appears, reminiscent of some of the frescoes done in Rome in the early years of the eighth century, particularly the heads of the apostles from the decoration of John VII in Sta. Maria Antiqua (Fig. 8). The head of St. Peter, like those on the Roman fresco decoration, conveys an impression of solid mass pressed into the confines of an extremely firm and regular over-all structure. Though in the Roman head this structure is made more explicit and emphatic by means of heavy, dark lines there is in both works a similar synthesis between modeling and schematism in technique, between lifelikeness and quiet solemnity in expression.

Prior to the appearance of the Sinai icon the style of the apostles in the decoration of John VII could be considered a result of a local Roman attempt to revive, on the basis of the illusionistic works of the seventh century, something of the monumental grandeur of figures of the early Justinianic period.[25] The Sinai icon suggests that this concept needs revision, or rather expansion, in the sense that a similar phenomenon may have existed in the East at the same period and may, indeed, have been the point of departure for the style of the works in Rome that are associated with the name of John VII. The period of direct Eastern intrusions in Rome, previously thought to be confined mainly to the first half of the seventh century, may have continued into the eighth. The artistic relations between Rome and the East in the period just before the outbreak of Iconoclasm may have to be reassessed and, as a result, it may be possible to make fuller use of the Roman material to reconstruct certain stylistic trends in Eastern painting of that time. In any case, the stylistic relationship between the icon of St. Peter from Mount Sinai and the apostles at Sta. Maria Antiqua suggests that a date close to the year 700 should be assigned to the former.

II

It is not the purpose of this paper to explore further the problems raised by these stylistic connections. Instead, the pages which follow will be devoted to a brief discussion of certain more general questions brought to the fore by the discovery of these icons.

If the dates here proposed are correct all three icons were painted during the last three, or at the most, four generations preceding the outbreak of Iconoclasm in Byzantium. One wonders whether portable paintings on wood and canvas are not perhaps, as a class, characteristic of that period.

[25] Kitzinger, *op. cit.*, pp. 16ff.

138

The total number of early icons that have come down to us is too small to permit a conclusive statement. The most important examples, aside from the three that have been discussed, are four panels, again from Mount Sinai, in Kiev, of which at least two should, in all probability, also be assigned to dates later than A.D. 600 (for one of these see Fig. 9).[26] Aside from these we have only the famous "Acheiropoieta" of the Lateran, a painting on canvas of which nothing definite can be said except that it was in existence in the time of Pope Stephen II (752-757),[27] and some portable paintings of provincial Coptic style, most of which have been recovered from excavations in Egypt. No precise dates can be assigned to these until we know more about the chronology of the frescoes in the Coptic monasteries, to which most of them are related.[28] For the moment one can only suggest tentatively that the center of gravity

[26] An extensive literature exists on these four icons, which were taken to Kiev in the nineteenth century. The principal publications are: D. Ainalov, "Sinai Encaustic Icons" (in Russian) in *Vizantiiskii Vremennik*, IX (1902), 343ff. and pls. I, III, IV, V; and O. Wulff and M. Alpatoff, *Denkmaeler der Ikonenmalerei*, Hellerau bei Dresden 1925, pp. 8ff., 18ff., 30ff. and figs. 2, 3, 8, 12. They are usually assigned to the sixth century. But in the case of the panel with Sts. Sergius and Bacchus (our Fig. 9) this date is certainly too early. Parts of both faces—particularly of that on the right—have suffered from repainting (Ainalov, *op. cit.*, p. 353), but enough is preserved to show that this panel, too, has connections with early eighth century frescoes in Rome and specially with those at S. Saba (fig. 10a-b; cf. Wilpert, *op. cit.*, pls. 169ff. and, for the date, Kitzinger, *op. cit.*, pp. 31f.). The strongly stylized highlights on the tunics—not affected by restoration according to Ainalov—are hardly conceivable in the sixth century, but occur in Roman painting close to the year 700 (Wilpert, *op. cit.*, pl. 144, 1; for the date Kitzinger, *op. cit.*, p. 21). Another panel, also with busts of two martyrs, is even more disfigured by modern restoration (Ainalov, *op. cit.*, pl. I; Wulff and Alpatoff, *op. cit.*, fig. 2). It appears to be somewhat earlier, but hardly earlier than the seventh century. The relatively well-preserved head on the left seems like a more stylized relative of the head of St. Demetrius on the icon published by Sotiriou (*BCH*, LXX, pl. XXVI), and is comparable also to some of the figures on the mosaics of S. Venanzio in Rome (640-649). As regards the other two icons in Kiev it seems advisable to reserve judgment for the time being. The remarkable panel depicting the Virgin and Child (Ainalov, *op. cit.*, pl. IV; Wulff and Alpatoff, *op. cit.*, fig. 12)—a fragment of an Adoration of the Magi, according to Ainalov— also appears to have some stylistic connection with the newly published icon of the enthroned Virgin (cf. the head of the Child with the head of the angel: *BCH*, LXX, pl. XXVI), but may be somewhat earlier. The standing figure of St. John (Ainalov, *op. cit.*, pl. V; Wulff and Alpatoff, *op. cit.*, fig. 8) shows no specific connection with any of the other icons or with datable paintings elsewhere, but its loose and cursive style suggests an early date. The freely treated busts in the medallions in the upper corners of this icon are in striking contrast to their much more stylized counterparts on the panels showing Sts. Sergius and Bacchus and St. Peter and are reminiscent of sixth century miniature painting (cf. the enlargements of heads from the Vienna Genesis published by P. Buberl in *Jahrbuch der kunsthistorischen Sammlungen in Wien*, N.S., X, 1936, pls. 1ff.). One other icon from Mount Sinai seems to be of pre-Iconoclastic date. This is a panel with a bust of St. Basil reproduced by Sotiriou in his article in *Byzantion*, XIV (above, note 21), pl. II. As Sotiriou pointed out (*ibid.*, p. 326), in style it is akin to Coptic work (see below, note 28). The Christ icon published by V. Beneševič, *Monumenta Sinaitica*, fasc. I, Leningrad 1925, pl. 17, is almost certainly post-Iconoclastic (*ibid.*, p. 27: "eighth, or, at the latest, ninth century").

[27] Wilpert, *op. cit.*, II, pp. 1101ff.; IV, pl. 139 and 141, 1. C. Cecchelli, in *Dedalo*, VII, 2, 1926-1927, pp. 295ff. So little is preserved of the original painting that any guess as to its date is extremely hazardous.

[28] Of these Coptic icons the best known is a portrait of a bishop in Berlin (O. Wulff, *Altchristliche und mittelalterliche byzantinische und italienische Bildwerke*, Part I, Berlin 1909, p. 301, no. 1607: "6th-7th cent."). The Louvre has a related panel, depicting Christ and St. Menas (illustrated side by side with the Berlin icon by H. Peirce and R. Tyler, *L'Art Byzantin*, II, Paris 1934, pl. 166: "6th cent."). From the Italian excavations at Antinoe, M. Salmi has published two busts in a more cursive style, painted on small panels with holes for suspension ("I dipinti paleocristiani di Antinoe" in *Scritti dedicati alla memoria di Ippolito Rosellini*, Florence 1945, pp. 157ff., especially p. 169 and pl. XXX, 5 and 6). An even smaller tablet with a figure of a saint, painted in somewhat similar style, was found in a church near Wadi Halfa (G. S. Mileham, *Churches in Lower Nubia=University of Pennsylvania, Eckley B. Coxe Junior Expedition to Nubia*, II, Philadelphia 1910, pl. I, pp. 49ff. and p. 54, no. 12: "probably seventh cent."). This may have been an applied piece of decoration rather than an independent icon. Another small panel in Berlin with busts of two saints has been thought to be a wing of a triptych (Wulff, *op. cit.*, p. 301, no. 1606 and pl. LXXIII: "6th-7th cent.") and the same has been claimed for a panel formerly in the Golenisheff Collection with

139

for portable paintings of pre-Iconoclastic date should indeed be sought in the seventh and early eighth, rather than in the fourth, fifth, and sixth centuries. If this conclusion should be borne out by further finds and studies, it would be of considerable interest in the light of what we learn from literary sources about the Christian cult of images in the post-Justinianic era.

Veneration of images by Christians was no longer a new phenomenon at that time. We hear of it occasionally from the end of the fourth century on. But it was the second half of the sixth century which saw arise that great vogue of iconodulism that was to culminate and break in the crisis of the eighth century. Two aspects of this vogue are particularly relevant to our present subject: The increasingly widespread use of religious images outside the church and particularly in the private and domestic sphere; and the parallel increase in the use of images for prophylactic and magic purposes. The sources of the late sixth and seventh centuries tell us—with much greater frequency than those of the preceding centuries—about pictures of Christ, the Virgin or saints in hermits' cells, offices, and ordinary private homes. Images became objects of intense personal devotion and, at the same time, they came to be considered increasingly as sources of divine protection and assistance, both at home and on travels. Magic practices were used to bring to bear their powers on particular situations. They were carried about in solemn processions. Armies and navies were placed under their protection and they were called upon to save the day in the crisis of battle.[29]

Obviously these functions must have created a great demand for portable images. Some of these probably took the form of carvings or reliefs. Wax seals are mentioned as amulets used by travelers and in connection with miraculous cures.[30] But in many instances they were undoubtedly paintings, either on canvas or, more commonly, on wood, icons in what was to become the normal sense of the word.[31] These materials

crude representations of Nativity and Baptism, the only piece in this group which has scenes rather than portraits (D. Ainalov, in *Vizantiiskii Vremennik*, v [1898], 181ff. and pl. II; p. 186: "not later than end of 6th cent."). Finally, there are two painted pieces of canvas of uncertain use. One, in Berlin, shows an enthroned Christ (Wulff, *op. cit.*, p. 303, no. 1612: "5th-6th cent."), another, in London, depicts a female saint (D. Roberts, "Zwei Fragmente aus Antinoe" in *Zeitschrift fuer die neutestamentliche Wissenschaft*, XXXVII [1938], 188ff. and pl. II, 2: "late 6th or beginning of 7th cent."). Portable paintings which were definitely used in an applied capacity, rather than as independent icons, have not been included in this note.

[29] The statements made in this paragraph are fully documented in my forthcoming study on "The Cult of Images in the Age before Iconoclasm" in *Dumbarton Oaks Papers*, VIII.

[30] Sts. Cosmas and Damian, Miracle no. 13 (L. Deubner, *Kosmas und Damian*, Leipzig and Berlin 1907, pp. 132ff.; it appears from the context that the icon mentioned p. 132, line 44ff., p. 133, line 33ff. must be identical with the κηρωτή mentioned p. 133, line 15f., p. 134, line 5of.). Miracle of St. Artemius (A. Papadopoulos-Kerameus, in *Zapiski of the Hist.-Phil. Faculty of the Imperial University of St. Petersburg*, XCV [1909], 16f.).

[31] Of the numerous texts of this period involving icons the majority does not specify the material of which the pictures were made. An image of the Virgin "in brevi tabula figurata lignea" is the subject of a miracle described by Arculf, *Relatio de locis sanctis*, III, 5 (T. Tobler, *Itinera et descriptiones terrae sanctae*, I, Geneva 1877, p. 200). Other icons on wooden tablets are mentioned in miracle stories which cannot be claimed with certainty as pre-Iconoclastic: cf. an image of St. Menas in the Coptic Encomium of that Saint (J. Drescher, *Apa Mena*, Cairo 1946, pp. 142f.; for the date see *ibid.*, p. 127); a painting on wooden boards at Beirut with a full-length figure of Christ, which forms the subject of a famous legend related at the Council of 787 (J. D. Mansi, *Sacrorum Conciliorum nova et amplissima collectio*, XIII, Florence 1767, col. 25B); and a similar tale in a Coptic sermon involving an image of the Virgin painted on wood (W. H. Worrell, *The Coptic Manuscripts in the Freer Collection*, New York 1923, pp. 370ff.). For textual references

140

were used for Christian religious images already in the fourth and fifth centuries,[32] but it was in the era after Justinian that they appear to have come into their own.

What recommended the portable image on wood or canvas was perhaps not only its maneuverability, which made it useful in many situations, including some intensely practical ones, but also the fact that it was already accepted as an object of worship and elaborate ritual in another sphere, namely, the cult of the emperor. The imperial portrait, the so-called "lauraton," which had long played an important and well-defined rôle in political and administrative ceremonies, was commonly a painting on wood or on canvas.[33] Even in Christian times it had never ceased to be an object of legitimate, indeed, mandatory veneration. What the development in the second half of the sixth century meant was, in a sense, that the religious image was moving into a position analogous to that traditionally held by the imperial "lauraton."[34] Widespread adoption of the same medium for representations of Christ, the Virgin, and the saints may have served to dramatize the increasing analogy of function, an analogy of which contemporaries were well aware.[35] It may also have served to allay possible scruples on the part of conscientious Christians. For the "lauraton" was not considered to be in the category of idols and the Church had tolerated its worship at a time when it was still objecting vigorously to the veneration of religious images.

to icons on canvas one must look primarily to the legends concerning miraculous images of Christ, the so-called acheiropoietai, which first made their appearance in literature in the second half of the sixth century (cf. the extant example in the Lateran; above, note 27). Particularly those of the "Veronica" type, which were thought to be direct impressions of the Savior's face, naturally had to be on cloth: Cf. the image at Memphis as described by Antoninus of Piacenza, *De locis sanctis*, c. 44 (Tobler, *op. cit.*, p. 116); the image of Edessa as referred to in the Acta Thaddaei (E. v. Dobschuetz, *Christusbilder*, Leipzig 1899, p. 182*); and the image of Camuliana in the version of Pseudo-Gregory (*ibid.*, p. 16**). But it seems that icons held to be of miraculous origin were altogether apt to be on cloth, even when they were not thought of as direct imprints of a face, witness the velum of Uzala (below, note 32) and the first account of the image of Camuliana, in which that image—"painted on a linen cloth"—appears mysteriously in a garden pool, though it then produces a mechanical copy on the material in which it is wrapped (F. J. Hamilton and E. W. Brooks, *The Syriac Chronicle known as that of Zachariah of Mitylene*, London 1899, p. 320; for the date of the text see *ibid.*, p. 5. Dobschuetz, *op. cit.*, p. 5**). An instance of figures of Christ and the apostles woven into a tapestry is reported by Arculf (*Relatio*, I, 12; Tobler, *op. cit.*, p. 156).

[32] Eusebius in his letter to the Empress Constantia, in which he answers her request for an—evidently portable—image of Christ, takes her request to mean a *painted* portrait, though no material is specified (Migne, *Pat. Gr.*, 20, cols. 1545ff., especially cols. 1545C, 1548B). Later in the same letter he mentions two portable images, supposedly of Christ and St. Paul (col. 1548C). A "velum variis pictum coloribus," allegedly of celestial origin and depicting a miracle operated by the relics of St. Stephen at Uzala in North Africa, is mentioned in a text of the early fifth century (*Pat. Lat.*, 41, col. 850f.; cf. Dobschuetz, *op. cit.*, pp. 35f. and 115*ff.). An encaustic painting mentioned in a sermon ascribed to St. John Chrysostom (*Pat. Gr.*, 56, cols. 407f.; Mansi, XIII, col. 9AB) cannot safely be included among portable religious icons of early date since the authorship of the text is uncertain (A. Xyngopoulos, "The Encaustic Painting of Chrysostom" [in Greek], in *Epeteris Hetaireias Byz. Spoudon*, XXI [1951], 49ff.). I also leave aside literary and archaeological evidence of an early date indicating that cloths with Christian pictorial representations were used as hangings for doors and walls.

[33] H. Kruse, *Studien zur offiziellen Geltung des Kaiserbildes im roemischen Reiche*, Paderborn 1934, pp. 49f.; also pp. 94ff. (Cod. Rossanensis) and pp. 99ff. (Notitia Dignitatum). The following passages may be added to those collected by Kruse: Libanius, *Oratio XXII*, 7 (*Opera*, ed. R. Foerster, II, Leipzig 1904, 474; cf. R. Browning, in *Journal of Roman Studies*, XLII [1952], 15); Leontius of Neapolis, *Sermo contra Iudaeos* (*Pat. Gr.*, 93, col. 1604C); Acts of Council of 787, Actio II, passage attributed to St. John Chrysostom, *De parabola seminis* (Mansi, XII, col. 1066E; note, however, that John of Damascus, who also quotes this passage—*Pat. Gr.*, 94, col. 1313C—, has εἰκόνα τὴν ἀπὸ ξύλου καὶ ἀνδριάντος χαλκοῦ instead of εἰκόνα τὴν ἐκ ξύλου καὶ χρωμάτων. I have not been able to locate the passage in Chrysostom).

[34] See my study referred to above, note 29. [35] See *ibid*.

141

The connection tentatively drawn between the spread of the portable painting as a medium and the increased cult of religious images is part of a larger problem well worth investigating. The whole history of Byzantine art in the still rather obscure period between the age of Justinian and the beginning of Iconoclasm should, in fact, be examined for possible reflections of the profound changes in the function of religious imagery which are indicated by the texts.

A problem of such magnitude obviously cannot be dealt with comprehensively in a brief study such as the present. All that can be done is to put forward some further points suggested by our icons.[36] But before doing so it is necessary to elaborate a little on the changes which the literary sources reveal. A new attitude towards religious art is manifest not only in what the texts tell us about practical uses to which images were increasingly put, but also in certain theoretical statements in defense of religious imagery dating from that time.[37] What was to be the Byzantine theory on images in its definitive form was, of course, elaborated during the Iconoclastic period by the spokesmen and thinkers of the orthodox party in rebuttal to the fierce onslaughts of their opponents. But already in the preceding 150 years the vastly increased cult of images provoked some fairly strong opposition, both inside and outside the Church, and this, in turn, called forth defensive statements of a general nature, statements which go decidedly beyond the traditional Early Christian arguments on the subject. Those of the early Fathers who had spoken in defense of artistic representations in churches had based their case primarily on the value of pictures as instruments of doctrinal and moral instruction.[38] The essential innovation of the post-Justinianic era is that attempts were made to justify images, not on the basis of their usefulness to the beholder, but on the strength of a transcendental relationship to their prototypes. They began to be thought of in terms of an extension, or repetition on a lower level, of the act of the Creation of Man (the image of God) or of the Incarnation of the Logos (the image of the Father). They thus came to be securely anchored in a metaphysical stratum and acquired a definite place and function in the divine order of the universe, a permanent and absolute status, not dependent on the faithful's momentary needs and demands. Less dependent on the beholder's intellectual or moral receptiveness and more intimately linked to its prototype, the image inevitably became a vehicle of the latter's supranatural powers. For the divine acts of creation which served as

[36] The discussion which follows touches on a number of points raised by A. Grabar in an important paper entitled "La représentation de l'intelligible dans l'art byzantin du moyen age" (in *Actes du VIe Congrès International d'Etudes Byzantines*, II [Paris 1951], 127ff.). In this paper Professor Grabar has stressed the crucial importance of the era between Justinian and Iconoclasm for the formation of Byzantine medieval art (cf. especially pp. 134f., where he also mentions the rise of icons and icon worship at this time). His remarks on actual monuments, however—and particularly his remarks on their stylistic qualities—are based primarily on works of the post-Iconoclastic period (cf. pp. 127, 136, 142). In the pages which follow an attempt will be made to show that the fundamental spiritual changes revealed by texts of the late sixth and seventh centuries found an echo in works of that same period, a period too much overshadowed by the more glamorous and much better known achievements of the Justinianic and Macedonian eras.

[37] Cf. the chapter "Defense" in my study referred to above, note 29.

[38] W. Elliger, *Die Stellung der alten Christen zu den Bildern in den ersten vier Jahrhunderten*, Leipzig 1930, pp. 61f. (St. Basil), 65 (St. Gregory of Nyssa), 77f. (St. Nilus), 85f. (Paulinus of Nola).

142

"precedents" for endowing the artist's work with a transcendental status also entailed the concept of a flow of substance or energy emanating from the prototype and received by the image. Hence it became possible to speak of the portrait of a saint as "overshadowed by the Holy Ghost," like the Virgin Mary in the act of the Incarnation (Luke 1:35),[39] or perhaps even as a "dwelling of the Holy Ghost."[40] In statements such as these the new functions of images as objects of intense adoration and instruments of magic received a metaphysical motivation.[41]

Obviously an image that may be thought of as overshadowed by the Holy Ghost is a very different thing from one that is merely an instrument of instruction. Artists of the post-Justinianic era, or at least the more perceptive among them, cannot have failed to be aware that both in practice and theory the social and religious function of images was undergoing a fundamental change. The question thus posed for the art historian is whether and in what way they responded to this change.

Returning to our icons with this problem in mind we find that—aside from the possible significance of the medium—two further aspects of these monuments may be relevant.

The first point is an apparent preference, at any rate in the field of panel painting, for simple portraiture. Most of the icons of the period depict individual saints, single or in pairs and most frequently as busts.[42] They perpetuate—and this is no doubt intentional—the secular portrait of classical times.[43] Scenes, though not unknown as subjects of portable religious paintings even as early as the fifth century,[44] occur only rarely on the extant panel paintings of the period between Justinian and Iconoclasm.[45] This concentration on portraiture is in striking agreement with the literary record. The icons mentioned in texts as objects of devotion or instruments of miracles are usually individual portraits of holy persons[46] and the increase of such uses must have produced an increased demand for representations of this kind, especially in panel form. Icons such as the "St Peter" on Mt. Sinai or the "Sts. Sergius and Bacchus" in Kiev (Figs. 7, 9) may, in fact, serve to give us a graphic idea of the kind of image that the texts tell

[39] *Life of St. Symeon the Thaumatourgos*, c. 118 (A. Papadopoulos-Kerameus, in *Vizantiiskii Vremennik*, I (1894), 607; quoted at the Council of 787: Mansi, XIII, col. 76B). K. Holl, "Der Anteil der Styliten am Aufkommen der Bilderverehrung" (reprinted in his *Gesammelte Aufsaetze zur Kirchengeschichte*, II, Tuebingen 1928, 388ff.) quotes from Cod. Monac. gr. 366, where the passage is more explicitly worded (p. 390).

[40] Leontius of Neapolis, *Sermo contra Iudaeos* (*Pat. Gr.*, 93, col. 1604CD). In my study quoted above, note 29, I have commented on this important but ambiguously worded passage.

[41] The statements just quoted were made in the seventh century with reference to actual images. For the general philosophical background of such statements, and particularly the mystic "image" concept of Pseudo-Dionysius and his followers see Grabar, *op. cit.*, pp. 138f.

[42] Cf. our figs. 1, 7, 9 and nearly all the icons referred to above in notes 26, 27, 28.

[43] Ainalov, *op. cit.* (above, note 26), p. 347. Wulff and Alpatoff, *op. cit.*, pp. 8, 16, 22ff.

[44] See above, note 32 (velum of Uzala).

[45] The only definite example is the panel with the scenes of the Nativity and Baptism of Christ formerly in the Golenisheff Collection (above, note 28). See also note 26 for a fragmentary panel in Kiev, presumably somewhat earlier, which is thought to have formed part of an Adoration of the Magi. An element of dramatic action is present in the icon of the Virgin on Mount Sinai (Fig. 4). As Sotiriou has pointed out (*BCH*, LXX, p. 555), its central theme is the Incarnation.

[46] See Chapter I of my study referred to above, note 29.

us watched over the safety of the home and the traveler, received the prayers of the faithful and was expected to operate miracles on Christ's behalf.[47]

Literary statements of an earlier period provide indirect but corroborative evidence that the increased emphasis on portraiture, particularly (but not exclusively) in this class of essentially devotional monuments, is in fact meaningful in the sense indicated. The portrait had been from a very early time a principal target of those who opposed images in the church,[48] and, by the same token, the early apologists for Christian religious imagery had preferred to base their defense on narrative representations depicting Biblical scenes or exploits of martyrs.[49] Such representations could be held to carry a specific message and were therefore in line with the standard argument that images served as Bibles and sermons, especially for the illiterate. Not so the portrait, whose only apparent function was to conjure up the physical features, the outward presence of the person represented.[50] To admit portraits, and especially portraits in isolation, in religious contexts carried the implication that to conjure up this presence was in itself an adequate raison d'être for an image. For in the portrait there is no action to absorb the attention of either subject or beholder. Quietly confronted with each other face to face they may easily enter into a relationship basically identical to that between the heathen worshiper and the cult image in the temple. It was, in fact, its inherent resemblance to the pagan cult image (the foremost target of all Christian opposition in the sphere of the visual arts), which made the portrait a particular stumbling block for Early Christian writers. The increasingly frequent and bold use of the portrait form in the art of the late sixth and seventh centuries is a measure of the degree to which the original scruples in the matter of graven images had been overcome at this time. It meant the emergence of what was in effect an equivalent of the pagan cult statue.[51]

[47] According to Ainalov (*op. cit.*, p. 352) the icon with Sts. Sergius and Bacchus originally had a sliding lid which made it suitable for travel. For a possible antecedent of this feature on a panel painting of the Roman period see O. Rubensohn in *Jahrb. d. Inst.*, xx (1905), 17.

[48] Cf. the letter of Eusebius quoted above, note 32. Several of the polemical statements concerning images which figure in writings of the Iconoclastic period as quotations from Epiphanius (late fourth century) show a preoccupation with images of portrait character; cf. G. Ostrogorsky, *Studien zur Geschichte des byzantinischen Bilderstreites*, Breslau 1929, pp. 68ff., nos. III (title), 6, 23, 27, 31; or K. Holl, "Die Schriften des Epiphanius gegen die Bilder" (reprinted in his *Gesammelte Aufsaetze zur Kirchengeschichte*, II, 351ff.), 356ff., nos. I (title), 2, 23. I have quoted the literature concerning the problem of the authenticity of these writings in my study referred to in note 29.

[49] See above, note 38 (patristic writings quoted by Elliger).

[50] For an interesting attempt to justify even portraits as didactic instruments see Paulinus of Nola, *Epistula XXXII*, 2-4 (*Corpus Scriptorum Ecclesiasticorum Latinorum*, XXIX: *S. Pontii Meropii Paulini Nolani opera, Pars I, Epistulae*, ed. by W. v. Hartel, Vienna 1894, pp. 276ff.).

[51] Portraits in series—especially in the form of medallions—had already, of course, formed part of the decoration of churches at a much earlier time. As distinct from these the portrait icon isolates a single holy figure or a small group, and, because of its movability, invites veneration and ritual practices. Isolated portraits are frequent also in wall mosaics and frescoes of the seventh century, such as those in the Church of St. Demetrius at Salonika and in Sta. Maria Antiqua in Rome (cf. Figs. 5, 6). These are really icons in fixed, but easily accessible, positions (cf. A. Grabar, *Martyrium*, II, Paris 1946, 118). Cf. also the mosaic icon of St. Sebastian at S. Pietro in Vincoli in Rome. The loss of inhibitions vis-à-vis the portrait form is noticeable also in certain apse compositions of this period, which show large statuesque figures, not involved in any action or scenic context quietly offering themselves to the worship of the faithful (Rome: S. Agnese, S. Venanzio). A similar tendency may be noticed in many of the frescoes in the monastic cells at Bawit and Saqqara, which presumably date from this period and fall in the category of devotional images.

1 4 4

Another point, which may be raised briefly in conclusion, is the specifically aesthetic character of these icons. In view of the scarcity of extant monuments and the diverse local styles they exhibit, it is difficult and dangerous to generalize on this subject. But one characteristic—a negative one—stands out: Figures, on the whole, lack bodily weight and volume. They are apt to appear emasculated, unsubstantial, almost phantom-like. The quality appears most clearly in the full-length standing figures of the newly discovered icon of the Virgin from Mt. Sinai, whose bodies seem hardly substantial enough to support their heads (Fig. 4). But faces, too, are apt to be deprived of their solidity. Even so sharply defined a head as that of the Virgin of Sta. Francesca Romana (Fig. 1) has something brittle and transparent and gives the impression of a very thin shell liable to break any moment. The precariousness of its physical existence enhances the spiritual content of the face. As the material weight decreases, the spiritual weight increases. There is a haunting, a quietly hypnotic quality—perhaps the strongest common characteristic of the whole group of icons with which this paper has dealt.

This spiritualization and loss of bodily volume is undoubtedly a basic characteristic of post-Justinianic art. In the Latin West, where we have a few dated monuments of the second half of the sixth and early seventh centuries, one can actually follow the growth of this phenomenon, which in certain mosaics of Rome and Ravenna was carried to the point of complete dehydration.[52] It was, however, a general characteristic of the period, to which the Greek East was not immune. We have remarked on the diversity of styles coexisting in the East at that time. The loss of volume and weight is common to abstract figures, such as those on the pier mosaics of the Church of St. Demetrius at Salonika, and to the boldly illusionistic work of the Greek masters at Sta. Maria Antiqua, best represented by the panel of the "Maccabees." By comparison with figures of the Justinianic—and particularly early Justinianic—period all these figures of the seventh century seem immaterial and elusive. A comparison with such overpowering and massive figures as those in the apse of SS. Cosma e Damiano in Rome (A.D. 526-530) or in the imperial panels at S. Vitale in Ravenna (about A.D. 547) brings home the point. Only towards the end of the seventh century did we find once more an attempt to recapture something of the monumentality of Justinianic art.[53]

The impression created by our icons is thus confirmed by observations on works in other media. The loss of volume and weight, the quiet gaze as if from afar—these are indeed characteristic of the period. One must guard against any attempt to establish an easy causal relationship between the spiritual development revealed by the texts and this stylistic trend which is a general one and not confined to devotional icons. But it is certainly permissible at least to correlate the two phenomena and to note the fact that the development whereby the saint's image was called upon increasingly to act as a representative of its prototype, as a magic instrument for securing a saint's actual presence and intervention and as a vessel of divine energy, was not accompanied on the aesthetic side by an increase in the material weight and physical tangibility of

[52] Kitzinger, *op. cit.* (above, note 14), pp. 5ff. [53] See above, p. 138.

145

figures, but, on the contrary, by an increasing dematerialization and remoteness.[54] It is as if artists had responded in the language of visual forms to the attempts of apologists to find the raison d'être of the religious image in transcendental relationships rather than in its own ability to exert a direct impact on the beholder. The image is, as it were, a mere shell dependent upon receiving power and life from on high.

It would be rash to assume that artists were making conscious efforts to give aesthetic expression to the fact that the saint's image had become "overshadowed by the Holy Ghost."[55] Developments in the realm of form cannot have been contingent on the work of theorists. They cannot even be assumed to be conditioned by a change in the practical function of religious art in the sense that all works which were destined for these new functions, and only they, exhibit a change in style.

The source of stylistic innovation is the artist's own creative genius. Whereas subject matter, choice of medium, physical location of an image may all be, and commonly are, imposed on him from outside (so that in these matters a tangible link exists between him and his social, intellectual, and religious environment), form is his own most intimate contribution. Yet it is not evolved in a vacuum. Contemporary trends, ideas and aspirations of a social, intellectual or religious nature are bound to go into its making. But absorbed by the artist these elements undergo the alchemy of all creative action to reemerge from his brush as shape, line, and color. The very completeness of the metamorphosis stands in the way of the scholar seeking to correlate intellectual development and artistic achievement. But a connection surely does exist and an attempt may legitimately be made to interpret the latter in the light of the former as revealed by literary texts.[56]

The post-Justinianic era offers singular opportunities in this regard. Thanks to the fact that its literature has so much to say about images, their uses and their nature, the scholar has a chance, rare in the medieval field, to interpret its specifically artistic achievement not merely in terms of a general Zeitgeist, nor through comparisons with cultural endeavors in other fields, but in the light of a profound change which the Zeitgeist is known to have wrought in the attitude towards religious art.

[54] On the loss of volume and weight as an aesthetic expression of increased spirituality see Grabar, *op. cit.* (above, note 36), pp. 128, 136.

[55] For the problem of the correlation of philosophical and aesthetic categories see *ibid.*, p. 136.

[56] The problem of integrating the results of stylistic inquiries with those of the "iconologist" and of achieving thereby a unified appreciation of a work of art in the light of the social and intellectual history of its period, is becoming increasingly urgent. See C. Gilbert's interesting remarks on this subject based on studies of Renaissance painting (*Art Bulletin*, xxxiv [1952], 202ff.) and E. Gombrich's review of A. Hauser's *Social History of Art* (*ibid.*, xxxv [1953], 79ff., especially 82), which stresses the importance of "social history"—not in Mr. Hauser's sense but in the sense of a changing "institutional framework" of artists and monuments—for an understanding of stylistic phenomena.

146

*Literary sources concerning the history
of the image of the Virgin at Sta. Francesca Romana.*

The statements made in archaeological literature on the history of the icon of Sta. Francesca Romana—or, to use the medieval name of the church, Sta. Maria Nova—all go back, directly or indirectly, to a manuscript document formerly preserved in the church. Though the document itself seems to be lost its text has survived in two transcripts which were made at different times and, in all probability, independently one from the other. The first may be found in Onofrio Panvinio's *History of the Frangipane Family*, which was completed in A.D. 1556 and exists only in manuscript form.[1] The second is contained in a treatise on pictures of the Virgin by St. Luke, written in the late sixteenth or beginning of the seventeenth century by Nicolo Cassiani, Curate of S. Apollinare, and likewise preserved only in manuscript.[2] In Cassiani's time the original document was in the archives of Sta. Maria Nova, but the wording of the document itself shows that it was intended for public display in the church, and, in fact, in the immediate neighborhood of the image. Its avowed purpose was to turn the minds of the faithful to prayer, a purpose which was to be achieved by recounting the icon's marvelous history.

The nature and purpose of the document, which opens with a voluble protest of the writer's absolute veracity, must be borne in mind when evaluating the information it contains. Far from being a legal instrument destined for the archives, it was more in the nature of a popular pamphlet intended for the edification of pilgrims and visitors. It was composed during the later Middle Ages, in any case after the time of Pope Honorius III (1216-1227), since it refers to events which took place during his pontificate. It may have been known to the author of a treatise on Roman churches appended to the *Mirabilia Urbis Romae* probably in the fourteenth century, though this author's remarks give the impression of being based on direct observation of the image itself rather than on a written source.[3] Not until the early sixteenth century is there unmistakable evidence of the existence of our document: It was clearly utilized by Fra Mariano da Firenze in a brief account he gives of our icon in his *Itinerarium Urbis Romae*, written after a visit to the Eternal City in A.D. 1517.[4]

Aside from minor variants the texts of the document given respectively by Panvinio and by Cassiani are identical. We learn first of all that the faithful, to whom the writer addresses himself, saw the image enshrined in a stone tabernacle and that the painting was completely concealed by a silver cover.[5] The latter fact is confirmed by a later passage where it is said that the (painted) figures of Mother and Child could be seen only "quando locus aperitur." A marginal gloss of the year 1612 in Cassiani's treatise informs us that the tabernacle consisted of four marble colonnettes and that they were removed when the church was restored by Paul V in that year.[6]

Next we learn that the image was surrounded by an inscription in silver letters saying

[1] O. Panvinio, *De gente Fregepania libri quatuor*: Cod. Barb. lat. 2481 (16th cent.), fols. 100v-101v; Biblioteca Angelica, Cod. 77 (18th cent.), pp. 257-260. For these codices see D. A. Perini, *O. Panvinio e le sue opere*, Rome 1899, p. 193.

[2] Cod. Vat. Reg. lat. 2100, fols. 5-15; our text is on fols. 13r-14r. It appears once more in an unsigned letter, evidently also by Cassiani, bound in with the treatise (*ibid.*, fols. 3r-4v). For the date of Cassiani's text see below, note 6.

[3] G. Parthey, *Mirabilia Romae*, Berlin 1869, p. 54; English translation: F. M. Nichols, *The Marvels of Rome*, London 1889, pp. 135f.; for the date of this text see *ibid.*, pp. xxii; 126, n. 261; 152 (the thirteenth century date given by M. Manitius, *Geschichte der lateinischen Literatur des Mittelalters*, III, Munich 1931, 248, seems to be mistaken).

[4] Edited by E. Bulletti, Rome 1931, p. 26.

[5] ". . . imago, quae hoc lapideo tabernaculo, ut cernitur circumsepta tota argentea est. . . ."

[6] Cod. Vat. Reg. lat. 2100, fol. 13v. The gloss gives a *terminus ante quem*, and probably an approximate *terminus ad quem*, for Cassiani's treatise. I have been unable to ascertain his exact dates.

147

that it had been painted in Troy in Greece by St. Luke.[7] Thus it was an inscription on the monument itself which proclaimed its Eastern origin, but it should be pointed out that in the inscription this item of information was linked to the attribution of the picture to St. Luke and figured as a circumstantial detail that would tend to reinforce the latter. For St. Luke was traditionally thought to have sojourned in Troy, one of the places mentioned in the so-called "we-passages" in the Acts of the Apostles.[8] The inscription was no longer in existence in the early seventeenth century. The gloss of the year 1612 in Cassiani's treatise tells us that at that time it had long been replaced by a frieze of "argento finto e falso."[9]

Our document then proceeds to relate that the image was donated to the church of Sta. Maria Nova by Angelo Frangipane, "soldier and citizen," who, "having ruled over a certain people," brought the icon to Rome on his return. No source is given for this statement. Panvinio suggested[10] that Angelo Frangipane may have been a participant in the First Crusade, but he could find no other record of him; nor does this Angelo figure in modern critical studies of the Frangipane family.[11] A writer of the later Middle Ages, anxious to explain the appearance of a supposedly Trojan image in Rome, might well have thought of a crusader as the most likely person to have brought it and when that image was located in Sta. Maria Nova the crusader obviously could be none but a member of the Frangipane family, in whose domain the church was situated.

The rest of our text is given over to a description of two miracles in which the icon was involved. The image miraculously remained unharmed in a fire which destroyed the church in the time of Honorius III, though its silver cover was blackened ("denigrato argento"). Subsequently a fight broke out between the Frangipane and a family named Boccacane over the restitution of the image, which had been taken to S. Adriano while Sta. Maria Nova was being rebuilt. While the battle was still going on the icon, without human aid, returned to its original position.

The fire in the time of Honorius III is historical.[12] Though the writer exaggerated its magnitude it was presumably this fire which occasioned the renewal of the faces of Mother and Child by a painter of the early Dugento.[13] To that extent the story related in the document is borne out by the icon itself. It is also true that the original figures of Mother and Child (or at least their faces) survived the fire though not apparently in what was considered to be sufficiently good condition to be able to attest to their miraculous survival without the aid of new faces with which it was evidently decided to mask them. In view of the damage which the icon must have suffered, one is tempted to assume that the blackened silver cover also required restoration. In that case the inscription in silver which the icon bore according to our document may have been a work of the time after the fire. It is, of course, possible that this inscription repeated a text that had been inscribed on the image before, but one cannot be sure of this. In other words, the inscription, which constitutes the sole piece of documentary evidence for the Trojan origin of the image, cannot be traced back with any certainty beyond the time of Honorius III. The tradition itself may, of course, be older,

[7] ". . . quam in Troade de Graeciae partibus manu depinxit beatus Lucas apostolus Jesu Christi, ut per literas argenteas eidem imagini circumscriptas efficaciter est collectum."

[8] Acts 16:8ff.; 20:5ff. On the "we-passages" and the traditional view that they involve St. Luke as a participant in the journeys they describe, see The Beginnings of Christianity, Part I: The Acts of the Apostles, edited by F. J. Foakes Jackson and K. Lake, II, London 1922, 158ff. Already Nicolo Cassiani in commenting on our document quite naturally called attention to St. Luke's sojourn in Troy as related in Acts (Vat. Reg. lat. 2100, fol. 4v).

[9] ibid., fol. 13v. [10] Cod. Barb. lat. 2481, fol. 101v.

[11] Cf. especially F. Ehrle, in Mélanges offerts à M. Emile Chatelain, Paris 1910, pp. 448ff., and the supplementary article by P. Fedele, in Archivio della R. Società Romana di Storia Patria, XXXIII (1910), 493ff. Only one member of the Frangipane family by the name of Angelo is known from reliable sources (cf. Fedele in the same Archivio, XXVIII [1905], 211, 213, 216); this Angelo was a boy in A.D. 1230, i.e. at a time when our icon certainly was already in Rome (see below).

[12] G. B. De Rossi, Musaici Cristiani delle Chiese di Roma, Rome 1899, text accompanying pl. 33.

[13] See above, p. 132.

148

but—coupled as it is with the attribution of the picture to St. Luke—it may well have grown up at a time when the true origin of the image had long been forgotten.

Thus the tradition which connects the painting with Troy does not in itself militate seriously against an attribution, such as has been proposed in this paper, to an artist working in Rome. Yet in combination with certain other data it leads to an interesting hypothesis which would enable us to trace the documentary history of the image several important steps beyond the point reached so far. Our account would be incomplete without at least mentioning this possibility. In the first place, once we free ourselves from the tradition concerning the Frangipane "Crusader," which is the least well-documented part of the story, there is nothing to prevent us from assuming that at the time of the fire in the early thirteenth century the image had been in the possession of the church of Sta. Maria Nova already for a very long time.[14] This possibility brings up the thought of Sta. Maria Antiqua, the ancient diaconia at the foot of the Palatine Hill of which Sta. Maria Nova was the heir and successor. Any object in the possession of Sta. Maria Nova which antedates the pontificate of Leo IV (847-855)—under whom the transfer of the diaconia appears to have taken place[15]—has an a priori chance of being inherited from the predecessor church. Our icon, in which we recognized a work of the seventh century, may once have belonged to the very church in which we found the best parallels for its style.

Here, however, a further possibility arises. We are told in the *Liber Pontificalis* that Pope Gregory III (731-741) "imaginem sancte Dei genetricis antiquam deargentavit ac investivit de argento mundissimo, pens. lib. L."[16] The church where this image was located is not specified, but already Duchesne suggested that it must have been Sta. Maria Antiqua.[17] This "imago antiqua" was evidently held in great veneration and would naturally be passed on to the successor church. One might even suggest, as was done already by Cellini,[18] that the extremely heavy silver cover given by Gregory III was the one that figures in the account of the fire under Honorius III. In other words, Gregory's munificent gift may be identical with the silver cover which was still to be seen—either in its original or, more probably, in a restored form—when our late medieval document was written. This, however, brings up yet another interesting possibility, namely, that the inscription with the attribution of the image to St. Luke and to Troy, which was executed in silver, may go back to the eighth century after all. Searching for early evidence for the traditions concerning St. Luke as a painter one soon comes upon two Greek texts which probably date from that very period, texts which were inspired by the outbreak of the Iconoclastic crisis in Byzantium. Not only do these texts speak of St. Luke as a painter of the Virgin, but they refer to an image painted by him and still preserved and venerated in Rome.[19]

At least one must admit a curious convergence of evidence. Rome possessed, at the time when Iconoclasm first began, a widely famed image of the Virgin supposedly painted by St. Luke. At precisely this time—and presumably in response to the challenge which

[14] The wonderful hymn "Sancta Maria quid est," which dates from the time of Otto III—or, according to some, from an even earlier period—and which refers to the annual procession of the famous Acheiropoieta of Christ from the Lateran via Sta. Maria Nova and S. Adriano to Sta. Maria Maggiore, may contain an allusion to an image of the enthroned Virgin, but there is no evidence that this image was at Sta. Maria Nova, let alone that it was identical with our icon. For this hymn see P. E. Schramm, *Kaiser, Rom und Renovatio*, I, Leipzig 1929, 150ff., with further references.

[15] L. Duchesne, *Le Liber Pontificalis*, II, Paris 1892, 145, 158.

[16] *ibid.*, I, 1886, 419.

[17] *ibid.*, I, 424, n. 19; cf. E. Tea, *La Basilica di Santa Maria Antiqua*, Milan 1937, pp. 35f. and P. Cellini, *La Madonna di S. Luca in S. Maria Maggiore*, Rome 1943, pp. 18f.

[18] *ibid.*, p. 30.

[19] E. v. Dobschuetz, *Christusbilder*, Leipzig 1899, pp. 185*ff. (fragment attributed to Andrew of Crete) and pp. 188*, 198* (speech made by Patriarch Germanos before the Emperor Leo III in the year A.D. 729, as quoted in the Chronicle of Georgios Monachos and—in a briefer form, without a clear reference to Rome—in the Life of St. Stephen the Younger). Admittedly we cannot be quite sure in either of these two cases that we are dealing with authentic texts of the early days of Iconoclasm. For the first-named text, see B. Laourdas in *Kretika Chronika*, v (1951), 47f.

149

Iconoclasm represented—Pope Gregory III endowed an "imago antiqua" of the Virgin with a precious silver cover. Now we learn from our document that our icon had such a cover and that at least in later medieval times it bore an inscription in silver attributing it to St. Luke. One is tempted to recognize in our icon the venerated image to which the Byzantine writers refer and to suggest that it was this image which Gregory III raised to special eminence, not only clothing it in a glittering garb but inscribing on its new cover a text which proclaimed—to the dismay and confusion of the Iconoclasts—its apostolic authorship.

Admittedly this hypothesis is hard to reconcile with the result of our stylistic analysis, according to which the icon is a Roman work of the seventh century. It is difficult to believe that Pope Gregory could have publicly proclaimed as a work of St. Luke coming from Troy a picture which had been painted in Rome almost within living memory. And since the identification of Gregory's "imago antiqua" with the portrait of the Madonna by St. Luke of which the Byzantine writers speak, and the identification of either of these images with the newly found canvas from Sta. Maria Nova, are purely hypothetical it seems advisable at this stage of our knowledge to attach greater weight to what appears to be clear stylistic evidence offered by the picture itself than to a combination of literary traditions, however suggestive.

150

2. Rome, S. Maria Antiqua. Fresco: Head of angel

3. Rome, S. Maria Antiqua. Fresco: Maria Regina (detail)

1. Rome, S. Francesca Romana. Canvas fragment with head of Virgin

4. Mt. Sinai. Encaustic icon: Virgin with Child

5. Rome, S. Maria Antiqua. Fresco: St. Demetrius

6. Rome, S. Maria Antiqua. Fresco: St. Barbara (detail)

Anderson

8. Rome, S. Maria Antiqua. Fresco: St. Bartholomew

7. Mt. Sinai. Encaustic icon: St. Peter

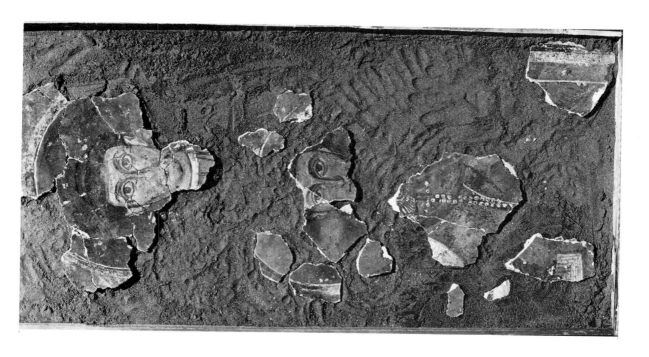

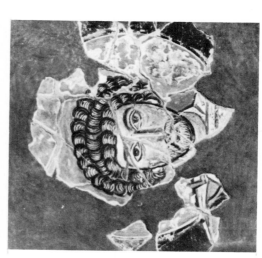

9. Kiev (formerly Mt. Sinai). Encaustic icon: Sts. Sergius and Bacchus

10a-b. Rome, S. Saba. Fresco: Fragments with heads of Saints

VIII

SOME REFLECTIONS ON PORTRAITURE IN BYZANTINE ART

Half a century ago Gabriel Millet drew attention to the fact that in the wallpaintings of the Palaeologan period at Mistra the faces of contemporary personages display formal and technical characteristics different from those of the religious subjects among which they are placed.[1] In these paintings, he concluded, „le Portrait et l'Iconographie religieuse constituent deux genres differents." Corresponding differences were observed subsequently by others elsewhere, for instance, by S. Radojčić in mural paintings of the thirteenth century in Serbia;[2] by A. Frolow in the famous „ktitor" mosaic of the ninth century over the Royal Door of Hagia Sophia;[3] and by G. Ladner in a number of works of art in Rome — some as early as the sixth century — in which contemporary portraits of popes or other donors figure side by with representations of saints.[4] The list undoubtedly is capable of expansion[5]. While it would

[1] G. Millet, „Portraits byzantins," *Revue de l'art chretien*, LXI, 1911, p. 445 ff.

[2] S. Radojčić, *Portreti srpskih vladara u srednjem veku*, Skoplje, 1934, pp. 19 ff., 24 f., 89; cf. French résumé, p. 100 f.

[3] A. Frolov, „La renaissance de l'art byzantin au IXe siècle et son origine", *IX Corso di cultura sull'arte ravennate e bizantina*, Ravenna, 1962, p. 281.

[4] G. B. Ladner, *Die Papstbildnisse des Altertums und des Mittelalters*, Vatican City, 1941, pp. 66 ff., 76, 84. See, however, below, n. 19, for S. Venanzio.

[5] I do not claim to have noted all relevant observations in published literature, let alone all monuments to which such observations might apply. Among other pertinen examples, in addition to some which will be mentioned in the course of the present discussion, are the mosaic panel in the south gallery of Hagia Sophia portraying Emperor John II Komnenos with his wife and son in the presence of the Virgin (Th. Whittemore, *The Imperial Portraits of the South Gallery* [= *The Byzantine Institute: The Mosaics of Haghia Sophia at Istanbul, Third Preliminary Report, Work done in 1935—1938*], 1942, p. 21 ff. and pl. XX ff.; especially pl. XXX as against pl. XXII); the wall paintings of Boyana with their numerous portraits (see the beautiful color reproductions in the recent Unesco volume *Bulgaria, Mediaeval Wall Paintings*, 1961, pls. III—XVIII, which afford convenient comparisons of the heads of contemporary personages and saints); Theodore Metochites' „ktitor" mosaic in the Karye Djami (Russian Archaeological Institute in Constantinople, *Izvestiia*, XI, 1906, Album, pl. LVII f.); and the Deesis mosaic in the same church, which affords a striking comparison between the heads of the Virgin and Christ, on the one hand, and those of Isaac Komnenos and Melane the Nun, on the other (P. A. Underwood, „The Deisis Mosaic in the Kahrie Cami at Istanbul," *Late Classical and Mediaeval Studies in Honor of Albert Mathias Friend, Jr.*, Princeton, 1955, p. 254 ff., especially figs. 2—5). The use of the portrait „mode" for the head of Isaac, who had died

be an exaggeration to claim for Millet's observation the status of a universal law applying to all Byzantine art, he certainly touched upon a fundamental point having ramifications in time and space far beyond the art of Palaeologan Mistra.

In order to define with precision the formal devices used by Byzantine artists to differentiate between the heads of saints and those of contemporary persons, a separate analysis would be needed of every ensemble in which these distinctions appear. Obviously, in each instance the differences depend to some degree on the artist's overall style of which they are, so to speak, sub-categories. But it is possible to generalize to the extent of saying that the usual way of setting off stylistically the heads of contemporary persons from those of religious figures is a greater degree of abstraction and simplification. Heads and faces tend to assume a more purely geometric shape, which may be that of an exact oval or a shield, or may even approximate that of a heart or a triangle. Within this precisely circumscribed area there is apt to be little or no modelling. In painting and mosaic — and these are the media primarily concerned — the „impressionistic" devices which Byzantine art had inherited from antiquity, i. e., highlights, shades and gradations of flesh tones, tend to be used sparingly or not at all, even when such devices are applied quite freely and boldly elsewhere in the same ensembles. Instead, the artist relies mainly on lines to indicate facial features, and these lines are often drawn with great subtlety, economy, and precision.

Let it be said immediately that the formal characteristics just described do not necessarily detract from the lifelikeness of a given portrayal or from its value as a record of an individual face. This, in essence, was the fallacy to which W. de Grüneisen succumbed in his attempt to write the history of portraiture in early mediaeval art. Confusing a painter's success in contriving an illusion of the third dimension with the degree of realism, or even with the absolute artistic quality attained, Grüneisen was unable to see anything but a progressive decline in the increasingly two-dimensional and schematized portraits of the period.[6] It was in order to point out the inadequacy of this approach that Millet wrote his essay on the Mistra portraits. More recently G. Ladner has attempted a sharper definition of early mediaeval portraits in their positive aspects. He rightly characterizes the basic geometric shapes in which they tend to be cast, as being in the nature of schemata — matrices might be another appropriate term — upon which natural features may be entered on a selective basis and in predominantly „graphic", i. e., linear, form.[7] Thus the faces of contemporary persons may be more, rather than less, „realistic" than those of the saints. They may be endowed, for instance, with a profusion of wrinkles, while even the white-haired among the saints

many years before the mosaic was made, shows that the „sitter" need not in every instance be a living person. There is such a thing as a pseudo-contemporary portrait. For the possibility that a contemporary likeness of Isaac was available to the fourteenth century mosaicist at the Kariye Djami, see Underwood, *op. cit.*, p. 258.

[6] W. de Grüneisen, *Le portrait, traditions hellénistiques et influences orientales*, Rome, 1911.

[7] Ladner, *op. cit.*, p. 4 ff.; see especially his remarks on what he calls „partial or symbolic naturalism."

or biblical figures in the same ensemble may be free of such tangible marks of old age. The flat ovals, shields or near-triangles are, so to speak, empty slates on which may be recorded certain at least externally characteristic features, and in the hands of a superior artist this configuration of features may also be infused with emotional or psychological content. To be sure, there still remains the question as to the extent to which this physiognomic record corresponds to the actual physical appearance of the „sitter".[8] The „realistic" features, like the matrices on which they appear, themselves tend to be stereotyped. But there is no doubt that they are meant to produce at least a semblance of a true record, and one might even go so far as to suggest that it was in order to give the artist the freedom to „write" this record that the faces of donors and other contemporary persons came to be conceived in a basically more „empty" and neutral form than those of saints.

When and where this differentiation was first introduced is at present an open question. A measure of geometric stylization of heads is a general phenomenon of the art of the fifth century, and linked, as it often is, with the adoption of a pure en face view it leads to the emergence of some of those symmetric and elementary base shapes which then become so pronounced in portraiture.[9] This general development, in a sense, sets the stage for the phenomenon with which we are dealing. It may even be possible to detect in certain works of this period the first tentative beginnings of a differentiation between the representations of saints and „true" portraiture. In the mosaic decoration of the chapel of San Vittore in Milan, dating from the last decades of the fifth century, the bust of the titular saint in the center of the dome is accompanied, on the side walls, by six standing figures of local saints and bishops. While the stylistic rendering of all seven heads is essentially uniform, it is worth noting that the outline of the face of St. Ambrose — the only figure in the ensemble for which an authentic portrait tradition is historically conceivable — is more emphatically geometric than that of any other, and, in fact, provides the first clear example of the „shield" shape.[10] One may also call to mind in this connection some of the portrait heads on the funerary mosaics of North Africa and Spain, in which the characteristic triangle and heart shapes make their appearance, while modelling is almost totally absent. Admittedly, these mosaics reflect a relatively modest level of craftsmanship, but they do in effect provide early examples of those simple matrices on

[8] See the reviews of Ladner's book by Th. E. Mommsen (*Traditio*, 5, 1947, p. 352 ff., especially, p. 357 f.) and myself (*Speculum*, 23, 1948, p. 312 ff., especially p. 314 f.).

[9] Cf. e. g. the more stylized among the heads of saints in en face view in the dome mosaics of Hagios Georgios in Salonika, heads such as those of St. Ananias (*Greece, Byzantine Mosaics*, Unesco, 1959, pl. II) or St. Damian and his neighbor (W. F. Volbach, *Frühchristliche Kunst*, Munich, 1958, pl. 125). If H. Torp's dating of these mosaics is accepted it would establish the existence of this degree of stylization as early as the reign of Theodosius I („Quelques remarques sur les mosaiques de l'église Saint-Georges à Thessalonique," *Acts of the Ninth International Congress of Byzantine Studies, Salonika 12—19 April 1953* [title in Greek], I, Athens, 1955, p. 489 ff.).

[10] F. Reggiori, *La Basilica Ambrosiana: Ricerche e ristauri 1929—1940*, Milan, 1941, pp. 113, 218, 225 ff.

which Byzantine portraitists will subsequently tend to base their work.[11] It is in the mosaics of Poreč (Parenzo), dating from about the middle of the sixth century, that a stylistic distinction in the rendering of contemporary and religious figures first becomes clearly discernible. Possibly, as Ladner suggests, the fact that at this time living persons began to be depicted with increasing frequency in the company of saints in celestial or paradisical glory may have prompted artists to accentuate the difference.[12] In any case, at Poreč the face of Bishop Euphrasius, the donor, exhibits the characteristic heart shape, while that of Claudius, his archdeacon, approximates a triangle. In both heads there is relatively little modelling and an essentially linear treatment of features which include a profusion of wrinkles, in striking contrast, for instance, to the rendering of the aged Zacharias, the father of John the Baptist, in the same ensemble (figs. 1, 2).[13] In principle, the stylistic distinction which subsequently will be made by many Byzantine artists down to the end of the Middle Ages is here already established.[14] It appears soon afterwards in Rome, in the mosaic of S. Lorenzo fuori le mura, where the head

[11] For illustrations see Academie des inscriptions et belles-lettres, *Inventaire des Mosaiques de la Gaule et de l'Afrique*, Plates, vol. II (Tunis), fasc. 2, Paris, 1914, nos. 941, 953, 965, 967, 1022; and *Ars Hispaniae*, II, Madrid, 1947, plates facing pp. 220 and 221. These funerary portraits were cited previously a propos of the representations of saints and bishops at S. Vittore in Milan by A. Grabar, *Martyrium*, Paris, 1946, II, p. 43.

[12] *Op. cit.*, p. 32; see also *ibid.*, pp. 94 and 105 and the same author's article in *Medieval Studies*, III, 1941, p. 15 ff., for the adoption of the „square nimbus" as a further means of emphasizing the difference. Ladner's view that the „square nimbus" was not used in Byzantine art proper, and that even in Rome it may not have acquired the connotation of „portrait" until the late eighth or ninth century (*Medieval Studies*, III, p. 36 f.) is no longer tenable. „Square nimbi" appear behind the heads of Abbot Longinus and Deacon John in the apse mosaic of Justinian's basilica on Mount Sinai and behind the heads of several of the donors in the ex-voto mosaics of the basilica of St. Demetrius in Salonika. The Sinai mosaic has recently been cleaned, and, as Prof. Underwood informs me, the „square nimbi", which were first observed by G. Soteriou (see *Atti dello VIIIº congresso internazionale di studi bizantini, Palermo 3—10 aprile 1951* [= *Studi bizantini e neoellenici, VIII*], Rome, 1953, II, p. 251), have been found to be white and without outlines, while the background is gold. In St. Demetrius the fragmentary panel at the west end of the inner south aisle, which dates from the period before the early seventh century fire, shows the two extant heads of votaries approaching the saint marked out by small rectangular background areas of green color, again without outlines and barely recognizable in reproductions (G. and M. Soteriou, *The Basilica of St. Demetrius in Salonika* [in Greek], Athens, 1952, pl. 62). Several of the donors in the ex-voto panels of the period after the fire show their heads set off by what are definitely meant to be „square nimbi." Though these „nimbi" are disguised as battlements (as is one of the squares in the Dura Synagogue panels) their interpretation is indisputable, as witness particularly the asymmetric battlement behind the donor on the east face of the south pier (*ibid.*, pl. 67; see also the text, pp. 193, 196). It is evident, then, that by the sixth and seventh centuries the „square nimbus", which originally, and certainly at Dura, was charged with different meanings, came to denote the living or recently dead, as distinct from saints, and that at that time it was used for this purpose in Byzantium, where, however, it did not long survive.

[13]. M. Prelog, *Les mosaiques de Poreč*, Belgrade, 1959, pp. 6, 11, 21.

[14] There was, of course, considerable development within the portrait category in the ensuing centuries. But its essential formal ingredients, which are those associated by Ladner with „partial or symbolic naturalism", were established by the middle of the sixth century. This period, therefore, seems to me to play a more pivotal role in the development from ancient to medieval portraiture than the Romanesque period to which Ladner attributes decisive importance (*Die Papstbildnisse*, pp. 5 f., 183 ff.).

of Pope Pelagius II, a more extreme version of the triangular type of the archdeacon of Poreč, differs in its haggard „realism" from that of the titular saint next to him, and, more strikingly, from that of St. Stephen opposite.[15] It appears in Salonika, in the second set of mosaic ex-votos made probably about the middle of the seventh century,[16] and in Rome again, and now most emphatically, in works of the period of Pope John VII (705—707)[17] and Pope Zacharias (741—752). The triangular and wrinkled faces of this latter pope and of the donor Theodotus in the murals of the Chapel of Sts. Quiricus and Julitta in Sta. Maria Antiqua are strikingly different, for instance, from the faces in the Crucifixion panel in the same ensemble; and the flat shield-shaped tablet of the face of Theodotus' young son makes a most instructive comparison with the much more elaborately modelled face of the boy-saint Quiricus, and shows particularly well that the economy of formal means characteristic of the portrait „mode" may result in a gain, rather than loss, of psychological depth (Figs. 3, 4).[18] It is true that even in this period there are ensembles in which no categorical distinction is discernible,[19] and there will be other exceptions throughout the subsequent history of Byzantine art.[20] I have said already that the phenomenon under discussion

[15] Ladner, *op. cit.*, p. 66 and fig. 81. For the head of St. Stephen see *Proporzioni*, III, 1950, pl. XIII, fig. 5. P. Baldass claims that a great part of the mosaic, including this latter head, was remade about 1100 A. D. („The Mosaic of the Triumphal Arch of San Lorenzo fuori le Mura," *Gazette des Beaux-Arts*, 6th series, 49, 1957, p. 1 ff.); but cf. E. Kitzinger, „Byzantine Art in the Period between Justinian and Iconoclasm," *Berichte zum XI. Internationalen Byzantinisten-Kongress*, IV, 1, Munich, 1958, p. 17, n. 62.

[16] *Greece, Byzantine Mosaics*, Unesco, 1959, pls. VII—IX and text figs. on pp. 12 and 17. For the date and the stylistic distinction between saints and contemporary portraits see Kitzinger, *op. cit.*, pp. 26, 30.

[17] Compare the mosaic portrait of this pope from Old St. Peter's with other heads from the same ensemble (W. de Grüneisen, *Sainte Marie Antique*, Rome, 1911, p. 280 ff. and figs. 228 ff.). The scanty remains of the head of John VII on the recently restored icon of the Virgin in Sta. Maria in Trastevere appear to resemble closely the mosaic portrait and to differ correspondingly from the other heads on the icon (C. Bertelli, *La Madonna di Santa Maria in Trastevere*, Rome, 1961, p. 65 and fig. 72). In the paintings of John VII in Sta. Maria Antiqua, his portrait, distinguished by a „square nimbus", is in too poor a condition to make it possible to decide whether its stylistic rendering differed from that of the other figures and in particular from the faces of the sainted popes in the same register (Ladner, *op. cit.*, pl. Xc).

[18] *Ibid.*, p. 99 ff.. figs. 90—92, and pl. XI. The heads of the pope and the donor in the panel on the back wall of the chapel were painted on a distinct layer. Recent investigations have proved, contrary to my earlier assumption, that the original layer did not display the portrait of an earlier pope but only a generalized sketch as in the case of the donor. See M. Cagiano de Azevedo in *Bollettino d'Arte*, 74, 1949, p. 60 ff., with the cautious suggestion that the painting of these two heads may have been entrusted to an artist specializing in portraits. Ladner, however, who had correctly predicted the absence of a fully finished portrait beneath the head of Zacharias, rejects this possibility (*Medieval Studies*, III, p. 21 f.).

[19] E. g. first group of ex-votos in St. Demetrius in Salonika and the mosaics in S. Venanzio, where I can see no basic difference between the rendering of the (unrestored) head of the donor pope to the right and that of his neighbor, the sainted and haloed Bishop Domnio (Ladner, *Papstbildnisse*, pl. IX b).

[20] There is, for instance, no essential difference in the stylistic treatment of the faces of Christ and Constantine IX in the Zoe panel in Hagia Sophia (Whittemore, *op. cit.* [above, n. 5], pls. VI and XI). On the other hand, it may be doubted that in Byzantium

is not of the order of a universal law. But from the middle of the sixth century on, and down to the end of the Byzantine development, it is very widespread. A high degree of geometric simplification and linearism is often a hallmark of the contemporary portrait, while a modicum of hellenistic pictorial techniques, just like the ancient costume of tunica and pallium, remain characteristic of the representation of saints. It is a prime example of a stylistic „mode" in Byzantine art being associated with a particular subject category, or, to put it paradoxically, of style assuming the role of an iconographic attribute.[21]

To probe the deeper reasons which caused the portrait „mode" to become permanently rooted in Byzantine artistic practice would be an interesting task. I have previously suggested that stylistic „modes" in Byzantium serve to denote not only different kinds of subjects, but in a larger sense different orders of being or levels of existence.[22] Without pursuing this question further I propose to comment briefly on what I believe to be a singular instance of a reflection of the portrait „mode" in religious iconography. The case in question is the portrayal of Christ on the coins of Justinian II. These coins are famous in the annals of Byzantine numismatics because they are the first on which the image of the Savior appears as a principal feature. For the first time the earthly autokrator cedes his traditional place on the obverse of the coin to his heavenly Overlord, while his own portrait is relegated to the reverse. Various explanations have been offered of the fact that two quite different facial types of Christ appear on these coin issues, one with broad features, long, flowing hair parted in the middle, and a long beard, the other more youthful with an almost triangular outline, short, curly hair and only a very short beard framing the face (figs. 5, 6). J. Breckenridge, who has attributed the coins showing the first type („A") to Justinian's first reign, or, more specifically, to the years 692—695, and those of the second type („B") to the second reign (705—711), has furnished an important clue to their interpretation by quoting à propos of Type „B" a number of Byzantine texts which refer to what appears to be just this type as being the „more truthful" or the „more familiar in the time of the Savior", and by showing, furthermore, that analogies to this type can be found primarily in works of art connected with Palestine or Syria.[23] Type „B", in other words, has connotations of authenticity — of being an actual record of Christ's physiognomy — which the other, more idealized, type lacks.[24] The evidence presented by Breckenridge seems to me incontrovertible, regardless of whether or not one

proper any artist would have gone so far as the court portraitist of Roger II of Sicily, who actually assimilated the King's likeness to that of Christ (E. Kitzinger, „On the Portrait of Roger II in the Martorana in Palermo," *Proporzioni*, III, 1950, p. 30 ff.).

[21] Kitzinger, „Byzantine Art in the Period between Justinian and Iconoclasm," pp. 36 f., 39, 46 ff.

[22] *Ibid.*, p. 47 f.

[23] J. D. Breckenridge, *The Numismatic Iconography of Justinian II*, New York, 1959, p. 59 ff.

[24] A. Grabar (*L'iconoclasme byzantin*, Paris, 1957, p. 40 ff.) also regards Type „B" as connoting the terrestrial and human as against the celestial Christ of Type "A" (and bases on this distinction his interpretation of the coins that bear Type "B", in contrast to those showing Type "A"), but without considering the specific aspect of "historic authenticity" which interests us here.

also follows him in his further and more tentative association of Type „A" with the image of the Olympian Zeus and of Type „B" with one of the venerated „acheiropoieta" icons purporting to bear an actual imprint (or, at any rate, a miraculously produced record) of Christ's face.[25] What makes Breckenridge's interpretation of Type „B" germane to the subject of this paper is the fact that in rendering this type the die-sinkers of Justinian II made use of stylistic devices characteristic of the portrait „mode". To be sure, these devices do not stand out as clearly in a small scale relief as they do in the paintings and mosaics previously discussed. But there can be no doubt that the Christ of Type „B" differs from Type „A" not only in a number of factual physiognomic traits, but also in being more clear-cut, more precisely defined in geometric terms. The basic shape of the face is extremely regular, its outline strongly emphasized, its surface smooth and unmodelled, its detail sharply drawn. These are the same stylistic features which the artist also employed in the rendering of the imperial portrait on the reverse of the same coin (fig. 7). Both are meant to be portraits „from life". It might be argued that the difference in the rendering of Christ's face in the images of Type „A" and Type „B" is solely a matter of the distinctive styles of particular artists or schools.[26] But there is the striking fact that the two heads of Christ with their marked stylistic differences are placed on draped busts that are well-nigh identical. Nothing could indicate more clearly that style in this case has „iconographic" connotations. The use of a highly geometric and abstract style for the Christ portrait of Type „B" must be related to the meaning of this type, and furnishes additional proof of Breckenridge's thesis that this rendering of the Savior's countenance was meant to have the ring of particular authenticity. Type „B" is indeed the exception that confirms the rule — the rule being that it is the face of the living person, as opposed to that of Christ or the Saint, which tends to be singled out for a particularly linear and abstract treatment.

It is true, of course, that in a sense both types of the Savior's image on the coins of Justinian II — „A" as well as „B" — are meant to be „portraits". Much has been made of the fact that the appearance of these numismatic images coincides with the pronouncements of the Quinisext Council forbidding the representation of Christ in the guise of a lamb and stipulating His representation in human form to aid „our comprehension of the height of the humiliation of God's Word and to remind us of His Incarnation, His Passion and His Salutary Death." The Council specifically rejected the symbolic and metaphorical language of Early Christian art. While the precise relationship between this pronouncement and the images of Christ on Justinian's coins is not clear, [27] it is evident that these official images in both their variants must be meant to be actual representations of the Word Incarnate and that neither of the two types can be intended as a mere sign or allu-

[25] *Op. cit.,* pp. 46 ff., 97 ff.

[26] Cf. A. R. Bellinger, „The Gold Coins of Justinian II," *Archaeology,* III, 1950, p. 107 ff. C. H. V. Sutherland, *Art in Coinage,* London, 1955, p. 126 f.

[27] On this point see A. Grabar, *L'empereur dans l'art byzantin,* Paris, 1936, p. 165; *id., L'iconoclasme byzantin,* pp. 36,41; Breckenridge, *op. cit.,* p. 78 ff.

sion. Granted that Type „A" is modelled after a classical god — and its „Jovian" flavor is undeniable whether or not one accepts Breckenridge's derivation from the Zeus of Phidias — the ancient prototype is here no longer used in the metaphorical way in which such types were used in the third and fourth century, when all Christian imagery was in the nature of a sign language. Type „A" no less than Type „B" is meant to be a „portrayal" of Christ. But it is a portrayal keyed not so much to physiognomic externals as to a certain ethos. Majestic, serene and benignly paternal, it conveys in human terms the Christian emperor's „image" of his heavenly Overlord. It is a „portrait" in the Hellenic tradition, in which the likenesses of mortals had met and merged with those of the eternal gods on the level of the generically human and humane. A classical stylistic „mode" serves the cause of this portrayal, as the abstract „mode" serves that of the factual physiognomic record.

It is interesting to note that the idea of a „literal" portrayal, as embodied in the coins of Type „B", had little future in Byzantine religious art. While the „Jovian" type of Christ was taken over from Justinian's coins by the die-sinkers of the post-iconoclastic period — and emerged indeed as the normal type for the representation of the All-Ruler in later Byzantine art — Type „B" was never taken up again in coinage and rarely elsewhere. This observation leads us to the last of these brief reflections.

The century and a half from about 550 to 700 A. D., during which the portrait „mode" emerges, is the period during which Byzantine art as a whole made its greatest strides towards abstract mediaeval form. Building up on stylistic trends which had originated much earlier, it is the one period in the history of Byzantine art when a complete and radical alienation from the classical artistic tradition might have occurred, despite some obvious and well-known „pockets" of relatively pure hellenistic survival. I have discussed this critical development in previous studies and I have shown that there is some inner relationship — albeit only an indirect one — between the emergence of the abstract style and the enhanced and central role which the religious image assumed during the same period as an object of devotion.[28] But I have also warned against oversimplifying this relationship, and one of the reasons for this warning is precisely the fact that abstraction tends to be carried to more extreme lengths in „secular" portraiture than in the representation of saints.[29]

This statement, of course, can be expressed conversely and will then be found to contain an essential and fundamental truth about Byzantine art. What it means is that even in its period of farthest alienation from the classical stylistic heritage Byzantium preserves a measure of this heritage in the central and crucial sphere of religious imagery. We have just seen a propos

[28] "On Some Icons of the Seventh Century," *Late Classical and Mediaeval Studies in Honor of A. M. Friend, Jr.*, Princeton, 1955, p. 132 ff., especially p. 142 ff.; „Byzantine Art in the Period between Justinian and Iconoclasm," (see above, n. 15), p. 44 ff.

[29] *Ibid.*, p. 46 f.

of the „Jovian" Christ of the coins of Justinian II that this is more than a matter of formal devices. These devices serve the cause of an essentially humanistic ethos which thus remains wedded to Byzantine artistic creation in its most vital sector. And it is these devices and this ethos which emerge victorious in the religious art of the post-iconoclastic era.

As for the portrait „mode", which the abstract trend of the sixth and seventh centuries did so much to bring into being, it was and remained a relatively marginal field of Byzantine artistic endeavor, though one which was not without its own special triumphs.

Fig. 1 — Poreč (Parenzo), Basilica, Apse. Detail of Mosaic: Bishop Euphrasius and Archdeacon Claudius

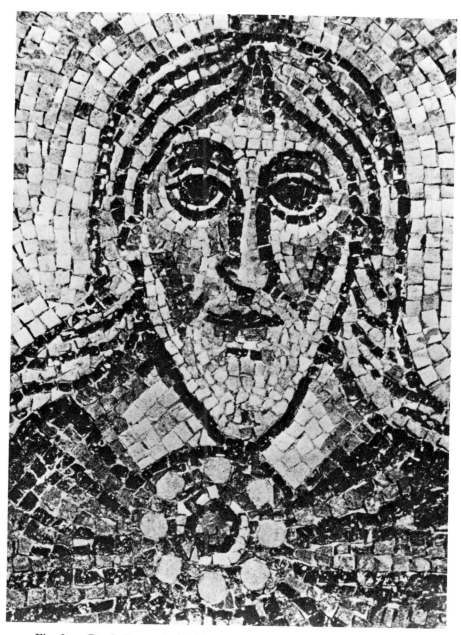

Fig. 2 — Poreč (Parenzo), Basilica, Apse. Detail of Mosaic: St. Zacharias

Fig. 3 — Rome, Sta. Maria Antiqua, Chapel of Theodotus. Detail
of Wall Painting: Son of Theodotus

Fig. 4 — Rome, Sta. Maria Antiqua, Chapel of Theodotus. Detail
of Wall Painting: St. Quiricus

Fig. 5 — Solidus of Justinian II, Obverse: Bust of Christ (Type „A")

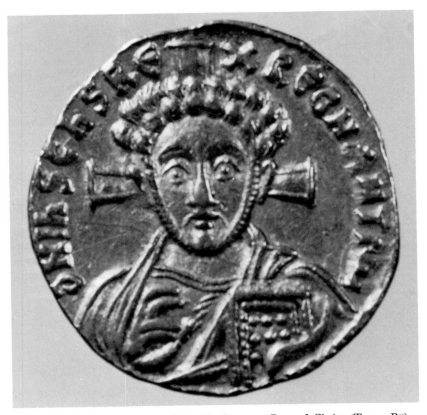

Fig. 6 — Solidus of Justinian II, Obverse: Bust of Christ (Type „B")

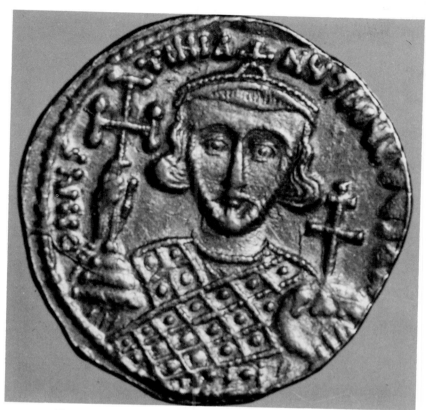

Fig. 7 — Solidus of Justinian II, Reverse: Bust of Emperor

PART THREE

BYZANTIUM AND THE

MEDIEVAL WEST

IX

THE FIRST MOSAIC DECORATION
OF SALERNO CATHEDRAL

The fragmentary mosaics in the area of the main apse of the Cathedral of Salerno (figs. 1, 2, 4—6) have led a rather shadowy existence in scholarly literature. "Wenig bekannt oder verkannt" — this is how Otto Demus referred to them a few years ago in his great synthesis of Romanesque mural painting[1]. Pending a full publication, a brief discussion may be offered in his honor of what is in fact a document of major importance for the history of early medieval art in Italy[2].

The existence of these mosaics has been known for at least sixty years[3]. Photographs of the principal surviving elements were first published in 1924[4]; and Pietro Toesca briefly referred to them in the first volume of his history of Italian art published in 1927[5]. But it was only in the 1930s, after the removal of the 18th century ceiling which had concealed them, that they became accessible to proper observation. Since then they have figured quite frequently in both local and general studies[6], though in some of the literature

[1] O. DEMUS, Romanische Wandmalerei. Munich 1968, 54.

[2] Much of the substance of this article, which was completed in August 1971, was first presented in a paper on "Byzantine Mosaicists in Italy: Their Background and Their Impact", read at the Dumbarton Oaks Symposium of 1965. A full publication of the Salerno mosaic is planned by Dr. Carlo BERTELLI and myself. I am most grateful to Dr. Bertelli for allowing me to illustrate the present article with some of the photographs taken by him in 1966 for our proposed joint study, and also for providing me with photographs of the mosaics of S. Clemente; and to Mr. H. M. Willard for generously letting me reproduce a photograph of the Salerno decoration taken by him in 1933 (fig. 6).

[3] M. DE ANGELIS (Le origini dell'architettura nell'Italia meridionale ed i mosaici della Cattedrale di Salerno. *Arch. Stor. della Provincia di Salerno* 4 [1924] 1 ff.) speaks of first having seen the mosaics in 1912 (p. 31). Cf. also J. WILPERT, Die römischen Mosaiken und Malereien der kirchlichen Bauten vom IV. bis XIII. Jahrhundert. Freiburg 1917, II 1196; Wilpert had received a photograph from C. Ricci.

[4] DE ANGELIS, op. cit., pl. IV.

[5] P. TOESCA, Storia dell'arte italiana I. Turin 1927, 938.

[6] M. DE ANGELIS, Il Duomo di Salerno nella sua storia, nelle sue vicende e nei suoi monumenti. Salerno 1936, 67, 95, 105, 113; id., Nuova guida del Duomo di Salerno.

no clear distinction is made between these mosaics and the much better known ones in the side apses and on the west wall of the church which had always been visible. Dates have ranged from the 11th to the 13th century, and there has been considerable uncertainty as to what "school" the mosaics should be ascribed to — Roman, Cassinese, Byzantine or some otherwise unknown artistic tradition.

The majority of extant fragments are on the flat surface of the east wall of the transept and belong to the decoration of the area framing the central apse (fig. 1). Presumably this decoration never extended to the wall spaces surrounding the side apses, for on the right hand side the corner of the upper ornamental frame (or, at any rate, of the inner part of that frame) is preserved, and this corner just clears the "longitude" of the southern lateral apse (fig. 6). Within the area thus framed there were, on gold ground, the symbols of the four Evangelists, of which, however, only two are reasonably well preserved. These two, with their huge wing spreads, filled a large part of the available space and must have dominated the composition. On the left is the half-length figure of the angel of St. Matthew turning toward the center (fig. 4); at the right the eagle of St. John, also half length, his head turned toward the left and surrounded by a turquoise blue halo, his breast adorned with a jewel, his claws holding an open book inscribed with the words † IN PRIN-CIPIO ERAT VERBU(M) ET VER(BUM) (fig. 5). In the spandrels beneath the two figures traces of the other two symbols are clearly visible. Small segments of two turquoise blue haloes are preserved on either side beneath the scattered clouds which form the background for the angel and the eagle respectively. On the right there also remain the tips of the lower symbol's right wing and, on an isolated mosaic fragment below, the background on which that symbol floated (fig. 5)[7]. It is not possible on the basis of these scanty remnants to decide which of these two symbols was the lion and which the bull. In scale they must have been quite small.

Salerno 1937 (not seen by me). — G. CHIERICI, Il Duomo di Salerno e la Chiesa di Monte-cassino. *Rassegna storica Salernitana* 1 (1937) 95ff., esp. 106f. — A. SCHIAVO, Monte-cassino e Salerno: Affinità stilistiche tra la chiesa Cassinese di Desiderio e quella Salerni-tana di Alfano I, in: Atti del II° convegno nazionale di storia dell'architettura, 1937. Rome 1939, 159ff., esp. 173. — S. ORTOLANI, *Bollettino d'Arte* 33 (1948) 298, fig. 3 and p. 300f. with n. 14. — O. DEMUS, The Mosaics of Norman Sicily. London 1949, 457, n. 34. — F. BOLOGNA, Opere d'arte nel Salernitano dal XII al XVIII secolo. Naples 1955, 20, 74. — A. PANTONI, La Basilica di Montecassino e quella di Salerno ai tempi di San Gregorio VII. *Benedictina* 10 (1956) 23ff., esp. 38. — F. BOLOGNA, La pittura italiana delle origini. Rome 1962, 80. — DEMUS, op. cit. supra n. 1, 54.

[7] This latter fragment includes, in addition to a few schematic lines representing clouds, a narrow blue and red band ascending at a slight angle toward the right. The meaning of this feature is not clear to me.

The ornament which formed the upper frame of the mosaic is preserved in large stretches (figs. 2, 4, 5). Its principal element is a frieze of linked, pointed ovals enriched with foliate motifs and stars and bordered above and below by a broad red band[8]. A motif of stylized dark blue tendrils is attached to the lower of these bands. A similar red band (but without the tendrils) formed part of the inner frame which accompanied the curvature of the apse. Small sections of this band are preserved on the right hand side in the two fragments containing respectively the wing tips of the lower symbol and the background beneath that symbol (fig. 5). The mosaicists who in recent years executed a new decoration inside the apse took these small remnants as a cue for repeating the ornament of the upper frame all around the opening of the apse[9]. Whether or not this reconstruction of the motif of the inner frame is correct, the width of that frame is assured by what remains of the red band. However — and here the modern reconstruction is definitely misleading —, both the upper and the inner frame were interrupted in the center, i. e. above the apex of the arch of the apse. In this area, where the two frames nearly touched, they were overlapped by a circular medallion of which a small segment remains on the right, its border studded with little white stars on blue ground (fig. 2). At San Clemente in Rome there is a medallion similarly placed and similarly bordered with stars which contains a bust of Christ (fig. 3).

Very little survives of the mosaic inside the conch of the apse. There are a few fragments of a rich garland border, now incorporated in the modern mosaic decoration. They can easily be distinguished from the recent work around them, having been set off by red outlines (figs. 2, 4). At the crown of the conch the garland was interrupted by a medallion of which only small segments of the frame remained and which has now been completed to show an ornamental cross. What followed originally beyond the blue and red bands that framed the garland is not certain, though at one point they were adjoined by a small area of blue. It is, in fact, possible that the entire background of the original apse mosaic was blue[10].

[8] For similar ornaments see H. Toubert, Le renouveau paléochrétien à Rome au debut du XIIe siècle. *Cah. Arch.* 20 (1970) 101ff. and figs. 4ff.

[9] These new mosaics, whose strident colors have badly impaired the effect of what remains of the medieval decoration, are the work of Baccio Maria Bacci, as Dr. Bertelli has ascertained (see infra, n. 10). They were not yet in existence when I visited the church in 1948 and made the notes on which the present description is largely based.

[10] M. de Angelis in 1924 had suggested this purely on *a priori* grounds; cf. op. cit. supra n. 3, 27f. — G. Chierici, in his account of the restoration carried out in 1933 when the eighteenth century work was removed, says that no trace of the apse mosaic was found; cf. op. cit. supra n. 6, 102ff. Dr. Bertelli, however, was informed by Sig. Bacci, whom he visited in 1966, that in executing the new mosaic decoration he found many

What is left, then, of our decoration is woefully little; and what little there is is woefully fragmentary. We do, however, know of one additional element which, although not physically extant, was undoubtedly part of this ensemble and which is extremely important. In a description of the Cathedral published in 1580 we are told not only that the walls at the eastern end of the building were beautifully adorned with mosaics but also that "in Emispherio maiori" the following verses were inscribed in mosaic lettering:

Da Matthaee pater patris hoc det et innuba mater
Ut pater Alphanus maneat sine fine beatus
Ecce dei natum sine matre deum generatum
Praedicunt vates nasci de virgine matre
Sic Christus natus nostros removendo reatus
Vivit cum patre in caelo et cum virgine matre[11].

The inscription perished, along with the rest of the mosaic in the apse, in the eighteenth century remodeling of the church. Presumably its place was on the lower frame of the decoration, a customary location for such dedicatory

dark blue tesserae in the conch of the apse. Sig. Bacci said he chose blue for the background of his own mosaics because he had formed the impression that this had been the original background color. Among a collection of small mosaic fragments in the Diocesan Museum at Salerno, to which Dr. Bertelli has drawn my attention, there is also a good deal of blue. The provenance of these fragments, however, is not entirely sure, though Dr. Bertelli thinks that many of them came from the central apse and the apse wall.

[11] M. A. MARSILIO COLONNA, De vita et gestis beati Matthaei apostoli et evangelistae. Naples 1580. I am quoting this source, which was not accessible to me, after N. ACOCELLA, La decorazione pittorica di Montecassino dalle didascalie di Alfano I (sec. XI). Salerno 1966, 27 f. and n. 21. Prior to its destruction in the eighteenth century, the inscription was published once more by A. MAZZA, Historiarum Epitome de Rebus Salernitanis. Naples 1681, 42. The wording in Mazza's transcription is identical, though the fourth word in the first line is abbreviated "Patr.". Professor Herbert Bloch has suggested to me that the word, which may have been abbreviated in the mosaic itself (or may no longer have been clearly legible in the sixteenth and seventeenth centuries; cf. ACOCELLA, op. cit. 28, n. 23) was actually *Pater*, like the preceding word, which would be metrically more accurate. For the play on the word *Pater* see infra, n. 17 [a]. Another testimony to the inscription written prior to its destruction is contained in the unpublished manuscript of M. PASTORE's "Platea della Chiesa Salernitana". See the quotation in A. CAPONE, Il Duomo di Salerno I. Salerno 1927, 244, which leaves no doubt that the inscription with Alfanus' name was an integral part of the decoration of the central apse. The inscription has been frequently republished and discussed, wholly or in part, in nineteenth and twentieth century literature on Salerno Cathedral and on Archbishop Alfanus; cf. A. LENTINI, Rassegna delle poesie di Alfano da Salerno. *Bull. Ist. Stor. Ital. per il Medio Evo* 69 (1957) 213 ff., esp. 225 f., 242.

verses since the early period of Christian mosaic art[12]. It has been suggested that the six verses constitute three separate couplets[13]; and at least the second of these, beginning with "Ecce," presumably refers to the subjects depicted in the apse. Very probably, then, the composition featured the Virgin and Child with Old Testament prophets[14].

For our purposes, however, principal importance attaches to the first couplet with its reference to "Pater Alphanus," which provides a clue to the date of our mosaic. Since Archbishop Alfanus (1058—85) was, together with Robert Guiscard (commemorated in two inscriptions over the entrance doors of the atrium and the nave of the Cathedral[15]), the co-founder of the church, it seems obvious that he must be the person to whom the verses refer. Scholarship on this point has been unduly hesitant, presumably because of the weight and authority carried by the opinions of Emile Bertaux. In his classic book that great scholar attributed the verses — he was not aware of the extant mosaic fragments, in his days concealed by the eighteenth century ceiling — to Alfanus' homonym and successor who occupied the see of Salerno from 1086 to 1121[16]. Modern students have not accepted this view and have included our six verses into the canon of the poetic oeuvre of Alfanus I, who was, of course, not only a prominent churchman but also one of the great literary and intellectual figures of eleventh century Italy[17]. The words, and the sentiments expressed, are entirely plausible as those with which he, as a co-founder, wished to be commemorated in his Cathedral[17a]. It is true that he may not have lived to see them actually executed in mosaic. The church, it is now

[12] Cf. e. g. Ss. Cosma e Damiano in Rome. The verses have been reproduced in the same location in the new mosaic. G. PAESANO, Memorie per servire alla storia della Chiesa Salernitana II. Salerno 1852, 223f., n. (b), erroneously stated that the inscription was in the pavement of the apse. On this error, subsequently repeated by L. STAIBANO, see DE ANGELIS, op. cit. supra n. 3, 24.

[13] LENTINI, op. cit. 225f. Certainly the verses, even if aligned in the same band, need not have been meant as a single poem; cf. e. g. the mosaic inscription at the base of the conch of the apse of S. Clemente in Rome, where two couplets are arranged in a single line in such a way that the two verses of the first are separated by the second. Cf. G. MATTHIAE, Mosaici medioevali delle chiese di Roma. Rome 1967, 303, n. 15.

[14] Cf. E. BERTAUX, L'Art dans l'Italie méridionale I. Paris 1904, 190.

[15] ACOCELLA, op. cit. 26f.

[16] BERTAUX, op. cit. 190.

[17] LENTINI, op. cit. 225f.,.242.

[17a] H. BLOCH, in his forthcoming book on Monte Cassino, compares our couplets with the dedicatory verses of Ms. lat. 1202 in the Vatican Library, in which very similar sentiments are expressed in regard to Abbot Desiderius, certainly within the latter's lifetime and again with the help of a play on the word *pater*:

"Faciat super astra beatum
Pater hunc socium fore patrum"

(D. M. INGUANEZ and M. AVERY, Miniature Cassinesi del Secolo XI. Montecassino 1934,

agreed, probably was not founded until 1080[18]; and Alfanus died in October, 1085[19]. But the building had been consecrated by Pope Gregory VII earlier in that year[20], and even if work had not progressed with quite the same speed and energy as in Desiderius' new Abbey Church at Monte Cassino — which was Alfanus' great model and which was also dedicated within five years of its founding — the apse mosaic could well have been in place at that time. In any case, nothing precludes its attribution to the years immediately following. On this purely internal evidence "circa 1085" is, in fact, a probable date for our mosaic. Consideration of the art historical affiliations of the work will further support this dating.

The fragments have their closest known relatives in two well-known mosaic decorations in Rome — those of S. Clemente and S. Maria in Trastevere. In both these churches we find on the wall of the apse the symbols of the Evangelists placed on either side of a central medallion. In both, the angel of St. Matthew and the eagle of St. John occupy positions corresponding to those they hold in Salerno. In both, the symbols are half-length figures equipped with pairs of triple wings and floating in a cloudy "sky." We have already noted the similarity of the frame of the central medallion with that at S. Clemente (fig. 3). Another unusual feature is the jewel or "bulla" which the Salerno eagle wears around its neck and which recurs in S. Maria in Trastevere. The floral garlands which in all three churches form the frame of the composition within the conch itself are also closely comparable[21].

In the light of this relationship, which has often been recognized, it is obvious that there must be some historical connection between the Salerno mosaic and the Roman ones. To assume that they are totally independent one from the others defies all probability. It is also clear, however, that the Salerno mosaic cannot be a derivative of these Roman works. For one thing,

[5]). That poem has also been attributed to Alfanus by a number of scholars; cf. Lentini, op. cit. 223f.

[18] A. Balducci, *Rassegna Storica Salernitana* 18 (1957) 156ff.; A. Pantoni, *Benedictina* 13 (1959) 152, n. 170.

[19] N. Acocella, La figura e l'opera di Alfano I di Salerno. *Rassegna Storica Salernitana* 19 (1958) 1ff., esp. 64.

[20] Bernoldi Chronicon, s. a. 1085 (*MGH* Scriptores V 444).

[21] For the two Roman mosaics see Matthiae, op. cit. supra. n. 13, Text, 279ff. and 420ff. (on restoration); Plate Vol., figs. 228ff. and diagram of S. Maria in Trastevere mosaic at end. Although the eagle in the latter mosaic is in large part restored, it is not likely that the jewel around its neck is a motif introduced by a restorer without basis in the original mosaic, the less so since the same detail also occurs on a closely related fresco at S. Croce in Gerusalemme (for references see infra, n. 37). For this unusual motif, see D. Mallardo, *Riv. Arch. Crist.* 25 (1949) 87ff.

it has a clear priority over them in purely chronological terms. The mosaics of S. Maria in Trastevere were commissioned by Pope Innocent II (1130—43). Those of S. Clemente are not so securely dated but can be safely attributed to the period of Cardinal Anastasius, who rebuilt the church during the pontificate of Pope Paschal II (1099—1118) and who died in 1125[22]. Thus, even allowing for the possibility that the Salerno mosaic was not executed until after the death of Alfanus I in 1085, the South Italian work still precedes its nearest relative in Rome by a number of years. This by itself would seem to rule out the possibility of its being influenced by the Roman "school"[23]. For there is no evidence at all of the work of S. Clemente having been preceded in the late eleventh century by similar decorations in other Roman churches.

On stylistic grounds, too, it seems unlikely that the Salerno mosaic should depend on the Roman ones. Anyone who examines carefully what remains of the angel of St. Matthew at Salerno (fig. 4) must be impressed by his full-bodied presence, the careful molding of jaw, lips and neck, and particularly the rich drapery of the mantle bunched at the waist in a multiplicity of small folds whose opulent, ruffle-like effect is heightened by sharp highlights. There is nothing like this at S. Clemente or in any other known mosaic or painting done in Rome during the period in question. The angel's drapery, however, also enables us to go beyond such purely negative conclusions; for it contains a tell-tale detail indicative of the source of this art. His tunic, which is shaded blue (as distinct from the mantle, which is shaded grey) and adorned at the sleeve with a gamma-shaped gold clavus, forms at the back a long, thin fold descending from the shoulder and tucked into the richly pleated "waist-band" just referred to. In spite of the damage in this area, the tuck, which takes the shape of a small S curve, is quite unmistakable. Now this is a motif familiar to all students of Byzantine art, where it became a standard convention, particularly in the Comnenian period. Both standing and seated figures are apt to show it[24], and it became a florid mannerism in late Comnenian

[22] See, most recently, TOUBERT, op. cit. supra n. 8, 100, n. 4.

[23] As assumed, for instance, by S. ORTOLANI, op. cit. supra n. 6, 301, 314, n. 14.

[24] Cf. e. g. some of the figures in the mosaic of the Communion of the Apostles at St. Michael's in Kiev (V. N. LAZAREV, Michailovskie Mozaiki. Moscow 1966, pls. 16, 20); many figures in the mosaics of the Norman period in Sicily (DEMUS, op. cit. supra n. 6, pls. 28A, 29A, 33, 34, 40, 42, 49A, 56, 67 etc.); or, in miniature painting, Ms. 2 in the Panteleimon Monastery on· Mount Athos (K. WEITZMANN, Aus den Bibliotheken des Athos. Hamburg 1967, pl. 16). When tunic and mantle are of different colors, as, for instance, in the Kiev mosaic and the Panteleimon miniature, it is clear that in Byzantine art proper the fold under discussion and the loop it forms at the waist normally belong to the mantle and not to the tunic. The Salerno mosaicist in using the motif for the tunic seems to have departed from the original Byzantine norm. This reinterpretation of the motif (which may account for the strange, angular shape of the gold clavus on

art[25]. There is, so far as I know, no securely dated Byzantine work of the eleventh century in which the motif appears[26]. But its "invention" must date back at least to 1070 A. D. For it crops up in the work of the illuminators who at that time adorned manuscripts for Desiderius of Monte Cassino and whose strong and direct dependence on Byzantium is beyond question (fig. 7). Indeed, as Otto Demus has shown, the angel of the Annunciation in Monte Cassino Ms. 99 (a work of 1072 A. D. or shortly thereafter) is practically a copy of the corresponding figure in a mosaic in the church of the Monastery of Vatopedi on Mount Athos[27]. The mosaic, which also shows the little loop, can thus be confidently claimed as an eleventh century work and, in fact, as a representative of the art brought to Monte Cassino by the craftsmen whom Desiderius procured from Constantinople[28].

Our Salerno angel, then, has antecedents in Byzantium; or, at any rate, there is in the design of this figure an unmistakable Byzantine ingredient. Once this is realized everything falls into place. For the Monte Cassino miniature is not merely a convenient stepping stone for the scholar who seeks to anchor the angel's drapery design in Byzantine art of the eleventh century. It indicates the route actually traveled by that design before reaching Salerno. Archbishop Alfanus was a close and lifelong friend of Abbot Desiderius. He had been a monk at Monte Cassino, was present at the dedication of Desiderius' new church in 1071 and wrote an ode in praise of the new building[29], as well as a series of *tituli* which probably accompanied the biblical paintings in the atrium of Desiderius' church[30]. The architecture of his own cathedral

the angel's sleeve) perhaps has to do with the presence of another element in the design of the angel's drapery, namely, a freely floating swath which issues from behind the angel's back and is definitely part of the mantle. For this latter motif see infra p. 159.

[25] Cf. e. g. the angel of the Annunciation at Kurbinovo; J. BECKWITH, Early Christian and Byzantine Art. Baltimore 1970, fig. 237.

[26] Some figures in the mosaics of the Nea Moni in Chios seem to show it, as it were, *in statu nascendi*; cf. A. GRABAR, Byzantine Painting. Geneva 1953, 108. — O. MORISANI, Bisanzio e la pittura Cassinese. Palermo 1955, fig. 7.

[27] O. DEMUS, Byzantine Art and the West. New York 1970, 27 and figs. 27, 28. Monte Cassino Ms. 99 was written in 1072 A. D., but E. A. LOWE considered that only the dedication scene on p. 1 is of that date and that the other pen-and-ink drawings, including the Annunciation on p. 5, were added somewhat later on pages that had been left blank (Scriptura Beneventana. Oxford 1929, commentary on pl. 68).

[28] For the mosaic see G. MILLET, Monuments de l'Athos I: Les Peintures. Paris 1927, pl. 1, 2. A. XYNGOPOULOS had already attributed it to the eleventh century and, more precisely, to the early years of that century (Mosaïques et fresques de l'Athos, in: Le Millénaire du Mont Athos, 963—1963, Études et Mélanges II. Venice 1964, 247ff., esp. 248).

[29] *PL* 147, 1234ff.; cf. LENTINI, op. cit. supra n. 11, 233f., no. 10. — N. ACOCELLA, *Napoli Nobilissima* 3 (1963) 67ff.

[30] LENTINI, op. cit. 238, no. 32. — ACOCELLA, op. cit. supra n. 11, passim.

closely followed that of the new basilica at Monte Cassino, as was indicated earlier [31]. There is every likelihood, therefore, that the mosaics also were inspired by, and influenced from, that source.

We know that the making of mosaic was one of the tasks, if not the major task, for which Desiderius had brought in Byzantine expertise. Finding that the craft had long fallen into disuse in Italy, he had obtained artists from Constantinople to decorate with mosaic the apse, the arch and the vestibule of his new church [32]. Thus it would appear that the very existence of mosaic in and around the main apse of Alfanus' church is due to the Archbishop's desire to emulate the example of Monte Cassino. Desiderius' mosaics were destroyed long ago, and it is impossible to decide whether there was any relation in subject matter between them and those of Alfanus. Not enough is known on this score in either case [33]. But the occurrence at Salerno of a Byzantine stylistic convention that in the second half of the eleventh century was new in Byzantium itself finds its natural explanation through the Monte Cassino relationship.

In fact, the question arises whether the Salerno mosaic could not itself have been, wholly or in part, the work of Desiderius' Byzantine artists. In theory this is quite possible since the time interval is only half a generation or a little more. We do not know what the Greek mosaicists did after completing their work on Desiderius' church. We do know that the Abbot had a large number of his young monks trained by them in order that their craft might not again be lost in Italy [34]. It is more likely, perhaps, that the decoration at Salerno is due to some of these disciples. In any case, however, we come here as close as we ever shall to the work of Desiderius' mosaicists at Monte Cassino.

As for the mosaics of Rome, and more specifically those of S. Clemente, they must be a subsequent offshoot from the same branch. This can be stated

[31] SCHIAVO, op. cit. supra n. 6, passim. — PANTONI, op. cit. supra n. 6, passim. Cf. supra p. 154.

[32] Chronicon Casinense III 27 (*PL* 173, 748f.).

[33] For Salerno see supra, p. 153. As regards the apse mosaic of Monte Cassino, all we know is that it included figures of St. John the Baptist and St. John the Evangelist; cf. Chron. Cas. III 28 (*PL* 173, 749).

[34] Chron. Cas. III 27 (*PL* 173, 749). Mosaic is known to have been used for the decoration of the apses of two other churches rebuilt by Desiderius, namely, the church of St. Martin at Monte Cassino and that of St. Benedict in Capua. For St. Martin's cf. Chron. Cas. III 33 and 34 (*PL* 173, 761ff.); for St. Benedict in Capua, where work was begun during the last years of Desiderius' life and completed by Oderisius, his successor as abbot of Monte Cassino, cf. M. MONACO, Sanctuarium Capuanum. Naples 1630, 164f.; BERTAUX, op. cit. supra n. 14, , 186. (The latter church was consecrated not in 1118, as Bertaux states, but in 1108; cf. *PL* 173, 858.)

with confidence without opening the whole complex of the so-called Benedictine Question. It must always be remembered that unless the San Clemente mosaics are brought into relationship with the Desiderian revival they hang completely in the air[35]. Recently Helène Toubert has drawn attention to the historical link which existed between the builders of S. Clemente and Monte Cassino, particularly in the person of Leo of Ostia[36]. The close relationship between the Roman mosaics and those of Salerno reinforces and illuminates this connection. We have said earlier that the two decorations cannot be totally independent one from another. The only question is whether the artists of S. Clemente were acquainted with the work at Salerno itself or whether the resemblance is due to common roots in the Desiderian school. Be this as it may, S. Clemente represents stylistically a phase subsequent to that of the Salerno mosaic. Abstraction and linearism have progressed apace. The angel's face is thin, bloodless and mask-like, his drapery far more schematic and summary, and the little tell-tale loop has disappeared (fig. 3)[37]. The Salerno angel is closer to the Byzantine source and the order of the two angel figures is irreversible. It is in this sense that the Roman work helps to corroborate the attribution of the Salerno mosaic to the period before or soon after the death of Alfanus I.

Pointing, as they do, both back to the Monte Cassino of Abbot Desiderius and forward to the Roman mosaic decorations of the period after 1100, the Salerno fragments lead us to look afresh at the words of the Cassinese Chronicle already cited. It was Desiderius' intent to establish a craft tradition so that the art of mosaic making should not again be lost in Italy. In this, it appears, he was entirely successful. To be sure, his was not the only effort made in his lifetime to reimport the medium. During the same period Byzantine mosaicists were also called to Venice[38]. But the Monte Cassino workshop

[35] See, for instance, the following "explanation" of the making of the S. Clemente mosaic, which amounts in effect to a counsel of despair: ". . . si ebbe ricorso a un gruppo di maestri mosaicisti, fatti venire chi sa da dove, ma presumibilmente addestrati in un paese del Levante, non meglio determinabile" (G. J. Hoogewerff, *Atti Pontif. Accad. Rom. Archeol.*, Rendiconti 27 [1951—54] 305).

[36] Toubert, op. cit. supra n. 8, 152.

[37] This is surely true regardless of possible restorations in the S. Clemente angel; cf. also the near-replica of this figure in the painted decoration of the triumphal arch of S. Croce in Gerusalemme (Wilpert, op. cit. supra n. 3, pl. 251, 1), recently republished and studied by G. Matthiae (Gli affreschi medioevali di S. Croce in Gerusalemme. Rome 1968, with color plate) and C. Bertelli (Un problema medioevale "romano". *Paragone* 231 [1969] 3ff., with fig. 1).

[38] See, most recently, O. Demus, *Starinar*, N. S. 20 (1969) 53ff., where the figures of the twelve apostles in the main apse of the Cathedral of Torcello are attributed to a date before or about 1050 A. D.

clearly did become a fountainhead from which within the next generation the craft was carried both South into Campania and North to papal Rome; and the process of acclimatization was so rapid that even in the early derivatives the Byzantine stylistic inheritance became all but unrecognizable. The controversies which have surrounded the art historical attribution of both the Salerno and the S. Clemente mosaics eloquently bespeak this fact. Surely these scholarly debates would have given Desiderius great satisfaction.

This quick absorption of the transplanted Byzantine art medium calls for some further comment. To explain the phenomenon we must, I submit, take into account the iconographic programs of the decorations concerned and the intent of the patrons as revealed in these programs. For S. Clemente this aspect has been explored so exhaustively and so convincingly in Helène Toubert's recent study[39] that only the briefest recapitulation is needed here. The S. Clemente mosaic constitutes an elaborate and somewhat eclectic effort to recreate the kind of mosaic decoration that adorned the Roman churches of what may broadly be called the Early Christian period. This clearly applies to Salerno too. The composition on the arch — repeated in enriched form at S. Clemente — derives from prototypes such as Galla Placidia's mosaic on the triumphal arch of S. Paolo fuori le mura and the mosaic of Pope Felix IV on the wall around the apse of Ss. Cosma e Damiano[40]. The arrangement at both Salerno and S. Clemente, with the angel to the left and the eagle to the right of the central motif, corresponds specifically to that at Ss. Cosma e Damiano. St. John's symbol at Salerno, while no match for the proud Roman eagle in the sixth century work, clearly is modelled after that image[41] or one very much like it. The triple wings of the symbols are a characteristic Early Christian motif[42]. The angel's drapery, in addition to its Byzantine details discussed above, also displayed a typically Early Christian feature, namely, a swath of the mantle issuing from behind the figure's back just beneath the wings and freely floating in the breeze (fig. 4)[43]. The extent to

[39] Op. cit. 122ff.

[40] ST. WAETZOLDT, Die Kopien des 17. Jahrhunderts nach Mosaiken und Wandmalereien in Rom. Vienna and Munich 1964, 32 and fig. 39; p. 64 and fig. 453.

[41] MATTHIAE, op. cit. supra n. 13, fig. 131; compare the close-up view of the Salerno eagle reproduced by ORTOLANI, op. cit. supra n. 6.

[42] Cf., e. g., the symbols in the mosaics of the Baptistery at Naples, where this motif is particularly clear (J.-L. MAIER, Le baptistère de Naples et ses mosaiques. Fribourg 1964, pls. 2, 6, 8ff.); also those in the Roman mosaic of Sta. Pudenziana (WILPERT, op. cit. supra n. 3, pls. 42—44). The scriptural basis is Apoc. 20, 8.

[43] Cf. supra n. 24. I cite for comparison the flying angels in the mosaics of S. Vitale in Ravenna (F. W. DEICHMANN, Frühchristliche Bauten und Mosaiken von Ravenna. Wiesbaden 1958, fig. 314f., angels to left). The angel in S. Clemente shows the swath descending from the shoulder, which is another variant of the motif in Christian art of

which the composition in the conch of the apse also harked back to early prototypes is hard to determine since so little is known about it. But the floral garland by which it was framed was certainly modelled after those which one finds in a corresponding position in early apse mosaics in Rome[44]; and if the ground was indeed blue[45] it would be, for the eleventh century, a palpably archaizing feature. For the Virgin as the principal figure in an apse mosaic the early antecedents are numerous[46].

In any event, there can be no doubt that at Salerno, no less than at S. Clemente, the mosaicists were called upon to emulate monuments that can broadly be called Early Christian. And, as was pointed out long ago by Emile Bertaux[47], there is every reason to believe that the same was true of the lost mosaics of Monte Cassino as well. They, too, were part of an Early Christian revival program. This applies not only to the architecture[48] but also, and most emphatically, to at least one known element of the mosaic decoration, namely, the verse inscription on the *arcus major* which was adapted from an inscription in a corresponding position in St. Peter's in Rome. The adaptation, incidentally, has been attributed to Alfanus[49].

Desiderius' whole transaction — and its sequel — must be seen in this light. Of course, we shall never know what his own mosaics actually looked like. But it may be suspected that even in them a good deal of the Byzantine stylistic identity was already lost. He imported Byzantine craftsmen not to create Byzantine mosaic on Italian soil but to create Early Christian mosaic. He merely wanted the Greeks' technical expertise in order to incorporate in his building a feature he considered indispensable if it was to be a true recreation of an Early Christian basilica. The motivation was quite different from what it was to be subsequently in Sicily where the Norman rulers again imported the craft from Byzantium. Although Roger II and his successors also bent the mosaic medium to their particular needs, essentially they wanted to surround themselves with the splendor of the Basileus. Hence the need

the early centuries; cf., e. g., the half-length figure of Moses in the apse of S. Apollinare in Classe (ibid., fig. 390).

[44] Cf., e. g., S. Lorenzo fuori le mura; S. Agnese (MATTHIAE, op. cit. supra n. 13, figs. 90, 101 f.).

[45] See supra n. 10.

[46] See C. IHM, Die Programme der christlichen Apsismalerei vom vierten Jahrhundert bis zur Mitte des achten Jahrhunderts. Wiesbaden 1960, Index, s. v. "Maria".

[47] Op. cit. supra n. 14, 188 ff.

[48] Cf. R. KRAUTHEIMER, *Art Bull.* 24 (1942) 27 f.

[49] LENTINI, op. cit. supra n. 11, 238, no. 32; ACOCELLA, op. cit. supra n. 11, 31 ff. In addition, the verses which were inscribed in the apse of Desiderius' church had an exact counterpart in the Basilica of the Lateran, but here the chronological relationship is problematic; cf. ACOCELLA 43 ff.

to procure fresh Byzantine teams for almost every major undertaking and the faithful reflection through a period of two generations of successive phases in the development of metropolitan Byzantine mosaic styles. In the Desiderian orbit, on the contrary, the Byzantine identity got lost very quickly because from the outset the artists were made to follow non-Byzantine models and because the patrons' purpose and motivation were entirely different from what they were in Sicily.

What this motivation was has again been explained very fully by Helène Toubert in regard to S. Clemente. She has related the Early Christian revival so evident in the mosaics of that church and other contemporary works in Rome to the *renovatio* ideology that was an integral part of the movement of Ecclesiastical Reform[50]. But this applies not only to the period of Paschal II and Calixtus II. It is true also of Desiderius of Monte Cassino and Alfanus of Salerno, both prominent representatives of the Reform movement in the age of Hildebrand[51]. The popes of the period of the Concordat of Worms may have proclaimed their attachment to the Roman past — and more particularly to that golden age of the papacy, the centuries from Silvester I to Gregory the Great — more emphatically and explicitly in visual images[52]. But the effort to give this attachment pictorial expression goes back to the time of Gregory VII. The Salerno mosaic bears clear witness to this.

To return, in conclusion, once more to the Monte Cassino Chronicle: Should not the famous reference to *magistra Latinitas* and her long neglect of the art of mosaic making[53] also be seen in this light? As a matter of fact, the Chronicler's statement was anticipated by Alfanus of Salerno, who in his poem on Monte Cassino speaks of a period of 450 years during which the technique of representing the human figure *in vitrea . . . materia* had been unknown in Italy[54]. In the Chronicle the time interval becomes "more than

[50] TOUBERT, op. cit. supra n. 8, 152 ff.

[51] For Alfanus, who expressed his adherence to Hildebrand's ideas in a famous ode (*PL* 147, 1262 f.), see ACOCELLA, op. cit. supra n. 19, passim. Desiderius, though likewise associated with Hildebrand/Gregory VII throughout his career, can be called a "Gregorian" only with qualifications. But he, too, was definitely a man of the Reform (cf. J. HALLER, Das Papsttum II/1. Stuttgart 1937, 406. — F. X. SEPPELT, Geschichte der Päpste III. Munich 1956, 115 f.). For the relationship between the Reform movement and the Early Christian revival in Italian art (and the art of Monte Cassino in particular) in the age of Hildebrand, see W. WEISBACH, Religiöse Reform und mittelalterliche Kunst. Einsiedeln and Zurich 1945, 54 ff., especially 58 ff.

[52] TOUBERT, op. cit. 153 f. and fig. 53.

[53] See supra n. 32.

[54] *PL* 147, 1237; cf. supra n. 29. The poem precedes the Chronicle, the composition of which was not undertaken until the time of Abbot Oderisius when Alfanus (who had originally been asked to write the Chronicle) was no longer alive; cf. M. MANITIUS, Geschichte der lateinischen Literatur des Mittelalters III. Munich 1931, 546.

500 years". In either case, the statement is obviously an error and, as has often been pointed out, seems to reveal its authors' poor knowledge of art history. After all, it would not have required a great deal of research to find out that a whole series of mosaics had been made in Rome within the past 250 years. But what if our authors were aware of these mosaics and deliberately ignored them because these works did not reach the level of what they considered "Latin mastery"? Rather than being poor art historians they would turn out to be, for their time, extraordinarily discriminating ones[55]. And again it would be a glorification of a period in art that came to an end with the sixth century — the same period to which Alfanus paid homage in his mosaic[56].

[55] This was suggested as long ago as 1827 by C. F. von RUMOHR, who wrote a propos of the supposed error in the Monte Cassino Chronicle: "Auch neueren Forschern dürfte es ankommen können, einmal, was ihnen durchaus verächtlich scheint, als nicht vorhanden anzusehen, als nicht der Rede wert unberührt zu lassen" (Italienische Forschungen I. Berlin and Stettin 1827, 288).

[56] In a lecture delivered at a Royal Historical Society Conference on "History and the Arts" in September, 1971, I have dealt more fully with some of the problems touched upon in the last part of this article. The lecture, entitled "The Gregorian Reform and the Visual Arts: A Problem of Method", will be published in the *Transactions of the Royal Historical Society*, 1972.

1 Salerno, Cathedral. Mosaic on East Wall of Transept

2 Salerno, Cathedral. Detail of Fig. 1

3 Rome, S. Clemente. Mosaic on Wall surrounding Apse

4 Salerno, Cathedral. Detail of Fig. 1: Symbol of St. Matthew

5 Salerno, Cathedral. Detail of Fig. 1: Symbol of St. John

6 Salerno,
Cathedral.
East Wall
of Transept.
Detail (1933)

7 Monte Cassino,
Library. Ms. 99,
p. 5, Detail

THE MOSAICS OF THE CAPPELLA PALATINA IN PALERMO

AN ESSAY ON THE CHOICE AND ARRANGEMENT OF SUBJECTS

D ISCUSSION of the mosaics of Norman Sicily has long centered on the question of the respective shares of Byzantine and local masters in their actual execution. In these investigations, which have led different scholars to widely different results, insufficient attention has been paid to the problems posed by the general Byzantine affinities of these mosaics, which are, after all, undeniable. Is it not significant that an artistic form so peculiarly "Byzantine" should have been adopted by a Western dynasty which was in almost perpetual conflict with the Eastern Empire and which was, in fact, in its time one of Byzantium's most formidable rivals? Is it not also worth investigating how the Normans were able to use in their churches iconographic patterns which had been invented for Greek sanctuaries and were bound up with orthodox theology and liturgy through many intricate ties of symbolism? Transferred to an alien setting could these iconographic themes amount to more than purely superficial imitations? Or was there a purpose behind the adoption of this particular art by the Norman rulers and was it adapted intelligently to its surroundings?

An inquiry into the choice and arrangement of subjects in the Cappella Palatina in Palermo—and, more particularly, in the sanctuary of the Chapel—throws considerable light on these questions. The mosaics in the eastern half of the Palermitan palace church constitute the earliest extant scheme of decoration undertaken by the Normans in Sicily. The arrangement follows in large part established rules of Byzantine church decoration. Yet it can be shown that the scheme is Byzantine in appearance only, and that it has been subtly and purposefully modified to serve as an expression of ideas which are outside the realm of Byzantine religious art and in a sense diametrically opposed to it.[1]

I

The Cappella Palatina was built by Roger II in the years following his assumption of the royal title in A.D. 1130. In A.D. 1140 the main parts of the structure must have been completed.[2] For the famous mosaic decoration, which covers almost the whole of the interior, two dates are available. The first is King Roger's dedicatory inscription; in its decipherable parts it does not

1. This article contains the substance of a paper on "The Mosaics of Norman Sicily and their Relation to Byzantium" read at a Dumbarton Oaks Symposium on "Byzantium and her Neighbors" on April 29, 1949. Much of the material was gathered during a visit to Sicily in the summer of 1948. The visit was sponsored by the Dumbarton Oaks Research Library and Collection (Harvard University), and, according to present intentions, is to be followed with further work on the mosaics of Norman Sicily. I wish to take this opportunity to thank Professor A. M. Friend, Jr., the Director of Research at Dumbarton Oaks, who provided essential stimuli for this study, and the authorities in Palermo, particularly Professor Guiotto, the Soprintendente ai Monumenti, and Mons. Pottino, who facilitated my researches in the most courteous manner. My colleagues at Dumbarton Oaks helped me in various ways at various stages of the work; thanks are due particularly to Professor P. A. Underwood, who was good enough to read the article in manuscript and suggested many improvements. I also wish to express my gratitude to Dr. Otto Demus for letting me see the proofs of his forthcoming book on the mosaics of Norman Sicily. Our results are parallel to some extent; I have not, however, entered into a discussion of points of disagreement.

2. The Chapel is first referred to in a document of A.D. 1132 in which it is merely described as "founded" and in which it is granted parish rights (A. Garofalo, *Tabularium Regiae ac Imperialis Capellae Collegiatae Divi Petri in Regio Panormitano Palatio*, Palermo, 1835, p. 7). But in the great instrument of endowment dated A.D. 1140 (*ibid.*, p. 11) King Roger speaks of the building of the Chapel in the past tense.

specifically mention the decoration, but since it is itself executed in mosaic and forms the lower frame of the decoration of the drum supporting the dome (cf. Fig. 5), work in this part of the Chapel must have been in progress in the year 1143, which is the year recorded in the inscription.[3] On the other hand, we learn from the chronicle of Romuald of Salerno that William I, Roger's son and successor, who ruled from 1154 to 1166, decorated the church with mosaics.[4] The two seemingly contradictory data have generally been reconciled by scholars through the assumption that William continued and completed the work initiated by Roger, but there is no unanimity as to the line of demarcation between the work of the father and that of the son.[5] Naturally, there need not be an obvious break between the two phases, since artists who worked for Roger may have continued under William according to an established program. Indeed, so far as the program is concerned, it will be shown in a later section of this study that a master plan was evolved in all likelihood under Roger, a plan which provided at least for the bulk of the mosaics in the sanctuary. There is some indication that the mosaics in the nave may have been planned simultaneously (see below, p. 282), even though the execution of the whole program may not have been completed in Roger's lifetime.

From the architectural point of view the Chapel is a hybrid. It combines a Western basilican nave with a domed sanctuary which can be understood best as the nucleus of a Byzantine central-ized church modified to some extent in order to bring it into harmony with the nave.[6] This is not merely a modern interpretation of the architecture. The designers of the mosaic program also looked upon the sanctuary as though it were a Greek *naos* and chose their subjects accordingly.

It is this decoration in the sanctuary which offers the principal interest for the purposes of our discussion. But before we begin to examine it in detail a few words must be said about the mosaics in the nave, which consist mainly of a Biblical cycle beginning with the Creation and ending with the story of Jacob. Extensive illustration of the Old Testament is a feature of Early Christian and Western mediaeval but not of Byzantine church decoration.[7] Hence the boundary line between the "Byzantine" program of the sanctuary and the "Western" program of the nave would seem to be an obvious place where a break in the continuity of the work might be assumed. Indeed, many scholars have adopted this as the dividing line between the work of Roger II and that of William I.[8] But the stylistic break at this point is by no means so clear as to be self-evident. In recent years other lines of demarcation between the two phases have been proposed.[9] And granting even a break in execution at this point, it has already been indicated that sanctuary and nave mosaics may well have been planned simultaneously.

3. For this inscription see N. Buscemi, *Notizie della Basilica di San Pietro detta la Cappella Regia*, Palermo, 1840, p. 31 and pl. VIII. It has suffered heavily from restoration, but the crucial words determining the decade and the year within Roger's reign are in a relatively well preserved section in the western half of the band on the northern side.

4. L. A. Muratori, *Raccolta degli storici italiani*, VII, pt. 1 (*Romualdi Salernitani Chronicon*, ed. C. A. Garufi), fasc. 3, Bologna, 1928, p. 254.

5. See below, notes 8 and 9.

6. Cf. H. M. Schwarz, "Die Baukunst Kalabriens und Siziliens im Zeitalter der Normannen," pt. 1, *Römisches Jahrbuch für Kunstgeschichte*, VI, 1942-44, p. 96. I cannot agree with A. Grabar (*Martyrium*, Paris, 1946, I, p. 577 n. 1) when he connects the architecture of the eastern half of the Cappella Palatina with the German "Doppelkapellen." The fact that there is underneath the sanctuary a lower story does not establish a specific connection with the German examples, since, according to Prof. Grabar's own demonstration, a two-story arrangement is a typical feature of palace churches generally. An essential characteristic of the "Doppelkapelle" is the connection of lower and upper church by means of a central opening (O. Schürer, "Romanische Doppelkapellen," *Marburger Jahrbuch für Kunstwissenschaft*, V, 1929, pp. 99ff.).

This feature is absent in the Cappella Palatina, where the lower story is more in the nature of a crypt and the upper church, which includes the nave, is completely self-contained. As will be pointed out later (p. 284), it is at least doubtful whether the throne at the western end of the nave belongs to the period of the original construction.

7. Grabar, *Martyrium*, II, pp. 320ff.; especially pp. 330f.

8. Domenico Lo Faso Pietrasanta Duca di Serradifalco, *Del Duomo di Monreale*, Palermo, 1838, pp. 26f.; G. Di Marzo, *Delle belle arti in Sicilia*, II, Palermo, 1859, p. 61; L. Boglino, in: A. Terzi, etc., *La Cappella di S. Pietro nella Reggia di Palermo*, Palermo, 1889, pt. 1, pp. 20f.; A. A. Pavlovskij, *Paintings of the Palatine Chapel in Palermo* (in Russian), St. Petersburg, 1890, p. 30; O. M. Dalton, *Byzantine Art and Archaeology*, Oxford, 1911, pp. 406f.; P. Muratov, *La Pittura bizantina*, n.d., pp. 113f.; F. Pottino, "Musaici e pitture nella Sicilia normanna. L'Età di Ruggero II," *Archivio storico siciliano*, N.S. LII, 1932, p. 48; V. Lasareff, "The Mosaics of Cefalù," ART BULLETIN, XVII, 1935, p. 221; S. Bottari, *I Mosaici della Sicilia*, Catania, 1943, p. 15.

9. F. Di Pietro, *I Musaici siciliani dell'età normanna*, Palermo, 1946, pp. 21ff. O. Demus in his forthcoming book on the Sicilian mosaics also places the break at a different point.

A master plan of this kind, allotting the western part of the church to the Old Testament while the eastern part is concerned primarily with the person and life of Christ, would be essentially un-Byzantine. If such a plan really did exist when the sanctuary mosaics were being executed a distinctly Western element was thereby injected also into this part of the decoration which in itself seems so Byzantine. The architecture with its strongly emphasized division between nave and sanctuary undoubtedly favored a two-part program but by no means demanded it. In the Christian East, after the earliest period, artists avoided Old Testament cycles even in decorating churches of longitudinal type.[10] Even in Early Christian and Western mediaeval basilicas, where large spaces were allotted to the Old Testament, it was by no means a rule that the Old and the New Testament should follow one another on the longitudinal axis of the church. In the schemes of Old St. Peter's and Old St. Paul's in Rome, which are thought to go back to the Early Christian period, Old and New Testament cycles confronted one another on the two walls of the nave.[11] This scheme was repeated in later churches in the West.[12] We do not know what subjects were depicted in the nave of Desiderius' church at Monte Cassino, which seems a likely source of inspiration for artists decorating a basilican nave in Norman Sicily, but we do know that there were both Old and New Testament scenes in the atrium.[13] In Desiderius' church at Sant' Angelo in Formis the whole nave was given over to a christological cycle, while the Old Testament scenes found a place in the aisles.

There is, however, a clear precedent in Early Christian art for an Old Testament cycle on both nave walls followed by a New Testament cycle in the area of the sanctuary, namely, the mosaic decoration of Santa Maria Maggiore in Rome. The specific characteristic of such an arrangement is that it expresses as a progression in space the time sequence of the two great phases in the history of salvation. It is this Early Christian scheme which was perpetuated or revived in the Cappella Palatina. Indeed, what we find here is perhaps more than a mere coordination of two phases. Certain devices seem to have been employed which would bring home to the beholder the fact that the Old Covenant had been defeated by the New and that the Era of Grace had triumphed over the Era of the Law.[14] Such ideas had no room in the Byzantine scheme of church decoration which was averse to all purely narrative or didactic elements. If in the Cappella Palatina these ideas were inherent in a master plan, as they may well have been, the mosaics in the sanctuary of the Sicilian church, however closely they may be modeled on Byzantine prototypes, lacked from the outset the timeless and static quality of the decoration of a Greek *naos*. They represent only one phase, albeit the principal one, in a two-phase narrative.

A discussion of the sanctuary mosaics themselves will reveal further interesting deviations from the spirit of Byzantine church decoration. The very fact that it is so dependent on Greek models makes this part of the program the most suitable object of comparison.

II

The mosaics in the sanctuary may be divided conveniently into three groups: those of the dome and drum, those of the three apses, and, finally, those of the transept, that is to say, the central square and its two lateral wings.

The dome (Fig. 20) is given over to the Pantokrator, a normal theme for the principal dome

10. E.g. in Cappadocia.
11. J. Garber, *Wirkungen der frühchristlichen Gemälde-zyklen der alten Peters- und Pauls-Basiliken in Rom*, Berlin and Vienna, 1918, plans I-IV. For the Early Christian origin of these decorations see *ibid.*, pp. 57ff. Cf. also the well-known letter of St. Nilus which seems to envisage a similar arrangement (J.-P. Migne, *Patrologia Graeca*, LXXIX, col. 577).

12. Garber, *op.cit.*, pp. 28ff. (Sta. Maria Antiqua, Ferentillo).
13. Cf. Leo of Ostia's chronicle (Migne, *Patrologia Latina*, CLXXIII, col. 750). The *tituli* in Cod. Casin. 280 are thought to have belonged to these scenes (cf. H. Bloch, "Monte Cassino, Byzantium and the West in the Earlier Middle Ages," *Dumbarton Oaks Papers*, III, 1946, pp. 198f.).
14. See below p. 282.

of a mid-Byzantine church. The bust of the All-Ruler is surrounded by four archangels in court costume and four "angels of the Lord." In the next zone—that of the drum—are four niches with full-length figures of prophets and forerunners (David, Solomon, Zacharias, and John the Baptist) bearing scrolls with prophetic texts. They are separated by seated figures of the evangelists in the four squinches. Eight additional prophets are depicted as half-length figures in the spandrels between niches and squinches (Fig. 5).

In comparing this scheme with that of Byzantine Pantokrator domes it must be remembered that in Byzantine churches the transition from the dome to the square beneath is normally effected by means of pendentives rather than squinches, so that the four Evangelists, who commonly act as "corner supports" for the dome, find their places beneath the drum rather than in the drum itself. Allowing for this difference we may compare for instance the dome of St. Sophia in Kiev, dating from the eleventh century.[15] Here, too, angels stand guard around the central bust, while the four Evangelists in the pendentives act as pillars supporting the celestial vision. In this case the figures in the intermediate zone are apostles, but there are also examples of Pantokrator domes with prophets, for instance at Daphni (eleventh century)[16] and in St. Sophia in Novgorod (probably early twelfth century),[17] to quote only works which certainly precede the Cappella Palatina in point of time.

The Byzantine affinities of the dome decoration are obvious and easily documented. The iconographic program in the apses seems to be less dependent upon Byzantine conventions, but the situation there is obscured by later changes—at least in the central apse—and by drastic restorations and additions in modern times. Indeed, the problems posed by these apses are so complex that they would require a separate study. Suffice it to say that most or all of the figures in the central apse (Fig. 1)—and particularly the colossal figure of the Pantokrator (Fig. 23), which dominates the view and challenges, as it were, the supremacy of the Pantokrator in the summit of the dome— probably belong to a later phase than the bulk of the mosaics in the sanctuary;[18] that we do not know what figures were originally planned for, and perhaps actually depicted in the central apse;[19] and that the lateral apses (Fig. 1), which in Byzantium would normally be given over to holy bishops and other representations connected with the liturgy, were here filled with two large busts of apostles (Figs. 14, 15)[20] accompanied, apparently from the outset, by figures of saints whose relics were preserved in the apses.[21]

15. D. Ainalov, *Geschichte der russischen Monumentalkunst der vormoskowitischen Zeit*, Berlin and Leipzig, 1932, pl. 4. The plate shows the dome with all its mosaics restored. Actually, when the mosaics were uncovered in 1885 only fragments were found, but these were sufficient to ascertain the layout as a whole. For a detailed description of these fragments see D. Ainalov and E. K. Riedin, "The Cathedral of St. Sophia in Kiev" (in Russian), *Zapiski of the Imperial Russian Archaeological Society*, N.S. IV, 1890, pp. 258ff.

16. E. Diez and O. Demus, *Byzantine Mosaics in Greece*, Cambridge, Mass., 1931, figs. 54-63.

17. V. K. Myasoyedov, "Fragments of Fresco Painting in St. Sophia in Novgorod" (in Russian), *Zapiski of the Department of Russian and Slavonic Archaeology of the Imperial Russian Archaeological Society*, X, 1915, pp. 15ff. and figs. 9-16. On the date, *ibid.*, p. 31.

18. For the date of the Pantokrator bust see below p. 288. It seems to belong to the advanced twelfth century. The two archangels flanking the Hetoimasia in the vault preceding the apse are completely restored. Whether they originally belonged to the same period as the Pantokrator I cannot say. Nor would I venture at this point an opinion on the date of the figures of St. Gregory and St. Sylvester placed beneath these angels. Buscemi (*op.cit., Note*, p. 35) suggests that they might be of the thirteenth century, but without adequate reproductions it is impossible either to confirm or deny this. Of the five figures in the lower zone of the apse the seated Virgin in the center is

a modern work and takes the place of a window; it was executed by Santi Cardini, who was in charge of restorations from 1781 to 1825 (G. Riolo, *Notizie dei restauratori delle pitture a mosaico della R. Cappella Palatina*, Palermo, 1870, p. 31). The saints flanking the Virgin are St. Peter, St. Mary Magdalen, St. John the Baptist, and St. James. According to Riolo (*ibid.*, pp. 40ff.) the first three of these were restored by Cardini, who, however, respected the heads at least partially. The figures, then, would be basically old, though hardly older than the Pantokrator bust above. This conclusion seems to me preferable to Buscemi's assumption (*op.cit., Note*, pp. 33f.) that the figures of St. Peter and St. Mary Magdalen were substituted for other saints in relatively modern times. For St. Peter, the titular saint of the church, see also footnote 20 below. The presence of St. John, but not that of St. Mary Magdalen and St. James, can be accounted for through the relics preserved in the main altar; cf. Buscemi, *op.cit., Note*, p. 26.

19. It will be shown in the next footnote that a case can be made for St. Peter having originally had a more conspicuous place in the main apse than he has now. To give a place of honor in the main apse to the titular saint would be a definitely Western idea.

20. In the southern apse is St. Paul (Fig. 15). The figure, though heavily restored, is basically authentic, and, as will be seen later, belongs in all likelihood to the original program (see below p. 287). The corresponding bust of St. Andrew in the northern apse (Fig. 14) is much more radically restored

It may well be significant that in the apses, where Greek orthodox custom demands a particularly close connection between imagery and liturgy, the deviation from the Byzantine norm seems to be considerable, but in view of the uncertainty as to the subject matter originally placed in the main apse it would be hazardous to insist on this point, the more so as there is at least one group of figures in this area which does perhaps reflect Greek liturgical practice.

The group referred to is on the wall above the northern apse and depicts the Virgin and Child with St. John the Baptist (Fig. 14). The image of the Virgin, as we shall see later, forms part of a larger scheme of mosaics which extends over the whole area of the transept and expresses a single unified idea.[22] But this larger scheme did not necessitate the inclusion of St. John. His figure, smaller in scale than that of the Virgin and oddly squeezed into the leftmost part of the wall, in spite of the abundance of available space, seems all the more redundant as the Saint is represented already among the prophets and forerunners in the drum of the dome. Even the text on his scroll ("Behold the Lamb of God which taketh away the sin of the world," John 1, 29) is the same in both cases. Possibly the figure of St. John above the northern apse should not be connected with the Virgin at all, but with the mosaics originally placed on the adjoining north wall of the north wing, which have disappeared completely and have been replaced by fanciful compositions of the late eighteenth and nineteenth centuries (Fig. 6).[23] On the other hand, there are good iconographic parallels which place the Baptist in association with the Virgin and Child, and good liturgical reasons for such an association. An eleventh century miniature in MS 49 of the Pantokrator Monastery on Mt. Athos is particularly instructive because it shows a similar discrepancy of scale between the two figures.[24] Liturgically the Virgin and Child and the Baptist are connected through the rite of the Proskomidi, the preparation of the eucharist in the Greek Church.[25] In this rite the priest extracts from the eucharistic bread the central particle which bears

(also by S. Cardini, according to G. Riolo, *op.cit.*, pp. 40ff.) but even in this case it is still possible to discover a mediaeval nucleus which is not unlike that of the figure of St. Andrew in the Martorana (Bottari, *op.cit.*, Fig. 57). I therefore am inclined to believe that the figure represented St. Andrew from the outset and was not put there in the seventeenth century to replace an original bust of St. Peter as Buscemi suggested (*op.cit.*, p. 37; *Note*, pp. 34, 39). Buscemi reasoned that the original pendant to the bust of St. Paul could only have been St. Peter and that some special event must have caused the replacement of his figure by that of St. Andrew. This event, he assumed, was the disappearance of the Chapel of St. Andrew which we know was a dependency of the Cappella Palatina from the very beginning (see the document of 1132 quoted in footnote 2 above) and which he says was destroyed perhaps in the seventeenth century (p. 37). It was then that, according to Buscemi, St. Andrew was put in the northern apse while St. Peter wandered into the main apse. Buscemi's theory was taken over by numerous other writers, including Boglino (*op.cit.*, p. 22), who, however, places the disappearance of the Chapel of St. Andrew in the first half of the sixteenth century. In reality neither the sixteenth nor the seventeenth century seems to be responsible for the figures of St. Andrew and St. Peter. Both appear to have a mediaeval nucleus and both were thoroughly restored in the late eighteenth century according to G. Riolo. It is in any case unlikely that St. Peter, the titular saint of the Cappella Palatina, should have been relegated to his present inconspicuous place in order to make room for St. Andrew. Instead I would suggest that St. Andrew, to whom the first dependency of the Palatine Chapel was dedicated, always occupied the northern apse and that St. Peter originally occupied a more prominent place in the main apse and was put into his present minor position in the advanced twelfth century in order to make room for the Pantokrator.

21. In the southern apse, beneath St. Paul, are St. Philip and St. Sebastian. In the northern apse, beneath St. Andrew, are St. Stephen and St. Barnabas. For the relics of these saints in the respective altars, see Buscemi, *op.cit.*, *Note*, p. 26. Cf. also Grabar, *Martyrium*, I, pp. 561ff., for relics in palace chapels.

The central figures in both apses are modern work by Cardini and take the place of windows, as does the Virgin in the main apse (see above footnote 18).

22. See below, p. 285.

23. The fact that St. John now seems to point to the Virgin need not necessarily militate against such an assumption, since his gesture might be the result of a restoration. If the figure of St. John were to be connected with a scene originally placed on the northern wall—presumably a Passion scene, as we shall see later—his eccentric position would find a natural explanation: he was removed as far as possible from the Virgin so as to show that he belongs to a different context. He would be a commentator with a prophetic text and would be exactly comparable to the figures of Isaiah and Joel in the opposite wing of the transept with prophecies likewise referring to scenes on adjoining walls (see below, footnote 32). It is interesting to note that the eighteenth century artist who designed the mosaic now on the adjoining right half of the northern wall definitely considered the figure of St. John as belonging to that wall, since he chose as his subject the "Lamb of God" (Fig. 6), of which the prophecy on the Saint's scroll speaks.

24. V. Lasareff, "Studies in the Iconography of the Virgin," ART BULLETIN, XX, 1938, p. 32, fig. 7. O. Demus in his forthcoming book adduces this miniature as a parallel to the Cappella Palatina mosaic. Other pertinent examples are frescoes in S. Vito dei Normanni, where the Baptist is flanked by the Virgin and Child and by Pope Clement (A. Medea, *Gli Affreschi delle cripte eremitiche pugliesi*, Rome, 1939, p. 101 and fig. 47), and in the church of Nereditsa, where the Virgin and St. John form pendants in the two lateral apses (J. Ebersolt, "Fresques Byzantines de Néréditsi," *Monuments Piot*, XIII, 1906, pl. IV). Cf. also an ivory at Dumbarton Oaks (H. Peirce and R. Tyler, "Three Byzantine Works of Art," *Dumbarton Oaks Papers*, II, 1941, pp. 11ff.) and an icon published by Xyngopoulos in *Cahiers archéologiques*, III, 1948, pp. 114ff. (see *ibid.*, pp. 126f. and n. 6, for further parallels).

25. For this rite, cf. Xyngopoulos, *op.cit.*, p. 125, and the literature quoted by him.

the seal of Christ and which is called the Lamb ("Amnos"). Byzantine liturgists likened the position of the "Amnos" in the center of the bread to the Divine Son in the womb of the Virgin Mary.[26] The rite is accompanied by the words of the Baptist referring to the Lamb of God (John 1, 29),[27] and takes place in the prothesis, the northern apse of the church. It can hardly be pure coincidence when we find in the Cappella Palatina above the northern apse the Virgin and Child and St. John with his prophecy referring to the "Lamb." The group appears as a perfect illustration of the Proskomidi, more perfect than any extant example in a church of the Greek rite, though there are well-known instances in the East where either the Virgin or St. John occupy a prominent place in the prothesis.[28]

Thus the two figures may represent a piece of Greek apsidal decoration retained more or less mechanically in a church of the Latin rite. But since at present very little is known about the liturgical practices in Norman Sicily it would be unwise to rule out *a priori* the possibility that the two figures were intended to provide an appropriate and meaningful background for a ceremony which may actually have taken place, at least on occasion, in the apse beneath.[29] Whichever solution is the correct one we shall see later that the figure of the Virgin was in addition invested with another function of an entirely different order.

The decoration in the main area beneath the dome in a Greek *naos* normally comprises two elements: a cycle of the life of Christ and a hierarchy of saints.[30] We descend from the heavenly sphere of the All-Ruler to the earth, the scene of his incarnate life and the sphere of action of his saints and martyrs. It is precisely these two elements that also form the subject of the decoration in the main area of the sanctuary of the Cappella Palatina, an area which includes, in addition to the square beneath the dome, the two wings on either side.

The hierarchy of saints is much abbreviated. Rows of martyrs are placed in medallions on the soffits of the arches supporting the dome (Figs. 1-4), a position they often occupy also in Greek churches.[31] Many of these martyrs are holy warriors. We are reminded of Hosios Lukas, where warrior saints are in sole and obviously symbolic possession of the arches on which the dome with its celestial inhabitants rests. In the Cappella Palatina, however, some of the most important warrior saints, including St. Demetrius, are not on the soffits, but on the outer, i.e. northern, face of the northern arch, out of sight of the beholder standing in the central area of the church. This curious disposition will be the subject of further comment later. The medallions on the inner faces of the northern and southern arches do not represent saints but Old Testament prophets (Figs. 3-5); they are a sequel to the series of prophets that starts in the dome, and this series comes to an end on the outer face of the southern arch, where there are five prophets corresponding to the group of warrior saints just mentioned.[32] The hierarchy of saints continues with figures of

26. Cf. e.g. Theodore of Andida (Migne, *PG*, CXL, col. 429; also col. 425).

27. F. E. Brightman, *Liturgies Eastern and Western*, Oxford, 1896, p. 357, line 15.

28. Cf. e.g. the figure of St. John in the prothesis at Daphni and that of the Virgin and Child in the prothesis at Nereditsa. See also the parallels given by Ebersolt, *op.cit.*, pp. 44f., and Xyngopoulos, *op.cit.*, p. 124ff., both of whom interpret these figures in the light of the symbolism of the Proskomidi.

29. When G. Di Marzo says (*Delle belle arti in Sicilia*, I, Palermo, 1858, p. 108) that in Norman Sicily the lateral apses served "alle preparazioni," he probably has in mind primarily the offertory procession (cf. Buscemi, *op.cit.*, *Note*, p. 25, with a quotation from a document from Cefalù, which indicates that this procession still took place in Sicily in the twelfth century; Buscemi interprets the passage as implying that the faithful deposited their offerings on the altar of the northern apse). Aside from this, however, it may be assumed that mass was celebrated occasionally in the Cappella Palatina according to the Greek rite. Since the Greek clergy still had the use of the Chapel on certain specified days of the year as late as A.D. 1274

(Garofalo, *op.cit.*, p. 78), it is reasonable to suppose that in Norman times, when they were much more powerful, the Greeks, at the least, enjoyed an equal privilege.

30. Cf. the "classical" examples of the eleventh century in Greece: Hosios Lukas, Chios, and Daphni (Diez and Demus, *op.cit.*). The closest comparisons for the Cappella Palatina are provided by fresco decorations of Russian churches of the twelfth century, where saints and christological scenes are not confined to individual niches and panels, but cover the entire wall surfaces in serried rows: e.g. Nereditsa (Ebersolt, *op.cit.*, pp. 47ff., figs. 5, 6; V. K. Myasoyedov, *Frescoes of Spas-Nereditsa* [in Russian], Leningrad, 1925, pl. 58) and the church of the Mirozh Monastery in Pskov (cf. the plates in A. I. Uspenskij, *Notices on the History of Russian Art* [in Russian], Moscow, 1910, pp. 139ff.).

31. For a list of these martyrs see Buscemi, *op.cit.*, pp. 32, 37, 39.

32. Unfortunately no reproductions of any kind are available of these two highly important groups of figures on the outer faces of the northern and southern arches. On the south side of the southern arch are three medallions with busts of

holy bishops on the outer walls of the two wings.[33] On the northern wall of the northern wing (Fig. 6) are five famous bishops of the Greek church (Basil, Gregory of Nyssa, Gregory of Nazianz, John Chrysostom, and Nicholas of Myra) confronted on the southern wall of the southern wing by St. Dionysius and St. Martin (Fig. 5). Finally, on the western wall of the northern wing are three holy women (Fig. 16), and in the soffits of the arches leading from the transept wings into the aisles of the nave holy physicians (*anargyroi*). These two groups are a regular part of the hierarchy of saints in Greek churches and are commonly placed toward the west.

The cycle of the life of Christ begins with the Annunciation on the eastern arch of the central square (Fig. 1). It continues, on the same level, in the southern wing, where we find on the eastern wall the Nativity with the Adoration of the Magi and the Annunciation to the Shepherds (Fig. 15). The panel is "folded over" onto the southern wall, where the cycle continues with the Dream of Joseph and the Flight into Egypt (Fig. 7). This latter scene is again "folded over" and continues on the western wall of the southern wing (Fig. 2). Thence we return to the central square where we find, still on the same level, the Presentation in the Temple. The main part of this scene occupies the western arch (Fig. 12), but Joseph and the Prophetess Anne are placed on adjoining spaces of the southern and northern arch respectively (Figs. 3-5). The cycle now descends to a lower zone in the southern wing where we find the Baptism, the Transfiguration, and the Raising of Lazarus, and, in a third zone, the Entry into Jerusalem (Figs. 5, 8). There it apparently stops. The corresponding wall in the northern wing, which would seem to be a logical place for a continuation, is occupied in its lower half by the five figures of Greek bishops previously referred to. Above these is the arched opening of a balcony or loggia (Fig. 6). What wall space is left around this opening is covered by the eighteenth and nineteenth century mosaics already mentioned. These mosaics were executed after the wall in this area had been disturbed, first by the installation and afterwards the removal of a wooden box in which the Bourbon court sat during the service.[34] The christological cycle does, however, continue above this area, for in the barrel vault of the northern wing we find the Ascension[35] and in the corresponding vault in the southern wing the Pentecost (Fig. 19). What is missing, then, is a sequence of Passion and post-Passion scenes between the Entry into Jerusalem in the southern wing and the Ascension in the northern wing, but matching this gap there is a free wall space on the northern wall of the northern wing.

We may assume with some confidence that this wall space originally accommodated the scenes which are needed to complete the illustration of the life of Christ. It is striking that with the exception of the Flight into Egypt (which, as we shall see, has a special *raison d'être* in the Cappella Palatina) the ten extant scenes occur regularly in the so-called "cycle of the twelve feasts of the Lord," a cycle which, in spite of a good deal of variation in practice, constitutes a kind of standard minimum for the illustration of the life of Christ in later Byzantine art.[36] The only two additional scenes which are absolutely essential to any "feast cycle" are the Crucifixion and the Anastasis (Descent into Hell).[37] Assuming that the arched opening in the upper part of the northern wall is an original feature of the architecture—and we shall have more to say about this later—there would still be room for these two pictures in the area now occupied by

Samuel, Micha, and Joshua flanked by two full-length figures of Joel and Isaiah. The latter do not belong to the series of prophets that starts in the dome, but to adjoining christological scenes. Isaiah holds a prophecy (Is. VII, 14) referring to the Nativity on the eastern wall, Joel a text pertaining to the Pentecost scene in the vault above (see below, p. 278). For the saints on the northern side of the northern arch see below, pp. 284f.

33. In Greek churches holy bishops are usually placed in or near the apses. There are, however, instances where some of the most important bishops are placed in conspicuous positions in the *naos* (e.g. Hosios Lukas).

34. For this royal box see below, pp. 283f.

35. Erroneously referred to by earlier writers as the Assumption of the Virgin. The mosaic, which is badly restored, apparently has never been reproduced.

36. For the "feast cycle" cf. G. Millet, *Recherches sur l'iconographie de l'Evangile*, Paris, 1916, pp. 15ff. A poem on the "feasts of the Lord" (*ibid.*, p. 21) attributed to John Euchaites (eleventh century) or Theodore Prodromos (twelfth century) enumerates twelve events, including all those that are depicted in the Palatina, with the sole difference that the Circumcision (rarely represented in Byzantine art) takes the place of the Flight into Egypt. For the limited validity of the term "feast cycle," cf. Grabar, *Martyrium*, II, p. 333.

37. Cf. the table Millet, *op.cit.*, p. 23.

mosaics of the eighteenth and nineteenth centuries.[38] If this reconstruction is correct the sanctuary of the Cappella Palatina originally contained what amounts to a standard version of the Byzantine iconography of the life of Christ.

III

As the description has shown, the themes depicted in the eastern part of the Chapel—with the possible exception of those in the apses—are those normally found in domed, centralized churches in the Greek and Slavonic world in the same period. But the description has also brought out certain peculiarities in the arrangement of these themes. The chief anomaly is the asymmetric distribution of the mosaics in the two wings of the transept. Not only is there a lack of balance between the figures on the outer faces of the northern and southern arches, but the whole New Testament cycle seems to be weighted to one side. Allowing even for two additional scenes in the northern wing the southern wing still has a larger share of subjects from the life of Christ. In the northern wing there are no scenes, but only figures of saints, in positions corresponding to the Nativity, the Entry into Jerusalem, and that part of the Flight into Egypt which is on the western wall.[39] When we consider that there was not so very much space for representations from the life of Christ in the first place and that more events could easily have been included, particularly in the Passion and post-Passion sequence, without unduly expanding the "narrative" element, it is certainly striking that the space in the northern wing was not utilized fully for the christological scenes. The asymmetry of the decoration in the two wings is anything but normal, and, as we shall see later, highly purposeful.

Let us now examine more closely the christological cycle. Evidently some scenes have received greater emphasis than others. The Annunciation and the Presentation in the Temple have been placed in very honored positions immediately beneath the dome. It seems that in order to be able to place the Presentation in the Temple in the central square the artist has spun out the preceding scene, the Flight into Egypt, in extraordinary fashion.[40] He has included not only a personification of "Egypt" reverently receiving the Christ Child, he has developed the city gate, in front of which the reception takes place, into an elaborate piece of architecture followed in turn by a large palm tree. Thus he has contrived to place considerable emphasis also on this scene which fills not only almost the entire width of the southern wall of the southern wing but the adjoining western wall as well (Figs. 2, 5, 7). Indeed, together with the Dream of Joseph, which belongs to it, the Flight covers as much wall space as the three scenes of the next lower zone combined, a fact which is all the more remarkable since it is the only one among the extant christological subjects in the Chapel that we have noted as an unnecessary representation in a "feast cycle." The Entry

38. It is quite possible that this hypothetical reconstruction of the missing part of the cycle can be tested by means of a thorough scrutiny of the wall area in question. The eighteenth century landscape with the "Agnus Dei" to the right of the arched opening (Fig. 6) is not altogether homogeneous and traces of the earlier work which it was meant to replace may still be extant in this area (cf. the photograph Anderson no. 29937). It would be highly desirable to carry out this investigation.

39. It is not quite certain that the five Greek bishops on the northern wall are an original part of the decoration (see below, footnote 91). But they can hardly have been put there —after what would be in any case only a short time interval— to replace any christological scenes.

40. For the sequence—Nativity, Adoration of Magi, Flight into Egypt, Presentation in the Temple—which we find also in Monreale, cf. several of the Cappadocian cycles: e.g. Qeledjar (G. de Jerphanion, *Les Eglises rupestres de Cappadoce*, I, 1, Paris, 1925, p. 205); Toqale, New Church (*ibid.*, I, 2, 1932,

pp. 310f.); Sts. Apostles (*ibid.*, II, 1, 1936, pp. 67f.). Since the story of the Magi and that of the Massacre of the Innocents are interrelated it is almost inevitable that in cases where the Adoration of the Magi is combined with the Nativity (as in the Palatina) the Presentation in the Temple, though depicting an event which took place only forty days after Christ's birth, should be placed after the Flight (or any other event connected with the Massacre). The difficulty can be avoided by taking the Presentation out of the cycle altogether, as is the case in the Old Church at Toqale (Jerphanion, *ibid.*, I, 1, pp. 269, 286). In the Cappella Palatina the Presentation clearly follows after the Flight into Egypt, though at the same time it is somewhat isolated from the sequence (cf. also below, p. 282). For the problems involved in the arrangement of these Childhood scenes, cf. G. de Jerphanion, *La Voix des monuments*, N.S., Rome and Paris, 1938, pp. 218ff.; A. De Capitani d'Arzago, in: G. P. Bognetti, etc., *Santa Maria di Castelseprio*, Milan, 1948, p. 594.

into Jerusalem also has been given a conspicuous and relatively large space, in fact one of the most favored places in the whole church. Finally, there are two scenes which have been allotted an entire vault each, the Ascension and the Pentecost.

Byzantine convention accounts for the placing of at least three of these scenes, the Annunciation, the Ascension, and the Pentecost. The first two need not detain us for more than a moment. The Annunciation was frequently placed on the eastern arch, for this arch, beyond which only the priest can pass, was interpreted symbolically as Ezekiel's eastern gate, through which no man shall enter because the Lord has entered in by it (Ez. XLIV, 1-2); that is to say, it was a symbol of the Miraculous Conception which the Annunciation represents.[41] The Ascension is one of the standard themes for domes and vaults.[42] The composition of the scene in the Cappella Palatina agrees completely, for instance, with that of the dome of St. Sophia in Salonika,[43] except that, owing to the restricted space, the full-length figure of Christ has been replaced by a bust. Evidently the artist treated the barrel vault as though it were an elongated dome. This could be said also of the Pentecost opposite (Fig. 19). But here the deviations from the Byzantine norm, as exemplified for instance by the presbytery dome of Hosios Lukas,[44] are more considerable and require a somewhat more detailed discussion.

The artist has made effective use of architectural conditions by placing in the two lunettes at either end of the barrel vault (Figs. 1, 2), on the one hand, two Jews,[45] to represent the nations who are to be converted by the apostles, and, on the other, a bust of Christ with an open book inscribed with the words of John VIII, 12: "I am the light of the world; he that followeth me shall not walk in darkness but shall have the light of life" (Fig. 21). The unbelievers are made to look, as it were, straight into the "light." The symbolism of the light which is to illuminate mankind plays a conspicuous role in both Eastern and Western liturgical and homiletic texts pertaining to Pentecost.[46] We also know that the conversion of the Jews was a particular concern of Roger II toward the end of his reign,[47] the precise period, as we shall see, during which these mosaics appear to have been made.[48] It was an ingenious idea to single out among the Races and Tongues frequently represented in Pentecost scenes the Jews and to confront them with the figure of Christ. But this latter feature also betrays the fact that we are here remote from the sphere of orthodox theology. It probably would be difficult to find anywhere in Byzantine art a representation of Pentecost in which the Deity is depicted in anthropomorphic shape. The presence of this figure might easily suggest to a beholder that the Son could be a source of the Holy Spirit and this thought was, of course, anathema to the Greek Church, which had parted company with

41. Ainalov and Riedin, op.cit. (see footnote 15), pp. 286f., à propos the Annunciation on the eastern arch of St. Sophia in Kiev. The same arrangement occurs in other churches in Russia: Kiev, St. Cyril (A. V. Prachov, "Monuments of Byzantino-Russian Art in Kiev" [in Russian], Drevnosti. Trudy of the Imperial Archaeological Society in Moscow, XI, 3, 1887, p. 17); Pskov, Mirozh Monastery (J. A. Olsufyev, "Recent Restorations of Ancient Russian Frescoes," ART BULLETIN, XX, 1938, p. 109, figs. 5, 6); Nereditsa (Myasoyedov, op.cit. [see footnote 30], pl. 38). An interesting case in the West is the cycle of Ezekiel scenes on the vault of the lower church at Schwarzrheindorf. The vision of the Lord's Entry through the Eastern Gate is placed toward the east at the entrance to the chancel; a fragment of an inscription on the arch underneath mentions the Virgin Mary (P. Clemen, Die Romanische Monumentalmalerei in den Rheinlanden, Düsseldorf, 1916, pp. 293f. and pl. XIX).

42. O. Demus, Byzantine Mosaic Decoration, London, 1947, pp. 17ff.

43. Ch. Diehl, M. Le Tourneau, H. Saladin, Les Monuments chrétiens de Salonique, Paris, 1918, pl. XLV.

44. E. Diez and O. Demus, op.cit., pl. V.

45. The two figures, barely visible on Fig. 19, were identi-fied correctly as Jews by G. Di Marzo, op.cit., II, p. 72, on the strength of the similarity of their costumes with those of the Jerusalemites in the scene of Christ's Entry. The "Iudei" represented among the "Races and Tongues" in the Pentecost dome in St. Mark's in Venice are also very similar (cf. the photograph by Alinari, pt. 2, no. 13742).

46. Cf. several prayers for Whitsun Eve and Whitsunday in the Roman Missal, particularly the prayer Praesta Quaesumus on Whitsun Eve (Migne, PL, LXXVIII, cols. 110f.) and prayers for Whitsunday in the Pentekostarion (Athens edition, pp. 210ff.). Among homiletic texts we may single out one that is close to our mosaics in time and space, the peroration of the Pentecost homily of Philagathos ("Theophanes Kerameus"): Ἀλλ', ὦ παράκλητε Θεέ, Πατρὸς καὶ Υἱοῦ ὁμοούσιε, καὶ σύνθρονε, καὶ ὁμότιμε! ὦ φῶς αὐτολαμπὲς ἐκ φωτὸς προιὸν τοῦ Πατρὸς, καὶ μένον ἐν φωτὶ τῷ Χριστῷ, καὶ φοιτῶν εἰς ἡμᾶς δι᾽ αὐτοῦ, πάρεσο καὶ ἡμῖν . . . , etc. (Migne, PG, CXXXII, col. 784; for the identity of the author see below, footnote 68).

47. Cf. Romuald of Salerno (see above, footnote 4), p. 236: [Roger II] circa finem . . . vite sue secularibus negotiis aliquantulum postpositis et ommissis Iudeos et Sarracenos ad fidem Christi convertere modis omnibus laborabat. . . .

48. See below, pp. 287f.

the Latin over the question of the "*filioque*." In the West Christ occurs in Pentecost scenes quite frequently.[49]

The figure of Christ was, however, perhaps not solely intended as a pendant to the Jews in the western lunette. It occupies the center between two rows of apostles, who, unlike the apostles in Byzantine Pentecost domes, are placed on continuous rather than individual seats. The resulting composition is curiously reminiscent of the main group of figures in scenes of the Last Judgment.[50] The presence of the four archangels in the summit of the vault perhaps also suggests an eschatological context rather than Pentecost. It is indeed possible that the mosaic, though clearly representing the Descent of the Holy Ghost, was also meant to imply the Second Coming at the end of time. Beneath the vault, among the prophets on the outer face of the arch separating the southern wing from the central square, there is a figure of the Prophet Joel, who plays the role of commentator to the Pentecost scene.[51] He holds up, toward the scene in the vault, a scroll inscribed with the prophecy in which he foretold the descent of the Spirit. But the words are not those of the prophet himself as recorded in Chapter II, verse 28 of the Book of Joel ("And it shall come to pass afterward that I will pour out my spirit"). Instead the mosaicist has put on the scroll the words of Joel as quoted by St. Peter in Acts II, 17, a quotation which includes the significant change: "And it shall come to pass *in the last days*, saith God, I will pour out of my spirit." The fact that the version from Acts was chosen rather than that from the Book of Joel itself may well mean that the artist was aware of and wished to underline certain eschatological overtones of the scene. This eschatological meaning was clearly intended by the writer of Acts himself[52] and was elaborated in patristic and mediaeval literature. Various more or less far-fetched reasons were given why Pentecost is a forerunner, a "figure" of the Last Things.[53] These ideas were known in Sicily in the twelfth century.[54] Within the realm of iconography there are other instances, aside from the mosaic in the Palatina, where the Pentecost scene may have been intended to embrace the events at the end of time as well.[55]

49. Cf. e.g. the Sacramentary of Drogo, initial for collect of Whitsunday (L. Weber, *Einbanddecken, Elfenbeintafeln, Miniaturen, Schriftproben aus Metzer liturgischen Handschriften*, I, Metz and Frankfurt a.M., 1913, pl. 17,2); Lectionary from St. Trond, Belgium (E. G. Millar, *The Library of A. Chester Beatty. A Descriptive Catalogue of the Western Manuscripts*, Oxford, 1927, I, pl. 68c); Missal of Limoges, Paris, Bibl. Nat., MS lat. 9438, fol. 87 (M. Lafargue, *Les Chapiteaux du cloître de Notre-Dame la Daurade*, Paris, 1940, pl. 21); New Testament MS, Vat. lat. 39 (A. Fabre, "L'Iconographie de la Pentecôte," *Gazette des Beaux-Arts*, LXV, 1923, 2, p. 37). The scene in the Cluny Lectionary (Paris, Bibl. Nat., lat. 2246, fol. 79ᵛ) does not illustrate the Pentecost proper (Fabre, *op.cit.*, pp. 36ff.). But we may add a South Italian example, a relief on the Farfa ivory box: H. Bloch, *op.cit.* (above, footnote 13), fig. 252.

50. Cf. particularly the twelfth century fresco of the Last Judgment in the Demetrius Church in Vladimir, where the two rows of apostles are placed on either side of a barrel vault, as they are in the Cappella Palatina. The figure of Christ, now destroyed, must have been in the lunette between two rows (I. Grabar, *Die Freskomalerei der Dimitrijkirche in Vladimir*, Berlin, n.d., pls. II, III and pp. 41ff.). The placing of the apostles on continuous seats, without a figure of Christ in the center, would not alone be sufficient to establish, even tentatively, a relationship between our mosaic and scenes of the Last Judgment.

51. For this figure see above, footnote 32. The fact that the figure belongs to the Pentecost scene is made abundantly clear by the verses which are placed on the band at the base of the vault:
Fit sonus e coelis et iuxta scripta Johelis
Imbuit affatus sancti vehementia flatus
Pectora mundorum succendens discipulorum
Ut vite verbum per eos terat omne superbum

52. Cf. K. Lake, in: F. J. Foakes Jackson and K. Lake, *The Beginnings of Christianity*, pt. I, *The Acts of the Apostles*, v, London, 1933, p. 113.

53. The argument may be found in both Eastern and Western writings. It is bound up with the symbolism of the number 50 (=7×7+1). The Jewish jubilee year, the Lord's rest on the seventh day of Creation, and the idea that the world will come to an end with the completion of the seventh age all combine to make of Pentecost a *figura futurae resurrectionis* (Isidorus, *De eccles. officiis*, I, 34; Migne, *PL*, LXXXIII, cols. 768f.) and a "*typos* of the Day of Remission, the Day Without Evening" (Leo the Wise, Oratio XII; Migne, *PG*, CVII, cols. 124f.).

54. Cf. the Pentecost homily of Philagathos (see above, footnote 46 and below, footnote 68): οὐκ ἐν ἄλλῳ καιρῷ, ἀλλὰ κατὰ τὴν Πεντηκοστὴν ταῦτα γίνεται τῆς μελλούσης ἡμέρας ἐστὶν ἀπεικόνισμα, καθ' ἣν τὸν ἑβδοματικὸν χρόνον πληρώσαντες εἰς τὴν τελείαν Πεντηκοστὴν καταντήσομεν, ἧς τύπος αὕτη καθέστηκε (Migne, *PG*, CXXXII, cols. 764f.; for the idea of universal resurrection at the end of the "sevenfold time" see also *ibid.*, cols. 149ff.).

55. There are, of course, numerous instances in which the Pentecost forms the concluding scene in a christological cycle. No secondary meaning need be intended in every such case. But it is perhaps significant that in certain programs which include, in addition to a christological cycle, the scene of the Last Judgment the Pentecost is omitted. The omission is particularly striking in the fresco decoration at Sant' Angelo in Formis, where the christological cycle is otherwise very rich and detailed; it concludes with the Ascension at the eastern end of the northern wall and is followed by the Last Judgment on the western wall (G. de Jerphanion, *La Voix des monuments*, Paris, 1930, pp. 265, 280). The equally rich cycle at Nereditsa probably provides a parallel case. In this decoration, which also includes a Last Judgment on the western wall, the

If this interpretation of our mosaic is correct, the position of the Christ bust is doubly meaningful. For we may then assume that it is meant to be related not only to the figures of the Jews opposite but also to the scene of the Nativity immediately below. It would be an image of the Christ of the Second Coming, towering magnificently over the humble scene of his First Epiphany. The bust would be, so to speak, a hinge marking the place where the sequence of scenes, having circled the entire sanctuary, returns to its starting point. It would be a link tying together the beginning and the ultimate climax of the Christ story in a dramatic contrast.

IV

We have been able to account through Byzantine conventions for three of the scenes prominently placed in the sanctuary of the Palatine Chapel. We still have to explain the emphasis placed on the Flight into Egypt, the Presentation in the Temple, and the Entry into Jerusalem. These are the three events in the life of Christ which in Early Christian iconography were conceived of in terms of the triumphal progress and solemn reception of a ruler, or, to use classical expressions, as the king's *profectio, adventus,* and *occursus.* The subject has been discussed fully and brilliantly in recent years.[56] In our present context the briefest summary must suffice. Invested with a messianic meaning ever since Hellenistic times the *adventus* ceremonial assumed considerable importance as a part of the Roman emperor cult. The emperor's arrival in a particular city or country was likened to, or symbolically interpreted as, the epiphany of the world savior. The scene is reflected in Roman imperial iconography,[57] where we may distinguish between a more "realistic" type of *adventus* scene, showing the emperor followed by his retinue and a crowd welcoming him

life of Christ apparently comes to an end with the Ascension in the central dome; we cannot be quite sure, however, that the Pentecost was not represented among the frescoes now lost (for references see above, footnotes 24, 30). Among several other early Russian church decorations which include the Last Judgment, there is none which has the Pentecost scene as well. But since most of these decorations are very imperfectly preserved no conclusions should be based on this fact. On the other hand, the case of the mid-twelfth century decoration in the church of the Mirozh Monastery in Pskov may be significant. Here the place over the main entrance—so often given over to the Last Judgment in Russian churches of this period—is occupied by the Pentecost scene (I. Tolstoi and N. Kondakov, *Russian Antiquities in Monuments of Art* [in Russian], VI, St. Petersburg, 1899, p. 184 and fig. 227). The Last Judgment was apparently omitted. Tolstoi and Kondakov, *op.cit.,* p. 179, mention a "Last Judgment on the western wall," but this is probably a mistake; the scene is referred to neither in N. V. Pokrovskij's detailed description of the Pskov frescoes in his *Notices of Monuments of Christian Art and Iconography* (in Russian), St. Petersburg, 1910, pp. 253ff., nor in I. Grabar's list of early representations of the Last Judgment in Russian churches, *op.cit.,* p. 32. It does seem, then, that Pentecost and Last Judgment were sometimes considered as interchangeable subjects, as indeed they might be, in the light of the texts quoted in the preceding footnotes. Certain twelfth century representations in the West seem to combine features of the Pentecost scene with eschatological elements (cf. H. Focillon's comments on the northern apse at St. Gilles at Montoire in *Peintures romanes des eglises de France*, Paris, 1938, pp. 40f., and A. Katzenellenbogen's interpretation of the tympanum at Vezelay as a "telescoped" representation of various phases of the mission of the apostles, including the Descent of the Holy Spirit and the Judgment of Mankind: ART BULLE-TIN, XXVI, 1944, pp. 141ff.). These observations naturally bring up the problem of the late twelfth century mosaic on the triumphal arch of the Abbey Church of Grottaferrata, a work commonly ascribed to Sicilian artists. The mosaic (J. Wilpert, *Die römischen Mosaiken und Malereien der kirchlichen Bauten*

vom 4. bis zum 13. Jahrhundert, Freiburg, 1916, IV, pl. 300) clearly depicts the Descent of the Holy Spirit. But in the center, between the two groups of six apostles, is a medallion with the apocalyptic lamb. The empty throne, which is to be seen above the lamb, was put there in modern times and we do not know what was in its place originally (on this question cf. A. Baumstark, "Il Mosaico degli apostoli nella Chiesa Abbaziale di Grottaferrata," *Oriens Christianus*, IV, 1904, pp. 132ff. and Wilpert, *op.cit.,* II, pp. 915f.). In any case the eschatological meaning of the scene was clearly brought out in the verses which once accompanied the mosaic:

Caetus apostolicus residens cum iudice (Christo)
Praemia iudicio meritis decernit in isto.

Admittedly we cannot be sure that this inscription is as old as the mosaic itself. But Baumstark was obviously wrong when he said (p. 132) that the inscription cannot have been original because it is in Latin, whereas the name inscriptions of the apostles are in Greek. This is a common phenomenon in twelfth century mosaics and the Cappella Palatina provides numerous examples (cf. e.g. footnote 51 above). Wilpert accepts the inscription as original and says the mosaic expresses "the idea of the Last Judgment by means of a representation which possesses all the characteristics of a Pentecost picture" (*ibid.,* p. 915). Wilpert, however, appears to have been unaware of the literary and iconographic parallels which make his interpretation plausible, and he erred in considering the mosaic as being of the same date as the Ducento fresco of the Trinity on the wall above.

56. A. Alföldi, "Die Ausgestaltung des monarchischen Zeremoniells am römischen Kaiserhofe," *Mitteilungen des Deutschen Archäologischen Instituts, Römische Abteilung*, 49, 1934, pp. 88ff. A. Grabar, *L'Empereur dans l'art byzantin*, Paris, 1936, pp. 234ff. E. H. Kantorowicz, "The 'King's Advent' and the Enigmatic Panels in the Doors of Santa Sabina," ART BULLETIN, XXVI, 1944, pp. 207ff. Further literature will be found quoted in these studies.

57. Grabar, *op.cit.,* p. 234. Kantorowicz, *op.cit.,* figs. 1-21. Our Figs. 8-11.

at the city gate, and a more allegorical type, in which he is preceded by a winged figure of Victory acting as a *cursor* or greeted by a personification of the city or country whose territory he is about to enter.

In Christian art there is one scene which more than any other underwent the influence of the *adventus* iconography, namely, Christ's Entry into Jerusalem. The Palm Sunday scene was the arrival in his capital city of the Messianic King of Israel. Within the christological cycle it is the royal event *par excellence*, and it is only natural that artists should have visualized it as an *adventus*. Most of the iconographic features in the representations of the Entry were borrowed from the "realistic" type of *adventus* scene, though allegorical elements were sometimes added.[58] The iconography of the scene underwent little change throughout the Middle Ages and the rendering, for instance, in the Cappella Palatina is essentially still the same as on Early Christian sarcophagi (Fig. 18).[59]

The connection of the Flight into Egypt with the ruler's *adventus* is less obvious but also perfectly logical in the light of the apocryphal accounts which describe the event as a triumphal progress of the Lord through heathen lands. The connection is expressed unambiguously in an Early Christian *enkolpion* which shows a personification of Egypt (the *Natio*) receiving the Holy Family and Joseph acting as a *cursor*.[60] In this case it is the allegorical rather than the realistic type of imperial *adventus* which has influenced the artist, and this influence was perpetuated by iconographic tradition, particularly in Byzantium. One or another of the features of the pagan *adventus* allegories occurs frequently in later representations of the Flight. But few if any representations of the scene combine as many elements of the *adventus* as the mosaic in the Cappella Palatina (Figs. 7-11). It shows the *Natio* greeting the ruler at the city gate,[61] the winged *cursor*—now an angel —leading the procession,[62] the Lord in a heroic pose of greeting or blessing,[63] and the *pedisequus*, who has inherited the role of the Roman standard bearer,[64] though his load now consists of a simple bundle containing the Holy Family's worldly possessions.

The Presentation in the Temple is the Lord's solemn reception by the aged Simeon. From an artistic point of view the scene was less well suited than the other two for an interpretation as an imperial *adventus*. But the influence of imperial iconography is evident nevertheless in the very first of all known renderings of the scene, a mosaic on the triumphal arch of Santa Maria Maggiore.[65] The name, *Hypapante*, by which the event is designated in Byzantine literature, liturgy and art is itself "a technical term for the constitutional welcome of royalty."[66]

It can hardly be pure coincidence that three scenes in which Christ figures specifically in the role of a triumphant ruler have received special emphasis in the cycle of the Palatina. The suspicion arises that this special emphasis may have something to do with the role of the Chapel as a palace church. In order to gain certainty in this respect it is not enough, however, to have shown that the scenes were originally conceived as, and to some extent modeled after, royal advents. We must be sure that they still carried these regal connotations in Sicily in the twelfth century.

This proof is readily forthcoming in the case of the Entry into Jerusalem. The Palm Sunday scene certainly never lost its regal associations throughout the Middle Ages. Originally modeled after the reception of Hellenistic kings and Roman emperors, it in turn became the inspiration, the ever-present archetype, of all ceremonial receptions of mediaeval rulers. The arrival of the

58. Grabar, *op.cit.*, pp. 235f. Kantorowicz, *op.cit.*, pp. 215f., 220.

59. Cf. e.g. Kantorowicz, *op.cit.*, fig. 24 (caption to be interchanged with that of fig. 23).

60. Grabar, *op.cit.*, p. 236 (cf. also *ibid.* pp. 228f. for the Aphrodisius scene in Sta. Maria Maggiore). Kantorowicz, *op.cit.*, pp. 220f. n. 87a and fig. 33a.

61. Kantorowicz, *op.cit.*, fig. 8 = our Fig. 8.

62. Kantorowicz, *op.cit.*, fig. 7 (=our Fig. 9), 15 (=our Fig. 10), 16, 17, 20.

63. Kantorowicz, *op.cit.*, fig. 7 (=our Fig. 9), 11 (=our Fig. 11), etc.

64. Kantorowicz, *op.cit.*, fig. 7 (=our Fig. 7), 14, etc.

65. Grabar, *op.cit.*, pp. 216ff.; *ibid.*, pp. 213f. for the role of the scene within the triumphal program of this decoration.

66. Kantorowicz, *op.cit.*, p. 211.

king is always a reenactment of the Advent of the Messiah, and there is, in fact, no other scene in which the persons of the heavenly and the earthly ruler are so inextricably fused.[67]

There could be no better illustration of this than the opening paragraphs of a Palm Sunday homily by the South Italian preacher Philagathos ("Theophanes Kerameus"), delivered, as the title says, in front of King Roger and therefore, quite possibly, in the Palatine Chapel itself.[68] To the speaker Palm Sunday is a divine and royal feast (θεία τε καὶ βασιλικὴ ἑορτὴ) and the occasion of an annual tribute to the king in the form of a sermon. The whole passage is a comparison between the triumphs of the king and the triumphs of Christ. The preacher describes in glowing terms King Roger's God-given victories (νίκας . . . καὶ . . . τρόπαια) and then applies identical words to Christ's Entry into Jerusalem, an entry which, unlike his previous arrivals in the city, was surrounded by pomp and glory. "For the divinely ordained plan was nearing its end, the Passion was approaching . . . and in addition to his other miracles Christ had proved himself victor over Death by snatching Lazarus from him. So he enters the city like a king with trophies and victories and with his guards (. . . οἷα βασιλεὺς μετὰ τρόπαια καὶ νίκας δορυφορούμενος)."

Another homily by the same author contains a brief account of the Flight into Egypt in which that event is described as a triumphal progress: "Christ . . . goes to Egypt shaking and confounding the idols in that country; then . . . called by his Father, he returns as a victor (νικηφόρος) already four years old according to the flesh."[69]

Two of the scenes, then, were certainly thought of as triumphal processions in twelfth century Sicily. The case of the *Hypapante* is more complex. Among the extant homilies of Philagathos none is dedicated to this event. So this source cannot help us to elucidate any special significance it may have.[70] The simplest and most obvious explanation of its prominent position on the western arch is that the artist selected it as a suitable pendant to the Annunciation on the eastern arch. But although there are other instances where the Presentation scene is accommodated on two sides of an arch[71] the scene is not really very well suited for this position, especially when the artist is unwilling to omit the temple scenery and is forced by the shape of the arch to show the architecture with its lower half cut off (Fig. 12). On the other hand, the arrangement of Annunciation and Presentation in the Temple as pendants is frequent enough to be considered a convention.[72] Hence among the scenes represented in the Palatina cycle the *Hypapante* was perhaps a natural choice for the western

67. Cf. the rich material gathered by Kantorowicz, *op.cit.*, pp. 208ff., and the same author's *Laudes Regiae*, Berkeley and Los Angeles, 1946, pp. 71ff.

68. Migne, *PG*, CXXXII, cols. 541ff. For the identity of the author, cf. A. Ehrhard, *Überlieferung und Bestand der hagiographischen und homiletischen Literatur der griechischen Kirche*, pt. 1, III, fasc. 5, Leipzig, 1943, pp. 631ff. On the basis of an exhaustive analysis of the manuscript tradition Ehrhard comes to the conclusion that the homilies later ascribed to a "Theophanes Kerameus, Archbishop of Taormina" were the work of a preaching monk by the name of Philagathos, "who normally officiated in the cathedral of Rossano but made his appearance also in Sicily under the rule, and perhaps at the bidding of King Roger II and his successors" (*ibid.*, p. 679). The Madrid MS gr. 16 contains a variant of the Palm Sunday homily with an invitation to pray for King William (*ibid.*, pp. 664, 672f.).

69. Migne, *PG*, CXXXII, col. 925.

70. In Madrid MS gr. 16, which contains a number of unpublished homilies by Philagathos, there is one on the *Hypapante*, which, however, according to Ehrhard (*op.cit.*, p. 660), is simply an extract from the Gospel commentary of Theophylactus of Bulgaria. This commentary (Migne, *PG*, CXXIII, cols. 725ff.) makes no particular point of the triumphal character of the event. But although Theophylactus seems to have been one of Philagathos' principal sources (Ehrhard, *op.cit.*, p. 665 n. 1) his text does not necessarily represent everything that Philagathos had to say on the subject. In particular, the

homily in the Madrid MS lacks a *prooemium*.

71. Kiev, St. Cyril; Milesevo. See next footnote.

72. The case of the Martorana, where the two scenes are in positions corresponding exactly to those they occupy in the Palatina, hardly counts since the greater part of the decoration of the Martorana is in all likelihood simply an abbreviated extract from the program of the Palatina (see below, footnote 107). Another exact parallel is provided by the thirteenth century fresco decoration of the church of Milesevo in Serbia, where Annunciation and Presentation in the Temple confront each other on the piers of the eastern and western arches of the central square (cf. nos. 7/107 and 29/95 on the diagrams in N. L. Okunev, "Milesevo," *Byzantino-Slavica*, VII, 1937-38, pp. 80, 81; also *ibid.*, pl. xxv,1). Since this decoration shows Italian influence (Okunev, *op.cit.*, pp. 101f.) it might conceivably owe something to our Sicilian examples. But Annunciation and Presentation in the Temple had already been treated as pendants on the triumphal arch of Sta. Maria Maggiore, and, later on, at Qeledjar (Jerphanion, *Les Eglises rupestres*, I, 1, pp. 202, 205, 216 and pl. 45,2). Perhaps the most pertinent example is the twelfth century fresco decoration in the church of the monastery of St. Cyril in Kiev. In this instance, which is certainly not under Italian influence, Annunciation and *Hypapante* are placed one beneath the other on the lateral piers of the triumphal arch. Cf. the description by Prachov, *op.cit.* (above, footnote 41), p. 17, and the illustration of one half of the *Hypapante* in I. Grabar, *History of Russian Art* (in Russian), VI, Moscow, n.d., p. 128.

arch, especially as it was thus, in a sense, taken out of the chronological sequence of the Childhood scenes in which it occupied a somewhat ambiguous position.[73] But although this may be one, or even the principal, reason why the *Hypapante* was put in this particular place there were probably other considerations as well. When we turn to the mosaics at Monreale, executed little more than a generation after those of the sanctuary of the Palatine Chapel, we find that the Presentation in the Temple is placed again on the western arch of the sanctuary square. Since this cycle contains a far richer series of scenes than that of the Palatina and since the architectural setting is by no means identical, a special effort must have been made to secure this position for the *Hypapante*. Yet the scene is not in this case a pendant to the Annunciation.[74] Instead there is on the same arch a complementary panel showing Christ among the Doctors (Fig. 13). There are other cycles in which this scene follows after the Presentation in the Temple.[75] But in Monreale there may well be a special intention in placing the Presentation in the Temple and Christ among the Doctors side by side on the western arch. The two scenes have this in common that they both depict Christ's triumph over representatives of the Old Law. The western arch is the divide between the sanctuary and the nave, i.e., between areas whose decorations are dedicated to the New and the Old Covenant respectively. Thus the scene, supplemented by another with similar content, provides a link with the subject matter of the nave mosaics. The arrangement serves, as it were, to put the world of the Old Testament into proper perspective. Indeed, when we look west from the sanctuary we see the events of the Old Testament framed by an arch on which representatives of the Old Law are depicted in the act of submitting to Jesus Christ. Returning now to the Cappella Palatina, we may suggest that here, too, the *Hypapante* had been designed as a link with the nave decoration. At least this may have been an additional reason why the scene was put on the western arch. This incidentally would be an indication that the Old Testament cycle in the nave must have been planned when the mosaics in the sanctuary were made.[76]

The relation of the *Hypapante* to the Old Testament cycle in the nave brings out the triumphal character of the scene. In Monreale this triumphal character is underlined further through the presence of a commentator in the person of the Prophet Malachi, who stands in the spandrel immediately beneath the *Hypapante* (cf. Fig. 13) and holds up a scroll with the first words of his prophecy: "ecce ego mittam angelum meum et preparabit viam ante faciem meam."[77] In the Roman missal the reading of this prophecy is prescribed for the feast of the Presentation in the Temple, a fact which presumably accounts for its presence in this particular place.[78] But the text

73. See above, footnote 40.

74. In Monreale there are two Annunciation scenes. One is ceremonial and symbolical and is placed in the obligatory position on the arch preceding the apse, which, however, is not the arch corresponding to that with the *Hypapante*. The two arches are separated by the eastern arch of the central square, which bears figures of military saints. The other Annunciation scene is purely narrative; it forms part of a sequence of four scenes on the southern arch of the central square, with which the Gospel narrative opens.

75. Toqale, New Church (Jerphanion, *op.cit.*, I, 2, p. 311); Sts. Apostles (*ibid.*, II, 1, pp. 68f.).

76. See above, p. 270. It is, indeed, possible that a linking of the New and Old Covenants was effected not only from the standpoint of the sanctuary, but from that of the nave as well. The last scene of the Old Testament cycle is Jacob's Struggle with the Angel. It is unusual for a Biblical cycle thus to break off halfway through the story of Jacob. In Monreale the Old Testament scenes occupy a far larger area, but instead of continuing the story beyond this point the artists preferred to fill the available space by telling the preceding events in greater detail. Jacob's Struggle with the Angel must have been considered particularly suitable to provide a final accent to the Old Testament series. In both churches the scene occupies a relatively large space and brings the cycle to an effective

halt. Were Jacob's struggle and Simeon's willing submission considered as complementary episodes? Was the *Nunc dimittis* thought to be related to the *Non dimittam te nisi benedixeris mihi*? So far I have not found any evidence that the two scenes were ever linked together specifically. But Isidorus had already said of the angel's struggle with Jacob: *Christi certamen cum populo Israel figuravit* ("Allegoriae quaedam Sacrae Scripturae," No. 30, Migne, *PL*, LXXXIII, col. 105). It is possible, then, that the two scenes on either side of the "divide" were selected especially to emphasize Christ's struggle with, and triumph over, the people of Israel. Was this another device aimed at the conversion of the Jews (see above p. 277 and footnote 47)?

77. Mal. III, 1. The text is here transcribed after D. B. Gravina, *Il Duomo di Monreale*, Palermo, 1859-, pl. 17D (=our Fig. 13). Strictly speaking the third word should read Mitto (see below, footnote 81). At present I cannot decide whether the change was introduced by the artist, by some later restorer, or by Gravina's copyist.

78. This statement is not intended to imply that liturgical usages of Rome can be assumed automatically to have been followed also in Norman Sicily. But the fact that in Monreale the text of Malachi is associated with the Presentation in the Temple is itself an indication that the Siculo-Norman liturgy shared with the Roman this particular detail, an assumption

had other associations aside from the liturgy of the feast. It is one of the principal messianic prophecies in the Old Testament and as such it was used in other contexts to hail the arrival of the heavenly king or his earthly representative. It is, in short, one of the principal *adventus* texts.[79] Specifically, it figures frequently in *ordines* for the reception and coronation of rulers.[80] It is not lacking in the one extant coronation *ordo* which has been attributed to Norman Sicily and which provides for the chanting of the Malachi prophecy during the king's solemn entry into the church.[81] The text, then, would always evoke visions of the king's advent and perhaps we are not stretching the evidence unduly when we suggest that this mental association extended also to the scene which the text accompanied. Admittedly we have no literary statement, aside from the indirect evidence derived from the prophecy of Malachi in Monreale, to prove that in twelfth century Sicily the *Hypapante* was still thought of in terms of the royal ceremony which had originally given it its name; we are, however, able to say that this meaning was preserved in mediaeval Greek literature.[82]

Granted even that for a spectator in Norman Sicily the royal element in the *Hypapante* may have been nothing more than a faint overtone and that these regal connotations may have provided only an incidental reason why the scene was prominently featured in the Palatine Chapel, there is still the fact that special emphasis was given also to two other scenes which definitely were thought of in terms of the ruler's *adventus*, namely, the Flight into Egypt and the Entry into Jerusalem. This fact should now be considered in conjunction with our earlier observations on the asymmetric layout of the christological cycle. Was not this cycle laid out to suit a particular viewpoint and, indeed, a particular spectator who could be no other than the king himself? The southern wall of the southern wing is the great picture wall of the sanctuary; its view is dominated by two *adventus* scenes, particularly by the Entry into Jerusalem, which has always impressed visitors as one of the climactic features of the whole decoration (Fig. 18). This would be the wall the king faced (Fig. 5). The corresponding wall in the northern wing, which presumably never carried the same weight iconographically, would be behind his back or out of his sight (Fig. 6).

There is, of course, even now a window in the northern wing which affords exactly the view just referred to. If this window could be proved to be an original feature of the architecture the hypothesis here outlined would gain greatly in probability. Unfortunately, at present the evidence in regard to this window is inconclusive. It has been mentioned above that a royal box did exist in the northern wing in the late eighteenth and early nineteenth centuries. According to one authority this box, which was a wooden structure in front of the lower part of the northern wall, was installed after the Bourbon court had moved to Palermo (A.D. 1798), because the small loggia higher up on that wall no longer sufficed.[83] This statement would seem to imply that a small window

which is all the more reasonable since the Sarum Missal also has the Malachi reading for the feast of the Presentation. This was pointed out to me by Dom A. Strittmatter. For the Sicilian affinities of the rite of Sarum, cf. E. H. Kantorowicz, "A Norman Finale of the Exultet and the Rite of Sarum," *Harvard Theological Review*, XXXIV, 1941, pp. 139f. It is interesting to note that in the Cappella Palatina the series of prophets in the central square is arranged in such a way that Malachi, though lacking a prophetic text, is placed next to the *Hypapante* (see Fig. 5).

79. Kantorowicz, ART BULLETIN, 1944, pp. 217f.

80. *Ibid.*, p. 217 n. 67.

81. Coronation *ordo* in Cod. Casanat. 614 published by J. Schwalm in *Neues Archiv für ältere deutsche Geschichtskunde*, 23, 1898, p. 19: *Postea archiepiscopus accepta aqua benedicta aspergat regem et dicat alta voce: Procedamus in pace. Et cantor episcopii incipiat resp.: Ecce mitto angelum.* This wording agrees with Malachi III, 1 (as quoted in Mark I, 2 and Luke VII, 27) and not with the related passage in Exodus XXIII, 20 (cf. the parallel remarks by Kantorowicz, *op.cit.* p. 217, *à propos* the formula for the reception of the emperor in the Roman Pontifical). For the attribution to Norman

Sicily of the *ordo* published by Schwalm, cf. P. E. Schramm, *A History of the English Coronation*, Oxford, 1937, p. 60 n. 2; Kantorowicz, *Harvard Theological Review*, 1941, p. 137 n. 29; *Idem, Laudes Regiae*, p. 166 n. 44.

82. Cf. particularly a homily ascribed to Leontius of Neapolis, in which the feast of the *Hypapante* is called a θεία καὶ Δεσποτικὴ ἑορτὴ (Migne, *PG*, XCIII, col. 1565; cf. above, p. 281, for the nearly identical words applied by Philagathos to Palm Sunday) and the arrival of the βασιλεὺς τῶν αἰώνων is described and hailed as a royal *adventus* (*ibid.*, cols. 1567f.). Cf. also a passage in a sermon of Leo the Wise in which the Christ Child's arrival in the Temple is described as a "negative" *adventus*: Ποῦ τῆς δεσποτείας ὁ ὄγκος; Ποῦ τοῦ ἀξιώματος τὰ γνωρίσματα; Οἱ δορυφόροι δὲ ποῦ; οἱ συντρέχοντες; οἱ προπομπεύοντες; οἱ ἐφεπόμενοι; (Migne, *PG*, CVII, col. 33).

83. Boglino, *op.cit.* (above, footnote 8) p. 24: "si era costruito questo palchetto quando la Corte napoletana si portò nella Reggia siciliana, non bastando più per essa la piccola loggia che più in alto nel muro medesimo si trovava." The Bourbon balcony, which was removed by order of Ferdinand II in 1838, may be seen on an engraving reproduced in F. Schillmann's edition of F. Gregorovius, *Wanderjahre in*

or loggia· was there prior to the work carried out in this area under the Bourbons in the late eighteenth century. But at present there is no positive archaeological or documentary proof that it goes back to the twelfth century.[84]

Since the king's apartments were situated north of the Chapel, the northern wall of the sanctuary certainly would be a logical place for a royal loggia. Behind this wall lies an ambulatory which skirts the entire length of the Chapel on the north side,[85] but there is some uncertainty as to the means of access to this ambulatory and to the Chapel from the royal apartments. Investigations recently carried out in this area have shown that there was a passage leading from the royal apartments to the ambulatory on the level of the crypt.[86] But this does not exclude the possibility that there was a connection on a higher level as well, where the evidence has been obscured by later building activities.[87]

A seemingly strong argument against the assumption that there was in Norman times a royal seat in any part of the sanctuary is the existence of a royal throne at the western end of the nave (Fig. 12). But the style of the mosaics in the area surrounding the top of this throne and on the wall above it—admittedly difficult to judge because of drastic restorations—makes it doubtful, to say the least, whether this throne is an original feature of the church. The whole western wall may have undergone a very thorough reorganization at a relatively advanced period.[88] Even if the throne at the western end were part of the original plan it would not really exclude the existence of a royal seat in the area of the sanctuary as well. Unfortunately we know next to nothing about the Norman kings' role in the church service, but in view of their exceptional and quasi-clerical status as papal legates they are a priori likely to have had at least a movable seat within the sanctuary. Indeed, there are royal thrones within the chancel both in Cefalù and in Monreale. In our context it is interesting to note that in both these instances the thrones are on the northern side. A royal seat in the balcony, on the other hand, would have an altogether different function and would be used for private attendance as distinct from official participation in the service.

The mosaic decoration itself provides corroborative evidence that the view across the sanctuary from north to south was indeed a royal view and that the king must have had a place on the northern side and, very probably, in what is even now a royal window. This corroborative evidence comes from the figures of saints which supplement the program. They provide a further curious case of asymmetry which has already been mentioned. On the outer face of the southern arch of the central square are three busts of prophets in medallions completing the series of prophets in the dome and central square. These are flanked, in the spandrels, by full-length figures of Isaiah and Joel with prophetic texts referring to adjoining New Testament scenes.[89] The corresponding wall of the northern arch, i.e. the wall facing the royal loggia, also shows three busts in medallions flanked by two full-length figures. But of these five figures, four are prominent warrior saints. The full-length figure in the left-hand spandrel is Theodorus Tiro; the three busts depict Demetrius, Nestor, and Mercurius. The standing saint to the right is a bishop—a rather incongruous-looking figure in this company of warriors—and, in fact, no other than St. Nicholas, whom one is all the more surprised to find here since he is represented also among the holy bishops on the wall opposite. Evidently he is represented here not so much as one of the great Eastern bishops, but as one of the

Italien, Dresden, 1928, pl. 51. The monograph by Pasca, to which Boglino refers, was not accessible to me.

84. So far as I am aware, the only author who has stated *expressis verbis* that the window in the northern wing is a royal loggia of the period of Roger II is Di Marzo, *Delle belle arti in Sicilia,* II, p. 161 (see also below, footnote 92). Demus attributes it to a change of plan under William I.

85. Cf. the plan in *Archivio storico siciliano,* 1936, facing p. 474.

86. M. Guiotto, *Palazzo Ex Reale di Palermo. Recenti restauri e ritrovamenti,* Palermo, 1947, pp. 31ff. and fig. 4 "G."

87. Guiotto, *op.cit.,* pp. 32f. The author points out, however, that the passage shown on Valenti's plans in *Bollettino d'arte,* 2nd series, IV, 1924-25, pp. 512f., figs. 1-2, is purely hypothetical.

88. Cf. F. Valenti's statement ("L'Arte nell'era normanna," *Il Regno normanno,* Messina and Milan, 1932, p. 220) that the narthex to the west of this wall is an addition of the period of William II. Some authors have gone so far as to attribute the throne to the Aragonese period (Di Marzo, *op.cit.,* II, pp. 160ff.; Di Pietro, *I Musaici siciliani,* p. 73).

89. See above, footnote 32 and p. 278.

principal patron saints of the Normans,[90] and, specifically, in his well-known role as a patron of sailors,[91] complementing the role of Demetrius and the rest as patrons of soldiers.

Thus the view from north to south comprises yet another element which would appeal particularly to a royal spectator and one, incidentally, which could hardly be appreciated from any other viewpoint except the window high up on the northern wall.[92] The saints on the walls flanking this window give further emphasis to the royal and military theme. On the western wall (Fig. 16) Catherine in royal garb is flanked by Agatha and another female saint, whose name is lost. The group clearly suggests a queen or princess with her ladies-in-waiting.[93] On the eastern wall is the group of the Virgin and Child and St. John, whose possible liturgical symbolism has already been discussed.[94] Two peculiarities of this group remain to be mentioned. The first is the eccentric position of the Virgin which is strange and disturbing when viewed from the front (Fig. 14), but not so when viewed from the loggia. This is in itself an indication that the loggia was already in existence when the mosaics were made.[95] The other is the fact that this image of the Virgin and Child not only belongs to the Hodegetria type, iconographically speaking, but is actually inscribed MHP ΘΥ Η ΟΔΗΓΗΤΡΙΑ. An inscription denoting an iconographic type is a very rare feature in monumental wall decoration prior to the late Byzantine period,[96] though it is somewhat more common on seals[97] and coins.[98] The implication in all such cases is that the image which bears the inscription depicts a specific icon.[99] In this instance we have before us a representation of the famous icon of the Hodegetria in Constantinople, palladium of empire and dispenser of victory, prayed to by emperors and generals upon departing on their campaigns, thanked and praised for victories upon their return, and even carried on the ramparts in extreme emergencies.[100] The cult of the Hodegetria had already been fostered by the Normans more than a generation before the mosaics of the Palatina were made. At the very beginning of the twelfth century the Abbey of Rossano, founded with the active support of the dynasty, was dedicated to the Virgin under the title of Nea Hodegetria.[101]

Thus the view from the loggia offers on all three sides subjects with military and royal conno-

90. K. Meisen, *Nikolauskult und Nikolausbrauch im Abendlande*, Düsseldorf, 1931, pp. 89, 94ff. Kantorowicz, *Harvard Theological Review*, 1941, pp. 141f. The center of the cult of St. Nicholas was, of course, Bari. St. Theodorus Tiro, his pendant in the Cappella Palatina, was a patron saint of Brindisi (cf. *Acta Sanctorum Novembris*, IV, p. 27).

91. G. Anrich, *Hagios Nikolaos*, II, Leipzig and Berlin, 1917, p. 504; Meisen, *op.cit.*, pp. 66, 89. The only miracle of the saint related by Philagathos (see above, footnote 68) in his Nicholas homily is a rescue at sea (Migne, *PG*, CXXXII, cols. 905ff.). The artist who aligned St. Nicholas with St. Theodore, St. Demetrius, etc., clearly did not share Anrich's view (*op.cit.*, p. 496) that the "gentle bishop was not suited as a warrior saint." Anrich was not aware of the dual representation of St. Nicholas in the Cappella Palatina (cf. p. 484). For other bishops featured by our artists in what seems to be largely a military capacity, see below, p. 289. But although the duplication of the figure of St. Nicholas can be explained by drawing a distinction between the saint as a bishop and as a local and naval patron, the fact that the figure occurs twice within one and the same part of the church might be used as an argument that the two sets of mosaics were planned and executed at different times. If so, it would be the row of five holy bishops, and not the warrior saints, which would have to be detached from the program as a whole. For they differ from all the other mosaics in the transept in having name inscriptions in both Greek and Latin. For stylistic reasons, however, the difference in time cannot be very great. See also above, footnote 39.

92. Cf. the sections, Figs. 1, 2. A connection between the warrior saints and the royal window was drawn already by Di Marzo, *op.cit.*, II, p. 76. The mosaics on the sidewalls of the chancel at Cefalù present a comparable case of asymmetry, clearly planned with the same intent. The four deacons depicted in the second zone from below on the northern wall (Lasareff, ART BULLETIN, XVII, 1935, p. 203, fig. 15) are matched on the southern wall by four military saints: Theodore Stratelates, George, Demetrius, Nestor (*ibid.*, p. 200, fig. 14). Here the relation to the king, whose throne faces the southern wall, can hardly be doubted.

93. This was observed by Mons. Pottino, *op.cit.* (above, footnote 8), p. 58.

94. See above, pp. 273f.

95. I owe this point to Dr. Demus' forthcoming book.

96. Prof. Grabar has drawn my attention to the icons of Christ and the Virgin, inscribed, respectively Ο ΑΝΤΙΦΩΝΙΤΗϹ and Η ΕΛΕΟΥϹΑ in the church of the Dormition at Nicaea. Cf. Th. Schmit, *Die Koimesis-Kirche von Nikaia*, Berlin and Leipzig, 1927, pls. 25-27 and pp. 44ff.: "10th century."

97. G. Schlumberger, *Sigillographie de l'empire byzantin*, Paris, 1884, pp. 37f.

98. W. Wroth, *Catalogue of the Imperial Byzantine Coins in the British Museum*, London, 1908, II, p. 503 and pl. LIX,5; p. 506 and pl. LX,5.

99. Cf. the remarks by Schlumberger, *op.cit.*, pp. 36ff.

100. The sources relating to the image of the Hodegetria and its role as a palladium are marshaled conveniently and critically in two recent articles: A. Frolow, "La Dédicace de Constantinople dans la tradition byzantine," *Revue de l'histoire des religions*, CXXVII, 1944, pp. 99ff.; R. L. Wolff, "Footnote to an Incident of the Latin Occupation of Constantinople: The Church and the Icon of the Hodegetria," *Traditio*, VI, 1948, pp. 323ff.

101. M. Scaduto, *Il Monachismo Basiliano nella Sicilia medievale*, Rome, 1947, pp. 167ff.

tations. Taking this fact in conjunction with the peculiar arrangement of the christological cycle one can hardly avoid the conclusion that the whole decoration was meant to gratify a royal spectator seated on the northern side and probably in the loggia. The view from north to south not only is richer than that from south to north, it shows a consistent and sustained emphasis on a single theme: royal power and glory. The theme is cleverly and semicryptically embedded in what is, to all intents and purposes, a normal Byzantine scheme of decoration. But it is present nevertheless. It finds expression in the saints and single figures no less than in the prominent featuring of the *adventus* scenes and particularly in the Entry into Jerusalem, which forms a very effective center piece. The two saints flanking this scene will be discussed later, and it will be seen that they give additional emphasis to the royal theme. The view from south to north offers no such keynote and is by comparison disjointed. The asymmetry of the whole layout must be purposeful. It is the view from north to south which counts most, and it is from the loggia that it can best be appreciated.

V

An attempt must now be made to determine the date of this "royal program." This requires a digression into the realm of style, admittedly treacherous ground because of the thorough restorations to which the mosaics of the Cappella Palatina have been subjected at various times. It is still possible, however, to distinguish at least two stylistic groups among the mosaics in the dome and transept. These two groups can be characterized conveniently by means of a comparison of two busts of Christ, one in the dome, the other in the lunette of the Pentecost vault (Figs. 20, 21). Among the characteristics of the latter as against the former are a slimmer, more elongated face, larger eyes, a generally more ascetic expression, and a more elaborate drapery design with a preference for rounded forms. A key to the source of this second style is provided by the magnificent bust of Christ in the apse at Cefalù (Fig. 22). The artist who designed the Christ in the Pentecost vault knew the work of that excellent atelier which decorated the apse in Cefalù. The artists of the dome apparently did not. The dome bears an inscription of A.D. 1143,[102] the mosaics in the apse at Cefalù are dated by an inscription in the year 1148.[103] The natural conclusion is that work in the Palatine Chapel started in the dome in the early forties and that by the time the southern transept wing was reached the Cefalù workshop had become operative and had started to exert its influence. Thus the mosaics in this area would seem to belong to the late forties at the earliest.[104]

Another clue is provided by the church of the Martorana in Palermo, built by George of Antioch, the faithful admiral of Roger II, prior to the year 1143.[105] The mosaic decoration in the Martorana must have been, if not completed, at least far advanced when George died in A.D. 1151.[106] This decoration, however, is in part an abbreviated excerpt of that in the Cappella Palatina. A reverse relationship is hardly conceivable.[107] Hence, those mosaics of the Palatine Chapel which are re-

102. See above, footnote 3.

103. Lasareff, ART BULLETIN, XVII, 1935, p. 185.

104. The priority of the dome mosaics of the Cappella Palatina over the artistically superior mosaics in the apse at Cefalù has been a stumbling block to those who, like Lasareff (*op.cit.*, pp. 221 ff.), conceived the Sicilian development as a simple "one-way" process starting with a pure Constantinopolitan style and undergoing a gradual provincialization. In actual fact the process is a good deal more complicated. The dome mosaics of the Cappella Palatina are important evidence of a school which worked for King Roger prior to the arrival of the Cefalù workshop. It is only by making this distinction that the full impact of the Cefalù workshop, as revealed in some of the mosaics of the southern wing of the Palatina, can be appreciated and the framework of a chronology for the Palatina mosaics can be established.

105. Garofalo, *op.cit.* (above, footnote 2), pp. 13 ff.

106. M. Amari, *Storia dei Musulmanni di Sicilia*, 2nd ed., III, pt. 2, Catania, 1938, p. 429 (in the first edition, III, Florence, 1868, p. 422, the date is given erroneously as 1149-50).

107. This can be demonstrated, for instance, in the case of the Presentation in the Temple. The mosaic in the Cappella Palatina follows an established type represented in southern Italy by the eleventh century ivory paliotto in Salerno (D. C. Shorr, "The Iconographic Development of the Presentation in the Temple," ART BULLETIN, XXVIII, 1946, pp. 17 ff. and fig. 9). In the Martorana the scene is repeated exactly, but simplified through the omission of Joseph, Anna, and the temple architecture. The Nativity scenes in the two churches are equally closely related and again the Martorana represents a reduced version (cf. Figs. 15 and 17).

flected in the decoration of the Martorana were probably in existence in the late forties. Among these are the Annunciation, the Presentation in the Temple, and the Nativity (Figs. 15, 17).

The Nativity scene, however, clearly belongs to the second of the two groups which we have distinguished in the Cappella Palatina. Immediately above it is the Christ bust which betrays unmistakably the influence of the Cefalù style. Immediately below is a bust of St. Paul, which, though very badly restored, still shows traces of the same Cefalù influence, and, indeed, reproduces the drapery design of the Cefalù Pantokrator (cf. Figs. 15, 22). The Nativity must have been executed simultaneously with the two busts between which it is bracketed. Thus this whole ensemble on the eastern wall of the southern wing is confined between very narrow chronological limits. Insofar as it shows the influence of the Cefalù workshop it can hardly be earlier than 1145 at the very earliest; insofar as it, in turn, influenced the work in the Martorana it can hardly be later than 1150 at the very latest.

A date in the second half of the forties is thereby suggested for at least part of the mosaics of the second group. How much of the work belongs to the second group can be determined, if at all, only on the basis of a more adequate photographic record and a more thorough scrutiny of authentic and restored parts than are at present available. It is hazardous even to attempt to draw a line of demarcation between the first and the second groups. Probably all the work above the inscription of 1143, that is to say, in the dome and in the drum, belongs to the first group, with the possible exception of the eight half-length figures of prophets in the spandrels of the drum. These do not agree altogether with the figures in the dome and with the full-length figures of prophets in the niches of the drum. In the rounded forms of some of their draperies there may be an influence of the Cefalù workshop. These half-length figures of prophets may, in fact, be an afterthought. They are awkwardly cut off at the waist and wedged into the narrow spaces between the niches (Fig. 5).

If this conclusion is correct one might tentatively reconstruct the progress of the work somewhat as follows: When the dedicatory verses were inscribed at the foot of the drum in A.D. 1143 the Pantokrator with his angelic guards had already been placed or was about to be placed in the dome and two groups of four Evangelists and four prophets and forerunners in the squinches and niches below.[108] It was, as we have seen, a typical Byzantine dome decoration, but there need not necessarily have been at that stage the full plan of decoration for the lower parts as it was later carried out. Indeed, the original plan may have provided merely for a descending hierarchy of prophets, apostles and martyrs, somewhat on the lines of the decoration of the Nea, the palace church of the Byzantine emperors. There may have ensued a lull in the work which may have lasted until 1146 or 1147 when a new impetus came from the recently established workshop at Cefalù. Possibly the inclusion of a New Testament cycle in the program of the sanctuary was decided upon only at this time, and this may be the reason why the series of prophets, for which there would have been space originally in the lower parts, was crowded into the spandrels of the drum and of the arches beneath in the form of busts.

Whether or not there was a change of plan, work on the mosaics in the lower parts of the sanctuary was in progress in the second half of the forties, when the southern wing was reached. How far the work progressed during this phase is difficult to say. What matters most in the present context is the probability that the over-all scheme of decoration was then established in its substantially final form and that this scheme included the royal view across the transept from north to south. Annunciation, Nativity, and Presentation in the Temple must have been in existence by

108. The group of prophets and forerunners was intended perhaps as a representation of two pairs of fathers and sons: David and Solomon, Zacharias and John. Zacharias' scroll is inscribed with a quotation from the prophet of that name (Zach. IX, 9), but the censer in his hand seems to characterize him as Zacharias the Priest and father of the Baptist. The two were sometimes confused (Grabar, *Martyrium*, II, p. 201). In some of the marginal psalters (Vatican, Barb. gr. 372, fol. 235r; London, British Museum, Add. 19352, fol. 185r) the prophet Zacharias also appears with a censer.

this time, since they are reflected in the Martorana. The Pentecost scene, or at least the figure of Christ which is part of it, must have been executed at the same time as the Nativity. It is hardly conceivable that these four scenes which comprise the beginning and the end of the "feast cycle" could have been allotted the places in which we find them unless there had been an over-all plan for such a cycle[109] and for its distribution over the transept, a distribution which, as we have seen, was far from haphazard and on the contrary extremely well thought out.[110] The supporting program of saints certainly was evolved at the same time. It is complementary to the New Testament cycle so far as distribution is concerned. It has the same regal emphasis and it, too, has ties with the Martorana mosaics.[111] It was mentioned earlier that the over-all plan, as it existed in the second half of the forties, may have provided also for the Old Testament cycle in the nave,[112] even though most writers believe that this cycle, at any rate, was not executed until the reign of William I.

We do not know how far the execution of the work had progressed when William I succeeded to the throne in A.D. 1154. But the over-all scheme of the mosaics, including the "royal view," was evolved, if not in the first phase of the work, certainly still within the reign of Roger II. In the sanctuary there is only one group of mosaics which seems to be altogether unconnected with this scheme, namely, the figures in the central apse. The Pantokrator appears here once more (Fig. 23) and although the figure is evidently derived from that in the conch at Cefalù (Fig. 22), we are here far removed from the latter's aristocratic countenance and ascetic proportions, which the artist of the Saviour in the Pentecost scene of the Palatina reproduced so faithfully (Fig. 21), and closer to the expansive and somewhat bloated Pantokrator bust of Monreale (Fig. 24) done under William II (1166-1189). The Pantokrator in the apse of the Cappella Palatina must surely belong to the advanced twelfth century. It was placed there as an afterthought in order to offset the vertical build-up of the original Byzantine scheme of decoration—a scheme designed for churches with a centralized plan—and to give primary emphasis to the longitudinal axis of the basilica. This change of plan seems to have affected also the figures in the lower zone of the central apse.[113]

VI

It was during the last decade of the reign of Roger II, greatest of the Norman rulers of Sicily, that the grand design for the mosaics in the sanctuary of the Palatine Chapel was evolved. This was the period when Roger, having finally become undisputed master within his own domain and having won the Pope's recognition of his kingship, stepped out onto the international scene and embarked on a course of open rivalry with the two greatest powers of his day, the Byzantine and the German Empires. It was a subtle political game punctuated by a number of warlike acts which culminated in A.D. 1147 in what seems to have been an attempt to oust the Comnenian dynasty and to set up a Latin Kingdom on the Bosphorus.[114]

The question arises whether the decoration of the sanctuary of the Cappella Palatina, with its stress on royal and military themes, was designed merely to enhance the courtly atmosphere of the church or whether it bears a specific relation to the events of those years.

There is one feature in the decoration which has so far been neglected and which more clearly than any other indicates the presence of quite specific political overtones. In the lower register of the principal picture wall of the sanctuary (Fig. 5), in positions corresponding to two of the

109. See above, p. 275 and footnote 36. For the reason why the Flight into Egypt—the only christological scene which does not correspond to a "feast"—was included in the cycle, see pp. 280f.

110. See above, pp. 279, 286.

111. Cf. the Hodegetria in the Cappella Palatina (Fig. 14)

with the figure of the Virgin in the Presentation in the Temple in the Martorana.

112. See above, p. 282.

113. See above, footnotes 18-20.

114. See below, footnotes 121, 122.

Greek bishops on the northern wall of the northern wing and flanking the scene of the Entry into Jerusalem, are two figures of bishops inscribed respectively St. Dionysius and St. Martin. St. Denis and St. Martin would not be an obvious choice were it simply a question of opposing Latin Fathers to the Greek ones on the wall opposite. They do not seem to have held a particularly prominent place in the Sicilian calendar. But they were exceedingly prominent in France, and their connection with France is, indeed, the principal bond between them. Denis was considered to have been the first bishop of Paris, or even the Apostle of Gaul, and since the Carolingian period he had been identified in Western thought with Dionysius the Areopagite.[115] Martin, of course, was a famous bishop of Tours. Both were traditional patrons of the French king and the French army and the nearest equivalent in France to the Byzantine warrior saints.[116] Both had given their names to famous French flags.[117] St. Denis' role particularly had never been more brilliant—or more worldly— than in the twelfth century, by which time he was firmly established as France's patron saint. His military valor became evident to all France in 1124 when the saint's flag, raised from the altar of the Abbey Church of St. Denis by Louis VI, secured the successful defense of the realm against the threatened invasion of the German emperor.[118] Twenty-three years later Louis VII, before embarking on the Second Crusade, went to the Abbey of St. Denis and asked the Saint for his *vexillum* and for permission to leave *qui mos semper victoriosis regibus fuit*.[119] The place of honor given to the two saints on a wall otherwise dedicated entirely to the life of Christ must be understood as a tribute to France, her army, and her king.

France was Roger's natural ally in his struggles with the two Empires and a special object of his attention since the early forties.[120] He began to woo Louis VII openly during the preparations for the Second Crusade, which to Roger was but a thinly disguised scheme for the conquest of Constantinople. It was a joint Franco-Sicilian attack on the capital which he seems to have had in mind when he sent out his fleet in 1147.[121] In any case such a plan was being discussed at that time in Louis' entourage.[122] But Louis did not respond openly to Roger's offers of friendship until 1149, when the Crusade had taken its disastrous course and the French king, now thoroughly disabused of the faithfulness of his Greek allies, was on his return journey. As a result of events which are not entirely clear Louis and his Queen found themselves landing on Norman shores. According to one version Louis was ambushed by a Byzantine fleet and rescued by the Normans.[123] Be this as it may, Roger, *desiderans oportunitatem exhibendi devotionem quam habebat regi et regno Francorum*[124] was able to play host to the French royal couple. Louis spent two months in Roger's kingdom.[125] We do not know that he visited Palermo, though his Queen did.[126] There was a confi-

115. M. Buchner, *Die Areopagitika des Abtes Hilduin von St. Denis und ihr kirchenpolitischer Hintergrund*, Paderborn, 1939, *passim*, especially pp. 41ff., 161ff., 200f.

116. Both Denis and Martin are among the saints invoked in the Laudes as protectors of the army (C. Erdmann, *Die Entstehung des Kreuzzugsgedankens*, Stuttgart, 1935, p. 256; Kantorowicz, *Laudes Regiae*, p. 15) and of the king (Kantorowicz, "Ivories and Litanies," *Journal of the Warburg and Courtauld Institutes*, v, 1942, p. 57). Since the early Middle Ages both the Abbey of St. Martin at Tours and the Abbey of St. Denis outside Paris had close and intimate connections with the French kings, with the emphasis gradually shifting from the former to the latter foundation as principal sanctuary of the realm (H. Meyer, "Die Oriflamme und das französische Nationalgefühl," *Nachrichten von der Gesellschaft der Wissenschaften zu Göttingen. Philol.-Histor. Klasse*, 1930, p. 115, also p. 113 n. 5; P. E. Schramm, *Der König von Frankreich*, Weimar, 1939, pp. 131ff.).

117. Meyer, *op.cit.*, pp. 110ff. (*ibid.*, p. 113 for the "cappa" of St. Martin, which in Merovingian times was kept as a relic in the royal palace—hence the word "cappella"—and taken into battle as a palladium); C. Erdmann, "Kaiserfahne und Blutfahne," *Sitzungsberichte der Preussischen Akademie der Wissenschaften. Philos.-Histor. Klasse*, 1932, pp.

890ff.; Schramm, *op.cit.*, p. 139.

118. Meyer, *op.cit.*, pp. 116ff.; Erdmann, *op.cit.*, p. 892; Schramm, *op.cit.*, p. 139.

119. Odo of Deuil, *De Profectione Ludovici VII in Orientem*, ed. V. G. Berry, New York, 1948, p. 16.

120. E. Caspar, *Roger II (1101-1154) und die Gründung der normannisch-sizilischen Monarchie*, Innsbruck, 1904, pp. 365ff.

121. *Ibid.*, pp. 377ff.

122. Odo of Deuil, *op.cit.*, p. 58.

123. Anonymus ad Petrum, Ch. 28 (printed by B. Kugler, *Studien zur Geschichte des zweiten Kreuzzuges*, Stuttgart, 1866, p. 19). Cinnamus (*Hist.* II, ed. Bonn, 1836, pp. 87f.), however, gives a different account. On these events see Kugler, *op.cit.*, pp. 209f.; Caspar, *op.cit.*, pp. 391ff.; F. Chalandon, *Histoire de la domination normande en Italie et en Sicile*, Paris, 1907, II, p. 144.

124. Anonymus ad Petrum, *op.cit.*, p. 19.

125. The King landed in Calabria on July 29 (cf. his letter to Abbot Suger, *Recueil des historiens des Gaules et de la France*, XV, Paris, 1808, pp. 513f. no. LXXXI) and was on his way to Rome on October 4, when he arrived in Monte Cassino (cf. the Chronicle of Monte Cassino, *ibid.*, p. 425).

126. Cf. Louis' letter to Suger quoted in the preceding

dential meeting lasting three days between Roger and Louis at Potenza,[127] a great event for Roger who thus found himself treated as a peer by one of the legitimately crowned heads of Europe. Although we have no record of what transpired at this meeting, we may infer from subsequent correspondence that a plan was hatched for another crusade, this time with Roger as a leader and with Byzantium as an avowed objective.[128] The plan petered out because of opposition from the pope. Relations with France continued to be friendly, but active political cooperation had ended for the time being.

Thus, a tribute to France would have been particularly appropriate in the period before, during and immediately after the Second Crusade. As we have seen, mosaicists were working in the southern wing of the Cappella Palatina at precisely this period. Indeed, in the light of the events of those years the appearance of the two patron saints of the French king and the French army on either side of the triumphal scene of the Entry into Jerusalem is peculiarly suggestive. But without additional evidence it would be hazardous to try to connect this group of mosaics with any specific event.

In any case, however, the prominent featuring of the two saints not only adds another regal and military element to the "royal view," it also shows that political considerations were not foreign to the designers of the mosaic program. No doubt the choice of a Byzantine form of decoration is itself a political gesture which must likewise be seen in the light of Roger's political aspirations. On the one hand it befits a ruler who, as a papal legate, occupied a position almost unique in the Western world. Roger certainly conceived his role within his own kingdom as being closely comparable to that of the basileus with its combination of secular and spiritual overlordship. On the other hand the Byzantine decoration also betokens his ambitions in the international field. Indeed, it was perhaps primarily as a potential usurper of the imperial crown that Roger, who allowed himself to be addressed and portrayed as a basileus,[129] laid claim to a Byzantine setting.

Yet, if the interpretation of these mosaics which has been offered in the foregoing pages is accepted it must also be conceded that Roger's artists have used Byzantine church decoration in a manner in which it hardly could have been used by any basileus. There were, to be sure, in Byzantium close ties between religious and imperial iconography. Christian art in its formative stage had borrowed from imperial imagery many motifs which helped to underline its own triumphal character.[130] In the period after the iconoclastic controversy the barriers separating the two spheres broke down to a large extent. The emperor was usually depicted in the company of sacred figures.[131] The celestial choirs were cast firmly in the mold of a court hierarchy. The hierarchical principles which govern all Byzantine imagery are nowhere more apparent than in the system of church decoration. But this system is timeless and impersonal. It is an embodiment of a Christian cosmos. The details of the arrangement may differ from case to case and the symbolical interpretations may also vary.[132] But the hierarchy of images always stands for an objective order and helps to make of the church a symbol of the Christian universe and the economy of Salvation. In this system the

footnote. According to the Anonymus ad Petrum, Louis himself also visited Palermo, whither he was conducted by Roger with great honors (*Occurrit ergo ei et adductis equitaturis ad sufficienciam perduxit eum Panormiam cum summo honore, et tam illum quam omnes suos multis donariis studuit honorare, op.cit.*, p. 19). This passage, however, has been discounted by historians (cf. Kugler, *op.cit.*, pp. 210f. n. 15), and probably rightly, since Louis himself, in his letters to Suger (*Recueil*, XV, pp. 513, 518), makes no mention of such a visit. A farcical account of the French King's alleged visit to Palermo is given by Bernardus Thesaurarius (thirteenth century) in his *Liber de Acquisitione Terrae Sanctae*, ch. CXXVI (L. A. Muratori, *Rerum Italicarum Scriptores*, VII, Milan, 1725, cols. 766f.).
127. Cf. the passage in the Monte Cassino Chronicle quoted in footnote 125 above, and Louis' letter to Suger, *Recueil*, XV,

pp. 518f., no. XCVI.
128. Cf. letters from Abbot Peter of Cluny to King Roger (Migne, *PL*, CLXXXIX, col. 424) and from King Konrad III to Empress Irene (Ph. Jaffé, *Bibliotheca Rerum Germanicarum*, I, Berlin, 1864, p. 365). Caspar, *op.cit.*, pp. 406f., also places in this period the undated exchange of letters between King Roger and Abbot Suger (Migne, *PL*, CLXXXVI, cols. 1415, 1417).
129. Cf. my forthcoming paper on the portrait of Roger II in the Martorana, to be published in a volume of studies in honor of Pietro Toesca (*Proporzioni*, III).
130. Grabar, *L'Empereur*, pp. 192ff.
131. *Ibid.*, pp. 173ff.
132. For a recent study of this subject see Demus, *Byzantine Mosaic Decoration*, pp. 14ff.

christological cycle and the choirs of saints have their allotted places and their specific functions.[133] A one-sided stress of the royal theme within the life of Christ, an underscoring of this theme by means of the accompanying figures of saints, and, above all, a centering of this whole group of images on a single spectator (even though it be the ruler himself)—all these things are hardly conceivable in Byzantium. The arrangement in the Cappella Palatina is not objective, but subjective. It is designed to gratify the king, who apparently was to find reflected in the sacred images his own militant power and his own real and anticipated triumphs. The use of religious imagery for such purposes is not altogether foreign to Byzantium.[134] But one may doubt whether in a Byzantine church sacred icons depicting the incarnate life of Christ or choirs of saints could have been used in this fashion. The Normans failed to understand or chose to ignore the true role of the icon in a Byzantine church, namely, to serve as a mystic enactment of a body of eternal and universal truths on which the empire was founded and of which the emperor was the principal custodian. Instead, the Normans made of at least part of the church decoration a paean to the king. Since their adoption of Byzantine imagery was probably bound up from the outset with practical politics, this change of emphasis is perhaps only logical.[135]

At present this interpretation of the mosaics in the Cappella Palatina can be proposed only as a hypothesis. It will remain a hypothesis as long as there is so much uncertainty on basic archaeological questions, such as the date of the loggia in the northern wing of the transept and the degree to which restorers may have falsified the style of certain mosaics crucial to the establishment of a secure chronology. Even an inquiry which, like the present one, is concerned only with the broad layout of subject matter must remain tentative until a firm basis can be provided by a close investigation of archaeological details.

Meanwhile, however, the interpretation offered in these pages can perhaps claim a certain inner plausibility. It is in keeping with the "enlightened" atmosphere of King Rogers court[136] and its sober and practical approach to religious matters.[137] Where there were so many different peoples and creeds religious dogma could not play the role of a universal and objective norm which it played in Byzantium. The state became viable only on the basis of extreme religious tolerance, avoidance of theological argument, and an extraordinary emphasis on the person of the ruler.

It is not surprising to find religious imagery also pressed into the service of this central idea. The phenomenon has a striking parallel in certain liturgical formulae which have been ascribed to Norman Sicily and which likewise display an unprecedented concentration on the royal person and the royal theme.[138] Furthermore, what we have found in the Sicilian mosaics perhaps is related to other phenomena in Western art of the same period. The boldest innovation in the design of Abbot Suger's new façade of the Abbey Church of St. Denis, royal burial church and symbolic if not actual seat of power of the French monarchy, was the prominent representation, in the form of column statues, of Biblical kings and queens, who were antecedents not only of Christ but of the

133. See above, p. 274.
134. Cf. the representation of Old Testament heroes and their deeds as prototypes of the emperors and their victorious exploits (Grabar, *L'Empereur*, pp. 95ff.; K. Weitzmann, *The Joshua Roll*, Princeton, 1948, pp. 113f.).
135. The portrayal of Roger II in the Martorana offers an analogous phenomenon; cf. my forthcoming paper quoted in footnote 129 above. It should be emphasized that the presence of un-Byzantine elements in the program of the mosaics in the Cappella Palatina, which this analysis has disclosed, does not, or at least not necessarily, have any bearing on the question of whether or not the executing artists were Byzantines. A clear distinction must be made between the design of the program (i.e. the choice of subjects and their distribution in the church) and the work on the mosaics themselves.
136. Caspar, *op.cit.*, pp. 436ff.; C. H. Haskins, *Studies in*

the History of Medieval Science, Cambridge, Mass., 1927, pp. 155ff.
137. Caspar, *op.cit.*, pp. 9ff., 446f.
138. Cf. Kantorowicz' analysis of the Laudes of Palermo, which he ascribes to Norman times (*Laudes Regiae*, pp. 157ff.): "There is no haggling over . . . symbols of spiritual or secular supremacy. Here the state has engulfed the Church. . . . It is the idea of royal absolutism in its then harshest form. . . ." Cf. also the same author's discussion of a South Italian variant of the finale of the Exultet, which he ascribes to the early twelfth century and which includes the martial triad . . . *vivis, regnas, imperas* . . . *Jhesu Christe* reminiscent of the *Christus vincit, Christus regnat, Christus imperat* of the Laudes Regiae (*Harvard Theological Review*, 1941, pp. 129ff.).

French kings as well. The theme was taken over soon afterwards at Chartres on the portal that is known even now—and was known already in the Middle Ages—as the Portail Royal.[139]

The comparison with St. Denis and Chartres cannot, of course, be sustained on the level of concrete detail either iconographic or stylistic. It concerns such elusive factors as the thoughts which may have motivated the designers of these programs and their mental attitudes towards religious imagery and its role in the church building. Scientific precision is difficult to achieve in such matters. Yet it is probably true to say that the mosaics of the Cappella Palatina, however Byzantine they may be in appearance, bear the imprint of a spirit ultimately more akin to the courtly and worldly atmosphere of the Ile de France than to the politico-religious mysticism of the Eastern Empire.

139. E. Houvet, *Cathédrale de Chartres. Portail Occidental ou Royal*, n.d., p. 2, n. 1, traces the name "Portail Royal" back as far as the first half of the thirteenth century.

FIG. 1. Cappella Palatina, Sanctuary, transversal section,
looking east (after Terzi)

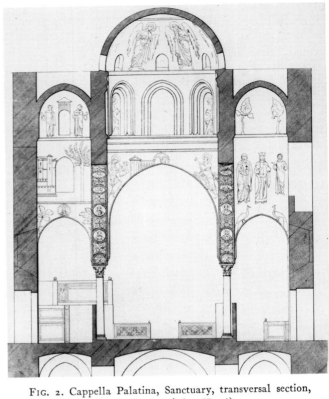

FIG. 2. Cappella Palatina, Sanctuary, transversal section,
looking west (after Terzi)

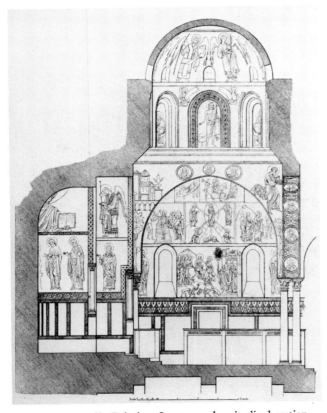

FIG. 3. Cappella Palatina, Sanctuary, longitudinal section,
looking south (after Terzi)

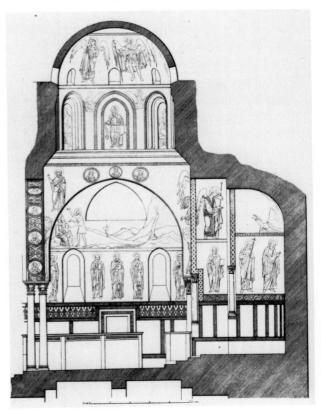

FIG. 4. Cappella Palatina, Sanctuary, longitudinal section,
looking north (after Terzi)

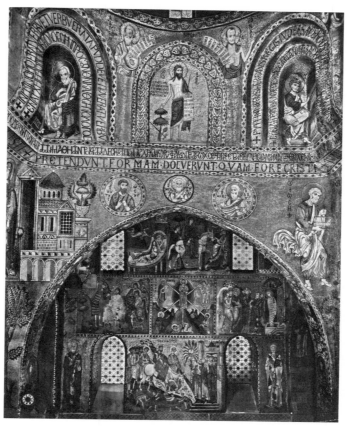

FIG. 5. Cappella Palatina, View across transept, looking south

FIG. 6. Cappella Palatina, Transept, northern wall

FIG. 13. Monreale, Cathedral, Sanctuary, western arch: *Nativity, Presentation in the Temple, Christ Among the Doctors, Prophets Malachi and Isaias* (composite print after Gravina)

FIG. 7. Cappella Palatina, Transept, southern wall: *Flight into Egypt* (after Buscemi)

FIGS. 8-11. Roman coins and medallions with *adventus* scenes: 8. Constantius Chlorus, Redditor Lucis Aeternae, Londinium. 9. Constantine, Adventus. 10. Tacitus, Adventus. 11. Commodus, Adventus

FIG. 12. Cappella Palatina, Sanctuary, western arch: *Presentation in the Temple*

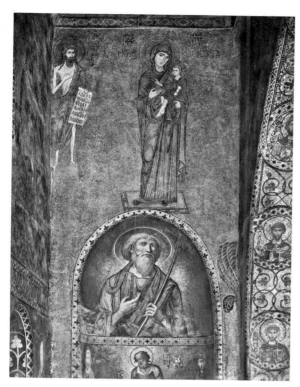

FIG. 14. Cappella Palatina, Transept, northern wing, east wall:
Hodegetria, St. John the Baptist, Apostle Andrew

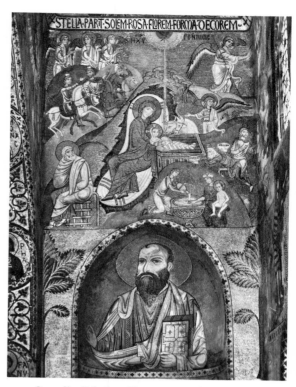

FIG. 15. Cappella Palatina, Transept, southern wing, east wall:
Nativity, Apostle Paul

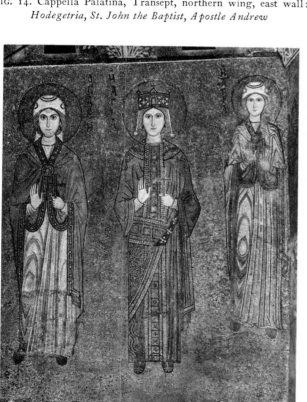

FIG. 16. Cappella Palatina, Transept, northern wing; west wall:
three female saints

FIG. 17. Palermo, Martorana:
Nativity

FIG. 18. Cappella Palatina, Transept, southern wing, south wall: *Entry into Jerusalem*

FIG. 19. Cappella Palatina, Transept, southern wing, vault: *Pentecost*

FIG. 20. Cappella Palatina, Dome

FIG. 21. Cappella Palatina, Transept, southern wing: Bust of Christ in eastern lunette of vault

FIG. 22. Cefalù, Cathedral, Main apse: *Pantokrator*

FIG. 23. Cappella Palatina, Main apse: *Pantokrator*

FIG. 24. Monreale, Cathedral, Main apse: *Pantokrator*

XI

ON THE PORTRAIT OF ROGER II
IN THE MARTORANA IN PALERMO

THE famous mosaic in the church of the Martorana in Palermo with the representation of King Roger II receiving his crown from Christ /figura 1/ is essentially a political manifesto. The king wears the costume of a Byzantine emperor, as he does on several of his coins and on his seals [1], and the pose in which he is shown is familiar from Byzantine imperial imagery [2]. That this is a reflection of Roger's ambitions during the later years of his highly successful career is evident from literary sources. He not only allowed himself to be addressed as « Basileus » [3], he is said to have demanded from an emissary of Manuel Comnenos that his rank should be recognized as being equal to that of the Emperor [4]. Indeed, there is reason to believe that during and after the Second Crusade he hatched far-reaching plans of ousting the Comnenian dynasty and setting up a Latin Kingdom on the Bosphorus [5].

« *Te Rogere potens, tu maxima gloria regum*

.

Grecia te timet et Syria et te Persa veretur

.

Te dignum imperio solum diiudicat orbis » [6].

There is additional significance in the choice of the particular theme of the granting of the crown by Christ. The implication is that Roger owes his crown not to any earthly power but to God alone. It is the pictorial equivalent of the « a deo coronatus » formula. Expressions to this effect occur frequently in Roger's documents and in eulogies addressed to him [7]. The concept was common among medieval rulers, but it was apt to receive particular emphasis whenever there was a question of challenging the claims of the Church. It is not pure accident, for instance, that the same iconographic theme of the deity crowning the ruler had so great a vogue in Germany under the Ottonian emperors, whose entire policy was predicated on the thesis that the pope was not an indispensable mediator between themselves and heaven. Nor is it a coincidence that theme disappears from German imperial iconography during

the period of the Investiture Controversy [8]. Roger was on safer ground than most Western rulers in claiming a large measure of independence from the pope; his status as an Apostolic Legate made him at least semi-autonomous within his own state in religious matters [9]. No doubt the choice of the « a deo coronatus » theme for the Martorana mosaic must be seen in this light [10].

Roger's status vis-à-vis the Church was in effect not dissimilar to that of the Basileus. Thus his portrayal in the guise of a Byzantine emperor becomes even more meaningful. The figure of the Basileus came nearest to epitomizing the role Roger meant to play within his own kingdom, a role of ecclesiastic as well as secular overlordship. The view frequently expressed that his attire on the Martorana panel reflects the grant of episcopal insignia by the pope is certainly without foundation [11]. But in an indirect way the picture does symbolize the clerical dignity to which he laid claim. The image of the Basileus serves to express not only Roger's ambitions in the international field but also the concept of « rex et sacerdos » [12].

Thus the use of a Byzantine iconographic model for Roger's portrait is intensely meaningful. Yet it seems to me that the panel has one peculiarity which is essentially un-Byzantine, and betrays the fact that Roger was, after all, a Western ruler. The feature I have in mind is a certain facial resemblance between Roger and Christ. I was struck by this resemblance when standing in front of the mosaic itself and was encouraged to consider it as more than a purely individual and subjective impression when I found that something of this kind had occured also to others [13].

It is difficult to say to what extent the resemblance may be conditioned by Roger's actual appearance. His portraits on coins and seals are too generic and their reproductions too inadequate to permit detailed physiognomic comparisons [14]. The literary « portrait » of the King sketched by Romuald of Salerno merely speaks of his « leonine face » [15]. But regardless of what basis Roger's actual features may have provided for establishing a physiognomic relationship between him and Christ, it can hardly be doubted that the artist has accentuated these features in striking fashion [16]. The King is transfigured; his image is assimilated to a higher ideal [17], indeed, to as high an ideal as it was possible for medieval man to conceive.

The portrait thus becomes a visual counterpart to the hyperbolic praise heaped upon Roger by the preacher Philagathos (« Theophanes Kerameus ») in his sermons held at the Norman court. When the painter models the King's face after that of Christ he exalts him in the same way in which the preacher does by addressing him as « σωτήρ » or by referring to his « χριστομίμητος γαληνότης » [18].

Such expressions admittedly occur also in Byzantine panegyrical literature. The underlying ideas of the ruler, the « christus domini », as a vicar or simile of Christ were widespread in the medieval world, both in the East and in the West [19]. But it is not likely that an artist in Byzantium would have taken it upon himself to express these ideas in visual terms. What is involved here is the role of the image, and particularly of the Christ icon, in religious thought [20]. In the West the image was merely a reminder, a means of evoking that which is not present to the eye. But to the Eastern orthodox mind the icon was much more than this. It was not an idol as the iconoclasts charged. But it was an essential manifestation of Christ's nature. The fact that Christ could be depicted in line and colour was one of the crucial proofs of His

incarnation. The struggle over the images, which shook the Byzantine Empire during the eighth and ninth centuries, was really a sequel to the earlier controversies over the true nature of Christ, with the icon, as it were, as a test case. From this controversy the icon emerged as a sacred proof of the Word Incarnate. God could be portrayed because He had adopted a human form, and, indeed, an *individual* form different from any other human being [21].

Thus there was in Byzantium a strong theoretical objection against the portrayal of any other person — and be it the emperor himself — in the likeness of the Saviour. No matter how hyperbolic the praise which may be heaped on the emperor in panegyrical language, the visual image of Christ could not easily be used in this loose and rhetorical manner. The deified ruler portrait of classical times [22] was not likely to find a succession in Byzantium.

In the West, however, where the Christ image was not charged with such profound theological significance, a reflection of it could serve more readily to enhance the glory of a mortal man. Characteristically enough, it is the German imperial imagery of the Ottonian period which provides a precedent for Roger's portrait also in this respect. Several portraits of the emperors of the Saxon dynasty have been thought to be modelled after the image of Christ [23]. Naturally, in such cases it is rarely possible to decide whether the resemblance is intentional and meaningful. But there is one instance which leaves little room for doubt about the artist's intention, since the Christ image is used as a model not so much for the facial features of the emperor but for the setting in which he is placed. I refer to the well-known dedication picture in the Gospel book of the Cathedral Treasury at Aix-la-Chapelle [24]. On this miniature one of the Ottos (the Second or Third of the name) is shown enthroned inside a mandorla; he is surrounded by the symbols of the four evangelists and supported by a personification of « Terra », while the hand of God places a crown upon his head. No other medieval artist ever went so far in assimilating the portrait of a ruler to that of Christ.

It is in keeping with this Western precedent if Roger's artist models the King's features after those of Christ. The Martorana mosaic, Byzantine in every other respect, is separated from the Greek sphere through this one peculiarity. It is Byzantine, but with a Western twist.

There is a parallel phenomenon in another work of Roger's period. The arrangement of the mosaics in the sanctuary of the Cappella Palatina, though modelled after Byzantine patterns, deviates in certain ways from the fixed rules of Byzantine church decoration. As I hope to show elsewhere, the purpose of these deviations seems to be to establish a specific relationship between Christ and the person of the King. The Palermitan court artists certainly had their eyes fixed on the Greek East. But untroubled by the subtleties of Greek theological speculation, they broke through certain unwritten laws of Byzantine iconography, in order to emphasize even more than the Byzantines did the absolute supremacy of the monarch. Unlike the Eastern Empire the young Norman state lacked the firm foundation of a uniform creed evolved through centuries of bitter struggles. Roger's Sicily was a medley of cultures, languages and religions and lacked the objective norm of a dogma binding for all. The only nor-

mative element was the King himself. No means was neglected to exalt his power and the divine majesty of his person.

Marc Bloch warns us, I think rightly, that medieval statements on the divinity of rulers should not be taken too literally because their blasphemous implications were well understood [25]. And yet, as he says, « les mots (or, we may paraphrase him, ' les images ') ne sont jamais tout à fait séparables des choses ».

NOTE

1/ A. ENGEL, *Recherches sur la Numismatique et la Sigillographie des Normands de Sicile et d'Italie*, Paris 1882, pl. I, nos. 11-14, pl. VI, nos. 24, 29, 30. Cf. K. A. KEHR, *Die Urkunden der Normannisch-Sizilischen Könige*, Innsbruck 1902, pp. 204, 206, 216 ff. S. H. STEINBERG, *I ritratti dei re Normanni di Sicilia*, in « Bibliofilia », 39, 1937, p. 5 of offprint.

2/ A. GRABAR, *L'Empéreur dans l'art Byzantin*, Paris 1936, pp. 116 ff. The closest parallel is an ivory in Moscow (*ibid.* pl. 25, 1; A. GOLDSCHMIDT & K. WEITZMANN, *Die Byzantinischen Elfenbeinskulpturen*, vol. II, Berlin 1934, pl. 14 no. 35 and p. 35f.).

3/ Cf. e. g. the homilies of Philagathos (« Theophanes Kerameus »): MIGNE, *Patrologia Graeca* 132, cols. 541C, 952 B. For the identity of the author see A. EHRHARD, *Überlieferung und Bestand der hagiographischen und homiletischen Literatur der griechischen Kirche*, Part I, vol. III, fasc. 5, Leipzig 1943, pp. 631 ff.

4/ *Joannis Cinnami Historiarum Lib. III* (Migne: PG 133, col. 420B).

5/ Cf. the analysis of events particularly in 1147 and 1149/50 by E. CASPAR, *Roger II (1101-1154) und die Gründung der normannisch-sizilischen Monarchie*, Innsbruck 1904, pp. 377ff, 403ff.

6/ Anonymous poem on Rouen quoted by E. KANTOROWICZ, *Laudes Regiae*, Berkeley and Los Angeles 1946, p. 158, n. 8.

7/ Cf. e. g. the preamble to the Assise: « a largitate divina gratia consecuta recepimus.... » (F. BRANDILEONE, *Il diritto Romano nelle leggi Normanne e Sveve*, Torino 1884, p. 94); also a document for San Salvatore in Messina, dated 1131: « (Christ)παρ' οὗ καὶ τὸ στέφος ἠλήφαμεν » (CASPAR, *loc. cit.*, Regesten no. 69); peroration of a homily of Philagathos (see above n. 3) addressed to Roger: « ὁ δοὺς αὐτῷ τό κράτος Χριστός » (Migne: PG 132, col. 969B); and a passage referred to by Mons. F. Pottino, in « Archivio Storico Siciliano », N. S. vol. 52, 1932, p. 41, n. 2.

8/ P. E. SCHRAMM, *Die deutschen Kaiser und Könige in Bildern ihrer Zeit*, Leipzig 1928, p. 73f. STEINBERG, *loc. cit.*, p. 17.

9/ For the Norman kings' role as apostolic legates cf. F. CHALANDON, *La domination normande en Italie et en Sicile*, Paris 1907, II, pp. 617 ff. Cf. also the grant of episcopal insignia by the pope (*Monumenta Germaniae Historica, Scriptores Rerum Germanicarum, Ottonis et Rahewini Gesta Frederici* I, ed. Waitz, 1912, p. 46), which, however, was intended perhaps not only as a confirmation but also as a limitation of Roger's ecclesiastical powers. The insignia granted to Roger also figure in the imperial coronation ordo known as « Cencius II », where the ceremony is accompanied by the words « ibique fatiit eum clericum » (P. E. SCHRAMM, in « Archiv für Urkundenforschung », XI, 1929-30, pp. 379 ff.). Both SCHRAMM (*ibid.* pp. 322ff.) and KANTOROWICZ (*loc. cit.*, pp. 329ff.) argue against the 10th — 11th century date previously assigned to this ordo and date it in the late 12th century. Its similarities to episcopal consecrations are interpreted by Schramm as an attempt by the curia to regularize the emperor's position in relation to the hierarchy. The grant of insignia to Roger II may be a precedent for this.

10/ Surely the choice of this iconographic type implies a challenge to the pope — and to the basileus, who claimed it for himself — rather than to the German emperor, as Steinberg maintains (*loc. cit.*, p. 18).

11/ For the grant of episcopal insignia see above n. 9. The thesis that there exists a connection between this grant and Roger's attire on the Martorana mosaic was advanced as long ago as 1832 by GIAMPALLARI (*Discorso sulle sagre insegne de' re di Sicilia*, Napoli 1932) and repeated by many others. The thesis was rejected by STEINBERG (*loc. cit.*, p. 16) and L. T. WHITE, Jr., *Latin Monasticism in Norman Sicily*, Cambridge, Mass., 1938, p. 127f. n. 4.

12/ « Regni officium quodquam sibi sacerdotii vendicat privilegium », says Roger in the preamble to the Assise previously quoted (see above n. 7). The statement is based on a passage in the opening paragraph of Justinian's Digest. For the use of this passage in the Middle Ages see also M. BLOCH, *Les rois thaumaturges*, Strasbourg 1924, p. 187 f., n. 3.

13/ H. PEIRCE & ROYALL TYLER, *Three Byzantine Works of Art* (« Dumbarton Oaks Papers », II), Cambridge, Mass., 1941, p. 7; H. P. L'ORANGE, *Apotheosis in ancient portraiture*, Oslo 1947, pp. 102, 147, n. 54. These authors have in mind primarily Roger's long hair descending to the shoulders like that of Christ. The feature certainly is unusual at this period (cf. L'ORANGE, *loc. cit.*, p. 31 and BLOCH, *loc. cit.*, p. 60f. for the privilege claimed by the Merovingian kings to wear their hair long: « Les *reges criniti* étaient autant de Samsons »). Curiously enough one of the few examples of a Byzantine emperor wearing long hair is on the ivory in Moscow, whose composition affords a close parallel to the Martorana mosaic (see above n. 2). But on the mosaic the resemblance between the King and Christ is not confined to the hair style and extends to the face as a whole. The King's head seems to be in reasonably good condition, though Mons. Pottino warns that the features are « sgraziate alquanto » (*loc. cit.*, p. 82, n. 1).

14/ Cf. the illustrations by Engel quoted above n. 1, and the remarks by KEHR (*loc cit.*, p. 206f. n. 7) and STEINBERG (*loc. cit.*, p. 6f).

15/ *Romualdi Salernitani Chronicon*, ed. C. A. Garufi (L. A. MURATORI, *Rerum Italicarum Scriptores*, vol. VII, part. I), fasc. 3, Bologna 1928, p. 236 line 12.

16/ On the enamel plaque in Bari, which shows Roger receiving his crown from St. Nicholas, the King's countenance also seems to be somewhat Christ-like, if the reproduction in the « Monuments Piot » (vol. VI, 1898, pl. VI) can be trusted.

17/ For this procedure in medieval portraiture cf. G. B. LADNER, *I ritratti dei Papi nell'Antichità e nel Medioevo*, I, Città del Vaticano 1941, pp. 3ff.

18/ Migne: PG 132, cols. 541C, 952B. For the author see above n. 3.

19/ For the basileus addressed as « σωτήρ » cf. the panegyric on Manuel Comnenos by Eustathius of Thessalonica (W. REGEL, *Fontes Rerum Byzantinarum*, I, St. Petersburg 1892, pp. 24ff); for « χριστομίμητος » cf. Theophanes Continuatus, ed. Bonn 1838, p. 447 line 7. I owe these references to my colleagues Professors Dvornik and Downey respectively. The imitation of the deity by the ruler is an old pagan concept applied to the Christian emperor already by Eusebius (*De Laudibus Constantini*, Migne: PG 20, col. 357A), whose panegyrics of Constantine contain many comparisons between the Emperor and Christ (cf. the passages collected by L'ORANGE, *loc. cit.*, p. 126f.). For Western medieval rulers likened to Christ cf. the references given by P. E. SCHRAMM, in « Vorträge der Bibliothek Warburg », 1922/23, p. 201, n. 193; G. TELLENBACH, *Libertas*, Stuttgart 1936, pp. 73ff. and n. 30, p. 176f.; and KANTOROWICZ, *loc. cit.*, p. 126f. Cf. also a curious incident in the « Pèlerinage de Charlemagne », a poem of the Crusader period: Charlemagne upon his arrival in Jerusalem sits down on the sealed chair of Christ, while his twelve vassal kings occupy the chairs of the apostles around him (verses 113 ff.; text by E. KOSCHWITZ in « Altfranzösische Bibliothek », 5th edition by G. Thurau, Leipzig 1907, p. 9f.). The poet evidently was quiete aware that the action he imputed to his hero might be considered blasphemous.

20/ Cf. for what follows P. LUCAS KOCH, *Zur Theologie der Christusikone*, in « Benediktinische Monatsschrift », 1937 and 1938.

21/ KOCH, *loc. cit.*, 1938, pp. 281ff.; cf. particularly the passage he quotes from Theodore the Studite (Migne: PG 99, col. 405-B, C).

22) L'ORANGE, *loc. cit.*, passim.

23/ SCHRAMM, *Die deutschen Kaiser und Könige....* p. 94 f. (portrait of Otto III in Clm., 4453 f. 247); p. 112 (portrait of Henry II in clm. 4456 f. 11 r). It was Prof. G. Ladner who first drew my attention to these observations by Schramm.

24/ SCHRAMM, *ibid.*, p. 81 ff. and fig. 64. A. GOLDSCHMIDT, *German Illumination*, vol. II: *Ottonian Period*, Firenze - New York, n. d., pl. I. L'ORANGE, *loc. cit.*, p. 123, fig. 94.

25/ *loc. cit.*, p. 354.

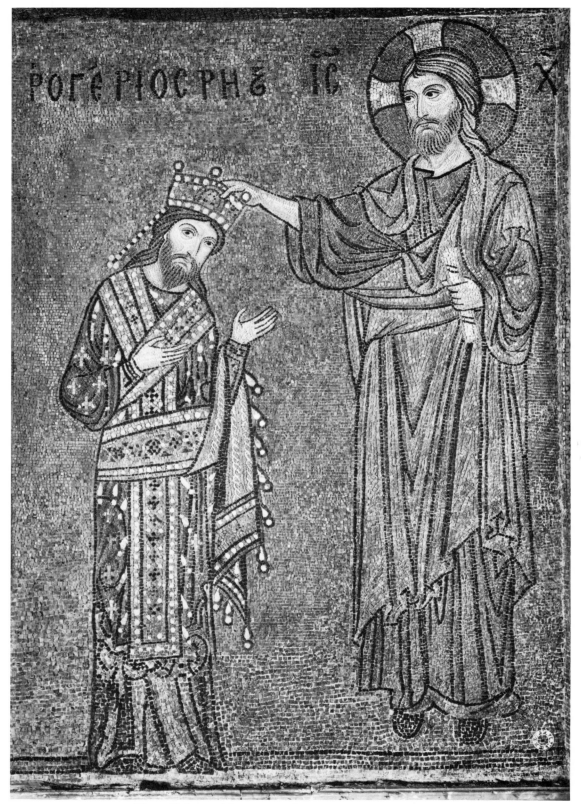

Fig. 1 Palermo, Martorana: Christ crowning King Roger II

XII

WORLD MAP AND FORTUNE'S WHEEL: A MEDIEVAL MOSAIC FLOOR IN TURIN

WHEN THE White House was being renovated in the early 1950's, Mr. Truman gave orders that the Presidential Seal be raised from the floor of the Reception Room and displayed in a place of honor above the door. The President explained at the time that it annoyed him to see the Seal desecrated by having people walk on it.[1]

Mr. Truman was voicing an age-old sentiment. In many periods in the past there has been sensitivity particularly in regard to religious symbols or representations on floors. As early as 427 A.D., the Byzantine emperor Theodosius II issued a decree prohibiting the representation of the "sign of Christ" (i.e., the cross) on pavements.[2] In the twelfth century, St. Bernard of Clairvaux, writing about the church floors of his time, protested in language more forceful and picturesque than Mr. Truman's against images of saints being ground underfoot and the faces of angels being spat on.[3] Obviously, in the decoration of churches the difficulty presents itself in an especially acute form. This paper will be about one particular church floor, of a period not far distant from St. Bernard's, in which the problem was solved in a rather interesting and illuminating fashion.

It was, of course, easy to avoid the whole difficulty by leaving the floor unadorned or by decorating it with abstract and ornamental designs only. This was normal practice during many periods of Christian art. At other times, however, there was a strong urge to make the floor a meaningful and articulate part of the over-all design and to give it an active share in the message which the church building as a whole and its interior decoration in particular were meant to convey. To do this without inviting desecration—this was the rub.

The problem presented itself to the designers of churches from the outset. Indeed, it was the formative period of ecclesiastical architecture, beginning with the official recognition of the Christian religion under Constantine in the early fourth century, which brought with it the first flowering of Christian pictorial floor decoration.[4] Pavement mosaic had been a ubiquitous and highly diversified medium in the Graeco-Roman world; and the craft carried over into the buildings of the triumphant church by the sheer momentum of its tradition. In the ensuing three or four centuries a range of suitable subject matter was established largely by a process of selection from and adaptation of the existing repertory of motifs and only to a much lesser degree by the introduction of new and specifically Christian themes. Very occasionally even a subject from classical mythology—Orpheus, for instance, playing his lyre to an assemblage of animals [5]—was taken over, with a motivation that is not always entirely clear to the modern observer. By far the richest store of usable images, however, was that pertaining to the world of nature and country life. Plants, animals, birds, and fishes, as well as hunting, fishing and other rural genre scenes were subjects of an essentially neutral kind and were readily absorbed into ecclesiastical settings. Such motifs

[1] *New York Times*, March 4, 1952. *Cf.* E. B. Morris (ed.), *Report of the Commission on the Renovation of the Executive Mansion* (U. S. Government Printing Office, 1952), p. 74.

[2] *Codex Justinianus*, I, 8, 1 (ed. P. Krueger [Berlin, 1954], p. 61).

[3] S. Bernardus, *Apologia ad Guillelmum Sancti-Theoderici abbatem*, ch. 12 (Migne, *Patrologia Latina*, 182, col. 915). English translation in G. G. Coulton, *Life in the Middle Ages* (New York and Cambridge, 1930) 4: p.173f.; *cf.* E. G. Holt, *Literary Sources of Art History* (Princeton, 1947), p. 18.

[4] Outstanding among the floor mosaics of this period are those in the twin churches built by Bishop Theodore at Aquileia (P. L. Zovatto, *Mosaici Paleocristiani delle Venezie* [Udine, n.d.], p. 63 ff.).

[5] *Cf.* a well-known pavement in the Archaeological Museum, Istanbul, found in the excavation of a Christian chapel in Jerusalem (A. Grabar, *The Golden Age of Justinian* [New York, 1967], p. 112 and fig. 119).

lent themselves to a variety of symbolic uses. Often they served to conjure up a vision of an idyllic garden landscape or paradise, and sometimes the reference was made quite specific by including, in the form of traditional personifications of river gods, the four rivers that flowed from the Garden of Eden.[6] Motifs from the same repertory could be selected and arranged to point up a specific Biblical theme such as Isaiah's vision of the Peaceable Kingdom ("the lion shall eat straw like the ox")[7] or the same prophet's Parable of the Vineyard.[8] They could be keyed to a liturgical action such as baptism,[9] the offertory rite[10] or even the eucharistic sacrifice.[11] Or else—and this is a category for which some examples will be noted in more detail later in this study—they could, in conjunction with other representations of the physical world such as sun and moon, cities and countries or personified months, seasons, and winds, present the faithful with a kind of encyclopedic view of creation.[12] All this could be done without incurring the risk

of desecration. For more explicitly Biblical subject matter there was the world of the Old Testament. Stories such as those of Jonah and Daniel, popular in all branches of Early Christian art, could be put on the floor with impunity.[13] The limit was reached with representations such as the Good Shepherd[14]—a direct reference to Christ which soon was banished from the floor—and the cross, which was the subject of Theodosius's edict.[15] Despite that imperial prohibition, however, crosses were occasionally depicted on floors even after it was issued.[16]

The first great flowering of Christian pictorial floor decoration came to an end in the chaotic conditions that engulfed the Mediterranean world in the seventh century. But a second such wave occurred in the eleventh and twelfth centuries, along with the rise of Romanesque architecture in Europe. It was this vogue, centered in France, the Rhineland, and Italy, that occasioned St. Bernard's perhaps somewhat exaggerated outburst. Again the world of nature—the animal kingdom in particular—furnished most of the models; again one finds a variety of genre scenes as well as encyclopedic and cosmographic subjects; and once more it was the Old Testament that provided most of the specifically religious themes.[17] What connection there may be between this second vogue of Christian floor decoration and the early one is still obscure. Only a trickle of examples from the intervening centuries links the two.[18] There are cases of mosaicists of the Romanesque period copying ornamental patterns of much

[6] See, for instance, the floor of a sixth-century church in Qasr el-Lebya (A. Grabar, in: *Bulletin de la société nationale des antiquaires de France*, 1968: p. 45 ff.); for other examples see H. Kier, *Der mittelalterliche Schmuckfussboden*, Die Kunstdenkmäler des Rheinlandes, Beiheft 14 (Düsseldorf, 1970): p. 71 and fig. 284.

[7] Isaiah 11, 7. *Cf.* floors at Ma'in (*Revue biblique* **47** [1938]: p. 227 ff., especially p. 233 f.); Korykos (E. Herzfeld and S. Guyer, *Meriamlik und Korykos*, Monumenta Asiae Minoris Antiqua 2 [Manchester, 1930]: p. 106 ff.); Karlik (M. Gough, in: *Türk Arkeoloji Dergisi* **9**, 2 [1959]: p. 5); and, in the West, at Mariana, Corsica (G. Moracchini-Mazel, *Les monuments paléochrétiens de la Corse* [Paris, 1967], p. 24 ff. and figs. 23, 27 f.).

[8] Is. 5, 1 ff. *Cf.* a floor in Ancona (G. B. de Rossi, in: *Bullettino di Archeologia Cristiana*, ser. 3, **4** [1879]: p. 128 ff. and pls. 9–10).

[9] *Cf.*, e.g., a well-known floor in the Baptistery at Salona, which shows a pair of drinking deer accompanied by an inscription citing Ps. 41(42), 1 (*Forschungen in Salona* 1 [Vienna, 1917]: p. 77 and pls. II–III).

[10] This is the most likely interpretation of the "genre figures" busying themselves with various edibles in the central compartment of the floor decoration in the southern of the two churches at Aquileia (Zovatto, *op. cit.* [*supra*, n. 4], figs. 85–89 and pp. 84, 100).

[11] *Cf.* the central figure in the mosaic compartment at Aquileia quoted in the preceding note (Zovatto, *op. cit.*, fig. 83 and pp. 84, 100). Also mosaics on the floors of several sixth- and early seventh-century churches in Jordan showing animals accompanied by a quotation from Psalm 50 (51), 21, a verse which figured in the Byzantine liturgy of the mass (S. J. Saller, *The Memorial of Moses on Mount Nebo* [Jerusalem, 1941], pp. 234 ff., 254 f.).

[12] E. Kitzinger, "Mosaic Pavements in the Greek East and the Question of a 'Renaissance' under Justinian," *Actes du VIe congrès international d'études byzantines* [Paris, 1948] 2 (Paris, 1951): p. 209 ff. See below, p. 369 ff.

[13] For Jonah see, e.g., a famous mosaic at Aquileia (Zovatto, *op. cit.*, p. 86 f. and figs. 92, 94); for Daniel a mosaic at Sfax (*Bulletin archéologique*, 1917: p. CLXII ff.). Elaborate mosaics relating to the stories of Noah and Samson have been found on the floors of a basilica at Mopsuestia, which, however, may be a synagogue rather than a church (L. Budde, *Antike Mosaiken in Kilikien* 1 [Recklinghausen, 1969]; *cf.* E. Kitzinger, in: *Art Bulletin* **55** [1973]: p. 140 ff., and in: *Dumbarton Oaks Papers* **27** [1973]).

[14] Zovatto, *op. cit.*, p. 76 and fig. 77; p. 112 ff. and figs. 110, 112; p. 118 ff. and fig. 116 (Aquileia).

[15] *Supra*, n. 2.

[16] H. Brandenburg, "Christussymbole in frühchristlichen Bodenmosaiken," *Römische Quartalschrift* **64** (1969): p. 74 ff., especially pp. 110 ff., 127. *Cf.* E. Kitzinger, in: *Kyriakon: Festschrift Johannes Quasten* (Münster, 1970) 2: p. 646.

[17] See, in general, Kier, *op. cit.* (*supra*, n. 6), p. 54 ff.

[18] H. Stern, in: *Cahiers de civilisation médiévale* **5** (1962): p. 13 ff. See also *Enciclopedia Universale dell'Arte* **9** (1963): col. 695 f. (*s.v.* "Mosaico"); X. Barral i Altet, in: *Les Cahiers de Saint-Michel de Cuxa* **3** (1972): p. 117 ff.

Fig. 1. Turin, Church of S. Salvatore. Plan of excavation (O. Zocchi, 1909).

earlier date;[19] and the mere fact of the new flowering of the craft may be a revival phenomenon. But it is doubtful that Romanesque artists could have seen a great deal of the earlier iconographic repertory. In their days much of it lay buried under layers of earth and debris, to become accessible again only in modern times through archaeological excavation. Much of it also was outside their geographical reach. Moreover, the similarities between the Early Christian and the Romanesque subject matter are on the whole generic rather than specific. The floors of the eleventh and twelfth centuries are replete with characteristically medieval motifs such as fantastic animals, fables, and personifications of Virtues and Vices. One even finds figures from Arthurian legend and the Song of Roland.[20] It may well be, then, that what these floors have in common with those of the earlier period is largely a matter of a similar response to the basic restrictions inherent in this particular form of church decoration.

The floor to be discussed here is a mature and rather late example of Romanesque art. Its

[19] H. Stern, "Le pavement de la basilique de Pomposa (Italie)," *Cahiers archéologiques* **18** (1968): p. 157 ff., especially p. 162.

[20] Kier, *op. cit.*, p. 63 ff., 68 f., 71 f.

analysis cannot help to throw light on the question of how the new vogue of pavement decoration began. It does, however, invite interesting comparisons with mosaics of the first period and it exemplifies particularly well both the unity and the distinctiveness of the two great phases of Christian pavement decoration. Its designer solved the problem of imagery on the church floor in a manner that was at once traditional and strikingly and specifically medieval.

I

In 1909 excavations on the north side of the Cathedral of Turin brought to light the remains of one of the churches that occupied the area before the Cathedral was built in the late fifteenth century (fig. 1). The church, a three-aisled basilica, was identified as S. Salvatore, a foundation going back to the Early Christian

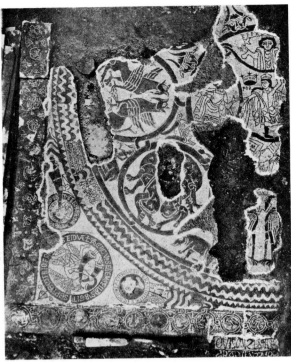

FIG. 3. Mosaic. Lower left-hand portion (*in situ*).

period but rebuilt in early medieval times.[21] The early medieval building in turn was found to have been remodeled subsequently by raising the level of the chancel; and on this raised platform, to which a flight of seven steps gave access from the west, had been laid a rich mosaic pavement which covered the area in front of the altar (figs. 2–11). Originally a square whose sides measured more than 7 meters, the pavement was found in fragmentary condition. Its south side had been truncated when the Cathedral was built. Other lacunae were due to graves subsequently installed in the area. What

FIG. 2. Turin, S. Salvatore. Floor Mosaic in Chancel (detail of fig. 1).

[21] P. Toesca, "Vicende di un' antica chiesa di Torino," *Bollettino d'arte* **4** (1910): p. 1 ff. *Cf.* A. Kingsley Porter, *Lombard Architecture* (New Haven, 1915–1917), **3**: p. 442 ff.; E. Olivero, *Architettura religiosa preromanica e romanica nell'archidiocesi di Torino* (Turin, 1941), pp. 3 ff., 249 ff.; P. Verzone, *L'architettura religiosa dell'alto medio evo nell'Italia settentrionale* (Milan, 1942), p. 37 f. Porter wrongly identified the church as S. Salutore (*sic*) and cited a document of bishop Gezo (early eleventh century) which is relevant to S. Solutore rather than to S. Salvatore. The church of S. Solutore was situated outside the walls and was destroyed by the French in 1536. See C. Brayda, "Vestigia architettoniche dell'Abbazia di San Solutore di Torino," *Società piemontese di archeologia e belle arti, Bollettino*, n.s., **18** (1964): p. 152 ff., esp. p. 153.

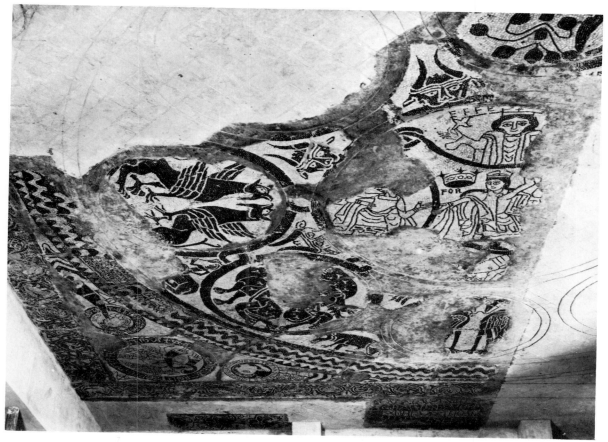

FIG. 4. Mosaic. Lower left-hand portion, as installed in Museo Civico.

remained of the mosaic was lifted shortly after it was discovered and taken to the Museo Civico (Palazzo Madama), where it was installed on the floor of a basement room.[22]

The mosaic, and the excavation as a whole, were published promptly and authoritatively by Pietro Toesca.[23] His article and its accompanying illustrations provide the essential basis of the description which follows. In installing the pavement in the museum, certain changes were made in the arrangement of the fragments; and some details, especially in the inscriptions, have been lost or are no longer discernible.[24] Adjust-

ments subsequently made in Toesca's readings of the inscriptions by P. Gribaudi[25] and F. Patetta[26] will be taken into account when this seems justified.

A person mounting the steps to the chancel was greeted first by a mosaic inscription in four lines in an oblong panel attached to the west side of the main square (fig. 6). The lines of lettering, which were rendered alternately in black on white ground and in white on black ground, were preserved to only about two-thirds of their length and have not yielded a coherent reading. What can be seen now in the museum

[22] The photograph reproduced in our fig. 3 was taken when the mosaic was still *in situ* and shows the main extant portion. Our fig. 2, enlarged from the plan drawing by O. Zocchi which accompanies Toesca's text (our fig. 1), records the remains of the pavement in their entirety.
[23] *Op. cit.* (*supra*, n. 21).
[24] I am indebted to Dr. Luigi Mallé, Director of the Museo Civico in Turin, for the photographs reproduced in figs. 4–11, all of which were taken in the museum. For

changes in the arrangement of the fragments, occasioned by their installation in the museum, see below, nn. 45, 57 f.
[25] P. Gribaudi, "Di un mosaico cosmografico medioevale scoperto a Torino," *Bollettino della Società geografica italiana*, ser. 4, **12**, 1 (1911): p. 619 ff.
[26] F. Patetta, "A proposito del mosaico medioevale scoperto a Torino nel Marzo del 1909," *Atti della Società piemontese di archeologia e belle arti*, **8** (1917): p. 318 ff

corresponds essentially to the transcription given by Toesca:

> QVISQVIS ES IN E. . . .
> GRADIENS SVPER I. . . .
> EXHINC VESTITOS N. . . .
> . . . D . . . RREPATITO. . . .[27]

Evidently this inscription was addressed to the visitor about to step on the mosaic pavement ("Whoever you are . . . stepping over . . ."). But we can only guess at the sentiment which it conveyed to him.[28]

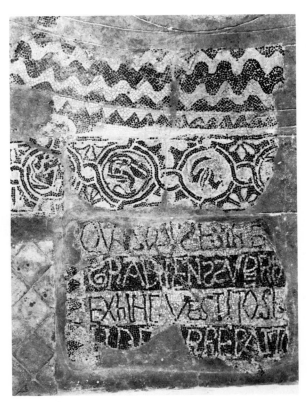

FIG. 6. Mosaic. Inscription at entrance.

The mosaic carpet itself is likewise in black and white, though Toesca noted also some red tesserae made of terracotta.[29] Its basic design consisted of a circle inscribed in a square field, with a smaller circle at its center, eight still smaller circles (interlaced with each other and with both the outer and inner circles) in the space between the two, and circles also in the four spandrels that remain between the outer circle and the square frame. As a purely geometric configuration the design has parallels among opus sectile floors, particularly among the rich pavements executed in that technique in medieval Byzantium and their Italian derivatives.[30] But, as we shall see, in the present instance the

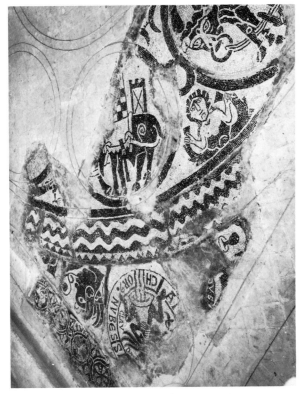

FIG. 5. Mosaic. Lower right-hand portion, as installed in Museo Civico.

[27] Cf. Toesca, *op. cit.*, p. 5. In my transcription, letters whose reading does not appear to be entirely certain are marked with dots. In the last line Patetta (*op. cit.*, p. 323) was able to read several more letters than Toesca. I have indicated what seems to me certain or probable.

[28] The reference to "clothed" persons (line 3) might be said to lend support to Patetta's suggestion (*op. cit.*, p. 324) that the inscription was a commentary on the representation of Fortuna's Wheel in the center of the mosaic. *Cf.* the verse "induo nudatos, denudo veste paratos" put into the mouth of Fortuna in the lost inscription that accompanied the representation of the same subject on the façade of S. Zeno in Verona (*infra*, n. 132). Both in

our mosaic and at S. Zeno the figure at the bottom of the wheel is in fact deprived of much of its clothing. See *infra*, p. 354.

[29] *Op. cit.*, p. 6.

[30] I cite examples at Hosios Lukas (R. W. Schultz and S. H. Barnsley, *The Monastery of Saint Luke of Stiris, in Phocis* [London, 1901], pl. 30 f.); Iznik, St. Sophia (S. Eyice, in: *Dumbarton Oaks Papers* **17** [1963]: p. 373 ff. and figs. 2 ff.); and Monte Cassino (H. Bloch, *ibid.* **3** [1946]: p. 196 f. and fig. 222). See also Kier, *op. cit.*, p. 196 f.

geometry is invested with a very concrete and specific content.

The square frame, which bears a pattern of small interlacing circles filled with various motifs, appears to be purely ornamental. Many of its filler motifs are indistinct, though a few figures of animals and birds and some ornaments, such as rosettes and an angular knot, can be made out (figs. 3, 6–8). It is the large circle inscribed in this square which provides the key to the meaning of the entire composition. That circle is rendered as a broad black band, framed by a narrow black band on the inside and a sawtooth border on the outside, and filled with two wavy white lines which seem to denote water (figs. 3–8). This is indeed how the broad band must be interpreted. For in the lower left-hand section, which is the best preserved part of the band, the "waves" are interrupted by two panels which are literally islands, as witness their inscriptions (figs. 3, 4, 7, 9). One, which is semicircular in shape, bears the words:

BRITANIA
INSVLA INTER
FVSA MARI
ORCADES INSVLE
TILE VLTIMA INSVLA

while the oblong panel immediately to the right is inscribed:

SCOCIA INSV
LA P(ro)XIMA BRI
TANIE VBI
NVLLA ANGV(is).

We are, then, in the presence of a map showing the islands of the far North and West. The legends with which they are inscribed are taken almost verbatim from the *Etymologiae* of Isidorus of Seville.[31] In terms of medieval geographic concepts, the water in which the islands are placed must represent the ocean while the area enclosed by the circle is the *orbis terrarum* girdled by the ocean.[32] Presumably when the mosaic was complete other islands could be seen in other parts of the water band. The spandrels in the four corners outside the "ocean" were given over to representations of

[31] Isidorus, *Etymologiae*, XIV, vi, 2–6 (ed. W. M. Lindsay [Oxford, 1911]): "Brittania Oceani insula interfuso [*sic*] mari . . . Thyle ultima insula . . . Orcades insulae . . . Scotia . . . proxima Brittaniae insula . . . Illic nulla anguis. . . ."
[32] See *infra*, p. 356 f.

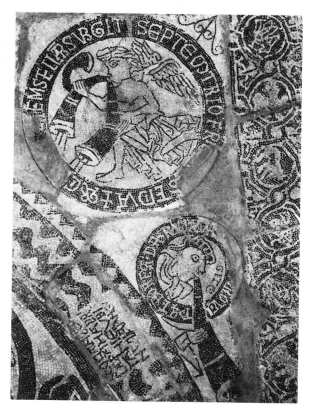

Fig. 7. Mosaic. Two Winds and Island.

winds. A common feature of medieval *mappae mundi*, these are a further indication that the design as a whole is to be understood as a depiction of the world. The scheme of the winds again was derived from Isidorus, who both in his *Etymologiae* and in his *De natura rerum* enumerates and describes (on the basis of earlier authorities) twelve winds, four principal and eight secondary ones. Texts from Isidorus's two treatises accompanied the representations on the mosaic. There must have been three winds in each spandrel, but again only the lower left-hand sector is fully preserved (figs. 3, 4, 7). In it are represented—correctly in terms of the adjacent islands—"Septemtrio," the North Wind, and its two satellite winds, "Aquilo" and "Circius." The principal wind is shown as a full-length figure in a circular frame; the other two appear as heads or busts in much smaller medallions on either side. "Septemtrio" is a winged, semi-nude figure running swiftly to the left. A rich drapery envelopes his legs. He holds to his mouth a curious twin horn from which air can be seen issuing and one half of which has mounted

on it another (smaller) horn curved backwards. The inscription on his frame reads:

SEPTEMTRIO [33] FRI[gidu]S ET NIVALI(s) AB [34] CIRCVLO SEPTEM [35] STELLAR(um) ṠVRGIT.[36]

"Aquilo," placed to the right (or "east") of "Septemtrio," is a profile bust blowing a large horn which projects outside his medallion and which he supports with his hand, also seen outside the frame. His inscription, which is fragmentary and now in part very indistinct, may be read as follows:

[aq]V(i)LO [37] VENT(us) Q(ui) ET BOREAS. DA(t) [38] NVBES ET AQVAS [39] Ṣ[trin]GIT.[40]

[33] That this is the first word of the inscription is indicated by the white dividing line to its left. Apparently all the inscriptions in this spandrel begin above the heads of the figures.

[34] In this tentative reading of what appears to be an unusual ligature I am following Patetta (*op. cit.*, p. 329). Toesca, who does not comment on this feature, evidently took it for a sign separating the end of the inscription from the beginning and started his reading with the word following on the right.

[35] These two words are now largely destroyed but were fully preserved when the mosaic was photographed *in situ; cf.* fig. 3.

[36] For the first part of this legend *cf.* Isidorus, *De natura rerum*, XXXVII, 1 (ed. J. Fontaine [Bordeaux, 1960], p. 295): "Septentrio frigidus et nivalis"; for the second part *cf. idem, Etymologiae*, XIII, xi, 11: "Septentrio dictus eo quod circulo septem stellarum consurgit."

[37] In taking this to be the first word I am following Patetta (*op. cit.*, p. 330) rather than Toesca. For the third letter, now no longer visible, see Toesca, *op. cit.*, p. 6.

[38] I am following Toesca's reading. Patetta read D(icitu)R, which is unlikely; the period preceding the word seems to mark the beginning of a new phrase.

[39] I am adopting Patetta's reading of the ligature which follows the word NVBES as ET A, rather than reading NVBES AEQVAS as does Toesca. As Patetta points out (*op. cit.*, p. 330), one only has a choice here between an unusual ligature and a corrupt text. The passages in Isidorus on which the inscription is based leave no doubt that the sentence was meant to refer to *nubes et aquas.*

[40] This reading was first suggested by Gribaudi (*op. cit.* [*supra, n.* 25], p. 626) and adopted by Patetta. It involves taking the letters placed inside the medallion as an "overflow" of the inscription on the frame and interpreting the final sign as a period within a circle rather than as a letter. Toesca read GITO and apparently took this to be another name for Aquilo-Boreas. Such a name, however, is not otherwise accounted for; and Toesca's reading in its entirety does not give the meaning that this inscription should convey. *Stringit* has the authority of Isidorus behind it and provides the meaning he intended. *Cf. De natura rerum*, XXXVII, 1 (Fontaine, p. 295): "Aquilo ventus qui et Boreas vocatur . . . qui non discutit nubes, sed stringit." The second part of the in-

"Circius" is "Aquilo's" pendant and blows his horn, which again projects far outside his circular frame, in the opposite direction. His hand holding the horn is inside the frame. The background of his medallion, as distinct from that of the other two, is black. Conversely, its framing band is white with lettering in black, whereas the other two medallions had black frames with the inscriptions in white. The inscription on the frame of "Circius," which is shorter than the others and easily legible, reads

CIRCIVS FACIT NIVES ET GRANDINGES [*sic*].

While this text derives from Isidorus's *De natura rerum*,[41] a second inscription, based on *Etymologiae*,[42] was placed outside the medallion above and below the projecting part of the horn:

CIR [43] [cius d]ICT(us) EO Q(uo)D CORO IVNCT VS EST.[44]

The only other spandrel of which a major portion has survived is the lower right-hand one (figs. 5, 8).[45] Again the principal wind is a full-length figure in a circular frame, and we may assume that it was flanked by two heads of satellite winds, though only one has survived.[46] The main wind, which has lost its head and part of its body, was a spritelike, nude, black figure, winged, with its legs sharply bent and spread

scription, however, is closer to *Etymologiae*, XIII, xi, 12: "Aquilo dictus eo quod aquas stringat et nubes dissipet."

[41] XXXVII, 1 (Fontaine, p. 295): "Circius . . . facit nives et grandinum coagulationes."

[42] XIII, xi, 12: "Circius dictus eo quod Coro sit iunctus."

[43] The letters are no longer extant but are clearly visible on the photograph taken *in situ* (fig. 3).

[44] Nothing now remains of the last line, but all five of its letters can be made out in the photograph fig. 3. It is not clear why Toesca transcribes the last two words of the inscription as though they were abbreviated.

[45] The pavement as now installed in the museum shows the lower right-hand fragment turned 180 degrees and placed on top—i.e., in terms of the original orientation, to the east—of the main extant portion. As a result, the lower right-hand spandrel now appears as the upper right-hand one. There is no photograph of the lower right-hand fragment *in situ*. To visualize it in its original position it is necessary to refer to Zocchi's drawing (fig. 2).

[46] Toesca (*op. cit.*, p. 6) speaks of a head on either side of the central figure, but Zocchi's drawing (fig. 2) makes it appear doubtful that anything could have survived of the head to the left of that figure. There is no trace of it in the mosaic as now installed in the museum. Patetta (*op. cit.*, p. 331) speaks of "pochi tratti" of a second lateral head.

FIG. 8. Mosaic. Two Winds.

wide apart. It holds with both hands an enormous horn from which air issues. To the right is a large head in profile—also black, and apparently meant to be negroid, with wings in the place of ears and what looks like a leafy tendril issuing from its mouth. This head is not framed and has no inscription unequivocally belonging to it.

FIG. 9. Mosaic. Griffins.

According to Isidorus, the three winds in this sector should be Zephyrus, the West Wind (also called Favonius), with Africus on his right and Corus on his left.[47] It would seem that all three names were accommodated on the circular frame of the main wind, of which, however, only about one-half is preserved. The first letter of A[fricus] and the last letter of [Zephyru]S (or [Favoniu]S) can still be seen. Lines separated these names (which were meant to be read from inside the circle, as are all the inscriptions in the preceding spandrel) from the words CHOR(us) .NVBES in the part of the frame that has remained intact. Since these latter words adjoin the negroid head and are to be read from the outside, they presumably are intended as a caption for that head, which by virtue of its location should indeed represent Corus. The head is identified also by the inscription accompanying "Circius," the next wind following in a clockwise direction, which, it will be remembered, quotes Isidorus to the effect that Circius adjoins Corus. The word NVBES seems to be a reference in telegram style to Isiodorus's statement in *De natura rerum* that "eo (scil. Coro) flante, in oriente *nubi*la sunt . . . ,"[48] while the word CLAVD-[at] placed inside the medallion just above NVBES must be taken as an equally condensed version of his assertion that "Corus . . . ventorum circulum *claudat*."[49]

Nothing has survived of the top left spandrel, which must have depicted the East Wind (Subsolanus or Apeliotes) with its satellites Vulturnus (or Caecias) and Eurus.[50] Of the top right spandrel, Zocchi's drawing reproduced by Toesca shows a few indistinct remnants, with which one may identify three small pieces now placed on either side of the fragment from the lower right spandrel (figs. 2, 5). One of these pieces shows part of a black circular frame, presumably belonging to a satellite wind and inscribed with the letters OVS;[51] the shapes on the other two are too fragmentary to be identified. The winds in this space must have been Auster

[47] *Etymologiae,* XIII, xi, 2f.; *De natura rerum*, XXXVII, 4 (Fontaine, p. 297).

[48] *Ibid.*

[49] *Etymologiae*, XIII, xi, 10. *Cf.* Gribaudi, *op. cit.*, p. 627; Patetta, *op. cit.*, p. 332.

[50] *Etymologiae*, XIII, xi, 2–5; *De natura rerum*, XXXVII 2 (Fontaine, p. 295).

[51] *Cf.* Patetta, *op. cit.*, pp. 326, 333; Toesca does not mention this fragment.

(or Notus), the South Wind, Euroauster and Euronotus (or Euroafricus).[52]

Inside the "ocean" band the design of the pavement was not carried through in cartographic terms. The area encircled by the ocean bears, instead of the continents, a geometric composition already described above as a system of eight circles around an inner circle. That inner circle, however, again carries an exact and clearly specified meaning, for it represents the well-known allegory of Fortuna's Wheel (figs. 3, 4, 11). Fortuna herself, a crowned figure wearing over a short tunic a richly draped mantle held together by a clasp on her left shoulder, stands at the hub of the circle and is ready to turn it. Her name was inscribed on either side of her head, though only the letters FOR/TV[na] have survived. Her left hand is destroyed, but it is clear that with both her hands she held on to two inward curving lines which form roughly elliptical compartments above and to the left of her and at the same time give her a grip on her wheel. When the mosaic was complete there were four such compartments surrounding her, each containing a figure which symbolized a state of human fortune. The figure on top, cut off at the waist, has long hair and is presumably meant to be female. She wears a crown similar to Fortuna's but with a small cross in front. Dressed in a long-sleeved tunic and a mantle which covers both shoulders, she holds in her right hand what looks like a flower, though the object may be intended to represent the fleur-de-lys finial of a scepter. The right side of her compartment is lost and with it both her left hand and the second half of the inscription that was placed on either side of her crown. The letters EFFE which remain to the left suffice to show that to label the four states of fortune the designer of our mosaic has not made use of the familiar hexameter "Regnabo/ Regno/ Regnavi/ Sum sine regno."[53] Though he depicted the vagaries of fortune in terms of the rise and fall of royalty, he spelled out the idea with a different set of words at which we can only guess. Toesca[54] proposed to complete the word inscribed on top to read EFFE[rtur], a reading I would emend to EFFE[ror], since normally these inscriptions are couched in the first person as though the figures themselves

FIG. 10. Mosaic. Bull.

were speaking. The difficulty in either case is that the notion of "being carried up" is more appropriate to the figure on the left which is in the process of rising.[55] Unfortunately, that figure has lost its inscription.

FIG. 11. Mosaic. Wheel of Fortuna, detail.

[52] *Etymologiae*, XIII, xi, 3, 6, 7; *De natura rerum*, XXXVII, 3 (Fontaine, p. 297).

[53] See *infra*, p. 363.

[54] *Op. cit.*, p. 6.

[55] *Cf.* another common set of inscriptions for the figures on Fortuna's Wheel, in which the words *rursus* (or *laetus*)

The compartment to the right, which must have contained a person tumbling down, is completely destroyed. Below there remains part of a prostrate figure symbolizing the nadir of misfortune. A crown, lost in the fall, lies on the ground beside it. The figure was semi-nude; and it is not impossible that the symbolism involved in this loss of attire was warningly alluded to in the inscription at the entrance.[56] The figure was accompanied by an inscription of which the single letter "M" is visible on the photograph taken when the mosaic was *in situ* (fig. 3). The letter has since been lost, along with what had remained of the figure's bare left arm and chest. More is preserved of the compartment on the left and of the hopefully rising young man it contains. He wears a mantle over a short tunic with an ornament at the lower hem and gesticulates vividly with both hands. Although his face is lost, enough is preserved of his neckline to indicate that his head was thrown back in an expectant glance upward toward a crown which hovers temptingly in the central compartment just beside Fortuna's head. The cycle of royal glory, misery, and aspiration is complete.

Of the eight circles that surrounded the Wheel of Fortuna, five are more or less fully preserved. Three in the lower left-hand sector contain pairs of animals in heraldic groupings (figs. 3, 4, 9). Two long-legged birds with long, pointed beaks—cranes, according to Toesca—face each other in the bottom roundel. There follows in clockwise direction a pair of spirited lions placed back to back, with their heads (not preserved) turned toward each other, and a pair of griffins sitting on their haunches and facing each other. The other two partially extant circles contain respectively a bull, whose nose is pierced by a ring that serves to hold a rope tying him to the trunk of a tree, and an elephant carrying on his back a howdah with a tower, while a second tower appears behind (figs. 5, 10). These two animals were in the "three o'clock" and "four to five o'clock" position and faced left, thus greeting a person entering the chancel.[57]

Finally, to complete the imagery of our pavement, there was a variety of motifs that filled the spandrels between the eight small circles and the inner and outer circles respectively. On the inside, biting into the band that forms the Wheel of Fortuna, were grotesque masks with horns, three of which are extant in the upper left-hand sector (figs. 3, 4, 11). One of these is white, the other two are black. The horns of another such mask have survived in the lower right-hand sector between the bull and the elephant (figs. 5, 10). Of the motifs in the outer spandrels there have been preserved a small nondescript quadruped facing left (between the circles containing the paired birds and the paired lions, figs. 3, 4), a nude figure, also facing left, mounted on an animal and holding a three-thonged whip (between the lion and griffin circles, figs. 3, 4, 9); part of a long-tailed bird (a peacock?) facing right (in the small area of mosaic that remained in the upper right-hand sector; fig. 5);[58] and a mermaid (between the bull and elephant circles; figs. 5, 10).

II

It is not possible to say with certainty when this remarkable mosaic was laid. There is no inscription that provides a date, a name or any other definite clue. Nor is the architectural context of any help, since we do not know when the floor of the chancel of S. Salvatore was raised to the level on which the mosaic was placed.

Toesca attributed the mosaic to the twelfth century, with an implied preference for the latter half or even the end of that century.[59] The soundness and perspicacity of his reasoning still stand out after an interval of more than sixty years; and there can be no doubt that his conclusion was correct. At the same time, it is sad to reflect that the intervening decades have brought forth so little additional evidence with which to support or refine it. Toesca referred in general terms to other figure pavements of the eleventh and twelfth centuries in Italy; to Italian illuminated manuscripts of the same period displaying a similar outline style; and to the popularity of the theme of Fortuna's

ad astra feror (or *vehor*) accompany the rising figure on the left, while for the figure on top the verb *efferre* is used in the past tense (*glorior elatus*). For this set of inscriptions see, e.g., Cambridge, Corpus Christi College, MS. 66, p. 66, and the Hortus Deliciarum (*infra*, n. 135).

[56] *Cf. supra*, n. 28.

[57] Owing to the rearrangement the mosaic underwent when it was installed in the museum, the bull and the elephant are now in the "twelve o'clock" and the "one to

two o'clock" positions respectively. For the original positions see Zocchi's drawing (fig. 2).

[58] In the installation in the museum the fragment with the bird has been placed next to the roundel with the elephant; *cf.* fig. 5.

[59] *Op. cit.*, p. 7 ff.

Wheel during the twelfth and thirteenth centuries. More specifically he called attention to the costumes, particularly the wide openings of the sleeves of the tunics worn by Fortuna and the figure on the top of her Wheel, a fashion characteristic of the twelfth and thirteenth centuries; and to the lettering of the inscriptions with its complicated ligatures and the "already clearly Gothic" form of the uncial "M." Other scholars who have written about the mosaic have added few new arguments. On the whole they have tended to agree with Toesca's dating,[60] though A. Kingsley Porter proposed a date *ca.* 1105 A.D.[61]

While our mosaic clearly belongs to the large family of figured pavements of the Romanesque period, it appears to have no really close relatives even among those that have survived in the same geographic area. There is as yet no corpus of Italian medieval floor mosaics. But those known to me either in the original or from publications do not include any that I would with confidence claim as products of the same workshop. Therefore, it is not possible for the present to broaden the base on which to establish the chronological limits of the period during which that workshop was active. A well-known pavement decoration in the crypt and chancel of the church of S. Savino in Piacenza comes relatively close to ours. More particularly the mosaic carpet in the chancel of that church recalls the Turin floor not only by its position, the circular design at its center (which includes four figures attached to a "wheel" in a manner reminiscent of and perhaps intended to allude to a Wheel of Fortuna), and the variety and liveliness of its subject matter, but also by its free and rather agitated outline style.[62] Whereas on many mosaic pavements draperies are rendered in a simplified manner, the artist at Piacenza, like his colleague in Turin, enlivens the surface

of garments with series of *V* and *U* shapes, bunches up folds for the sake of an interesting configuration of lines, and likes to render hems in zigzag formations. These characteristics, however, appear at Turin in even more exaggerated form. In any case, the affinity does not help to settle the question of date, since firm chronological evidence is lacking for the work at S. Savino just as it is for our floor.[63] This is true also of the pavements of the Cathedral of Novara,[64] pavements which might claim our particular attention on account of that city's geographic proximity to Turin. The church is said to have been consecrated in 1132,[65] but we do not know whether this date applies to the floor decoration; and judgment here is further impeded by the deplorable condition of the mosaics. A fragmentary figure from the lost pavement of the nave, thought to be a personification of Sol,[66] is somewhat comparable to the figures inside the Wheel of Fortuna at Turin, but the style of the representations in the chancel, insofar as it can still be judged, appears to be more archaic.[67] Interestingly enough, the composition in the chancel includes personifications of winds, but in a rendering much simpler than that at Turin.

Comparisons with other, more securely dated mosaic floors in Italy do, however, serve to reinforce the attribution of the Turin floor to the latter half or even the last third of the twelfth century. The pavement of S. Donato in Murano, executed in 1141 in a combination of opus sectile and tesselated mosaic, displays, in the passages done in the latter technique, heraldically confronted animals, which, though not dissimilar to those in our mosaic, are much more severely stylized.[68] We find a looser, more fluid, though still a good deal more controlled and less exuberant manner in a pavement at S. Benedetto Po (Poli-

[60] Gribaudi, *op. cit.*, p. 627; P. Clemen, *Die romanische Monumentalmalerei in den Rheinlanden* (Düsseldorf, 1916), p. 183; Patetta, *op. cit.*, p. 337 ff.; Olivero, *op. cit.* (*supra*, n. 21), p. 253.

[61] *Op. cit.* (*supra*, n. 21) **3**: p. 447. Porter's view was based on a general comparison with floors at S. Savino in Piacenza and S. Michele in Pavia. Neither of these floors, however, is securely dated (for S. Savino see *infra*, n. 62 f.). Kier, *op. cit.*, *passim*, and Barral i Altet, *op. cit.* (*supra*, n. 18), p. 124, have accepted Porter's date.

[62] *La Regia Basilica di S. Savino in Piacenza* (Piacenza, 1903), p. 47, fig. 11; A. Venturi, *Storia dell'arte italiana* **3** (Milan, 1904): fig. 402; Porter, *op. cit.* **4**: pl. 183; Kier, *op. cit.*, fig. 371.

[63] Porter, *op. cit.* **3**: p. 266 f., cites evidence for a consecration of the church in 1107 A.D. There is no reason to believe that this date applies to the mosaic floors.

[64] P. Verzone, *L'architettura romanica nel Novarese* **1** (Novara, 1935): figs. 75, 93–100, 108; Kier, *op. cit.*, figs. 373 f.

[65] Verzone, *op. cit.* (*supra*, n. 64), p. 76 ff.

[66] *Ibid.*, fig. 75.

[67] *Ibid.*, fig. 100; Kier, *op. cit.*, fig. 374.

[68] H. Rahtgens, *S. Donato zu Murano* (Berlin, 1903), plate facing p. 82; Zovatto, *op. cit.* (*supra*, n. 4), fig. 170; Kier, *op. cit.*, fig. 336. The date given in the inscription in the center of the pavement (Rahtgens, p. 9 and fig. 2) is not 1140, as is usually claimed, but 1141. The month of September of that year corresponds to the fifth indiction.

rone) made in 1151;[69] and we come fairly close to the Turin work with the floor of S. Prospero at Reggio Emilia (1160–1171), which includes grotesque masks quite similar to those on the rim of our Wheel of Fortuna.[70] Despite its geographic remoteness, I also quote the famous floor of the Cathedral of Otranto (1163–1165), because of the very free and lively outline style employed in the rendering of its figures and its characteristic snub-nosed profile heads not unlike those of the Turin winds.[71] But in surveying the material one feels that the Turin floor may be still later than any of those I have mentioned and may, in fact, belong to the last decades of the twelfth century. Once we have a better knowledge of illuminated manuscripts made in northern Italy during that period—and in this field again there is a lack of adequate and fully illustrated basic publications—it may be possible to reinforce this dating with additional comparisons. Although among published miniatures I have not found any close stylistic parallels for the Turin mosaic, Toesca was certainly right in drawing attention to the relationship which generally exists between the outline styles employed in floor mosaics and those practiced in Italian regional scriptoria during the Romanesque period. Meanwhile, some further support for the dating of our pavement can be gained from its inscriptions. In Paul Deschamps's systematic survey of medieval lapidary letter forms the uncial "M," already singled out by Toesca, has turned out to be indeed a valuable chronological indicator.[72] The particular form employed by our mosaicist for the inscription of "Septemtrio," with the left and center strokes joined to form an "O" and the right-hand stroke turned inwards (fig. 7), is relatively infrequent. Deschamps's examples are in effect confined to the twelfth century, with those from northern Italy and southern France all concentrated in

the 1160's, '70's, and '80's.[73] Significance may attach also to the use of a simple uncial "E" without a cedilla for the diphthong "AE."[74] To the paleographer, at any rate, and the student of Italian scribal practices in particular, this again would indicate a date well along in the twelfth century.[75]

For our purposes the relatively broad chronological limits at which we have arrived for the Turin pavement are sufficient. Our main concern will be its iconography. We shall try to identify the principal pictorial sources on which the designer drew, and we shall seek to understand his choice and combination of subjects in the perspective of the history of Christian floor decoration.

III

It makes good sense to begin our iconographic inquiry with the cartographic features of the mosaic. Not only are they extremely concrete and explicit but they are clearly basic to the entire composition. The ocean encircling the earth is what the design as a whole represents. Nor does the mosaic give merely a generalized expression to a geographic concept popular since ancient times and universally held during the Middle Ages.[76] By placing islands in the ocean and labeling them, the artist makes it evident that he has actually used cartographic material and, indeed, wishes his design to be understood as a map. Let us therefore inquire first what his cartographic sources were and how far their influence on his composition extends.

World maps of antiquity, insofar as they can be reconstructed from scanty evidence, and those of the Middle Ages often showed the all-embracing ocean surrounding the earth.[77] Dis-

[69] Venturi, op. cit. **3**: fig. 410 f.; Kier, op. cit., figs. 383–385. For the inscription with the date see C. D'Arco, Delle arti e degli artefici di Mantova **1** (Mantua, 1857): p. 14 f.

[70] M. Degani, I mosaici romanici di Reggio Emilia (Reggio Emilia, 1961), pls. 24–30 (for the date see pp. 17; 35); Kier, op. cit., figs. 386, 388. Compare Degani, pl. 30, or Kier, fig. 388, with our figs. 3, 4, 11.

[71] G. Gianfreda, Il mosaico pavimentale della basilica cattedrale di Otranto, 2nd ed., (1965); see e.g. the illustrations on pp. 62, 85, 103; for the date see p. 39 ff.

[72] P. Deschamps, "Étude sur la paléographie des inscriptions lapidaires de la fin de l'époque mérovingienne aux dernières années du XIIe siècle," Bulletin monumental **88** (1929): p. 5 ff., especially p. 39 ff.

[73] Ibid., pp. 41 (with n. 3), 43 f., 74.

[74] Supra, p. 350: BRITANIE. Cf. fig. 7.

[75] G. Battelli, Lezioni di paleografia (3rd ed., Vatican City, 1949), p. 196 f. I wish to express my thanks to Prof. James J. John, who, in a fruitful discussion of the epigraphy of the Turin mosaic, drew my attention to the absence of the AE diphthong as possibly significant for purposes of dating and gave me the above reference.

[76] See in general A. Norlind, Das Problem des gegenseitigen Verhältnisses von Land und Wasser und seine Behandlung, im Mittelalter, Lunds Universitets Årsskrift, n.s., class I. 14, 12 (Lund and Leipzig, 1918), especially p. 21. J. K. Wright, The Geographic Lore of the Time of the Crusades (New York, 1925), pp. 18, 187.

[77] K. Miller, Mappaemundi: Die ältesten Weltkarten (Stuttgart, 1895–1898). C. R. Beazley, The Dawn of Modern Geography **2** (London, 1901): p. 549 ff. M. Des-

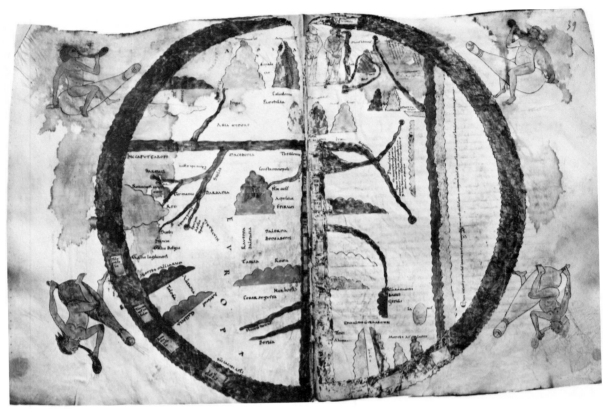

FIG. 12. World Map in Beatus Manuscript (Turin, Bibl. Naz., MS. I.II.1, fol. 38v–39r).

tinctive characteristics of the map incorporated into the design of our mosaic are the circular shape of the earth; the clear delineation of the ocean surrounding it; and the islands inside the ocean with their legends. This particular combination of features is rare in the admittedly small corpus of extant maps that are chronologically pertinent. Much the closest parallels are among the maps normally included in the illuminated manuscripts of Beatus's Commentary on the Apocalypse.[78] Even among the Beatus maps, however, only a few afford a really close comparison with our mosaic. While they normally show the ocean forming a regular frame around the earth, and islands—schematically shaped and inscribed with their names—within the ocean, the majority of these maps are

oblong (rectangular or oval). Only a few are circular and, curiously enough, one of these is in a manuscript preserved in the National Library of Turin (fig. 12).[79] The Turin example, moreover, also shows personified winds in the four corners. Though winds are commonly represented or indicated on medieval world maps, few of the maps in Beatus manuscripts show this feature.[80] In sum, no other single map known from early medieval times shares so many characteristics with our pavement as that in the Turin manuscript. How tempting it would be to assume that it was this very manuscript, written and illuminated in Catalonia ca. 1100 A.D.,[81] that provided the model for the

tombes, *Mappemondes A.D. 1200–1500,* Imago Mundi, Supplement IV, i (Amsterdam, 1964).

[78] Miller, *op. cit.* **1**: *passim;* **2**: pls. 2–9. Beazley, *op. cit.,* **2**: p. 549 ff. W. Neuss, *Die Apokalypse des hl. Johannes in der altspanischen und altchristlichen Bibel-Illustration* (Münster, 1931) **1**: p. 62 ff.; **2**: figs. 70–73. Destombes, *op. cit.,* pp. 40 ff., 79 ff. and pl. 9.

[79] Turin, Bibl. Naz., MS. I. II. 1 (*olim* 93), fol. 38v–39r; *cf.* G. Ottino, *Il "Mappamondo di Torino"* (Turin, 1892); Miller, *op. cit.* **1**: pp. 17, 26 f., 38 ff.; **2**: pl. 8; Neuss, *op. cit.* **1**: p. 41 ff. Other maps of circular shape are in Beatus manuscripts in Burgo de Osma and Paris (Bibl. Nat., MS. n.a. lat. 2290); *cf.* Miller, *op. cit.* **2**: pls. 3b, 9; Neuss, *op. cit.* **2**: fig. 71.

[80] Miller, *op. cit.* **1**: p. 42 f.; see also *infra,* p. 358.

[81] Neuss, *op. cit.* **1**: p. 42 f.

mosaic of S. Salvatore. Unfortunately we do not know when the manuscript came to Turin. Its presence there cannot be traced back beyond the early eighteenth century.[82] But in any event there is weighty evidence against the assumption that the map in the Turin manuscript or any of the other Beatus maps served as a model for our mosaic. Although the legends of the Beatus maps are also based largely on Isidorus of Seville,[83] the selection of islands in the northwest sector—the only part of the ocean frame which we can compare—is not exactly the same as on the mosaic;[84] and their inscriptions are confined to names accompanied by the word "insula." It is, of course, possible to assume that the designer of our pavement, while using a Beatus map for his layout, went back to Isidorus's *Etymologiae* to procure fuller texts for his legends.[85] But the same difficulty arises in aggravated form in connection with the winds.

The Turin Beatus manuscript shows only four winds. Like the personifications of the main winds on our mosaic, they are full-length figures blowing horns. But they are seated astride inflated skins and have no inscriptions. A map in a Beatus manuscript in Paris shows outside the ocean frame eight half-length figures or busts blowing horns but again without inscriptions.[86] Only the map of the famous Beatus manuscript from S. Sever is inscribed with the names of twelve winds.[87] The scribe followed the Isidoran scheme which was used in our mosaic but did not add any of the texts explaining the qualities of the winds. Again it might be argued that the designer of the mosaic went back to the writings of Isidorus for supplementary information. But there are maps—albeit somewhat later in date than our mosaic—which do have fuller Isidoran legends for the winds; and legends, moreover, which combine in the same way as ours excerpts from both the *Etymologiae* and from *De natura rerum*. I refer to the Ebstorf and Hereford maps—two famous world maps of the thirteenth century—both of

which have legends for winds strikingly similar to ours.[88] It is likely, therefore, that our designer derived the bulk of his cosmographic material from a single source, namely, a world map which provided not only a pictorial model but also the texts for his inscriptions and which consequently must have had legends much fuller than those of the maps in Beatus manuscripts.[89]

No extant map, however, provides fully adequate parallels for the actual rendering of the winds on our mosaic. I have already mentioned the four figures in the corners of the Turin Beatus map riding on wind bags and the eight horn-blowers on the map of a Beatus manuscript in Paris. The latter, in part reduced to representations of heads and of hands holding horns, are comparable to our "Aquilo" and "Circius" (figs. 3, 7) but leave our full-length figures unaccounted for. On the Hereford map the four nude grotesque figures in a squatting position which personify the main winds are reminiscent of the West Wind in Turin, but they

[82] Miller, *op. cit.* 1: p. 17.

[83] *Ibid.*, p. 63 ff.

[84] The Turin map shows "B(r)itania," "Scotia," and "Tile," but omits the "Orcades" and has "Tantutes" (Thanet) instead (*ibid.*, p. 40). The "Orcades" appear on the Burgo de Osma map (*ibid.*, p. 36; *cf. supra*, n. 79).

[85] *Cf. supra*, n. 31.

[86] Paris, Bibl. Nat., MS. n.a. lat. 1366 (late twelfth century); Miller, *op. cit.* 1: p. 31.

[87] Paris, Bibl. Nat., MS. lat. 8878; Miller, *op. cit.* 1: p. 42 f. and folding plate; Neuss, *op. cit.* 2: fig. 70.

[88] Miller, *op. cit.* 4: p. 7 f. (Hereford); 5: p. 10 (Ebstorf). For the Hereford map see G. R. Crone (ed.), *The World Map by Richard of Haldingham in Hereford Cathedral*, Royal Geographical Society, Reproductions of Early Manuscript Maps, 3 (London, 1954). The legends of the winds on the Ebstorf map are mostly taken from the *Etymologiae*; those on the Hereford map combine quotations from the two works of Isidorus in a manner very similar to what we find on the Turin mosaic (*cf.* especially the legends for Circius). For the dates of the Ebstorf and Hereford maps see Destombes, *op. cit.* (*supra*, n. 77), pp. 194 ff., 197 ff. The Ebstorf map—also known as the Hannover map—was destroyed in World War II.

[89] Mention should be made, along with the Hereford and Ebstorf maps, of an interesting though poorly preserved map discovered in 1908 in the Archivio Capitolare at Vercelli. Though it too is probably somewhat later in date than our mosaic—it has been attributed to the end of the twelfth or, more frequently, to the thirteenth century—its location in a city so close to Turin lends it potential interest for our inquiry. The history of this map is not known, though the suggestion has been made by C. F. Capello that it was brought to Vercelli in 1219. The earth is here depicted as nearly or fully circular. It is surrounded by a band-shaped ocean which contains numerous islands, including some with lengthy inscriptions. In the absence of a full publication it is difficult to judge the extent of the correspondence between this map and our mosaic—for one unusual detail both have in common see infra, p. 361—but the winds do not seem to figure on the Vercelli *mappa mundi* at all. See C. Errera, in: *Atti della R. Accademia delle scienze di Torino* 46 (1910–1911): p. 8 ff.; A. M. Brizio, *Vercelli*, Catalogo delle cose d'arte e di antichità d'Italia (Rome, 1935), p. 109 f.; C. F. Capello, in: *Atti del XVII congresso geografico italiano* 3 (Bari, 1957): p. 577 ff.; Destombes, *op. cit.*, p. 193 ff. and pl. 23.

do not blow horns and the secondary winds take the form of animal heads.[90] On the Ebstorf map the winds were not represented pictorially, and the same is true of a map contained in a twelfth-century manuscript in Cambridge, though the latter shows in the corners four figures of angels which may have taken the place of personifications of the main winds.[91] On a map in a thirteenth-century Psalter in the British Museum, all the winds are represented in the form of head protomes only.[92] In short, none of these comparisons is entirely satisfactory. Not only are a number of distinctive details of our wind personifications left unaccounted for, but in general our figures stand apart by being unusually active. Our designer has made every effort to indicate through postures and attitudes that large quantities of air are being circulated. In fact, "Aquilo" and "Circius" seem to be stirring up "tidal waves" in the ocean (fig. 3). I know of no other medieval world map with anthropomorphic winds which shows these figures so closely and actively integrated into the cosmic scheme. As we shall see later, our artist had special reasons for emphasizing their active role and may for this purpose have introduced motifs that were not in his map model. We may recall here also the irregularity in the use of frames and the placing of inscriptions which we encountered in the representations of the West Wind and his satellites.[93] This too suggests that in the design of the wind spandrels the artist may have exercised a certain amount of independence vis-à-vis his map model.

This does not mean that any of his figures of winds were free inventions. Once we extend our search beyond the field of cartography a number of characteristic features of the personified winds on our mosaic fall into place quite readily. The wings on the head of "Corus" (fig. 8), for instance, have a venerable ancestry going back to the wind gods of antiquity.[94] In early medieval art the detail is familiar from personified representations of winds in the pictorial rotae that sometimes served to illustrate the relevant chapters in Isidorus's De natura rerum [95] and Etymologiae,[96] as well as other texts of an entirely different nature.[97] The heads of the "Four Winds of the Earth" which angels hold in their hands in illustrations of the seventh chapter of the Apocalypse (verses 1–3) are also often winged.[98] In some of these same contexts one finds winds represented in the manner of "Aquilo" and "Circius" on our mosaic (figs. 3, 7), that is to say, as heads or busts blowing large horns with or without a hand being shown to support the instrument.[99] Again, illustrations of Apocalypse, ch. 7, 1–3, may account for the rather exceptional rendering of "Septemtrio" on our pavement as a draped figure (fig. 7). Normally in medieval "scientific"

90 Miller, op. cit. 4: p. 7 and folding plate; Crone, op. cit., plates, passim. Compare our fig. 8.

91 Cambridge, Corpus Christi College, MS. 66 (twelfth century); cf. Miller, op. cit. 2: pl. 13; 3: p. 23 and pl. 2. The map, on p. 2 of the manuscript, is a frontispiece to a text which here goes under the name of Henry of Mainz but which is actually the De imagine mundi of Honorius Augustodunensis (cf. M. R. James, A Descriptive Catalogue of the Manuscripts in the Library of Corpus Christi College, Cambridge 1 [Cambridge, 1909]: p. 137 ff.; for the authorship cf. infra n. 151). For wind angels see infra, p. 360.

92 London, British Museum, MS. Add. 28681; cf. Miller, op. cit. 2: pl. 1; 3: p. 37 ff. and pl. 3 (here called "MS. 6806"); Destombes, op. cit., p. 168 ff.

93 Supra, p. 351 f.

94 G. Calza, in: Bullettino della Commissione archeologica comunale di Roma 40 (1912): p. 103 ff.; G. Becatti, Scavi di Ostia, IV, Mosaici e pavimenti marmorei (Rome, 1961), p. 46 f. and pl. 122 f.

95 Laon, Bibl. mun., MS. 422, fol. 5v.; cf. J. Hubert, J. Porcher, W. F. Volbach, L'empire carolingien, L'univers des formes ([Paris], 1968), p. 191, fig. 176.

96 London, British Museum, MS. Cotton Tiberius E. IV, fol. 30 r; cf. H. Bober, in: The Journal of the Walters Art Gallery 19–20 (1956–1957): p. 77 f. and fig. 6. In the corresponding miniature in Baltimore, Walters Art Gallery, MS. 73, fol. 1v (ibid., p. 71 ff. and fig. 7) the characterization of the headgear of some of the figures as wings is less distinct. For the relationship between the rotae in the two manuscripts see ibid., pp. 78, 87 f.

97 Bari, Cathedral, Exultet Roll; cf. M. Avery, The Exultet Rolls of South Italy (Princeton, London and The Hague, 1936), pl. 8 and p. 12. Florence, Bibl. Laur., Psalter, MS. Plut. 17.3, fol. 1; cf. K. Berg, Studies in Tuscan Twelfth Century Illumination (Oslo, Bergen and Tromsö, 1968), fig. 148 and p. 118 ff., 236 ff. See also a miniature in a manuscript in the library at Reims reproduced by R. van Marle, Iconographie de l'art profane 2 (The Hague, 1932): fig. 341 and pp. 277, 295 f.

98 Trier, Stadtbibliothek, MS. 31, fol. 21r (photograph Aachen, Stadtbildstelle). See also the relevant illustrations in some of the Beatus manuscripts (Neuss, op. cit. [supra, n. 78] 2: figs. 108, 243) and in the Roda Bible (ibid., fig. 244).

99 Bari Exultet Roll (supra, n. 97); Beatus manuscripts (Neuss, op. cit. 2: figs. 110, 111); also, in Byzantine art, the representations of winds in manuscripts of Cosmas Indicopleustes' Christian Topography (C. Stornajolo, Le miniature della Topografia Cristiana di Cosma Indicopleuste, Codice Vaticano greco 699, Codices e Vaticanis selecti, 10 [Milan, 1908]: pl. 7 and p. 26 f.; E. O. Winstedt, Christian Topography of Cosmas Indicopleustes [Cambridge, 1909], pl. 7; W. Wolska-Conus, Cosmas Indicopleustès: Topographie chrétienne, I, Sources chrétiennes, 141 [Paris, 1968]: p. 545).

representations, when winds are represented as full-length figures they are nude, as is our West Wind. This is true not only of the examples in maps already cited [100] but also of other cosmographic diagrams and schemes.[101] In a number of Apocalypse illustrations, however, and especially in the Beatus group, a conflation takes place whereby the four draped angels that are meant to "hold" the Winds of the Earth (in the form of heads held in their hands)[102] themselves become the winds mightily blowing air, with or without the help of horns.[103] To these angelic winds, of which the famous ceiling paintings at Zillis provide another twelfth-century example,[104] our "Septemtrio" may be compared. And, curiously enough, it is once again the Turin manuscript of Beatus which affords the best parallel: the angels in the illustration of Apoc. 7, 1–3, in that manuscript are quite close to our figure not only in their costumes but also in their postures.[105]

Some features of our winds, however, seem to be pure caprice. I know of no set of wind personifications in which the west winds are singled out by being rendered as black men (fig. 8). All winds may, of course, appear black when depicted in silhouette, as they are on a Roman mosaic floor at Ostia [106] and a medieval one at Novara.[107] But in our case the blackness appears to be selective and descriptive. The rendering of the main West Wind as a little

black devil is particularly striking,[108] and the tendril issuing from the mouth of Corus—perhaps a playful elaboration of the air so often seen issuing from the mouths of personified winds—is surely altogether outside iconographic convention, as is the peculiar wind instrument that Septemtrio holds in his mouth (fig. 7). This fanciful contrivance apparently is meant to add further to the impression that large and powerful air currents are being set in motion.[109]

Our conclusion, then, is that the designer of the Turin mosaic must have had before him a world map rather like that of the Turin Beatus manuscript in layout and appearance but more nearly resembling a map such as the later one at Hereford in its lengthy legends excerpted from Isidorus. While this model may also have included representations of all the twelve winds in anthropomorphic form, in the rendering of these personifications our artist seems to have exercised a certain amount of independence, one of

[100] *Supra*, p. 357 ff (Turin Beatus; Hereford map).

[101] Laon, Bibl. mun., MS. 422, fol. 5v (cf. *supra*, n. 95). Milan, Bibl. Ambros., MS. A.220.Inf., fol. 1r (ninth century); cf. P. Revelli, in: *Bollettino della Società geografica italiana*, ser. 4, **11**, 1 (1910): p. 269 ff., especially p. 271 (ill.). Florence, Bibl. Laur., MS. Plut. 17.3, fol. 1 (cf. *supra*, n. 97). Heidelberg, Universitätsbibl., MS. Salem X, 16, fol. 2v; cf. A. von Oechelhaeuser, *Die Miniaturen der Universitäts-Bibliothek zu Heidelberg* **1** (Heidelberg, 1887): pl. 12 and p. 83 ff.; Van Marle, *op. cit.* (*supra*, n. 97), fig. 359 and p. 312 f. (with wrong interpretation of the full-length figures of winds as devils: see *infra*, n. 108). Also the Creation Tapestry in the Cathedral Museum at Gerona with nude personifications of winds seated astride windbags as on the Turin Beatus map (fig. 12); cf. P. de Palol and M. Hirmer, *Early Medieval Art in Spain* (New York, n.d.), pl. XXXVf.

[102] See *supra*, n. 98.

[103] Neuss, *op. cit.* **2**: figs. 109, 113–122; cf. *ibid.* **1**: p. 65 ff.

[104] E. Poeschel, *Die romanischen Deckengemälde von Zillis* (Erlenbach-Zurich, 1941), p. 11 f. and pls. 1; 2; 41,1; 42,3.

[105] Neuss, *op. cit.* **2**: fig. 119; cf. especially the angel in the lower right-hand corner.

[106] *Supra*, n. 94.

[107] *Supra*, n. 64.

[108] According to Isidorus, *De natura rerum*, XXXVII, 1, it is the northeast wind (Aquilo or Boreas) which assumes the form of a devil (Fontaine, p. 295). In a Byzantine Job manuscript of the thirteenth century in the Vatican Library the "great wind" which destroys Job's sons and daughters (Job 1, 19) is depicted as a black winged devil (MS. Vat. gr. 1231, fol. 40v). On a miniature in the Heidelberg manuscript of the *Liber Scivias* of Hildegard of Bingen all four of the principal winds have the appearance of devils, though they are not black (see *supra*, n. 101).

[109] In studying this detail I have had the generous help of Dr. Emanuel Winternitz of the Metropolitan Museum, New York, the unrivaled authority on the history of musical instruments and their representation in art. Dr. Winternitz informs me that while our North Wind's triple horn shows certain realistic features, such as the uneven curvature of the lower of the two large horns, as a whole it is utterly unfunctional and corresponds to no traditional or generally used instrument. He has drawn my attention to the relevant material assembled by E. Buhle (*Die musikalischen Instrumente in den Miniaturen des frühen Mittelalters* **1** [Leipzig, 1903]) and has pointed out to me that even a relatively simpler and more plausible looking instrument such as that Buhle reproduces from a tenth-century manuscript in Paris (Bibl. Nat., MS. lat. 7900A; see third folding plate, under "4. Krummer Zink") has no basis in reality. That instrument looks like a double horn (as distinct from two separate horns blown simultaneously, which are not uncommon) and is considered by Dr. Winternitz to be either a misunderstood aulos or entirely fantastic (see also Buhle, p. 24, n. 2). *A fortiori* our triple horn must be wholly imaginary. Dr. Winternitz suggests that it is meant to be "allegorical, perhaps indicating the power of the wind," a conclusion fully in keeping with my overall interpretation of the winds on the Turin pavement. I am very much indebted to Dr. Winternitz for the trouble he took to clear up this question for me.

his purposes being to make them appear as active as possible.

Let us now turn to the area within the ocean border where the map design was completely transformed. No doubt this dissembling was deliberate. I have previously cited the abstract patterns of opus sectile floors as a comparison for the system of circles that organizes the entire surface of our mosaic.[110] One gets the impression that the artist wished to avoid too open a display of "scientific" geography. He neatly equated his theme with a conventional and familiar decorative design that can be enjoyed as a pattern before the beholder, on closer inspection, discovers its highly articulate content.

Within the circular area that stands for the earth the decorative element at first sight seems to predominate entirely. But actually the ambiguity between map and pattern continues. It is true that the roundels with animals (figs. 3, 4, 5, 9, 10), particularly those in which quadrupeds or birds are displayed in heraldic pairs, appear to be purely ornamental. Derived directly or indirectly from the repeat patterns of Byzantine or Islamic silk weavings,[111] they belong to the stock repertory of medieval pavement decoration.[112] But let us remember that animals of various kinds, including many fantastic ones, are commonly displayed also on medieval maps to denote the fauna of various countries. In all probability the animals in our mosaic are meant to allude to this convention. They are map symbols in disguise. The elephant with his castle appears on the Hereford map as a symbol for India and the accompanying text refers to the Indians' military use of towers mounted on elephants.[113] The griffin is depicted as an inhabitant of Scythia on both the Hereford and Ebstorf maps.[114] Lions are associated with a variety of countries.[115] And is it altogether fanciful to suggest that the splendid figure of a bull in one of our roundels (fig. 10) may allude to the very city of Taurinum?[116]

Obviously these cartographic interpretations must not be pressed. But in a generalized way not only the animals in the eight circles but also the various figures in the outer spandrels formed by these circles may be taken to stand for the creatures that people the earth. Among the motifs in the outer spandrels we may single out the mermaid and the rider with a whip (figs. 5, 9, 10). The latter strikingly recalls the figure of "Philip, King of France" depicted on a map of the late twelfth or, more probably, the thirteenth century in the Archivio Capitolare in Vercelli as an emblem next to the Atlas mountain.[117] Both this map and the Hereford map also feature mermaids.[118] The eight horned masks in the inner spandrels, on the other hand, may allude once more to the winds (figs. 3, 4, 11). In certain Apocalypse illustrations winds are represented as horned heads;[119] and we may also recall in this connection the eight animal heads distributed over the rim of the earth on the Hereford map to represent the secondary winds.[120]

Cartographic conventions and allusions are left behind once and for all as we reach the inner circle gripped by these masks. But far from being content with mere ornamentation, the artist here has imposed on the design another very specific theme. In rendering this inner circle as a Wheel of Fortuna he has enriched and complicated his image of the world in an unexpected manner. To this seemingly extraneous subject we must now address ourselves.

IV

By the time our mosaic was made, the image of man ascending and descending on Fortuna's

[110] Supra, n. 30.

[111] O. von Falke, Kunstgeschichte der Seidenweberei (Berlin, 1913) 2: p. 20 f. and passim.

[112] Kier, op. cit. (supra, n. 6), figs. 308, 328, 332, 354, 356, 383 f., 399 (note the elephant with "castle"), 404, 407, 409, 411 ff., 416.

[113] Miller, op. cit. 4: p. 37; Crone, op. cit. (supra, n. 88), p. 3.

[114] Miller, op. cit. 4: p. 27 f.; 5: pp. 33, 35; Crone, op. cit., pl. 4.

[115] Miller, op. cit. 2: p. 10, and 3: p. 32 (Scythia); 4: p. 45 (Ethiopia; cf. Crone, op. cit., pl. 9); 5: p. 48 (Parthia).

[116] This interpretation was suggested to me by Dr. Mary K. Donaldson. The bull figures as an emblem of the city in a miniature of 1360; cf. P. Toesca, Torino (Bergamo, 1911), p. 28. For the period of our mosaic I have been unable to find an example which carries this meaning indisputably.

[117] Destombes, op. cit. (supra, n. 77), pl. 23 (lower right-hand corner); for the bibliography see supra, n. 89.

[118] Destombes, op. cit., pl. 23 (upper right-hand section). Miller, op. cit. 4: p. 23; cf. Crone, op. cit., pl. 5 (lower right).

[119] Bamberg Apocalypse, fol. 17v (H. Wölfflin, Die Bamberger Apokalypse [Munich, 1921], pl. 15); also miniatures in Paris, Bibl. Nat., MS. n.a. lat. 1132, fol. 9v, and Valenciennes, Bibl. mun., MS. 99, fol. 14, described but not illustrated by H. Omont, in: Bulletin de la société française de reproductions de manuscrits à peintures 6 (1922): pp. 68, 78.

[120] See supra, n. 90.

362

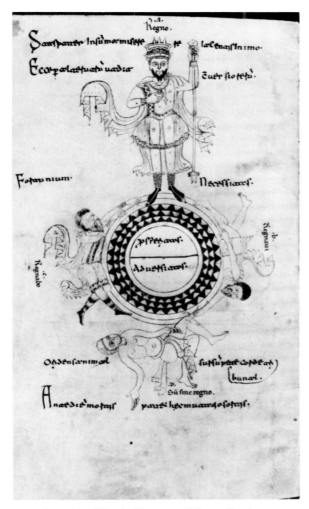

FIG. 13. Wheel of Fortuna (Monte Cassino, MS. 189, p. 146).

revolving wheel was well established as an iconographic commonplace. Its literary progenitor was Boethius, the scholar and statesman of the early sixth century, who in his *Consolation of Philosophy* had gained for the discredited Roman "Allerweltsgöttin" (Doren) a new lease on life by making her in effect an agent of divine Providence. A wheel or sphere had long figured in literature and art as her symbol, attribute, or support. But it was Boethius who more clearly and graphically than earlier writers visualized her with a wheel as an instrument which she turns capriciously and on which man ascends and descends.[121] Although the *Consola-*

tion of Philosophy had been copied, read, and commented on extensively since the Carolingian period,[122] apparently it was not until the eleventh century that Boethius's vivid image was rendered in visual terms. The time lag has not so far been fully explained.[123] It is also worth noting that of the early pictorial representations of Fortuna's Wheel which have come down to us, none is associated with Boethius's text. But whatever the circumstances were that gave rise to it, the image once created quickly gained favor.

The earliest known example is a miniature in an eleventh-century manuscript at Monte Cassino, of which detailed descriptions have long been available though it has been reproduced only recently (fig. 13).[124] The volume contains a miscellany of computistic writings, including Boethius's *De arithmetica* (pp. 1–132) and Gerbert of Aurillac's *De numerorum divisione* (pp. 132–144). The miniature occupies the verso of a folio (p. 146) and is followed by excerpts from Isidorus's *Etymologiae* on the subject of the liberal arts[125] and by the first chapter of Bede's *De temporum ratione*. The latter text is accompanied by illustrations in the same style as the Wheel of Fortuna and clearly by the same hand. The excerpts from Isidorus which begin on the recto page facing our miniature (p. 147) are preceded on that page by a poem of sixteen lines which has to do with the vicissitudes of

1957], p. 20). On Boethius's allegory and its antecedents see A. Doren, "Fortuna im Mittelalter und in der Renaissance," *Vorträge der Bibliothek Warburg* **2**, 1 (1922–1923): p. 71 ff.; H. R. Patch, *The Goddess Fortuna in Medieval Literature* (Cambridge, Mass., 1927), p. 147 ff.; P. Courcelle, *La Consolation de Philosophie dans la tradition littéraire* (Paris, 1967), p. 103 ff.; F. P. Pickering, *Literature and Art in the Middle Ages* (Coral Gables, Florida, 1970), p. 168 ff.

[122] Courcelle, *op. cit.*, pp. 9, 241 ff.

[123] But *cf.* E. Baldwin Smith, *Architectural Symbolism of Imperial Rome and the Middle Ages* (Princeton, 1956), p. 89, n. 51, where the emergence of the motif on the rose windows of twelfth-century churches is interpreted in political terms.

[124] Monte Cassino MS. 189, p. 146 (=fol. 73v); *Bibliotheca Casinensis* **4** (Monte Cassino, 1880): p. 82 f.; M. Inguanez, *Codicum Casinensium Manuscriptorum Catalogus*, I, 2 (Monte Cassino, 1923), p. 272. *Cf.* Doren, *op. cit.*, p. 89, n. 41; Courcelle, *op. cit.*, p. 141 ff. and pl. 65 (with incorrect folio number). For the date of the manuscript see E. A. Loew, *The Beneventan Script* (Oxford, 1914), p. 346 ("saec. XI"). I am grateful to Prof. Penelope Mayo for photographs and detailed descriptions of this miniature as well as its unfinished version on the preceding page.

[125] *Bibliotheca Casinensis* **4**: p. 222 f.

[121] *Boethii Philosophiae Consolatio*, II, 2, 9 ff. (ed. L. Bieler, Corpus Christianorum, ser. lat., 94 [Turnhout,

fortune.[126] Couched in extremely convoluted language, this poem still awaits interpretation. But miniature and poem evidently belong together; and there is no reason to doubt that the former is an original and integral part of the manuscript.[127] At the same time, it gives the impression of an experiment rather than a mere reproduction of an already established formula. As a matter of fact, there is an unfinished version on the preceding recto page (p. 145) which differs in a number of details and which evidently was abandoned (fig. 14). In both versions the figure on top is extraordinarily large in relation to the "wheel" or circle, as though the artist had in mind ancient representations of Kairos or Fortuna in which a wheel or sphere served as a palpably unstable support for the god or goddess.[128] But in adding three other figures, albeit of smaller size, and showing them clinging to or plowed under by the wheel, he made it clear that the figure on top is to be understood as a participant in the dismal cycle of man's vicissitudes and the wheel as the instrument of his rise and fall in Boethius's sense; and here already all four figures are accompanied by their characteristic inscriptions ("Regnabo/Regno/Regnavi/Sum sine regno")[129] in addition to other appropriate texts.[130] The basic iconographic concept, then, is firmly established in this miniature. In the final version (though not in the preliminary one) the figure on top is characterized as a king with a crown and a long staff or sceptre,[131] while the bottom figure is semi-nude as in our mosaic. The only essential element that is lacking is the figure of Fortuna herself. Her absence may be another sign that the group was developed out of an image of the goddess (or her male counterpart) standing on a sphere or wheel. The crowned figure on top may have taken her place.

Wheels with figures revolving on their rims but without Fortuna subsequently made their

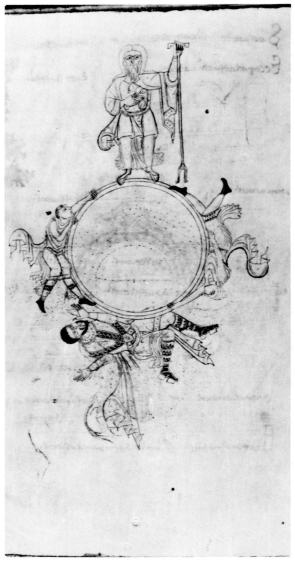

Fig. 14. Wheel of Fortuna (Monte Cassino, MS. 189, p. 145).

[126] *Ibid.*, p. 83.

[127] It cannot, therefore, have served originally as an illustration of the *Consolation of Philosophy* as Courcelle suggests (*op. cit.*, p. 141).

[128] An influence of that iconography was suggested by Courcelle (*op. cit.*, p. 142; *cf.* also *ibid.*, pl. 66, for a twelfth-century example).

[129] *Cf.* Patch, *op. cit.* (*supra*, n. 121), p. 164 ff., with further references.

[130] Courcelle has connected some of the accompanying inscriptions with Boethius (*op. cit.*, p. 142 n. 1).

[131] Courcelle's suggestion (*op. cit.*, p. 143) that the artist intended this figure to represent the Almighty is implausible.

appearance on a number of twelfth- and thirteenth-century church façades whose rose windows were designed to portray our theme.[132]

[132] Beauvais, S. Étienne, North Transept (J. Evans, *Art in Medieval France 987–1498* [London, New York, Toronto, 1948], pl. 115 and p. 218; Courcelle, *op. cit.*, pl. 69); generally considered to be of the period *ca.* 1130–1140 (*cf.* H. G. Franz, in: *Zeitschrift für Kunstwissenschaft* 10 [1956]: p. 1 ff.).

Basel, Cathedral, North Transept (H. Reinhardt, *Das Basler Münster* [Basel, 1961], pls. 64–66); late twelfth century (*cf. ibid.*, p. 14 f.).

Otherwise, however, a personification of fickle fortune becomes in this period a normal part of the composition. For our purpose it is relevant to note two basic variants in the position assigned to her. Fortuna may either be placed beside the wheel and rotate it and its occupants from the outside, sometimes with the help of a crank; or else she herself may be within the wheel as in our mosaic. Of the latter type there are some well-known examples belonging to the first half of the thirteenth century, notably a drawing in the Album of Villard de Honnecourt[133] and a miniature in the Munich manuscript of the Carmina Burana (fig. 15).[134] In the twelfth

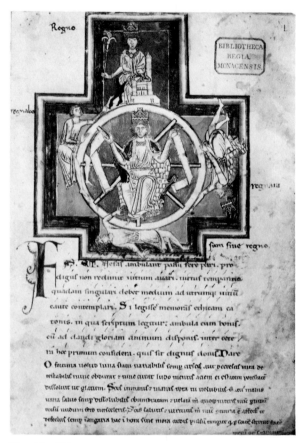

FIG. 15. Wheel of Fortuna in Carmina Burana Manuscript (Munich, Bayer. Staatsbibl., MS. lat. 4660, fol. 1r).

Verona, S. Zeno, West Façade (Porter, op. cit. [supra, n. 21] 3: pp. 526, 537 f.; 4: pl. 224, fig. 1; W. Arslan, L'architettura romanica veronese [Verona, 1939], pp. 190, 202 and pl. 111; A. da Lisca, La. Basilica di S. Zenone in Verona [Verona, 1956], p. 82 ff. and figs. 51–55); late twelfth or early thirteenth century (cf. Arslan, p. 190).

Amiens, Cathedral, South Transept (M. Eschapasse, Notre-Dame d'Amiens [Paris, 1960], pl. 68; Courcelle, op. cit., pl. 70); end of thirteenth century (Eschapasse, p. 110).

Each one of these windows poses problems of interpretation, partly because of poor preservation or later restorations. All certainly have to do with the Fortuna theme, and in the case of the Verona window an inscription testifies to the fact (cf. supra, n. 28). But Fortuna herself does not seem to have been represented in any of these examples, and in this sense they perpetuate the tradition of the Monte Cassino illumination. The figure on the top of the Beauvais window has been called Fortuna (H. J. Dow, "The Rose-Window," Journal of the Warburg and Courtauld Institutes 20 [1957]: p. 269), but the interpretation is not convincing. On the other hand, a thirteenth-century rose window on the north transept façade of the Cathedral of Trent shows in the center a sculptured figure which may well be Fortuna (Van Marle, op. cit. [supra, n. 97], fig. 217; B. Passamani, La scultura romanica del Trentino [Trent, 1963], p. 88 ff. and figs. 40–46). H. R. Hahnloser has suggested that the drawing of Villard de Honnecourt which shows Fortuna in the center of her wheel was likewise intended as a design for a rose window; for this see the next footnote.

[133] H. R. Hahnloser, Villard de Honnecourt (Vienna, 1935), pl. 42 and p. 127 ff.

[134] Clm. 4660, fol. 1r; B. Bischoff (ed.), Carmina Burana (facsimile edition, Munich, 1967). I cite in addition the following thirteenth-century representations of Fortuna in the center of the wheel: Cambridge, Fitzwilliam Museum, MS. 330, Leaf of Psalter of W. de Brailes (E. G. Millar, The Library of A. Chester Beatty; A Descriptive Catalogue of the Western Manuscripts 1 [London, 1927]: pl. 91b; Text, p. 124 ff.); Dijon, Bibliothèque municipale, MS. 562, fol. 171v (H. Buchthal, Miniature Painting in the Latin Kingdom of Jerusalem [Oxford, 1957], pl. 121b and p. 149); Rochester, Cathedral, fresco (E. W. Tristram, English Medieval Wall Painting: The Thirteenth Century [London, 1950], pls. 133 ff.; Text, p. 286 ff.). See also supra, n. 132, for the rose window of the Cathedral of Trent.

century, on the other hand, the type with Fortuna activating the wheel from outside predominates.[135]

[135] Cambridge, Corpus Christi College, MS. 66, p. 66 (E. G. Millar, English Illuminated Manuscripts from the Xth to the XIIIth Century [Paris and Brussels, 1926], pl. 54b and p. 88); Bern, Burgerbibliothek, MS. 120, fols. 146r, 147r (Peter of Eboli, De rebus siculis carmen, ed. E. Rota, Rerum Italicarum Scriptores 31, 1 [Città di Castello, 1904]: pls. 52, 53; cf. Doren, op. cit. [supra, n. 121], pl. III, figs. 10a, b, and p. 141 f.; Pickering, op. cit. [supra, n. 121], pl. 3 and p. 200 ff.); Manchester, John Rylands Library, MS. 83, fol. 214b (M. R. James, A Descriptive Catalogue of the Latin Manuscripts in the John Rylands Library at Manchester [Manchester and London, 1921] 1: p. 152; 2: pl. 110; cf. Pickering, op. cit., pl. 2a and p. 213); Schulpforta, Landesschule, MS. lat. A.10, fol. 3r, medallion at lower right (A. de Laborde, Les manuscrits à peintures de la Cité de Dieu [Paris, 1909] 1: p. 218 ff.; 3: pl. 3; cf. Pickering, op. cit., pp. 190, 214); Hortus Deliciarum of Herrad of Landsberg, fol. 215v (A. Straub and G. Keller, Herrade de Landsberg, Hortus Deliciarum [Strasbourg, 1901], p. 42 f. and pl. 55bis [Supplement] = our fig. 16; cf. Doren, op. cit., pl. II, fig. 7, and p. 141; Pickering, op.

H. R. Hahnloser appears to be the only scholar to have made a point of distinguishing between the two iconographic types. Observing that the variant with Fortuna inside the wheel prevailed generally in the thirteenth century, he speaks of a more abstract as against a more mechanistic and realistic rendering of the theme.[136] This may well be a correct interpretation in some instances. Fortuna placed in the center of the composition may be meant to be in control of her nefarious game no less clearly—if more symbolically—than when she is shown operating an actual machine. But in other instances— and especially when she is seen grasping the spokes or frame of the wheel from the inside, as on our mosaic—perhaps this rendering too should be read realistically, the implication being that she herself is about to be rotated. Lest this interpretation be rejected as unduly literal, I quote a well-known twelfth-century text which has often been cited as a contemporary commentary on the subject of Fortuna's Wheel and which spells out this notion in so many words. Honorius Augustodunensis (*ca.* 1080-*ca.* 1137), in a sermon in which he enumerates various figures and stories from Greek mythology that can be used to good advantage in Christian moralistic teaching, gives as his first example the following:

Scribunt itaque philosophi quod mulier rotae innexa jugiter circumferatur; cujus caput nunc in alta erigatur, nunc in ima demergatur. Rota haec quae volvitur est gloria hujus mundi quae jugiter circumfertur. Mulier rotae innexa est fortuna gloriae intexta. Hujus caput aliquando sursum, aliquando fertur deorsum, quia plerique multocies potentia et divitiis exaltantur, saepe egestate et miseriis exalliantur [*sic*].[137]

Some scholars [138] have claimed that in this passage Honorius must have had in mind Boethius, despite the fact that in the context of his sermon the "philosophers" to whom he refers should be pagans. On the other hand, it has

also been suggested that the image he so vividly conjures up is based on a tradition distinct from Boethius.[139] Whatever Honorius's source, for our purposes the interesting point is that in literature there was in the twelfth century a variant of the Fortuna motif in which she does not turn the wheel, as Boethius had described, but is herself turned within it.

In the pictorial arts our mosaic appears to be the earliest extant example to show Fortuna within the wheel. Surely the type was not the invention of our artist. Its popularity in the immediately ensuing period suggests that more widely accessible *exempla* must have existed by this time. Indeed, one may wonder whether Honorius would have written as graphically as he did had there not been pictorial representations of the "mulier rotae innexa" even in his day. But the type can hardly have been common in the twelfth century. Its use by the Turin designer will be seen to make excellent sense once we have considered the context in which the Fortuna theme appears in this instance.

The context is unique in medieval art. I know of no other example of Fortuna's Wheel being combined with a world map.[140] Again we need not assume a total lack of precedents. Indeed, it may not seem likely on *a priori* grounds that our artist was the first ever to put the two themes together. But in the absence of any known model he may have followed, we must leave the question open. What we can say—and this is ultimately more important—is that the combination is far from haphazard. It has its roots in a set of concepts which can be identified with some accuracy.

There is first of all the important fact that the earth itself had long been likened to a wheel. No other than Isidorus of Seville had thus described its shape. Having devoted Book XIII of his *Etymologiae* to the universe (*mundus*),

cit., pl. 6a and pp. 190 f., 215; G. Cames, *Allégories et symboles dans l'Hortus Deliciarum* [Leiden, 1971], p. 86 f., fig. 79; see also *infra*, p. 368 f. In the Manchester, Schulpforta and Hortus miniatures Fortuna is shown operating the wheel by means of a crank.

[136] *Op. cit.*, p. 128 f.

[137] Honorius Augustodunensis, Speculum Ecclesiae, Dominica XI post Pentecosten (Migne, *Patrologia Latina*, 172, col. 1057). On the dates of Honorius see H. Menhardt, in: *Zeitschrift für deutsches Altertum und deutsche Literatur* **89** (1958): p. 23 ff., esp. p. 67 ff. The passage on Fortuna was included by Herrad of Landsberg in her florilegium; *cf.* Cames, *op. cit.*, p. 86.

[138] E. Mâle, *L'art religieux du XIIIe siècle en France* (Paris, 1919), p. 119, n. 2; Courcelle, *op. cit.*, p. 136.

[139] Patch, *op. cit.* (*supra*, n. 121), p. 152 ff.

[140] The most nearly analogous case of which I am aware is Henry III's decoration of the hall of his palace at Winchester, which included both a Wheel of Fortune and a world map. But the two works were commissioned at different times (in 1236 and 1239 respectively) and there is no evidence that they were pendants. See Tristram, *op. cit.* (*supra*, n. 134), pp. 180, 610. MS. 66 in Corpus Christi College, Cambridge, contains both a world map (*cf. supra*, n. 91) and a representation of Fortuna with her Wheel (*cf. supra*, n. 135), but the manuscript is a miscellany and the two miniatures are associated with entirely different texts; see M. R. James, *op. cit.* (*supra*, n. 91), p. 137 ff.

which he envisaged as a globe in perpetual motion,[141] he turns in Book XIV to the earth, situated in the midst of the universe. He explains that *terra*, in the singular, is synonymous with *orbis* and likens the latter to a wheel ("Orbis . . . sicut rota est").[142] Although he had spoken of the force of the winds as great enough to bring turbulence not only to heaven and the seas, but also to the earth,[143] there is no doubt that Isidorus thought of the earth as essentially immobile and that in comparing it with a wheel he had in mind its shape. Indeed, the notion that the earth stood firm in the center of the universe was hardly ever challenged scientifically throughout the ensuing half-millennium.[144] But—and this is an important step in the direction of the image in which we are interested—the comparison with the wheel lent itself to an allegorical elaboration. Walafrid Strabo in the ninth century concludes a poem in which he bemoans the separation from a friend with a general reflection on the misery of this world:

. . . dolor est possessio mundi,
Quaeque serena putas, magis haec in nubila tristes
Et tenebras fugiunt; volucri qui pendet in orbe
Nunc scandit, nunc descendit, rota sic trahit orbis.[145]

The reference to man's rising and falling shows that the primary inspiration for this verse was Boethius's allegory of Fortuna's Wheel.[146] But the author appears to make use of a poet's license in alluding at the same time to Isidorus's

rota simile for the earth. Surely no scientific theory concerning the rotation of the earth is involved. It is rather a writer's fancy that here seems to set Isidorus's wheel in motion to reinforce a reflection on the transitoriness of the things of this world. The *rota Fortunae* blends into the *orbis terrae*. This is the germ of the idea which centuries later found a visual realization in our mosaic.

There were certain factors which facilitated a correlation between a wheel-shaped earth and Boethius's rotating wheel. Psalm 76 (77), verse 19 (18), speaks of "the voice of thy thunder" in the wheel:

Vox tonitrui tui in rota.
Illuxerunt coruscationes tuae orbi terrae;
Commota est et contremuit terra.

Strictly speaking, the wheel here is the seat of the Deity distinct from the *orbis terrae*; and representations of "God in the Wheel" do, in fact, exist.[147] But the artist who illustrated the verse in the Utrecht Psalter—a near contemporary of Walafrid Strabo—depicted the wheel at the Lord's feet and fiercely blowing winds beside it.[148] The example shows how easily the *rota* of the first sentence of the verse could become the *orbis terrae* of the second. A wheel-shaped earth may thus be thought of as being in a state of commotion.

More important still perhaps is a familiar semantic confusion—easily documented in literature—between *mundus* or the universe, on the one hand, and the *orbis terrae* on the other.[149] Our own loose usage whereby we refer to either as "the world" ("Welt," "monde") in common parlance illustrates the point. Now while the earth is static the universe, as Isidorus tells us, is in perpetual motion; and, rhetorically, this rotating "world" can easily become confounded with our terrestial world. Once again I cite Honorius Augustodunensis who, in a commentary on the Psalm verse just quoted, writes as follows:

Per rotam hic mundus figuratur qui celeri circuitione ut rota jugiter volutatur.[150]

[141] *Etymologiae* (ed. Lindsay; *cf. supra*, n. 31), XIII, i, 1; xi, 3.

[142] *Ibid.*, XIV, i, 1; ii, 1.

[143] *Ibid.*, XIII, xi, 1.

[144] Wright, *op. cit.* (*supra*, n. 76), p. 153 ff. See also the commentary of William of Conches on the words ". . . stabilisque manens das cuncta moveri" which Boethius (*Consolation of Philosophy*, III, ix, 3) addresses to the Father of Heaven and Earth (J. M. Parent, *La doctrine de la création dans l'école de Chartres* [Paris and Ottawa, 1938], p. 126 f.; *cf.* Courcelle, *op. cit.*, p. 307). The anonymous writer of a late twelfth-century treatise on the elements does, however, reckon at least with the theoretical possibility that the earth might rotate (R. C. Dales, "Anonymi *De elementis*: From a Twelfth Century Collection of Scientific Works in British Museum MS Cotton Galba E. IV," *Isis*, **56** [1965]: p. 174 ff., especially pp. 177 f., 184). I am grateful to Dr. M. K. Donaldson for exploring the literature on the subject and supplying me with these references.

[145] Monumenta Germaniae Historica, Poet., II (ed. E. Duemmler [Berlin, 1884]), p. 385, no. 32.

[146] For Boethius's influence on Walafrid see Courcelle, *op. cit.*, pp. 59, 62.

[147] Dow, *op. cit.* (*supra*, n. 132), p. 272 f.

[148] Fol. 44r; E. T. DeWald, *The Illustrations of the Utrecht Psalter* (Princeton, London and Leipzig, n.d.), pl. 71 and .p 35.

[149] *Thesaurus linguae latinae*, VIII (Leipzig, 1936–1966), col. 1636 ff.

[150] Speculum Ecclesiae, De nativitate domini (Migne, *Patrologia Latina*, 172, col. 833).

Like the illustrator of the Utrecht Psalter, he identifies the wheel with the "world" rather than with God's abode. The fact that he sees it in fast and perpetual motion—and the words he uses are strikingly similar to those which in the sermon previously cited he applies to Fortuna's Wheel—would suggest that he has in mind the universe in Isidorus's sense. Yet in that sense the wheel simile would hardly be appropriate; it applies more properly to the *orbis terrae*. Is not the latter, in fact, what is meant here primarily by "hic mundus"? [151]

In his poem *De contemptu mundi*, Bernard of Cluny ("Bernard of Morval"), who flourished about 1150, took an important step further on the same path. Again *mundus* is compared to a revolving wheel, but the term is here used in effect as a synonym for *orbis*; pictorial representations of "the world" are cited; and the whole forms part of a lamentation over the instability of things. It is the same note that Walafrid Strabo had struck centuries earlier, but now with a much more explicit reference to the physical world, including even its depiction in circular form:

Orbis honos ruit, et fugit, et fluit orbe dierum.
Ut rota volvitur, indeque pingitur ut rota mundus,
Quippe volubilis et variabilis ac ruibundus.[152]

Had the poet introduced into his plaint the figure of Fortuna personified, his verses might almost have served as an epigraph for the Turin floor.

A few decades later another poet who was geographically much closer to the designer of our mosaic did, in fact, introduce Fortuna into a work of similar tenor. Henry of Settimello, whose *Elegia* was written in or near Florence in 1193–1194 (that is to say, very close to the time when our mosaic was probably made), was deeply influenced by Boethius. Like the latter he has Fortuna speak in the first person; and, as Pierre Courcelle has remarked,[153] he is literally obsessed with the Boethian image of her turning her wheel. But what is particularly interesting

to us is that Henry's Fortuna speaks of the *orbis* [*terrae*] and the ocean encircling it as her proper domain where she may legitimately pursue her art:

Ast ego, que dea sum, qua nulla potentior orbe,
Quem ligat Occeani circulus orbe suo,
Nonne meam licite, stultissime, prosequar artem?
Sic opus est ut te precipitando rotem.[154]

This too might be a text for our mosaic, though, as we shall see, its designer probably would not have been willing to grant Fortuna the status of a goddess—if only a self-styled one—with unlimited power on earth.

No doubt texts such as these provide a conceptual framework for our mosaic and illuminate the intellectual and spiritual climate in which it was created. Meditations on the vanity of earthly things were very much in vogue in the period in which it was made.[155] Someone—either the designer of the Turin pavement or a predecessor—had the idea of putting Fortuna's Wheel, which was, as we have seen, no longer an unusual iconographic motif by this time, on a *mappa mundi* so as to characterize the earth as a scene of vain pursuits. In a sense the motif was introduced here as another cartographic symbol like the animals and other motifs surrounding it on the "earth's" surface.[156] But something more is involved. We have seen that the variant of the Fortuna image showing the personification inside the wheel rather than on the outside was not common at the time. While not likely to be our artist's invention, it may well have been created first for a context such as this. In any case, it makes for the closest possible integration between the *rota Fortunae* and the *orbis terrae*. Completely fusing circle into circle, wheel into wheel, the artist has linked the two literally and indissolubly. He has created a visual equivalent to the rhetorical similes of the poets and has imparted to their message an extraordinary palpability. Admittedly a modern observer, thinking in Copernican terms, risks an ana-

[151] It should be noted, however, that Honorius, along with many scientific writers of his age, knew of the sphericity of the earth, so that the simile of the wheel is not entirely appropriate in any case; cf. De imagine mundi, I, 5 (Migne, *Patrologia Latina*, 172, col. 122). See Wright, *op. cit.* (*supra*, n. 76), p. 152, and, for the authorship, Menhardt, *op. cit.* (*supra*, n. 137), p. 68 f.

[152] Bernard of Morval, *De contemptu mundi*, 980–982 (ed. H. C. Hoskier [London, 1929], p. 33 f.).

[153] *Op. cit.*, p. 136 f.

[154] Henry of Settimello, *Elegia*, II, 105–108 (ed. G. Cremaschi [Bergamo, 1949], p. 52).

[155] See, in general, F. Lazzari, *Il contemptus mundi nella scuola di S. Vittore* (Naples, 1965), p. 11 ff., esp. p. 13 ff.; R. Bultot, "Grammatica, ethica et contemptus mundi aux XIIe et XIIIe siècles," *Arts libéraux et philosophie au moyen âge* (Actes du quatrième congrès international de philosophie médiévale, Montreal and Paris, 1969), p. 815 ff; (cf. especially p. 823 ff., on the relationship of the *De contemptu mundi* literature to Boethius). I owe these references to my colleague Giles Constable.

[156] See *supra*, p. 361.

chronistic interpretation here. To him the earth will almost automatically rotate, along with Fortuna's wheel. But in the light of the texts I have quoted it may well be that even in the eyes of a twelfth-century beholder the two *rotae* were linked not merely in terms of shape but also—at least emotionally and irrationally—in terms of movement.[157]

It must in any case be granted that the motion of Fortuna's wheel is not here thought of as freely and autonomously governed by the "goddess" herself. She is depicted not as a sovereign power, but rather as the "mulier rotae innexa" of whom Honorius had written and who, in another instant, may well have her head turned upside down.[158] The personified winds blowing so vigorously from the four corners will see to this. Although we have found these personifications to be a traditional and conventional feature of world maps, we have also seen that in this instance some of them are unusually active;[159] and we are surely meant to understand that they impart motion to Fortuna's wheel. Here again one can point to literary sources in which there was a long-standing association between fortune and the winds. Boethius's Fortuna refers to them, though only by way of a simile to illustrate her own powers and the inevitability of constant change.[160] The same comparison is made in a poem which Herrad of Landsberg, a contemporary of our artist, included in her *Hortus Deliciarum*;[161] while Alanus ab Insulis, another contemporary, in a graphic description of Fortuna's abode, assigns a conspicuous role to the winds blowing around her house.[162] No doubt, the beholder of our mosaic must have been meant to understand that Fortuna was not fully in control of her wheel, and the iconographic type was chosen with this in mind. The rotation of the wheel is at the mercy of the winds and at least to this extent subject to cosmic forces. To this same extent, however, the *rota Fortunae* may certainly be said to be correlated

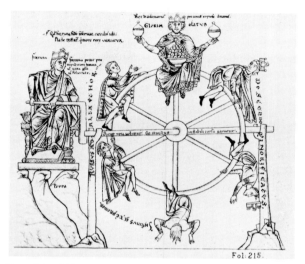

Fig. 16. Wheel of Fortuna in Hortus Deliciarum of Herrad of Landsberg (after Straub and Keller).

in dynamic terms with the *orbis terrae* whose hub it forms. Let it be recalled that even the static earth of medieval science was thought capable of being shaken by the winds.[163]

It is interesting, in concluding these observations, to compare the Turin mosaic with another nearly contemporary rendering of Fortuna's Wheel. The *Hortus Deliciarum* of Herrad of Landsberg contained not only the poem just referred to but also a miniature which was cited earlier among the examples of what we have seen to be the normal iconography of Fortuna in the twelfth century (fig. 16).[164] It is, in fact, one of the instances in which the "goddess" is placed outside the wheel and shown turning it with the help of a crank. The wheel with its six occupants is mounted on an axle to which the crank is attached and whose ends are placed in the forked tops of two posts placed on hillocks. There is nothing out of the ordinary in this representation except the fact that Fortuna, a regal figure wearing a crown, practices her art from the top of a mountain which rises behind the left-hand post. And what is particularly interesting in our context is that this mountain, on which her ornate throne rests, is inscribed "terra." It is the only other medieval instance known to me in which the earth is explicitly featured in connection with Fortuna and graphically depicted as the latter's abode. In this sense Herrad's

[157] "The thought of the artist is clear. This world of ours, surrounded by the ocean . . . , is but the revolving Wheel of Fortune raising men up to the acme of power, or casting them down to the extreme of misery" (Porter, *op. cit.* [*supra*, n. 21] **3**: p. 446).

[158] *Supra*, p. 365.

[159] *Supra*, p. 358 ff.

[160] *Consolation of Philosophy*, II, 1, 18 (Bieler, p. 18).

[161] Ch. M. Engelhardt, *Herrad von Landsperg* (Stuttgart and Tübingen, 1818), p. 160 ("Labilis ut ventus sic transit laeta juventus").

[162] Alanus ab Insulis, *Anticlaudianus*, VIII, 1 ff. (ed. R. Bossuat [Paris, 1955], p. 173).

[163] See *supra*, n. 143; *cf.* also Hildegard of Bingen, Scivias, Visio III (Migne, *Patrologia Latina*, **197**, col. 404C).

[164] See *supra*, n. 135.

miniature is a close relative—indeed, the only close relative—of the Turin mosaic. But the manner of conveying the idea could hardly be more different. Herrad's representation avoids all cosmological problems and ambiguities. The earth is firm and immovable. It is to the "world" (*mundus*) that the rotating wheel may be compared, as the verse inscribed on its axle explains ("sicut rota volvitur sic mundus instabili cursu variatur"). But the picture is not without problems of its own. Fortuna appears as an absolute and wholly autonomous mistress of the earth. To explore the philosophical and theological implications of such a rendering is beyond the scope of the present study (to say nothing of its author's lack of competence in this area). But it can hardly be denied that such implications are present; and they could well have given pause to a twelfth-century observer.[165] There is not even, as in some other representations of the period, a countervailing force in the guise of other personifications ("Virtutes," "Sapientia") with whom Fortuna must contend for power.[166] Furthermore, in a purely visual sense the correlation between Fortuna and the earth is weak.

Perhaps one can best sum up the essence of the Turin composition by saying that its designer addressed himself to these problems. Fortuna has been dethroned. Depicted as part of a cosmic system, she herself has become a plaything subject to greater forces. At the same time, the identification of her domain with the earth is made visually palpable to a degree far greater than that which the *Hortus* miniature was able to convey. But the Turin artist, too, paid a price. His rendering ran counter to accepted views and everyday experience of the physical world. A literary play on the words *mundus— orbis—rota* was one thing; a near equation of an actual map of the earth with a rotating wheel was quite another. A medieval beholder, knowing the earth to be firmly placed in the center of the universe, could not instinctively accept such an equation in his mind as a modern observer can. On the contrary, there must have been for him an inherent contradiction between what science and experience taught him and the artist's interpretation of these data. The very matter-of-factness of the image, the "scientific" quality of at least that part of the composition which is rendered as a piece of undisguised cartography, must have put a considerable strain on his imagination.

This surely explains why the design remained without a future. On the other hand, it is perhaps no accident that the one example we have is on a floor, for in this position it does have a particular meaning and a peculiar relevance. To complete our study we must finally return to the history of Christian floor decoration with which we started and view the Turin mosaic in the perspective of that history.

V

With a map of the world as its basic element, the Turin mosaic belongs to a category of geographic and cosmographic representations for which there was ample precedent in Christian pavement decoration of an earlier age. Representations of this kind were part of the rich store of subjects which had appeared in the floor mosaics of early churches as an inheritance from pagan antiquity.[167] They first became prominent in a vogue of increasingly exuberant pictorial elaboration which can be observed in church pavements in the lands around the eastern Mediterranean during the fifth century; and they reached a peak of frequency, complexity, and "scientific" explicitness in the period during and after the reign of Justinian (527–565).[168] The largest number of floors of that period displaying these and other "encyclopedic" subjects has been found in the excavations of churches in Palestine and Syria, but there are others in other parts of what was then the Byzantine domain. Three examples are particularly interesting in our context. A famous mosaic pavement in a church at Madaba (in present-day Jordan), well known to all students of early cartography, takes the shape of an actual map with a detailed representation of Palestine and parts of Egypt, complete with elaborate legends.[169] A floor in the church of St.

[165] For a critical voice raised in the twelfth century against Boethius's use of the Fortuna motif see Courcelle, *op. cit.*, p. 343.

[166] Bern MS. of Peter of Eboli, fols. 146r, 147r; Cambridge, Corpus Christi College, MS. 66, p. 66. *Cf. supra*, n. 135.

[167] See *supra*, p. 344 f.

[168] Kitzinger, *op. cit.* (*supra*, n. 12).

[169] M. Avi-Yonah, *The Madaba Mosaic Map* (Jerusalem, 1954). A new publication, by H. Donner, based on a recent re-exploration of the mosaic and its site, has been announced. See the preliminary report by H. Donner and H. Cüppers in: *Zeitschrift des deutschen Palästina-Vereins* **83** (1967): p. 1 ff.; also the contribution by V. R. Gold to

FIG. 17. Nikopolis, Church of St. Demetrius.
Floor Mosaic.

Demetrius at Nikopolis, the ancient Actium, on the coast of Epirus, is adorned with what appears to be simply a stylized landscape with trees and birds in a frame of water full of fishes; an accompanying inscription informs us that this modest picture is meant to represent nothing less than "the boundless ocean having in its midst the earth" (fig. 17).[170] Finally, a basilica at Kabr Hiram near Tyre, whose floors were lavishly decorated with mosaics in 575 A.D., displays in its aisles, together with personifications of months and seasons, four busts representing winds.[171]

The Nikopolis floor is especially relevant to the present study.[172] Its theme is the same as that of the Turin mosaic; and here too the cartographic scheme has been dissembled by being merged with or translated into a decorative formula familiar in floor designs of its period. In this instance the idea of the earth in the midst of the ocean is conveyed by means of the classical device of an *emblema* (or panel picture) surrounded by an elaborate frame; and the disguise is so complete that the beholder would not

be aware of the intended meaning were it not for the inscription. In rendering the ocean but not the earth cartographically, the Turin mosaic occupies a position midway between the pure cartography of the floor at Madaba and the exclusively decorative composition of that at Nikopolis. Like the latter, it can be described in essence as a decorator's paraphrase of a world map.[173] If the few stylized trees and birds in the Nikopolis *emblema* are meant to represent "everything that breathes and creeps," as the inscription says in a literal quotation from Homer, so can the much richer but even more formalized display of living beings inside the ocean frame at Turin. Pictorial map symbols always function on a *pars pro toto* principle. Both the Greek mosaicist of the sixth century and his successor in twelfth-century Italy made use of this method to present a view of the world with the help of the stock vocabulary of his craft.

I have said earlier that on general grounds there is no likelihood of a direct influence of the imagery of Early Christian and Early Byzantine floor mosaics on that of Romanesque ones.[174] So far as our particular instance is concerned, the geographic lore which the Turin artist incorporated in his work, though of ancient origin, had been funneled through the compendia of Isidorus of Seville and his countless medieval excerptors before it reached the Turin designer. His pictorial devices, too, are specifically medieval. Striking as the similarity of theme and method is, the Nikopolis and Turin floors must be looked upon as independent creations.

The depiction of earth and ocean at Nikopolis and the whole group of cosmographic floor mosaics to which it belongs do, however, provide an illuminating foil against which to view the Turin composition. As I have shown in an earlier study,[175] the flowering of this encyclopedic subject matter on sixth-century church floors in the eastern Mediterranean region coincides with a reevaluation of the entire world of the senses under the influence of that mysterious late fifth-century author who wrote under the name of Dionysius the Areopagite. The Christianized Neoplatonism of these writings, proclaimed under the authority of St. Paul's Athenian disciple, exerted an enormous impact on Byzantine religious thinking. The physical world became

E. F. Campbell, Jr., and D. N. Freedman, *The Biblical Archaeologist Reader* 3 (New York, 1970): p. 366 ff.

[170] E. Kitzinger, "Studies on Late Antique and Early Byzantine Floor Mosaics, I: Mosaics at Nikopolis," *Dumbarton Oaks Papers* 6 (1951): p. 81 ff., especially p. 95 ff. and figs. 18 f.

[171] H. Stern, "Sur quelques pavements paléo-chrétiens du Liban," *Cahiers archéologiques* 15 (1965): p. 21 ff., especially p. 26 and fig. 6 f.; for a color reproduction of one of the winds see Grabar, *op. cit.* (*supra*, n. 5), p. 111, fig. 116.

[172] I have previously drawn attention to the kinship between the Nikopolis and Turin floors in the article cited *supra*, n. 12 (see p. 222 f.).

[173] *Cf.* Kitzinger, *op. cit.* (*supra*, n. 170), p. 106.
[174] *Cf. supra*, p. 345 f.
[175] *Op. cit.* (*supra*, n. 12), p. 220 ff.

a mirror which reflects, a step whereby we can ascend to and reach the world of the intelligible and ultimately God Himself. This "anagogical" approach—the idea of the sensible as a means of attaining to the intelligible—was promptly applied to the church building and its fittings. The architecture of the church was interpreted as an image of the cosmos; and the cosmos in turn stood for divine "Essence."[176] The symbolism was made even more explicit when early in the seventh century Maximus the Confessor, further developing the same line of thought, equated the nave of the church with the physical world and the sanctuary with the spiritual.[177] The concept justified and, indeed, encouraged a purely factual and "scientific" representation of nature subjects within the building; and the floor—unsuitable for sacred images in any case—became an obvious carrier for such representations. Pictorial decoration of the church floor first truly came into its own here. Without risking desecration, without even implying esoteric religious references, the artist was able to deploy on the floor a rich array of images. Secular iconography in and by itself came to have a *raison d'être* in the house of God. And when the floor took the shape of a map, its decoration was doubly meaningful. In this guise it could help most directly to express the role of the building as an image of the cosmos. The visitor literally stepped on the earth, just as the dome or ceiling above him might, and often did, represent or suggest heaven.[178] Precisely the image of the earth surrounded by the ocean which the floor at Nikopolis (and centuries later our floor at Turin) was meant to convey was, in fact, invoked in a text of the sixth or early seventh century in which the location of a church between two bodies of water was thus interpreted.[179] The equation of the building with the cosmos was taken very literally indeed.

The twelfth and thirteenth centuries were the peak period of a second and far more comprehensive effort to integrate nature and science into a Christian world view. Centered in the Latin West, this effort is reflected above all in the great *summae*, "mirrors," and encyclopedic treatises which then had their heyday. Less concerned than their Byzantine counterparts with direct symbolic relevance, and intent, on the other hand, on a systematic coordination of all knowledge, Western scholars ranged more broadly, deeply, and freely over the phenomena of the physical world. By the same token, subjects from the encyclopedia of nature and science came to play during this period a conspicuous role in church art in general. One need only think of the sculptured decor of Romanesque and early Gothic cathedrals, in which much space is given to these secular representations alongside the figures and events from sacred history.[180] Again, however, it was the floor that offered a peculiarly suitable home for the secular category; and the new flowering during this period of pictorial floor mosaic as a craft, already referred to in the introduction to this study, may in fact be due in part to this circumstance. At any rate, beginning in the eleventh century the church floor became once more a frequent and conspicuous carrier of images pertaining to the encyclopedia of nature and science, witness a long list of examples in France, Germany, and Italy.[181]

Curiously enough, within this category of Romanesque floor decorations specifically geographic themes are not very common.[182] A mosaic in the church of St. Remi at Reims, destroyed in the eighteenth century and known only from descriptions, included in its rich encyclopedic program personifications of "Terra,

[176] See a Syriac hymn on the Cathedral of Edessa (*ibid.*, p. 220 f.), now available in English translation (C. Mango, *The Art of the Byzantine Empire 312–1453*, Sources and Documents in the History of Art Series [H. W. Janson, ed., Englewood Cliffs, N. J., 1972], p. 57 ff.). The hymn entails a dual interpretation of the church building, which it proclaims to be a representation of the mysteries of divine Essence and divine Dispensation (verse 3); the first interpretation is carried through in terms of cosmography (verses 4–8), the second in Biblical and theological terms (verses 11–19); see A. Grabar, in: *Cahiers archéologiques* 2 (1947): p. 41 ff., especially p. 54 ff. For the "anagogical" interpretation of church fittings see a text of Hypatius of Ephesus (*ca.* 530–540 A.D.) which I have discussed in: *Dumbarton Oaks Papers* 8 (1954): p. 138 (*cf.* also J. Gouillard, in: *Revue des études byzantines* 19 [1961]: p. 63 ff., especially p. 72 ff.).

[177] Maximus Confessor, Mystagogia, ch. 3 (Migne, *Patrologia Graeca*, 91, col. 672); *cf.* H.-J. Schulz, *Die byzantinische Liturgie* (Freiburg i.B., 1964), p. 81 ff.

[178] K. Lehmann, "The Dome of Heaven," *Art Bulletin* 27 (1945): p. 1 ff.

[179] See the hymn cited in n. 176 (Mango, *op. cit.*, p. 58, verse 4).

[180] E. Mâle, *L'art religieux du XIIe siècle en France* (3rd ed., Paris, 1928), p. 315 ff.; *idem*, *L'art religieux du XIIIe siècle en France* (Paris, 1919), p. 37 ff.

[181] Kier, *op. cit.* (*supra*, n. 6), p. 69 ff.

[182] I leave aside floors such as that in the crypt of S. Savino in Piacenza (Kier, *op. cit.*, fig. 369) which include motifs with a purely generic reference to the sea.

Mare" and "Orbis terrae."[183] Fragmentary church pavements at Lyons and Saint-Paul-Trois-Châteaux contain representations of cities;[184] while another at Casale Monferrato displays among its varied subjects some of those strange creatures which according to the notions of medieval geographers inhabited the less accessible parts of the world.[185] We may mention also representations of the terrestial paradise, an integral part of medieval geography which was represented on a number of floors.[186] But none of these pavements present any cartographic features pure and undisguised. In this respect the only true parallel in Romanesque art for the Turin mosaic is a floor that never existed. A poem written about the year 1100 by Baudri, at that time abbot of Bourgueil, describes in great detail the decor of the chamber of Adele, Countess of Blois (a daughter of William the Conqueror), as imagined by the author. While the ceiling of the apartment was rendered as the sky, with constellations and planets, and the walls were hung with tapestries depicting a wide variety of historical, Biblical, and mythological subjects, the floor was a *mappa mundi* showing the earth encircled by the ocean. The water was filled with islands and all manner of fish and sea monsters; the earth displayed the three continents, their rivers, seas, mountains, and characteristic animals; and everything was extensively labeled.[187] At the end of his lengthy opus, the author freely admits that he let his imagination carry him away ("Plus quod decuit quam quod erat cecini").[188] But conceptually, at least, the rendering of the floor as an explicit piece of cartography had emerged—or rather, reemerged—here, two or three generations before the Turin mosaic was made.

In the context of Baudri's imaginary chamber,

the *mappa mundi* clearly served to equate the floor with the earth and helped to make of the architectural space as a whole a universe *in parvo*, much in the same way as the floors in Nikopolis and Madaba may be presumed to have done centuries earlier. Possibly this element of cosmic symbolism was present also in our church at Turin. It is interesting in this connection to note that the orientation of the mosaic map on the chancel floor corresponds with the realities of the building. The northwest sector of the ocean with its islands lies actually to the northwest. The point should not be stressed unduly since most medieval maps show East on top, so that a map placed on the longitudinal axis of a normally oriented church will automatically be in a "correct" position. But whether or not the Turin *mappa mundi* was intended to impart a measure of cosmic symbolism to the architectural space in which it was set, its peculiar interest lies not so much in its conformity with traditional cosmographic pavement decoration as in the new departure it entails *vis-à-vis* that tradition. For the physical world was introduced here in a spirit and with an accent quite different from that which had characterized the related decorations of the Early Byzantine period. The decisive difference lies in the Wheel of Fortuna which the designer has placed at the center of the earth.

In the thought world of the Christian East in the sixth century, earth and ocean, heaven and stars—figuratively or literally represented in the church building—mirrored "the mysteries of the divine Essence."[189] Contemplating God's creation was a means for the faithful to attain to a contemplation of God Himself. By contrast, our twelfth-century artist has linked his representation of the earth with a moral allegory that spells instability, transitoriness, and vanity; and he has made that link so palpable and indissoluble that the earth itself becomes in effect an object of contempt. A moralistic and essentially pessimistic view of the sensible world has replaced the "idealistic" interpretation of an earlier age.

It is through the intimate fusion of Fortuna's Wheel with the circle of the earth that the lesson is driven home. But the image and its message gain additional force through being placed on a floor. The earth is literally "put in its place"

[183] H. Stern, *Recueil général des mosaiques de la Gaule* (Gallia, Supplement X) 1, i (Paris, 1957): p. 91 ff.

[184] *Ibid.* 2, i (Paris, 1967): p. 117 f. and pls. 82–85. *Idem*, in: *Cahiers archéologiques* 14 (1964): p. 217 ff.

[185] Porter, *op. cit.* (*supra*, n. 21) 2: p. 254 f.

[186] See pavements at Die (H. Stern, in: *Cahiers archéologiques* 16 [1966]: p. 138 ff.); Cruas (Kier, *op. cit.*, fig. 397; *cf. Dumbarton Oaks Papers* 6 [1951]: p. 119 f.); and Novara (Verzone, *op. cit.* [*supra*, n. 64], figs. 100, 108; Kier, *op. cit.*, fig. 373). For personifications of the Rivers of Paradise see also pavements at St. Remi in Reims (*supra*, n. 183) and Aosta (Kier, *op. cit.*, fig. 375).

[187] Ph. Abrahams, *Les œuvres poétiques de Baudri de Bourgueil (1046–1130)* (Paris, 1926), p. 196 ff.; for the pavement see verses 719 ff. (p. 215 ff.).

[188] Verse 1353 (*ibid.*, p. 231).

[189] See *supra*, n. 176.

in the divine scheme of things. He who enters the sanctuary is obliged to step on it as he approaches the altar. It is at the altar alone, and not in the contemplation of the created world, that we reach God. Only at the altar does true and lasting fortune reside. The picture of the earth is meant to be trodden on. There was no danger of desecration here such as St. Bernard had so vigorously decried. On the contrary, this is a representation which gained in effectiveness by being placed underfoot. Rarely had the problem of a meaningful Christian floor decoration been solved so neatly. Even the stern abbot of Clairvaux might have approved.

THE BYZANTINE CONTRIBUTION TO WESTERN ART OF THE TWELFTH AND THIRTEENTH CENTURIES

This paper contains the substance of the "Conclusions" presented by the author at the final session of a Symposium on "The Byzantine Contribution to Western Art of the Twelfth and Thirteenth Centuries," held at Dumbarton Oaks in May 1965. Originally sub-titled "Carriers, Phases, and Meaning of the Byzantine Contribution," it was subsequently rewritten for delivery as an independent lecture. The author wishes to thank his colleagues who participated in the Symposium and its preparation. Without the advice, information, and criticism he received from them, this attempt at a broad synthesis could not have been undertaken. A synopsis of the entire program of the Symposium will be found at the end of this volume.

For help in the procurement of illustrations, thanks are due to Mr. John Beckwith, Mrs. E. Frankfort, Mrs. E. Kraft-Frodl, Mrs. J. Lafontaine-Dosogne, Dr. P. J. Nordhagen, and Professors P. Rotondi, P. A. Underwood and D. H. Wright.

THE problem to which I shall address myself in these pages can be stated quite simply. The two centuries from A.D. 1100 to 1300 witnessed the greatest achievements in the history of Western mediaeval art, namely, the creation of Gothic cathedral art in the North and a new birth of painting in Italy. During this same two hundred years' span Western Europe was brought into the closest contact it ever had with the art of the Greek East, the art of Byzantium. The question is whether there is any causal connection between these two sets of facts, and, if so, what that connection is.[1]

The question was answered in essentially negative terms by the originators of modern art historical inquiry, Lorenzo Ghiberti in the fifteenth century and Giorgio Vasari in the sixteenth. Solely concerned, of course, with Italy, they blamed the *maniera greca* for everything that was wrong with painting in that country before the genius of Giotto ushered in a new era.[2] Actually, in a sense, they grossly overstated the role of the "Greeks," i.e., the Byzantines, for they claimed that Greek painters alone had maintained or established any sort of tradition during the long night of the Dark Ages and that the only masters available to teach at least the rudiments of the art to the young geniuses of the dawning Renaissance in Tuscany were Greeks. But the *maniera greca* was taught only to be overcome. It was simply the dead hand of tradition and had no positive role in the emergence of Western art. Italy attained its new heights of greatness in spite of, rather than thanks to, its Byzantine contacts.

Since the days of Ghiberti and Vasari, and more particularly during the last hundred years, a good deal of study has been devoted to Byzantine art. Along with this exploratory work has come a thorough-going reappraisal of the role of Byzantium vis-à-vis the art of the West. To stay within the Italian domain for the moment, a school of thought has developed which credits Byzantium with a constructive and positive contribution to the dramatic evolution of painting in that country, particularly in the thirteenth century.[3] Yet, the assessment of Byzantium's role remains ambiguous. As recently as 1948 Roberto Longhi, one of Italy's most brilliant art historians, published a now famous article in which—so far as the value of the Byzantine contribution is concerned—Vasari's case is in effect restated.[4] The *maniera greca* was a

[1] The problem is part, or rather the core, of the Byzantine Question, which has occupied historians of mediaeval art for more than one hundred years. See Ch. Diehl, *Manuel d'art byzantin*, 2nd ed., II (Paris, 1926), p. 712 ff.

[2] On *maniera greca*, see, in general, E. Panofsky, *Renaissance and Renascences in Western Art* (Stockholm, 1960), pp. 24 f., 34.

[3] See especially P. Toesca, *Storia dell'arte italiana*, I (Turin, 1927), p. 918 ff.; P. Muratoff, *La peinture byzantine* (Paris, 1928), p. 132 ff.; R. Oertel, *Die Frühzeit der italienischen Malerei* (Stuttgart, 1953), pp. 38, 57, and *passim*; also G. Millet, "L'art des Balkans et l'Italie au XIIIe siècle," *Atti del V congresso internazionale di studi bizantini*, II (= *Studi bizantini e neoellenici*, VI [Rome, 1940]), p. 272 ff., where, however, a rather sharp distinction is drawn between the art of the Balkans and the art of Byzantium proper. Millet's ideas are developed further in a recent book by R. Valland, eloquently entitled *Aquilée et les origines byzantines de la Renaissance* (Paris, 1963).

[4] R. Longhi, "Giudizio sul Duecento," *Proporzioni*, 2 (1948), p. 5 ff., especially pp. 9 f., 21 f., 24 ff. See also F. Bologna, *La pittura italiana delle origini* (Rome, 1962), a book based on Longhi's premises.

27

blight, the Greeks were the "sterilizers" of Dugento painting, the triumphs of Giotto and Duccio were achieved in the teeth of, rather than with the help of, this alien intrusion. While Longhi's article displays a startling lack of comprehension of Byzantine art and its history, Victor Lazareff, one of the foremost living authorities in that field, with excellent credentials also as a student of Italian art, likewise takes a rather negative view of Byzantium's over-all role in relation to the latter.[5] Thus the issue remains very much alive in our own day; indeed, so far as Italy is concerned, the negative appraisals of the Byzantine contribution have, on balance, won out over the positive.

Study of mediaeval art in the transalpine countries is, of course, of much more recent origin. Born of the historical and aesthetic concepts of Romanticism, it tended from the outset to put a positive evaluation on whatever Byzantine influences and affinities were observed, and this positive attitude has remained characteristic of much of the research in that field. But even in the North examples of the "Vasarian" approach are not lacking. For instance, in a fairly recent and authoritative book on the great school of metalwork which flourished in the valley of the Meuse in the twelfth century we read, à propos of the famous triptych from Stavelot in the Morgan Library in New York, in which Byzantine and Western enamels appear side by side, the following impassioned generalization: "Quelle réserve et quelle froideur dans celles-là (i.e., the Byzantine work), quelle vie, quelle liberté, quel naturel, dans celles-ci! (i.e., the Meusan). Non, l'esprit byzantin n'a pas dompté encore l'esprit narratif et improvisateur de nos orfèvres. Et c'est infiniment heureux, convenons-en!"[6]

The point at issue, then, is not whether Byzantine influences are present in Western art of the twelfth and thirteenth centuries—on this the proponents of Byzantium and its detractors are on the whole agreed—but the evaluation of its role. Was Byzantium essentially a retarding, chilling, and obstructing element in Western art or was it a positive, life-giving, and constructive one?

Before going further, I should make it clear that my observations will be confined to the pictorial arts on which the whole debate has been traditionally focussed. Architecture, which of course constitutes an essential part of the total Western achievement during the period in question, had its own distinct development, to which the Byzantine contribution is at best elusive and indirect.[7] Our topic is the role of Byzantium vis-à-vis the emergent Gothic in Northern sculpture and painting, on the one hand, and vis-à-vis the new birth of painting in Italy, on the other.

The conflicting assessments of this role are due in large part to uncertainties about Byzantine art itself. Here again it is useful to go back to Vasari whose

[5] V. N. Lazareff, "An Unknown Monument of Florentine Dugento Painting and some General Problems Concerning the History of Italian Art in the Thirteenth Century" (in Russian), *Ezhegodnik Instituta Istorii Iskusstv,* (1956; published in 1957), p. 383 ff., especially p. 427 ff. While Lazareff explicitly rejects Longhi's extreme position (p. 437), essentially he considers the *maniera greca* of the thirteenth century as a foreign interlude antithetic to what he regards as the main line of development of a national Italian art.

[6] S. Collon-Gevaert, *Histoire des arts du métal en Belgique* (Brussels, 1951), p. 170.

[7] H. Sedlmayr, *Die Entstehung der Kathedrale* (Zurich, 1950), pp. 198 ff., 346 f.

concept of that art was of extreme simplicity. To him the *maniera greca* meant monotonous and repetitious representations of saints, tinted rather than painted (i.e., drawn with lines and primary colors rather than modeled in the round), standing on the tips of their toes, with eyes staring and hands open. Moreover, it meant a totally static art, entirely determined by usages and traditions handed on from one painter to another, generation after generation, without any attempt at change or improvement, and thus wholly lacking in development.[8] This is Vasari's "image" of Byzantine art, and in spite of all the attention—and in great part sympathetic attention—given to this art in more recent times, this image (like the image which, two centuries after Vasari, Edward Gibbon drew of the Byzantine state and Byzantine civilization as a whole) is still very much with us, witness the modern art historians whom I quoted. Vasari's concept refuses to die for the same reason, no doubt, that Gibbon's will not die, namely, that it is partly true. Monotonous rows of saints with staring eyes and open hands are not hard to find in Byzantine art. It is also true that such representations recur without essential change through many hundreds of years, so that one may well speak of virtual stagnation, especially if one uses as a yardstick the pace of development, say, in the Italian Renaissance, or in our own time. But, of course, there is another side to Byzantine art, a side perpetually nourished and reinvigorated by Byzantium's Graco-Roman heritage, thanks to which figures may appear in lively action, in three-dimensional corporeality, and in spatial settings. Frescoes such as those of Castelseprio and Sopoćani, and miniatures such as those of the Joshua Roll or the Paris Nicander Manuscript (B.N., suppl. gr. 247) are just as "Byzantine" as Vasari's rows of saints, and it is on works displaying to a greater or lesser degree this antique heritage that the proponents of a positive role of Byzantine art vis-à-vis the West have most often drawn. In one sense, however, these proponents have tended to agree with Vasari. They, too, have often treated Byzantine art as essentially static, witness the fact that the examples with which they have illustrated Byzantine influences have at times been chosen rather indiscriminately from different centuries. Yet, one of the achievements of modern scholarship has been an increasingly clear understanding of the development that took place within Byzantine art through the long centuries of its existence. While this development has not as wide a range as that of Western art, while the swings of the pendulum are, as it were, less great, the evolutionary pattern is nevertheless real and organic. To be aware of this, to take the measure of where Byzantine art itself stood at the time the intensive contacts with the West began and how it progressed from this point on is a first prerequisite for a proper appraisal of the East-West relationship.

The mosaics of Daphni (fig. 1), the most representative monument of Byzantine pictorial art remaining to us of the period about A.D. 1100, provide a logical starting point for such a survey, which in the circumstances must

[8] G. Vasari, *Le vite de' più eccellenti pittori scultori ed architettori*, ed. by G. Milanesi, I (Florence, 1878), pp. 242 f., 250 f.

necessarily be brief and somewhat oversimplified. The Daphni style embodies a rare synthesis, a moment of extraordinary equilibrium between the two antithetic elements always present in Byzantine art, the "classical" and the "abstract." Figures stand out clearly, almost starkly, against large areas of empty ground and are structured firmly by means of a rather simple and schematic system of lines, which also stands out very clearly, particularly in the draperies, and recurs time and again in more or less identical and stereo-typed patterns. But, in spite of these abstract settings and linear "armatures," figures are organic and three-dimensional. This is due partly to subtle and skillful modeling within the linear framework, but chiefly to a bold use of contrasts of light and dark, whereby the figures acquire a great deal of relief and a solid bodily presence.

Of the two elements so nicely balanced here—the organic and the linear—it is the latter which wins out more and more in Byzantine art in the course of the twelfth century. In the votive panel of the Emperor John II Comnenus in the south gallery of St. Sophia, a mosaic of about 1120, the "painterly" elements of the Daphni style have already been largely eliminated (fig. 2). Every feature—eyes, nose, mouth, hands—is so fully and clearly defined by neat and emphatic lines and all shading is so smooth and regular that, instead of solid flesh, we seem to behold a brittle, sharp-edged mask of fine porcelain. This calligraphic, linear quality remains dominant in Byzantine painting throughout the twelfth century. The head of St. Panteleimon from the frescoes at Nerezi in Macedonia, dated 1164, is indeed a direct descendent of the heads of the mosaic panel of John II, with the pattern of lines refined almost to the point of preciousness (fig. 3). But Nerezi, in its famous cycle of Gospel scenes, also illustrates a further step, namely, an increasing complexity of these linear patterns (fig. 4). In the draperies these begin to form all manner of zigzags, curls, and eddies, which, though not really motivated by the action of the body underneath, do impart to the figures a new liveliness, a nervous inten-sity. And this agitation is not confined to draperies; it seizes the entire figure, as well as the scenic setting, so that the whole composition begins to heave and swirl. What we see here is, in fact, the beginning of that "dynamic" phase which was to dominate Byzantine art in the last decades of the twelfth century. It is only rather recently that this phase has come to be recognized as a major and distinctive phenomenon in the main stream of the Byzantine stylistic evolution.[9] As we shall see, to be aware of this phase is of considerable im-portance for a correct understanding of what happens in the West during the same period.

When paintings such as those of Nerezi first became known they were called "neo-hellenistic," because of the evident fact that there is in them a new in-tensity of gesture and facial expression, a new emotional power and human

[9] O. Demus, *The Mosaics of Norman Sicily* (London, 1949), p. 417 ff.; E. Kitzinger, *The Mosaics of Monreale* (Palermo, 1960), p. 75 ff.; K. Weitzmann, "Eine spätkomnenische Verkündigungsikone des Sinai und die zweite byzantinische Welle des 12. Jahrhunderts," *Festschrift für Herbert von Einem* (Berlin, 1965), p. 299 ff.

empathy.[10] But in the purely formal sense the term is misleading because these paintings remain essentially within the linear tradition of the first half of the century. There is no return here either to the "painterly" devices or to the solidity and monumentality (or, for that matter, to the classic nobility and poise) of the human form which we found at Daphni. Certainly the highly sophisticated interplay of agitated linear patterns adds to the emotional power of these figures, and to do so may well have been the original purpose of the new dynamism. But it soon becomes an end in itself, divorced from all inner motivation, and what may at first have seemed to have the makings of a powerful Byzantine baroque ends up, in the 1190's, in a strange sort of mannerism (fig. 5). Looking back from this point to the mosaics of Daphni, one must certainly grant that there was in Byzantine art of the twelfth century a stylistic development of considerable magnitude.

What is true of the twelfth century applies even more to the thirteenth. In the whole history of Byzantine art this is one of the most crucial centuries and one of the most obscure. At one time it was considered simply a hiatus. Art in Constantinople was thought to have gone into a decline in the latter half of the twelfth century and to have come to a virtual standstill during the period of the occupation of the city by the Crusaders (1204–1261).[11] The new flowering under the Palaeologan dynasty in the early fourteenth century was thought to have been due to new impulses from Italy.[12] Today this view is no longer tenable. We still lack, and probably always shall, a coherent series of monumental mosaics and paintings from the capital itself with which to bridge the gap between the late twelfth and the early fourteenth century. But in miniature painting a continuity of production has been conclusively demonstrated.[13] And the more we have learned of mural paintings in some of the Byzantine "successor states," notably Serbia, Bulgaria, and Trebizond, the more we have come to realize that the monuments in these areas reflect a common tradition, a single, organic development. It may well be that Constantinople was the main generative center of this development throughout.

Having already made use of mural paintings in the Balkans as representatives of some stylistic phases in the twelfth century, I shall draw on the great Serbian fresco decorations of the thirteenth century to illustrate the major evolutionary trends in Byzantine art of that period. Except in certain provincial backwaters[14] the phase of excessive, mannerist agitation was at an end by A.D. 1200. In its place (and, one is tempted to assume, by way of a reaction)

[10] Muratoff, *op. cit.*, p. 127.

[11] N. Kondakoff, *Histoire de l'art byzantin considéré principalement dans les miniatures*, II (Paris, 1891), p. 166ff.

[12] The principal proponent of this thesis was D. V. Ainalov; for references, see O. Demus, "Die Entstehung des Paläologenstils in der Malerei," *Berichte zum XI. Internationalen Byzantinisten-Kongress München 1958*, IV, 2 (Munich, 1958), p. 33f., note 141; p. 36, note 158.

[13] K. Weitzmann, "Constantinopolitan Book Illumination in the Period of the Latin Conquest," *Gazette des beaux-arts*, 6th ser., 25 (1944), p. 193ff.

[14] O. Demus, "Studien zur byzantinischen Buchmalerei des 13. Jahrhunderts," *Jahrbuch der österreichischen byzantinischen Gesellschaft*, 9 (1960), p. 77ff., especially p. 86ff.

there now appear a new simplicity and calm monumentality both of form and expression.[15] The change is strikingly apparent in wall paintings of the Church of the Virgin at Studenica, dated A.D. 1208–9 (fig. 6). This new concentration on the essential structure and integrity of the human form and on the power of its simple presence is the basis of the entire subsequent development. At first the monumental effects are still achieved with the linear means inherited from the twelfth century. But—and this is the essence of the stylistic evolution in the thirteenth century—increasingly this linear frame is filled with volume and weight. Monumentality, at first achieved mainly through great, sweeping lines, becomes more and more a matter of solid modeling and heavy mass and is vastly enhanced in the process. The frescoes of Mileševo show how far this evolution had progressed by about 1235; those of Sopoćani, another thirty years later represent its peak (figs. 7, 38). It is still possible here to detect in many figures the old linear framework underlying the design, particularly of the draperies. But certain passages—thighs, elbows, heads above all—are modelled so conspicuously as to appear to be thrust forward from the picture plane. What is more important, these thrusts are not isolated; they are centrally motivated and controlled by a powerful body which thus appears endowed with an autonomous inner force, rhythm, and weight, such as it had not possessed at any time since classical antiquity. It is by their own power that these figures seem to bulge out from the wall. It is their own volume also which appears to create space around and depth behind them, so that the traditional and conventional "stage props," the mountains, buildings, and pieces of furniture likewise curve and bulge—but inward *into* the picture, thus creating a "cave space" for the figures to breathe and act in. This "volume style" has long been known from the mosaics of the Kariye Djami, its outstanding representative in Constantinople itself. Actually, in this great and miraculously well-preserved ensemble dating from the first decades of the fourteenth century the style already appears slightly prettified, mannered, and overcharged with conscious classical reminiscences. The heroic age of the "volume style" was the 1260's and 1270's, the period immediately following the Greek reconquest of Constantinople under the Palaeologan dynasty.[16] It hardly needs emphasizing that the remarkable—and still imperfectly understood—stylistic evolution leading up to this climax is one to which Vasari's description of the *maniera greca* is almost entirely irrelevant.

Before trying to determine what bearing all this has on the art of the West we must consider two preliminary questions. The first is whether, in focussing on the stylistic aspects of Byzantine art, we have not from the start narrowed down the issue too much. Are there not other aspects—Byzantium's preeminence in certain crafts and techniques, for instance, or its highly developed religious and imperial iconography—which loom just as large, or larger, in the total picture? Our other preliminary question—and a very basic one—is what

[15] Demus, *op. cit.* (*supra*, note 12), p. 25 ff.
[16] *Ibid.*, p. 29 f.

actual knowledge of Byzantine art the West can be shown or presumed to have had in the period which concerns us.

As to the first of these two questions, the artistic relationship between East and West does, of course, have other aspects aside from the stylistic one. There are, for one thing, certain *media* which became prominent in Western art during the twelfth and thirteenth centuries and which were wholly or largely imported from Byzantium. One such medium is wall mosaic, a forgotten art in the West until it was revived in the latter half of the eleventh century under Byzantine tutelage;[17] another is panel painting, which we are apt to think of as a typically Western art form until we pause to consider how much its central role in the history of Western art owes to the impact of the Byzantine icon on Italian Dugento painting;[18] a third medium which should be mentioned here is stained glass, an art form which until recently was considered quite exclusively Western, but which in the light of some new finds in Istanbul may turn out also to have received an initial stimulus from Byzantium, though the Greeks never developed the aesthetic potential of this medium as it was developed in the Gothic cathedral.[19]

Then there is the Byzantine canon of *iconographic themes and types*, which all along had exerted great and authoritative influence in the West; this, too, was heavily drawn upon in certain contexts, in the "imperially" oriented art of Sicily and Venice, for instance;[20] in the illumination of luxury manuscripts in England and France about and after 1200;[21] and in thirteenth-century panel painting in Tuscany.[22]

Finally, mention must be made of the West's perennial fascination with the splendor and luxuriousness of the Byzantine *sumptuary arts*, a fascination powerfully stimulated during this period through reliquaries and other precious objects brought back by the Crusaders, and particularly through the mass of Byzantine objets d'art which came to the West after the sack of Constantinople in 1204. In certain types, especially of devotional and liturgical objects and utensils, this influence is clearly discernible.[23]

Yet, for our purposes, I feel justified in concentrating on the strictly stylistic aspect. In an over-all assessment of the role and meaning of Byzantine influ-

[17] See *infra*, p.36 .

[18] Lazareff, *op. cit.* (*supra*, note 5), p. 428ff., especially p. 436; H. Hager, *Die Anfänge des italienischen Altarbildes* (Munich, 1962), *passim*.

[19] A. H. S. Megaw, "Notes on Recent Work of the Byzantine Institute in Istanbul," *Dumbarton Oaks Papers*, 17 (1963), p. 333ff., esp. p. 349ff.

[20] The most obvious examples in these two centers are provided by mosaic decorations; see, in general, O. Demus, *Byzantine Mosaic Decoration* (London, 1947), p. 63ff.

[21] H. Buchthal, *Miniature Painting in the Latin Kingdom of Jerusalem* (Oxford, 1957), p. 56.

[22] Cf. note 18, *supra*.

[23] A. Grabar, "Orfèvrerie mosane—orfèvrerie byzantine," in: *L'art mosan*, ed. by P. Francastel (Paris, 1953), p. 119ff.; idem, "Le reliquaire byzantin de la cathédrale d'Aix-la-Chapelle," *Forschungen zur Kunstgeschichte und christlichen Archäologie*, III: *Karolingische und Ottonische Kunst* (Wiesbaden, 1957), p. 282ff. (Grabar, however, fails to mention the key witness for the adoption in the West of the Byzantine type of utensil symbolizing the Heavenly Jerusalem, namely, Theophilus' chapters on censers: *Theophilus De Diversis Artibus*, ed. by C. R. Dodwell [London-Edinburgh-Paris-Melbourne-Toronto-New York, 1961], p. 111ff.). R. Rückert, "Zur Form der byzantinischen Reliquiare," *Münchner Jahrbuch der bildenden Kunst*, 3rd ser., 8 (1957), p. 7ff. A. Frolow, *Les reliquaires de la vraie croix* (Paris, 1965), pp. 105ff., 126ff. and *passim*.

34

ences in Western art in the twelfth and thirteenth centuries style undoubtedly is the crucial issue.[24]

Turning now to the question of the actual means of transmission whereby Byzantine art became known in the West, the first point to be made is that opportunities for contact were, of course, plentiful in the age of the Crusades. I have just now referred to the objets d'art brought back in large quantities by the Crusaders themselves. Merchants and diplomats also added to this traffic. The two Byzantine reliquaries enshrined in the Morgan Library Triptych, for instance, probably were brought to the Monastery of Stavelot by its great Abbot Wibald, who travelled to Constantinople twice on diplomatic missions.[25] Other contacts were established not through travellers but through commissions placed in Constantinopolitan workshops by wealthy Western patrons, and it is noteworthy that this practice is well attested as early as the second half of the eleventh century.[26]

Still, when one tries to put together all the solid evidence, the picture remains spotty. What important and representative examples of Byzantine art would a twelfth-century artist, say in France or England, actually have had occasion to see? How many Western artists ever did set eyes on the mosaics of Daphni or of St. Sophia? Even in the case of so massive an exposure to Byzantine art as is generally agreed to underlie the *maniera greca* in thirteenth-century Italy, how much do we know of actual, concrete links?

In trying to give an answer, however summary, to these questions it is necessary to distinguish between the travel of *objects* and the travel of *artists*. So far as the former is concerned, the richest and most consecutive evidence is indeed in the area of the sumptuary arts, especially metalwork. Beginning with the series of bronze doors commissioned in Constantinople by the Pantaleoni and other South Italian magnates since the 1060's,[27] and the great gold and enamel pala ordered in the Byzantine capital soon thereafter by the Venetians for the high altar of San Marco,[28] there was a steady flow of such objects, a flow powerfully reinforced by the Crusaders' quest for relics which also involved the relics' precious containers.[29] But for portable objects in the pictorial media—especially illuminated manuscripts and icons—which are of

[24] For evidence that during the period here under consideration the stylistic aspect of Byzantine works of art became for Western artists an object of study and imitation in its own right, quite often dissociated from iconographic meaning, see the two papers by K. Weitzmann in the present volume (especially pp. 20, 76); also my remarks on "motif books" on p. 139 ff. of a paper published in Athens (cf. *infra*, note 40).

[25] A. Frolow, *La relique de la vraie croix* (Paris, 1961), p. 335f.

[26] H. R. Hahnloser, "Magistra latinitas und peritia greca," *Festschrift für Herbert von Einem* (Berlin, 1965), p. 77 ff., esp. p. 79 ff.

[27] *Ibid.*, p. 81.

[28] *Ibid.*, p. 80 ff. Hahnloser questions the traditional date of 1105 for this commission and suggests that work on it may have begun soon after the accession of Alexius I in A.D. 1081 (p. 93). He also suggests that in commissioning works of art in Constantinople the Venetians may have been influenced by South Italian precedents (p. 80).

[29] (Comte Riant), *Exuviae sacrae Constantinopolitanae* (Geneva, 1877/78). Frolow, *op. cit.* (*supra*, note 25), p. 144 ff. (on relics and reliquaries of the True Cross; see also the interesting graph on p. 111).

particular interest in relation to our central problem of stylistic influences, the evidence is far less ample. Thus, it must be borne in mind that few, if any, of the great examples of Byzantine miniature painting preserved in Western libraries today were in the West during the Middle Ages. Most of these manuscripts came to the West during the age of Humanism. Undoubtedly, Byzantine illuminated manuscripts had travelled earlier. One manuscript, now in Vienna, was commissioned in Constantinople for the Church of St. Gereon in Cologne about A.D. 1077.[30] Another, in Paris, apparently came to France with a Constantinopolitan delegation in 1269.[31] There is also the remarkable group of manuscripts with miniatures in a near-Byzantine style, recently identified by Professor Buchthal as products of ateliers in the Crusader States.[32] All these manuscripts are in Western European Libraries, and in the great majority of cases this presumably means that they were brought to the West before the final collapse of Latin rule in 1291. In a few instances there are specific indications to that effect.[33] This, however, is the only major group of manuscripts which one can point to as a possible conveyor of a fairly continuous, if not altogether pure, sampling of Byzantine artistic developments. In the matter of icons the evidence is more meager still. Important as this medium came to be for the West, I know of only one authentically Byzantine icon of the Crusader period which is definitely known to have reached the West within that period, namely, the icon of the Virgin which Frederick Barbarossa gave to the Cathedral of Spoleto in 1185.[34] A number of twelfth- and thirteenth-century mosaic icons—outstanding among works of Byzantine art of those centuries— may have reached Italy (and particularly Sicily) at an early date,[35] but we do not know how early and the same is true of the one and only icon from the Crusaders' ateliers in the Holy Land so far located on Western soil.[36]

One may well wonder whether in the over-all picture the traffic in objects was as important as it is sometimes thought to be. It is true that this traffic, aside from exposing Western artists to samples of more or less contemporary Byzantine art, may also have brought to their attention works of earlier and in some cases perhaps *much* earlier periods; we shall have occasion to refer to the role which Byzantine "antiques" may have played in the Western stylistic development.[37] I strongly suspect, however, that in the final reckoning the

[30] Vienna, Nationalbibliothek, MS Theol. gr. 336. See P. Buberl and H. Gerstinger, *Die byzantinischen Handschriften, 2 = Beschreibendes Verzeichnis der illuminierten Handschriften in Oesterreich*, N. S. IV, 2 (Leipzig, 1938), p. 35 ff. I am grateful to Prof. H. Buchthal for drawing my attention to this manuscript.

[31] Paris, Bibliothèque Nationale, MS Coislin gr. 200. See *Byzance et la France médiévale* (exhibition catalog, Paris, Bibl. Nat., 1958), p. 30 f.

[32] Buchthal, *op. cit.* (*supra*, note 21).

[33] *Ibid.*, pp. 41, 66 f., 92 note 2.

[34] S. G. Mercati, "Sulla Santissima Icone nel duomo di Spoleto," *Spoletium*, 3 (1956), p. 3 ff.

[35] V. Lazareff, "Early Italo-Byzantine Painting in Sicily," *The Burlington Magazine*, 63 (1933), p. 279 (icons in Palermo and Berlin). There is reason to believe that the mosaic icon of the Transfiguration in the Louvre (E. Coche de la Ferté, *L'antiquité chrétienne au Musée du Louvre* [Paris, 1958], p. 71) also was in Sicily before it came to Paris; the evidence for this is in the papers of the architect L. Dufourny (Paris, Bibl. Nat., Cabinet des Estampes, Ub 236, vol. VII).

[36] See K. Weitzmann's paper on Crusader icons in the present volume (p. 75 and fig. 52).

[37] *Infra*, p. 41 f.

migration of artists was of greater moment than the mute challenge of objects.[38] Here mention must be made first of all of the Byzantine mosaicists working in Italy. The first such workshop was established in Montecassino about the year 1070 at the bidding of Abbot Desiderius,[39] and this is, in fact, the only quite reliably documented case of Byzantine artists executing wall mosaics on Western soil during the entire period which we are considering. There is no doubt, however, that further teams of Byzantine mosaicists were imported by Italian patrons (notably the kings of Sicily and the doges of Venice) throughout the twelfth century, and the influx continued, if on a reduced scale, in the thirteenth. Thanks to the activities of these workshops, a major and highly representative branch of Byzantine pictorial art was continuously and through successive phases of its development kept before the eyes of Westerners, and while the influence of the mosaics, particularly in the countries north of the Alps, has sometimes been overrated, it was certainly real and important. What counts here is not only the example of the finished product, but also the opportunity of personal contacts with Greek masters which the mosaic workshops afforded.[40] Occasionally a Greek icon painter also may have found his way to the West.[41] As for Western artists travelling East, we now know, thanks to the recent explorations by Professors Buchthal and Weitzmann, that there were illuminators and panel painters from Italy, France, and other Western countries in the Crusader states.[42] It is possible, or even probable, that some of these artists eventually returned to their homelands.[42a] Much scantier, but in many ways more important, evidence is provided by certain fragments of sketchbooks, especially those of Freiburg and Wolfenbuettel. Here we see Western artists in the actual process of noting down motifs from Byzantine models—and very up-to-date models—for subsequent use in their own or their colleagues' work. It is most unlikely that these studies and exercises were done at home solely with the help of some stray objects from the East that happened to have come to hand. In all probability these are travel notes—comparable in this sense to many of the drawings in Villard de

[38] As long ago as 1893, E. Muentz wrote: "...l'influence byzantine...s'exerça pour le moins autant par l'action personnelle des artistes fixés en Italie principalement, que par l'importation des oeuvres d'art." ("Les artistes byzantins dans l'Europe latine," *Revue de l'art chrétien*, 36 [1893], p. 182 ff.). Muentz' study, supplemented for Italy by A. L. Frothingham (in *American Journal of Archaeology*, 9 [1894], p. 32 ff.), was based on literary and epigraphic evidence. I do not know of any systematic modern re-examination of that evidence.

[39] Leo of Ostia, *Chronicon Casinense*, III, 27 (Migne, PL, 173, col. 748).

[40] I have discussed the background and the impact of the Byzantine mosaicists working in Italy in the twelfth and thirteenth centuries in another paper read at the Dumbarton Oaks symposium of 1965; also, with special reference to the Sicilian workshops, in a lecture given in Athens in 1964 ("Norman Sicily as a Source of Byzantine Influence on Western Art in the Twelfth Century," *Byzantine Art—An European Art*: Lectures Given on the Occasion of the Ninth Exhibition of the Council of Euopre [Athens, 1966], p. 121 ff.).

[41] The icons discussed by Lazareff in his paper "Duccio and Thirteenth-Century Greek Ikons" (*Burlington Magazine*, 59 [1931], p. 154 ff.) are probably too late in date to prove this point for the period before A.D. 1300. See the paper by J. Stubblebine in the present volume (p. 101). On the other hand, Professor Stubblebine has suggested that the two icons from Calahorra in the National Gallery in Washington may have been painted by Greek artists on Italian soil (*ibid.*, note 38).

[42] Buchthal, *op. cit.*, p. xxxiii and *passim*; K. Weitzmann, "Icon Painting in the Crusader Kingdom" (in the present volume, p. 49 ff.).

[42a] Weitzmann, *ibid.*, p. 75.

Honnecourt's famous and nearly contemporary sketchbook—but travel notes made in a Byzantine, or, at any rate, semi-Byzantine milieu.[43]

So much for the actual contacts, the channels of communication, between Byzantine art and the West. The fact that there is a strong "live" element in this relationship is important, especially when considered in conjunction with our earlier observations concerning the internal development in Byzantine art during the period under discussion. The existence of these live contacts further adds to the image of Byzantine art as a living entity. This is indeed a basic point, essential to a true understanding of our entire problem. The greatest obstacle to a correct assessment of Byzantium's contribution to the art of the West is what may be called the "ice box" concept, the idea that the art of Byzantium was merely a sort of storehouse, an inert receptacle in which a repertory of traditional forms was conveniently and immutably preserved for the West to draw on. In actual fact it was an art still in the process of evolution and still capable of sending forth live impulses and live emissaries. How crucial a point this is will soon become apparent as we turn to the art of the West and consider its relationship to Byzantium in its successive phases.

A major breakthrough in the study of this relationship was accomplished exactly twenty-five years ago by Wilhelm Koehler. In a lecture given at the inauguration of Dumbarton Oaks,[44] Koehler introduced the concept of a great wave of Byzantine stylistic influence which powerfully affected the pictorial arts of Western Europe in the first half of the twelfth century. All of Koehler's specific observations were not new. But there was a three-fold significance to this truly seminal study: It pointed up the essential unity of what had until then been treated as more or less disparate phenomena in various branches of the pictorial arts in Italy, in France, in England, and in Germany; it focussed on style as the crucial area of contact between East and West during this period; and it penetrated beyond the mere definition of stylistic features to an understanding of what motivated Western artists in adopting these features.

The epitome of this international style of the first half of the twelfth century is what Koehler called the "damp fold," the soft, clinging drapery which so often is seen enveloping the limbs of painted or carved figures of this period in characteristic curvilinear patterns. When one compares earlier (or contemporary, but conservative) work from the same regions in which this feature does not appear, it becomes apparent that behind this purely formal device lies a new interest in the human form and its organic structure and movement; it signifies, to use Koehler's own words, "a new type of human being." The "damp fold" implies a fully rounded, actively and autonomously functioning body such as the flat, wraith-like creatures of the preceding era—creatures that were, so to speak, bent, twisted, and patterned by an outside force—do not possess. And it is quite evident that the source of the "damp fold"—and of the underlying concept of the human form—was Byzantium.

[43] *Ibid.*, pp. 76, 79 ff. See also my paper published in Athens (*supra*, note 40), especially, p. 139 ff.
[44] "Byzantine Art in the West," *Dumbarton Oaks Papers*, I (1941), p. 61 ff.

Koehler was aware that this massive Byzantine influence had its origin in the greatly intensified artistic contacts with the Greek East which were established in the second half of the eleventh century, particularly in Italy.[45] I have referred to some of these contacts, which, be it noted, belong to what would seem to be from a purely historical point of view an unpropitious era, the era just after the great Schism of 1054 and before the First Crusade. The arrival of Byzantine artists and objects in Montecassino, Venice, and elsewhere during this period can be shown to have had stylistic repercussions in the West even before the "damp fold" became the hallmark of an international Western European style.[46] Indeed, that style already embodies a mature and sophisticated stage in the process of Western apprenticeship. The emergence of the "damp fold" and all that it implies may have been, however, not only a matter of the West gradually penetrating closer to the essential formal qualities of Byzantine art. It may have been aided by recent stylistic trends in Byzantium itself; specifically, by the increased linearism which we have found to be characteristic of Byzantine art after 1100, and by the clearer exposure of the body's organic structure inherent in that development. A comparison of a mature exponent of the "damp fold" style from the far European West (fig. 9)[47] with an early twelfth-century wall painting from Cyprus (fig. 8)[48] illustrates the point. Byzantium may indeed have set, early in the twelfth century, new patterns and new challenges to which the West responded.

This was most certainly true in the second half of the twelfth century. I referred earlier to the "dynamic" style which emerged in Byzantine pictorial art during that period, and I said that this stylistic phase has been recognized only rather recently as a distinct and important one within the Byzantine development itself. The realization of what this phase meant for the West is more recent still. Indeed, its importance is only just beginning to be understood. Art historians have begun to speak of a "dynamic" wave following upon Koehler's "damp fold" wave,[49] and inasmuch as the "dynamic" wave was based on the most recent developments in Byzantine art itself, it is a prime example of Byzantium as a living force.

On Italian soil the Byzantine dynamic style is represented in pure, or almost pure, form by a number of mosaic and fresco decorations. Foremost among these are the mosaics of Monreale, executed by a team of Greek artists largely, or even entirely, within the decade from 1180 to 1190 (figs. 10, 12, 16, 19).[50] Reflections of the style can be seen in many places in Austria (fig. 11),[51] in

[45] *Ibid.*, p. 79.

[46] Cf., e.g., the wall paintings of the baptistery of Concordia Sagittaria, which reflect the style of the mosaics of the main portal of San Marco in Venice, mosaics which in turn are closely dependent on those of Hosios Lukas (see the exhibition catalog *Pitture murali nel Veneto e tecnica dell'affresco* [Venice, 1960], p. 36 f. and pl. 3. I owe this reference to Professor O. Demus.).

[47] Koehler, *op. cit.* (*supra*, note 44), p. 74.

[48] A. H. S. Megaw and A. Stylianou, *Cyprus: Byzantine Mosaics and Frescoes*, Unesco World Art Series (1963), pl. 8.

[49] Weitzmann, *op. cit.* (*supra*, note 9); also the same author's remarks in the present volume (p. 23 f.).

[50] For references, see *supra*, note 9.

[51] The pen drawing of the seated Christ in Vienna MS 953 (from Salzburg), which generally has been attributed to the period about or soon after 1150 (see H. J. Hermann, *Die deutschen*

Saxony,[52] in the Rhineland,[53] in France,[54] and in England.[55] English art was particularly deeply touched by this wave and, more than any other, derived from it ways of expressing extremes of emotional agitation (fig. 13).

Yet we must beware lest we go too far. A spirit of more or less intense agitation is an almost universal phenomenon in the pictorial art of Western Europe in the final decades of the twelfth century, and all of this agitation cannot be ascribed to the influence, or, at any rate, the *direct* influence of Byzantium. Byzantium is not a universal key. To illustrate the limits of what it can account for let me refer to one of the great masterpieces produced in the West during this period, the Klosterneuburg Altar of 1181.[56] Its superb series of enamel plaques illustrating events from the Old and New Testaments in typological confrontation is the work of Nicholas of Verdun, the enigmatic genius whose oeuvre is the culminating glory of the great twelfth-century flowering of the goldsmith's art in the Meuse valley and the Rhineland. That there is a good deal of Byzantium in Nicholas' stylistic background there can be no doubt.[57] This Byzantine ingredient (e.g., in fig. 15), however, is not really the dynamic style (fig. 16), but rather the art of the 1150's and 1160's (fig. 14), when that style had not yet come into being. Where Nicholas' basic Byzantine affinities lie can be shown best, not through the finished enamels, but through an unfinished engraving (fig. 18) which came to light on the back of one of the plaques in a recent restoration: this plaque, which depicts the Holy Women's visit to the Sepulchre, shows, so to speak, the skeleton of Nicholas' style, and the relationship to Byzantine work of about 1160–1170 (fig. 17) is evident.[58] On the basis of such antecedents Nicholas develops his own version of the dynamic style, and while it is impossible to ignore the fact that the date of the Klosterneuburg Altar coincides roughly with the beginning of the work at Monreale (compare figs. 19, 20) the relationship here is not specific. Time and again in studying and analyzing Nicholas' enamels, one is reminded of Byzantine work of the "dynamic" phase.[59] Yet it is difficult to point to any concrete connections.

romanischen Handschriften = *Beschreibendes Verzeichnis der illuminierten Handschriften in Oesterreich*, N. S., II [Leipzig, 1926], p. 138 ff. and fig. 84), in my opinion cannot be earlier than the mosaics of Monreale.

[52] Weitzmann, *op. cit.* (*supra*, note 9), p. 309 ff.

[53] Demus, *op. cit.* (*supra*, note 9), p. 445 ff.; also my paper published in Athens (*supra*, note 40), especially, pp. 131 f., 135 f.; and K. Weitzmann's paper quoted *supra*, note 42, p. 23 f.

[54] J. Porcher, *L'enluminure française* (Paris, 1959), pl. 36 and p. 38.

[55] Demus, *op. cit.* (*supra*, note 9), p. 450 f.; also my paper published in Athens (*supra*, note 40), especially, p. 136 ff.

[56] Fl. Röhrig, *Der Verduner Altar*, 2nd ed. (Vienna, 1955).

[57] For general discussions of Nicholas' background, in which many influences converge, see H. Swarzenski, *Monuments of Romanesque Art* (Chicago, 1954), p. 29 ff.; Röhrig, *op. cit.*, p. 30 ff.; H. Schnitzler in *Der Meister des Dreikönigenschreins* (exhibition catalog, Cologne, 1964), p. 7 ff.

[58] O. Demus, "Neue Funde an den Emails des Nikolaus von Verdun in Klosterneuburg," *Oesterreichische Zeitschrift für Denkmalpflege*, 5 (1951), p. 13 ff., esp. p. 16 ff. and fig. 26. Röhrig, *op. cit.*, fig. 53.

[59] H. Schnitzler, *Rheinische Schatzkammer: Die Romanik* (Düsseldorf, 1959), p. 9. What H. Swarzenski once called "the enigmatically early date" of the Klosterneuburg Altar ("Zwei Zeichnungen der Martinslegende aus Tournai," *Adolph Goldschmidt zu seinem siebenzigsten Geburtstag* [Berlin, 1935], p. 40) certainly appears less puzzling when seen in this light.

Thus, there arises here the problem of *parallelisms* between East and West as distinct from that of direct influences. Of course, the problem can arise only because Byzantine art was a moving stream, not a stagnant pool. It now appears that not only was there a succession of currents branching off from this stream and flowing into the stream of Western art, but, in addition, the two streams shared a common general direction. As a matter of fact, this was true not only in the late twelfth century, but in other periods also. Parallelism, as distinct from, and in addition to, direct influences, may have been a factor of some importance as early as the year one thousand when the Ottonian style was reaching maturity in the West, and Constantinople was distilling from the classical revivals of the "Macedonian renaissance" a mature mediaeval style of its own. Indeed, from that time on, and until about A.D. 1300, one can speak in a very broad sense of a common artistic evolution embracing both East and West and betokening a common cultural framework for all of European Christendom.[60] But in the late twelfth century this phenomenon becomes particularly evident and it will remain so for the ensuing one hundred years. Perhaps one should avoid the slightly mystical concept of a "Zeitstil" and think rather in terms of loose and broad connections, of general impulses which may have gone in either direction. In the particular case of Klosterneuburg there may have been a vague and perhaps indirect stimulus from Byzantium's "dynamic" phase, a stimulus which in the mind of a great artist like Nicholas of Verdun merged and coalesced with others from quite different sources to produce a broadly comparable result.

I have purposely singled out Nicholas of Verdun. He was a dominant figure in a region which played a leading role in Western Europe at the time when the Gothic pictorial style took shape. By focussing a little longer on his oeuvre and sphere of influence I can best illustrate Byzantium's role in that process, a role which after the 1180's and the 1190's becomes more and more elusive. Nicholas' own style undergoes a striking development.[61] Agitation and dynamic power reach a climax in the latter stages of the Klosterneuburg series and in some of the majestic figures of prophets from the Cologne Shrine of the Three Kings which are generally agreed to be his work (fig. 22). But the storm abates in his late work, the Shrine of the Virgin at Tournai dated 1205, and gives way to a calm, quiet serenity (fig. 24). It is a remarkable change, perhaps the most remarkable that can be observed in any one personality in the generally anonymous world of mediaeval art. Nicholas, in his later years, became an exponent of a style which about the year 1200 began to dominate the pictorial arts, not only in his own region of the Meuse, but in northern France and in England as well. Towering figure that he was, he himself undoubtedly had helped to pioneer the new style. The classic calm and lucid serenity which characterizes his work at Tournai had appeared a few years earlier in English and northern French art: in the last of the miniatures of the great Winchester

[60] See in general M. Gigante, "Antico, bizantino e medioevo," *La Parola del Passato*, 96 (May-June 1964), p. 194 ff., esp. p. 212.
[61] Schnitzler, *op. cit.* (*supra*, note 57), p. 9 ff.

Bible, for instance; in the Westminster Psalter; and in the Psalter of Queen Ingeborg (figs. 26, 30). It was a broad and broadly-based movement to which terms such as "neo-classicism" and "classical revival" have been aptly applied. It was a prelude to true Gothic rather than Gothic itself.[62]

Now there was, as we have seen, at precisely the same time a return to calm and monumental serenity also in Byzantine art, where this phase played much the same role in relation to subsequent developments that the Meusan, French, and English "neo-classicism" was to play in the evolution of Gothic. But this surely is *only* a case of parallellism, and parallelism of the most general kind. There is no question, no evidence here of a broad and massive wave of influence comparable to the great Byzantine waves that swept the West in the twelfth century.

The sources of this Western "neo-classicism" are varied and complex. The heritage of the West's earlier classical revivals—the Carolingian and Ottonian particularly—undoubtedly played an important part. Indeed, in the Meuse region, which was Nicholas' true home ground, a taste for classical forms was almost endemic. But there is in his style, and in his late work particularly, a closeness to the real antique, an almost Phidian quality which time and again has defied explanation. An acquaintance with such remains of Roman provincial art as may have been visible in northwestern Europe could not by itself account for this quality. On the other hand, I also find it hard to believe that Nicholas travelled to Greece and studied the sculptures of the Parthenon. I would suggest that an important part was played in his development by an encounter, not so much with true antiques, as with works of what has come to be known as the "Byzantinische Antike" of the sixth and seventh centuries, works of the minor arts of the period of Justinian and Heraclius in which there is a very strong classical element. When one places side by side with figures from the Tournai Shrine (fig. 24) reliefs from Maximian's Chair (figs. 21, 23), one finds specific similarities in facial types, in stances, in the strange apron-like garments, and in details of drapery design which it would be difficult to match elsewhere. The heads of certain of the prophets of the Cologne Shrine (fig. 22) also invite such comparisons, and similar sixth-century sources (fig. 25) can be named for some of the most important features of the Ingeborg Psalter (fig. 26), particularly for those characteristic, softly-grooved draperies (or "Mulden") which are one of the decisive innovations in this manuscript, and in the art of its time.[63]

[62] O. Homburger, "Zur Stilbestimmung der figürlichen Kunst Deutschlands und des westlichen Europas im Zeitraum zwischen 1190 und 1250," *Formositas Romanica*: *Beiträge zur Erforschung der romanischen Kunst Joseph Gantner zugeeignet* (Frauenfeld, 1958), p. 29 ff. O. Pächt, "A Cycle of English Frescoes in Spain," *Burlington Magazine*, 103 (1961), p. 166 ff., esp. p. 171. L. Grodecki, "Problèmes de la peinture en Champagne pendant la seconde moitié du douzième siècle," *Romanesque and Gothic Art = Studies in Western Art*: *Acts of the Twentieth International Congress of the History of Art*, I (Princeton, 1963), p. 129 ff., esp. p. 140 f.

[63] These stylistic connections seem to me more specific than those with more recent products of Byzantine metalwork, such as the silver reliefs from Tekali and Bochorma (H. Schnitzler, *op. cit.* [*supra*, note 57], p. 10 and figs. on pp. 7, 57). Works of the minor arts of the *early* Byzantine period were cited long ago by Wilhelm Vöge to account for the classicizing strain in early Gothic art ("Ueber die Bamberger Domsculpturen," *Repertorium für Kunstwissenschaft*, 22 (1899), p. 94 ff., esp. p. 97 ff.;

42

Thus, there *is* a Byzantine element here, but it is an element stemming from a Byzantine past so remote that in the perspective of the year 1200 it must have seemed like antiquity itself. I have previously suggested that during the Crusades such ancient works may have reached the West in increased numbers, and although examples of Justinianic ivory carving and metalwork had been available all along, interest in this art may have been stimulated by new imports. In this sense the Western "neo-classicism" of A.D. 1200 may owe something to the East-West traffic of the time. Also, there are relationships to more recent Byzantine works. One of the miniatures of the Ingeborg Psalter has been convincingly compared to a tenth-century ivory, an exponent of the Byzantine "renaissance" of that period at its most serene.[64] The English master who, about the year 1200, executed the frescoes at Sigena (fig. 28) and who was clearly a close associate of the painter of the Westminster Psalter, must have studied, on his way to Spain, the twelfth-century frescoes and mosaics in southern Italy (fig. 27) and Sicily, though he translates their style into that pure, becalmed classicism which was his own ideal, or, perhaps, one should say, extracts from them this element latently present in all Byzantine art.[65] But the point is that the Western "neo-classicism" of about 1200 was an essentially autonomous achievement inspired primarily by works of the distant past and not dependent on, though vaguely parallel to, the exactly contemporary phase in Byzantine art.

This "neo-classicism," however, was the seed bed in which the classical phase of French thirteenth-century cathedral art grew. There are paths leading from Nicholas of Verdun and the Ingeborg Psalter to the sculptures of Laon, Chartres, and Rheims (figs. 29–32).[66] I cannot follow these steps in any detail. Many scholars believe that the great classical statuary of Rheims could not have come into being had not their creators seen true and large-scale Greek or Roman sculptures.[67] But, if so, they merely broadened and deepened the approach to the antique which Nicholas and his contemporaries had made a generation earlier.

Thus, we can now see what the over-all contribution of Byzantium to the nascent Gothic was. We have moved, step by step, from waves of massive influence to parallelism, and finally to a classical revival which draws on sources altogether independent, at any rate, from contemporary Byzantium. The waves of influence were absorbed only to be transcended, and, in the end,

ibid., 24 (1901), p. 195 ff., esp. p. 196 f.). Influences from works of Byzantine art of the tenth and subsequent centuries should not, however, be ruled out altogether (see *infra*).

[64] This comparison was made by Dr. F. Deuchler at a colloquium on the Master of the Shrine of the Three Kings, held in Cologne in July 1964, a colloquium which I was privileged to attend.

[65] Pächt, *op. cit.* (*supra*, note 62), esp. p. 172 ff. See also my paper published in Athens (*supra*, note 40), especially p. 130 f.

[66] W. Sauerländer, "Beiträge zur Geschichte der 'frühgotischen' Skulptur," *Zeitschrift für Kunstgeschichte*, 19 (1956), p. 1 ff., esp. p. 2 (importance of Meusan metalwork; for earlier literature on this subject, see the references in note 5), p. 15 with note 59 (relationship of Laon to Nicholas of Verdun), p. 21 ff. (relationship of Chartres to Laon); see also *idem*, "Die Marienkrönungsportale von Senlis and Mantes," *Wallraf-Richartz-Jahrbuch*, 20 (1958), p. 115 ff., especially p. 135 (importance of English illuminated manuscripts). H. Reinhardt, *La cathédrale de Reims* (Paris, 1963), p. 145 ff.

[67] Reinhardt, *ibid.*, p. 148 f.

the West achieved its own sovereign approach to classical antiquity.[68] There had been moves in this direction before. The importance of the various "proto-Renaissances" of the twelfth century, especially in Italy and France, should not be minimized.[69] But it was Byzantine art with its continuous and living challenge which had provided the principal schooling for the great and decisive breakthrough in the early thirteenth century. In successive stages it had held before Western eyes an ideal of the human form, first as a coherent and autonomous organism, then as an instrument of intense action and emotion. This was what enabled the West finally to make its own terms with the classical past, and to create its own version of a humanistic art. Ultimately Byzantium's role was that of a midwife, a pace-maker. Though, in this sense, the part it played was crucial, it had little direct influence on mature Gothic art. Once the great independent breakthrough toward the classical had been accomplished in the early thirteenth century, the countries that had been responsible for it—northern France, Flanders, and England primarily—were no longer susceptible to massive stylistic influences from the Greek East. Of the transalpine countries, only Germany experienced a further strong wave of Byzantine stylistic influence in the first half of the thirteenth century, a wave which produced the so-called "Zackenstil"; but this, in European terms, was a cul-de-sac.[70] Otherwise, from here on, so far as northern Europe is concerned, the relationship to Byzantium is mainly a matter of that broad and elusive parallelism of which I spoke earlier. This parallelism, however, continues throughout the great period of "high" Gothic. When one stands in the church at Sopoćani and beholds its fresco decoration with those great statuesque figures seemingly bulging forward from the walls (fig. 7), and, at the same time, soaring upward with a powerful thrust, one cannot help thinking of the sculptured statues of French and German cathedrals.[71] But what, if any, concrete links this may involve is still a mystery.[72]

[68] See the excellent formulation by O. Demus apropos of Nicholas of Verdun: "Er dürfte der erste nordische Meister gewesen sein, der durch die Oberflächenschicht des italobyzantinischen Stilhabitus zu den antiken Grundlagen der Form durchstieß und damit der langdauernden Lehrzeit der nordischen Kunst bei der byzantinischen ein Ende machte" (op. cit. [supra, note 58], p. 18).

[69] Panofsky, op. cit. (supra, note 2), p. 55 ff.

[70] H. Swarzenski, Die lateinischen illuminierten Handschriften des XIII. Jahrhunderts in den Ländern an Rhein,.Main und Donau (Berlin, 1936), p. 8; O. Demus, op. cit. (supra, note 14), p. 88. The "Zackenstil" is not simply a lingering reflection of the Byzantine "dynamic" wave of the late twelfth century, but was formed on the basis of quite up-to-date Byzantine models; see Weitzmann, op. cit. (supra, note 13).

[71] This was my experience when visiting Sopoćani in 1953. I was happy to find during the preparations for the 1965 symposium at Dumbarton Oaks that my friend Professor Otto Demus had independently come to the same conclusion. In the lecture on wall paintings which he gave at the Symposium, Professor Demus made striking comparisons between figures from Sopoćani and statues from Naumburg Cathedral which are of virtually the same date.

[72] A. Frolow has recently suggested a direct influence of Byzantine paintings and mosaics to account, or to help account, for the characteristic sweeping curve of Gothic statues ("L'origine des personnages hanchés dans l'art gothique," Revue archéologique [1965], I, p. 65 ff.). But, if there was such an influence in the thirteenth century—as distinct from, and in addition to, a development growing from seeds sown during the period of the West's own "neoclassicism" about A.D. 1200—that influence was absorbed and transposed in the freest and most sovereign manner. The gradual and essentially autonomous emergence of the motif in French early thirteenth-century sculpture has been beautifully described by W. Vöge ("Vom gotischen Schwung und den plastischen Schulen des 13. Jahrhunderts," Repertorium für Kunstwissenschaft, 27 [1904], p. 1 ff., esp. p. 5).

I shall be brief on the subject of the new birth of painting in Italy at the end of the thirteenth century. Obviously I could not do justice here to this vast and complex story. I only want to make one point which I consider essential, namely, that in its broad outlines, in its over-all pattern, the evolution in the Italian Dugento repeats that which we have just followed in the north: waves of Byzantine influence lead to an intensive and independent encounter with the antique which, in turn, is the prelude to complete emancipation.[73]

The further waves of Byzantine influence which reach Italy in the thirteenth century are what is commonly known as the *maniera greca*, that controversial phenomenon of which I spoke at the outset. In claiming it as analogous in character and effect to the Byzantine waves of the twelfth century that led to the emergence of Gothic, I have, by implication, declared my view of the matter. The *maniera greca* was not the dead hand of tradition. It reflects a series of live impulses from a living art. These impulses entered the main stream of the Italian development, and far from retarding or interrupting that development played an important, if indirect, part in bringing about its final climax.

This can be shown most readily by focussing on the second half of the Dugento and, more particularly, on the impact made on Italian painting of that period by what was then the latest Byzantine development, namely, the "volume style" of the early Palaeologan period. The influence of this style was immediate and obvious in the Venetian mosaic workshops (fig. 33),[74] but it also made itself felt as early as the 1270's in central Italy,[75] and, above all, in what was to become the heartland of the Italian Renaissance, Tuscany. Some details from the mosaics in the dome of the Florence Baptistery which have sometimes been attributed to the young Cimabue invite direct comparison with Palaeologan work (figs. 34, 35).[76] So do the frescoed Evangelists in the Upper Church at Assisi, which are generally agreed to be a work of Cimabue of the 1280's or early 1290's. If these figures are heavy and corporeal, if, with their obliquely placed furniture, they seem to come forward from the picture plane, if the accompanying architecture appears staged in depth, it is obvious where the principal source for all this lies.[77] In the young Duccio's Ruccellai Madonna, also a work of the 1280's, the same influence may be less immediately identifiable because it has been sublimated, as it were, and

[73] This parallelism between the Northern and the Italian development was noted by Koehler, *op. cit.* (*supra*, note 44), p. 86f., and Panofsky, *op. cit.* (*supra*, note 2), p. 137.

[74] O. Demus, "The Ciborium Mosaics of Parenzo," *Burlington Magazine*, 87 (1945), p. 238ff., esp. pl. I A and p. 242; *idem, op. cit.* (*supra*, note 12), p. 39.

[75] Toesca, *op. cit.* (*supra*, note 3), p. 970f. (Grottaferrata).

[76] *Ibid.*, p. 1003 and fig. 705. The figures of prophets in the central disk of the vault of the Scarsella, which also derive very obviously from Palaeologan art, have been attributed by O. Demus to Venetian mosaicists who came to Florence after 1301 ("The Tribuna Mosaics of the Florence Baptistery," *Actes du VIᵉ congrès international d'études byzantines,* II [Paris, 1951], p. 101ff., esp. p. 106ff.; for illustrations, see *I mosaici del Battistero di Firenze* [a cura della Cassa di Risparmio di Firenze], V [Florence, 1959], pl. 15ff.).

[77] Demus, *op. cit.* (*supra*, note 12), p. 40 and figs. 18, 32. For Cimabue's work at Assisi and its Byzantine affinities, see also the paper by J. Stubblebine in the present volume (p. 96f. and figs. 14–17).

tempered with other elements, most obviously in the throne.[78] Shown in the same oblique and depth-creating view as that of the Assisi Evangelists, it has become a fanciful and elegant piece of miniature Gothic architecture. But Duccio's strong and direct indebtedness to contemporary Byzantium becomes evident in comparing the busts on the frame of the Madonna with Byzantine miniatures of the same period,[79] or the head of one of the angels[80] with an angel from Sopoćani.[81] What is even more important here than the purely formal similarities is an ethos of serene, aristocratic humaneness which these figures share. And whatever the complexities of Duccio's development, whatever other ingredients contributed to the further evolution of his style, there is still a strong Palaeologan flavor in his Maestà of 1308, witness a comparison with the almost contemporary work in the Kariye Djami (figs. 36, 37).

Clearly, then, the Greek influence involved something more than an endless repetition by unimaginative Italian craftsmen of stale and outworn Byzantine formulae. It was a living challenge emanating from the most recent developments in Constantinople and taken up by leading artists.[82]

Meanwhile, however, there had been another movement of great importance, namely, a return to Italy's own antique heritage. A number of Italian thirteenth-century artists borrowed consciously and systematically from Roman and early Christian art, thus continuing the chain of "proto-renaissances" of the twelfth century. Niccolo Pisano is a famous example. But the most systematic and deliberate effort to revive the ancient native heritage took place in Rome in the last decades of the century, when Cavallini restored the fifth-century wall paintings of San Paolo f.l.m. and Torriti "recreated" in the apse of S. Maria Maggiore an early Christian type of mosaic complete with rich, fleshy acanthus rinceaux and a Nilotic landscape with sporting cupids.[83] What is important here—and to realize it one need only look at the figures of saints in Torriti's mosaic—is that the early Christian element merges and coalesces with a strong influence from the Byzantine "volume style" (figs. 38, 39).[84] What might otherwise have been a fussy accumulation of antiquarian detail becomes part of a monumental vision in which the grandeur and majesty of the human figure are powerfully proclaimed. And it was from this fusion of Eastern Hellenism and native late antique art, accomplished in Rome in the closing decades of the thirteenth century, that Giotto received decisive impulses. Giotto's new image of man—dignified, autonomous, creating, and

[78] Stubblebine, *ibid.*, p. 99 f. and fig. 22.

[79] *Ibid.*, p. 99 and figs. 16, 21, 23. See also V. N. Lazareff, in *Vizantiiskii Vremennik*, 5 (1952), p. 178 ff., esp. fig. 8.

[80] Stubblebine, *op. cit.*, fig. 26.

[81] V. J. Durić, *Sopoćani* (Belgrade, 1963), pl. 32. For comparisons with Byzantine icons, see Stubblebine, *op. cit.*, figs. 28, 29 and p. 99 f.

[82] Stubblebine, *ibid.*, p. 100. For Palaeologan influences on miniature painting in Sicily in the early fourteenth century, see the paper by H. Buchthal in the present volume (p. 103 ff.).

[83] W. Päseler, "Der Rückgriff der römischen Spätdugentomalerei auf die christliche Spätantike," *Beiträge zur Kunst des Mittelalters* (Berlin, 1950), p. 157 ff. Panofsky, *op. cit.* (*supra*, note 2), p. 137. For Cavallini's work in S. Paolo see J. White, "Cavallini and the Lost Frescoes in S. Paolo," *Journal of the Warburg and Courtauld Institutes*, 19 (1956), p. 84 ff.

[84] P. Toesca, *Pietro Cavallini* (Milan, 1959), p. 6.

completely dominating his spatial environment—owes much to Cavallini and his Roman circle, though it was nurtured also by further borrowings from the antique.[85] Thus, there is indeed a repetition of the chain of evolution that a century before had led from direct Byzantine influence to the "neo-classicism" of Nicholas of Verdun, and, finally, to the classic art of Chartres and Rheims.

Both in Italy and in the Gothic North, the Byzantine contribution was essentially a midwife service. It is not true to say that the Byzantine currents were without a future, let alone that they were merely obstructions. It *is* true to say that in the end the West found salvation elsewhere. Both of the decisive breakthroughs in the history of Western mediaeval art involved intensive and independent study of, and borrowing from, classical and early Christian antiquity. In this sense they were reactions against Byzantium. But they were preceded and, indeed, triggered by intensive waves of Byzantine influence.

It is clear also what accounts for this influence. The spell which Byzantine art held for so long—and in Italy so much longer than in the North—was due to its sustained quest for humane values. The Greek artists who in the twelfth and thirteenth centuries pursued their age-old interest in the human form and proclaimed successively its organic cohesion, its capability of conveying emotions and moods, and, finally, its power to create and dominate space, held out challenges and provided lessons such as the West's own mute relics of antiquity could never have provided by themselves. Italy, for profound historical reasons, was captivated by these values far more strongly than were the transalpine countries. Hence the long duration of her state of apprenticeship—but hence also the thoroughness of the humanistic revolution which followed. Italy after 1300 was far less prone to "mediaeval reactions" than was the Gothic North; she was, in fact, firmly launched on the road to the Renaissance.

My subject was the Byzantine contribution to Western art, not the artistic relationship between East and West in its entirety. Had the latter been my theme more would have had to be said about the limitations to which Byzantine influence always was subject in the West. Whenever one puts side by side with a Byzantine work of art a Western mediaeval one—even, and, indeed, especially, a Western work that cleaves very closely to a Byzantine model— one cannot help being forcibly struck by what are, from the Byzantine point of view, misunderstandings, misreadings, or, at any rate, reinterpretations. The manner and direction of the departure from the Byzantine norm differ depending on the period and on the national background of the Western artists involved. But there are definite trends. There are strictly morphological changes, such as the tendency to replace Byzantium's soft, painterly lines by sharper and more calligraphic ones,[86] or its rather loose and vague correlation of figures and objects in space by some form of constructivism whereby the

[85] Oertel, *op. cit.* (*supra*, note 3), p. 68. Panofsky, *op. cit.* (*supra*, note 2), pp. 119, 137, 148, 151 ff. (with further references).

[86] See, e.g., figs. 34, 35; also K. Weitzmann's two papers in the present volume, *passim* (e.g., p. 7 f. and figs. 8–11; p. 66 and fig. 32; p. 69 and fig. 33 f.; p. 81 f. and fig. 66 ff.).

single elements of a picture become, so to speak, building blocks neatly and often tightly stacked in zones and staged in receding planes.[87] And there are the more subtle psychological changes, the casting-off of emotional restraints, the attempts at increased empathy, the unwonted touches of drastic realism, and the expressionist excesses which in some instances lead to distortion and caricature.[88] All these are Western attitudes of long standing; most of them can be discerned in the Western approach to the art of the Greek East even in the Carolingian period, and some earlier still. They bespeak deep and fundamental differences, differences that reach far beyond the realm of form and have to do with wholly divergent attitudes toward the role and function of religious art, and ultimately toward the entire world of the senses.

Here lies a vast field of further enquiry. It is a fascinating field encompassing as it does the whole problem of the Greek and the Western world in their estrangement as well as in their kinship. But my purpose was a more limited one. It will have been accomplished if I have been able to show that during a crucial period of its artistic development the West received from Byzantium vital help in finding itself.

[87] See, e.g., Stubblebine, *op. cit.*, p. 87 f. and fig. 1 f.; p. 92 f. and fig. 11 f.; p. 97 and fig. 18.

[88] See, e.g., fig. 13; also K. Weitzmann's two papers, p. 16 f. and fig. 27; p. 60 and fig. 19; p. 63 f. and fig. 23; p. 64 and fig. 26.

1. Daphni, Naos. Mosaic, Annunciation, detail

2. Istanbul, St. Sophia, South Gallery.
Mosaic Panel of Emperor John II Comnenus,
detail, the Empress Irene

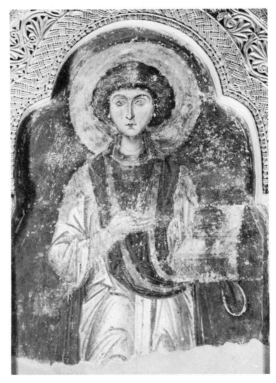

3. Nerezi, Church of St. Panteleimon, Iconostasis.
Wall Painting, St. Panteleimon

4. Nerezi, Church of St. Panteleimon, Naos. Wall Painting,
 Lamentation of Christ

5. Kurbinovo, Church of St. George, Bema Arch.
 Wall Painting, Angel of the Annunciation

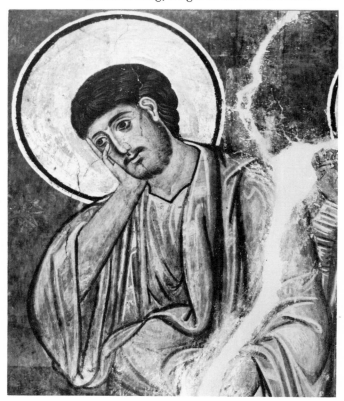

7. Sopoćani, Church of the Holy Trinity, Naos.
 Wall Painting, a Patriarch

6. Studenica, Church of the Virgin, Naos, West Wall. Wall Painting,
 Crucifixion, detail, St. John

9. Canterbury, Cathedral, St. Anselm's Chapel.
Wall Painting, St. Paul at Malta

8. Asinou, Church of the Panaghia Phorbiotissa, Naos.
Wall Painting, Dormition, detail

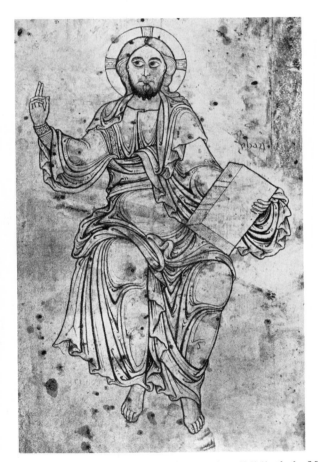

11. Vienna, Oesterreichische Nationalbibliothek. MS 953,
Inside of Cover, Pen Drawing, Christ

10. Monreale, Cathedral, West Wall. Mosaic, Lot and the Angels,
detail

12. Monreale, Cathedral, South Aisle. Mosaic,
Healing of the Daughter of the Canaanite Woman, detail

13. Winchester, Cathedral Library. Bible,
vol. III, fol. 215, Healing of Demoniac, detail

15. Klosterneuburg, Altar of Nicholas
of Verdun. Annunciation, detail

14. Palermo, Cappella Palatina,
Nave. Mosaic, Expulsion of Adam
and Eve from Paradise, detail

16. Monreale, Cathedral, Nave. Mosaic,
Expulsion of Adam and Eve
from Paradise, detail

17. Cefalù, Cathedral, Chancel Vault. Mosaic, detail, Angel

18. Klosterneuburg, Altar of Nicholas of Verdun. Back of Plaque depicting Hell, the Holy Women at the Sepulcher

19. Monreale, Cathedral, North Chapel. Mosaic, St. Paul handing Letters to Timothy and Silas, detail

20. Klosterneuburg, Altar of Nicholas of Verdun. Entry into Jerusalem

21.

23.

Ravenna, Museo Arcivescovile. Ivory Chair of Maximian, detail, Four Evangelists

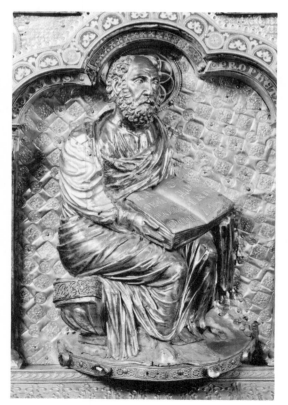

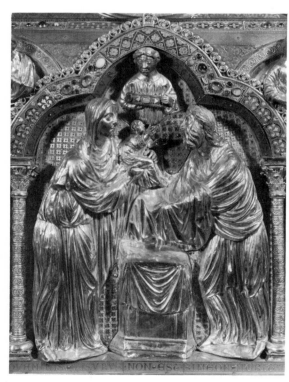

24. Tournai, Cathedral. Shrine of the Virgin, detail,
Presentation in the Temple

22. Cologne, Cathedral. Shrine of the Three Kings,
detail, Prophet Amos

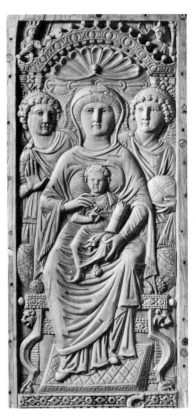

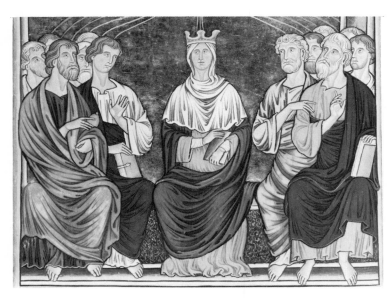

26. Chantilly, Musée Condé. MS 9/1695 (Psalter of Queen Ingeborg), Fol. 32ᵛ, Pentecost, detail

25. Berlin, Staatliche Museen, Stiftung Preussischer Kulturbesitz. Panel of Ivory Diptych, Virgin and Child

27. Rongolise, Grotta di S. Maria. Wall Painting, Dormition, detail, Christ

28. Sigena, Chapter House. Wall Painting, Genesis Scene, detail, the Lord

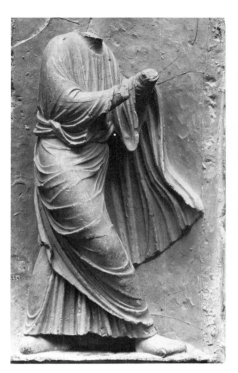

30. Chantilly, Musée Condé. MS 9/1695 (Psalter of Queen Ingeborg),
Fol. 33, Last Judgement, detail

29. Laon, Cathedral, West Façade,
North Portal. Archivolt Figure, from a cast

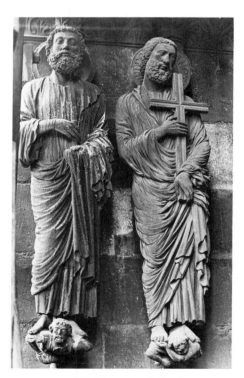

31. SS. Peter and Andrew

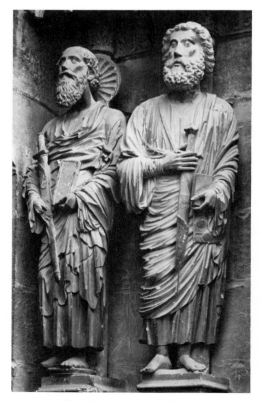

32. SS. Paul and James

Rheims, Cathedral, North Transept, Portal of the Last Judgement.

33. Venice, San Marco, Atrium, North Wing. Mosaic, Water Miracle of Moses

34. Washington, Dumbarton Oaks Collection.
Mosaic Icon of the Forty Martyrs, enlarged detail

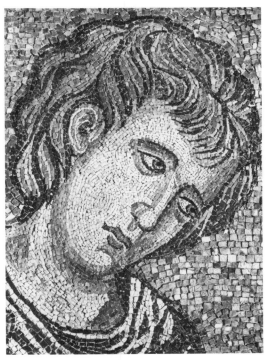

35. Florence, Baptistery, Dome. Mosaic,
Birth of John the Baptist, detail

36. Istanbul, Kariye Djami, Outer Narthex. Mosaic, The Temptations of Christ, detail

37. Siena, Opera del Duomo. *Maestà* by Duccio Gethsemane Scene, detail

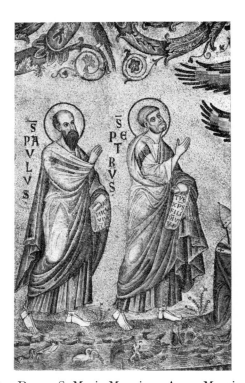

38. Sopoćani, Church of the Holy Trinity, Naos. Wall Painting, a Patriarch

39. Rome, S. Maria Maggiore, Apse. Mosaic by Jacopo Torriti, detail, SS. Peter and Paul

AUTHOR'S POSTSCRIPTS

The following postscripts by Ernst Kitzinger guide the reader to more recent literature either on the general subject of each paper or on some key monuments or problems discussed therein and are not intended to be exhaustive. The page numbers in brackets refer to this volume.

—EDITOR.

I. A Marble Relief of the Theodosian Period

The problems of the Theodosian style in Constantinopolitan sculpture, its antecedents, its sequel and its relationship to developments in the Latin West, have been discussed more recently by J. Kollwitz, "Probleme der theodosianischen Kunst Roms," *Rivista di Archeologia Cristiana*, 39 (1963), pp. 191 ff.; B. Brenk, "Zwei Reliefs des späten 4. Jahrhunderts," Institutum Romanum Norvegiae, *Acta ad Archaeologiam et Artium Historiam Pertinentia*, 4 (1969), pp. 51 ff.; H.-G. Severin, "Oströmische Plastik unter Valens und Theodosius I," *Jahrbuch der Berliner Museen*, 12 (1970), pp. 211 ff.; H. Brandenburg, "Ein frühchristliches Relief in Berlin," *Mitteilungen des Deutschen Archaeologischen Instituts, Römische Abteilung*, 79 (1972), pp. 123 ff.

For marble table tops and their function and uses in pagan and Christian contexts see O. Nussbaum, "Zum Problem der runden und sigmaförmigen Altarplatten," *Jahrbuch für Antike und Christentum*, 4 (1961), pp. 18 ff.; G. Roux, "Tables chrétiennes en marbre découvertes à Salamine," *Salamine de Chypre*, IV, *Anthologie Salaminienne*, Paris, 1973, pp. 133 ff.; G. Akerström-Hougen, *The Calendar and Hunting Mosaics of the Villa of the Falconer in Argos*, Lund, 1974, pp. 101 ff.

The last sentence [on page 25] should read: It leads us directly into the main current of Greek Christian art and is, indeed, a key piece, showing as it does that as early as A.D. 400 that art had its focus in Constantinople and hence should be called Byzantine.

II. On the Interpretation of Stylistic Changes in Late Antique Art

"Other-direction"—*i.e.* the role of the patron in the creation of works of art—has in recent years increasingly attracted the attention of art historians in different fields (see, for instance, P. Hirschfeld, *Mäzene. Die Rolle des Auftraggebers in der Kunst*, Munich and Berlin, 1968). But, at least for the period with which this article is concerned, the stylistic aspect of the problem—that is to say, the part played by patrons in setting or encouraging stylistic trends—is still awaiting a full exploration. For a general discussion of the phenomenon

[389

of an earlier style being revived for its associative value see W. Götz, "His-torismus," *Zeitschrift des deutschen Vereins für Kunstwissenschaft*, 24, 1970, pp. 196 ff. Art historians have paid less attention to the problem of "inner-directed" style changes and their interpretation.

III. Mosaic Pavements in the Greek East and the Question of a "Renaissance" under Justinian

I have returned to the subject of this article in another study published in 1973 [see pp. 327 ff., especially pp. 327–328, 352 ff.]. Relevant literature of more recent date will be found cited in that study.

The reference to figure 5 [p. 54] in this article was erroneously retained by the French editors when they reduced the number of illustrations. Figure 5 was to have been an illustration of the floor mosaic at Tabgha, which is illus-trated in figure 17 [p. 86] of article IV in this volume.

IV. Stylistic Developments in Pavement Mosaics in the Greek East from the Age of Constantine to the Age of Justinian

Among the developments sketched in this paper, it is the phenomenon of the "figure carpet" [pp. 65 ff.] that has been most frequently and critically discussed in more recent literature, particularly with reference to I. Lavin's study published in *Dumbarton Oaks Papers*, Vol. 17. See A. Carandini, "La villa di Piazza Armerina, la circolazione della cultura figurativa africana nel tardo impero ed altre precisazioni," *Dialoghi di Archeologia*, 1, 1967, pp. 93 ff., especially pp. 108 ff.; J. W. Salomonson, "Kunstgeschichtliche und ikonographische Unter-suchungen zu einem Tonfragment der Sammlung Benaki in Athen," *Bulletin Antieke Beschaving*, 48, 1973, pp. 3 ff., especially pp. 38 ff. The important hunt-ing floor at Apamea [cf. p. 69] has been claimed as a work of the late fourth century by J. Balty, *La grande mosaïque de chasse du triclinos*, Brussels, 1969. According to this author, the inscription of 539 A.D. on the adjoining threshold refers not to the execution of the mosaic but to a restoration of the room which the mosaic adorns. Her thesis, however, leaves a number of questions unresolved.

V. The Cult of Images in the Age before Iconoclasm

Since the publication of this paper a number of important general studies on Byzantine iconoclasm have appeared, notably A. Grabar, *L'iconoclasme by-zantin, Dossier archéologique*, Paris, 1957, and P. J. Alexander, *The Patriarch Nicephorus of Constantinople*, Oxford, 1958. In both these books it is the early chapters that are especially relevant to the topic of this paper. There are also pertinent observations in the early chapters of P. Lemerle, *Le premier humanisme byzantin*, Paris, 1971. The article by P. Brown, "A Dark-Age Crisis: Aspects of the Iconoclastic Controversy," *The English Historical Review*, 346, January 1973,

pp. 1 ff., has been reviewed critically by S. Gero, "Notes on Byzantine Iconoclasm in the Eighth Century," *Byzantion*, 44, 1974, pp. 23 ff., especially pp. 38 ff.

Concerning the role of the emperors in promoting the cult of religious images [pp. 127 ff.], W. L. Barnard, in an article entitled "The Emperor Cult and the Origins of the Iconoclastic Controversy," *Byzantion*, 43, 1973 (1974), pp. 13 ff., has propounded a thesis essentially identical with mine, taking over long passages from Part III of my paper in only slightly paraphrased form and without citing his source (see also Chapter 5 of his book *The Graeco-Roman and Oriental Background of the Iconoclastic Controversy*, Leiden, 1974, pp. 65 ff., which is virtually a reprint of his own article).

The question of Hypatius of Ephesus and his relation to the writings of Pseudo-Dionysus [pp. 143 ff.] has been discussed by J. Gouillard, "Hypatios d'Éphèse ou Du Pseudo-Denys à Théodore Studite," *Revue des Études Byzantines*, 19, 1961, pp. 63 ff., and by S. Gero, "Hypatius of Ephesus on the Cult of Images," *Christianity, Judaism and Other Greco-Roman Cults: Studies for Morton Smith at Sixty*, II, Leiden, 1975, pp. 208 ff.

I take this opportunity to correct a mistranslation of a quotation from Epiphanius of Salamis with note 30 [p. 99]. The translation should read: "When they have set up these images they then carry out the customs of the pagans."

VI. Byzantine Art in the Period between Justinian and Iconoclasm

V. Lazarev's discussion of Byzantine paintings and mosaics in the period covered by this paper has become more easily accessible thanks to the appearance of his Russian work of 1947–48 in an Italian version, which also contains important revisions (*Storia della pittura bizantina*, Turin, 1967; see especially Chapter IV). Problems of stylistic developments in the East and in Rome during this period are also dealt with by G. Lorenzoni in Chapters III to VI of his book *Aspetti e problemi del medioevo artistico: Le origini*, Turin, 1969.

The following references pertain to individual monuments, groups of monuments or problems with which my paper is concerned. Silver [pp. 159 ff., 174 ff., 189–190]: The study of hallmarks by Erica Cruikshank Dodd was published under the title *Byzantine Silver Stamps*, Washington, D. C., 1961. Supplements have appeared in *Dumbarton Oaks Papers*, 18, 1964, pp. 237 ff., and 22, 1968, pp. 141 ff. The respective claims of Constantinople and Syria as centers of manufacture are still a matter of extensive debate; see most recently E. Cruikshank Dodd, *Byzantine Silver Treasures*, Bern, 1973, especially pp. 33 ff., and articles by P. Angiolini Martinelli and G. de Francovich in *XXI Corso di cultura sull'arte ravennate e bizantina*, Ravenna, 1974, pp. 7 ff., 31 ff., 137 ff.

Frescoes of S. Maria Antiqua and the hellenistic style in Roman paintings of the seventh and early eighth centuries [pp. 163, 188 ff.]: See C. Bertelli, *La Madonna di Santa Maria in Trastevere*, Rome, 1961, pp. 80 ff.; P. J. Nordhagen, *The Frescoes of John VII* (A.D. 705–707) *in S. Maria Antiqua in Rome*, Acta ad Archaeologiam et Artium Historiam Pertinentia, III, Rome, 1968, pp. 106 ff.;

idem, " 'Hellenism' and the Frescoes in Santa Maria Antiqua," *Konsthistorisk Tidskrift*, 41, 1972, pp. 73 ff. It should be noted that acceptance of a 570 to 580 date for the remodelling of the architecture of S. Maria Antiqua (*cf.* Nordhagen's 1968 study, p. 110, note 7) would necessitate a substantial revision of the chronology of some of the paintings in question. But the archaeological evidence on which this dating is based is at present poorly documented and, in any case, inconclusive.

Mosaics of the bema of the Church of the Dormition at Nicaea [pp. 168 ff.]: The thesis tentatively put forward [p. 172, note 59], was corroborated, and the study of the monument significantly advanced, by P. A. Underwood in an article entitled "The Evidence of Restorations in the Sanctuary Mosaics of the Dormition at Nicaea," *Dumbarton Oaks Papers*, 13, 1959, pp. 235 ff. An important discovery made in Istanbul in 1969 has at last given us an indubitably pre-Iconoclastic wall mosaic with figures from the Byzantine capital itself; see C. L. Striker and Y. D. Kuban, "Work at Kalenderhane Camii in Istanbul: Third and Fourth Preliminary Reports," *Dumbarton Oaks Papers*, 25, 1971, pp. 251 ff., especially pp. 255–256, and fig. 11.

Roman mosaics of the sixth and seventh centuries [pp. 172 ff.]: See the full publication by G. Matthiae, *Mosaici medioevali delle chiese di Roma*, Rome, 1967.

Byzantine coins of the sixth and seventh centuries [pp. 176, 188–189]: The standard reference work is now the *Catalogue of the Byzantine Coins in the Dumbarton Oaks Collection and in the Whittemore Collection*, Vol. I (by A. R. Bellinger): *Anastasius I to Maurice 491–602*, Washington, D.C., 1966; Vol. II (by Ph. Grierson): *Phocas to Theodosius III 602–717*, Washington, D.C., 1968. See also M. Restle, *Kunst und byzantinische Münzprägung von Justinian I. bis zum Bilderstreit*, Athens, 1964.

Mosaics in Salonika [pp. 176 ff.]: While there is general agreement that the second group of mosaics in the Church of St. Demetrius must be of a date close to the middle of the seventh century [see p. 182], the dating of all the other Salonikan mosaics of the pre-Iconoclastic period continues to be under discussion, with recent investigators advocating relatively late dates for the mosaics of the rotunda of St. George and relatively early dates for the rest. R. Cormack has attributed the first group of mosaics in St. Demetrius, the ornamental mosaics of the Acheiropoietos Basilica, and the apse mosaic of Hosios David to the late fifth century ("The Mosaic Decoration of S. Demetrios, Thessaloniki," *Annual of the British School of Archaeology at Athens*, 64, 1969, pp. 17 ff.). W. E. Kleinbauer has proposed a date in the third quarter of the fifth century for the mosaics of St. George, and he considers those of the Acheiropoietos Church and the first group of mosaics in St. Demetrius as contemporaneous and only those of Hosios David as somewhat later ("Some Observations on the Dating of S. Demetrios in Thessaloniki," *Byzantion*, 40, 1970, pp. 36 ff.; "The Iconography and the Date of the Mosaics of the Rotunda of Hagios Georgios, Thessaloniki," *Viator*, 3, 1972, pp. 27 ff.). M. Vickers, on the basis of an investigation of brick stamps, has postulated a comprehensive building program in Salonika in the

440s, of which the churches and the mosaics in question, with the exception of Hosios David, would be a part ("Fifth Century Brick Stamps from Thessaloniki," *Annual of the British School of Archaeology at Athens*, 68, 1973, pp. 285 ff., with references to his earlier studies).

Mosaics in the Monastery of St. Catherine on Mount Sinai [p. 185]: See now the publication of G. H. Forsyth and K. Weitzmann, *The Monastery of Saint Catherine at Mount Sinai: The Church and Fortress of Justinian, Plates*, Ann Arbor [1973], pp. 11 ff. and pls. 103–129, 136–187. The mosaics are certainly of the period 548–565 A.D. (*ibid.*, pp. 11–12).

Icons on Mount Sinai [pp. 186, 188]: See the bibliographical postscript for Article VII.

Mosaic floor of the Imperial Palace in Constantinople [pp. 190–191]: The dating in the fifth century has become untenable in the light of subsequent investigations; see the literature cited in my article of 1963 [p. 68].

Syrian manuscript illumination [pp. 191–192]: J. Leroy, *Les manuscrits syriaques à peintures*, Paris, 1964, pp. 93 ff., 139 ff.

Religious images in accessible positions [pp. 197 ff.]: See A. Weis, "Ein vorjustinianischer Ikonentypus in S. Maria Antiqua," *Römisches Jahrbuch für Kunstgeschichte*, 8, 1958, pp. 17 ff., especially pp. 47 ff. For a recent summary of archaeological and literary evidence relating to the early history of the iconostasis see the article "Ikonostas" by M. Chatzidakis in *Reallexikon zur byzantinischen Kunst* (K. Wessel and M. Restle, editors), III, Stuttgart, 1973– , col. 326 ff. For icons see the bibliographical postscript for Article VII.

Interpretation of stylistic dichotomy in seventh century art [pp. 202 ff.]: I have returned to this problem in my article on portraiture [pp. 256 ff., especially pp. 263–264].

VII. On Some Icons of the Seventh Century

The general argument of this article was taken up on a more comprehensive basis in the study of 1958 which precedes it in this volume [pp. 157 ff.]. More early icons have since come to light in Rome; see especially C. Bertelli, *La Madonna di Santa Maria in Trastevere*, Rome, 1961, and a report by H. Hager, "Rückgewonnene Marienikonen des früher Mittelalters in Rom," *Römische Quartalschrift*, 61, 1966, pp. 209 ff. A full catalogue of the early icons in the Monastery of St. Catherine on Mount Sinai by K. Weitzmann is in the press. Skillful restoration has added another important panel to the group (see M. Chatzidakis, "An Encaustic Icon of Christ at Sinai," *Art Bulletin*, 49, 1967, pp. 197 ff.), but the dating of these icons is still in dispute. The icons from Sinai in Kiev have been reproduced in color by A. Banck, *Byzantine Art in the Collections of the U.S.S.R.*, Leningrad and Moscow, 1966, pls. 110–115. A large tapestry from Egypt acquired by the Museum in Cleveland, Ohio, provides new insight into the range and variety of portable religious images in the pre-Iconoclastic period; see D. G. Shepherd, "An Icon of the Virgin," *Bulletin of The Cleveland Museum of Art*, 56, 1969, pp. 90 ff.

VIII. Some Reflections on Portraiture in Byzantine Art

I am not aware of further studies of Byzantine portraiture on the lines of Millet's or my own paper.

For further discussion of the two types of Christ on the coins of Justinian II [pp. 261 ff.] see Ph. Grierson, *Catalogue of the Byzantine Coins in the Dumbarton Oaks Collection*, II, 2, Washington, D.C., 1968, pp. 569–70, 644–45; P. J. Nordhagen, *The Frescoes of John VII* (A.D. *705–707*) *in S. Maria Antiqua in Rome*, Acta ad Archaeologiam et Artium Historiam Pertinentia, III, Rome, 1968, pp. 52–53; J. D. Breckenridge, "Evidence for the Nature of Relations between Pope John VII and the Byzantine Emperor Justinian II," *Byzantinische Zeitschrift*, 65, 1972, pp. 364 ff.

IX. The First Mosaic Decoration of Salerno Cathedral

No further literature on the eleventh century mosaics of Salerno Cathedral has come to my notice.

On the Byzantine "intervention" in Monte Cassino under Desiderius [pp. 279 ff.] see most recently H. Belting, "Byzantine Art Among Greeks and Latins in Southern Italy," *Dumbarton Oaks Papers*, 28, 1974, pp. 1 ff., especially pp. 17–18.

X. The Mosaics of the Cappella Palatina in Palermo

After this article was published I found corroborative evidence that a royal box on the north wall of the transept was indeed an integral part of the twelfth century architecture of the Cappella Palatina, as surmised on [pp. 304–305], and that the layout of the mosaics in the transept was keyed to this royal prospect from the outset; see my review of O. Demus, *The Mosaics of Norman Sicily* in *Speculum*, 28, 1953, pp. 143 ff., especially pp. 146–147. A study by W. Krönig, focussed on the Transfiguration scene in the center of the south wall, has carried this iconological interpretation further ("Zur Transfiguration der Cappella Palatina in Palermo," *Zeitschrift für Kunstgeschichte*, 19, 1956, pp. 162 ff.). A similar approach has also been used by I. Beck, "The First Mosaics of the Cappella Palatina in Palermo," *Byzantion*, 40, 1970, pp. 119 ff., but her article contains a number of inaccuracies and questionable statements.

For Philagathos [p. 302] see now G. Rossi Taibbi, *Filagato da Cerami, Omelie per i vangeli domenicali e le feste di tutto l'anno*, I, Palermo, 1969. Unfortunately there is no proof for the thesis put forward by B. Cappelli that the program for the mosaic decoration of the Cappella Palatina was drawn up by Philagathos ("Da Rossano alla Cappella Palatina di Palermo," *Bollettino della Badia greca di Grottaferrata*, n.s. 16, 1962, pp. 77 ff., especially pp. 88 ff.).

XI. On the Portrait of Roger II in the Martorana in Palermo

I have come back to the Martorana mosaic and its interpretation in the introductory section of my paper "The Gregorian Reform and the Visual Arts:

A Problem of Method," *Transactions of The Royal Historical Society*, series 5, 22, 1972, pp. 87 ff.

XII. World Map and Fortune's Wheel: A Medieval Mosaic Floor in Turin

A pavement of the thirteenth century discovered in 1974 at Oberpleis in the Rhineland is an interesting addition to the corpus of cosmographical representations on church floors. See the exhibition catalogue *Monumenta Annonis*, Cologne, 1975, pp. 120 ff.

XIII. The Byzantine Contribution to Western Art of the Twelfth and Thirteenth Centuries

The overall subject of this paper was discussed in a broad context by O. Demus in his Wrightsman Lectures of 1966, subsequently published in book form (*Byzantine Art and the West*, New York, 1970). For a critical review of this approach, with emphasis on the limits of Byzantine influence, see W. Grape, *Grenzprobleme der byzantinischen Malerei*, diss. Vienna, 1973.

For Byzantine influence on Western art of the twelfth century (with particular reference to Salzburg) see O. Demus' contribution to *Das Antiphonar von St. Peter*, Codices selecti, Vol. 21, *Kommentar*, Graz, 1974, pp. 195 ff., especially pp. 263 ff. I have further explored developments in the West in the light of the Byzantine "dynamic" style in a paper entitled "Byzantium and the West in the Second Half of the Twelfth Century: Problems of Stylistic Relationships," *Gesta*, IX/2, 1970, pp. 49 ff.

Much attention has been devoted in recent years to Western art in the decades about 1200 A.D., partly in connection with two major exhibitions held respectively in New York in 1970 and in Cologne and Brussels in 1972; see *The Year 1200*, I, *The Exhibition* (K. Hoffmann, ed.), II, *A Background Survey* (F. Deuchler, ed.), New York, 1970; and *Rhein und Maas*, Cologne, 1972. For Nicholas of Verdun and the problem of the relationship of his art to the art of Byzantium, see also a review by H. Fillitz of the Cologne exhibition (*Pantheon*, 30, 1972, pp. 326.ff.) and an article by R. Hamann-MacLean published in Russian in a volume of studies in honor of V. N. Lazarev (*Vizantiia, Iuzhnye Slaviane i Drevniaia Rus, Zapadnaia Evropa*, Moscow, 1973, pp. 396 ff.). For England see L. Ayres, "The Work of the Morgan Master at Winchester and English Painting of the Early Gothic Period," *Art Bulletin*, 56, 1974, pp. 201 ff.; for the Sigena frescoes, W. Oakeshott, *Sigena*, London, 1972. A further volume relating to the New York exhibition (*The Year 1200: A Symposium*) was published by the Metropolitan Museum in 1975.

For Byzantine influences on Italian painting of the late thirteenth and early fourteenth century I cite two recent studies: W. Grape, "Zum Stil der Mosaiken in der Kilise Camii in Istanbul," *Pantheon*, 32, 1974, pp. 3 ff.; and J. Stubblebine, "Byzantine Sources for the Iconography of Duccio's Maestà," *Art Bulletin*, 57, 1975, pp. 176 ff.

ERNST KITZINGER: BIBLIOGRAPHY

Römische Malerei vom Beginn des 7. bis zur Mitte des 8. Jahrhunderts, Munich, 1936 (dissertation).

"Anglo-Saxon Vinescroll Ornament," *Antiquity,* 10 (1936), 61–71.

Review of K. Weitzmann, *Die Byzantinische Buchmalerei des 9. und 10. Jahrhunderts* in *Journal of Hellenic Studies,* 56 (1936), 117–119.

Review of G. Millet and D. Talbot Rice, *Byzantine Painting at Trebizond* in *Journal of Hellenic Studies,* 56 (1936), 271–272.

Review of A. Grabar, *L'Empereur dans l'art byzantin* in *Journal of Hellenic Studies,* 57 (1937), 278–280.

"The Story of Joseph on a Coptic Tapestry," *Journal of the Warburg Institute,* 1 (1937–1938), 266–268.

"Notes on Early Coptic Sculpture," *Archaeologia,* 87 (1938), 181–215.

"A Romanesque Capital," *British Museum Quarterly,* 12 (1938), 56–57.

Review of J. Strzygowski, *L'ancien art chrétien de Syrie* in *Journal of Hellenic Studies,* 58 (1938), 124–126.

"The Sutton Hoo Finds: The Silver," *British Museum Quarterly,* 13 (1939), 118–126.

"The Sutton Hoo Ship Burial: The Silver," *Antiquity,* 14 (1940), 40–63.

Early Medieval Art in the British Museum, London: British Museum, 1940; second edition 1955; Bloomington, Indiana: Midland Books, Indiana University Press, 1964.

Portraits of Christ, Harmondsworth: The King Penguin Books, with Elizabeth Senior, 1940.

Review of J. Cooney, *Late Egyptian and Coptic Art. An Introduction to the Collections in the Brooklyn Museum* in *Art Bulletin,* 26 (1944), 204–205.

"The Horse and Lion Tapestry at Dumbarton Oaks: A Study in Coptic and Sassanian Textile Design," *Dumbarton Oaks Papers,* 3 (1946), 1–72.

"A Survey of the Early Christian Town of Stobi," *Dumbarton Oaks Papers,* 3 (1946), 81–161.

Review, "The Byzantine Exhibition at Baltimore," in *College Art Journal,* 7 (1947), 69–71.

Review of G. B. Ladner, *Die Papstbildnisse des Altertums und des Mittelalters,* I, *Bis zum Ende des Investiturstreits,* in *Speculum,* 23 (1948), 312–317.

"The Mosaics of the Cappella Palatina in Palermo: An Essay on the Choice and Arrangement of Subjects," *Art Bulletin,* 31 (1949), 269–292.

Review of A. Grabar, *Les Peintures de l'Evangéliaire de Sinope (Bibliothèque Nationale Suppl. gr. 1286)* in *Speculum,* 24 (1949), 445–446.

The Coffin of Saint Cuthbert, Oxford: University Press, 1950.

"On the Portrait of Roger II in the Martorana in Palermo," *Proporzioni*, 3 (1950), 30–35.

"Mosaic Pavements in the Greek East and the Question of a 'Renaissance' under Justinian," *Actes du VI^e Congrès International d'Études Byzantines, Paris, 27 juillet–2 août 1948*, 2 (Paris, 1951), 209–223.

"Studies on Late Antique and Early Byzantine Floor Mosaics: I. Mosaics at Nikopolis," *Dumbarton Oaks Papers*, 6 (1951), 81–122.

"Studi documentarii sui restauri dei mosaici della Cappella Palatina," *Atti dello VIII Congresso Internazionale di Studi Bizantini, Palermo, 3–10 Aprile 1951 = Studi Bizantini e Neoellenici*, 8 (Rome, 1953), 162 (résumé).

Review of O. Demus, *The Mosaics of Norman Sicily* in *Speculum*, 28 (1953), 143–150.

"The Cult of Images in the Age before Iconoclasm," *Dumbarton Oaks Papers*, 8 (1954), 83–150.

"On Some Icons of the Seventh Century," *Late Classical and Mediaeval Studies in Honor of Albert Mathias Friend, Jr.*, ed. K. Weitzmann *et al.*, Princeton: Princeton University Press, 1955, 132–150.

"The Coffin-Reliquary," in *The Relics of Saint Cuthbert*, ed. C. F. Battiscombe, Oxford: University Press, 1956, 202–304.

Review of M. Avi-Yonah, *The Madaba Mosaic Map* in *Journal of Hellenic Studies*, 76 (1956), 152–153.

"Byzantine Art in the Period between Justinian and Iconoclasm," *Berichte zum XI. Internationalen Byzantinisten-Kongress, München, 1958* (Munich, 1958), IV/1, 1–50; Japanese translation by S. Tsuji, Tokyo, 1971.

"Byzantium in the Seventh Century: Report on a Dumbarton Oaks Symposium," *Dumbarton Oaks Papers*, 13 (1959), 271–273.

"A Marble Relief of the Theodosian Period," *Dumbarton Oaks Papers*, 14 (1960), 17–42.

The Mosaics of Monreale, Palermo: S. F. Flaccovio Editore, 1960; also in Italian: *I Mosaici di Monreale*, tr. F. Bonajuto.

"The Dumbarton Oaks Center for Byzantine Studies," *Jahrbücher für Geschichte Osteuropas*, N.F., 10, Heft 3 (1962), 485–491; reprinted with minor changes in *Harvard Library Bulletin*, 19 (1971), 28–32.

Review of W. Koehler, *Die Karolingischen Miniaturen*, III, in *Art Bulletin*, 44 (1962), 61–65.

"Mosaico," *Enciclopedia Universale dell'Arte*, Venice and Rome: Istituto per la collaborazione culturale, Vol. 9, 1963, columns 673–675, 688–696; English edition: "Mosaics," *Encyclopedia of World Art*, New York, Toronto and London: McGraw-Hill, Vol. 10, 1965, columns 326–327, 342–349.

"Some Reflections on Portraiture in Byzantine Art," *Zbornik radova*, 8/1 = *Recueil des travaux de l'Institut d'Études byzantines*, No. VIII = Mélanges G. Ostrogorsky, I (Belgrade, 1963), 185–193.

"The Hellenistic Heritage in Byzantine Art," *Dumbarton Oaks Papers*, 17 (1963), 95–115. Reprinted in abridged form in *Readings in Art History* (H. Spencer, ed.), New York: Charles Scribner's Sons, 1969, I, 167–188.

Israeli Mosaics of the Byzantine Period, UNESCO. New York: The New American Library, Inc., 1965. Also published in Dutch, French, German, Italian, and Spanish.

"Stylistic Developments in Pavement Mosaics in the Greek East from the Age of Constantine to the Age of Justinian," *La Mosaïque Gréco-Romaine*, Colloques Internationaux du Centre National de la Recherche Scientifique, Paris, 29 août–3 septembre, 1963, Paris, 1965, 341–352.

"Norman Sicily as a Source of Byzantine Influence on Western Art in the Twelfth Century," *Byzantine Art—An European Art*, lectures given on the occasion of the 9th Exhibition of the Council of Europe, Athens, 1966, 123–147.

"The Byzantine Contribution to Western Art of the Twelfth and Thirteenth Centuries," *Dumbarton Oaks Papers*, 20 (1966), 25–47, 265–266.

"The Cross of Cerularius: An Art-Historical Comment," *Dumbarton Oaks Papers*, 21 (1967), 243–249.

Introduction, *Handbook of the Byzantine Collection*, Washington, D. C. Dumbarton Oaks: 1967, 9–17.

"On the Interpretation of Stylistic Changes in Late Antique Art," *Bucknell Review*, 15/3 (December, 1967), 1–10.

Review of H. P. L'Orange, *Art Forms and Civic Life in the Late Roman Empire*, in *Art Bulletin*, 49 (1967), 350–351.

Review of G. B. Ladner, *Ad Imaginem Dei: The Image of Man in Mediaeval Art*, in *Speculum*, 43 (1968), 355–359.

Review of V. Lazarev, *Old Russian Murals and Mosaics from the XI to the XVI Century*, in *Art Bulletin*, 50 (1968), 288–292.

Review of F. W. Deichmann, *Repertorium der christlich-antiken Sarkophage*, I, *Rom und Ostia*, in *Jahrbuch für Antike und Christentum*, 11–12 (1968–1969), 191–198.

Review of H. P. L'Orange and P. J. Nordhagen, *Mosaics* in *Cahiers de Civilisation médiévale*, 12 (1969), 321–322.

Review of *Der Stuttgarter Bilderpsalter* in *Art Bulletin*, 51 (1969), 393–397.

"Paul Atkins Underwood (1902–1968)," *Dumbarton Oaks Papers*, 23–24 (1969–1970), 1–4.

"The Threshold of the Holy Shrine: Observations on Floor Mosaics at Antioch and Bethlehem," *Kyriakon*, Festschrift Johannes Quasten, ed. P. Granfield, Münster i. W.: Aschendorff, 1970, Vol. II, 639–647.

"Byzantium and the West in the Second Half of the Twelfth Century: Problems of Stylistic Relationships," *Gesta*, 9 (1970), 49–56.

(Co-editor with F. Mütherich): Wilhelm Koehler, *Buchmalerei des frühen Mittelalters, Fragmente und Entwürfe aus dem Nachlass*, Munich: Prestel, 1972.

"The Gregorian Reform and the Visual Arts: A Problem of Method," *Transactions of the Royal Historical Society*, 5th series, 22 (1972), 87–102.

"The First Mosaic Decoration of Salerno Cathedral," *Jahrbuch der Österreichischen Byzantinistik*, 21 (1972) = Festschrift für Otto Demus zum 70. Geburtstag, 149–162.

"World Map and Fortune's Wheel: A Medieval Mosaic Floor in Turin," *Proceedings of the American Philosophical Society*, 117/5 (1973), 343–373.

"Observations on the Samson Floor at Mopsuestia," *Dumbarton Oaks Papers*, 27 (1973), 133–144.

Review of L. Budde, *Antike Mosaiken in Kilikien*, I and II in *Art Bulletin*, 55 (1973), 140–142.

Preface to *Corpus des mosaïques de Tunisie*, codirectors M. A. Alexander and M. Ennaifer, Vol. I, fascicle I, Tunis, 1973, vii–ix.

"A Pair of Silver Book Covers in the Sion Treasure," *Gatherings in Honor of Dorothy E. Miner*, eds. U. McCracken, L. and R. Randall, Baltimore: Walters Art Gallery, 1974, 3–17.

"A Fourth Century Mosaic Floor in Pisidian Antioch," *Mansel'e Armagan: Mélanges Mansel* [Arif Müfid Mansel], Türk Tarih Kurumu Yayinlari Dizi VII-Sa. 60, Ankara, 1974, Vol. I, 385–395.

"Christus und die zwölf Apostel," *Das Einhardkreuz*, Vorträge und Studien der Münsteraner Diskussion zum arcus Einhardi, ed. Karl Hauck, Abhandlungen der Akademie der Wissenschaften in Göttingen, Philologisch-Historische Klasse, 3. Folge, Nr. 87, Göttingen, 1974, 82–92.

"The Date of Philagathos' Homily for the Feast of Sts. Peter and Paul," *Byzantino-Sicula* II, *Miscellanea di scritti in memoria di Giuseppe Rossi Taibbi*, Istituto Siciliano di Studi Bizantini e Neoellenici, Quaderni 8, ed. B. Lavagnini, Palermo, 1975, 301–306.

"The Role of Miniature Painting in Mural Decoration," *The Place of Book Illumination in Byzantine Art*, ed. K. Weitzmann, Princeton: Princeton University Art Museum, 1975, 99–142.

INDEX

The page numbers in this index refer to the page numbers at the foot in this volume. Illustrations are indexed by figure number and page number. An attempt has been made to include in this index cross references to works of art whose geographical location has changed since they were published by the author and to writers whose names have changed since he mentioned them in his texts or footnotes.—EDITOR.

Jerusalem—Cont.

 saics of 164, 166, Fig. 9 (p. 214); Holy Sepulcher, copies of 111; Palestine Archaeological Museum, carved marble slabs 5; Praetorium of Pilate, image of Christ 102–3, 111, 122; Sion Church, Column of the Flagellation, image of Christ 110–1, 119, 121–2; tapestry of Christ and Twelve Apostles 103, 121–2

Jews: conversion of 303; policy on images 135–6, 138

Job: 343

Joel, prophet: image of 296, 299

John VII, Pope: art of 188, 197, 239, 260; portrait of 260

John Moschus: *Pratum Spirituale* 103–5, 107, 113, 124

John of Antioch: chronicle of 108

John of Damascus: writings of 97, 103–5, 107, 113, 120, 129–30, 147, 151, 154–5, 242

John of Salonica: 99, 141, 145, 148, 182

John the Faster, Patriarch of Constantinople: *See* Photinus

John the Monk: 140

Jonah: image of 328

Joseph: Dream of 296–7; and Anne 296

Joseph the Stylite: 129

Joshua: image of 296

Julian of Atramytion: opposition to sculpture 100–1, 137–9, 141, 144

Julian the Apostate, Emperor: 96, 154; use of Herodotus' story of footbath of Amasis 137

Junius Bassus: *See* Rome: St. Peter's

Justin I, Emperor: 136

Justin II, Emperor: 132, 136, 160; artistic policy of 133, 199. *See also* Rome: St. Peter's, Treasury

Justinian I, Emperor: art of 49–51, 59–60, 63–74, 180, 372–3; coinage revived by Emperor Constantine IV 189; law of 129; policy on church decoration 133

Justinian II, Emperor: coins of 132, 176, 189, 261–3, Figs. 21a (p. 225), 21b (p. 225), 5 (p. 268), 6 (p. 268), 7 (p. 269); image of 132

Kabr Hiram: St. Christopher, floor mosaic of 49, 52, 57, 62, 190, 353

Kähler, H.: 159

Kampia (Greece): Ionic impost capital 34, Fig. 2 (p. 43)

Kantorowicz, E. H.: 107, 113, 300–2, 304

Karlik: floor mosaic of 328

Kaufmann, C. M.: 123

Kautzsch, R.: 34, 179

Kendrick, T. D.: 164

Khaldé (Lebanon): Christian basilica, floor mosaics of 71

Khirbat al Mafjar (Jordan): palace 164, 190–1

Khirbet et-Tannur (Palestine): 187

Kier, H.: 328–9, 332, 338–9, 344, 354–5

Kiev: Museum of Western and Eastern Art, icons from Mount Sinai 240, 244–5, Fig. 9 (p. 255); St. Cyril, frescoes of 298, 302; St. Michael, mosaics of 277; St. Sophia, mosaics of 293, 298

Kildare (Ireland): church 198

Klauser, T.: 18, 111, 129

Klimova: shepherd plate from 163

Klosterneuburg (Vienna): altar of 370–1, Figs. 15 (p. 382), 18 (p. 383), 20 (p. 383)

Kluge, N. K.: 176–8, 181–2

Koch, H.: 92, 96

Koch, L.: 131, 134, 150, 324–5

Koehler, W.: 368–9

Kollwitz, J.: 3–4, 16–7, 20, 24, 193, 196–7, 199, 201

Kondakoff, N. P.: 177, 183–4, 362

Konrad III, King: 311

Korykos (Turkey): floor mosaic of 328

Kraeling, C. H.: 64, 70, 72, 184, 193

Krautheimer, R.: 111, 282

Krueger, G.: 106, 130

Krumbacher, K.: 103, 105, 114, 118

Kruse, H.: 97, 128, 130, 242

Kubler, G.: 34–5

Kurbinovo (Yugoslavia): St. George, frescoes of 278, 362, Fig. 5 (p. 380)

Labarum: 96, 132

Laborde, L. de: 185

Ladner, G.: 134, 141, 146–7, 256–7, 324

Lamb of God: image of 294, 297, 300

Laon: Bibliothèque Municipale, Cod. 422 (Isidore of Seville, *De natura rerum*) 342–3; Cathedral 385, Fig. 29 (p. 386)

Laourdas, B.: 250

Lassus, J.: 12

Last Judgment: image of 299–300, Fig. 30 (p. 386)

Last Supper: *See* Christ: Last Supper

Lauraton: 130, 242

Lavagnino, E.: 233

Lavin, I.: 69

Medina: mosque 167

Megalopsychia: See Antioch-on-the-Orontes: Yakto

Megaw, A. H. S.: 364, 369

Meleagar: *See* Leningrad: Hermitage

Melos: marble slabs from 5, 9

Memphis: image of Christ 103, 119–20, 242

Menges, H.: 151, 155

Mensa: 8–9, 11–2

Mensurae: 111, 114

Mercati, J. M.: 147

Mercati, S. G.: 133, 199

Mesarites, Nicholas: 199

Mesnard, M.: 198

Messina: S. Salvatore, document dated 1131 323

Metalwork: beaded rim in 7–8; Byzantine style of 160, 165, 189; hallmarks on 108, 159–62, 174–5, 189–90; of Meuse valley 359, 370, 372–3; shrines 370–1; silver platters 8; 'silver with five stamps' 108. *See also* Icon

Methodius of Olympos: Treatise on the Resurrection 97

Mettlach: sigma-shaped table at 15

Meuse valley: *See* Metalwork

Micha: image of 296

Michael III, Emperor: 132

Michon, E.: 5–7, 10, 15

Milan: Ambrosiana, Cod. A.220.Inf. 343; Castello Sforzesco, ivory plaque of Holy Women at the Sepulcher 22, 161; S. Ambrogio, S. Vittore Chapel, mosaics of 258–9; S. Lorenzo, Sant'Aquilino Chapel, mosaics of 184

Mileševo (Yugoslavia): church, frescoes of 302, 363

Millar, E. G.: 347

Miller, K.: 339–42, 344

Millet, G.: 256–7, 278, 296

Minucius Felix: *Octavius* 95, 146

Mirabilia Urbis Romae: 248

Miracula S. Demetrii: 182

Misis: *See* Mopsuestia

Mission of the Apostles: *See* Apostles

Mistra (Greece): 256–7

Modes: *See* Artistic modes

Mommsen, T. E.: 258

Monachos, Georgios: Chronicle of 250

Monophysites: 126; religious imagery of 137

Monreale (Sicily): Cathedral 297, 303–5, 369–70, Figs. 13 (p. 316), 24 (p. 319),

10 (p. 381), 12 (p. 382), 16 (p. 382), 19 (p. 383)

Monte Cassino (Italy): monastery 275–6, 278, 292, 310–1, 332, 367, Biblioteca, Cod. 99 278, Fig. 7 (p. 289), Cod. 189 345–6, Fig. 13 (p. 345), Cod. 280 292; Byzantine artists at 279, 282–3; St. Martin 279

Montoire: St. Gilles 300

Mopsuestia (Turkey): basilica, floor mosaics of 68, 328

Morey, C. R.: 65, 68, 164–6, 177, 180, 191, 193–4, 233, 237

Moscow: Museum of Fine Arts, ivory plaque of Emperor Constantine VII Porphyrogenitus 323–4; Tretyakov Gallery, icon of the Annunciation 235

Moses; cult of 58; Miracle of Fig. 33 (p. 387)

Moss, C.: 130

Motif books: *See* Sketchbooks

Mount Athos: *See* Athos

Mount Nebo: *See* Nebo

Mount Sinai: *See* Sinai

Mshatta (Jordan): 164

Muentz, E.: 367

Munich: Bayerische Staatsbibliothek, Cod. 4453 (Gospel Book) 325, Cod. 4456 (Sacramentary) 325, Cod. lat. 4660 (Carmina Burana), 347, Fig. 15 (p. 347); Bayerisches Nationalmuseum, ivory panel 22

Muñoz, A.: 173

Murano: S. Donato, floor of 338

Naples: Baptistery, mosaics of 281; early liturgy of 18

Naqsh i Rustam: Sasanian reliefs of 37

Narbonne: image of Crucified Christ 107

Nativity of Christ: *See* Christ: Nativity of

Naukratios of Nicaea: 168–72

Nea Anchialos (Greece): Basilica A, marble slabs 5; table slabs 13

Nebo, Mount: 190; sigma-shaped slab from 14

'Neo-classicism': *See* Gothic

Neoplatonism: 123, 143, 152, 202, 353

Nereditsa (Russia): frescoes of 294–5, 298–9

Nerezi (Yugoslavia): St. Panteleimon, frescoes of 361, Figs. 3 (p. 379), 4 (p. 380)

Neuss, W.: 340–2

New Testament: illustration of 6, 192–3, 195, 292. *See also* Palestine

Statue: crowning of 97; made animate by human action 152

Stavelot: *See* New York, Pierpont Morgan Library

Stephen II, Pope: 121, 240

Stephen of Bosra: 147

Stern, H.: 74, 170, 197, 329, 353, 355

Stillwell, R.: 64

Stobi (Yugoslavia): sigma-shaped table from 14

Stornajolo, C.: 342

Strzygowski, J.: 10–2

Stubblebine, J.: 367, 375–6, 378

Studenica (Yugoslavia): Church of the Virgin 363, Fig. 6 (p. 380)

Stuma: *See* Istanbul: Archaeological Museum

Style: abstract, in Byzantine art 158, 184–8, 195, 201–2, 204, 263, 361; and cult of images 204, 246; as iconographic attribute 203, 261–2; Byzantine (*see* Byzantine art; *Byzantinische Antike*; Perennial Hellenism; Theodosius I, art of); classical (*see* Style, Hellenistic); Comnenian 235, 277, 360–2 (*see also* Style, 'dynamic' phase); Coptic 194, 240–1; correlation with social, religious, and intellectual phenomena 37–9, 196–7, 201–5, 246–7, 263, 283; 'dynamic' phase in Byzantine art 361, 369, 371, 374; functional approach to 195, 200–2; Hellenistic, in Byzantine art 158, 163–4, 175, 177, 179, 186–8, 193, 234, 257, 263, 361; in early medieval art of Rome 134–8, 172–4; 'inner-directed' change 35, 38, 40–1; 'neo-hellenistic' 361; 'other-directed' change 34, 38, 41; Palaeologan 362–3, 375; 'Pompeian' survival in Byzantine art 186, 234, 236; 'rainbow' 70; source of change in 32–41, 247; sub-antique 37–8. *See also* Alexandrian style; Artistic modes; Asiatic abstraction; Garments; Gothic; Impressionistic techniques; Macedonian Renaissance; Metalwork; Perennial Hellenism; Volume-style; 'Zackenstil'; Zeitgeist; Zeitstil

Stylite saints: and rise of image worship 100, 123

Suger, abbot: 310–2

Sumptuary arts: of Byzantium 364

Sutherland, C. H. V.: 262

Swarzenski, H.: 370, 374

Symmachus, Q. Aurelius: 21–3, 33; ivory diptych of 22, 33, Fig. 1 (p. 42)

Synnaoi: of St. Demetrius 181

Syria: art of 165–7, 175, 185–7, 189–94; expressionism in art of 175, 191, 193–4; New Testament iconography of 24

Tabgha (Palestine): Church of the Multiplication of the Loaves and Fishes, floor mosaics of 54, 59, 72, Fig. 17 (p. 86)

Tables: functions of 7–9, 11–3; marble tops 1–25, Figs. 7 (p. 28), 8 (p. 28), 12 (p. 29); sigma-shaped tops 6, 8–10, 12, Fig. 8 (p. 28)

Tabulatum: 198

Tarragona (Spain): tomb at 9

Taurinum: 344

Tébessa (Algeria): basilica, baptistery of 14, Fig. 16 (p. 30)

Tebtunis: church, sigma-shaped slab of 12–4, Fig. 17 (p. 30)

Tegea (Greece): floor mosaic of 58

Tekali: silver relief from 372

Tertullian: 147; remarks on images of the Good Shepherd 92

Tetrarchs: image of 37–8, Fig. 10 (p. 48)

Theodore, abbot in Cilicia: 113

Theodore, bishop of Aquileia: 327

Theodore, presbyter of Mount Sinai Monastery: 185

Theodore of Andida: 295

Theodore Synkellos: 118

Theodore the Studite: defense of images 147, 155

Theodoretus: *Religiosa Historia* 100, 123

Theodosius I, Emperor: art of 3–25, 193, 258; revival of art of 162–3, 193

Theodosius II, Emperor: Code of 97, 129; edict prohibiting images of 'sign of Christ' 327

Theodosius, bishop of Caesarea: 105

Theodosius, pilgrim: 111, 119

Theodotus, chapel of: *See* Rome: S. Maria Antiqua

Theophanes: *Chronographia* 108, 117, 133, 137, 199, 324

Theophanes Kerameus: *See* Philagathos

Theophilus, bishop of Alexandria: Coptic sermon falsely claiming its author as 107–8

Theophilus: *De Diversis Artibus* 364

Theophilus, Emperor: 116, 126